Monet, Narcissus, and Self-Reflection

Monet,

Narcissus,

The University of Chicago Press *Chicago and London*

and Self-Reflection

The Modernist Myth of the Self

Steven Z. Levine

Steven Z. Levine is the Leslie Clark Professor in the Humanities and professor of the history of art at Bryn Mawr College. He is the author of *Monet and His Critics*.

The University of Chicago Press, Chicago 60637
The University of Chicago Press, Ltd., London
© 1994 by The University of Chicago
All rights reserved. Published 1994
Printed in the United States of America
03 02 01 00 99 98 97 96 95 94 1 2 3 4 5

ISBN: 0-226-47543-3 (cloth)
 0-226-47544-1 (paper)

Library of Congress Cataloging-in-Publication Data

Levine, Steven Z.
 Monet, Narcissus, and self-reflection : the modernist myth of
 the self / Steven Z. Levine.
 p. cm.
 Includes bibliographical references and index.
 1. Monet, Claude, 1840–1926—Criticism and interpretation.
 2. Narcissism in art. 3. Subjectivity in art. 4. Self (Philosophy).
 5. Water in art. I. Monet, Claude, 1840–1926. II. Title.
 ND553.M 7L49 1994 94-1105
 759.4—dc20 CIP

Contents

Preface and Acknowledgments

N<small>ARCISSUS IS THE ENDURING</small> W<small>ESTERN FIGURE</small> of male self-reflection, and in this book I use the myth of Narcissus as a means of reflection on the water paintings of Claude Monet.[1] During the eight decades of the artist's career, from 1858 to 1926, representations of Narcissus are increasingly visible in the painting and sculpture, poetry and prose, and philosophical and psychological speculation that together comprise the varied contexts for my readings of Monet's life and work.[2] In the course of these readings I do not seek to offer a continuous psychobiography of the artist, a comprehensive iconographical or formal analysis of his art, or a consistently sociohistorical account of its production and reception; but in appealing to each of these familiar narrative forms at various points in my text I make extensive use of the personal correspondence of the artist and the critical reviews of his art that provide the common basis for our art-writing task.[3]

In these readings I reflect on the life and works of Claude Monet only insofar as I take these elements to constitute fragments of the modernist discourse on the self, specifically on the European, bourgeois, masculine self of the last two centuries.[4] During Monet's long career—and precisely in and around the painter's and his critics' accounts of his work—the very notion of an individual self, its capacities and its limits, undergoes the massive discursive consolidation and interrogation that we have in our turn inherited in our so-called "culture of narcissism."[5] Many writers across the disciplines have become interested in the historical sources of this modernist sense of self in both its positive forms of self-mastery and its negative forms of self-doubt.[6] Largely inspired by the genealogical studies of our current practices of the self undertaken by the late Michel Foucault,[7] these writers have begun to recount a series of compelling stories regarding, on the one hand, the self's rise to dominance in the epistemology and social theory of the Enlightenment and in its rationalist and utilitarian aftermath and, on the other hand, regarding that same self's parallel fall from grace at the hands of a host of romantic and postromantic critiques.[8] Psychoanalysis is merely one such critical idiom in which this modernist melodrama of self-constitution and self-dissolution has come to be explicitly staged,[9] but it will be its conflictual metaphor of self-reflection that will furnish the reiterated rhetorical framework for much of what will follow here.[10]

From Freud to Ovid, and, in France, from the *Roman de la Rose,* Pierre de Ronsard, and Jean-Jacques Rousseau to Jacques Lacan, Julia Kristeva, Jacques Derrida, and Maurice Blanchot,[11] the myth of Narcissus embodies the precarious and ambivalent coupling of charmed self-love (*philautia, amor sui, amour de soi*) and disenchanted self-knowledge (*gnothi seauton, nosce te ipsum, connaissance de soi*).[12] In the emblematic form of the image handed down from Andrea Alciati in the sixteenth century to Honoré Daumier in 1842, the self-mirroring Narcissus epitomizes the scholar who forsakes the wise ways of his elders to dwell instead upon the insubstantial glimmerings of his own meager reflection (figs. 1–2).[13] For me this means forsaking the well-trodden paths of Michael Fried, my respected teacher, and Timothy Clark, his vigorous interlocutor, with regard to their much-publicized dispute on the workings of modernism.[14] Very crudely put, their antagonistic positions dramatize the split within the art-historical community today between a strategy of writing that is convinced of the potential fullness of self-presence in the face of the modernist work of art and a countervailing strategy that argues with equal rhetorical force for the emptiness of any such private aesthetic meditation in view of art's alleged alienation under the commodified conditions of capital. In refusing to choose between these nonambivalent alternatives of Enlightenment faith in art and romantic doubt in its efficacy, I present my own reflections on Monet and Narcissus as but one provisional form of dramatizing this theatrical and theoretical impasse.[15] Against both these species of that "transcendental pretense" whereby the assertion is made that "the structures of one's own mind, culture, and personality are in some sense necessary and universal for all humankind,"[16] I seek to affirm the radical disparity of response to an art such as Monet's not only between individuals of diverse ideology, class, race, ethnicity, gender, generation, and so forth, but also, and more important, *within* such individuals—from Monet and his first critics down to me and to you and to those who are still to come.[17]

As a graduate student at the Fogg Art Museum more than twenty years ago I was daily struck by the continuities and discrepancies between two adjacent paintings of a seaside cabin painted across a fifteen-year gap in Monet's visits to the site (figs. 92–93).[18] Here was my first bewildered sense of a personal and cultural inertia in Monet's art which lurked beneath the veneer of stylistic change. This book is the arduous playing out of an argument for which I then lacked tractable tools and terms, but at the same time it is also the record of my own anxious obsessiveness in sticking to these loved and loathed pictures through years of personal, professional, and cultural change. In his obsessive repetitions of a watery dream the

Monet you will encounter here also mirrors me. And the ambivalence of his and my self-reflection suggests to me that the mirror is often, even always, cracked.

In the opening chapter I make an initial effort to associate Monet and Narcissus by way of the poet and critic Charles Baudelaire, who wrote about the small marine sketches of Monet's first mentor, Eugène Boudin, at the Salon of 1859. Marine painting and mythology are further juxtaposed in the response during the 1860s by critic Théophile Thoré to the work of Gustave Courbet, another of Monet's major mentors. In Baudelaire's treatment the legend of Narcissus principally serves as a warning against the meretricious allure of outward appearance; in Thoré's writing, however, the latent allegorical associations of myth are generally seen to supplement a certain lack in the manifest appearance of the world.

In chapter two I attend to Monet's water landscapes of the 1870s in view of the alternative interpretations of Narcissus: on the one hand he is seen as an immature creature foolishly infatuated with a mere image, on the other hand, as a mature individual who somberly reflects on the material conditions of his transient self-embodiment. An encyclopedic article by Pierre Larousse lays out the range of the myth's meanings at this time, and the practical rigors of self-reflection are further addressed in the will-subduing philosophy of Arthur Schopenhauer, introduced into the impressionist context in 1878 by Monet's friend Théodore Duret.

In his enthrallment by an ideal image and in his subsequent grief for its loss Narcissus turns away from the proffered love of the nymph Echo; in turn she withers away into the silence of stone. In 1879 Monet's first wife, Camille Doncieux, died; no letters to or from her have survived, but Monet's ensuing liaison with his eventual second wife, Alice Hoschedé, generates the intimate context of correspondence which forms the reiterated and conflictual basis for chapters three through thirteen. In chapter three I trace Monet's return to the sites of his youthful origins along the Normandy coast, the myth of Narcissus turning at this point into a generalized metaphor for the artist's obsessive self-absorption in the verbal and visual aspects of his pictorial enterprise. Monet's critics increasingly speak to the issue of whether and to what effect the painter manifests himself in his art, with Monet's friend Philippe Burty emphasizing the theme in chapter three and the young critic Paul Guigou carrying it forward in chapter four, where I treat Monet's first Riviera campaign.

In chapter five Monet is back in Normandy at Etretat, where Courbet had painted before him and where the posthumous burden of that father-like authority continued to constrain his own belated efforts. A suicidal

scenario by the sea overcomes Monet at this time, and the narcissistic themes of bodily finitude and the incorporation of loss are adumbrated in the painter's letters as well as in the critical responses to his work by the writers Félix Fénéon, Celen Sabbrin, and Guy de Maupassant. The sublime acknowledgment of human limitation is further considered in chapter six, where I focus on the storm-tossed paintings of Belle-Ile.

In chapter seven I move from the death-laden imagery of the Atlantic Ocean to Monet's tranquilly unnerving representations of the Mediterranean at Antibes. Maupassant's soliloquy on solitude at sea serves as the rhetorical frame for the Riviera sites which he shared with his friend Monet. In chapter eight it is Monet's much closer friend Octave Mirbeau who articulates the vexed discourse of the autonomous, anarchic self which structures the remainder of the book. Monet finds a self-professed neurotic companion for his worried practice of self-reflection in the person of poet Maurice Rollinat, whose remote home in central France sets the stage for Monet's series of the Creuse River, treated in chapter nine. The Creuse paintings were featured in the large retrospective exhibition which Monet shared with his friend Auguste Rodin in 1889, the year of the Paris World's Fair. Also featured there was a group of figure paintings of women and water, which I discuss in chapter ten where I utilize the rigorously self-reflexive poetry of Monet's friend Stéphane Mallarmé as my guide.

In the course of chapters three through ten the figure of Narcissus only intermittently appears, but the myth is scarcely absent from the book thereafter. In chapter eleven I look at Monet's paintings of poplars on the Epte River in 1891 in the mirror of the contemporaneous Narcissus poems of Paul Valéry, André Gide, and Camille Mauclair. All three were followers of Mallarmé as well as commentators or acquaintances of the painter; so too were Henri de Régnier, Joachim Gasquet, and, once again, Maurice Rollinat, whose literary representations of Narcissus provide the rhetorical apparatus of chapter twelve through which I focus on Monet's 1897 series of *Mornings on the Seine.*

Monet's several series of *Water Lilies* at Giverny comprise the pictorial matter for chapters thirteen through fifteen, in which the double discourse of Narcissus and narcissism is extended into the generation of Sigmund Freud.[19] Rémy de Gourmont, Roger Marx, Louis Gillet, and Monet's biographer Gustave Geffroy articulate a parallel discourse on the self to that of the psychoanalyst in which its putative status as imaginary or real, empty or full, is repeatedly put at stake. With Monet's death in 1926—the subject of the final chapter as seen across the account of the artist's late self-portrait by his close friend, French Premier Georges Clemenceau—we are already

on the threshold of the psychoanalysis of Jacques Lacan, and it is generally my claim throughout this book that the familiar psychoanalytic metaphors of Narcissus and self-reflection provide a means of representing something troubling and compelling in and around the water paintings of Claude Monet.

In representing Monet as Narcissus I am of course projecting my own narcissistic absorption in the antinomies of self-reflection upon an artist who does not here speak for himself, however much I may repeat his words. In this respect I am Echo too, the female voice condemned first to repetition and then to silence as the living body of her would-be lover is transformed into a funereal flower before her very eyes.[20] If in repeating what others have said I acknowledge the impossibility of speaking for Monet himself I nonetheless do so in my own translation, turning nineteenth-century French into twentieth-century English precisely so as to give body to the irreducible interpretative gap that lies (in both senses) at the center of this art-historical work.[21]

Many institutions and individuals have either facilitated or impeded this overlong labor first sketched out at Bryn Mawr College in a lecture on Monet and Narcissus in 1979. Michael Fried has been generously supportive of my work on numerous occasions, and my parents, Reevan and Natalie Levine, have been lovingly supportive throughout. At the Institute for Advanced Study in 1980, under the auspices of Irving Lavin and the Samuel H. Kress Foundation, I had the benefit of the challenging critique of T. J. Clark prior to speaking on Monet and Narcissus at the College Art Association in a panel on modern art and mythology chaired by Frederick Levine. In 1982 the National Endowment for the Humanities funded a summer trip to France, where I was treated with great courtesy by Rodolphe Walter of the Fondation Wildenstein and Gérard van der Kemp of the Musée Claude Monet at Giverny. That same year Thomas and Barbara Gaehtgens invited me to the Free University of Berlin, Nancy Davenport to the Philadelphia College of Art, and Keith Moxey and David Summers to the University of Virginia to deliver a further chapter of my story, which Ralph Cohen of *New Literary History* later published. In 1983 Donald Fritz invited me to present my myth of Narcissus at a conference on narcissism, "The World as Mirror," at Miami University, and at the College Art Association Donald Preziosi permitted me to address the discourse of gender in nineteenth-century France in a paper entitled "*Ut pictura amor:* Love and Painting in 1859." In 1984 Wendy Steiner offered me the rigorous interdisciplinary audience of her National Endowment for the Humanities summer seminar on literature and art. Mary Mathews

Gedo encouraged me to publish two papers on Monet and narcissism in *Psychoanalytic Perspectives on Art* in 1985 and 1987, and a third appeared in *October* in 1986 thanks to the invitation of Rosalind Krauss, in whose College Art Association panel on repetition I had been very pleased to participate.

My own College Art Association panel on art and psychoanalysis in 1987 gave me a chance to further clarify my views in exchanges with Michael Fried, Jack Spector, and Ellen Handler Spitz, among others, and throughout this past decade Henry Eisner of the Philadelphia Association for Psychoanalysis has offered me the occasion of an annual seminar in which my approach to Monet as well as other topics of art and psychoanalytic theory has been submitted and resubmitted to highly useful critical response. Nina Athanassoglou-Kallmyer and Larry Lutchmansingh invited me to speak on "Monet's Eye/I" at the University of Delaware and at Bowdoin College in 1986–87, and Rochelle Kainer and Martin Rubel gave me the daunting task of addressing the Washington Society of Psychoanalytic Psychology and the Philadelphia Psychoanalytic Society in 1990 and 1994. In speaking at these venues over the years, and especially in writing a précis of this book for Norma Broude's Rizzoli Art series in 1993, I began to discover what my Monet was all about.

In 1991 and 1994 I spoke on Monet and Narcissus at Villanova University and Temple University at the invitation of my former students Mark Sullivan and Thérèse Dolan, and let my thanks to them extend to all my students and colleagues at Bryn Mawr College who have endured the repetition of my story since 1975 and to whom I am unrepayably in debt. In the difficult process of reducing a doubly long manuscript to the shape that is offered here Karen Wilson of the University of Chicago Press showed great forbearance in the face of my very considerable frustration, and Richard Shiff provided the Press with a sympathetic reading that both clinched the publication and showed me aspects of my text that I had not adequately stressed. I am very grateful to him. During the penultimate stages of revision Judith Shapiro, provost of Bryn Mawr College, provided the invaluable gift of time released from teaching, and Mary Campo, secretary of the departments of art, archaeology, and cities, performed the material miracle of turning draft upon draft upon draft into a final, if still provisional, text. Carol Saller edited the text with great care and attention, and Kathryn Casey supportively shared the tasks of proofreading and indexing with me. Charles Stuckey and Paul Tucker offered useful advice on the procuring of photographs, and Maya Hoptman pursued them with dogged determination; their expense was generously underwritten by the Bryn Mawr College Faculty Research Fund.

Almost twenty years at Bryn Mawr College have not inured me to the masculine dilemma of speaking within a feminist frame of reference,[22] so it is to my wife Susan and daughter Madeleine that I dedicate this effort not to seek to echo their pleasure or their pain but merely to reflect upon my own. Suspended over an image in these pages I am Narcissus; separated from the sources of these words I am Echo as well. Or perhaps not.[23]

1

Baudelaire and the Error of Narcissus (1859–70)

IN HIS REVIEW of the Salon of 1859 Charles Baudelaire insists that the photographic reflection of nature will bring about the suicide of art. The allegorical figure of this self-destruction is Narcissus, the boy who dies through the fatal allure of the visual image. In Baudelaire's version of the myth, the photographic emulsion replaces the reflecting pool: "From this moment on this vile society rushed, like a single Narcissus, to contemplate its trivial image on the metal. . . . A short while later, thousands of avid eyes bent over the holes in the stereoscope as over the skylights of infinity. The love of obscenity, which is as perennial in the natural heart of man as is his love of self, did not let escape such a fine occasion for satisfaction."[1] Photography, pornography, and naturalistic painting are all united in Baudelaire's scenario of Narcissus. Here Baudelaire follows the traditional interpretation of the myth, according to which the superficial charm of physical appearance is foolishly embraced at the expense of the invisible grace of self-transcendence.

In his polemic against art as imitation, Baudelaire invokes Narcissus in order to indict the cultural narcissism of his society.[2] He turns the myth against the pompous self-importance of a manufacturer of vaccine: "This fat pock-marked sir poses like Narcissus, / And each of his fingers has the look of a sausage"; and of the prostitute and pimp who comprise standard types for the critical gaze of the painter of modern life he is equally brutal: "These two creatures do not think. Is it even certain that they look, unless, Narcissuses of imbecility, they contemplate the crowd like a river that reflects their own image."[3] Like Narcissus at the pool they are transfixed by the allure of outward display and fail to see that human worth lies elsewhere.

Art is art, for Baudelaire, by virtue of its capacity to communicate the self-transcending responses that nature may elicit from the beholder. To postulate a world without thoughtful observers is to assassinate the contemplative agency that alone redeems art from crass materiality by virtue of "comparison, metaphor, and allegory."[4] For Baudelaire art is a system of correspondences through which the substance of the world, psychological experience, poetic utterance, and pictorial representation are bound indissolubly in an ideal unity of meaning.

For Baudelaire in 1859, the art of Claude Monet's mentor Eugène Boudin marks a limit in the capacity of naturalistic representation to project a world of human value. Alone among the critics of 1859, Baudelaire devotes a lengthy passage to Boudin's little pictures of the sea. There was a painting by Boudin on view in Paris—his first Salon entry—but this was a conventional Breton scene ("bon" and "sage" Baudelaire calls it) showing an outdoor religious folk-ritual.[5] What attracts the poet to Boudin's art is not this Salon machine but the hundreds of sea and sky studies that Baudelaire could only have seen at the artist's studio in Honfleur (fig. 3).

In keeping with the picture-sketch dichotomy that had traditionally organized the discourse of Salon criticism, Baudelaire assumes that Boudin's abbreviated images would ultimately be transformed into finished works of art: "It is necessary that all this become a picture by means of the poetic impression recalled at will." Only an act of emotion recollected in tranquillity could validate the painter's ephemeral record of "the prodigious magic of the air and the water." In spite of his adamance regarding completion Baudelaire concedes his attraction to Boudin's sketches: "In the end all these clouds of fantastic and luminous form, these chaotic glooms, these green and pink immensities suspended and added one to the others, these gaping furnaces, these firmaments of black or violet satin, crumpled, rolled, or torn, these horizons in mourning or streaming with molten metal, all these depths, all these splendors, mounted to my brain like a heady drink or like the eloquence of opium."[6]

The absorption of alcohol and opium may be conducive to the sort of visual splendors that Baudelaire conjures up in front of Boudin's pictures, but for such pleasures a heavy price is extorted: "Shall I add that hashish, like all solitary joys, renders the individual useless to others and society superfluous for the individual, pushing him ceaselessly to admire himself and precipitating him day by day toward the luminous gulf where he admires his face of Narcissus?"[7] In spite of this denunciation, elsewhere in the same essay Baudelaire celebrates the drug-induced experience of

interiority in language that is reminiscent of his response to Boudin's sea-scapes: "It is . . . to this essentially voluptuous and sensual phase that must be related the love of limpid, running, or stagnant waters, which develops so astonishingly in the cerebral intoxication of some artists. Mirrors become a pretext for that reverie that resembles a spiritual thirst. . . ; fleeting waters, fountains, harmonious cascades, the blue immensity of the sea roll, sing, sleep with an inexpressible charm." As in the case of the admired and abjured paintings, Baudelaire ends this passage with an affirmation of the danger to be incurred in the "contemplation of a limpid gulf."[8]

Baudelaire's intoxicated vision of Boudin's pictures of water and air is characteristic of the romantic ideology we find in the painter's own journals: "To swim in the open sky. To achieve the tenderness of clouds. To suspend these masses in the distance, very far away in the gray mist, to make the blue explode. I feel all this coming, dawning in my intentions. What joy and what torment!"[9] In addition to the anxious idealism which Boudin shares with the poet he too remains imprisoned by the prevailing convention of the completed picture.

In Baudelaire's critical view "nature without man" is the misguided goal of the contemporary school of landscape painting in France. A first-person art of the solitary contemplator threatens the aesthetic presuppositions of Baudelaire; in the end Boudin is rather sententiously abjured from pursuing his figureless painting of water and air. Yet for all of his theoretical invective Baudelaire's expression of pleasure is no less intense: "A rather curious thing, it did not once occur to me, in front of these liquid or aerial feats of magic, to complain of the absence of man."[10]

Baudelaire's ambivalence leads to the wishful conclusion of his lengthy section on Boudin: "It is not only marine painters that are lacking, a genre nevertheless so poetic!"[11] In a letter written to Boudin from the Salon of 1859, the first which he visited, the nineteen-year-old Monet can be seen to agree with Baudelaire's assessment: "There is not a single seascape that is barely possible. . . . In sum, marine painters are totally lacking, and for you this is a path that could take you far" (3 June 1859; L. 2). As I see it, it was to be the task of Monet's career to remake into large-scale pictorial cycles the intimate allegory of water and clouds for which Baudelaire finds the first raw notes in Boudin's small-scale studies. In Monet's monumental series of water subjects the ostensible lack of narrative figuration comes to be compensated by the beholder's own appropriation of the agencies of vision, meditation, and dream. The first catalogued painting in Monet's *oeuvre* depicts a solitary observer seated above a river's reflections (W. 1; fig. 4), but soon this position within the space of narrative representation

will be adopted by the artist-spectator, whose self-reflective presence comes to be implicitly mirrored in the features of the landscape.

Although Baudelaire does not encourage such a subjective development in painting, he is already, in *Les Fleurs du mal,* the practitioner of a subjective poetry of nature: "The sea is your mirror; you contemplate your soul / In the infinite unrolling of her wave."[12] Leo Bersani suggests that the poet's invocations of the sea point to "the memory of a prenatal life in the liquid environment of the womb, of being carried along on an inner sea by the boat-mother's movements."[13] Whatever one may judge to be the utility of psychoanalytic interpretation in this regard, it remains to be explained why Baudelaire (and Monet, too, as we shall see) could speak of the sea as providing "the highest idea of beauty offered to man in his transient abode."[14]

The aquatic and erotic discourses at work in Baudelaire are by no means unique to that poet. This confluence of affect and image courses through the poetry, criticism, correspondence, and painting with which I am concerned throughout this book. In 1859 the art of Boudin provides a personal point of contact between Monet and this complex of discourses. Monet may well have read Baudelaire's critique of Boudin's work, and may even have met the poet on some unrecorded occasion in Paris or in Honfleur. We know that he owned *Les Fleurs du mal.* As for the other critics of 1859, if Monet's well-documented scrutiny of the critical press in later years is any indication, he would have probably come to know at least some of their views as well. In his detailed letters to Boudin, Monet assays the critical genre of the Salon review in order to keep his mentor in touch with events in Paris. His favorites at the Salon are the landscapists, chiefly Camille Corot and Charles-François Daubigny; it is in the context of the critical response to their art that Monet's own response to the challenge of landscape and seascape would have been framed.

From the beginning of his public career Monet has been associated with the painting of water. At his first exhibition at Le Havre in 1858 Monet is said to share "in the qualities of Boudin."[15] An inland river view was Monet's entry then, but in 1865 the painter made his debut at the Paris Salon with a pair of seascapes of the beach and estuary at Le Havre (W. 51, 52; figs. 5–6). Riverbank and seashore remained his preferred subjects for more than sixty years, and the terms of the earliest critical response to this imagery largely stayed in play throughout that time.

Monet's first significant critical notice appeared in the prestigious *Gazette des Beaux-Arts.* In the July 1865 issue, in which Monet's pictures were discussed, Champfleury published documents concerning seventeenth-

century "realist" painters, the brothers Le Nain; Charles Blanc presented a serialized chapter from his influential *Grammaire des arts du dessin;* Philippe Burty, subsequently a critical defender and personal friend of Monet, wrote on engraving, lithography, and photography at the Salon; a translation of Tintoretto's testament was published by De Mas-Latrie; and Léon Lagrange contributed his monthly bulletin of exhibition and book reviews. Much of this material might have been of interest to Monet, such as Blanc's comments on the sublimity of light and space in landscape, Lagrange's remarks on Ferdinand Hildebrandt's one-man show of three hundred watercolor landscapes, or Burty's description of a thirty-part series of landscape photographs of the Marne: "There are sunrises, mills barring the river, islands more verdant if not more deserted than that of Robinson, willows that reflect themselves in the blond crystal of the Marne."[16] But it was Paul Mantz's review of the Salon that would have attracted Monet's most careful attention.

In his analysis of landscape painting Mantz adumbrates the romantic theory according to which the artist seeks first to express an interpretation of nature—what the critic calls a dream—and then proceeds to evoke in the spectator's soul the corresponding impression. In words that later will often be used to describe Monet, Corot is proclaimed "the painter of tranquil and sleeping waters, great pale horizons, veiled skies, sleepy woods, cool dusks."[17]

Mantz also admires Daubigny for his infusion of personal feeling into the landscape. Personality is conveyed in the artist's touch, characterized as "violent, abrupt, loose" and hence "free and emancipated" in expression. Rubens and Rembrandt are invoked in order to justify Daubigny's sacrifice of the rendering of detail in favor of "the striking aspect of large wholes." Details are similarly seen to be subordinated to the effect of the whole in a large painting of a mountain torrent by Paul Huet, like Monet a resident of Normandy, who seizes things "in their violent aspect."[18]

Melancholy, memory, solitude, and violence are the themes that run through Mantz's descriptions of landscapes in 1865. Seascapes, however, are perceived as being in short supply, hence the importance of the notice that Mantz accords Monet. In his characteristic idiom of emotional projection Mantz compliments Monet's "taste for harmonious colorations in the play of similar tones, the feeling for values, the striking aspect of the whole, a bold manner of seeing things and of imposing himself upon the attention of the spectator." Nevertheless, Monet is criticized for a certain lack of finesse, a quality "that one obtains only at the price of long study."[19]

For the next Salon Monet left behind the marine genre and sought to

rival Edouard Manet's *Luncheon on the Grass* of 1863 with a still larger version of his own (W. 63). Unable to complete the work as planned, Monet exhibited instead a portrait of his mistress, Camille Doncieux, in a green silk dress as well as a landscape of the forest of Fontainebleau (W. 19, 65). Although the critics in 1866 understandably do not dwell on Monet as a painter of water, in their discussion of other artists we may find elements of the interpretation of the water imagery that is to come.

Among the critics in 1866, the most notable for my purposes is Théophile Thoré, who especially admired Monet's green silk dress, "sparkling like the stuffs of Paul Veronese."[20] The author of compelling Salon criticism during the 1840s, Thoré insists on finding discursive meaning even in the most naturalistic art, asserting that "the most spontaneous painters, devoted solely to the image without any preoccupation for the underlying thought, sometimes make pictures in which reflection may discover symbolic poems and analogies unsuspected by the author."[21] Active in radical politics, Thoré spent the decade of the 1850s in exile and returned to France only after the general amnesty of 1859. Thoré's Salon reviews of the 1860s provide an allegorical interpretation of landscape and seascape that I believe is highly pertinent to the work of Monet.

In 1861 Thoré concludes an analysis of landscape painting with an explanation of the genre's contemporary predominance. In an age of uncertainty in "ideas and feelings, philosophy and ethics, literature and the arts, the meaning of history such as the trends of the present day," the solitary artist in the landscape seems a reassuring instance of knowledge of world and of self.[22] Concerned for the subjective abuse of this knowledge Thoré calls for "naturalism mixed with humanity," an art of observation that would not be devoid of communicable meaning even though it renounces the shared iconographic signs of the past: "There are no sirens on the Seine but for the lady boaters in their smocks of sky-blue flannel."[23]

Thoré attacks the anachronistic imposition of mythology upon the modern landscape, but he also seeks something of significance to put in its place. In 1844 Thoré had ridiculed an academic landscape by Alexandre Desgoffe—"his Narcissus who admires himself in a colorless pool must find himself quite ugly, if the crystal of the water is limpid enough to cast back to him his image"—and twenty years later he still takes to task Jehan-Georges Vibert's medal-winning *Narcissus* as an inappropriate emulation of Nicolas Poussin's famous depiction of the subject in the Louvre (figs. 7–9). To thus hold to the academic ideal within oneself and not look up from one's reflection is as though to commit the error of Narcissus: "The majority of men do not think to look; they occupy themselves with

other things that stop up their eyes: when it would be necessary, on some excellent occasion, to utilize their vision, they set about reflecting stupidly. And what do they reflect? Having no image to reflect, the mirror of their brain remains like a muddled pool beneath the fog. Rather than give themselves up to a vivifying contemplation they get lost in some idea of no rapport with the situation."[24]

In 1864 Thoré praises the seascapes of Johann Barthold Jongkind, at that time perhaps Monet's most important mentor. Boudin had initially shown the young artist the secrets of sea and sky, as Monet later acknowledged, but it was Jongkind who preserved in the energetic brushwork of the finished picture what Boudin suppressed after the stage of the sketch: "There is hardly a more frank painter than M. Jongkind. His brush goes all by itself and chisels the forms of a landscape like the boldest point of an etcher. . . . It is his temperament, very impressionable, a bit brusque, strange."[25] Thoré's endorsement in the following year of Corot's watery "impressions" might also have had some resonance for Monet: "What is curious is that he has brought back from the banks of the Tiber and the lake of Nemi only his habitual fog from the banks of the Seine. . . . Some object that these are some sort of sketches, and positivistic folk would like to recognize more distinctly the essence of the trees, the form of the branches, the plane of the terrain, and the rest. But this has nothing to do with evoking in the spectator through these subtle images the feeling that he would have in the country, on a gentle morning, by the banks of a lake."[26] We will encounter much these same terms in later descriptions of Monet's art.

In 1866 Thoré does not fail to remark the work of Monet, but only as a portraitist and landscapist. In that year, however, Thoré is especially eloquent on the subject of Courbet's so-called "paysages de mer." If Jongkind's maritime art reminiscent of seventeenth-century Dutch models offers the standard for Monet's beach and harbor scenes of Honfleur and Sainte-Adresse in 1865, the Fontainebleau and Paris campaigns of the following season are carried out under the artistic aegis of Gustave Courbet. Manet's celebrated picture is certainly at stake in Monet's *Luncheon on the Grass,* but it is Courbet's own visage that finally comes to preside over the central fragment of the failed canvas (W. 63b; fig. 10). Photographs show Monet to have been a handsome young man of rather dandified manners who might well have chosen to identify himself in his painting with Courbet's much-vaunted physical beauty and artistic pride. One critic, Théophile Silvestre, went so far as to say that Courbet exhibited "no violence but that of self-love: the soul of Narcissus has come to a stop in him upon its latest

migration."[27] Whereas the older artist frequently incorporated his own image into his art, all that Monet ultimately preserved of Narcissus was the representation of his gaze.

Monet may have met Courbet as early as 1859, but by 1865 the two artists were on familiar terms. During a visit to Deauville in the autumn of 1866 Courbet invited Monet to lunch, and it is not unlikely that at some such time the two painters would have worked on channel seascapes side by side (figs. 11–12). Already during the previous year at Trouville Courbet had made a considerable quantity of paintings of sea and sky, and although he did not exhibit them at the Salon of 1866 they were well enough known for Thoré to describe them in language that is suggestive of Monet's later imagery and serial practice: "The sea fascinates him. . . . And each morning the effects of the great water and great sky always changing, each morning he makes a study of what he sees on the beach, sea landscapes, as he says. He has brought back forty of them, extraordinary in impression and of the rarest quality." In addition to the figureless marines, Thoré also describes a painting of a female sculler who was a well-known seaside figure at the time: "This beautiful young girl on an almond-wood shell, is she not as interesting to paint as Venus on her marine conch? That is not to say that tradition is proscribed or that painting may not represent history and allegory, on the condition however to allegorize as the moderns that we are, and to interpret history with a progressive sensibility, and in some sense through the introduction of permanent humanity into its variable and temporary episodes."[28] Here the allegorizing critic may be following the artist's own lead, for Courbet called the painting his "modern Amphitrite."[29]

The context of Thoré's discussion is a comparison of Courbet's *Stonebreakers* (1849) and *Woman with a Parrot* (1866), which the critic sees as twin modern allegories of rude labor and nude lassitude. Discussion of Monet's *Camille* almost immediately follows and the modern allegorical mode is pertinent here as well, for Thoré renames the painting "The Woman in the Green Dress," a sister to Courbet's undressed woman of that year. Monet himself later insisted that his painting was not simply a transcription of the particular features of his mistress but rather her transformation into a visual type of the epoch (7 May 1906; L. 1803).

In 1866 Thoré confines allegory to figure painting; the following year he extends allegory to seascape, and even though Monet, both of whose submissions to the Salon were rejected by the jury, again goes unremarked it is his mentor Courbet who occasions some of the critic's most interesting interpretations. In 1867 twenty-three recent seascapes were included in

Courbet's retrospective exhibition, which he mounted in lieu of sending anything to the Salon and anything more than a token representation to the Exposition Universelle: "In France what painter has a passion for the sea and the talent to express her effects? I know only Courbet who has made, as he says, sea landscapes of an extraordinary reality and in consequence very poetic. Immensity, it is not easy to translate. Two elements— the word is apt—water and air to make a picture: the deep water, the infinite sky; as far as the eye can see, ceaselessly moving waves beneath the ceaselessly changing sky." Thoré goes on to describe two of Courbet's Trouville seascapes, one of which he metaphorically denominates "the marching rain" and the other "the burning sea"; "these effects, at once real and fantastic," he writes, "are familiar to lovers of the sea."[30]

Thoré's most explicitly allegorical treatment of seascape comes in reference to the work of Belgian Paul-Jean Clays (fig. 13), a former pupil of history painter Horace Vernet and seascapist Théodore Gudin: "M. Clays loves and knows the sea. The intense character of the great water, heavy and violent, he expresses in the general tone of color. The sea does not at all resemble soapy water or fountain water. She has a *sui generis* nuance whatever may be her momentary caprice, calmness or rage. The sky however dominates her and imposes his reflections. In order to be a good marine painter, it is necessary to understand the ménage of the sky and sea, their battles and their harmonies. The marriage of Neptune, son of Saturn the old god of the sky, and Amphitrite, goddess of the sea, is a very natural allegory. Mythology has some value."[31] "La mythologie a du bon," says Thoré, the inveterate spurner of obsolete mythological painting. In his writings Thoré repeatedly reaches for mythological metaphors in order to express the erotic and emotional associations of landscape. Thoré's attitude toward the utility of myth is echoed in 1867 in a learned article on marine physics by the oceanographer Elisée Reclus. "Water is the best," writes Pindar; and for Reclus this estimation is reflected in the mythologies and cosmogonies of so-called primitive peoples according to which the earth is the daughter of the ocean. As the scientist concludes, "it is not at all simply a myth, it is reality itself."[32]

In 1868 Thoré once again responds allegorically to the seascapes of Clays: "What we call *the sky* is the accumulation of more or less dense vapors that rise and fall—like a sort of respiration of the globe—under the action of heat, that more or less hide from us the ethereal and rarefied regions of the upper atmosphere, that let more or less light pass through to give the landscape color, movement, life. The turbulent and passionate sea thus sets up a capricious sky, never at rest, and which gives back to

her fanciful colors, unexpected effects, ceaselessly renewed. Ah! but it is beautiful, the sea!"[33] The anthropomorphism of Thoré's passage is part of a broad discursive formation that includes the imaginative natural history of Jules Michelet. Michelet remarks of the sea that "she is, it seems, the great female of the globe, whose indefatigable desire, whose permanent conceiving, whose childbearing, is never finished."[34] However gratuitous it may seem to us today, the gendered play of masculine artist and feminine sea is repeatedly exploited in the verbal and visual texts we will be considering.

In 1868 Clays's sea and estuary scenes and Jongkind's views of river and canal activities in Holland would have been among the closest mates at the Salon to Monet's lost painting, *Ships Leaving the Jetty at Le Havre* (W. 89). Writing in the official imperial newspaper, *Le Moniteur Universel,* Théophile Gautier forcefully objects to Monet's picture: "Formerly such a work would have scarcely passed for a sketch." The much-maligned pictorial surface of the 1860s is an embattled terrain upon which opposing ideological forces of order and change confront one another: "We do not very much like to see boat blacking applied to the hulls of ships; these blue or green spots destined to reproduce the lapping of the sea, this opaque gray sky so grossly brushed displeases us. . . . The spot and the impression, grand words very much used nowadays, . . . do not suffice for us. We do not want licked painting, but we need painting that is done."[35] Gautier compares Monet's vulgar brushwork to a commercial signboard and contrasts it with the sophisticated pictorial wit of the marine painter Eugène Isabey.

Gautier's troubled response to Monet is the occasion for a moment of self-doubt. In answer to his own question as to whether he is "a dotard, an old fogey, a mummy, an antediluvian fossil no longer understanding anything of his century," the critic insists that he has been fair to the art of Courbet, Manet, and Monet no matter how repugnant he feels that art to be. And yet Gautier concedes that their pictures may "contain beauties which escape us others, former Romantic manes already mingled with silver threads, and which are particularly apparent to young people in short jackets and fencing caps."[36] In an earlier essay Gautier had been quick to repudiate the repetition of academic conventions untouched by current concerns: "Is it thus to say that art must lock itself in an indifference of perspective, in a glacial detachment from every lively and contemporary thing only to admire, ideal Narcissus, its own reflection in the water and fall in love with itself?" Gautier's answer acknowledges the independent temperament of the young artist, but he is also at pains to set constraints

upon that freedom: "No, an artist is before all else a man; he may reflect in his work, whether he shares them or rejects them, the loves, hatreds, passions, beliefs, and prejudices of his time, on the condition that sacred art will always be for him the end and not the means. Whatever has been executed in an intention other than to satisfy the eternal laws of beauty shall not have value in the future."[37] To thus place oneself above the law is to risk the fate of the "late Narcissus of egoistic memory."[38]

Emile Zola is one of the chief opponents of the anti-individualistic position espoused by Gautier. Already notorious as the outspoken supporter of Manet, Monet, and the "new manner in painting" since 1866, in 1868 Zola devotes a long discussion to Monet's marines. In a reversal of Gautier's polarities, Zola contrasts Isabey's artifice with the conviction of Monet: "He understands the genre in his own way, and here again I find his deep love for present-day realities. . . . Moreover he loves the water like a lover, he knows each piece of the hull of a ship, he could name the slightest riggings of the masts."[39]

Zola's description is the fullest verbal account of Monet's lost work. The sea is evoked as a female presence, "still shuddering beneath the shock of the enormous mass that has just cut her through." The critic's prose recalls the contemporary sea-writing of Baudelaire or Thoré or Michelet in the exploitation of the feminine associations of water: "With him, water is alive, deep, above all true. She laps around boats in little greenish waves cut by white gleams, she stretches out in glaucous pools suddenly sent shivering by a breeze, she lengthens the masts which she reflects while breaking up their images, she has pale and dull tints which brighten up with intense lights. She is not at all the factitious, crystalline, and pure water of indoor seascapists, she is the stagnant water of ports spread out in oily sheets, she is the great livid water of the enormous ocean that sprawls while shaking its filthy foam."[40]

Zola concedes that other spectators at the Salon might reject the roughly handled surface of Monet's *Ships;* he, on the other hand, readily interprets the artist's formal eccentricities as the "willed asperities" of his temperament. Zola seems to court the outrage of a critic such as Gautier here, for as he says of Monet's rejected canvas of the jetty at Le Havre, "it is these dirty waves, these thrusts of earthen water which must have terrified the jury used to the little, garrulous, and sparkling waves of sugar-candy marines."[41]

Although Zola insists on the socially progressive value of Monet's self-determined art, he does not endorse an unambivalent notion of autonomous selfhood any more than does Gautier or Baudelaire. Born in the same year

as Monet (and thus twenty and thirty years younger than his two senior colleagues), Zola castigates the dominant mores of Second Empire society with great vehemence but with a traditional sense that the artist cannot survive in isolation from institutionalized norms. In the novel *La Curée* (1871) Zola prominently stages a *tableau vivant* of Narcissus as an allegory of the individual who repudiates the capitalistic lucre and prostitutional allure of the day only to succumb to a monstrous absorption in himself: "The beautiful Narcissus, lying upon the banks of a stream which descended from the depths of the scene, was looking at himself in a clear mirror. . . . Death surprised him in the midst of the ravished admiration of his image. . . . He was becoming a flower. And the great nascent flower, human still, was bending his head toward the source, his eyes flooded, his face smiling with voluptuous ecstasy, as though the beautiful Narcissus had finally satisfied in death the desires he had inspired in himself."[42]

The artist who repeatedly puts himself beyond collective protocols is just such a monstrous Narcissus. There is a temptation to think this of Monet even on the part of a friend such as Zacharie Astruc: "This year he has somewhat disconcerted those who follow him with a friendly eye by sending a painting brushed in haste, of rather fine and fresh color, but without form and without depth. This is but a pure accident, I think, and we will soon see it erased by works which he has the power to make excellent." Astruc stresses the artist's accuracy of vision over any insufficiencies of execution, and he also identifies Monet's pictorial gift as deeply motivated: "He possesses a love of water and a knowledge of ships; still a child, he played on the beaches; his spirit became familiarized with the phenomena of the sea."[43] Perhaps recalling the stress that Baudelaire places on the childlike spontaneity of the artist, Astruc implies a causal relation between Monet's childhood experience and his adult love and knowledge of the sea and its ships.

In 1869 and 1870 Monet was refused admission to the Salon, his threat to artistic decorum now clearly being deemed insupportable by the jury. Astruc, who had apparently observed Monet at work on the Etretat seascape rejected in 1869 (W. 126; fig. 14), was indignant when the rejection was repeated in the following year: "His large canvas (Luncheon) [W. 132], a marine [W. 136?] . . . were refused. Why, I ask you? What! Are you going to tell me that amongst so many as[ses] one could not find a place for this spontaneous art? In preference to a colorless group do you not prefer a character however spotted he may be? At least, he will be corrected by your counsel, by your disdain—but let him come to you—to you the public! It is his right, he has earned it, for he fashions his little world." If

it had been the jurors' intention to suppress Monet's pictorial world their gesture was in vain, for, as Astruc notes, the painter was already imitated as the "creator of a new element of which the trace is visible at the Salon and which is saluted with the most sympathetic gaze by artists of proven judgment."[44]

Writing in the month of the imperial plebiscite on constitutional changes, Philippe Burty devoted a large portion of his column in the republican newspaper *Le Rappel* to a critique of the jury system which had led to the rejection of Monet's paintings. Asking that votes be cast by secret ballot in order to lessen official pressure, Burty speculates on the repudiation of Monet's "undisciplined art": "This uncouthness of a freshly disembarked seaman appeared indecent to the jury, and the artist, who was not there to plead his cause because the jury's decrees are rendered behind closed doors, received the grave and useless injury of an exclusion." Although the paintings were not on view at the Salon, Burty describes Monet's marine pictures in language similar to both Zola and Astruc. Monet's lack of academic discipline and the energetic touch of his brush might have horrified the conservative members of the jury, but not the liberal Burty; the critic delights in "the violent oppositions of the blue sky and the white shore, of the sea furrowed as by a plough by steamboats with their long black plumes and the green grass of the orchard or the chalk tiers of the cliffs."[45] As he acknowledges in his article, Burty's eye for Monet's contrasts of color was educated by the graphic effects of Japanese woodblock prints. In a related vein Burty also praises the Etretat seascapes of Courbet, whose powerful paternal presence at the Salon may well have rankled the humiliated disciple. If in 1870 Courbet's narcissism is largely echoed in positive external regard, Monet's for the most part as yet is not.

From Self-Infatuation to Self-Reflection (1870–80)

IN THE 1860s Monet concentrated on marine painting at Le Havre, Honfleur, and Etretat. In the 1870s Monet shifted his focus to river motifs, first in London and Holland at the time of his flight from the Franco-Prussian war and then in the towns along the Seine where he settled after his return to France. For more than fifty years Monet concentrated on the waters of the Seine, but he also reprised many of his earlier seascape motifs during the time he made his home along the Seine at Giverny.

During the 1870s Monet's river scenes repeatedly challenged critical interpretation. Armand Silvestre was one of the first writers to connect Monet's formal experiments with the characteristics of water: "He loves to juxtapose upon barely moving water the multicolored reflections of the setting sun, of brightly colored boats, of the changing sky. Metallic tones due to the polish of the waves that splash in tiny even surfaces sparkle on his canvases, and the image of the bank trembles upon them, the houses there becoming cut up as in that children's game in which objects are reconstructed by pieces."[1] Invoking the stereotype of the childlike innocence of the Japanese printmaker, Silvestre relishes the fresh patterns of Monet's art but qualifies his support by way of reference to the norms of Western illusionism.

Others were much less sympathetic than Silvestre. Of the notorious *Impression, Sunrise* (W. 263; fig. 15), shown at what has come to be known as the first impressionist exhibition in 1874, Louis Leroy sarcastically writes that "wallpaper in an embryonic state is still more done than this marine."[2] Reviewing the 1877 exhibition, the pseudonymous female writer Marc de Montifaud pointedly wonders, "what good does it do to place the trees above the sky, the sky in the place of the road, and the road above the

trees; why these vengeful asperities?"[3] Monet's putatively infantile self-assertiveness is simply not to be tolerated by these custodians of European culture, and for them the myth of Narcissus was an available resource for the repudiation of such individualistic transgression.

For Paul Mantz, Monet's effectively realistic painting of the 1860s had unfortunately taken on the insubstantiality of dreams: "The planes are blurred, the values intermingle, everything grows dim and mixed together in an anarchic jumble."[4] This anarchism is akin to the egoism of Narcissus, who "obstinately persists in studying his own reflection, when he has beneath his hand, at two steps from him, a reality that perhaps encloses a soul." In this reference to the forsaken female personification of the spring in Jules-Louis Machard's painting at the Salon of 1872, Mantz rejects the same antisocial self-centeredness of Narcissus that he also rejects in impressionist painting. Monet does not depict "this young boy, madly in love with his image reflected in a stream,"[5] but he makes a specialty of the reflections themselves (figs. 16–17). In similar fashion contemporary writers repeatedly exploit the allusive value of this upside-down world: "The shadows of the trees in the misty river / Die like smoke / While in the air, amongst the real branches / The turtle-doves sing. / How well, o voyager, this pallid landscape / Will mirror your pallid face / And how sadly in the high leaves / Your drowned hopes weep."[6] These verses by Paul Verlaine carry an epigraph from a famous letter on Narcissus by Cyrano de Bergerac; in such writings, as in Monet's paintings of mirrored depths, the fluid forms of the modern self begin to swirl into iconographical shape.

Narcissus is the fundamental Western myth of self-reflection, and we can measure the range of the myth's meanings at this time by considering the article on Narcissus in Pierre Larousse's encyclopedia. As a word in general use the name refers both to a flower and to a "man in love with his person, smitten with his beauty," but Larousse acknowledges the cultural relativism of this association in the West: "Thus, contrary to our floral symbolism, the narcissus, instead of indicating, as for us, blind self-love even unto egoism and stupidity, expresses for Orientals modesty, obedience, the pious detachment from one's self."[7] Through the 1870s the predominant interpretation of the myth stresses the youth's vain folly as we have seen, but the symbolist elaboration of the myth—and Monet's later water paintings as well—will have much to do with the self-abnegation of the Orient that is adumbrated here.

In explicating the myth Larousse begins with a recitation of the canonical Ovidian version. Disdaining the love of the nymph Echo, Narcissus is punished by the gods along the banks of a reflecting pool: "Narcissus at

the same time admires, and is admired; / Narcissus at the same time desires, and is desired."[8] Eventually recognizing the error that it is himself whom he sees in the watery illusion, Narcissus nonetheless persists in his love and finds divine pity in the self-union of metamorphosis. In contrast to this mortal drama of self-recognition, in Jacques-Charles-Louis Malfilâtre's satirical poem, *Narcisse dans l'île de Vénus* (1768), summarized by Larousse, the youth dies of loving an image that he fails to recognize as his own, foolishly taking it to be that of a water nymph instead. Smitten with self-love by the narcotizing fumes of the narcissus flower, the youth's companions, male and female alike, become "This whirlwind of ridiculous creatures / That one has named coquettes, little-masters: / Vain Narcissuses, for themselves alone prepossessed."[9]

Larousse indicates that the myth of Narcissus has provoked a variety of modern interpretations. For popular eighteenth-century poet Jean-Joseph Vadé the self-admiration of the youth is rediscovered not in water but in wine, where, "a new Narcissus," "I swallow my image." In the more erudite poetry of Alfred de Musset the ancient belief in the infernal qualities of the flower is recalled in the Satanlike beauty of the rake who takes the love of others only thereby to love himself: "Watching his shadow move in the sun; / When a source is pure and one can see oneself there, / Coming, like Narcissus, to bend over his pale face, / And to seek out sorrow to make a mirror of it." "His ideal is himself," the poet writes, and psychoanalysis will later speak of this self-centered mode of loving as narcissistic object-choice. In the sociocultural writings on love by Alphonse Esquiros we come still closer to the later development of psychoanalysis: "Love, as one understands it in the world, is not love; it is an exalted egoism: one loves oneself in another. Oh, how many young blond women thought themselves adored who were only the crystalline surface of the water upon which a blond Narcissus as conceited but less handsome than the son of Cephisus lovingly admired himself."[10]

Musset and Esquiros maintain the familiar connection between narcissism and sexuality, and in writing about Monet's relations with others I will do the same. I will also stress the self-idealizing component of the myth apart from sexuality, and this vexed relation to the ego-ideal is anticipated by Larousse as well. In an antipositivist polemic that Nietzsche might have welcomed, theologian Jean-Baptiste Lacordaire insists that "the pride of science is the infatuation of a mind drunken with itself, that mirrors itself in what it knows, like Narcissus in his lake." For the religionist the limits of human knowledge point to a transcendental realm, but in the most recent writings of the Young Hegelians, as mediated by the Frenchman

Saint-René Taillandier, this too is a narcissistic projection: "God is nothing other than our figure reproduced in a marvelous mirage; it is the sublime reflection, the grandiose shadow of the human species. It is high time that humanity, like Narcissus admiring himself in the fountain, finally tear itself away from this sterile contemplation."[11] In the 1870s the self-reflection of Narcissus can be glossed as either sexual or intellectual, but in the examples given by Larousse it is always a posture that is not to be praised. In art, however, there will be an exception to this rule.

As an artist Monet would have known the story of Narcissus through its visual representations. Larousse lists earlier paintings by Poussin, Claude Lorrain, René-Antoine Houasse, François Lemoyne, Nicolas-Bernard Lépicié, Alexandre Desgoffe, Georges-Jehan Vibert, and Jules-Louis Machard, as well as a medal-winning sculpture of 1863 by Paul Dubois (fig. 18) about which Paul Mantz had asked, "Is this really the mythological Narcissus that one has so much abused?" "No, without a doubt," he insists, for the young man "seems less occupied in looking at his floating image in the water that flows at his feet than in following in his thoughts the course of a vague reverie."[12] The same distinction between adolescent self-regard and mature self-reflection is repeated by Anatole de Montaiglon at the time of the reexhibition of the figure in 1878: "Rather than stupidly admiring himself, he seems rather to think and dream."[13] By this time Dubois had been elected to the Institut de France and appointed director of the Ecole des Beaux-Arts. His *Narcissus* would later reappear at the Exposition Centennale of 1900 when thirteen of Monet's paintings were also included in the officially sponsored show.

In the years following the publication of Larousse's encyclopedia the theme of Narcissus remained in vogue. Jules Massenet's opera, *Narcisse: Idylle antique pour solo et choeur* (1878), bears an illustration on its cover of a water lily, and in the libretto by Paul Collin the youth's "strange folly" is reinterpreted as the soul's contemplation of beauty.[14] In contrast to this idealizing impulse, verses by Charles Grandmougin more conventionally describe a painting by Gustave Courtois at the Salon of 1877 (fig. 19): "The beautiful Narcissus dies from loving himself too much, / He admires himself in the water; his eye is tender and vague, / Of the noises in the forest he will hear none, / And in his own sight he remains ensnared. / And with a smile on his lips he feels himself die."[15]

For Charles Tardieu writing in *L'Art,* the myth of the "martyr of self-love" is not convincingly illustrated in Courtois's medal-winning painting.[16] Far from resembling the handsome youth of the story, the painted figure seems so school-boyishly thin as to discourage the love of any Echo.

The gap between figural posture and dramatic expression is further widened in the comments of Henry Houssaye, for whom the boy's thin body takes on the emaciated appearance of an Egyptian mummy.[17] Houssaye's brother Arsène also notes the problematic interpretation of myth in the painting. He notes the similarity of Courtois's *Narcissus* to the work of Charles Gleyre, himself the author of a painting of Echo (fig. 20) and, more important, the tradition-minded instructor of Monet, Pierre-Auguste Renoir, Frédéric Bazille, and others for a brief time in 1863. It is thus of some interest that Houssaye remarks of Courtois's figure that its "head reflecting itself in the water would make M. Renoir laugh."[18] Edmond Duranty, the author of *La Nouvelle Peinture* (1876), attributes the laughter to Courtois himself. For Duranty, here is an ironic Narcissus who bends over the pool not for a loving look but for a cooling drink. The painting thus offers the renewal of a somnolent tradition that is also a betrayal, a passage "to the enemy, to the modern," since, as he concludes, "the gods are dead."[19]

In 1877 Arsène Houssaye and Edmond Duranty provide a rather fragile conjuncture between the traditional iconography of Narcissus and the modern imagery of impressionism. A more philosophical link between narcissistic introspection and the practice of impressionist painting is found in the contemporary writing of Théodore Duret. Best known as a friend and later biographer of Manet and as an avid enthusiast for the art of Japan, where he traveled, Duret was also an early explicator of the post-Kantian philosophies of Arthur Schopenhauer and Herbert Spencer. In his writings Duret combines the German idealist's theory of will and the British empiricist's theory of force in a peculiarly French amalgam with immediate implications for impressionist art: "The piercing gaze of Schopenhauer thus very well glimpsed what appears more and more, that particular existences and individual energies are only manifestations of a single cause, of a universal motor which science now calls force. However we are far from claiming to know force in itself, and we know very well that although the explanation of phenomena is connected with it, in itself it remains inexplicable and incomprehensible."[20] This is how Duret proposes to understand attempts of impressionist painters to grasp the unseizable ether; and this also explains the self-abnegation that characterizes their impossible search for a fixed comprehension of the world and the self.

In Duret's account of Schopenhauer what is most pertinent to my picture of Monet is the philosopher's gesture of renunciation, for to seek to arrest change is precisely to come up against the futility of possession: "The past belongs to us no more; the present is but a moment that cease-

lessly flees, that one perceives only when it has vanished; the future is a closed and indecipherable page." Duret mentions both the disengagement of Buddhism and the resignation of *Ecclesiastes* in order to situate Schopenhauer's pessimistic view of the human condition. As mayor of the fourth arrondissement of Paris during the Commune, Duret had been formerly committed to revolutionary action, but according to Schopenhauer such action is never wholly autonomous. Whether imperial, bourgeois, or communard, every ideology turns out to be regulated by the self-deceptive machinations of the will. Duret recognizes the paradoxical position in which he has landed. On the one hand, "it is necessary that man resign himself to stay within the dependency of the natural forces that enclose him, and that he lose the hope to acquire other knowledge than that which is revealed by the patient study of the laws that govern the world." On the other hand, such resignation must not imply a total withdrawal from society: "Is this to say that it is necessary, with Schopenhauer, to become ascetic and Buddhist, to renounce love and the family, to live in the sole company of one's dog? Evidently not; these are individual eccentricities that should not be taken as a rule."[21]

Duret is saved from Schopenhauer's Narcissus-like introversion by Spencer's evolutionary notions of the adaptability of the organism to the environment. Like Zola, Duret always urged Monet and his colleagues to expend their efforts at self-expression within the social context of the Salon. As his 1878 brochure on impressionism suggests, Duret regarded the ridicule of critical response as an inevitable stage in the working of the will. Nonetheless Duret concludes his article on Schopenhauer with a dictum that would increasingly govern Monet's conduct, namely, "that one must cultivate one's garden."[22]

According to Duret the naturalistic subjects and sketchlike techniques of Corot, Courbet, and Manet constitute the antecedents of impressionism, but he also hails the bright, flat color of Japanese art as the prime liberating example: "Ah well! it may seem strange but is nonetheless true: the arrival of Japanese albums amongst us was necessary for someone to dare sit down on the bank of a river in order to juxtapose upon a canvas a roof that was boldly red, a wall that was white, a green poplar, a yellowish road, and blue water" (fig. 21). As Duret goes on to relate, this riverside contemplation of color above all characterizes Monet, "l'Impressioniste par excellence."[23]

Water "holds the principal place" in Monet's work: "He is the painter of water par excellence. In the olden landscape, water appeared in a fixed and regular manner with its color of water, like a simple mirror to reflect objects. In the work of Monet, it takes on appearances of infinite variety

which it owes to the state of the atmosphere, the nature of the bed upon which it flows or the silt which it carries; it is limpid, opaque, calm, tormented, dashing or dormant according to the momentary aspect which the artist finds upon the liquid sheet in front of which he has planted his easel."[24] Although Duret does not inquire into the psychological or allegorical investment of the artist in his water paintings, his interest in Schopenhauer encourages me to think that he may well have understood Monet's paintings of reflections in relation to the more general philosophical enterprise of self-reflection.

As Duret predicts, many of Monet's former critics begin to acquire a taste for his art. Even the cynicism of Louis Leroy is chastened by the sight of a harbor scene not too dissimilar from the one he had lampooned in 1874 (W. 154; fig. 22). *The Entry to the Port of Trouville at Low Tide* now garners the reluctant admission that not all impressionist painting is absurd.[25] Appreciated for its atmospheric tonality, this coastal motif from 1870 evokes at the end of the decade the kind of praise that Monet's first seascapes had elicited back in 1865. In the figures of its foreground fishermen, their gazes absorbed by the reflective sheen of the water upon which their lines are cast, the painting also repeats the motif of the field-and-stream Narcissus found in Monet's first landscape from 1858.

In 1879 Monet is widely noted in the press for his water paintings. Writing in *La Presse,* Renoir's brother Edmond narrates Monet's history from *Camille* on but concludes that the painter had found his true way only along "the banks of water, whether of river or sea."[26] For his part, Armand Silvestre enumerates a number of the "suburban marines" of 1879, but insists that they are characterized by a certain unwelcome repetitiveness.[27] The issue of repetition will become a key issue of contention in the later writing on Monet's water series.

A central text concerning Monet's predilection for water was published in *Le Gaulois* under the pseudonym Montjoyeux. In a front-page column headed "Chroniques parisiennes," Montjoyeux presents an intimate portrait of the thirty-seven-year-old artist: "He is married and father of a family. He is a really handsome brunette with a beautiful beard made for the passage of beautiful fingers. After having lived for a long time at Argenteuil, for a year now he has been settled at Vétheuil, near La Roche-Guyon. One of the most exceptionally endowed painters. Artistic temperament, stretched to splitting. The neurosis of the times has passed through him. As prompt to hope as to despair. Capable of powerful enthusiasms and subject to invincible disgusts. A quarry floating between the exaltations of triumph and the annihilations of defeat. He had his day of glory at the Salon, just

like any other, with his Green Lady. Since, he has voluntarily retired from official ambitions."[28] The voluntarism of the last sentence may reflect some autobiographic distortion inasmuch as Monet's Salon career had not at first been one of arrogant abstention but rather of repeated rejection. Monet subsequently reconstituted his career beyond the reach of the jury, but his repudiation of authority came to an end at the Salon of 1880 with a rather muted painting of reflections on the Seine (W. 578; fig. 23).

If Montjoyeux's account reflects a source close to, or indeed identical with, the artist, the psychological description shows a certain distance. Philippe Pinel had coined the term "neurosis" at the beginning of the century, and from the middle years onward psychiatric treatises and novels alike exploited the new types of the hysteric, the neurasthenic, and the melancholic. In describing Monet, Montjoyeux uses the phrase "la névrose du temps," a condition of mental torment, according to a manual of 1860, in people who have nothing physically wrong with them.[29] Montjoyeux describes Monet as a typically high-strung artist prey to shifting states of self-esteem. Daniel Wildenstein's biography provides numerous instances of this oscillating behavioral pattern, but in finding much descriptive cogency in Montjoyeux's portrayal I am also concerned to look for particular ways in which such a psychological constellation may have affected the production and reception of Monet's art.

An inference I would like to draw from Montjoyeux's account concerns a relation between Monet's "floating" psychology and his aquatic imagery. Immediately following the personality portrait and a brief history of Monet's career, Montjoyeux offers the following citation: "Manet, the great Manet, has nicknamed him the Raphael of water. The fact is that he is past master in this genre. His Islets on the Seine are marvels of lightness and transparence. I further cite his Flags, a view of the rue Saint-Denis and the rue Montorgueil on 30 June. A teeming of crowds, a brouhaha, a hustle and bustle full of movement and life."[30] Although the flag paintings (W. 469–70) are repeatedly noted with admiration by the critics in 1879, they virtually bring to an end Monet's efforts as a Baudelairean painter of modern life. Henceforth Monet forsakes the urban scene for more remote or depopulated scenes of water and light. Reflections come to play an ever greater role in this private enterprise and the mirrored islets mentioned by Montjoyeux (W. 479–87; fig. 24) become canonical for what will follow.

From 1878 to 1881 the hamlet of Vétheuil was Monet's "port," as he calls it in an interview published in 1880 in La Vie Moderne. Ornamented by a portrait-sketch of the artist by Manet, the interview constitutes the first opportunity taken by the artist to present his story directly to the

public. The rather grandiose (or perhaps ironic) reference to the port corresponds to the modest dock at the foot of Monet's rented property at Vétheuil. It is from this point that the apparently wary Monet designated his studio to the interviewer, Emile Taboureux: " 'My studio! But I have never had a studio and I do not understand shutting oneself up in a room. To draw, yes; to paint, no.' And with a gesture as broad as the horizon, pointing to the Seine all strewn with the gold of the setting sun, to the hills bathed in cool shadows, and to all of Vétheuil that seemed to sleep in the quiet of the April sun . . . : 'Here's my studio, mine!' "[31] Whatever Taboureux may have suspected as to the veracity of Monet's claim, we now know from the artist's letters that he often completed his open-air canvases in his indoor studio. In the interview it is Monet's self-mythology that we encounter for the first time in print, a manipulated history whose future chapters will be elaborated in numerous interviews and witness accounts over the next forty years.

"Ah! it was above all on the water that I learned to know Monet!" With these words Taboureux launches into an account of Monet's career that I presume to have been largely gathered from the artist himself: "Monet is a true freshwater sailor. It could perfectly well have been saltwater, since a great part of his youth was passed at Le Havre and his first two pictures in 1865, unless I am mistaken, had the honors of the Salon and the most passionate critical response. What is more, Monet owes his first laurels to the marine . . . no, to his marines. Since that time he has put a bit less salt in his water, that is all." Taboureux goes on to record the elements of Monet's myth: his intuitive "impressionism"; his brief stay in the studio of Gleyre "to please his family"; his encounters with Courbet and Manet; his systematic exclusion from the Salon and subsequent disparagement in the press; his withdrawal from his colleagues' independent exhibition on the grounds that while he alone had remained the true impressionist they had become "a banal school that opens its doors to the first dauber to come." Monet further credits himself with the coining of the group's name but then acknowledges the role of "some reporter of the *Figaro*."[32] This could easily be a mistake of Taboureux but it may also represent a symptomatic misremembering of the distinguished Albert Wolff of *Le Figaro* in place of the sarcastic Louis Leroy of *Le Charivari*.

Taboureux records that Monet loaned him a file of press clippings at the time of their meeting. The resulting interview preceded by a week a brief notice of Monet's first one-man show at the offices of *La Vie Moderne*. In this unsigned piece particular note is taken of the large *Ice Floes* recently refused by the jury of the Salon (W. 568); various views of Vétheuil "at

different hours"; and the colored reflections of a Venice-like scene of boats at Argenteuil (see W. 368–72).[33] Reproduced alongside the article is a drawing expressly prepared by the artist after a coastal scene of Sainte-Adresse (W. 94; fig. 25). A downward view of a cabin silhouetted against a tipped-up sea, this first image by Monet to be prominently reproduced is at the origin of a series of seaside cabins that extends from 1867 to 1897. In this recurrent motif of the solitary, watchful habitation set against the embracing panorama of the sea I propose to see a symbol of Monet's own Narcissuslike stance.

The notice in *La Vie Moderne* recommends Théodore Duret's monograph on the artist which accompanied the catalogue of the one-man show. Duret remarks that over the years the Seine had offered the artist "the capricious and changing waters for which he has a very particular affection": "In spite of the repetitive absorption in landscape motifs, no artist has less known monotony, for, working in front of nature, in intimate contact with her, he seizes all her mobile aspects and thus can perpetually renew himself."[34] Although Duret does not offer us the myth of Narcissus by which to figure the artist's aquatic fixation, it is my contention nevertheless that it is just some such allegory that may help us make sense of Monet's obsessive operations. In Pausanias's alternative version of the myth it is the likeness of his beloved dead sister that Narcissus seeks to seize in the reflections of the pool: "After the death of the young woman, he used to come every day to a spring in order to contemplate his own image which restored that of his sister to him, thus to triumph over his chagrin."[35] In 1879, the year of this text, Monet's wife Camille had died. In her troubling deathbed portrait Camille is no longer Monet's luminous counterpart but rather his spurned and silenced Echo (W. 543; fig. 26), yet in painting her wavery image perhaps he sought to assuage his loss.

Normandy's Beaches and Maritime Origins (1880–83)

THE REPRODUCTION IN 1880 of Monet's thirteen-year-old *Cabin at Sainte-Adresse* (W. 94) marks a renewal of interest in the marine genre after nearly a decade of painting along the Seine at Argenteuil and Vétheuil. Apart from the visit to Le Havre that eventuated in *Impression, Sunrise,* Monet undertook no extended coastal campaign during the 1870s. In the autumn of 1880 Monet left his now motherless children in the keeping of Alice Hoschedé at Vétheuil and embarked upon what was to become only the first of twenty or so painting campaigns that periodically separated the painter from his family over the course of the next two decades. Little correspondence survives concerning either this first trip to Les Petites-Dalles, where his brother seems to have had a villa (W. 621–24), or the next to nearby Fécamp (W. 644–60), where Monet, Camille, and their one-year-old son Jean had lived briefly in 1868. In contrast to this paucity of documentation, some 2,500 letters have been catalogued from 1882 to 1926 to Monet's dealers, family, and friends. The Durand-Ruel archive of correspondence documents Monet's activities and attitudes insofar as he makes them known to his dealer. Here pecuniary matters predominate. More revealing on a personal plane are the nearly daily letters that Monet writes while away from home to his mistress and eventual second wife, Alice Hoschedé.

In this chapter I will concentrate on Monet's written references to water and the sea. My aim is to describe the rhetorical dimension of the painter's engagement with aquatic imagery. Monet provides what may be the first surviving account of his motivation in a letter to Durand-Ruel written toward the end of the artist's three-year residence at Vétheuil: "Here I am back at Vétheuil. The persistence of bad weather having

prevented any kind of work, I was forced to return and to return empty-handed. Thus I am very discouraged, for you to whom I would like to give very good things, and for me who was counting so much on this stay at the sea to get myself over my discouragement. This grieves me all the more in that I have to leave Vétheuil in a month, . . . and in that I will not dare ask you [for money] if I cannot give you the masterpieces that you expect from me. . . . Do not be too angry at me for my momentary impotence" (13 September 1881; L. 222).

Starting with the last line, we may note a number of characteristic strategies in this letter. Monet's alleged pictorial ineffectiveness during this coastal campaign is couched in the language of powerlessness or impotence. This disclaimer is addressed to the artist's dealer, a strong male figure who holds the threat of the purse over the head of the dependent artist. (In previous years the role of powerful patron had been held by Amand Gautier, Bazille, Manet, Duret, Georges de Bellio, Georges Charpentier, and others.) In order to please this figure Monet imagines that masterpieces are required of him, but these turn out to be beyond the artist's reach. In this admission of failure, however, the artist himself is crucially absolved, for it is not he but the weather that is at fault. Monet's financial dependence on the paternal Durand-Ruel is thus doubled by an uncanny dependence on (mother) nature. Monet counts on this latter dependence as a remedy to depression in spite of his knowledge concerning the changeability of the weather along the Normandy coast.

For the next twenty years Monet's letters repeat the cycle of an initial depression followed by great expectations for a seaside campaign; followed by frustrated dependence upon the maritime environment; followed by irresponsible disavowal of the pictorial results; followed once again by a renewed depression. Trapped between the oscillating moments of grandiose self-inflation and abject devaluation, Monet reiterates an aquatic obsession whose origins are plausibly to be found in his youthful rearing at Le Havre by the side of the sea and in his earliest campaigns along the coast in the company of Boudin, Jongkind, Bazille (d. 1870), Courbet (d. 1877), and his wife Camille (d. 1879). The adult content of Monet's depressions will vary, but the residual core of the impulse appears to me to remain the same.

In my view this core impulse may be located in the layers of love and loss that build up in the artist during the episodes of elation and deflation that mark Monet's artistic enterprise from its earliest days. Emotionally and materially supported in this effort by his mother, aunt, and first wife until their deaths in 1857, 1870, and 1879, respectively, Monet was at the same time emotionally depleted by the repeated repudiations of his father,

the Salon jurors, and the Parisian critics. Around 1881, however, Monet's fortunes began to improve with the return of Durand-Ruel as a regular and fairly reliable patron; it was also at about this same time that Monet became definitively involved with Alice Hoschedé, whose estranged marriage to one of the artist's early patrons lasted until Ernest Hoschedé's death in 1891.

At the time of the letter that I have quoted, the financial and emotional precariousness of the Monet-Hoschedé ménage provides the context of discouragement to which the artist often alludes. Wildenstein speculates that in order to permit the usually absent Ernest Hoschedé to share in the celebration of his oldest son's holy communion at Vétheuil, Monet takes leave from the controversial joint household for the trip to the sea which his 1881 letter records. Monet's socially anomalous relationship with Ernest Hoschedé's wife should be seen to constitute an important aspect of the depressed state that this painting campaign is meant to overcome. With the removal of Monet, Mme Hoschedé, and their collective total of eight children from Vétheuil in the last weeks of 1881, and with their subsequent installation first at Poissy and then at Giverny, the tenuous bonds of propriety which linked Ernest and Alice Hoschedé are effectively sundered. Nevertheless, an acute emotional uncertainty continues to characterize the relations of Monet and Mme Hoschedé, as the extant correspondence attests.

Scarcely installed along the Seine at Poissy, Monet begins to plan a visit to the coast. From Dieppe he writes to Mme Hoschedé, whom he had left ill at home, that there is much to do: "The sea is superb, but in their disposition the cliffs are less beautiful than at Fécamp. Here I will certainly do more boats" (6 February 1882; L. 233). In what will become a typical gesture, Monet unfavorably contrasts the circumstances of the current campaign with the memory of sites past. In a letter of the previous year to Durand-Ruel, Monet had written of his gratifying sojourn at Fécamp, "by the shores of the sea" (23 March 1881; L. 212), where he had once lived with Camille. Whatever may have been the private burden of the past, after little more than a week at Dieppe, Monet withdraws from the "boring" provincial banalities of the town for the greater solitude of the tiny beach hamlet of Pourville. Like the yearned-for Fécamp, Pourville was notable for its cliffs. From Pourville Monet writes of his contentment to the increasingly anxious and "tormented" Alice Hoschedé: "The countryside is very beautiful and I really regret not to have come here earlier rather than waste my time at Dieppe. One could not be closer to the sea than I am, on the beach itself, with the sea beating at the foot of the house.

People are fearful for Sunday, for perhaps you know from the papers that [Sunday] is the strongest tide of the year" (15 February 1882; L. 242). In spite of the joy of Monet's return to the sea, all does not go well: "But alas, today the weather is atrocious and here I cannot, as at Fécamp, work in all sorts of weather. There are no shelters or cavities in the cliff where I might go when it rains, but I become enraged at doing nothing, for each day that is lost retards my return and, despite the view and the beauty of the sea, I am full of sadness and my thoughts are always in Poissy, certainly not on account of that horrible place as you know" (17 February 1882; L. 243).

At this time Durand-Ruel was undertaking the organization of the seventh group exhibition of impressionists, and after much hesitation Monet agreed to participate. His exhibits included half a dozen floral still lifes, numerous winter and summer scenes of the Seine at Vétheuil, and perhaps a dozen marine pictures of Fécamp, Trouville, and Les Petites-Dalles. This was the most substantial display of Monet's seascapes to date and included a four-part series of plunging cliff views from Fécamp that are nearly identically framed although varied in color and in weather (W. 647–50; fig. 27—two are on no. 20 figure formats [60 × 73 cm] and two on no. 25 landscape canvases [60 × 81 cm]). Although far from unanimous, critical response to Monet's Fécamp marines established him as a leading painter of seascapes.

One of Monet's chief advocates in 1882 is veteran novelist and critic Ernest Chesneau, whose article Monet considered "very well done": "That is just what I like" (14–15 March 1882; L. 254–55). Back in 1874 Chesneau had mistaken Monet's *Impression* for a sunrise on the Thames, but in 1882 he proves much more attentive: "I come to a stop by these admirable marines, where, for the first time, I see rendered with such power of illusion the swellings and long sighs of the sea, the streaming of the surf as it withdraws, the glaucous coloring of the deep water, and the violet tints of the shallow water upon its bed of sand."[1] The stress here is upon the truthfulness of Monet's work, yet the ornamental and anthropomorphic flavor of Chesneau's language recalls his position in literature between naturalism and symbolism. In his novel of 1879, *La Chimère,* published by Monet's patron Charpentier, Chesneau blends naturalistic landscape imagery with the theories of Gustave Moreau, the text's dedicatee: "And what mysteries in water's inversions! Go to the Luxembourg toward mid-November, lean against the balustrade at the entrance to the water alley leading to the Medici fountain, and look. You will see the marvel! At your feet the great plane trees plunge straight down, head first, lengthening to

infinity their master branches."[2] Just such metaphysically disorienting effects of reflection had been Monet's stock-in-trade from the mid-1870s on (see, e.g., W. 397, 417–20, 423–29, 479–87, 537–40, 560–78).

Another novelist who responds to Monet's water effects in 1882 is Joris-Karl Huysmans. On the cusp between a proletarian naturalism and an esoteric form of symbolism, Huysmans now recants his earlier opinion of Monet's technical failings in order to acknowledge the artist's latest accomplishments: "For a long time M. Monet stammered, blurting out brief improvisations, hurrying over bits of landscape, bitter salads of orange peel, green scallions, and wigmaker's-blue ribbons; it all resembled the rushing waters of a river." Decked out in the extravagant metaphors of taste and color that will soon characterize his novel *A Rebours* (1884), Monet's once rudimentary sketches are now seen to have become complete works of art: "How true is the spray of his waves lashed by a ray of light, how his rivers flow, mottled by the swarming colors of the things they reflect, how in his canvases the slight cold breathing of the water mounts into the foliage and passes into the grasses' tips! M. Monet is the marine painter par excellence! . . . We are now far from his former pictures where the liquid element seemed to be of glass spun from streaks of vermilion and Prussian blue."[3]

Rather than attribute his revision in judgment to an alteration in his own critical taste, Huysmans insists that it is Monet who has reformed his style. Conversely, the critic of *Le National,* Charles Flor, recognizes a transformation only in the audience and not in the artist himself, who continues to exhibit poor sketches in place of finished pictures: "M. Claude Monet is showing some abominable marines, things without name and without excuse. I congratulate the artist on possessing an income of one hundred thousand pounds, for if he was given over solely to the resources drawn from the sale of his marines, his situation could not fail but be disquieting." Flor's sarcastic dismissal of Monet's "satanic marines" suggests that the paintings continued to provoke an emotional irritation most easily alleviated through the reactions of the joke.[4]

The critics are generally unable to endorse Monet's pictures until they first overcome their resistance to his apparent abrogation of the conventions of oil painting. The critic of *Le Petit Parisien* conjoins the familiar elements of disquiet with a no less typical though reluctant admiration: "That he spreads upon all his canvases a vaguely blue tint, I do not say the contrary, but how there is in all his works—in spite of oddities of color and other willed eccentricities—a true and troubling impression of the capricious and delicious sea!"[5] More than most other criticism of the moment, this

antithetical description of Monet's "true and troubling" art comes close to my reading of the painter's ambivalent discourse of the sea.

While the critics were wrestling with the Fécamp marines Monet was at work on a much more numerous series from the contiguous sites of Pourville and Varengeville near Dieppe (W. 709–43, 751–808). Apart from the post-1900 *Water Lilies,* these pictures represent the most prolific and homogeneous campaign of Monet's career. Situated at its midpoint, the 1882 series repeats coastal motifs of 1867 (W. 90–94) even as it in turn will be recapitulated in the forty-six-part *Cliffs* series of 1896–97 (W. 1421–34, 1440–71; figs. 28–30). At Monet's one-man show at Durand-Ruel's in 1883, some thirty of the recent paintings were exhibited alongside still lifes and earlier views of Vétheuil, Paris, Argenteuil, Rouen, and Zaandam in Holland. As though to affirm the continuity of his enterprise as the painter of water par excellence, Monet also exhibited a sketch for his Salon painting of 1865, *The Pointe de la Hève* (W. 39), the beach scene that had established the standard format for the Pourville paintings of 1882 and beyond.

In 1882 Monet spent two months alone at Pourville from mid-February to mid-April; during the summer he returned with his sons and Mme Hoschedé and her six children for a further campaign of three months. Although the letters to Durand-Ruel from the second season along the coast repeat the artist's litany of discouragement and depression, they lack the explicit reference to the sea which correspondence with the absent Mme Hoschedé seems to occasion. The consolation of water remains on Monet's mind in the depths of his exhaustion, and once back at Poissy he takes off for a few days of restorative vacation along the banks of the Seine (W. 748–49; fig. 31). At Poissy, however, the Seine does not prove to be a beneficent force. There the river overflows its banks and Monet has to give up the role of painter for those of "salvager, ferryman, mover, etc.": "We are literally in the water, surrounded by water on all sides, and the house no longer accessible except by boat; it was necessary for us to seek refuge on the first floor and the water rises continually, and how far will it go? It is terrifying" (7 December 1882; L. 304).

Apart from the flooded condition of his house and the plight of his family, the anxiety which Monet seeks to master at this time also concerns the preparation of his work for exhibition in the early months of 1883. The situation in the Monet-Hoschedé home remains so insecure at the turn of the year (see letter to E. Hoschedé, 1 January 1883, L. 306) that Monet soon goes off to the coast for a month of solitary painting at Le Havre and Etretat.

Monet's first letter from Le Havre in 1883 recalls a decade-old observa-

tion he had made on the same spot to Camille Pissarro: "I am working, but when one has ceased to do seascape, it is the devil afterward—very difficult; it changes at every instant and here the weather varies several times in the same day" (27 January 1874; L. 76). To Mme Hoschedé, Monet expresses his hopes for the new campaign, but only one unfinished canvas survives from this short sojourn of 1883 (W. 815), a harbor scene of boats very much like the motif described in a letter to Alice: "As for me, I have been able to begin work; the weather has calmed down and is very fine; it is truly admirable the continual movement of boats, but also very diffi- cult" (25 January 1883; L. 307). In order to surmount his difficulty Monet leaves the harbor project behind and travels the thirty kilometers up the coast to Etretat, the site of his home with Camille back in 1868.

Like Le Havre, Fécamp, and Sainte-Adresse, Etretat is heavily en- dowed with reminiscence for Monet. After a brief stay in a hotel at Fécamp in the autumn of 1868, Monet had for the first time been able to take comfortable lodgings for himself, his mistress, and their son amid the extraordinary surroundings of the cliffs of Etretat. At this time shunned by his family on account of his locally scandalous liaison with Camille (her notorious Salon portrait had been re-exhibited at Le Havre earlier that year), Monet owed his installation at Etretat to M. Gaudibert, the wealthy patron of the now well-known portrait of his wife (W. 121). Gratified accounts of Monet's family life at Etretat are preserved in several important letters to Bazille; the iconography of family life is also recorded in the monumental *Luncheon* (W. 132) featuring baby Jean, a servant, and Camille in the dual role of attentive mother and languid woman of fashion. Rejected at the Salon of 1870, this major work was re-exhibited at the first impres- sionist exhibition in 1874; in addition, a related smaller-scale work was shown at the artist's one-man show of 1880 (W. 129 or 130). This first Etretat campaign produced two other large rejected works (W. 126, 133; a seascape and a snow painting) as well as an unexhibited canvas of high seas at the foot of the arched Etretat cliffs (W. 127). As we have already seen, this last motif was made famous by Courbet at the very Salon of 1870 from which Monet had been excluded.

Here is how Monet describes his life at Etretat in 1868 in a letter written to his friend Bazille: "I am enjoying myself like a real fighting cock, for I am surrounded here by everything I love. I pass my time in the open air on the beach when it is really heavy weather or when the boats go out fishing. . . . And then at night, my dear friend, I find in my little cottage a good fire and a good little family. . . . Thanks to the gentleman from Le Havre who comes to my aid, I am enjoying the most

perfect tranquillity since I am relieved of worries, and my desire would be always to remain like this, in a really tranquil corner of nature such as here. . . . Do you not think that alone with nature one does better? Me, I am sure of it. Furthermore, I have always thought so. . . . What I do here will at least have the merit of resembling no one, at least I think so, because it will simply be the expression of what I will have felt, me, personally" (December 1868; L. 44). This letter is a prime early document of Monet's narcissism. Freed from pecuniary responsibilities by a powerful and protective patron; nourished by the emotional sustenance of a home and "a good little family"; alone within the environing embrace of his beloved sea: these are the conditions for the fantasy of autonomy which Monet asserts to Bazille.

In 1883 Monet acknowledges to Mme Hoschedé that his work at Etretat will not be altogether new. Always with a doubly retrospective and prospective glance for what he did not but might yet still do at Le Havre, Monet settles down to work at Etretat with the belated consciousness of having done all this before: "I worked admirably today, I am very content; furthermore the weather is superb though a bit cold. I am planning to do a large canvas of the cliff at Etretat even though it is terribly audacious of me to do it after Courbet, who did it admirably, but I will try to do it differently; I will also do some boats with the aim of another large canvas, in sum I am grinding away and would be satisfied if I did not know of all your worries and if you were not far from me" (1 February 1883; L. 312). Apart from the anxieties attendant upon his mistress's absence, what Harold Bloom calls the anxiety of influence assails Monet in the form of the haunting priority of Courbet's monumental work.[6] Monet's largest painting of the cliffs in 1883 (W. 821, 81 × 100 cm) is substantially smaller than Courbet's famous Salon painting of 1870 (133 × 162 cm; figs. 32–33). Monet achieves a kind of additive monumentality through the accumulation of seven midsized views of the arch known as the *falaise d'aval*, five of the *falaise d'amont*, and two of the most massive of Etretat's three rock-arches, the Manneporte (W. 816–22, 826–30, 832–33). In this group of paintings of agitated seas, Monet follows his former mentor's practice, but he also repeats the format and motif of his own canvas of 1868 (W. 127; fig. 34). Broadly brushed in an unrelieved earthen palette of browns and grays, the earlier picture is now superseded by the broken touch and prismatic color of the 1880s. As in 1868, however, Monet continues to insist on the narrative motif of the gaze by which the painter's own act of observation is doubled in the watchful attitudes of tiny figures silhouetted against the elemental scene (W. 826; fig. 35). These figures may be traced

back to the sublime watchers in the preromantic seascapes of Joseph Vernet; this device of confrontation and identification with the sea recurs in paintings such as Courbet's *Seaside at Palavas* (1854), Whistler's painting of Courbet at Trouville known as *Harmony in Blue and Silver* (1865), and numerous paintings by Monet over a thirty-year period from Le Havre, Sainte-Adresse, Les Petites-Dalles, Fécamp, Pourville, and Etretat (see W. 88, 91–92, 109, 127, 621, 658, 665, 754, 758, 776, 780–81, 793, 821, 826, 831–32, 1444).

Several orders of concern coalesce in Monet's anxiety in 1883; there is the meteorological elusiveness of his maritime motifs, the impossibility of recapturing the idyllic memory of the Etretat sojourn of 1868, the ambiguous paternal burden of Courbet's marine painting. Monet expresses his ambivalence in the following letter to an ever-dissatisfied Mme Hoschedé: "You are right to envy me, you cannot have any idea of the beauty of the sea over the last two days, but what talent would be necessary to render it; it is enough to drive one mad. As for the cliffs, here they are as nowhere else. I went down today to a spot where I had never dared adventure before and there I saw some admirable things, and so I quickly came back to get my canvases; in sum I am very content and regret only having lost my time at Le Havre, and so I will have to work devilishly in order to arrive in time by your side as I promised and in order to be ready for my exhibition" (3 February 1883; L. 314).

The weather, the fishermen, and the sea all prove to be unaccommodating. Even in good weather the painter lingers over his unfinished canvases, vainly waiting for the return of a once glimpsed but now vanished configuration or effect: "I am very unhappy for I have very few days remaining and you must realize that it is not everything to have the desired weather; it is additionally necessary for the sun or the gray weather to coincide with the tide which I need to be low or high according to my motifs" (15 February 1883; L. 328). Monet's frustration is exacerbated by the anticipation of a meeting between Mme Hoschedé and her husband. Whatever may have been his omnipotent fantasy in both the domestic and artistic realm, Monet is no more successful in summoning the unproblematic cooperation of the sea than he is in admonishing Mme Hoschedé to be happy. Unable to tear himself away from endlessly changing motifs and unable to return to Poissy on account of the visit by Alice's husband, Monet gives way to a suicidal scenario on the beach: "Pardon me for having tormented you with my telegram, but I have been in such a state for the last few days that I am overcome and nearly crazy. . . . I wanted to pretend to go to work, to try even, but my things stayed beside me on the beach without

my being able even to think of opening my box; I remained stupidly watching the waves, wishing for the cliff to crush me. There my poor, dear, well-beloved, there is the state of him who, you sometimes say, does not love you any more as before" (19 February 1883; L. 334). Similar words of self-abasement and rage characterize Monet's correspondence with Mme Hoschedé for years to come. No matter the familial pressures, however, Monet continues to be drawn to the sea.

None of the recent Etretat canvases were made available by the artist for his one-man show at Durand-Ruel's in March. The Pourville seascapes of the previous year were on view in abundance, and the critics responded at greater length than before to Monet's troubling iconography of the sea. Their response does not come soon enough to suit the artist, as he writes to Durand-Ruel: "I find that when one addresses oneself to the public and it responds with silence and indifference, I find that that is a non-success. As for me I make very little case of the opinion of the papers, but it is very necessary to recognize that in our day one does nothing without the press (6 March 1883; L. 337). . . . As for me, I am very touched by this indifference to which I had not been accustomed. When in the papers we were criticized, often insulted, you knew how to tell us then that this proved our value, that otherwise they would not have dealt with us. So what am I to think today of this silence?" (7 March 1883; L. 338). Within a week a number of studies of the paintings began to appear.

For Louis de Fourcaud, writing in *Le Gaulois,* Monet is the painter of the "bedazzlement and desolation" of the sea. Through the inclusion of solitary cabins on the cliffs Monet is said to meld "the idea of the human with the feeling for vegetation, atmosphere, and space."[7] In contrast Arthur d'Echerac, writing as C. Dargenty in *Courrier de l'Art,* refuses to see the proper protocols of picture-making in Monet's "agreeable colors, lively touches, transparent fluidities, rays of sun, blue holes, dark spots, formless though true oppositions, sparkling water, foliage reflections, and the whole series of things that play in the atmosphere without precise contours." The critic acknowledges that among the exhibited paintings there are "some bright skies, some limpid waters," but he concludes that these are nothing but "spots strewn about by chance, whims of the brush, the whole drowned in a universal slush."[8] Dargenty's angry criticism of these so-called debaucheries in paint is perhaps an effect of the anxiety-provoking boundlessness of Monet's images of rivers and sea.

Other critics who respond more equably than Dargenty agree in rejecting the claim to truthfulness on which Monet's critical fortune had been based. Quoting Duret's veristic account unsympathetically, Paul Labarrière

insists that no more than the Japanese printmaker is Monet a naturalist: "Let the devil take me if I have ever seen in nature the Veronese-green sky and the sea the color of his *Sunset at Pourville* and his *Sea at Pourville.*" Labarrière criticizes the artist's Turner-like disregard for nature, yet at the same time he praises "luminous" and "poetic" seascapes such as the early *The Pointe de la Hève* (W. 39), *The Mill at Zaandam* (W. 177), or the recent *Church at Varengeville* (W. 726), "a pure masterpiece."[9]

Monet featured the two last-named pictures in reproductive drawings in 1883. A full-page gillotype illustration of the Dutch painting of 1871–72 accompanies Armand Silvestre's article in *La Vie Moderne,* and along with a river view of Rouen with its famous cathedral reflected in the center (W. 217; fig. 36), the Varengeville painting is reproduced in the *Gazette des Beaux-Arts.* The latter painting shows only a small colored wedge of distant sea brought forward and held in place by a flattened screen of trees, architecture, and cliffs, whereas the Zaandam and Rouen pictures present the familiar mirror-inversion of the riverside forms of the windmill and church.

Like Fourcaud the week before, Silvestre emphasizes the unity in diversity of Monet's river and marine motifs: "It is impossible to refuse a profound admiration for the artistic unity . . . which binds this ensemble of pictures whose motifs are so different. One senses here a powerful synthesis, a reflective action of the mind, something willful and enduring. Whether he lives in the environs of Paris, on the banks of Poissy, whether he takes us upon the high cliffs at Dieppe, M. Claude Monet retains a vision of things that is absolutely personal to him but which imposes itself."[10] The pictorial unity that Silvestre identifies is what modernism has largely come to value in Monet's work, but it is my argument throughout this book that this putative unity of personality is a prime effect of the modernist myth of the self which is under construction during these years.

Some moderate and conservative critics may have felt that Monet's depiction of ecclesiastical architecture elevated his landscapes above the mere commonplace of rivers and fields. Alfred de Lostalot chose Monet's views of the churches at Rouen and Varengeville for reproduction in the *Gazette des Beaux-Arts,* and in his article insists on the traditional qualities of Monet's vision. Lostalot had somewhat half-heartedly admired the artist's work as early as 1876, but now he animates two of Monet's Varengeville pictures in the allusive fashion that we have previously encountered in the writings of Thoré.

The first of Lostalot's descriptions refers to Monet's most accessible work: "There are pictures where M. Monet manages to please everyone,

except perhaps himself; these are the ones that have been painted in a
discrete light, muted by a sky laden with mist, intercepting in large part
the violet radiation: such as this *View Taken at Rouen* [W. 217], with its
faded, deep, amber sky which seems cut out from a picture by Cuyp; such
as these *Views of Holland* [W. 172, 177, 184], this *Snow Effect at Argenteuil*
[W. 356], this *Church at Varengeville* at sunset [W. 726], and *Low Tide* [W.
722], with its imposing cliffs of Varengeville, laden with moss and looking
at themselves in the tranquil water filtered by the sands of the beach: a
marvelous impression."

In front of these seascapes Lostalot evokes the self-reflective trope of
the landscape mirror much as contemporary mythographers such as George
Cox and his translator Stéphane Mallarmé claim to see in the reflection of
the setting sun in the sea the phenomenal equivalent of the Narcissus
myth.[11] Lostalot's second description presents what he takes to be a less
accessible example of the artist's work: "The dazzle of the yellow rays
exalts the nervous sensibility of the painter, then blinds him, and this then
produces in him the well-known physiological phenomenon of the evoca-
tion of the complementary color; he sees violet. Those who like this color
are going to be satisfied: for them M. Monet executes an exquisite sym-
phony in violet. The motif is always well chosen: it may be a powerful
cliff, its twisted vegetation browned by the sea breezes, disclosing in places
its sturdy skeleton and gazing at the silhouette of its shadow in the blue
water."[12] Lostalot's further mention of a small, red-roofed cabin clearly
identifies the painting (W. 806); another example of a cliff appearing to
gaze at its shadow in the waves is found in a painting from Varengeville
(W. 808), an effect which first appears in a Fécamp motif of the year before
(W. 653–55).

In 1883 Monet supplied illustrations of his paintings to Silvestre and
Lostalot. He also solicited an article from Philippe Burty in anticipation
of which he sent the critic a small sketch (see 22 March 1883; L. 342).
Burty's article in *La République Française* constitutes the second major
installment in Monet's autobiographical myth. Compiled from information
supplied by the artist, the essay extends the basic narrative recounted by
Taboureux in 1880. Burty repudiates the charge of hasty production for-
merly leveled at the artist and attributes the artist's deliberative practice to
the financial support of collectors and dealers such as Durand-Ruel. This
is an ironic affirmation in view of the ceaseless stream of dunning letters
that Monet continued to send during these years.

Burty relates the story of Monet's early transplantation from Paris to
Le Havre and the youth's subsequent repugnance for "the physical fatigues

and limited horizons" of his father's commerce in nautical provisioning.[13] The fifteen-year-old Monet is said to have taken to drawing and selling caricatures of local figures in order to be free of paternal economic control. Monet's relationship with his father was often troubled until the latter's death in 1871, and his precocious activity of graphic distortion may have offered an outlet for the expression of adolescent rage even as it provided proof of his power to support himself on his own. Such proof might also have been experienced as a vindication of the encouragement shown him by his mother and aunt. In later interviews Monet repeats the story of maternal support and paternal resistance to his choice of career. A letter sent by Monet's father to Bazille in the months before Camille's delivery records the intimate conflict concerning Monet's mistress.[14] Although he himself had fathered an illegitimate child by the family maid in 1860, Monet's father advised his son in 1867 to abandon the pregnant Camille. Painted at about the same time is a garden picture in which the ghostly figure of Adolphe Monet appears as a *repentir;* only temporarily effaced by his son's overpainting, with each passing year the father's image shines ever more clearly through the translucent veneer (W. 68).

The psychological speculations that I entertain here are undoubtedly foreign to the intentions of Monet and Burty in 1883. Nevertheless, it is in this article that Monet's conflict with his father is first publicly noted. Monet's repudiation of his father is linked in the 1883 account with the arrival of Boudin as a positive parental surrogate. In Taboureux's interview of 1880 only Courbet and Manet are named as the artist's mentors and precursors. Boudin had recently had an exhibition in the same locale as Monet's current show, and it may have been this coincidence which elicited the following anecdote: "One day that M. Boudin was going off to paint in the countryside Monet accompanied him. He had never seen a canvas executed; it is a sight that excites anyone with a lively imagination. . . . It takes on its grandeur when the light has clarified the forms, the color has translated the infinite effects of tints submerged within a relative unity, and a penetrating poetry betrays the state of the artist's soul in a study in which nature is reflected."[15] In this soul-revealing reflection, the artist's self is made visible as in a mirror. But this mirror is not passive; in the artist's reflection upon nature's appearance nature too is in the process of reflecting herself [*une étude ou se réfléchit la nature*].

Moving from anecdote to anecdote, Burty enumerates the salient points of Monet's career: the conventional seascapes (he mentions only one) at the Salon of 1865; the challenging encounter with Manet's (the text reads Monet's) radical abbreviation of traditional value-modeling; the "modern"

and "scandalous" *Camille;* the subsequent process of exclusion from the Salon; Monet's reappearance there in 1880 with a river scene (W. 578) hung "at a height that defied the view and in an anemic neighborhood."[16] Burty also recalls the independent group exhibition of 1874 and especially his own role as the artist's only favorable critic. This is undoubtedly an exaggeration, yet Burty may well have been the most sympathetic commentator on ideological grounds. In 1874 Burty already insists on the truth of Monet's effects, as "when one looks all at once at the flight of poplars along the banks of a river, the branches no longer arrest the gaze."[17]

Burty's criticism illustrates the difficulties in the way of an allegorical interpretation of Monet's art. Writing in 1874 about Edgar Degas's pictures of laundresses which seem "classic" in the assurance of their design, harmony, and characterization, Burty complains that these artistic qualities would be more readily acknowledged by a timid public were the painter to depict Nausicaä, the washerwoman of ancient myth.[18] Burty repeats his charge in front of Monet's paintings in 1883: "After all, we are not Greeks, we are not Romans, we do not drink wine that smells of resin, we eat Brie that runs. Recognizing that we are building the republican edifice block by block, let us also recognize that art is called upon to give it its definitive ornamentation. Pediments were fine once. Who approves of them today, at the end of the Rue Royale, placed on the colonnade like the flattened silhouette of the cap of a Greek gendarme?" Burty wants modern art for modern times, not the Italianate and Hellenic imitations of the "poor laureates of the Ecole and the Salons." Unlike Thoré, who had written of Clays's naturalistic seascapes that "la mythologie a du bon," Burty now puts his phrase in the past tense: "les frontons [pediments] ont eu du bon."[19] Both critics agree in rejecting the academic classicism of their own decades, but whereas Thoré remains nostalgic for the lost power of myth, Burty maintains a more antagonistic stance.

In order not to constrain the freedom of the gallery-going reader, Burty foregoes extensive description of Monet's landscapes and seascapes. He briefly notes Monet's "half-crumbling cliffs, sunken paths, Norman farms, yellowing poplars," and lingers only in front of "a marine where the surf, broken on black reefs, the *Rocks* of Tourville [*sic*], evokes the multiple sensations of the obstinate groaning of the mounting seas, of the salt-spray that pricks the lips, of the obscure desire for a long voyage to unknown lands, for a conversation without words with an intelligent and beloved being."[20] It is through just such a lure of self-transcendence that the seductive waters of Burty's scenario affect the beholder with the naturalized equivalent of myth.

The Riviera and the
Impossibility of the Blues
(1884–85)

MONET WAS ALWAYS concerned to find appropriate subjects in nature. After Argenteuil and Vétheuil, Poissy did not gratify him in this respect, and in the spring of 1883, thanks to the relative success of his exhibition and the growing financial support of Durand-Ruel, Monet was able to install himself along the Seine, this time once and for all, at Giverny. To Duret he writes that he is enraptured: "Giverny is a splendid place for me" (20 May 1883; L. 354); to Pissarro he worries, however, that perhaps he is too "remote and alone" (June 1883; L. 357); yet to Durand-Ruel he concedes that "it always takes a certain time to familiarize oneself with a new place" (3 July 1883; L. 362). During this initial period Monet manages to finish some Pourville and Etretat paintings as well as a short series of views of the Seine at Giverny. These first pictures at Giverny bring his long-time motif of river reflections to a new level of formal simplicity and reaffirm a format that will be repeated with virtually no change in the major water series of 1894 and 1897 (compare W. 834–36, 838 and 1370–82; W. 842–44 and 1386–91; W. 841 and 1493–94; figs. 37–38). The public was shown several of the 1883 pictures at an exhibition in 1885, but we learn little about these paintings from Monet himself, owing to a lack of detailed letters such as he writes to Mme Hoschedé when away from home.

A large batch of letters records Monet's next maritime campaign, an extended stay along the Italian and French Riviera in early 1884. Hopeful that he would bring back "some astonishing things" (he had used the same phrase to describe his first series of seascapes twenty years earlier: see letters to Bazille and Durand-Ruel, 15 July 1864 and 17 January 1884; L. 8, 390), Monet reported on the progress of his work in some dozen letters to his dealer and in more than seventy-five almost daily letters to Mme Hoschedé.

Several letters to Duret and to Berthe Morisot also survive, but much additional correspondence is to be presumed lost.

"I will do water, beautiful blue water": this is how Monet describes his project in the first letter to Durand-Ruel from Bordighera in Italy (23 January 1884; L. 391). Working on four canvases at once, Monet's ardor turns to discouragement as the seaside motifs prove "difficult to grasp, to put on the canvas." To Mme Hoschedé he rehearses the same complaint in sunny and stormy weather alike: "I would like to do orange-trees and lemon-trees standing out against the blue sea; I cannot manage to find them as I wish. As to the blue of the sea and the sky, it is impossible. . . . When it rains down below, it is snowing on the enormous heights; then the sun up above, clouds half-way down the mountains; and the sea always and even still more blue; no, it cannot be described. As to painting it, one must not think of it, these are effects of too short duration which cannot be found again" (26 and 27 January 1884; L. 394–95). Monet repeatedly insists upon his "mute and solitary life"; this disengagement from the society of the place responds both to the jealous suspicions of his mistress and to his own desire for self-absorption in the marine element of his dream.

The renewal of good weather and the resumption of his series are never enough to dispel the anxiety that Monet experiences in reading Mme Hoschedé's unhappy letters, and he makes a promise of outings on the river in reparation for the distress caused by his absence from home. At Bordighera Monet begins to find motifs where he had not at first, and so he stays on and on, struggling both with the unfamiliar Mediterranean effects and with the resistant effects of prose in his efforts to reassure Alice: "I say poorly what I feel" (1 February 1884; L. 401). In a letter to his friend Duret, however, Monet's prose seems more than adequate to the task of evoking his beloved blue sea: "I am installed in a fairylike place. I do not know where to poke my head; everything is superb and I would like to do everything; so I use up and squander lots of color, for there are trials to be made. It is an altogether new subject for me, this place, and I am only beginning to recognize myself and to know where I am going, what I can do. It is terribly difficult; one would need a palette of diamonds and gems. As to blue and pink, there is plenty here. So I grind away. I will bring back some palm trees, some olive trees (they are admirable, the olives), and then my blues" (2 February 1884; L. 403).

A prevailing tinge of violet or blue had previously been diagnosed as a symptom of optical (or even moral) malady by Monet's critics.[1] Disengaged from any referent, Monet's blue is a fluid screen mirroring his desire.

To Mme Hoschedé he writes that now that he knows the place, "I dare put in all the tones of pink and blue; it is fairylike, it is delicious, and I hope that it will please you." But he can hardly expect this to please his mistress when all he can offer is the repeatedly deferred formula: "How I would wish to be near you too!" (3 February 1884; L. 404).

In another letter to Mme Hoschedé, Monet recounts a nightmare in which his pictures all seem to him false in tone and everyone in Paris, including Durand-Ruel, finds them incomprehensible. This dream reenacts the rhetoric of Monet's self-deprecation as well as the history of his critical reception. The dream is said to leave him with a severe headache the next morning which causes him to take the day off. As a result Monet sets out on a pleasure trip from Bordighera that takes him across the border to Cap Martin, a narrow spit of land extending out into the sea between Menton and Monte Carlo. On a brief trip with Renoir in December 1883 Monet had already reconnoitered this section of the coast, and for the remaining weeks of his stay in Italy the French site will continue to stand as a beacon tempting the artist beyond the garden motifs that predominate at Bordighera. Referring to the water motifs of Cap Martin, Monet writes that "they differ totally from here, where the sea does not play a large role in my studies" (6 February 1884; L. 409).

The sea makes only a restricted appearance in fewer than a third of the three dozen Bordighera paintings (see W. 852–54, 864, 876–80; fig. 39). Nevertheless, the sea may be inferred in the ubiquitous blue shimmer of the coastal vegetation. To Mme Hoschedé, Monet writes of his fixation upon a series of foliate motifs from which he cannot tear himself away. It is as though the dense screen of tropical trees is used to ward off the overwhelming intensity of the sea itself: "I do not know what effect all this will have on you, but it is really terrible and the blue plays a large role in everything I do. Today I worked on an olive grove in gray weather: everything is blue and yet it is that way" (7 February 1884; L. 410).

Grappling with the sea is scarcely Monet's only problem. Mme Hoschedé remains unappeasable. Whereas she seems to him like some imperious heroine in Zola in threatening a separation, he feels entitled to her loving support: "I therefore demand that you love me as I love you" (9 February 1884; L. 412). In this letter we find the unprecedented eruption of the intimate *tu* into the midst of a discourse hitherto characterized by the formal *vous;* moreover, the verb *exiger* is the index of Monet's habitual inability to acknowledge the autonomy of others. Whether Bazille, Camille, Durand-Ruel, or Alice, all the main figures of support in Monet's life are treated as though they exist to gratify his exigencies alone. A possible

corollary of this mode of relationship is the artist's elimination of figures from his paintings and his self-identification with the unpeopled extension of nature.

Water is the medium of extension, yet alongside its absorptive and buoyant capacities water also threatens the dissolution of Monet's limits. Hence the ambivalence of Monet's relation to the sea and the resulting oscillation in his drive to paint it. Bordighera remains intractable to Monet's compositional practice, "especially since broad, general motifs are rare": "It is too bushy, and there are always fragments with lots of details, jumbles that are terrible to render, and me precisely the man of isolated trees and great spaces." In contrast to the difficulties of Bordighera there are the imagined advantages of Monte Carlo: "There the grand lines of mountain and sea are admirable and, apart from the exotic vegetation that is here, Monte Carlo is certainly the most beautiful spot of the entire coast: the motifs there are more complete, more picturelike and consequently easier to execute. And so I am troubled and from time to time I am afraid that I have made a blunder in coming here; yet it is as fairylike and seductive as possible" (11 February 1884; L. 415).

Caught between the labor of the *morceau*—the arbitrary scene not yet transformed into a painting—and the dream of the unified *tableau*, Monet permits the immediate seduction of the place to prolong his stay at Bordighera. Now apostrophized as "satanic," the site retains its grip on Monet in spite of, or perhaps on account of, its difficulties (12 February 1884; L. 416). These difficulties elicit a corresponding "obsession" with the thought of his failure to surmount them (15 February 1884; L. 419).

Writing to Mme Hoschedé, Monet indicates that he has good news, yet within a few lines he concedes defeat: "The sun has returned superb, but with a terrible, frightful wind, a tempest with sun; the sea is unimaginable. Figure for yourself the agitated sea at Pourville, but with a marvelous blue and spume like silver. I wanted to try it, but umbrella, canvases, everything was carried off and the easel broken; I had to beat a retreat, furious." Defeated by the stormy sea Monet turns to an inland motif, and as long as he keeps at work he also keeps his rage at bay. Such compulsive warding off of anxiety does not last very long and "as soon as I stop working, I am always afraid to arrive at nothing; perhaps I am wrong to be fearful" (19 February 1884; L. 424).

Monet's compulsiveness is expressed in the nearly automatic fashion in which he retails his self-doubt to Mme Hoschedé, a behavior which he both regrets and yet repeats again and again (23 February 1884; L. 428). It is this largely uncensored quality of Monet's nightly letters which seems

to me to empower a psychoanalytic attentiveness to the painter's discourse. To be sure, the artist can no longer supply further associations in response to my tentative interpretations, but as in the clinical interpretation of the overdetermined symbols of any dream, the letters defy exhaustive discussion through the sheer density of their representation of conscious as well as repressed affect. Whereas the emotional interaction with Mme Hoschedé is textually overt, Monet's discourse of water and the sea becomes comprehensible when read as the repetition of a meaning that he never explicitly states.

On account of his delay Monet is accused of infidelity by his impatient mistress (28 February 1884; L. 433); he responds to her in the language of his own private pain: "I have made enormous efforts which must not be sterile. If I have said that I erred in coming here, it is that I did not find things easy at first, and then there is certainly one thing that is terrible for me, that in no canvas, except two or three, is there any sea, which is rather significantly my element. That is why I want to do two or three motifs at Menton, by the shore of the sea. Here that does not go so well with the place which has other charms; but all my studies are advancing, and perhaps I will be less long than you suppose" (3 March 1884; L. 436). "Less long" soon turns into an absence of six more weeks. First Bordighera, then Menton, and only then Giverny; but Giverny under its aquatic aspect, for Monet's homeward nostalgia is couched in terms of "our dear Ile aux Orties," a nettle-filled islet in the Seine that was a favored goal for Monet's "little flotilla" of boats (17 March 1884; L. 448: see W. 841, 1006–8, 1489–94).

Enmeshed in the endless repetitions of brush upon canvas, Monet comes to realize that no amount of further work, no amount of perfect weather, will ever contrive to bring him satisfaction (26 March 1884; L. 462). Afraid for the fate of his overworked canvases, Monet's obsessiveness is opposed by pragmatic self-reflection; toward the end of March he begins to plan his departure in earnest. A complication with Italian customs agents further delays the removal to Menton, and the eventual installation is compromised by recriminations regarding his "obstinacy" in having stayed so long at Bordighera (7 April 1884; L. 477). As he writes to Durand-Ruel, Menton is "very much more my affair" (8 April 1884; L. 478), but "irrevocably" fixed to return by the fourteenth, Monet now refuses to be "lured" by the sea and wishes only to be back in Giverny with Mme Hoschedé whose sudden silence torments him (9, 10, and 11 April 1884; L. 479–83). As before, the grip of the sea soon takes hold and Monet abjectly begs his mistress to be allowed to postpone his return for a day or two (12 April

1884; L. 484). As a result Monet is finally able to complete a closely coordinated series of motifs, three pairs of paintings all pivoting around a single point at the tip of Cap Martin (W. 889–90, 893–94, 896–97; figs. 40–41). Back home in the studio at Giverny, one of these Menton canvases will later become the basis for an unfinished decoration (W. 891, 139 × 180 cm). A near-anagram of his own name, Menton remains even at a distance a self-reflecting mirage that Monet cannot resist.

In 1885 Monet exhibited a canvas closely related to his unfinished decorative composition of the brightly hued red road, green shrubs, white mountains, and blue waters of Cap Martin (W. 889 or 897). Along with a hazier picture showing the same segment of the Riviera coastline from a much greater distance (W. 879), the Cap Martin painting forms a part of Monet's selection of ten works for the fifth international exhibition held at the galleries of Georges Petit, a major rival of Durand-Ruel. Sponsored at Petit's by the officially decorated landscapist and history painter Jean-Charles Cazin, Monet is included at the Exposition Internationale among a fashionable company of French and foreign painters including Jean Béraud, Albert Besnard, Léon Bonnat, Albert Edelfelt, Henri Gervex, Peter Kröyer, Max Liebermann, Jean-François Raffaelli, John Singer Sargent, and Alfred Stevens. Although he had partially broken with the Durand-Ruel group of impressionists at the time of his return to the Salon in 1880, it is Monet's participation in the Petit group of painters that opens the way for public acceptance of his art. As Judith Gautier writes of this post-Salon manifestation, "the tout-Paris has recovered its appetite for this little snack served apart." For her Monet's landscapes merit a special note on account of their "lively feeling of nature and a very personal manner of rendering it."[2]

Among Monet's most important supporters in 1885 was Albert Wolff of Le Figaro. With a daily circulation of some 80,000, Wolff was perhaps the most influential of Parisian critics. He had sat for his portrait by Manet, yet nevertheless remained skeptical of the artists of the Manet-Monet circle. Wolff had claimed to be offended by Monet's lack of finish in 1876, 1879, and 1882, but at the Petit Gallery in 1885 he accords Monet's landscapes and seascapes the lengthiest analysis of all the exhibited works.

Wolff offers his account of Monet as the voice of consensus: "We are all agreed on one point, that is that the landscapist has a great deal of talent: he has his own way of looking at nature; she appears to him in a tonality invisible to the eye of common mortals. Taken separately, the colors of M. Monet seem false, but in the ensemble, through some kind of art of trompe l'oeil, he manages to seize the broad aspects of the landscape with a surprising truth." Committed to a veristic interpretation of Monet's

art, Wolff judges the reflective capacity of water as the phenomenon most appropriate to the painter. Reminiscent of Silvestre's metaphor of the jigsaw puzzle, Wolff imagines Monet's technique as a kind of game: "Masses of water especially lend themselves to this curious juggling, and it is for this that the marines of M. Monet are much superior to his landscapes. There is even a view of the cliffs of Etretat [W. 832] and another of Cap Martin [W. 889 or 897] which on my word are full of air and sun, two very rare qualities which make me forget a number of cruel failings in other canvases of M. Monet."[3]

Unlike Wolff, Paul Gilbert refuses to concede that a general truth pervades Monet's canvases: "By force of wanting to persuade oneself that nature may, at certain moments, appear such as the artist represents her, one must fatally arrive at a great incertitude of mind close to mental derangement. For us, we admit only having seen in the fantasy of dreams or in the narrative of the *Thousand and One Nights* these streamings of molten gems, flowing like scintillating lava and becoming beneath the hand of the painter roofs of sapphire, terrains of emerald, and rivers of ruby."[4] As we have seen in a letter to Duret, Monet uses a similar rhetoric in order to communicate his response to Mediterranean color and light, and even Gilbert's derisive judgment is not unlike the artist's own self-recriminations. Neither the artist nor the critic as yet possesses a theory of non-naturalistic expression which might serve to validate these works.

We can find evidence for the existence of just such a theory in some of the little magazines of the period. The article in the *Revue Moderniste* (Marseilles) is more committed to the esoteric aspects of Monet's paintings than any of the reviews in the Parisian press. The author is twenty-year-old writer Paul Guigou, whose namesake, Paul-Camille Guigou (1834–71), had exhibited a series of landscapes of Provence at the Salons of 1863 to 1872. Monet's paintings of the Midi are not compared to those of the senior Guigou in the article, but in their "audacities of intense color" they are compared to the works of "a bizarre and rather unknown painter" from Marseilles, Adolphe Monticelli (1824–86). Guigou refers to Monet's exhibits as "an entire series of landscapes, works beyond price, of an unparalleled personal accent and an incomparable splendor." The brightly colored Menton view noted by Wolff (W. 897) also attracts the attention of Guigou, but instead of striking a veristic note the critic takes up the language of fantasy: "Fields stretch out, of red ocher earth, daring in a gamut of frightening boldness. One might speak—beneath the intense azure sky, vibrating with the heat of the sun—one might speak of a rolling fire of embers, a flow of blazing lava. It bleeds its bright purple in front of the

sparkling green and blue sea, which sets out at the feet of the violet mountains, as in a cup, its cool transparency and its emerald dazzle. Stocky parasol pines mass up their tufts of vigorous vegetation. This triumphal and violent bouquet of colors seems sonorous and strident; the hallucinated ear thinks it hears a fanfare made of trumpet blasts."[5] The last sentence recalls the stifled fanfare of Weber's music that Baudelaire had famously claimed to hear in Delacroix's blood-red lakes shaded by evergreen pines.[6]

Water is the prime element of Monet's transformations. A Fécamp cliff scales the sky and overlooks "the bright immensities of the sea, the abyss of translucent water" (W. 653); a Varengeville point "crowned with houses and a church, vague, imprecise, enveloped in violet and blue shadow, seems to float on the moving spaces like some fantastic Delos" (W. 726); and, at the foot of an Etretat arch, "the sea lives, stirs, and shudders in a thousand choppy waves; it is a streaming of gems, sapphires, topazes, emeralds, amethysts, scintillating, dazzling; the blinding treasures of the reflections of the sea, of the crystalline sea, gleam and quiver in all the facets of the prism. The eyes drink in the diapered splendors of this adamantine nature." For Guigou, Monet's water is the crystalline lens where the rays that emanate from self and world converge; the painter has the "protean capacity to incarnate himself in things."[7]

As opposed to the self-reflexive account of Guigou, the evocation of Monet's water paintings by the Belgian poet Emile Verhaeren stresses a hermeneutics of the world rather than a phenomenology of the self. Once again water is seen as Monet's element: "Water, in its infinite variety, fluid, running water, bright, pensive, dormant water, water that is diamonded with sun, water with a momentary image which it displays and immediately bears away; water all imprinted with azure or all swaddled in fog, crystalline water, if the bottom is pure; turbid, opaque water, if the bottom is muddy; shuddering, whispering, living water." Animated like the water, the sky and air are also viewed as active agents in Monet's art: "The water, sky, and air are treated and as though combined, influencing one another, attracting one another, interpenetrating with one another. It is especially in these landscapes that he gives the feeling of extension, immensity, infinity." Although Verhaeren eschews allegory he insists on the rhetoricity of his account of Monet's art: "pour ainsi dire."[8] Verhaeren's generalized imagery allows me to identify no paintings in particular, but the oceanic scope of his last three nouns—extension, immensity, infinity—embraces the titles of some of Courbet's seascapes and also extends to the paintings of Monet's next campaign at Etretat.

Etretat and Death
by the Sea (1885–86)

IN FEBRUARY 1883 Monet spent three solitary weeks at Etretat (W. 816–33). He returned to the site in August 1884 with his family, and seems to have worked on at least two canvases begun during the previous stay (W. 907–8). In November 1884 Octave Mirbeau made special mention of a *"Night at Etretat* illuminated by the pink moon . . . a simple and mysterious thing"￼(W. 817; fig. 42),[1] and, as we have seen, in May 1885 Albert Wolff singled out an Etretat scene from among Monet's exhibited water paintings of Fécamp, Pourville, Varengeville, Port-Villez, Vernon, and the Riviera. Monet returned to the famous cliffs of Etretat for a final campaign that intermittently extended from September 1885 to March 1886 (W. 1009–53).

For Monet in 1885 Etretat represents the promise of renewal. Discouraged by the unaccommodating weather at Giverny which causes him "to lose many studies," Monet resolves to take to the sea. The maritime prospect permits him to anticipate a bout of productivity to offset Durand-Ruel's periodic advances of funds: "I will go to Etretat to make you some fine marines" (12 September 1885; L. 584). Although Monet's work frequently languishes, he is quick to acknowledge the consequences: "I could not bring to completion, as I would hope, the canvases that have been underway for so long and which I would have done much better to abandon weeks ago; I would have had time to redo others. Instead of that I have only managed to do and undo." Breaking with this sterile syndrome of deferral and destruction, Monet leaves for Etretat "full of ardor and in order not to fall back into the same errors" (16 September 1885; L. 585).

The ambivalence of Monet's situation at Etretat is apparent in the first letter to Mme Hoschedé that is preserved: "Indeed I think of you, I assure you, and despite my love for the sea and my desire to bring back lots of

canvases, I would really like to be in Giverny, but it is necessary to work whatever the cost and notwithstanding the bad weather, which does not have the look of turning fine." Crammed together like the symbols in a dream, here we have an inventory of Monet's perpetual struggle between desire and obligation. He loves the sea, but he loves Alice as well. He loves Alice, but he must pay the emotional cost of their separation in order to recoup the financial expenses of their ménage. He pays this price in work for Durand-Ruel, but the weather refuses to accommodate his needs. He stays and paints nonetheless, but must always reassure Alice that his absence is a painful obligation rather than a creative joy. In the meantime she is at home tending the poultry and the dahlias as he asks, and he is abroad, stimulated and refreshed: "The countryside is very beautiful and I am happy to have gone" (13 October 1885; L. 589).

Having previously experienced the inclemency of Etretat, Monet guards against dependence upon the elements by contriving vantage points in stairways and behind windows. Nevertheless the combination of weather and sea defeats him and he fails to recover the precise configurations of his motifs: "When the tide was just as I needed it, the weather was not" (24 October 1883; L. 597). But Monet persists: "Etretat is becoming more and more amazing, now is the real moment, the beach with all its fine boats, it is superb and I am enraged not to be more skillful in rendering all this. I would need two hands and hundreds of canvases" (20 October 1885; L. 592). Monet's subsequent serial practice consolidates the strategy of repetition that he adumbrates here.

As at Bordighera, the forced intimacies of hotel life soon come to threaten Monet's equilibrium; in spite of the praise of his fellow painters, he prefers to be alone or, were it possible, alone with Mme Hoschedé (22 October 1885; L. 595). Her letters make him nostalgic for home, especially when he contrasts the absent "beauties" of Giverny with the present fury of the sea. Monet remains committed to Etretat, but his commitment is riven by longing: "It is true that I love the sea, but finally I love you too and would indeed like to be by your side" (26 October 1885; L. 598).

The irritations of companionship are eventually eliminated, and for a brief moment Monet revels in his solitary possession of the site. He writes to Mme Hoschedé in words that repeat the sentiments of a much earlier declaration of the benefits of seaside solitude. From Honfleur in 1864 Monet had written to Bazille that "it would be better to be all alone, and yet, all alone there are a lot of things that one cannot make out" (15 July 1864; L. 8). In 1885 his feelings are much the same: "I am enchanted to be alone; it seems to me that I am going to work better even in bad weather, for

alone I cannot stay unoccupied and yet I would really have liked to take advantage of [the painter Michel's] railway carriage and come surprise you tonight at 10 o'clock" (1 November 1885; L. 605). It will turn out that upon the receipt of additional funds from Durand-Ruel it is not Monet but Mme Hoschedé who makes the trip.

While awaiting her arrival Monet fails to get forward in his work: "I was furious just now with those changeable fishermen; they were supposed to go fishing at 4 o'clock and I had arranged to be there in order to do a sketch; I installed myself on the beach to get the sea ready and I waited; seeing them make their preparations, I stayed, but the night arrived without their having left and I learned that with the barometer falling they would not be going fishing, even though on the open sea I saw the others going off. I was furious because they made me lose my time" (2 November 1885; L. 606). Possessed by grandiose thoughts of control over events, Monet is repeatedly devastated by the unpredictability of human relations and the natural environment.

When finally the sun and sea combine to please him, Monet sets furiously to work: "Finally here is a beautiful day, a superb sun like at Giverny. So I worked without stopping, for the tide at this moment is just as I need it for several motifs. This has bucked me up a bit" (6 November 1885; L. 612). Compulsively held by the lure of the sea, he cannot leave his easel even to meet his mistress's train: "You will not be angry at me not to go to meet you, but I am working well in this regular weather and if the weather changed I would be desolated, all the more since several canvases in gray misty weather are almost finished" (12 November 1885; L. 619). One wonders how mutually fulfilling their brief reunion was, his desire to "possess" her overrun by his desire to possess the sea-image of his dreams. Mme Hoschedé's testimony is lacking since her letters were systematically destroyed by Monet with a "heavy heart" (18 November 1885; L. 623).

In compensation for her absence, Monet returns to work at the Manneporte on "that so beautiful motif of green water" which Mme Hoschedé had seen. The rhetorical juxtaposition of Alice and the sea suggests that Monet seeks release from the strain of their relationship by a return to the element associated with his youth, his mother, his mentors, his wife, his first and most lasting success as a painter. This release, however, is very hard to achieve.

Monet tries to anticipate meteorological and maritime change by starting canvases in all weathers and with different effects, but he knows that this is futile. To Pissarro he writes that "it was to no avail to set out canvases for all weathers; I do not come to the end of it" (27 October 1885;

L. 599). No matter how many canvases he starts he can bring none to completion; as he writes to Mme Hoschedé, "so many things are necessary in order to find again one's effects with the seas low or high, calm or agitated, I think that I have not had so much difficulty or weather so variable" (25 November 1885; L. 629).

An unforeseen event soon convinces Monet of the unproductiveness of his practice. His account of it seems to have terrified Mme Hoschedé, as we learn in a subsequent letter, and Monet acknowledges his faulty judgment in not waiting to tell her at home. A lack of empathy typifies Monet's correspondence with Mme Hoschedé, for his dramatic recitation from Etretat is only the most egregious example of an impetuous habit of communication that Monet comes to regret:

> After yet another rainy morning, I was pleased to see the weather improve a bit; although a strong wind was blowing and the sea was furious, yet just because of that I counted on having a rich session at the Manneporte, but an accident happened: do not alarm yourself, I am safe and sound since I am writing to you, but little was lacking for you to have no news of me and for me not to see you again. I was in the full ardor of work beneath the cliff, well in the lee of the wind, at the place where you came with me; convinced that the tide was dropping I did not become frightened of the waves that were coming in to die a few steps from me. Briefly, all absorbed, I did not see an enormous wave that threw me against the cliff and I fell head over heels in the foam, with all my materials! I immediately saw myself lost, for the water held me, but finally I was able to get out on all fours, but in what a state, good God!, with my boots, my heavy stockings, and the old dotard soaked; stuck in my hand, my palette struck me in the face and my beard was covered with red, yellow, etc. But finally, the emotion passed; it is nothing at all. The worst is that I lost my canvas, broken right away, as well as my easel, my sack, etc. Impossible to fish anything out. Moreover, it was all crushed by the sea, the tramp, as your sister says. In sum, I had a narrow escape, but how I raged to see myself unable to work once I had changed and to see my canvas, on which I was counting, lost, I was furious. . . . The cause of all this, for I am very prudent and I never go out without worrying about the exact hour of the high tide, is that in seeing the schedule at the hotel that indicates the tides I did not notice that yesterday's leaf had not been torn off, so that the sea was rising instead of falling as I was convinced. (27 November 1885; L. 631)

For anyone who trudges about the vertiginous Etretat cliffs today, it will be quite apparent that Monet repeatedly puts himself at risk in his clambering from spot to spot in search of motifs to paint. In spite of the anxiety expressed by his mistress after she received his letter, Monet refuses to promise Mme Hoschedé to forsake the sea (29 November 1885; L. 634).

Quite soon after the artist's death, the critic Thiébault-Sisson recalled this episode as a parable of the uselessness of seeking to wrestle with nature: "One does not enter into a struggle with her," Monet is quoted as having said. The Etretat story then follows in Thiébault-Sisson's words:

> Finding himself on a day of the equinox at Etretat, he had sought to reproduce a tempest in all its details. Having exactly informed himself of the height which the waves might attain, he had planted his easel at the requisite height in order not to be submerged by the waves, in an anfractuosity of the cliff. For greater precaution he moored his easel with heavy cord and solidly fixed his canvas upon the easel. After which he had started to paint. The sketch was already auguring well when, from the sky, bursts of rain poured down upon him. At the same time the tempest redoubled in violence. More and more powerful, the waves rose up in furious volutes and imperceptibly drew near the artist. Indifferent to everything, Monet was working with rage. All of a sudden an enormous, heavy sea tore him from his folding-chair. Suffocated and submerged all at once, he was going to be carried away when, by a sudden inspiration, he let go palette and brush in order to seize the cord holding up his easel. He was nonetheless rolled about like an empty barrel and, without the chance that had brought two fishermen to the cliff, he would have gone to dinner at Pluto's table.[2]

It might be interesting to know whether the reference to Pluto is the artist's or his interlocutor's, but more important are the divergences of the 1927 anecdote from the narrative sent to Mme Hoschedé in 1885. A torrential downpour of rain has been added to the clearing weather of the letter, but Monet is now depicted as both informed and prudent in his attention to the safety of his perch. The overwhelming force of the natural event is magnified, as is the artist's fight for survival, yet Monet's superhuman efforts would still have failed but for the arrival of two fishermen who are nowhere described in the letter. In the next chapter I will more fully examine the self-destructive implications of Monet's enterprise by the rocks of the sea, but for the moment let us consider some of the tropes of his original text.

First, the fury of the sea. From Bernardin de Saint-Pierre and Cha-
teaubriand to Michelet and Victor Hugo, the elemental fury of the channel
waves is a much-repeated allegory for the destructive energy of erotic
passion. This romantic animation of the sea has its pictorial counterpart in
the works of Eugène Isabey, Théodore Gudin, and Paul Huet, the painters
prior to Monet most closely associated with the depiction of channel storms.
Huet's *High Tide of the Equinox in the Environs of Honfleur* (1861) was one
of the most famous paintings of Monet's own stretch of the Normandy
coast, but Courbet is surely Monet's most burdensome precursor with his
Stormy Sea exhibited to great acclaim at the Salon of 1870.

After the fury of the sea there is the artist's absorption in the spectacle.
Spurred by the sight of Courbet's seascapes back in 1859, Zacharie Astruc
had written: "The waves entice me and smile at me / Smile at me like a
mistress; / And her voice, powerful caress, / Resounds in my ear."[3] In "La
Gloire de l'eau," published in *La Mer* in 1886 by another of Monet's literary
acquaintances, Jean Richepin, we find a contrary indictment of the act of
self-reflection: "From eternal Isis the inexhaustible breasts / Forever offer
their magic milk to our kiss . . . / The poets of yore only searched on the
strand / For a melancholy promenade for their dreams, / A resonant echo
to their own sobs. / Those of the present hour search there for pictures. /
But for each of these bunglers with lyre or palette / The sea is but a mirror
where their self reflects." Richepin insists that the artist must attend not
to his personal reflection in nature but rather to "her own face."[4] The
poet's repudiation of artistic self-reflection in the name of an untrammeled
empiricism provides an interesting account of the dilemma of an artist
such as Monet, caught as he is between nature and myth, reality and dream.
He sits by the dying waves of the sea seeking to grasp her face, *la gueuse,*
the tramp or scamp or beggar or bitch; it is the sea's face he paints, but
his response to its feminine gaze is so intense that I persist in seeing in his
pictures the very mirror of the *moi* which Richepin rejects.

After the sea's fury and the artist's ardor there is also Monet's fury
that this "accident" should have befallen him, he who knows the times of
the tides, he who imagines himself in control of his fate. This time the sea
deals Monet's self-esteem both a pictorial and physical blow; he loses his
canvas, he almost loses his life. The question I will defer is whether this
last loss is not also in some respects his most hidden wish.

As Monet lingers at Etretat his death wish increases. Projected inward,
this wish culminates in the suicidal scenario by the foot of the Manneporte;
projected outward, Monet's rage puts each one of his paintings at risk.
Fever, nightmares, and loss of voice assail him (28 November 1885; L.

632); repeated brushings assail his interminable pictures. The shifting sun no longer illuminates "my Manneporte" in the same way: "They would thus be canvases impossible to finish" (8 December 1885; L. 636). Absolutely "demoralized" and "disgusted" Monet now speaks of a lost campaign; his thoughts turn to Giverny and to his little fleet of boats which must be protected from the wintry Seine (10 December 1885; L. 639). Removal from Etretat proves as indecisive as all the previous actions of the trip; he wishes that he had left earlier, he looks forward to returning in February or March (13 December 1885; L. 641).

Nine weeks after his two-and-a-half month struggle at Etretat, Monet returns for a final stay of ten days. The painter's actions at just that moment seem not to have been motivated solely by professional considerations; Monet's last campaign at Etretat coincides with the presence of Ernest Hoschedé at the birthday celebration of his wife at Giverny. Monet is "annihilated" by this development, and although he acknowledges that it would be better not to send Mme Hoschedé such a bleak account, he cannot resist acquainting her of his pain. Along with obsessive thoughts of her, Monet also claims to have unceasing concern for "our two little ones, so cute and nice" (20 February 1886; L. 655). The reference is to Camille Monet's son Michel (b. 1878) and Alice Hoschedé's son Jean-Pierre (b. 1877); the implication here and elsewhere in the correspondence may be that Monet is the father of both. Whatever may be the truth in the matter of paternity, Monet's anxiety at Etretat is intense, and becomes manifest in insomnia, nightmares, melancholia, and an inability to work. Apparently threatened by Mme Hoschedé with a separation, Monet writes that "the painter in me is dead" (22 February 1886; L. 656): "I have so little heart to work that I dare not touch a single canvas" (28 February 1886; L. 660). Wildenstein catalogues twelve paintings of Etretat from 1886 (W. 1042–53), but from subsequent letters it seems clear that these pictures were for the most part finished after the painter's return to Giverny.

At least two of the paintings from Etretat dated 1886 were among the thirteen works shown at Petit's Exposition Internationale in June. Although Monet also exhibited paintings from Giverny, Menton, and Holland (where he had recently spent ten days painting tulips, windmills, and canals), the Etretat pictures were especially remarked by the critics. In 1885 Albert Wolff had lavishly praised a closely cropped view of the massive Manneporte (W. 832); at the base of the rock arch two tiny gazers are silhouetted against the horizon of the agitated sea. In 1886 Monet exhibited a similar painting (W. 1053), this one more monumental in scale, owing to its closer view and enlarged vertical format (92 × 73 as opposed to 65 × 81 cm;

figs. 43–44). In spite of this intensified repetition of the motif, Wolff over-looks the Manneport scene in 1886 and concentrates on a more distant view of Etretat's famous rock-needle seen from the top of the cliffs (W. 1032).

Wolff briefly enumerates the works of the other exhibitors and then devotes to Monet almost half of his one hundred thirty-six lines. Whereas in 1885 Wolff had approvingly mentioned Monet's largely waterless view of Cap Martin, upon its (or one of its mates') reexhibition in 1886 the critic now writes that the vivid seaside road resembles "a torrent of red-currant jelly clearing a path across the greenery." He prefers a more muted seascape of Etretat: "Of the thirteen canvases that he exhibits, only one is really very good. *The Sea at Etretat* nevertheless does not belong to the naturalistic genre. It is a lake of enchantment. Prince Charming could arrive in the background in his wherry without one experiencing any surprise. Hence it is a sea of fantasy in a fantastic though very distinguished coloration, with fantastic rocks."[5]

As opposed to the veristic understanding of the Etretat painting of the year before, Wolff's analysis in 1886 asserts a non-naturalistic interpretation of Monet's work. In a quatrain by the polemicist of the symbolist move-ment, Jean Moréas, a woodland fairy personifies the active agency of Mo-net's art: "The Fairy-of-the-Wood, not chary / Upon his palette of flowers / Has from her rich cornucopia / Poured out colors."[6] Other critics also emphasize the fantastic coloring of Monet's art, and they do so both posi-tively and negatively. Adamant in the face of Monet's "fantasmagorias," Paul Gilbert refuses "to recognize the least appearance of reality, the least sincerity of impression in these chimerical paintings which would evidently have pleased the unfortunate monarch of Bavaria."[7] On the other hand, like Diderot in the face of twenty-five seascapes by Vernet at the Salon of 1765 (the critic says 1763), Marcel Fouquier is struck by the artistic unity of Monet's thirteen canvases: "However violent may be the facture, there is the absolute sincerity of the artist. . . . The very fury of his palette only translates for the eyes the anxiety and as though intimate torment of his thought." Monet's Etretat paintings are said to resound with "the poem of the silent sea" and "the whistling noise of the rain upon the furious waves which whiten with foam." Even Monet's tulip fields (W. 1067) seem oceanic to Fouquier, for their "crests light up with reflections like waves."[8]

Two well-known writers comment on the Etretat paintings in 1886 and the disparity of their response exemplifies the transitional nature of this moment in French literature and art. A first-hand witness to the painter's seaside campaign, Guy de Maupassant published an article entitled

"La Vie d'un paysagiste" in which Monet's struggle to render the dynamic effect in *Rainy Weather (Impression)* (W. 1044) is related to the theories of artistic creation recently sensationalized in the novel *L'Oeuvre* (1886) by Zola. In contrast to the romantic dramatization of artistic practice in Maupassant, Félix Fénéon provides his readers with a symbolist evocation of Monet's art. In his pamphlet *Les Impressionnistes en 1886,* Fénéon juxtaposes Monet's allegedly intuitive decomposition of color with the ostensibly scientific divisionism of Georges Seurat. Whereas in their day Monet and his colleagues are said to have been heroic revolutionaries of painting, Seurat and his followers are now seen to be the initiators of a rigorously objective transformation of modern art. Fénéon's appropriation of science, however, may have been as much in the spirit of mystery as in the name of rational explanation. Fénéon was a frequenter of Mallarmé's "Mardis" as well as the editor of Rimbaud's *Illuminations,* and it is the symbolist literary practices of eccentric ellipsis and metaphorical condensation that characterize Fénéon's treatment of Monet.

Fénéon concentrates on Monet's seas: "His seas, seen with a glance which falls perpendicularly upon them, cover the whole rectangle of the frame; but the sky, though invisible, may be divined: all its changing emotion [*émoi*] betrays itself in restless plays of light upon the water. We are a bit far from the wave of Backysen [*sic*], perfected by Courbet, from the volute of green sheet-metal crested with white foam in the banal drama of tempests."[9] In an earlier version of the text, the play of light upon the water is said to be fleeting, *fugace;* in the final version, the adjective is *inquiet.* With the disquiet that attends all the acts of translation in this book I have rendered the word as "restless" rather than "anxious"; depending on whether we take the *émoi* to be that of the artist or of the sea we will prefer to see mirrored in Fénéon's text the face of Monet's anxiety or the traces of an agitated sea. Or perhaps both.

The sea and the sky are endowed with reflexivity in Fénéon's text; taken in by the artist's glance, it is the scene that *se devine, se trahit.* In contrast to Monet's animated sea, Fénéon notes the formulaic storms in the work of Dutch artist Ludolf Backhuysen (1631–1708) and his nineteenth-century successor Courbet. Courbet constructed his marines in a conventional manner indoors, but Backhuysen was known for having gone out into the storm to sketch the sea, and several of his and his colleagues' storm-tossed views were in the museum at Le Havre already at the time of Monet's youth.

In his first version Fénéon writes that "Etretat especially requires this marinist"; in the revised text published in October, *requiert* is changed to

sollicite, just conceivably a response to Maupassant's late September article in which Monet's motivations are stressed: "He takes pleasure in its surging blocks, in its terebrated masses, in its abrupt ramparts from which spring up, like trunks, flying buttresses of granite. The *Needle of Etretat* [W. 1032]—and, sails barely blued, flying skiffs crudely invert themselves in this water-sheet whose violet stirs there in icy greens, precursors of hesitant blues and furtive incarnadines. *Rainy Weather* [W. 1044]: the rocks, the needle dissolve themselves in this mist in which delicate gray harmonies play. *Marine* [W. 1009?]: a pinkish beach, and greens, mauves, and violets drown themselves in splashing waves. The intrados of the Manneporte" (W. 1053).[10] Fénéon's descriptions suit the surface of the sea as well as the psyche of the artist, for both are sensitive surfaces capable of registering impressions as colored marks. In their reflexive verbs and reflected strokes Fénéon's texts and Monet's pictures are icons of self-reference whose embedded trope is Narcissus.

Nowhere does Fénéon make a direct case for the philosophical implications of Monet's artifice. In a footnote, however, he introduces into the discussion the most speculative text on Monet in 1886: this is the brochure *Science and Philosophy in Art,* written under the pen-name Celen Sabbrin by the American chemist Helen Cecelia De Silver Abbot Michael. Her twenty-page essay reviews an exhibition of paintings by the impressionists held by Durand-Ruel in New York. She focuses almost exclusively on Monet and proposes that his pictures "come first as the latest expressions of scientific and philosophical thought": "No one in art before him has ever approached so near the domain of the philosopher." By science Sabbrin has in mind Pasteur's theory of molecular dissymmetry, which claims to distinguish the forms of organic life from the symmetrical structures of artificial synthesis; and by philosophy she seems to have in mind the Schopenhauerian perspective that "the indifference of nature to suffering or happiness is terrible to contemplate." The so-called triangulated organizations of Monet's pictures provide Sabbrin with the evidence that his is an art of perfection, fixation, reflection, and death. In an unidentified painting, *Mail Post at Etretat,* she discovers that the sea's "lovely transparency, which is finally lost in depth, reminds us of how we are lured on in our search after truth—simplicity and clearness at the start, ever increasing dimness following"; in *Fog Effect near Dieppe* (W. 724) she imagines that "on just such a coast line might life have originated, as the sport of accident, by the cruel sea, indifferent to the origin, progress and destiny of this life, to which she had given birth"; and in *Morning at Pourville* (W. 711) she sees "the blind, immutable forces of unsympathetic nature": "Innocence is

depicted upon the siren's countenance. In the past, how many adventurous mariners she has lured on to repose upon her trustful bosom, only to drag them to her distant abode, the dwelling of death."[11] I will return to the deathly lure of Monet's art in the next chapter, but for the moment I wish merely to insist on Fénéon's role in pointing to Sabbrin's interpretation of Monet's art.

The Etretat series constitutes the high-water mark from which Fénéon's subsequent evaluation of Monet's seascapes sharply recedes. Two years later he finds that he cannot appreciate the artist's "vulgar" improvisations at Antibes, where Monet had once again submitted himself to the lure of the "extraordinary blue" of the Mediterranean Sea (see letter to Mme Hoschedé, 10 April 1888; L. 867).[12] At Antibes Monet finds himself comfortably installed and generally admired; in part this seems to have been due to a recommendation from one of the familiars of the place, his friend from Etretat, Guy de Maupassant (see letter to Mme Hoschedé, 15 January 1888; L. 807).

From Etretat Monet writes to Mme Hoschedé of pleasant evenings spent in the company of Maupassant (15 October 1885; L. 590). Although not convinced that the writer really understands what his art is about, Monet seems pleased to record of Maupassant that "the rain-effect absolutely amazed him" (31 October 1885; L. 604). Monet came to own a number of Maupassant's works of fiction dating from 1880 to 1885, and several of these stories feature the sites at Etretat that Monet also depicts. Maupassant's article on the artist includes an account of a site both men knew well: "Last year, in this same place, I often followed Claude Monet in pursuit of impressions. He was no longer a painter but a hunter. He would go followed by children who carried his canvases, five or six canvases representing the same subject at diverse times and with different effects. He took them and left them each in turn, following all the changes in the sky. And the painter, in the face of the subject, waited, lay in wait for the lights and shadows, gathered in a few strokes of the brush the falling ray or the passing cloud, and, disdainful of the false and the conventional, put them down upon the canvas with rapidity." Though somewhat reminiscent of Boudin's journal entries of the 1850s, Maupassant's 1886 account subordinates inspired virtuosity to patient discipline. Nevertheless, the climactic moments of the artist's wrestling with his effect are still related in the language of romanticism: "I have seen him thus seize a scintillating fall of light upon the white cliff and fix it with a flow of yellow tones which strangely rendered the surprising and fugitive effect of this unseizable and blinding bedazzlement. Another time he took by handfuls a rainstorm

beating down upon the sea and threw it upon the canvas. And it was truly rain that he painted this way, nothing but rain obscuring the waves, the rocks, and the sky, scarcely distinct beneath this deluge."[13]

Maupassant's discourse of attentive observation and ardent execution echoes the language of Baudelaire's well-known passages on Delacroix in the *Salons* of 1846 and 1859. Although Delacroix painted several watercolors at Etretat in 1834, Maupassant recalls instead the visits of Corot and Courbet, and it is the latter's work indoors upon a painting of the stormy sea that Maupassant sets in contrast to Monet's *Rainy Weather* (figs. 45–46): "In a large bare room a fat, greasy, and dirty man was pasting slabs of white color on a large bare canvas with a kitchen knife. From time to time he went to lean his face against the window and looked at the tempest. The sea came up so close that it seemed to beat the house, which was enveloped in foam and noise. The salt water struck the panes like hail and streamed down the walls. On the chimney a bottle of cider next to a glass half full. From time to time Courbet went and drank a few drops, then he came back to his work. Now, that work became *The Wave* and made something of a noise in the world." The creative struggle of Courbet and Monet is the living counterpart of novelistic fiction. In Monet's practice Maupassant admires "the entire terrible combat which Zola recounts in his admirable *Oeuvre,* all that infinite struggle of man with his thought, all that superb and frightful battle of the artist with his Idea, with the picture glimpsed and unseizable."[14]

In making Monet into a kind of epistemological hero of the elusive impression, Maupassant distorts Zola's recent book in which the painter is portrayed as morally flawed and ineffectual. Named Claude, the novel's brilliant but failed artist seems to be largely based on Monet's career prior to 1880; during this period Zola criticized Monet's work as hasty, superficial, and incomplete. Monet was very troubled by the publication of the book, as he writes both to Pissarro (10 April 1886; L. 667) and to Zola himself: "Excuse me for saying this to you. It is not a criticism; I have read *L'Oeuvre* with very great pleasure, finding memories on each page. Moreover you know my fanatical admiration for your talent. No, but I have been struggling for rather a long time and I have fears lest at the moment of arrival enemies make use of your book to slaughter us" (5 April 1886; L. 664).

It may well be that Monet came to internalize Maupassant's account of his pictorial practice. Similar language shows up in a major interview published in 1889 in Maupassant's newspaper, *Gil Blas,* by Hugues Le Roux. It is here, in the enumerated company of Bernardin de Saint-Pierre,

Jean-François Millet, Paul Huet, and Camille Corot, that Monet declares, "I have remained faithful to that sea in front of which I grew up." The article describes Monet's work at Etretat at length, but it is not possible to determine whether the journalist relies upon an account by the painter or upon Maupassant's text: "Streaming water beneath his cape, Claude Monet painted the hurricane amid spatterings of salt water. Between his knees he had two or three canvases which successively, during the course of some moments, moved in procession across his easel. On the same raging sea, within the same frame of the cliff, there were different effects of light, sudden infiltrations of day falling through embrasures in the cloud, as though through windows of caves, illuminating the surging night of the sea with islets of gold and emerald, with flows of livid lead. The painter lay in wait for each one of his effects, slave to the returns and disappearances of the light, arresting his brush at the end of his sighting, depositing at his feet the unfinished canvas, lying in wait for the return of the vanished impression in order to continue his initial work."[15] Between 1886 and 1889 Maupassant's heroic hunter of seaside impressions is transformed despite the litany of repetition. However much Monet and others might have still sought to promulgate an empiricist discourse concerning his art, the non-naturalistic intensification of images conveyed in Le Roux's platonic metaphor of the illuminated cave increasingly comes to characterize the critical response to his art.

6

Belle-Ile and the Oceanic Feeling (1886–87)

BELLE-ILE-EN-MER IS A SMALL ISLAND in the Atlantic off the coast of Brittany. With its grottoes, needles, and reefs formed by the wind and waves, Belle-Ile offers a fine example of that category of natural scenery that has come to be designated as the sublime. Well before Boileau's translation of Longinus in 1674, landscapes and seascapes of the sublime were commonplace motifs in French literature. Belle-Ile finds its first sublime description in an ode, "La Solitude" (ca. 1618), by the sailor-poet Marc-Antoine de Saint-Amant.[1] Closer in time to Monet, Gustave Flaubert testifies to the sublime thoughts provoked by a sojourn on Belle-Ile. In a book of travel writings Flaubert records how long walks on the cliffs leave him and a companion willing prey to the alluring vastness of nature:

> Our spirit revolved in the profusion of these splendors, we drank them in with our eyes; we flared our nostrils to them, we opened our ears to them. . . . As in the transports of love one desires more hands to touch, more lips to kiss, more eyes to see, more soul to love, stretching ourselves out upon nature in a movement full of delirium and joy, we regretted that our eyes could not reach to the bosom of the rocks, to the depths of the seas, to the end of the sky, in order to see how the rocks grow, the waves flow, the stars light up; that our ears could not hear the rumbling of the formation of granite in the earth, the pressing of sap in plants, the rolling of coral in the solitudes of the ocean, and, in the sympathy of this contemplative effusion, we would have wished that our soul, everywhere irradiant, could go live amid all this life so as to don all its forms, endure like them, and forever varying, forever undergo its metamorphoses beneath the eternal sun.[2]

Flaubert had traveled to Belle-Ile in 1847, but his account was published only in 1886. Monet owned this book; a fellow Norman, in his artistic anxiety he later compares himself to Flaubert (30 April 1889; L. 968).

Flaubert's companion and coauthor on Belle-Ile is Maxime Du Camp; at the Salon of 1859 he advocates the island as a spot where a painter might study "nature in one of her grandest manifestations." The occasion for this recommendation is a "curious" canvas by Octave Penguilly-l'Haridon, *The Little Gulls: The Shore of Belle-Ile-en-Mer, Port-Donan (Morbihan)* (fig. 47): "It is in this desert, in this *retiro* which no human step troubles, where no fisherman appears, before which no ship passes along the horizon, that the gulls have assembled by the hundreds, by the thousands, by the millions. They cover the strand, pile up upon the rocks, fly above the cliffs, innumerable with their pointed and white wings like the flowers of jasmine. It has a strange aspect, very restful, at the same time full of life."[3] Baudelaire responds similarly to "the intense azure of the sky and the water, two regions of rock that make a portal open onto infinity (you know that the infinite appears more profound when it is the more closed in), a cloud, a multitude, an avalanche, a *wound* of white birds, and the solitude!"[4] In 1859 Monet might easily not have noticed Penguilly-l'Haridon's painting, and the descriptions of Flaubert, Du Camp, and Baudelaire probably had less to do with the painter's eventual trip than personal recommendations from Renoir and Mirbeau. The literary tradition is nonetheless preserved in the guidebooks to Brittany which Monet is reported to have consulted prior to his trip.

Monet's letters from Belle-Ile invoke the sublime in everything but the word itself: "It is tragic, but completely beautiful, and a sea unparalleled in color" (13 September 1886; L. 685); "It is sinister, diabolical, but superb" (14 September 1886; L. 686); "The sea is completely beautiful, as for the rocks, there is a pile of grottoes, points, extraordinary needles" (18 September 1886; L. 688); "The place is very beautiful but very savage, but the sea is incomparably beautiful and accompanied by fantastic rocks" (25 September 1886; L. 694); "I am in a land superb in savagery, a piling up of terrible rocks and a sea unbelievable in color" (11 October 1886; L. 709); "It is extraordinary to see the sea; what a spectacle! She is so unfettered that one wonders whether it is possible that she again become calm" (15 October 1886; L. 713); "For three days there has been a terrible tempest and I have never seen a comparable spectacle" (17 October 1886; L. 715); "I am enthusiastic for this sinister land and precisely because it takes me out of what I am in the habit of doing" (28 October 1886; L. 727); "What a tempest and what a terrible spectacle" (29 October 1886; L. 728); "For [the

sea] is terrible; she offers you those tones of glaucous green and absolutely terrible aspects (I repeat myself)" (30 October 1886; L. 730); "A terrible, sinister land, but very beautiful" (1 November 1886; L. 733). Mirroring the verbal repetitions found in the letters, Monet's paintings from Belle-Ile repeat the traits of their mates in all particulars but for telling alterations in size, scale, color, and atmospheric effect (W. 1084–1119; figs. 48–49).

Monet's multiple images of a single site would seem in part to result from the painter's inability to complete an individual picture, ostensibly on account of changing effects of light and weather. He is repeatedly beset by bouts of fury and despair and yet always recommences the same motif, "always imagining that what I begin will be better and that I will be able to do it in two or three sessions; sometimes it works but it fails me still more often" (1 November 1886; L. 732). As a consequence, Monet is forced to finish some of his pictures back at Giverny.

Monet's doubt regarding his pictorial repetitions alternates with a much more hopeful endorsement of the practice: "In brief, I am mad about [the sea]; but I well know that truly to paint the sea one has to see her every day, at every hour, and from the same spot in order to know her life just at that spot; and so I redo the same motifs up to four and six times even" (30 October 1886; L. 730). In his next letter to Mme Hoschedé, Monet depreciates the canvases "which are no more than repetitions of the same motifs" (31 October 1886; L. 731). Monet insists on leaving Belle-Ile a victor in his struggle with the sea, yet at the same time he candidly acknowledges that "to be rained on for hours in order to be able to get in a few strokes of the brush, no, that is demented" (16 November 1886; L. 749).

Monet describes himself as prone to melancholia and maniacal in his habits (15 October and 23 November 1886; L. 713, 756). He often ends a day of work "harassed, soaked, drenched, disgusted, discouraged" (12 November 1886; L. 744), but at other times a more heroic self-portrayal emerges: "Still miserable weather; yesterday afternoon I was able to work and thought that the weather was going to clear up again, but the clearing was of short duration, the barometer once again fell this morning; I went to work all the same; attaching canvas and easel and having bought a suit of oilskins, I bravely set to work, but this afternoon it is a fury and the rain has not let up" (12 October 1886; L. 710). Elements of this account accord with that of the critic Gustave Geffroy, subsequently the artist's lifelong friend and biographer, who by chance was staying on Belle-Ile during a portion of Monet's visit. Geffroy was on the island in order to write a biography of Auguste Blanqui (1805–81), who had been imprisoned

on Belle-Ile, and he later attributes to Monet's confrontation with the elements some of the same courage which he ascribes to the radical leader's political engagement.

Geffroy transcribes his notes of Monet at Belle-Ile in the travel book *Pays d'ouest:* "Claude Monet works in front of the cathedrals of Port-Domois, in the wind and the rain. He has to be dressed like the men of the coast, booted, covered with woolens, enveloped by an 'oilskin' with a hood. The squalls sometimes rip the palette and brushes from his hands. No matter, the painter holds on and goes off to work as to a battle."[5] Like Maupassant's portrayal of Monet at Etretat, Geffroy's rendition presents an image of the artist engaged in a quasi-religious ("cathedrals"), quasi-military ("battle") quest. Geffroy's eyewitness version of Monet's enterprise is similar to an anonymous account of the artist at work published in a regional paper: "At Port Domois, on Belle-Ile, Breton fishermen are astonished to see a man, dressed like them, in oilskins, heavy boots, and sou'wester, stubbornly painting, during the storm, upon canvases fixed to an easel lashed to the rocks with ropes. Often a squall will rip palette and brushes from the hands of the painter, who begins over again without ever becoming discouraged. This is Claude Monet, seeking to render the fleeting splendors of the storm. With the same aim, Vernet had himself attached to the mast of a ship."[6] Monet appreciatively notes this item in a letter to Mme Hoschedé in which he also reports the community's pride in his achievement (9 November 1886; L. 740).

Joseph Vernet's legendary exploit was illustrated by Horace Vernet, the artist's grandson, and described in the catalogue of the Salon of 1822 (fig. 50): "Called back to his country in 1752 in order to paint the *Ports of France,* this painter leaves Italy and embarks at Livorno in a small felucca. During the crossing, a violent squall comes up and threatens to break the frail vessel on the rocks. In the midst of the keen alarm of the crew and passengers, J. Vernet experiences no other fear than not to be able to see the admirable spectacle of a tempest well enough and close enough; tied down at the bow of the vessel, and there, rapturously contemplating the terrible scene that is offered to his view, he confides at one and the same time to his memory and his notebook the fugitive effects of a stormy sky and an angry sea."[7] This description matches earlier versions of the story that emphasize Vernet's empirical motives for studying the tempest, but the word *ravissement* also poses the issue of deathly pleasure to which I will wish to return.

In his famous first-century treatise Longinus asks why we are driven "by a sort of natural impulse" to contemplate the "astounding" ocean from

our position of frail mortality.[8] Immanuel Kant answers this question in the *Critique of Judgment* of 1790 where he proposes a psychological explanation: "Bold, overhanging, and, as it were, threatening rocks; clouds piled up in the sky, moving with lightning flashes and thunder peals; volcanoes in all their violence of destruction; hurricanes with their track of devastation; the boundless ocean in a state of tumult; the lofty waterfall of a mighty river, and such like—these exhibit our faculty of resistance as insignificantly small in comparison with their might. But the sight of them is the more attractive, the more fearful it is, provided only that we are in security; and we willingly call these objects sublime, because they raise the energies of the soul above their accustomed height and discover in us a faculty of resistance of a quite different kind, which gives us courage to measure ourselves against the apparent almightiness of nature." Like the Kantian observer Monet also strives to achieve a position of contemplative security: "Yesterday very fine weather and today weather that could not be more dreadful, rain and wind, the sea furious, but impossible to stick my nose out of doors. . . . In order to overcome my boredom I painted an *Effect of Rain,* a sketch" (9 October 1886; L. 707); "I am making some indifferent sketches from my window in order to pass the time, but at bottom I am very anxious for my poor canvases" (12 October 1886; L. 710). Monet chafes under the enforced constraints of indoor painting and insists on working out-of-doors whenever possible: "I was able to find a little sheltered corner in order to make a sketch, even two, which only very feebly give the idea of this upheaval; but, if tomorrow the weather is the same I hope to do better; but what difficulty to attain this sheltered spot! The wind is so strong that my porter and I had a terrible time advancing, and the sea almost everywhere invaded the brink of the coast even though it is 50 meters high" (15 October 1886; L. 713). Later in the campaign Monet admits that "I received so much hail that tonight my face and hands still hurt and at times I feared that my canvases would split apart" (11 November 1886; L. 743). This seems hardly in keeping with Kant's insistence on the safety of the beholder, yet as Kant further argues, in the self-conscious aftermath of fear we discover "in our own mind . . . a superiority to nature even in its immensity."[9]

Here we glimpse an explanation for the courting of danger that characterizes the anecdotes about Vernet and Monet. Whatever portion of their motivation might be attributed to the aesthetic cultivation of a sublime experience, there is by Kant's account the deeper determination of a self-contemplative consciousness that alone in the universe can acknowledge the destiny of its own death. By way of a fictive identification with the

painter's storm-tossed peril, the paintings' spectators are able to imagine their mastery over the abyss.

If the Belle-Ile paintings of 1886 exemplify the sublime of grandeur and terror, the process of their serial production exhibits Monet at work in the second of Kant's modes of sublime contemplation. On the one hand, nature's ineluctable might is apprehended; on the other hand, it is the acknowledgment of infinite extension in time and space that gives rise to the characteristic sensation of the sublime. In this respect the extended shape in time of Monet's series embodies the consciousness of beholding oneself beholding the world.

Unlike Monet's Normandy beach scenes of the 1880s which present anecdotal versions of the sublime by means of figures incorporated into the space of contemplation, the Belle-Ile pictures offer the oceanic view as the artist's own. For Kant such a redemption of subjectivity as the decisive human function is understood as a reflection of divinity. Much closer to Monet's own atheism and pessimism is Schopenhauer, already introduced to the impressionist circle in the criticism of Théodore Duret in the 1870s and whose influence in France was at its peak in 1886, the year of the translation of *The World as Will and Idea*.

For Schopenhauer, art alone releases the spectator from the cycle of desire and denial that accompanies a life subservient to the workings of will. In opposition to Kant, the sublime is now defined as the response to phenomena that stand in a hostile relation to human survival; gone are the metaphysics of human interiority as a reflection of the ideality of God. In Schopenhauer's enumeration, sunlight, open spaces, barren plains, rushing torrents, overhanging cliffs, and thunderous storms all give way before the intensity of the oceanic sublime, "where the mountainous waves rise and fall, dash themselves furiously against steep cliffs, and toss their spray high into the air; the storm howls, the sea boils, the lightning flashes from black clouds, and the peals of thunder drown the voice of storm and sea." For the "undismayed beholder," such a display will yield "the complete impression of the sublime": "He perceives himself, on the one hand, as an individual, as the frail phenomenon of will, which the slightest touch of these forces can utterly destroy, helpless against powerful nature, dependent, the victim of chance, a vanishing nothing in the presence of stupendous might; and, on the other hand, as the eternal, peaceful, knowing subject, the condition of the object, and, therefore, the supporter of this whole world; the terrific strife of nature only his idea; the subject itself free and apart from all desires and necessities, in the quiet comprehension of the Ideas."[10]

The repudiation of will and its replacement by idea is the characteristic of the individual in the grip of the sublime. Hence the fearlessness of Vernet and Monet in the face of the storm; hence their apparent suspension of the self-interest of the passing moment in preference for an interest beyond self, that is yet the goal of the self. In his metapsychological postulation of a death instinct that struggles with the foredoomed will to live, Freud later finds in the philosophy of Schopenhauer an acknowledgment that "death is the 'true result and to that extent the purpose of life.' "[11]

Against both the theistic and atheistic triumph of human judgment over the obduracy of nature, we can range the agnostic observation by eighteenth-century landscape painter and theoretician Pierre-Henri de Valenciennes that in the tempestuous sea "death has established its domain."[12] He acknowledges no attraction for this watery death, unlike the painter Anne-Louis Girodet, who writes a poem about Vernet in 1820:

> Absorbed all together in his pure pleasure,
> The painter knows how to enjoy all nature.
> To know her better, he seeks out danger,
> On a frail vessel the studious passenger,
> By the glints of lightning that shine overhead,
> Always calm, Vernet draws the tempest.
> Suspended over death, while the anger of the waves
> Impress pallor on the sailor's face,
> He admires, he observes, and, braving shipwreck,
> Glory is his lamp in the midst of the storm.[13]

Pleasure, joy, knowledge, death: in French these phrases resonate with the energy of a libidinous wish for bodily extinction in a watery embrace. In 1811 Stendhal confides to his journal the fantasy of savoring "the pleasure of being drowned."[14] Vernet himself is quoted as exclaiming "I too will marry the sea"; and later Victor Hugo writes "I, I married the sea, the hurricane, an immense beach of sand, sadness, and all the stars of night."[15]

The metaphor of the marriage of the sailor and the sea is conspicuous in the popular novel by Pierre Loti, *Pêcheur d'Islande* (1886). The 1892 edition of this book is in the library at Giverny, but Monet might easily have come to know the book at the time of its initial publication. Loti's story is set in the ports of Brittany and on the waters of Iceland, and tells of the struggle of the fisherman Yann torn between his human spouse and his marine-bride: "He never came back. One August night, out there on the seas of dark Iceland, in the midst of a great noise of fury, his marriage with the sea had been celebrated. With the sea who formerly had been his

wet-nurse as well; it was she who had rocked him, who made him into a large and strong adolescent,—and then she had taken him back in his superb virility, for herself alone. . . . He, remembering Gaud, his wife of flesh, had defended himself, with the struggle of a giant, against this bride of the grave."[16]

Monet's joy of the sea is also couched in a language of love and violence that often overflows the usual bounds of sense. He calls her "scamp" and "minx" (27, 30 October 1886; L. 725, 730) and, like Yann, cannot forgo her alluring charms however dangerous they may be. Soon after arrival on the island Monet writes that he has not been able "to resist bathing (without a suit) in a delicious spot, in extraordinary water; the water of Etretat is mud alongside" (14 September 1886; L. 686). On another occasion he goes out upon the high seas and, after being stranded in an impassable grotto in heavy weather, finds the homeward trip "admirable and delicious, but what bounds our poor boat made!" (26 September 1886; L. 696). After Monet accompanies the fishermen on a nocturnal expedition for conger eel, he reports his jubilation with the "admirable evening I had there, by an astounding light of the moon, but we were well rocked, for the sea was not precisely like a lake" (11 November 1886; L. 743).

Monet records that "it was a joy for me to see that sea in fury; it was like nervous exhaustion, and I was so wrapped up in it that yesterday I was desolated to see the weather become calm so quickly" (17 October 1886; L. 714). Ambivalence characterizes all his transactions with the marine element, and he experiences sharply split emotions while at work: "I am in joy, but that devilish sea is terrible to render" (21 October 1886; L. 719). To his mistress and dealers he repeatedly writes that "this coast excites me with passion" (17, 26, 30 October 1886; L. 715, 724, 730), yet he remains "powerless in rendering the intensity," "at pains to render this somber and terrible aspect" (23, 28 October 1886; L. 721, 727). Destructive reworking, overpainting, and unpainting ensue, and in disgust Monet leaves Belle-Ile, convinced that he has irretrievably besmirched the images of his impossible desire. After more than two months at work on a campaign that was to have lasted no more than two weeks, Monet writes of his dilemma to an impatient Mme Hoschedé: "I really must acknowledge that it is no longer possible to find my effects again, and I would have done better to leave three weeks ago, for since that time, I realize now too late, I have only destroyed what I had done well, and, chancing to bring back only incomplete things, it would have been better to have them *in their purity* of accent. . . . Finally, I am still going to try to save some canvases; the weather really seems to be turning fine" (19 November 1886; L. 752). Even

with the weather turning fine there could be no guarantee of the artistic result, for just then Monet might wish for the storm to return. The demands of home life finally intervened to put an end to Monet's solo affair with the "savage sea," and in early 1887 ten of the pictures, much reworked at Giverny, were exhibited in Paris.

One of the most provocative responses to the paintings comes from Joris-Karl Huysmans. Invoking Denis Diderot's treatment of Vernet's Salon exhibits in 1765 as an *ensemble,* Huysmans writes of Monet's unified vision: "From Claude Monet a series of tumultuous landscapes, of abrupt seas, violent, with ferocious tones, vicious blue, raw violet, harsh green, of rock-work waves with solid crests, beneath skies in rage. . . . The savagery of this painting seen by the eye of a cannibal is disconcerting at first, but in front of the force it discloses, in front of the faith that animates it, in front of the powerful inspiration of the man who brushes it, one submits oneself to the forbidding charms of this unpolished art." The critic's response of repulsion followed by submission parallels the Kantian experience of active astonishment followed by passive acceptance. Even though Huysmans finds himself not in the midst of nature but in the face of art, he balks at arriving at the point of Kantian fulfillment due to the sheer unexpectedness of Monet's "aggregated and compacted masses" and "impenetrable whorls striated with streaks like marble." In spite of his recognition of the power of Monet's new painting Huysmans persists in preferring the "truly liquid" seascapes of the Normandy coast.[17]

Other critics are similarly unsettled by the violence of Monet's art. Jules Desclozeaux, Fénéon's colleague at *La Revue Indépendante,* dismisses the paintings as "brutal," but Huysmans's associate, Alfred de Lostalot, uses the same term to less pejorative ends: "M. Claude Monet, more violent, more excessive than ever in his impastoes and colorations, attains a power of effect that imposes silence upon his critics. With good or ill will it is necessary to admire these feverish canvases in which, despite the intensity of the colors and the brutality of the touch, the discipline is so perfect that the feeling for nature freely emanates in an impression full of grandeur."[18] For Lostalot it is the aesthetics of conscious beholding that converts Monet's brutal touch into the disembodied emanations of mind. As Monet writes to Mme Hoschedé regarding his much-mauled canvases, "it will be necessary for me to mull all this over by seeing [them] in the studio by your side on the poor old settee" (8 November 1886; L. 739).

If Lostalot stresses the reflective discipline of Monet's artistic practice, other critics voice doubt. The symbolist poet Gustave Kahn, a friend of Félix Fénéon and like him an advocate of neoimpressionism, regards Monet

as slapdash in his handling of both the elements of nature and art: "[He] juggles with all the glittering and splashing of the sea . . . but the artist's technique is not unified; disparate is the execution of the foreground, that of the middleground, that of the sky. The impression of M. Monet's pictures is not definitive."[19] Kahn prefers the uniform surface of Seurat's pointillist technique, but others rally round the "sage" canvases of Monet, whose works are said to be "less slashed up than usual in minute hatchings of such a disagreeable effect."[20]

One of the most thoughtful critics in 1887 is Pierre Héela. Writing for *Le Journal des Arts,* Héela acknowledges that the existence of the painter's "numerous partisans" necessitates a responsible interpretation: "I heard it said around me that never has [an artist] rendered the sea with so much truth and poetry. Although I do not always very well understand the pictures of this courageous artist, I recognize that in placing oneself at a certain distance one experiences the impression of a liquid surface, transparent, calm, or agitated, the same as one feels while walking along the shores of the Atlantic or the Mediterranean." The gap between art and nature is seen as minimal here, yet Héela goes on to develop a critique of Monet's unconventional images of the sea: "But there is not, in the presence of the sea, merely the sensation of humidity, of fluidity, and I confess for my part that, without her picturesque shores, without her abrupt cliffs that brusquely rise to the sky, without her islands rising up against the background of the horizon, in a word without the immense framework which is unique to her, which attracts us and strikes us, salt water, however extensive it may be, interests me mediocrely."[21] Like Baudelaire in front of Boudin's studies in 1859, Héela does not find sufficient pictorial incident in Monet's marines.

In eliminating conventional anecdote from his canvases Monet places himself in the position of lone human subject. Human responsiveness to the alluring sea is no longer enacted by way of an illustrated action; action is now reserved for the artist-beholder who manifests the range of human response in gestures of paint. In so doing the artist creates a work that is also a world; this haughty view is evident in the writing of Octave Mirbeau, whom the painter describes as "in ecstasy" while visiting him for a week on Belle-Ile (6 November 1886; L. 737).

Mirbeau had a residence on the Breton island of Noirmoutier, and it was there that Monet went at the end of his Belle-Ile campaign. No paintings are catalogued from the time of the artist's brief stay, but Mirbeau twice makes literary use of Monet's visit. In January 1887 Mirbeau presents a Parisian's perspective on savage life in the Belle-Ile hamlet where he and

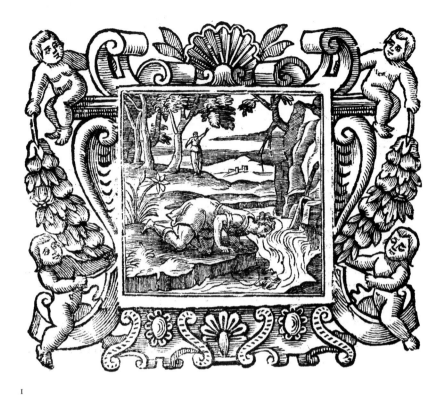

I

1. *Philautia (Emblema LXIX),* 1531, woodcut, from Andrea Alciati, *Emblemata* (Padua, 1661). Bryn Mawr College Library, Rare Book Collection

2. Honoré Daumier, *Narcissus,* 1842, lithograph, Museum of Fine Arts, Boston, Babcock Bequest

2

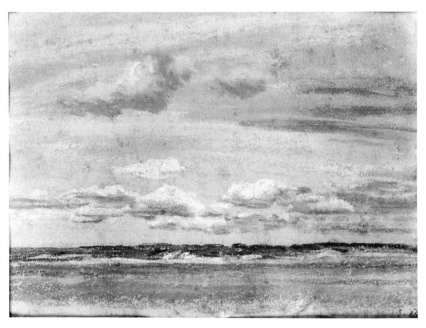

3

3. Eugène Boudin, *White Clouds over the Estuary,* ca. 1859, pastel,
Musée Eugène Boudin, Honfleur

4. *View Taken at Rouelles* (W. 1), 1858, 46 x 65 cm, Private Collection

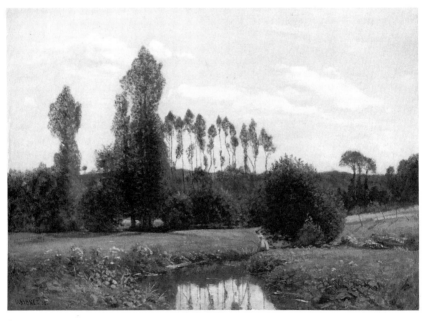

4

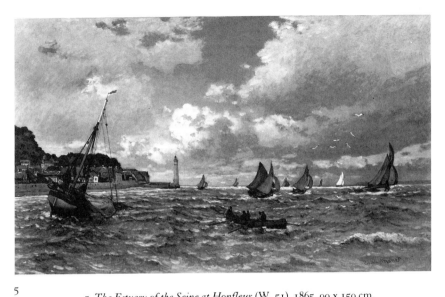

5

5. *The Estuary of the Seine at Honfleur* (W. 51), 1865, 90 x 150 cm,
Norton Simon Foundation, Pasadena
6. *The Pointe de la Hève at Low Tide* (W. 52), 1865, 90 x 150 cm,
 Kimbell Art Museum, Fort Worth, Texas

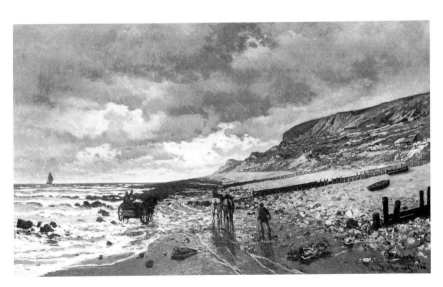

6

7

7. Alexandre Desgoffe, *Narcissus at the Fountain,* 1844, 105 x 150 cm,
Musée de Semur-en-Auxois

8. Jehan-Georges Vibert, *Narcissus,* 1864, 112 x 203 cm, Musée des
Beaux-Arts, Bordeaux

8

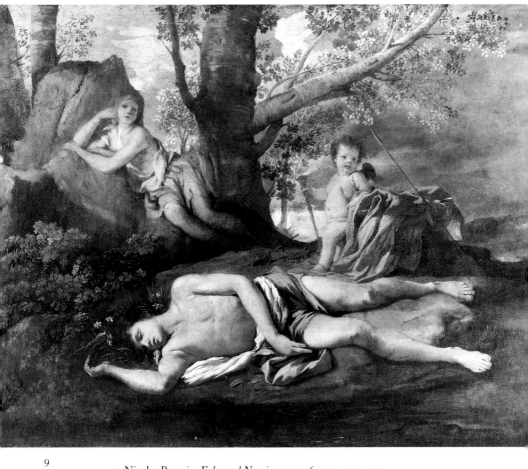

9

9. Nicolas Poussin, *Echo and Narcissus,* ca. 1630, 74 x 100 cm,
Musée du Louvre, Paris

10. *Luncheon on the Grass*
(W. 63b), 1865– 66, 248 x
217 cm, Musée d'Orsay,
Paris
11. Gustave Courbet,
Marine, 1865, 50 x 61 cm,
Norton Simon Foundation,
Pasadena

10

11

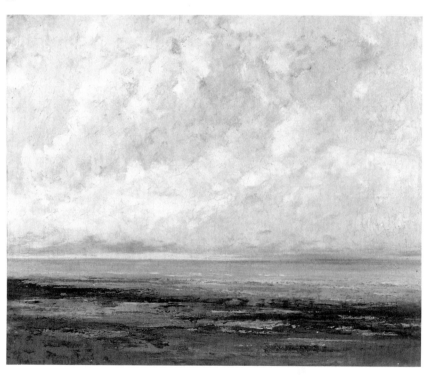

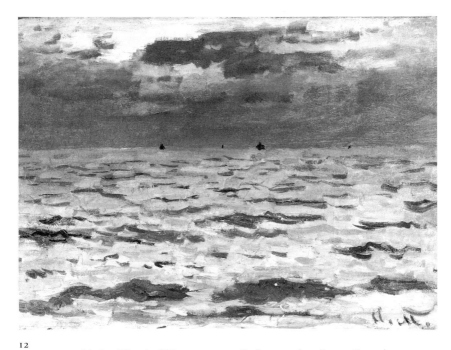

12. *Marine* (W. 72), 1866, 42 x 59.5 cm, Ordrupgaardsamlingen, Copenhagen

13. Paul-Jean Clays, *Agitated Sea,* 1875, 75.5 x 136 cm, Groeningemuseum, Bruges

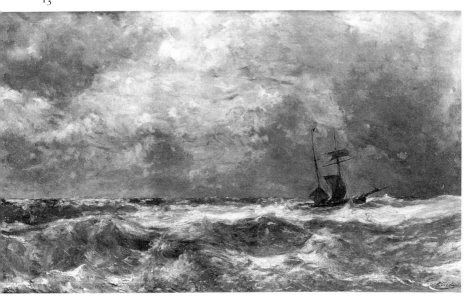

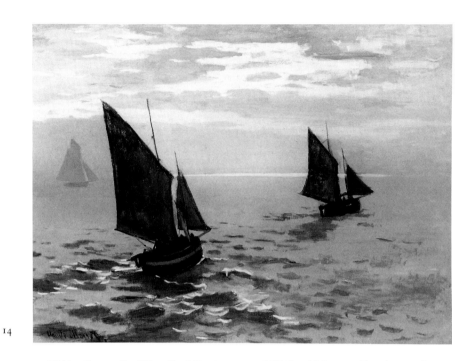

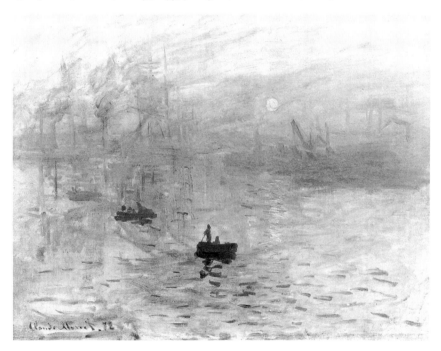

14. *Fishing Boats at Sea* (W. 126), 1868, 96 x 130 cm, Hill-Stead Museum, Farmington, Conn.

15. *Impression, Sunrise* (W. 263), 1873, 48 x 63 cm, © Musée Marmottan, Paris

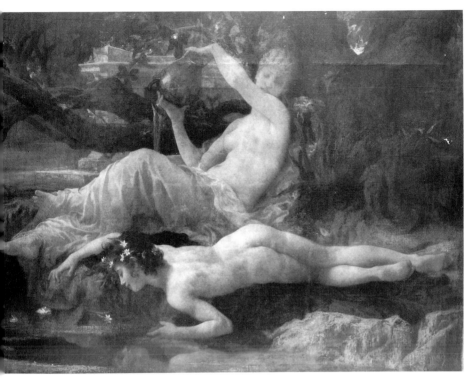

16

16. Jules-Louis Machard, *Narcissus and the Source,* 1872,
Musée des Beaux-Arts, Chartres

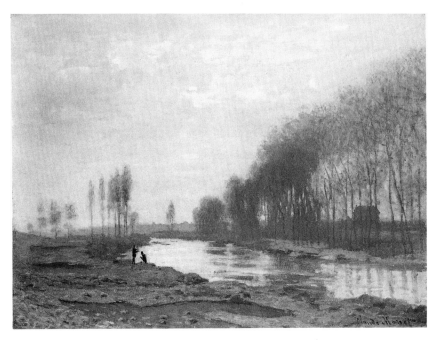

17

17. *The Little Branch of the Seine at Argenteuil*
(W. 196), 1872, 53 x 73 cm, Courtesy of the
Trustees, The National Gallery, London
18. Paul Dubois, *Narcissus,* 1863, Musée
d'Orsay, Paris, from *Gazette des Beaux-Arts,*
July 1863

18

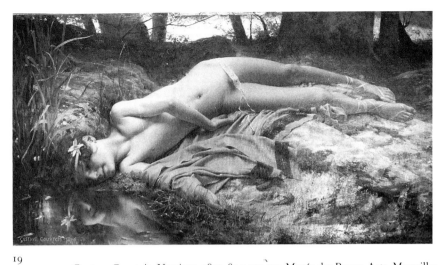

19

19. Gustave Courtois, *Narcissus,* 1877, 80 x 152 cm, Musée des Beaux-Arts, Marseilles

20. Charles Gleyre, *The Nymph Echo,* 1847, 129 x 95cm, location unknown

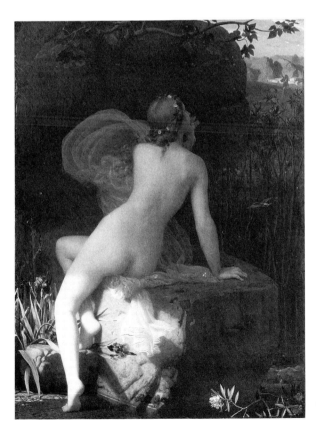

20

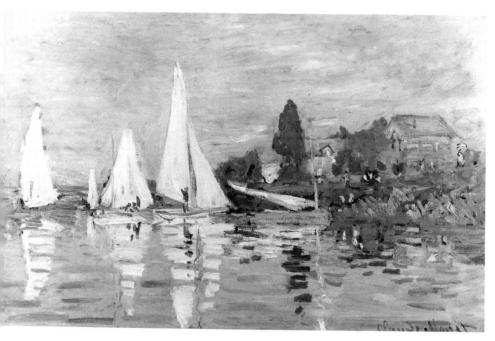

21

21. *Regattas at Argenteuil* (W. 233), 1872, 48 x 75 cm,
Musée d'Orsay, Paris
22. *The Entry to the Port of Trouville* (W. 154), 1870, 54 x 66 cm,
Szépmüvészeti Múzeum, Budapest
23. *Lavacourt* (W. 578), 1880, 100 x 150 cm,
Dallas Museum of Arts, Munger Fund

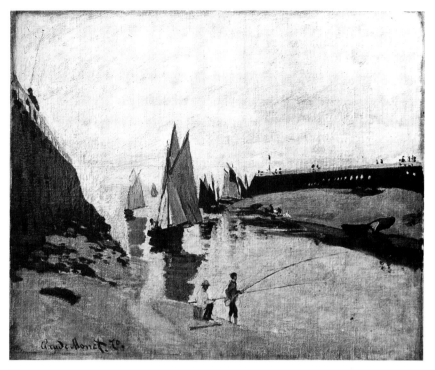

22

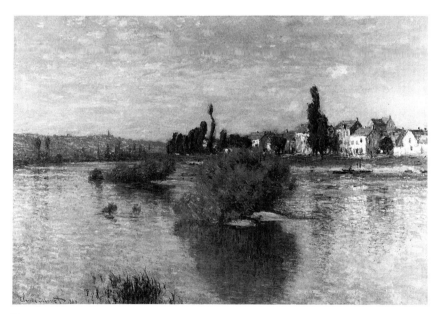

23

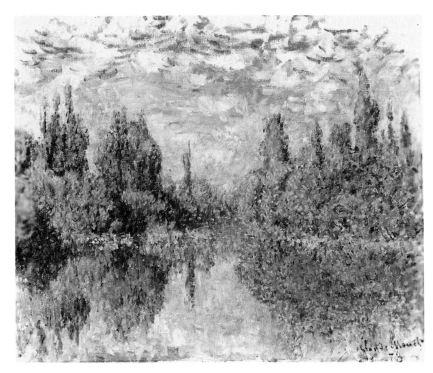

24

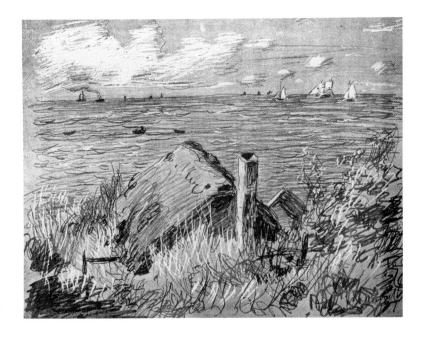

25

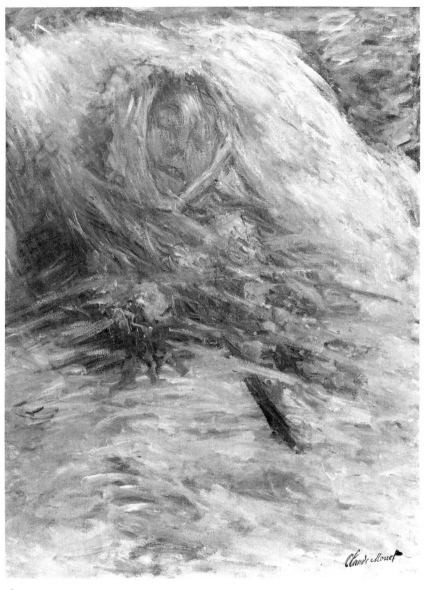

26

24. *Small Branch of the Seine at Vétheuil* (W. 481), 1878, 50 x 61 cm,
Private Collection

25. *Cabin at Sainte-Adresse* (W. D436), 1880, drawing (after W. 94,
1867), from *La Vie Moderne,* June 1880

26. *Camille Monet on Her Death-Bed* (W. 543), 1879, 90 x 68 cm,
 Musée d'Orsay, Paris

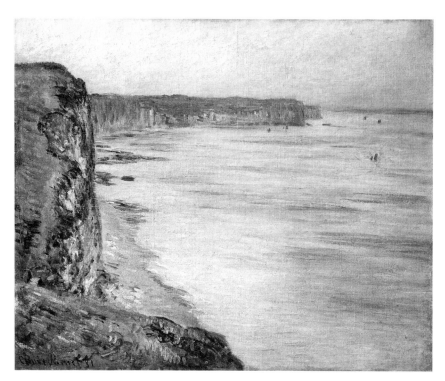

27

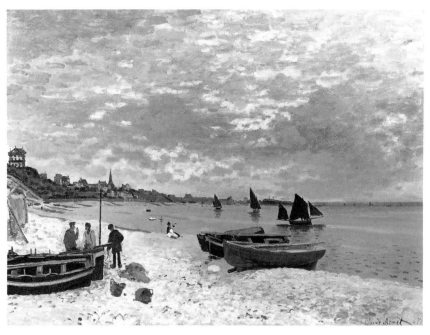

28

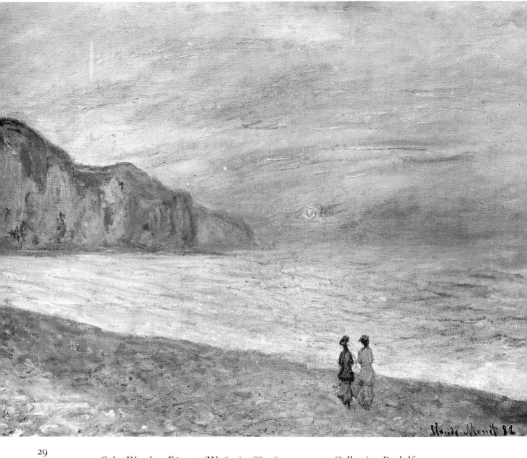

29

27. *Calm Weather, Fécamp* (W. 650), 1881, 60 x 73.5 cm, Collection Rudolf
Staechelin, Basel

28. *The Beach at Sainte-Adresse* (W. 92), 1867, 75 x 101 cm,
The Art Institute of Chicago

29. *Sunset at Pourville* (W. 781), 1882, 60 x 81 cm, Private Collection

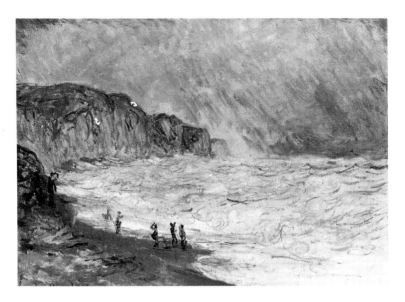

30

30. *Agitated Sea at Pourville* (W. 1444), 1897, 73 x 100 cm, National Museum of Western Art, Tokyo

31. *Fishermen at Poissy* (W. D435), 1883, 25 x 34.5 cm, drawing (after W. 749, 1882), Fogg Art Museum, Cambridge, Mass.

31

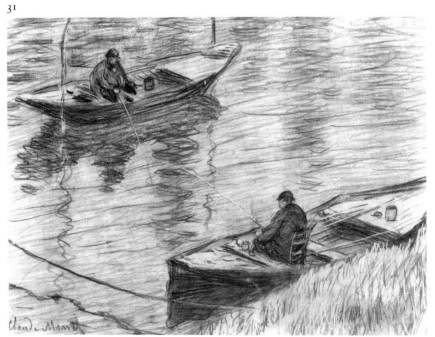

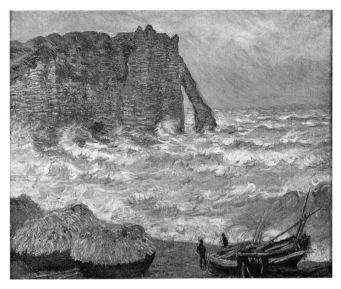

32

32. *Etretat, Agitated Sea* (W. 821), 1883, 81 x 100 cm,
Musée des Beaux-Arts, Lyons

33. Gustave Courbet, *The Cliff at Etretat after the Storm,*
1869, 133 x 162 cm, Musée d'Orsay, Paris

33

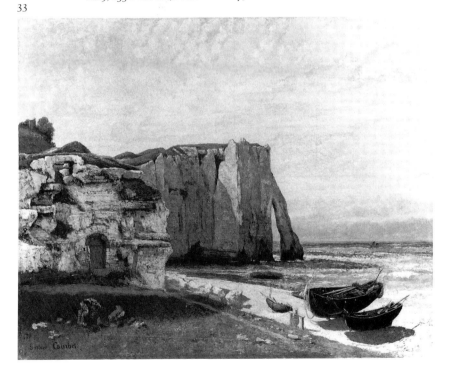

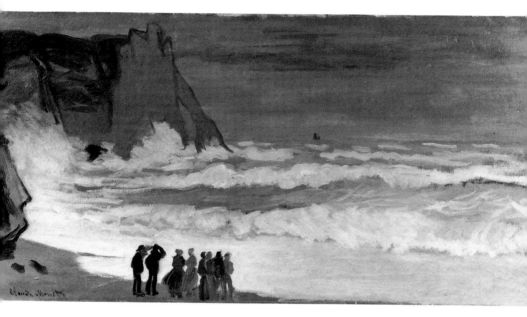

34

34. *High Seas at Etretat* (W. 127), 1868, 66 x 131 cm, Musée d'Orsay, Paris
35. *Heavy Weather at Etretat* (W. 826), 1883, 65 x 81 cm, National Gallery of
Victoria, Melbourne, Felton Bequest 1913
36. *View of Rouen* (W. D434), 1883, 31 x 47.5 cm, drawing (after W. 217, 1872),
Sterling and Francine Clark Institute, Williamstown, Mass.

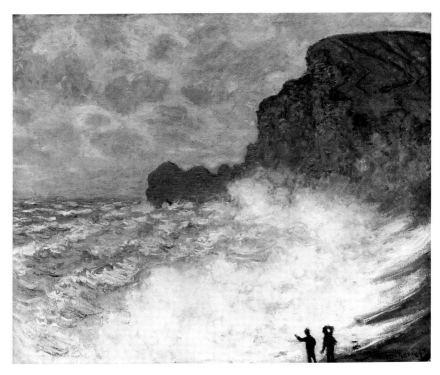

35

36

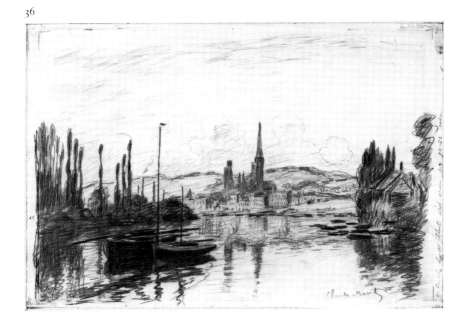

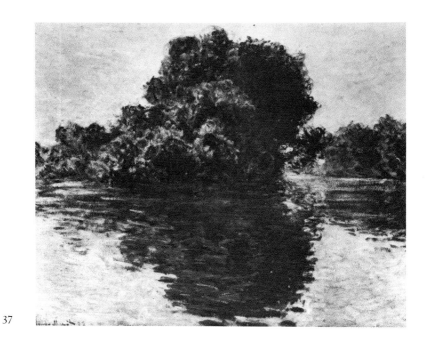

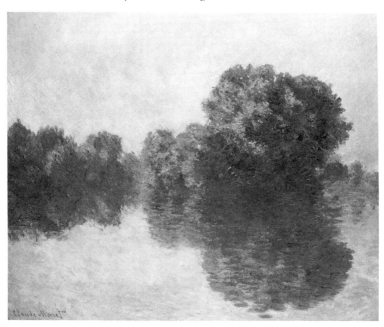

37. *The Islands at Port-Villez* (W. 841), 1883, 65 x 81 cm,
Private Collection
38. *The Seine near Giverny* (W. 1494), 1897, 81 x 100 cm,
National Gallery of Art, Washington

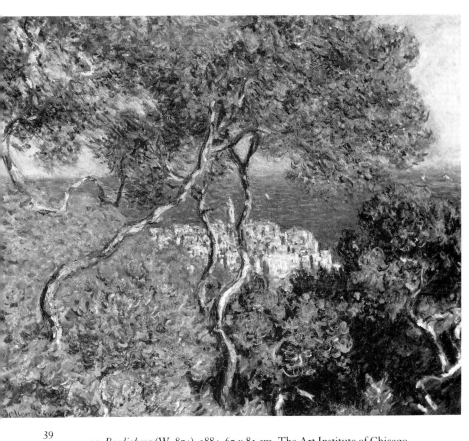

39

39. *Bordighera* (W. 854), 1884, 65 x 81 cm, The Art Institute of Chicago

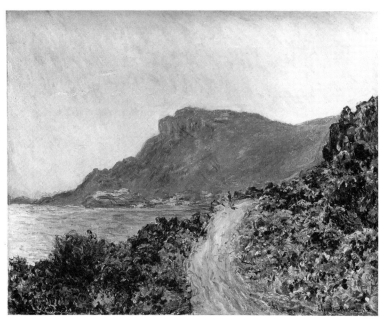

40

40. *The Corniche at Monaco* (W. 890), 1884, 74 x 92 cm,
Stedelijk Museum, Amsterdam
41. *Menton Seen from Cap Martin* (W. 897), 1884, 68 x 84 cm,
Museum of Fine Arts, Boston

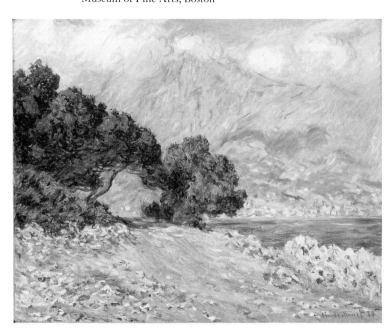

41

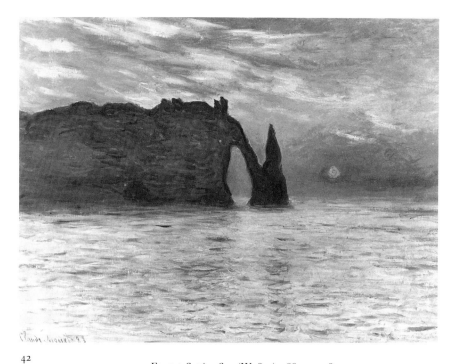

42

42. *Etretat, Setting Sun* (W. 817), 1883, 55 x 81 cm,
North Carolina Museum of Art, Raleigh
43. *The Manneporte* (W. 832), 1883, 65 x 81 cm,
The Metropolitan Museum of Art, New York

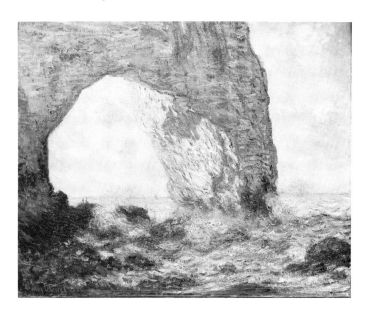

43

44. *The Manneporte* (W. 1053),
1886, 92 x 73 cm, Private
Collection
45. *Etretat, The Rain* (W. 1044),
1886, 60.5 x 73.5 cm,
Nasjonalgalleriet, Oslo

44

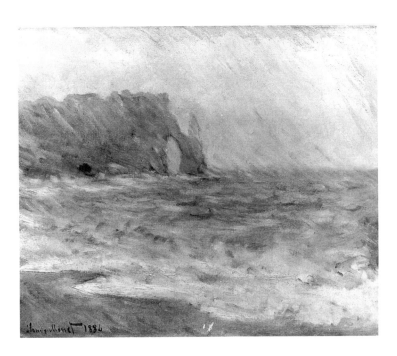

45

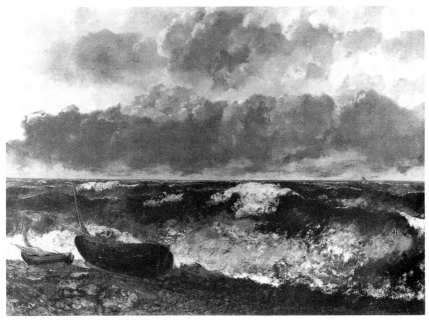

46

46. Gustave Courbet, *The Stormy Sea* (or *The Wave*),
1870, 117 x 160 cm, Musée d'Orsay, Paris
47. Octave Penguilly-l'Haridon, *The Little Gulls: The Shore
of Belle-Ile-en-Mer, Port-Donan (Morbihan),* 1859, 75 x 95 cm,
Musée des Beaux-Arts, Rennes

47

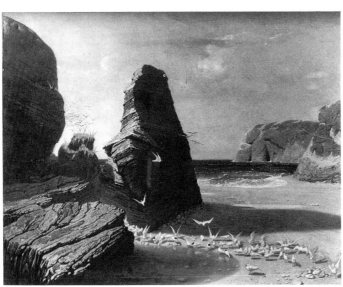

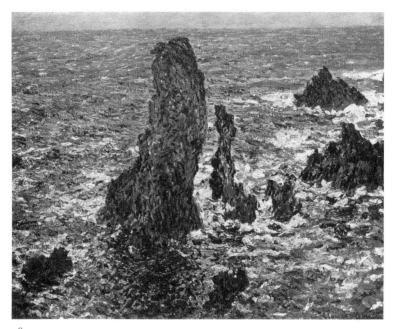

48

48. *Pyramids of Port-Coton, Mer Sauvage* (W. 1084), 1886, 65 x 81 cm,
Pushkin Museum, Moscow

49. *Rocks at Belle-Ile* (W. 1086), 1886, 60 x 73 cm

49

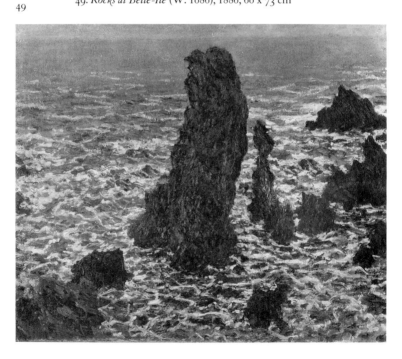

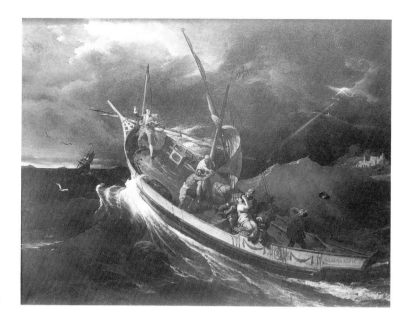

50. Horace Vernet, *Joseph Vernet, Attached to a Mast, Studies the Effects of the Tempest,* 1822, 275 x 356 cm, Musée Calvet, Avignon
51. *The "Great Blue" at Antibes* (W. 1182), 1888, 60 x 73 cm, Öffentliche Kunstsammlung Basel, Kunstmuseum

52

52. *Antibes, Afternoon Effect* (W. 1158), 1888, 65 x 81 cm, Museum of Fine Arts, Boston

53. *Antibes, Morning* (W. 1170), 1888, 65 x 81 cm, Philadelphia Museum of Art

53

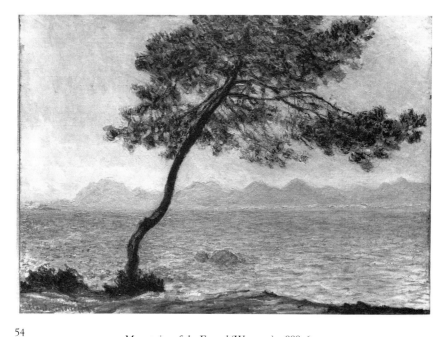

54

54. *Mountains of the Esterel* (W. 1192), 1888, 65 x 92 cm,
Courtauld Institute Galleries, London
55. *Vétheuil in the Fog* (W. 518), 1879, 60 x 71 cm,
© Musée Marmottan, Paris

55

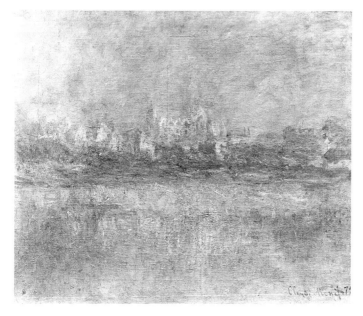

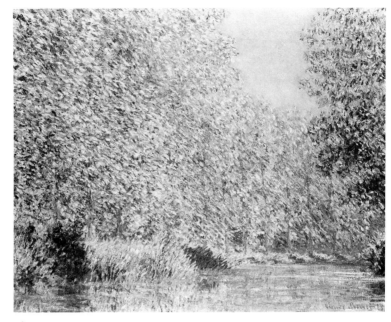

56

56. *A Turning of the Epte* (W. 1209), 1888, 73 x 92 cm,
Philadelphia Museum of Art

57. *Les Eaux Semblantes, Creuse, Sunshine Effect* (W. 1219), 1889, 65 x
92 cm, Museum of Fine Arts, Boston

57

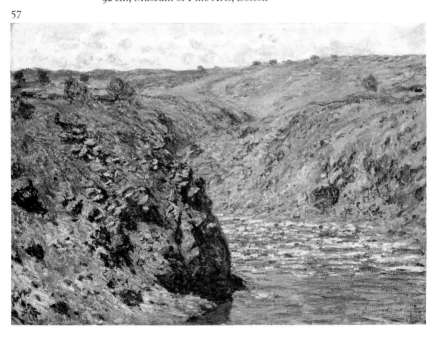

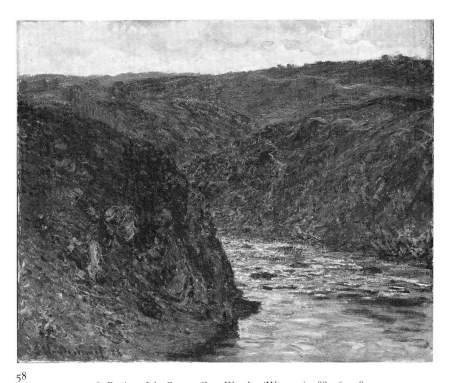

58

58. *Ravine of the Creuse, Gray Weather* (W. 1221), 1889, 65 x 81 cm,
Museum of Fine Arts, Boston

59. *The Old Tree at Fresselines* (W. 1229), 1889, 81 x 100 cm, location unknown

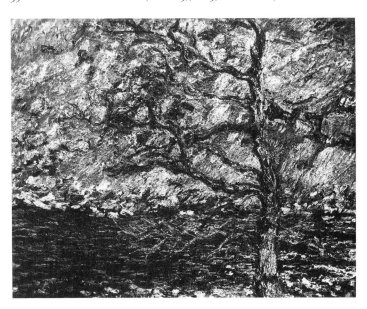

59

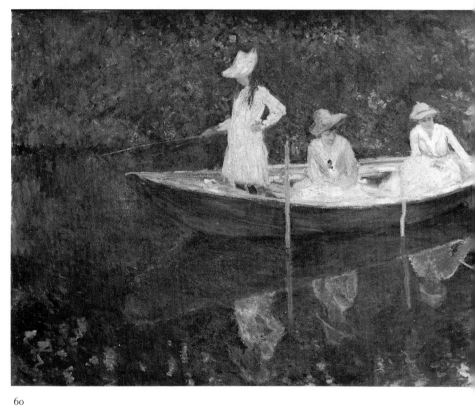

60

60. *In the Norwegian Canoe* (W. 1151), 1887, 98 x 131 cm, Musée d'Orsay, Paris

61. Constance Charpentier, *Melancholy,* 1801, 130 x 165 cm, Musée de Picardie, Amiens

62. *The River, Bennecourt* (W. 110), 1868, 81 x 100 cm, The Art Institute of Chicago

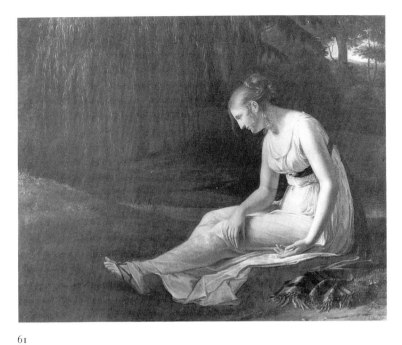

61

62

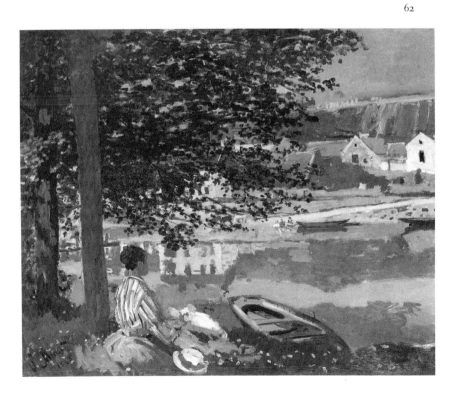

63

63. *The Pond at Montgeron* (W. 420), 1876, 172 x 193 cm,
Hermitage Museum, St. Petersburg, Russia

64. *Fisherwoman with a Line on the Banks of the Epte* (W. 1134),
1887, 81 x 100 cm, Private Collection

64

65

65. *Canoeing on the Epte* (W. 1250), 1890, 133 x 145 cm,
Museu de Arte, São Paolo

66. *The Train at Jeufosse* (W. 912), 1884, 60 x 81 cm, Private Collection

66

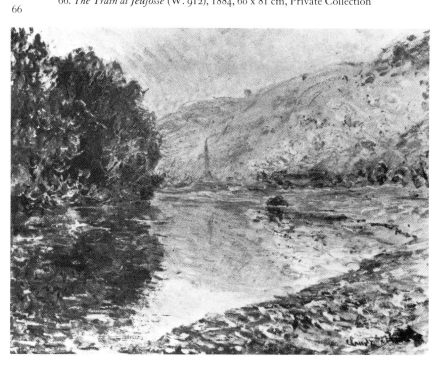

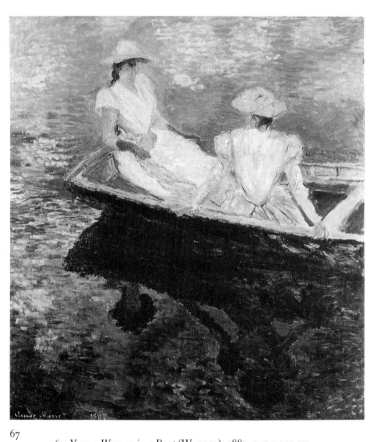

67. *Young Women in a Boat* (W. 1152), 1887, 145 x 132 cm,
National Museum of Western Art, Tokyo

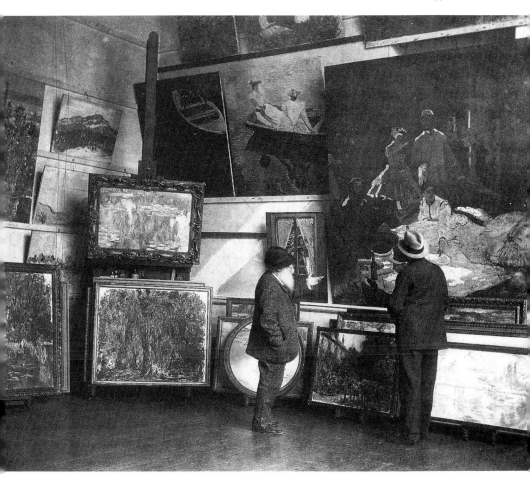

68. Photograph of Monet with the Duc de Trevise in his second studio, 1920, from *La Revue de l'Art Ancien et Moderne*, January 1927

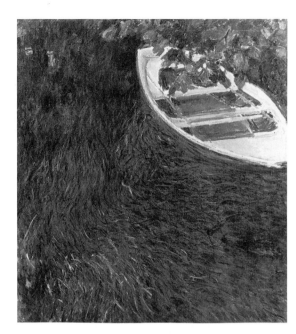

69. *The Boat* (W. 1154), 1887,
146 x 133 cm, © Musée
Marmottan, Paris
70. *The Bridge in Monet's
Garden* (W. 1419 bis), 1895
(signed 1900), 89 x 92 cm,
Private Collection

69

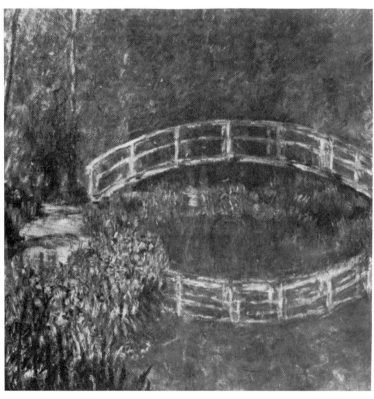

70

71. *Essay in Open-Air Figures
(To the Left)* (W. 1077), 1886,
131 x 88 cm, Musée d'Orsay,
Paris
72. Charles-François Daubigny,
The Banks of the Oise, 1859, 90 x
182 cm, Musée des Beaux-Arts,
Bordeaux

71

72

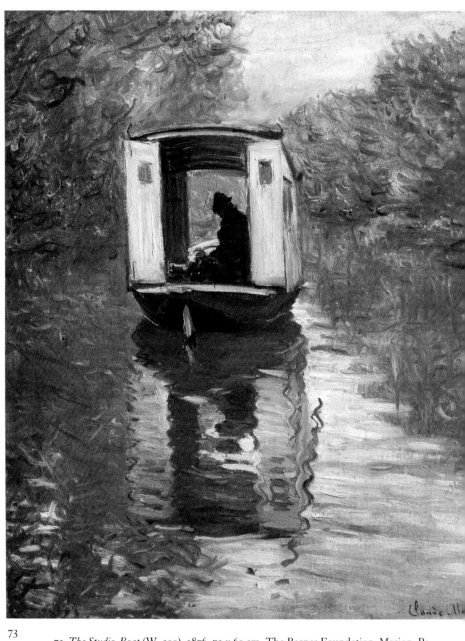

73

73. *The Studio-Boat* (W. 390), 1876, 72 x 60 cm, The Barnes Foundation, Merion, Pa.

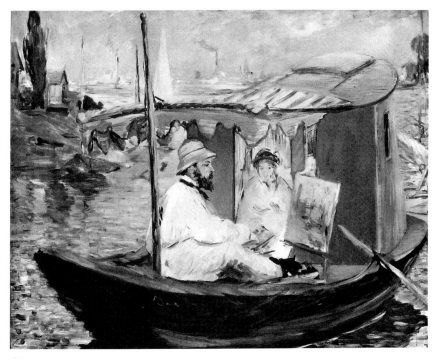

74

74. Edouard Manet, *Claude Monet Painting on His Studio-Boat*,
1874, 82.5 x 100.5 cm, Neue Pinakothek, Munich
75. *Water Lilies* (W. 1501), 1897–98, 65 x 100 cm,
Los Angeles County Museum of Art

75

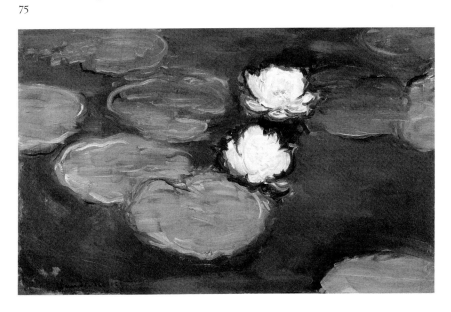

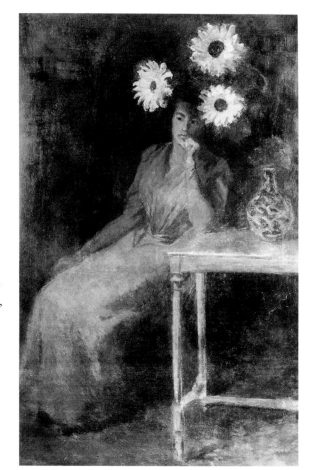

76. *Portrait of Suzanne with
Sunflowers* (W. 1261), 1890,
162 x 107 cm, Private
Collection
77. Jules-Cyrille Cavé,
Narcissus, 1890, from *Salon
de 1890: Catalogue illustré*

76

77

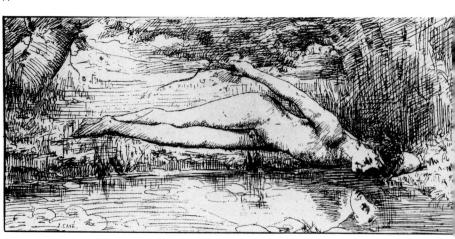

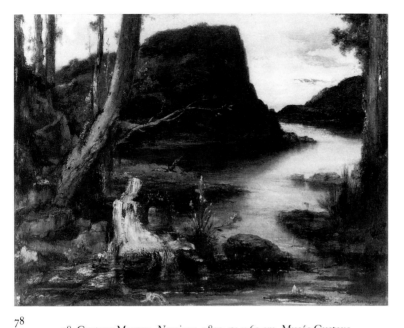

78. Gustave Moreau, *Narcissus,* 1890, 53 x 61 cm, Musée Gustave
Moreau, Paris

79. *The Four Poplars* (W. 1309), 1891, 82 x 81.5 cm, The Metropolitan
Museum of Art, New York

79

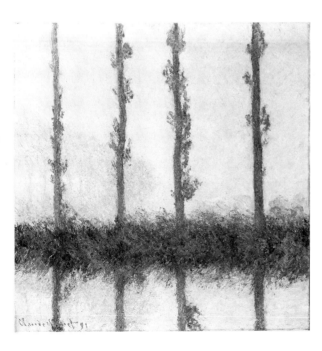

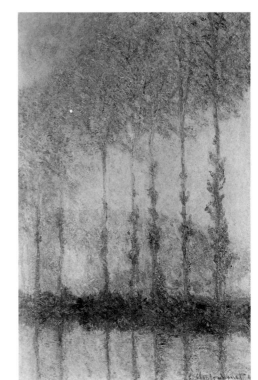

80. *The Poplars, White and Yellow
Effect* (W. 1298), 1891, 100 x 65 cm,
Philadelphia Museum of Art
81. *The Poplars, Three Pink Trees,
Autumn* (W. 1307), 1891, 92 x 73 cm,
Philadelphia Museum of Art

80

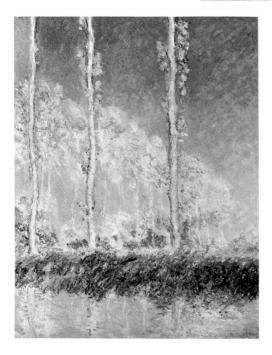

81

82. George Desvallières, *Narcissus,*
1893, Private Collection
83. Gustave Lemaître, *The Nymph
Echo,* 1894, from *Salon de 1894:
Catalogue illustré*

82

83

84

84. Léon Oble, *The Death of Narcissus,* 1895, from *Salon de 1895: Catalogue illustré*

85. *The Ice Floes* (W. 568), 1880, 97 x 150.5 cm, Shelburne Museum, Shelburne, Vt.

85

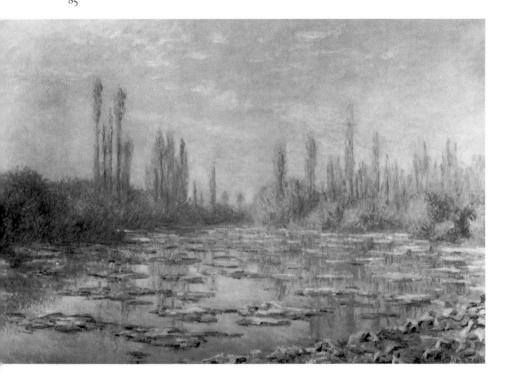

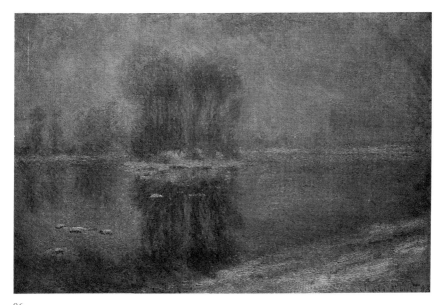

86

86. *The Ice Floes* (W. 1335), 1893, 65 x 100 cm,
The Metropolitan Museum of Art, New York
87. Camille Corot, *Souvenir of Mortefontaine,* 1864, 65 x 89 cm,
Musée du Louvre, Paris

87

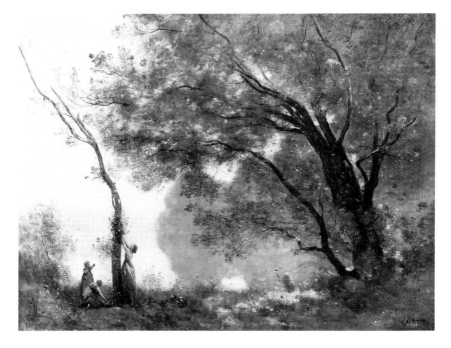

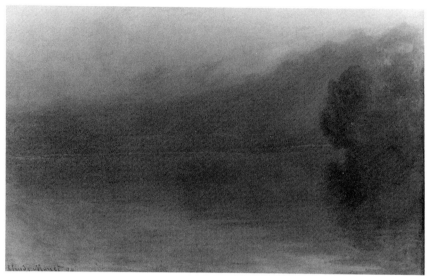

88

88. *The Seine at Port-Villez* (W. 1370), 1894, 65 x 100 cm,
Musée des Beaux-Arts, Rouen

89. *The Church of Vernon, Fog* (W. 1390), 1894, 65 x 92 cm,
Shelburne Museum, Shelburne, Vt.

89

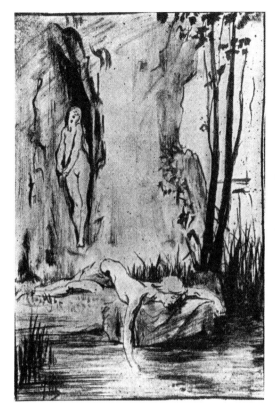

90. Isaac-Edmond Boisson, *Echo and Narcissus,* 1896, from *Salon de 1896: Catalogue illustré*

91. Ernest Bisson, *The Nymph Echo,* 1896, from Armand Silvestre, *le Nu au Salon de 1896 (Champs-Elysées)*

90

91

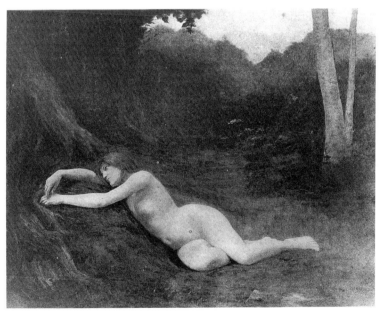

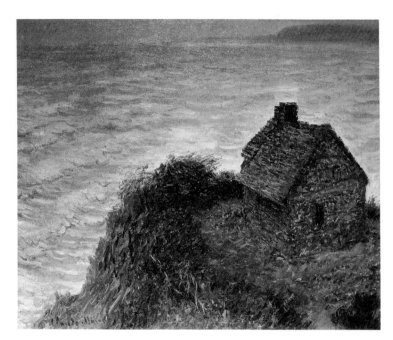

92

92. *The Customs-Officer's Cabin* (W. 739), 1882, 62 x 76 cm,
Fogg Art Museum, Cambridge, Mass.

93. *The Gorge of Varengeville, Late Afternoon* (W. 1452), 1897, 65 x 92 cm,
Fogg Art Museum, Cambridge, Mass.

93

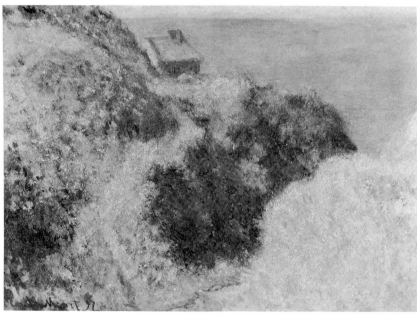

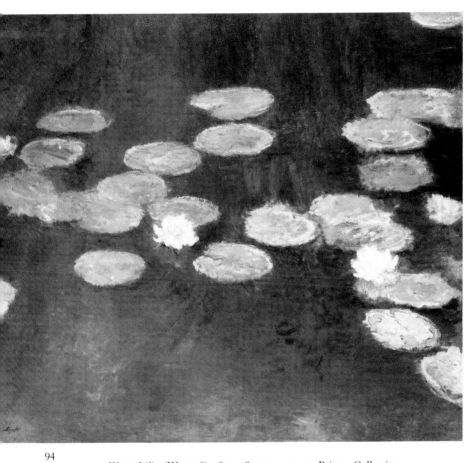

94. *Water Lilies* (W. 1508), 1897–98, 130 x 152 cm, Private Collection

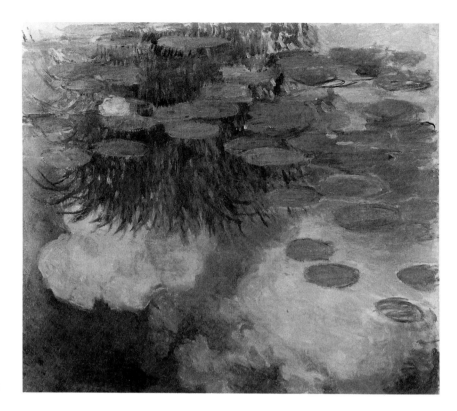

95

95. *Water Lilies* (W. 1783), 1914–17, 130 x 150 cm, © Musée Marmottan, Paris
96. Alexandre Charpentier, *Narcissus,* 1897, ceramic model by Emile Muller for a fountain, from *Société Nationale des Beaux-Arts: Exposition de 1897, Catalogue illustré*

96

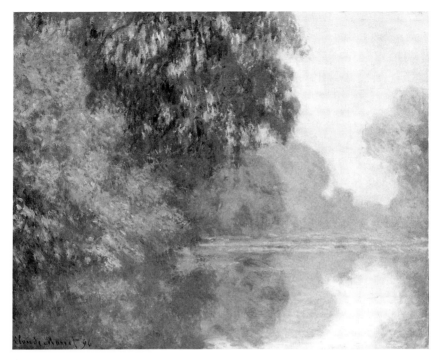

97. *Branch of the Seine near Giverny* (W. 1435), 1896, 73 x 92 cm,
Museum of Fine Arts, Boston
98. *Branch of the Seine near Giverny* (W. 1481), 1897, 81 x 92 cm,
Museum of Fine Arts, Boston

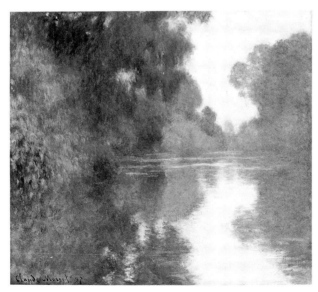

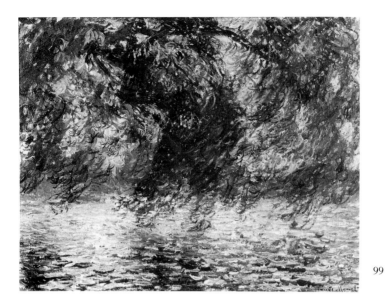

99

99. *Willows* (W. 1500), 1898, 71 x 89.5 cm, National Museum of Western Art, Tokyo
100. *The River with Willows* (W. 396), 1876, 71.5 x 60 cm, Private Collection

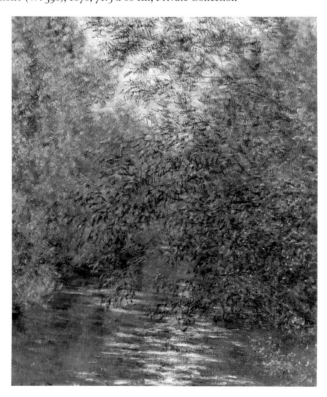

100

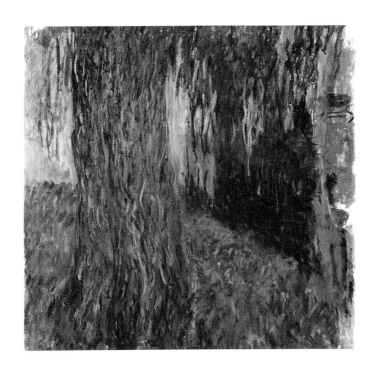

101

101. *Weeping Willow and Water Lilies* (W. 1848), 1916–19, 200 x 180 cm,
© Musée Marmottan, Paris

102. *Morning with Willows* (W. 4:333), 1916–26, 200 x 425 cm, right panel
of triptych, room 2, wall 2, Musée de l'Orangerie, Paris

102

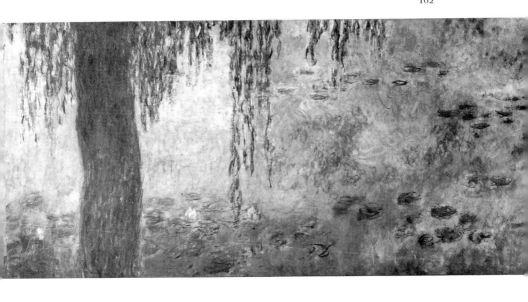

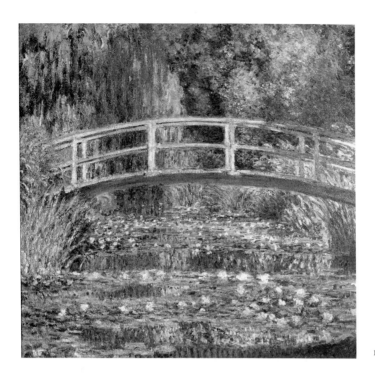

103

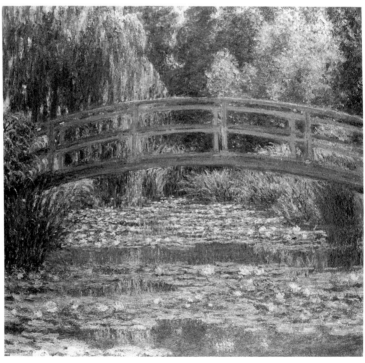

104

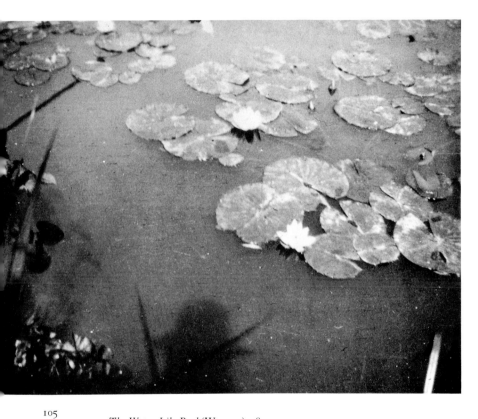

105

103. *The Water-Lily Pool* (W. 1509), 1899, 90 x 90 cm,
The Art Museum, Princeton University, Princeton, N.J.
104. *The Water-Lily Pool* (W. 1512), 1899, 89 x 93 cm,
Philadelphia Museum of Art
105. Monet's photograph of his shadow on the water-lily pond.
Collection Philippe Piguet

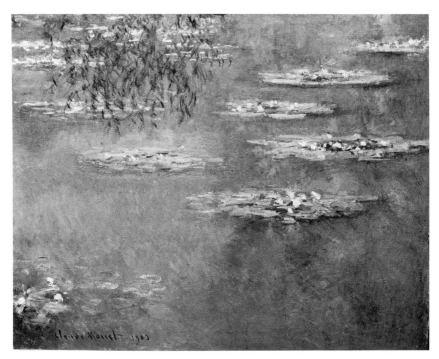

106

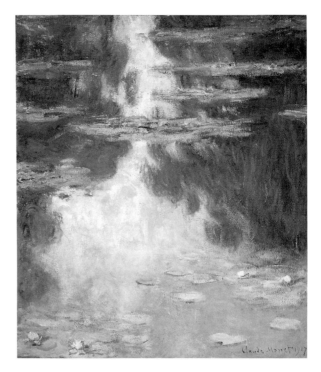

107

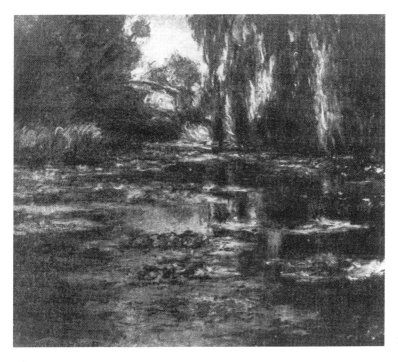

108

106. *Water Lilies* (W. 1657), 1903, 81 x 100 cm,
Dayton Art Institute
107. *Water Lilies* (W. 1703), 1907, 92 x 81 cm,
Museum of Fine Arts, Houston
108. *Water-Lily Pool, The Bridge* (W. 1668), 1905,
90 x 100 cm, Private Collection, from *Gazette des
Beaux-Arts,* June 1909
109. H. L. Greber, *Narcissus,* 1909, marble fountain,
from *Gazette des Beaux-Arts,* September 1909

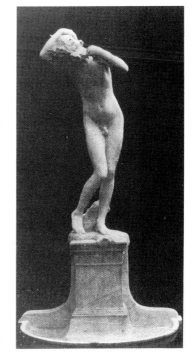

109

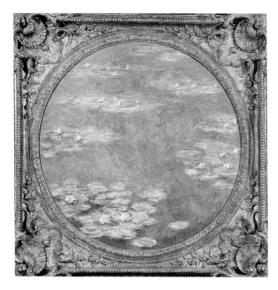

110. *Water Lilies* (W. 1729), 1908, 81 cm diameter, Dallas Museum of Art
111. *The Flowering Arches, Giverny* (W. 1779), 1913, 81 x 92 cm,
Phoenix Art Museum

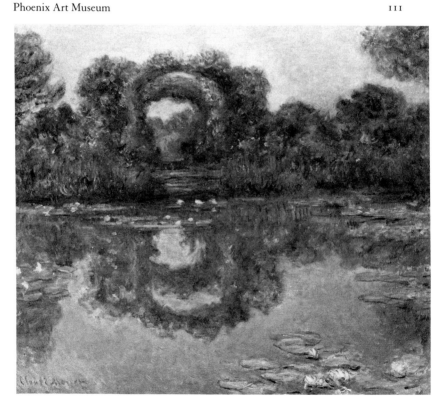

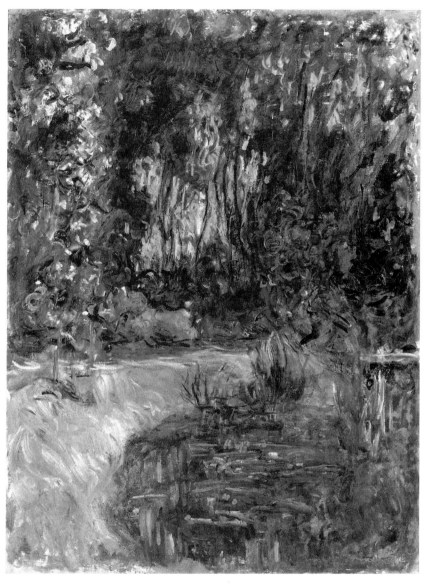

112. *Corner of the Pond at Giverny* (W. 1878), 1917,
117 x 83 cm, Musée de Peinture et de Sculpture, Grenoble

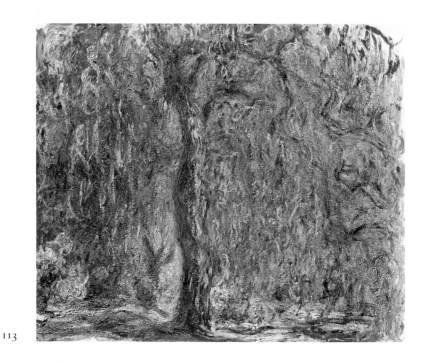

113

113. *Weeping Willow* (W. 1875), 1919, 100 x 120 cm, © Musée Marmottan, Paris
114. *Water Lilies* (W. 1800), 1916, 200 x 200 cm, National Museum of Western Art, Tokyo

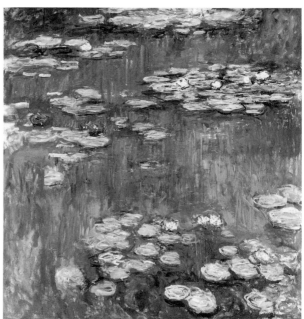

114

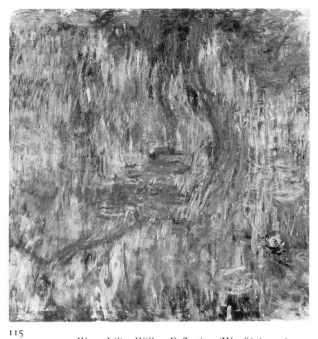

115. *Water Lilies, Willow Reflections* (W. 1862), 1916–19,
200 x 200 cm, © Musée Marmottan, Paris
116. *The House through the Roses* (W. 1959), 1925–26,
66 x 82 cm, Stedelijk Museum, Amsterdam

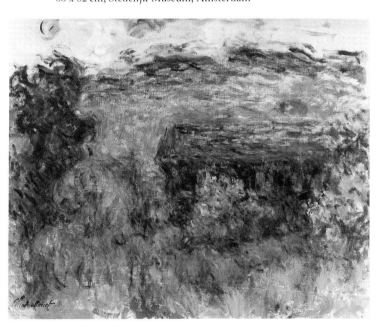

116

117

118

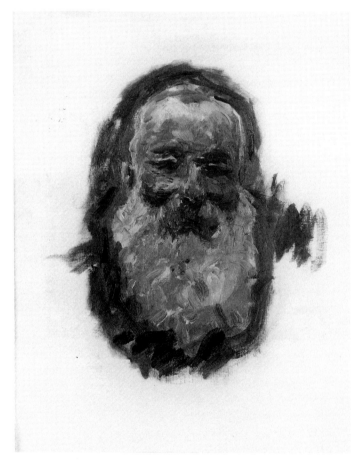

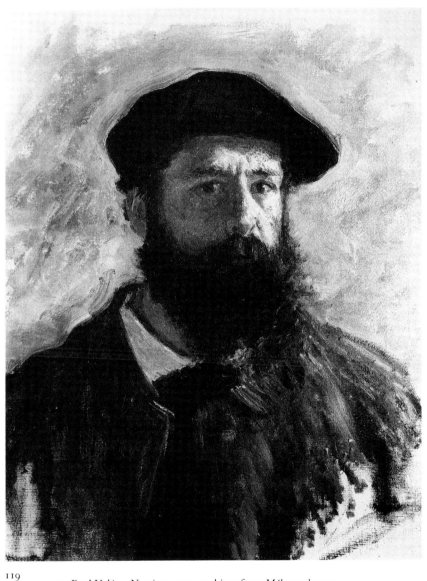

117. Paul Valéry, *Narcissus,* 1939, etching, from *Mélange de prose et de poësie: Album plus ou moins illustré d'images sur cuivre de l'auteur* (Paris, 1939). Bibliothèque nationale de France, Paris
118. *Self-Portrait* (W. 1843), 1917, 70 x 55 cm, Musée d'Orsay, Paris
119. *Self-Portrait with a Beret* (W. 1078), 1886, 56 x 46 cm, Private Collection

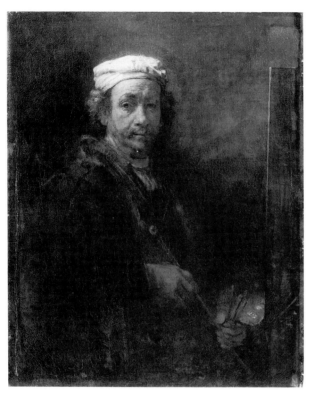

120

120. Rembrandt van Rijn, *Portrait of the Artist at His Easel,*
1660, 111 x 90 cm, Musée du Louvre, Paris

121. Gustave Courbet, *Burial at Ornans,*

121 1850, 315 x 668 cm, Musée d'Orsay, Paris

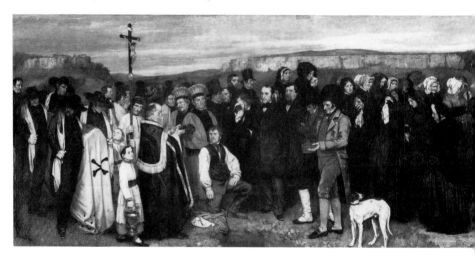

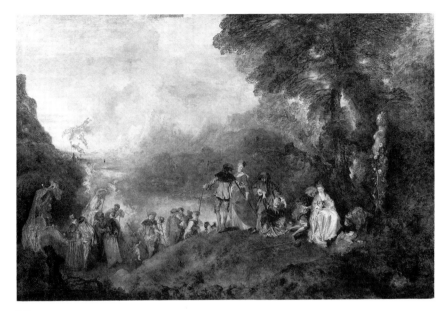

122. Jean-Antoine Watteau, *The Embarkation for Cythera,*
1717, 129 x 194 cm, Musée du Louvre, Paris
123. Eugène Delacroix, *Portrait of the Artist,*
1835–37, 65 x 55 cm, Musée du Louvre, Paris

123

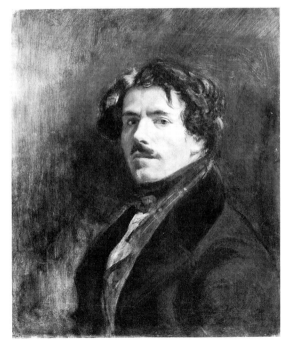

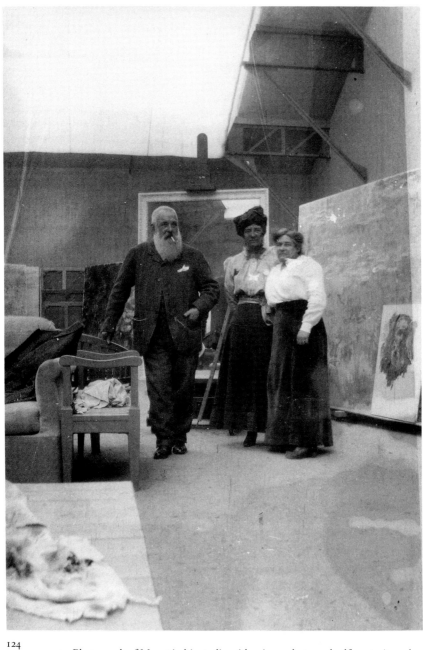

124. Photograph of Monet in his studio with mirror, destroyed self-portrait, and *Water Lilies,* and in the company of Germaine Hoschedé-Salerou and Blanche Hoschedé-Monet, 1917. Collection Philippe Piguet

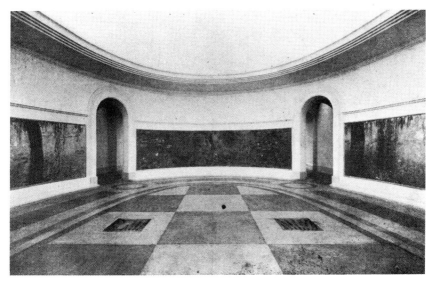

125. Photograph of room 2, Musée de l'Orangerie, Paris, showing *Reflections of Trees* (W. 4:332–33), 1927. from *La Revue de l'Art Ancien et Moderne,* June 1927
126. Philippe Smit, *The Innocent,* 1918, 132 x 120 cm, Museum of Fine Arts, Springfield, Mass.

126

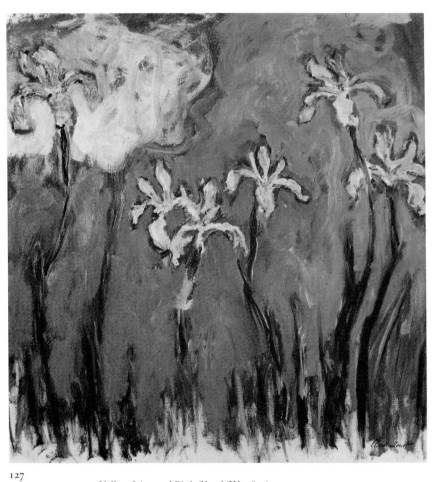

127. *Yellow Irises and Pink Cloud* (W. 1835), 1924–25,
107 x 107 cm, Private Collection

Monet lodged. Monet is not mentioned, but the sea is, "that formidable and resounding sea that, in the Guides, is called the 'Terrible Sea'": "One hears her growling, engulfing herself with a frightful fracas in the grottoes that she herself has dug, and the land is all shaken by this angry voice."[22] Here is the ocean of sublime might, the killer of men such as Garrec, the sailor from Kervilahouen crushed while seeking to pilot a steamer into port. Conversely, in his review of Monet's exhibition several months later Mirbeau evokes the ocean of sublime extension: "One could say that he truly invented the sea, for he is the only one who has thus understood her and rendered her with her changing aspects, her enormous rhythms, her movement, her infinite and ceaselessly renewed reflections, her odor."[23]

Monet habitually deprecates extravagant praise such as this. He calls Mirbeau's "overflowing" enthusiasm "fanatical" (4 November 1886; L. 735) and "too indulgent": "I alone know what I have done well or ill" (8 December 1886; L. 762). Monet says much the same of Gustave Geffroy, whose admiration the painter is pleased to elicit yet quick to dismiss. Nevertheless, Monet reports Geffroy's remark that, in the Belle-Ile paintings, "it is the first time that one will have painted Brittany" (5 October 1886; L. 705).

Geffroy appends to his Salon review two special articles on Monet: "One may say that he has emerged triumphant from the battle which he went to wage with the waves of the Ocean and the rocks of Brittany; his talent has found itself strong enough and has been able to vanquish that granitic land and those redoubtable waters. For the first time, the terrible sea out there has found her painter and poet."[24] Here the texts of Geffroy and Mirbeau intersect in the image of Monet as progenitor of a new and true portrait of the sea. Geffroy's article contains such highly particularized descriptions of the ten seascapes on view that Wildenstein has sought to utilize them for the purpose of identifying works in his catalogue. There is however an allusiveness in Geffroy's writing that transforms description into allegory as well.

Geffroy's principal rhetorical device is a form of serial syntax that elides the distinctions among individual parts in pursuit of a higher unity of the whole. Unlike Mirbeau, who often permits the painting to slip beneath the evoked scene, Geffroy remains attentive to the difference between imaginative portrayal and empirical reference: "Port-Coton, Port-Goulphar, Port-Domois, these are the names that one finds in each case beneath these capes, these blocks, excavated into grottoes, agglomerated into fortifications. There are deserted coasts, jagged rocks, pyramids set up solitarily before the cliffs, scored by the spume, slimed by the lichens and

moss,—hollowed out grottoes that open up like mysterious crypts,—bald breastworks, yellowed and reddened by the vegetation of autumn, rounded and thick like poorly roughed out beasts, pachyderms with thick skins,—rocks pierced like arches,—promontories the color of iron and rust, high, square and massive like cathedrals, that go off into the distance to fall straight into the sea."[25]

Geffroy stresses the battle of the elements, what Monet himself calls "that terrible struggle of the old south and the young north" (29 October 1886; L. 728). Geffroy's recitation recalls the tradition of the sublime of oceanic might: "But the waves that appear, that unfurl from the tops of the frames, are adversaries who are worthy of these immobile combatants [the rocks]. They rush up in serried ranks and one is stupefied by the infinity of their number; they fill up the space with their large leaps, they break like blades against the inflexible walls, they dissolve into streams." Geffroy's response to Monet's pictures yields a preponderance of metaphors of violent confrontation, but I also wish to bring out the barely concealed eroticism of his writing. The female/male juxtaposition of *mer/rocher* is perhaps a mere artifact of the French gendering of nouns, but images come forward in Geffroy's criticism as in Monet's letters that seem to exploit this inherent sexuality of Romance language: "At the entry to this grotto, this agitated water becomes calm, the traitress strokes the rock, kisses it, caresses it, becomes transparent, becomes fixed in her green and blue depths."[26]

Throughout Geffroy's description the narrative of oceanic drama is repeatedly recomposed as a timeless state of oceanic bliss. The breaking of water upon rock is "reproduced" as patterns of circles, lozenges, and lines and as the colors of precious stones. Blue water becomes blue pigment and marks off the land as though by a garment's hem. All this work of painting and drawing is seen as a form of writing in time, for "all the hours of the tides are written on the levels of these walls that overlook the abyss."[27]

Abyss, horror, extension, unconscious: these are terms that in Geffroy's text evoke the literature of the sublime. For Geffroy, Monet's encounter with Belle-Ile is heroic precisely in its resigned embrace of the death of love. Geffroy's various accounts span the years 1886 to 1922; and during these years of Monet's efforts to capture the sublime the psychoanalytic theory of sublimation is in the process of being formed. Touched on briefly in 1905 in *Three Essays on the Theory of Sexuality* and then more extensively in the *Leonardo* paper of 1910, sublimation is described by Freud as a process by which conflicts between opposed drives of love and hate find a substitute outlet for feelings that if discharged would yield intolerable

consequences for the conscious life of the individual. The process of sublimation converts the unsayable into the said, the unseeable into the seen, but the underlying drive remains ever ready to erupt. At the level of theory this provides an explanation of the insufficiency of any one of Monet's attempts to retain the sublime: "The repressed instinct never ceases to drive for complete satisfaction, which would consist in the repetition of a primary experience of satisfaction. No substitution or reactive formations will suffice to remove the repressed instinct's persisting tension; and it is the difference in amount between the pleasure of satisfaction which is *demanded* and that which is actually achieved that provides the driving factor which will permit of no halting at any position attained, but in the poet's words, 'presses ever forward unsubdued.'"[28] Freud takes his quotation from Goethe, yet another poet of the romantic sublime. In Vernet's *ravissement* and Monet's *jouissance* the sea is the medium for the displacement of the desire to forgo the tremors of life for the tranquillity of death.

In the interview of 1889 with which I closed the previous chapter, Monet is quoted as saying, "I have remained faithful to that sea in front of which I grew up."[29] The wished-for return to the seaside sites of his youth is repeated at intervals for the rest of his life. Eros is fooled here, however, for the erotic investment in the oceanic sublime is but a pretext to permit the triumph of Thanatos, Eros's silent twin. As Monet tells Geffroy, "I would like always to be before or upon [the sea], and when I die to be buried in a buoy."[30]

Antibes and the
Intoxication of Solitude
(1888)

IF THE SINISTER ALLURE OF THE *mer terrible* proved irresistible to Monet, it was only after he had rejected the advice to abandon Belle-Ile's gloom-ridden seas for sunnier climes. To Mme Hoschedé, Monet insists that "the lugubrious does not need sun; the sea remains blue, green, and transparent all the same" (28 September 1886; L. 698); he concedes, however, that he has "to make great efforts to paint somber, to render this sinister, tragic aspect, I, more inclined toward sweet, tender tints" (23 October 1886; L. 721). The latter inclination is reasserted in the Antibes paintings of 1888, yet Monet again sounds a contradictory note. To Berthe Morisot he complains that the sites of the Riviera are "so difficult, so tender, and so delicate; and precisely I who am so inclined to brutality!" (10 March 1888, L. 852).

Alice Hoschedé and Paul Durand-Ruel both express reservations about the eventual salability of the Belle-Ile canvases. To Mme Hoschedé Monet writes: "Like you Durand fears that this desolate land, with its rocks, may not be my affair and he seems to regret that I am not at Pourville instead" (14 October 1886; L. 712); "Like you, he seems to me decidedly anxious to see me painting this so sad land; . . . he counsels me to come back and to go pass the winter in the South, because, he says, the sun, that is my affair. Ah well! It will end with you beating my brains in with the sun. One should do everything, and it is just for that reason that I congratulate myself on doing what I am doing" (28 October 1886; L. 726). To Durand-Ruel he writes, "it is useless to be the man of the sun; as you say, one must not specialize in a single note" (28 October 1886; L. 727); for the still dubious Alice he becomes "the man of the fog as well" (30 October 1886; L. 730). The Belle-Ile series is the result of Monet's self-absorption in the

splendors and terrors of fog and storm, but the campaign at Antibes suggests that the objections of his correspondents may have been reflections of his own doubts.

Even in the bright sunlight Monet becomes entrapped in the pursuit of an unattainable ideal. As Monet writes to Duret from Antibes, "after Belle-Ile the terrible, it will be the tender: here there is only blue, pink, and gold, but what difficulty, good God!" (10 March 1888; L. 855); and to Durand-Ruel, "the farther I go the more difficult I am to content myself" (11 April 1888; L. 868).

Unlike Belle-Ile, Antibes was a fashionable watering spot frequented by successful writers and painters such as Guy de Maupassant, Ernest Meissonier, and Henri-Joseph Harpignies. Even on lonely Belle-Ile, Monet's pursuit of privacy had come in conflict with the admiring companionship of critics Geffroy and Mirbeau and Australian painter John Russell; at Antibes the situation was much more congested and Monet repeatedly threatens to leave the hotel: "The house here is becoming impossible: every day there are new arrivals, painters and painteresses, all pupils of old man Harpignies. It is a scream to hear these people, all in ecstasy before their master. . . . Naturally, for them I am a curious beast to view up close, and they all want to see what I do, doubtlessly in order to ridicule me" (21 January 1888; L. 812).

At Etretat in 1885 Monet had disparaged Maupassant's critical acumen even as he accepted the writer's homage with unconcealed pleasure (see letter to Alice Hoschedé, 31 October 1885; L. 604). No such record exists of the interchanges between Monet and Maupassant in 1888, but Monet's letters reveal that more than once he willingly took time off from his work in the hopes of spending a day on Maupassant's yacht. Unfortunately Belle-Ile-like weather arose to prevent the outing aboard the *Bel-Ami:* "During the night, the rain had stopped; a terrible northeast wind was blowing up a storm, the sun was superb, but it was impossible for us to set out, the sea being so heavy" (30 March 1888; L. 862). In spite of this lost opportunity we may get a sense of the projected expedition by reading Monet's letters alongside Maupassant's journal, *Sur l'eau* (1888).

Before being issued in volume form Maupassant's notes were serially published in *Les Lettres et les Arts* during the three months that Monet was at Antibes. The travelogue presents observations on a cruise from Antibes to Saint-Tropez which the writer had undertaken the previous spring, and which he urged the artist to repeat with him in 1888. Maupassant's plotless text is an instance of the nascent symbolist vogue that shifts the focus from the empirical dynamics of nature to the allegorical exploration of self. As

one of Maupassant's critics writes in 1908, "*Sur l'eau* is the book of modern disenchantment, the faithful mirror of the latest pessimism."[1]

As *Sur l'eau* begins, Maupassant's yacht is preparing to weigh anchor and soon is dancing "on light waves, innumerable and low, moving furrows in a limitless plain."[2] Although most of Monet's thirty-six Riviera views show enclosed prospects of the sea framed by mountains, a series of four canvases—including the one known as The "*Great Blue*" at Antibes (W. 1182; fig. 51)—portrays Maupassant's limitless Mediterranean plain as seen from the very point of Cap d'Antibes.

As Maupassant's yacht leaves the harbor it passes several of the sites where Monet worked: "I am painting the town of Antibes, a little fortified town all gilded by the sun, standing out against beautiful blue and pink mountains and the chain of the Alps eternally covered in snows" (20 January 1888; L. 811). From the beach of La Garoupe, Monet paints telescoped views of the mountains and sea that Maupassant also describes (W. 1175–76): "Now, the whole chain of the Alps appears, a monstrous wave that menaces the sea, a wave of granite crowned with snow, all of whose pointed summits seem to be spurts of immobile and frozen foam. And the sun rises beyond the ice, upon which its light falls in silver streams."[3] Just as the molten silver of sunlit snow presents itself to the writer as a vehicle of intense emotional experience, Monet too becomes "infatuated with mountains covered in snow" (24 January 1888; L. 816). Their variations in appearance lead Monet to recommence his canvases, but such "repetitions" are at the same time his constant fear (17 January 1888; L. 808).

As Maupassant's yacht turns the cape of Antibes, the writer records the distant view of the Esterel Mountains to the west and south. The sublimity of the scene is threatened, however, by the reminiscence of hackneyed pictures in which "the tormented chain of the Esterel" merely becomes "the backdrop of Cannes, a charming keepsake mountain, bluish and elegantly cut out, with a stylish yet rather artistic fancy, painted in watercolor on a theatrical sky by a creator willing to serve as the model for English lady-landscapists and as the subject of admiration for consumptive or idle highnesses."[4] Maupassant's caustic markers of culture, gender, and class castigate the traducement of the Esterel's scenery in the name of an effeminate, fashionable decor. For Monet it is Agay on the Esterel corniche that serves as a rugged alternative to the pretty spots that he has been lured into commencing to paint. Repeatedly he insists that Cap d'Antibes "is not my affair"; like Belle-Ile, Agay is "a terrible and savage land . . . but there I am sure to find what to do" (15 January 1888; L. 807). Even though Agay is "more my affair" (24 January 1888; L. 816), Monet

remains fixed at Antibes. His "dream of Agay" fails to be realized and he settles down to do battle with Antibes: "It is decidedly beautiful, but it is so difficult! I have a good glimpse of what I want to do, but am not there yet. It is so bright, so purely pink and blue that the least not-right touch makes a mark of filth" (1 February 1888; L. 824). Ultimately Monet becomes reconciled to the beauty of Antibes, but Belle-Ile and Agay remain the sublime counterfoils for his "battle, for it really is one, with the sun and the light": "What I will bring back from [Antibes] will be sweetness itself, white, pink, and blue, all that enveloped with this enchanting light; it has no connection with Belle-Ile, but watch out for the colors of Agay" (3 February 1888; L. 827).

Monet's ambivalence concerning the feminine beauty of the Riviera is comparable to that of Maupassant: "The correctly and neatly drawn chain of mountains is cut out in the morning against the blue sky, a blue tender and pure, a blue clean and pretty, an ideal blue of the southern shore. But at night, the wooded flanks of the slopes darken and place a black mark upon the fiery sky, upon a sky implausibly dramatic and red. Nowhere have I ever seen these fairy-tale sunsets, these blazes of the entire horizon, these explosions of clouds, this cunning and superb *mise-en-scène,* this daily renewal of excessive and magnificent effects which compel the admiration and would make us smile a bit if they were painted by men."[5] In his paintings of the Esterel and its bay at Juan-les-Pins, Monet may be seen to represent Maupassant's dramatic decor. In one painting the anthropomorphic silhouette of a seaside pine juts out against the horizon of the distant mountain haze, and in another a bloody sunset throbs amidst the interstices of a blue stand of quivering trees (W. 1191–92). Vincent van Gogh knew the latter painting only from his brother Theo's description when he wrote of it to Monet's erstwhile Belle-Ile colleague, John Russell: "My brother has an exhibition of 10 new pictures by Claude Monet—his latest works, for instance a landscape with red sunset and a group of dark fir trees by the seaside. The red sun casts an orange or blood red reflection on the blue green trees and the ground. I wished I could see them."[6] Van Gogh also records a visit by Maupassant to Monet's show.

In *Sur l'eau* Maupassant explores not only the physical sites of the Riviera but "the intoxication of being alone."[7] Monet likewise cultivates his artistic independence, and although he grudgingly accedes to a visit from Mirbeau he insists that Renoir not be apprised of his whereabouts: "I have too great a need to be alone and tranquil" (21 January 1888; L. 812).

Maupassant's postulation of aloneness juxtaposes a tragic view of the human condition with an ironic affirmation of art. His sense of the limita-

tions of human reason—"We know nothing, we see nothing, we can do nothing, we divine nothing, we imagine nothing, we are enclosed, imprisoned in ourselves"—generates a critique of artistic imitation: "The arts? Painting consists in reproducing with colors monotonous landscapes that never resemble nature, in drawing people by striving, without ever succeeding, to give them the aspect of life." Instead of this deficient naturalism Maupassant asks for an art of metaphysical transcendence: "Ah! If poets could traverse space, explore the stars, discover other worlds, other beings, endlessly vary for my mind the nature and form of things, endlessly lead me into a changing and surprising unknown, open mysterious doors upon unexpected and marvelous horizons, I would read them day and night. But these impotents can only change the place of a word, and show me my image like the painters. What is the good of it?" Ultimately Maupassant finds a fragile answer to his own nihilism: "Still and yet, for want of better, it is sweet to think, when one lives alone. On this little boat tossed by the sea, which a wave could fill up and turn over, I know and I feel how much nothing exists that we understand, for the earth that floats in the void is still more isolated than this bark on the waves."[8]

The letter in which Monet discusses his abortive plans to go aboard the *Bel-Ami* has come down to us as a fragment. It begins in mid-sentence and parallels Maupassant's disparagement of the limits of art: ". . . for perhaps it is that which will save me from this terrible specialty of landscapist, and from this brutalized state in which I am stuck" (28 January 1888; L. 820). Atlantic or Mediterranean, stormy ocean or placid sea, Monet's feeling of helplessness is always the same: "The farther I go, the more I seek the impossible and the more I feel powerless" (to artist Paul Helleu, 10 March 1888; L. 854).

Impossibility is the name of Monet's desire: "In a word, I become bored to death as soon as I no longer have my painting, which obsesses me and greatly torments me. I do not know where I am going; one day I believe in masterpieces, then it is nothing at all; I struggle, I struggle without advancing. I think that I am seeking the impossible. Nevertheless I am very courageous. It is so beautiful" (5 February 1888; L. 829). For Monet the pursuit of beauty is a travail that seems scarcely justified by the prize: "What a curse is this confounded painting" (6 February 1888; L. 830). Maupassant's sense of his calling is similar. In the face of the unrepresentable beauties of the world Maupassant is "reduced to looking at everything without seizing anything"; and the writer's fate is like that of the painter who fails to seize an impression: "I carry in me that second sight that is at the same time the force and the entire misery of writers. I write

because I understand and I suffer on account of everything that is, because I understand it too well and above all because, without being able to taste it, I look upon it in myself, in the mirror of my thought."[9]

The self-scrutinizing artistic drive traces its reflex arc in the "torturous, harrying, unknown, unappeasable, unforgettable, ferocious" repetitions of which Maupassant's adjectival stream is itself an enactment.[10] Monet's compulsion to repeat finds its form in his self-reflexive verbs and in the format of the series itself: "I feel that I am redoing each day the same task without advancing. One day, I delude myself, and, the next day, I resee it all bad. I assure you that I am afraid of being finished, emptied. I eat my heart out" (11 February 1888; L. 834). Elsewhere he writes that the changing position of the sun forces him to "re-cover" and "recommence" (29 February, 2 March 1888; L. 846, 848), and yet Monet also concedes the unproductive nature of his repetitive drive: "I am in an impossible state of fever and enervation. I work in vain, I can finish nothing; there are only some canvases that are finished by dint of force and are in consequence incomplete; and then, I feel that what I recommence is better, but, with new stoppages, they will have the same fate as the others" (16 March 1888; L. 858). Burying himself at the Belle-Ile-like outpost of Agay is seen as potentially recuperative, but no more than Maupassant can Monet disengage from the mirror of his own thought. As Maupassant describes the perpetual lot of the artist, "he lives condemned always to be, at every occasion, a reflection of himself and a reflection of others, condemned to watch himself feel, act, love, think, suffer, and never to suffer, think, love, feel like everyone, plainly, frankly, simply, without analyzing himself after each joy and each sob."[11]

Monet's self-inspection is painful for him and for those close to him. Apart from himself Alice Hoschedé is the primary victim of his interminable self-analysis; she also plays a reciprocal part in seeking to coerce him to live as her reflection, but the material facts of the ménage are such that Monet has the traditional prerogatives of the money-earning male on his side. Thus Alice is badgered and cajoled into accepting the reverberant role of Echo to the radiant Narcissus of Claude: "And you, know well that I desire you as much as you [do me], but that it is painting, this diabolical painting, my life and in consequence yours, that retains me for some days still at a distance from you" (18 April 1888; L. 874).

In his 1922 biography of the artist, Gustave Geffroy cites a letter from Antibes that characterizes Monet's transactions with the motif: "I pick away and give myself the trouble of all the devils, am very anxious for

what I am doing. It is so beautiful here, so bright, so luminous! One swims in blue air, it is frightening" (12 February 1888; L. 836). *Sur l'eau* concludes with a similar image. The writer looks seaward and sees a plain of "long, powerful, and slow waves, these hills of water that march, one behind the other, without noise, without shock, without foam, menacing without anger, frightening in their tranquillity." Maupassant's emphasis on the tranquillity of fright is perhaps more metaphysical than Monet's language of pain, but elsewhere Maupassant also records "the mysterious, redoubtable, terrifying, and superb force of the waves."[12]

Both aspects of the sublime are present in Geffroy's review of the Antibes series which Monet exhibited in June 1888 under the auspices of Theo van Gogh. Geffroy's metaphorical language recalls particular phrases of Monet: "I skirmish and battle with the sun. And what sun here! One would have to paint it with gold and gems" (to Rodin, 1 February 1888; L. 825). The sequential structure of Geffroy's text also echoes the variations among the paintings of Antibes.

Embedded in Geffroy's account is the master metaphor of transformation. By way of a "secret coloristic alchemy" Monet is said to transmute the data of observation into a fairylike array of precious metals and jewels (figs. 52–53): "Antibes, first, with its groups of houses and its two towers, is resplendent with all its stones ignited by the sun. There are bright fires, pink fires, a precious and calcinated fairy tale that multiplies itself in reflections upon the sea [W. 1158]. . . . —Antibes, otherwise seen, more sheltered by the hill, profiles itself less upon the sea, loses its simple nudity, ornaments itself with several shrubs, a tree, and a bright verdure that grows upon the pink soil [W. 1171]. —Antibes, still, in the golden pallor of the dawn, awakens to the nascent scintillations of the sun, while in the foreground, at the bend of the shore, a large tree spreads its branches still blue and dark, indistinct and weeping branches that pour night into the light of the rising day" (W. 1167).[13] Resplendence, reflection, nudity, ornament, bending, and weeping are so many rhetorical seeds around which the image of Narcissus will come to crystallize during the decade ahead.

If there is a reminiscence of Narcissus bending over his own reflection in Geffroy's article it is indirect. We have seen that in Mallarmé's *Les Dieux antiques* Narcissus is related to the deathlike plunge of the sun into the sea. In *Sur l'eau* Maupassant approaches the parameters of myth in an excursus on "the poor moon disdained by the sun," another classical figure of death and virginity: "And it is for this that she fills us, with her timid light, with unrealizable hopes and inaccessible desires. Everything that we

obscurely and vainly wait for upon this earth stirs our heart like an impo-
tent and mysterious sap beneath the pale rays of the moon. We become,
our eyes raised up to her, trembling with impossible dreams and thirsting
for inexpressible tenderness."[14]

A similar sense of the permanence of desire and the impermanence of
satisfaction pervades Geffroy's review. Monet's humanoid trees, five times
featured within the ten-painting show, become for Geffroy the bearers of
this affectual burden (fig. 54): "Here, now, a tree with rounded head, all
alone on the pink shore, and over there, very far away, mountains with
luminous summits of snow [W. 1175]. —Another tree, bent over, surges
up from the soil like a sinuous and vigorous fire-work fuse, opens out in
a bouquet of branches and leaves [W. 1192]. A group of trees, bent over a
milky indentation of the seacoast near a green row of hedge, is already
languid beneath the visible heat that descends from the sky in transverse
rays [W. 1187]. —A group of pines, of black green, by the banks of a
swollen and vaporous sea, spaces out its high trunks upon an earth red
like blood [W. 1191]. . . . The same pines, upon the same red earth, at
another hour, carry leaves of a lighter green, the sea is more visible, the
waves more accentuated" (W. 1190).[15] These trees of the Riviera present
Geffroy with occasions for metaphorical association as their growth is made
to conform to the burst of a rocket, the bend of a body, the bloom of a
flower, or the spill of blood.

Geffroy concludes his survey of Monet's paintings with a virtual prose
poem on the sea: "Finally, two different sea views. —One of these seas,
angry, all roughened by the cold north wind, is the deep blue of a dark
precious stone. . . . A patch of rocky ground descends in a gentle slope
into the water, places this moving landscape in a setting by means of its
hard lines [W. 1181]. —The other sea space, in front of the distant Alps,
is pierced only by an islet at the level of the waves. The expanse is immense,
furrowed by gentle lights, mottled by bright shadows, a green marine
prairie flowering with violets" (W. 1179). Geffroy calls the ensemble of
Monet's views a resume of the Mediterranean. Green, blue, gray, white;
iridescent, cloudy, snowy; pallor, darkness, dazzlement; roseate, golden, lit
by the sun: these are so many attributes of a meaning that can never be
fixed, "one could almost say."[16]

Toward the end of his life Geffroy collected together a series of verbal
images summing up his view of the world. "La Mer" reiterates many of
the responses that Geffroy had long since had in front of Monet's work.
For Geffroy "the great poetry of water is evoked by the shores of the sea,"

but the joys of poetry are at one with the rigors of philosophy: "Before its flight to the horizon and its return with a mechanical perpetuity, the contradictory ideas of infinite extension and miserable smallness are born together, and the movement and equilibrium of matter inscribe themselves in our mind by means of a magnificent and formidable image." Geffroy cites Victor Hugo—"The Ocean speaks to thought"—but the critic's scenario may also implicate his friend Monet: "To board ship, to depart, to go far away behind the line of the horizon, to see if there are still more waves and still more clouds, that is the mad desire of him who long stays here, hypnotized by the sight and by the sound, ready to evaporate, to lose himself in the alluring mystery of this contemplation."[17]

Narcissistic entrapment in self-annihilating contemplation is the story of Monet at Antibes. Headaches, anxieties, tortures, and curses beset him: "to have given myself so much pain and not to manage to satisfy myself, I am going mad" (26 April 1888; L. 880). Monet repeatedly postpones his departure, perpetually looking to the sea in the hopes of salvation: "Therefore pardon me, I beseech you, for delaying yet a day or two; it is a must. I cannot leave these canvases in this state, it is absolutely necessary that I insert what they lack. I think that they will be very good, or else I will pack it in and become mad" (30 April 1888; L. 883).

This was Monet's last letter home from Antibes. His anxiety about the value of his pictures and their reception in Paris might soon have passed, for the exhibition enjoyed both critical and commercial success. Maupassant saw the show but we do not know what he thought. Mallarmé, however, did write his appreciations to Monet, whom the poet came to know through their joint friendship with Edouard Manet's sister-in-law, Berthe Morisot. For Morisot, Monet's exhibition is "a dazzle," and Mallarmé conveys his respects with the very same word: "I leave dazzled by your work of this winter; it has been a long time that I have placed what you do above all else, but I think that you are in your finest hour. Ah! yes, as the poor Edouard liked to repeat, Monet has genius."[18] Monet expresses great pleasure at these remarks, especially in that "the praise [comes] from an artist like you" (19 June 1888; L. 897). Other letters show Monet to have been an appreciative reader of Mallarmé; Monet received dedicated copies of the writer's works, and it is to one poem in particular that I now wish to turn.

"Brise Marine" was first published in 1866 in *Le Parnasse Contemporain,* but it only became widely known in the 1887 collection of the *Poésies.* The sonnet embraces the marine breeze as the harbinger of a flight beyond the

confines of domesticity, much as the blues of Antibes function to lure
Monet beyond the thrall of Giverny:

> The flesh is sad, alas! and I have read all the books.
> To flee! to flee out there! I feel that birds are drunk
> From being among the unknown spume and skies!
> Nothing, not old gardens reflected in the eyes
> Will retain this heart that steeps itself in the sea
> O nights! not the desert light of my lamp
> On the empty paper that the whiteness defends
> And not the young wife nursing her child.
> I will go away! Steamer swinging your mast,
> Lift anchor for an exotic land![19]

Mallarmé's sonnet echoes the sounds of the mariners' song that accompanies Baudelaire's invitation to oceanic transcendence by way of the heady elixir of a woman's scent.[20] Geffroy invokes Baudelaire's principle of synesthesia in commenting on the "essence of perfume" wafted up in the face of Monet's landscapes that are "bouquets of color" as well.[21] Geffroy's critical review, Maupassant's travel account, and Mallarmé's sonnet are all elements of a cultural lattice that surrounds Monet's paintings in a self-referential framework of desire, regret, introspection, and loss.

The Monet-Mallarmé nexus is further extended in a comment by symbolist poet Maurice Bouchor. Bouchor is the author of *Les Symboles* (1888), a dedicated copy of which he sent to Monet at Giverny. In a series of scholarly poems Bouchor alludes to ancient mythology and religion in an effort to reanimate the experience of the natural world with its lost aura. Viewed through the eyes of Buddha, the "reflection of the sky in the water, mirage, distant echo" all confirm that the universe "is no more than a lie, with its marvelous cortege / Of forms, of colors, and of bursting sounds." Here the Baudelairean triad of sensory stimuli is given the introverted twist of the late 1880s, for in spite of the rich panoply of our sensorium we find ourselves "captives in the links of time / Like the squirrel in a snare."[22]

After viewing the paintings of Antibes at the Goupil gallery in Paris, Bouchor launches off into interior space: "I saw five magnificent [paintings]—a savage sea, white mountains, an emerald lake, a marine landscape that has in the foreground a large tree (plane tree?)—all things that seem admirable to me at once by their interiority and an extreme delicacy, of golden haze, of impalpable things, these two fundamental qualities being moreover variously apportioned according to the subjects. The *Mediterra-*

nean is dazzling."[23] Dazzle is variously evoked by Mallarmé, Morisot, and Bouchor in order to account for the impact of Monet's hues. There is no doubt that the light of the Riviera is the very cliche of dazzling light, but the point which I am trying to stress is that dazzle and its cognates are metaphors for a process by which a view of the outer world becomes a mirror of the inner eye.

The metaphorical strategy of interpretation is ubiquitous in 1888. Writing in *La Cravache Parisienne,* Georges Jeanniot offers a lengthy front-page article on Monet that moves easily from eyewitness account of the painter at work to esoteric associations stimulated by the pictures on display. His fundamental premise is that Monet manifests "the ambition that his painting speak not only to the eyes but also to the most delicate sensibilities and imaginations." Psychology thus subsumes physiology, and the prime faculty of this process is "reflection."[24]

The sea is the subject that most attracts the artist: "It is by means of his landscapes from the shores of the Atlantic and the Mediterranean that he most violently impresses. Does a more poignant painting exist than that which he brought back last year from Belle-Ile? The wind rushes up from the depths of the horizon pushing before it the roaring and liquid army; at the sill of the painting, backed up against the frame, terrible black rocks, veritable Titans, are erected in order to halt the invasion that ever, ever comes to break upon them. . . . I hear in the distance the echo of the weeping voices calling for help, the knell of the victims sounds in my brain and I murmur very low that lugubrious and legendary Breton name: the Bay of the Departed!" Jeanniot shifts from the Bay of the Departed to the Bay of the Angels without even a paragraph to mark the move: "Here now is the sea of Antibes, the sea radiant, calm, and gay, with white edifices, snowy mountains, turquoise skies, dark green trees and sprinklings of southern plants; the sun, the good sun that changes dung into gold and reanimates the old inundates these seraphic pictures."[25] Whether by way of the struggle of the Titans or the flight of the seraphs, the trajectory of Jeanniot's eye is from the surfaces of Monet's seas to the depths of the mind.

Whatever may be the intent behind Monet's works from Antibes, Jeanniot feels impelled "to run under sail upon the satin of the blue waters or to immerse himself in the morning in these reflections of opal or mother-of-pearl." The critic is seduced by an illusion of life in spite of his recognition of the artifice employed—"What science made from simplicity, and what audacious precision!"—but it is the affectivity of Monet's art that commands his respect. The paintings of Antibes "have the air of distant

evocations of spectacles formerly seen, spectacles that strike the memory and imprint an indelible mark upon it."[26]

Jeanniot understands that it is not all a matter of mind. Unlike Geffroy, for whom "resume" encompasses the assorted empirical aspects of Antibes, for Jeanniot the paintings are "the knowing and complete resume of a suite of ideas and of facts." In this pictorial fusion of mind and body Jeanniot takes "the measure of the penetrability of the artist and of his potent isolation in the face of nature."[27] Monet's reiterated fears of *impuissance* are thus converted into *puissance* in the gaze of the beholder of his art. Far from being the vain and powerless youth of Ovidian fun, the Narcissuslike artist is now the empowering author of a cosmic rapprochement of the world and the self.

In Jeanniot's final paragraph he returns to the juxtaposition of Antibes and Belle-Ile: "In the 'marines' brought back from Antibes, the wind circulates as in those described above; but the attentive observation of the luminous phenomena indicates a light breeze charged with joyous thoughts; it carries the odors of the orange trees and the eucalyptus. Was Monet conscious while painting of the strange affinity that exists among perfumes, sounds, and colors? Yes." Here is the clearest reference yet to the correspondences of Baudelaire, but Jeanniot presses the sensuous analogy into the realm of allegory: "Beneath his brush the waves of the Mediterranean murmur like lovers, whereas those of the Atlantic howl and cry like shipwrecked men. In front of his paintings of Belle-Ile one receives in the face the briny and cold wind of the open sea; in front of those of Antibes the air comes forth like a warm and perfumed caress."[28] The images of Baudelaire's "Correspondances," Mallarmé's "Brise Marine," Loti's *Pêcheur d'Islande,* and Maupassant's *Sur l'eau* fuse together in the journalistic amalgam of Jeanniot's text, without elaborate literary intention no doubt but with that force of intertextual momentum that traverses even casual responses to Monet's work.

The second half of Jeanniot's article comprises an account of a day in the country spent in the company of the artist. Mirbeau takes note of the article in a letter to Monet; and Monet himself writes to thank Jeanniot and to ask a personal favor as well (1 October 1888; L. 905). It remains unclear whether we are to take this as a recognition of the commercial value of critical support, as an endorsement of the critic's interpretation, or as both. Some critics in 1888 insist on the "impression of grand and natural poetry" that emanates from these "personal" works,[29] but still others ridicule Monet's technique as well as the pretention of his symbolist supporters. Paul Robert, who signs himself Eaque, expostulates that "in

order to enliven all this, [Monet applies] the debris from his palette that represents, it seems, 'one of those reefs from the coast of Provence, burned by the sun, red like a bloody wound, similar to the heavy caress of an amphibian.'"[30] I do not know the source of Robert's mockingly cited passage, but I take it as all the more curious that in his own account a view of Antibes at dawn elicits thoughts of the ruins of Pompeii.

The metaphorical solicitation of Monet's paintings exerts itself even in the most dismissive texts of 1888. Félix Fénéon is now of the opinion that Monet's "talent does not seem to be gaining ground since the series of Etretat," yet the series of Antibes still occasions a striking passage from the neoimpressionist champion. Like Huysmans in 1887 and Geffroy in 1888 Fénéon treats the works as a single if variegated whole: "All of 1888. —Trees that fleece out at the top of tall trunks, the sea where sails flag, mounts in light tempests beneath the sun, an illuminescent town on the near horizon. In the foreground, enormous packets of violently modeled paste; in the middle, masonries less heavy; the backgrounds, in smooth scumbles." The technical focus on the painter's *frottis* and *maçonnerie* conveys a sense of slapdash artisanal work and effete aristocratic show: "M. Claude Monet is a spontaneous painter; the word 'impression' was created for him and suits him better than anyone. He becomes brusquely excited by a spectacle; but in him nothing of the contemplator or the analyst. Served by an excessive bravura of execution, an improvisational fecundity and a brilliant vulgarity, his renown grows."[31]

Fénéon's account bears the traces of the sublime of oceanic extension annulled by the lurid facts of material excess. Not raised to the level of Schopenhauerian contemplation or Kantian analysis, Monet's painting succumbs to the centripetal force of its own matter and fails to break free into the orbit of idea. Yet Fénéon indirectly acknowledges the power of Monet's art by suggesting that Celen Sabbrin be hired to explicate the pictures to the spectators at the gallery. Although Fénéon eschews her allegorical speculations, in his text trees turn into sheep, mountains into waves, towns into dreamlike condensations of iridescence and luminosity: the word *illuminescente* is a hallucinatory composite of Fénéon's invention. Monet is criticized here, but the terms are not certain and may repeat some of the ambivalence that the painter himself feels. In the end, Fénéon pronounces his verdict against the pictures; and, as Pissarro reports, Monet claims to have foreseen as much.[32]

8

Mirbeau and the Cult
of the Self (1889)

BY 1889 Monet's life was already the stuff of historical inquiry. This is the implication of Hugues Le Roux's question concerning the "legend" of Monet's Norman birth. The occasion was a small exhibition organized by Theo van Gogh at the galleries of Boussod and Valadon; in response to the interviewer Monet attests to his birth in Paris, but in reference to his childhood at Le Havre he insists, "I have remained faithful to the sea in front of which I grew up."[1] I, too, have insisted upon Monet's fidelity to this *mer/mère*, to this maritime matrix through which Monet's private reserves of memory are repeatedly transformed into public images. In the interview just quoted and in other articles Monet takes full advantage of the glare of publicity that is turned upon him in this year of the Paris World's Fair. Many of the legends that today surround his name trace their perhaps dubious authority to the writings of 1889.

In the manner of a self-satisfied genius recounting the inevitable unfolding of his talent, Monet narrates the tale of his encounter with Boudin, his military service in North Africa, his stint under the tutelage of Gleyre, who criticizes the young artist for an "unfortunate tendency to look at nature too grossly as she is." Monet's repudiation of the "absolute notion" of the Ecole des Beaux-Arts and his reliance upon direct sensory perception are compared to the perceptual theories of Théodule Ribot of the Collège de France: "Impressionism as it is understood by Claude Monet is before all else the painting of the envelope, of the movement of the ether, of the vibration of light that throbs around objects."[2]

Ribot was well known not only for his psychology of perception but also as Schopenhauer's chief commentator in France. In Le Roux's portrayal, Monet's perceptualism is seen to have the redemptive consequences

of a life given over to pure contemplation, and the paintings of Gare Saint-Lazare (W. 438–49) are cited as prime examples of the attempt to represent the optical flux of experience. With his brush at the ready Monet is said to be "like a hunter, lying in wait for the moment of his touch." This tension-laden metaphor recurs twice in the anecdote about Monet at Etretat which I have already had occasion to examine. In reference to *Etretat, The Rain* (W. 1044) Monet is seen lying in wait for "the returns and disappearances of the light," and lying in wait for "the return of the vanished impression."[3]

Monet's elusive impression is the bearer of an uncanny charge. Of the dozen or so paintings on display in 1889, Le Roux singles out one work in particular as most characteristic of the methods and meanings of Monet's art: "At first you see only white masses, diverse values, then, all at once, a river bank appears, the silhouette of a church, of a bell-tower of a village. It is there and it is nothing at all." This is a painting of Vétheuil in the fog from 1879 (W. 518; fig. 55), and for Le Roux it is reminiscent of "that shuddering apparition of the phantom vessel that terrifies the Icelandic fishermen in the novel by Loti."[4]

In the chapter on Belle-Ile I discussed the imagery of love and death in Monet and Loti. Here it is the spectral looming of Loti's silent ship that is conjured up by the fog-shrouded village of Vétheuil afloat upon the Seine: "And, truly, Claude Monet has put into this canvas the emotion of the supernatural. He was, as always, upon the Seine, in his little boat, one drizzly day. The fog was so dense that, in order to paint, he was waiting for the end of this enchantment that walled him in in a wad of cotton wool. All at once, two steps away, he saw surge up a village, a church. Did they really exist, or was it a phantasmagoria of the sun at play with the clouds? The apparition vanished without having cleared. But the painter had had the time to fix it upon the canvas."[5]

The episode of Loti's novel which Le Roux cites begins with the sounding of a fog alarm at sea: "And then, as though an apparition had been conversely evoked by this vibrant sound from the pipes, a large unexpected thing took form in grisaille, rose up menacingly, very high, quite close to them: masts, yards, ropes, an outline of a ship that had been drawn in the air, everywhere all at once and at a single blow, like those frightening phantasmagorias that, with a single jet of light, are created upon stretched screens." Through this play of graphic and filmic metaphors Loti projects the encounter of two fishing boats deep within the concealment of the fog. No catastrophe occurs at this time, but later in the novel the hero's widow has an "obsessive vision, always the same: a stoved in and empty wreck,

rocked upon a silent, gray-rose sea; rocked slowly, slowly, without a sound, with extreme gentleness, out of irony, in the midst of the great calm of dead water."[6]

Le Roux proposes the emergence of the village of Vétheuil from the fog as a paradigm of Monet's enterprise: "Thus, unfinished and poetic, he hung it up in his grange at Giverny. He ended up by deciding to bring it to the exhibition of the Boulevard Montmartre. He thought that it would give notice of his process of work, that it would have a lot to say about its author and about his dream." In support of the oneiric nature of Monet's vision, Le Roux further cites a definition of painting by Eugène Fromentin: "The art of painting is no more than the art of expressing the invisible by the visible."[7]

The appropriation in 1889 of this antiempirical axiom of romanticism is characteristic of a symbolist discourse which will increasingly come to claim the allusive art of Monet. Musical metaphors proliferate in this interpretative idiom, and Le Roux concludes by referring to *Vétheuil in the Fog* as a "white symphony."[8] Twenty-five years earlier the critic Paul Mantz had first used the phrase "symphony in white" in reference to the portrait which Monet's friend James McNeill Whistler had exhibited at the Salon des Refusés of 1863 under the title of *Lady in White*.[9] Two further symphonies in white followed in 1864 and 1867, and if Le Roux's phrase was intended as an overt Whistlerian reference it would have been quite appropriate, for Monet's painting was one of his most Whistlerian works to date.

Vétheuil in the Fog is the painting that opera singer and art collector Jean-Baptiste Faure reputedly rejected around 1879 as merely a bit of white paint on canvas. If we are to believe Monet's account of this incident from some thirty-five years later, this rejection would have taken place only several months after Whistler had brought his libel suit against John Ruskin for having been accused by the critic of "flinging a pot of paint in the public's face."[10] According to Monet, sometime during the 1890s Faure reversed himself and sought to acquire the painting from the now unwilling artist who, in later years, persisted in retelling the story of consternation that had initially greeted *Vétheuil in the Fog*.

During the years around 1889 Monet and Whistler were in close and frequent touch. At Georges Petit's Exposition Internationale in 1887, when *Vétheuil in the Fog* was publicly exhibited for the first time, Whistler's fifty small pictures of the French seashore and other motifs hung in the company of the larger landscapes and seascapes of Monet with which they were compared in the press. Shortly thereafter Monet visited his colleague abroad

for a dozen days or so; as he wrote to Duret, he was "amazed by London and also by Whistler, who is a great artist" (13 August 1887; L. 794). Upon Whistler's invitation Monet sent four recent paintings to the winter exhibition of the Royal Society of British Artists, whose hanging committee, the artist hoped, would not be "too frightened" by the works (25 October 1887; L. 798). By the time of Le Roux's article the relations between the two painters had become even further strengthened through the friendship of Stéphane Mallarmé, to whom Monet introduced Whistler in 1888.

In 1888 Whistler was eager for Mallarmé to translate the *Ten O'Clock*, a lecture which the painter had delivered on several occasions in England in 1885. The text offers a paean to the authentic artist as well as a critique of the professional critic. Upon its appearance in France, Monet received a dedicated copy of the translation from Mallarmé, whom he thanked (5 June 1888; L. 894). In the French version of Whistler's remarks Monet might have noticed the following passage that seems pertinent to his own past and future portrayals of the Seine, the Thames, and the Venetian lagoon: "When the evening mist clothes the riverside with poetry, as with a veil, and the poor buildings lose themselves in the dim sky, and the tall chimneys become campanili, and the warehouses are palaces in the night, and the whole city hangs in the heavens, and fairyland is upon us—then the wayfarer hastens home; the working man and the cultured one, the wise man and the one of pleasure, cease to understand, as they have ceased to see, and Nature, who, for once, has sung in tune, sings her exquisite song to the artist alone, her son and her master—her son in that he loves her, her master in that he knows her."[11]

Whistler's stated purpose is to defeat the vulgar supposition of the empiricists and philistines "that Nature is to be taken as she is, . . . that nature is always right." On the contrary, "Nature is very rarely right, to such an extent even, that it might almost be said that Nature is usually wrong: that is to say, the condition of things that shall bring about the perfection of harmony worthy a picture is rare, and not common at all." "Seldom does Nature succeed in producing a picture," whereas to the properly contemplative artist "her secrets are unfolded, to him her lessons have become gradually clear."[12] This doctrine of the artist's solitary intuition of the beauties of nature is entirely congenial to Mallarmé and Monet. In this regard Mallarmé compares the aesthetic vision of Whistler to that of Edgar Allan Poe, with whose works both men were for many years engaged. Whistler was the painter of *Annabel Lee* (Hunterian Museum and Art Gallery, Glasgow), the heroine of Poe's famous poem where she lived "in a kingdom by the sea."[13]

In February 1889 Monet received a copy of Mallarmé's prose translation of the poems of Poe and soon sent back word of his "ravishment": "I was completely ignorant of the poetry of Poe; it is admirable, it is poetry itself, the dream, and how one feels that you have translated its soul! I am no more than a completely illiterate ignoramus, but am not any the less moved by it. I knew only Poe's prose, which I had read and admired very young before I had heard it spoken of, but how your poems complete and express the man he was" (15 February 1889; L. 911). Just before his first sojourn in London, Monet referred to Poe's stories in a letter to Pissarro (17 June 1871; L. 59), and although I do not want to stress unduly either Whistler's or Poe's significance, I do wish to relate several of Mallarmé's translations of Poe to Monet's work.

For Poe, writing in "Eulalie," "my soul was a stagnant tide." For the poet water is both decor and trope, a background to action as well as a framework of ideas. "The City in the Sea" describes a reflected realm of Vétheuil-like stony towers where "resignedly beneath the sky / The melancholy waters lie." This watery world is a land of dreams, a "Dreamland" of "Seas that restlessly aspire, / Surging, unto skies of fire; / Lakes that endlessly outspread / Their lone waters—lone and dead,— / Their still waters—still and chilly / With the snows of the lolling lilly."[14] Poe's world of sublime extension and deathly quiescence is also the realm of Whistler's Nocturnes, Mallarmé's "Le Nénuphar blanc," and Monet's paintings of *Water Lilies* which we will be considering in the pages ahead.

A number of critics in 1889 noted the talismanic significance of *Vétheuil in the Fog*. For Marcel Fouquier it is a "fantastic apparition": "The effect was almost unseizable and M. Claude Monet has rendered it in the most seizing way."[15] For Charles Frémine the painting conjures up an image of "cathedrals run aground in the river's fog."[16] A nave is etymologically a ship before it is a church, and Vétheuil's floating and fogbound church, like Loti's ship, may loom as the vessel of death of Camille Monet, who was buried there. Before proliferating this motif at Vétheuil in 1879–80 (W. 507, 527, 531–34, 559, 590–91, 601–2), Monet had painted the cruciform prominence of waterside church towers at Honfleur in 1864 (W. 35), Paris and Sainte-Adresse in 1867 (W. 84, 90–92, 98), Zaandam in 1871 (W. 183), Argenteuil, Rouen, and Carrières-Saint-Denis in 1872 and 1873 (W. 197–98, 217, 229–31, 237, 268), Amsterdam and Argenteuil in 1874 (W. 308–9, 321–22), and Paris again in 1876 (W. 402–4). After the campaign at Vétheuil, Monet continued to favor the reflected or silhouetted forms of church towers at Dieppe and Varengeville in 1882 (W. 706–7, 725–28, 794–96), Port-Villez and Vernon in 1883 (W. 837, 842–44), Bor-

dighera and Jeufosse in 1884 (W. 852–54, 881, 911–13), Giverny, Benne-court, and Etretat in 1885 (W. 961, 986–87, 989–90, 1009–11), Giverny and Vernon in 1886 (W. 1058, 1060–61), and Antibes in 1888 (W. 1158–74). In 1892 two panoramic views of Rouen's Seine-side cathedral (W. 1314–15) preceded the close-up elaboration of the famous series of façades. Monet subsequently repeated two of his previous riverside and mist-shrouded ecclesiastical motifs at Vernon in 1894 (W. 1386–91) and Vétheuil in 1901 (W. 1635–49), before proceeding to elaborate his most extensive series of water-borne façades at London (1899–1905; W. 1521–1614) and Venice (1908–12; W. 1736–71). It may be merely my obstinacy to see the emblematic mirroring of Narcissus in these reflections of the forms of mast, tree, or church, but at least some of Monet's critics in 1889 see a similar imagery of contemplation and death in *Vétheuil in the Fog*.

For Joseph Gayda it is not Monet's ecclesiastical subject matter that is sublime but his material manner itself that "has in some fashion become sublimated." In the alchemical tradition sublimation represents the transformation of base elements into precious metals, and thus, "with a nothing, . . . a bit of town divined rather than perceived through the mists," Monet is seen as making "masterpieces of contemplation from which one tears oneself away only with regret, so profound, subtle, and rare is their charm."[17] For many critics in 1889 Monet's world of reflection and contemplation carries with it a message of release from the perceived materialism of the bourgeois world.

At the time of Monet's exhibition at Boussod and Valadon, Paris was preoccupied by politics. In a letter to Whistler from his retreat at Giverny, Monet makes a sardonic reference to "our M. Boulanger" (January 1889; L. 908), whose supporters were then threatening to bring down the increasingly conservative Third Republic in a Bonapartelike electoral landslide. Monet's friend Mirbeau was at this time the leading advocate of political anarchism in the mainstream press, and his attacks on the bankruptcy of electoral politics were even reprinted by Jean Grave, editor of the anarchist journal *La Révolte*.[18] Mirbeau's antimilitary and anticlerical novels *Le Calvaire* (1886) and *L'Abbé Jules* (1888) as well as his essays of social protest, such as "La Grève des électeurs," celebrate the same subversive individualism that is the central tenet in his interpretation of Monet.

In an essay entitled "Le Chemin de la Croix" Mirbeau castigates the collusion of art and politics. The cross in question is that of the Legion of Honor, and Mirbeau urges its refusal on the part of friends such as Monet. Art, like woman, he characteristically says, is "the dream of immaculate beauty," and he cringes at the thought that true artists—"the seekers of

lines, the shapers of forms, the tamers of life"—should be placed on the same level as pickle vendors and "the specialists whose names and recipes haunt the ammoniated and confident penumbra of street urinals."[19]

The topical reference in Mirbeau's article is to the scandalous sale of decorations by Daniel Wilson, son-in-law of President Jules Grévy. The coveted ribbon is no more than an "advertising gimmick between the automatic jaws of American dentists," and Mirbeau portrays the autonomous artist as the antithesis to the honor-grubbing manipulators of official favor: "The artist is a privileged being by way of the intellectual quality of his joys and by his sufferings themselves, whence he snatches the effort necessary for the birthing of his work. . . . Before the mystery that is the shudder of life, and which is impossible completely to embrace in order to fix it in a verse, upon a canvas, in marble; before that grace, that fantasy, that sensibility that renews itself without cease; before that palpitation that rises from the little flower and the humble blade of grass, the most triumphant of artists, even a Shakespeare, even a Velasquez, even a Rodin, feels quite small and quite powerless."[20] Monet is not named in this article of January 1888, which focuses on the sculptor Rodin, but one year later it is Monet who is made the incarnation of the incorruptible artist whose episodes of creative impotence are seen as the marks of the purity of his love.

Mirbeau begins his article on the Boussod and Valadon show with the statement that Monet's canvases are "incomparable." "No painter, at no time": this is Mirbeau's formula for the uniqueness of Monet's achievement. It is the alleged lack of historical derivation that makes such a powerful ideological antidote in Monet's art, "if moreover, in these times of imbecilic agitation it is still permitted to occupy oneself with something noble, in which muddy politics have nothing to do."[21]

For Mirbeau the precondition of Monet's art is his lack of master. Since 1864 Monet had repeatedly insisted upon his originality in spite of any resemblance to the works of others his paintings might seem to possess (see letter to Bazille, 14 October 1864; L. 11). The story of Monet's artistic independence had been in the literature at least since Taboureux's interview in 1880, but it was Mirbeau's task in 1889 to consolidate the legend of Monet's autonomy. Rather than describe the paintings, Mirbeau describes the independent self of the painter as the true work of art: "In painting everyone is the master or pupil of someone, according to whether one is old or young, and more or less decorated. . . . The master puts his self-esteem toward possessing the most pupils possible, the pupil toward copying the most faithfully possible the manner of the master, who had copied his master, who himself had copied his. And this goes, in this way, from

pupils to masters, back into the centuries most distant from us. This uninterrupted sequence of people copying one another across the ages, we call tradition. . . . With M. Claude Monet, we are far from tradition." His art is a threat to the status quo, and in his artistic autonomy Monet is Mirbeau's anarchist hero: "One of his great originalities is that he was the pupil of no one."[22]

Mirbeau is an informed reporter as well as a political agitator and accordingly must acknowledge the facts of Monet's early apprenticeship: "Very young, it is true, he entered the studio of *père* Gleyre, but, when he had understood and verified the strange cookery that one did there, he hastened to flee without having unfolded his portfolio or opened his box of colors. Then he had an idea of genius, but highly irreverent and by means of which, certainly, he deserves to have become the admirable painter he is: he copied no picture at the Louvre."[23] In quoting Mirbeau my purpose is less to find fault with his exaggerated historical narrative than to highlight his aim to make of Monet a symbol of the anarchic self.

The source of Monet's anarchic self is nature. Nature is virginal in Mirbeau's account, a vivifying contrast to "all those masters sadly peeling, in their tarnished frames, beneath the successive layers of varnish and dust with which they are afflicted." Monet is said to appreciate the merits of Giotto, Holbein, Velàzquez, Delacroix, Daumier, and Hokusai, but in their own spirit he repudiates their works in order to create his own: "He started out from the principle that the law of the world is movement; that art, like literature, like music, science, and philosophy, is continuously on the march toward new pursuits and new conquests; that the discoveries of tomorrow succeed the discoveries of yesterday, and that there are no definitive epochs as M. Renan believes or sacred men in whom the final effort of the human spirit is forever fixed."[24] Here Mirbeau breaks with Ernest Renan, the author of *Vie de Jésus* (1863), who is seen as still committed to the conventional humanism of a culture which Mirbeau can no longer endorse.

In contrast to the conservatism of Renan, Monet puts the past in its place and turns directly to nature: "He looked at nature, in whom the treasure of genius that the breath of man has not awakened still sleeps; he lived in her, dazzled by the inexhaustible magic of her changing forms, of her unexpected music, and he let his dream run, rove upon the gentle, the fairylike dream of light that envelops all living things and that animates all dead things with the charming life of colors. He wanted no other master than she."[25] Here the extended metaphor of amorous sleep-watching recalls the mythic encounter of Jupiter with the sleeping nymph Antiope. In terms

of its implications for an allegory of art, this tragic drama of vision and desire forms a violent counterpart to the autoerotic instance of Narcissus similarly suspended above his ideal.

Mirbeau abandons the quasi-mythological order of discourse of the sleep-watching metaphor in order to qualify his polemic. Monet turns out to be not quite as autonomous as initially advertised, at least in his youthful works, where the influences of Courbet, Manet, and Pissarro are to be discerned. But this susceptibility to the power of his precursors was merely a temporary state of affairs, "and he put all his energy, by means of an even more intimate and more abstract communication with nature, toward ridding himself of those few external souvenirs that prejudiced the complete development of his personality."[26]

Mirbeau's cult of personality is by no means unique in 1889. *Sous l'oeil des barbares* (1888) and *Un homme libre* (1889) were the first two installments in Maurice Barrès's widely read cycle of novels known collectively as *Le Culte du moi*.[27] Mirbeau's writings in these years similarly take up the theme of the need for the individual to achieve a sense of selfhood in opposition to the impersonality of social convention. For Mirbeau, Monet embodies the self-cult of the period: "Soon, by force of isolation, of self-concentration, by force of aesthetic forgetting of everything that was not the motif of the present hour, his eye became accustomed to the capricious fire, to the quiver of the subtlest lights; his hand became at the same time firm and supple with respect to the sometimes baffling unexpectedness of the aerial line; his palette became bright. . . . In a few years he managed to disencumber himself of conventions, of reminiscences, to have no more than a single set purpose, that of sincerity, no more than a single passion, that of life."[28]

Throughout his review Mirbeau insists on Monet's single-minded pursuit of his goal. Mirbeau knows of Monet's depressions at first-hand and repeatedly warns him of "the folly of the always perfect," but the public portrayal we are given is one in which Monet's "discouragements [are] quickly surmounted and immediately followed by relentless work." The result is an idealized image of self-sufficiency, and Monet is said to live "in the most beautiful, in the most unfailing artistic serenity in which an artist may take refuge."[29]

Monet's withdrawal into himself is seen to yield public dividends, for if Monet expresses the "unseizable" and the "inexpressible" he does not do so irrationally: "Everything is combined, everything accords with the atmospheric laws, with the regular and precise march of terrestrial or celestial phenomena. That is why he gives us a complete illusion of life."

The invocation of science may have been intended to answer Fénéon's critique of the improvisational nature of Monet's method, but Mirbeau quickly moves from the manifest meteorology of Monet's landscapes to a latent mythology that lurks in the text: "Life sings in the sonority of his distances, she blooms, perfumed, with her sprays of flowers, she glitters in hot sheets of sun, veils herself in the mysterious effacement of mist, grows sad upon the savage nudity of rocks modeled like the faces of old men." It is the external world of air, water, and light that Monet paints, but Monet paints this world under its "most suggestive" aspects. In a letter to the painter, Mirbeau explains that in his article he is attempting "to express all that your canvases suggest to me."[30]

Mirbeau's descriptions of Monet's paintings are therefore always interpretations. Once again the paintings of Belle-Ile and Antibes are formed into an antithetical allegorical pair. The paintings are said to be animated by the "breaths of marine breezes" which resonate either with "the howling orchestras of the open sea or the appeased song of the coves" (W. 1087, 1188). For Mirbeau it is less perceptual illusion than affectual experience that characterizes Monet's paintings of the sea: "Art disappears, is effaced, and . . . we find ourselves solely in the presence of living nature completely conquered and subdued by this miraculous painter."[31]

Jacques Lacan's account of the *dompte-regard* and the *trompe l'oeil* suggests that the regressive allure of the object of desire may be held at bay by the substitute satisfactions of the illusory image (of which the allegedly autonomous ego itself is the most perspicuous instance).[32] Something more than the disinterested connoisseurship of artistic form seems at stake in Mirbeau's ecstatic annulment of the boundaries of his own embodied self: "In front of his ferocious seas of Belle-Ile or his smiling seas of Antibes and Bordighera, often I have forgotten that they were made on a piece of canvas with paints, and it has seemed to me that I was lying down upon the shore and was following with a charmed eye the living dream that rises from the brilliant water and loses itself, across infinity, beyond the horizon line merged with the sky" (W. 1181).[33]

The counterparts of Monet's seductive seas are his alluring rivers and ponds. In them "shadows progressively invade the swards of green or surfaces of water that fall asleep in the purple glory of the evenings or wake up in the cool virginity of the mornings" (W. 1209; fig. 56).[34] Mirbeau envisions the world as the erotic realm of a Panlike Monet; here the gaze of the painter is the transmogrifying force that turns the world's natural phenomena into dramatis personae of his projective vision.

Monet's redemptive art can thus be said to be incarnated "in his very flesh." At once "madness" and "wisdom," Monet's Christlike stance is that of "an obstinate contemplator" who turns away from the intrigue of Paris for a life of pure mental acts. "The open air is his only studio," the hagiographer tells us; and we are left with the image of a wisely mad artist who, shunning the corrupt social world of his day, becomes an ethical exemplar in the single-mindedness of his absorption in nature. And "in the meantime, he is unaware that there is a Salon, Academies, that one decorates artists, and he pursues far from the coteries, the intrigues, the most beautiful and most considerable among the works of this time."[35]

Mirbeau published his article in *Le Figaro*—the longest on Monet to date—on 10 March 1889, and one week later its reverberations were registered in Monet's letters from the Creuse Valley where he had gone to paint. According to Theo van Gogh, Mirbeau's article was responsible for bringing many potential buyers into Monet's show (18 March 1889; L. 919), and furthermore served as the "point of departure" for other sympathetic reviews. Those are Monet's words, and their point of reference is to an article by Léon Roger-Milès in *L'Evénement*. Monet thought this article "très bien," but expresses anxiety that the new "sympathy that comes to me more and more from the press" would not be translated into commercial success (20 March 1889; L. 922). I will soon return to Monet's discourse from the Creuse, but here I want to stress the intertextual dimension of journalism in Paris at this time, as well as the artist's concern for the practical consequences of that powerful network of prose.

Like Mirbeau, Roger-Milès sets up an opposition between the "tumultuous sea-blows" of Belle-Ile and the "radiant sunshine with magic reflections" of Bordighera and Antibes. The critic retains the familiar oceanic idiom in writing of the viewer's self-abandonment to the illusion of being "rocked by the scintillating poetry that is released!" Roger-Milès also adds an important new formula of his own: "Claude Monet, in effect, is not content to look at things in the extension of the landscape, he looks at them in time; he sees them enliven the hours that slip away, and what he paints are not only corners of nature, but instants of nature, if I may express myself thus."[36]

Roger-Milès repeats many of the themes of Mirbeau's text, emphasizing in particular the courageous individualism of the painter. Monet is also celebrated as a nonconformist in an article in *La Revue Indépendante* by Frantz Jourdain. Like others before him, Jourdain too is "dazzled" by the independent personality of Monet's art and offers it as a counterfoil to

"those laborious and slimy termites who, for twenty years, work to clear a way for themselves by utilizing shadowy maneuvers, by accepting degrading procedures, slovenly promiscuities, dishonorable grovelings."[37]

In opposition to Jourdain's sycophantish artists of the bourgeoisie stands the autonomous hero, Claude Monet. Here we see the modernist fable of avant-garde originality in a prime moment of its constitution: "M. Claude Monet, he owes nothing to anybody and never has he begged anyone's support, and never has he executed gallant pirouettes in order to attract the customer." According to Jourdain, Monet "scarcely pays attention to what one thinks or to what one says about him." Such is his indifference to public acclaim that it is deemed a privilege simply to have the opportunity to behold the painter's works. For the hero of Jourdain's narrative the plot leads to a highly worthy conclusion: "And so, by way of a bizarre phenomenon, in spite of the killing laughter of yesteryear, the deliberate silences, the bitter attacks, the filthy insults, this isolate who pushed straight ahead of himself, brutally, without worrying about the mediocrities whom he crushed, today finds himself in one of the most enviable artistic situations of the times."[38]

The key to Monet's achievement would seem to be found in the single formula: "He lets himself follow his temperament and his hand knows how to execute docilely what his eye sees, what his brain desires." When Jourdain gets down to the business of critical description it turns out that Monet's independent vision yields both naturalistic transcription and poetic transmutation: "Nobody better than he renders the heavy and viscous opacity of the sea, whether—dormant beast—she slyly swings her blue waves along the length of the rocks of Antibes which disintegrate beneath the bites of the sun, or—furious, epileptic—she 'tresses,' Rollinat would say, with her soapy foam the reefs of Belle-Ile which seem to tremble beneath her barking rage" (W. 1087, 1181).[39]

In the next chapter I will compare the poems of Rollinat and the paintings of Monet, but for the moment I have not quite finished with Jourdain's review. The critic's evocation of the crisp silhouettes of the paintings of Antibes and Juan-les-Pins calls up by contrast "the exquisite indecision of a winter landscape on the banks of the Seine." This is a reference to *Vétheuil in the Fog,* "a marvel, that church of Vétheuil, softly shading off through the silvery veil of the fog." Jourdain praises Monet's powers of truthful representation, but Monet "is also a poet at once potent and tender, a lover of nature letting himself always be moved in front of the model that he has beneath his eyes and whose vibrating heart knows

nothing of tepidness and satiety." Whereas for Maupassant and Le Roux, Monet is a hunter waiting to pounce upon the landscape in the instant of its maximum vulnerability, here pictorial appropriation is imagined as an act of love whose violence is sublimated as the seizing of the other at a moment of "apotheotic" melancholy or splendor.[40] Waiting for this apotheosis Monet is poised like Narcissus at the pool.

The Creuse and Neurotic Obsession (1889)

FRANTZ JOURDAIN WAS a companion of Monet and Geffroy when together they visited Maurice Rollinat's remote Creuse Valley home in central France in February 1889. Monet returned to the Creuse for a protracted bout of work that stretched from March to May, and his correspondence provides a day-by-day record of the painter's struggle to still the course of time (W. 1218–40; figs. 57–58).

Monet's host in the Creuse was a disciple of Baudelaire and Poe whose volume *Les Névroses,* "that sorrowful and medical title," had briefly been the vogue of literary Paris in 1883. Geffroy devoted two articles to a review of Rollinat's poetry in 1883 and utilized a pictorial idiom in order to describe the effects of the verse: "The poet goes alongside the roads and streams bordered by cress, like a painter goes off to make his study, and notes upon returning home the impression he felt."[1]

For Geffroy, Rollinat's impressions are notable in their repetitions: "The eye ends up by seeing only certain spectacles, just as thoughts, attracted and hypnotized by the same obsession, end up by moving in a single sphere." In the case of "this nervous and sensitive artist" the mental sphere to which Rollinat always returns is "the obsessive idea of death." Even "by the banks of the pond, at the hour of sunset," Rollinat's poems take on the cadences of melancholy in the musical accompaniment which the poet composes, "a trembling music like water that flows." Geffroy's aquatic metaphor is well suited to Rollinat, who defines art as the "abyss where the heart's tenderness is engulfed." Rollinat calls this abyssal art the "Inaccessible," just as he names "Undiscoverable" the woman of his dream.[2]

The flowing water that Rollinat invokes, the melancholy water that

Monet paints, is the water of the confluence of the Petite and Grande Creuse near the town of Fresselines. At least since June 1888 Rollinat had been pressing Geffroy to pay him a visit and to bring along such literary and artistic friends as Louis Mullem, editor of *La Justice;* Frantz Jourdain, architect and writer; and Auguste Rodin, who in the final event did not come. Eager to meet Monet, "the master-painter whom I admire profoundly," Rollinat hopes that his isolation will be alleviated through contact with like-minded artists so as to "avoid as much as possible the face-to-face with my self, this so slyly funereal and nihilistic self of mine."[3]

The collective visit of February was brief, but Monet's enthusiasm for the landscape brought him back for a solo campaign in less than a month. "It was poorly grasped, poorly understood," he writes of his first day's work to Mme Hoschedé, and adds with a certain amount of practical wisdom that "it is always like that in the beginning." Most important, Rollinat—at whose home Monet took his meals but did not lodge—left him "free and alone" (9 March 1889; L. 914). The poet's "respect" for Monet's artistic solitude left the painter free to develop a series of river motifs according to the variable conditions of "the morning and afternoon, sun and gray weather." Under these conditions of liberty Monet enjoyed the nightly discussions of art and recitals of music and verse in Rollinat's home; all the painter additionally required was "to be sufficiently favored by the weather" (11 March 1889; L. 915).

Monet thus found himself in the frigid remoteness of the Creuse, boarding with a melancholy poet, elaborating a series of landscapes, and negotiating with an exigent Georges Petit and an "impenetrable" Rodin, whose sculptures were to share the gallery with the painter's works in a major retrospective exhibition planned for the summer months (15 March 1889; L. 917). Domestic and emotional crises also continued to press in on Monet in the form of near-daily letters from Giverny. Nevertheless, within ten days of his arrival he boasts of having fourteen canvases under way: "It is going along, but very slowly and with lots of trouble; the further I go the more it is thus, [and] I was thinking to do this countryside at the first go? Ah! Well yes, it is incredibly difficult" (18 March 1889; L. 919). Monet's self-inflicted dilemma also affects the members of his family, in this case his son Michel, whose birthday Monet forgets and whose disappointment is to be made good by Mme Hoschedé (19 March 1889; L. 920). A tone of irritation is rarely absent from Monet's correspondence, and thus news of good weather at Giverny elicits a recitation of his own meteorological woes: "Here, far from being gentle and fine, it is a dog's weather, rain, wind, sun: thus, for the last two days, I have been giving myself a lot of

trouble, working all the same, but poorly, and up to the present I am
scarcely content with myself. It is not coming at all and then like always
it is poorly grasped, poorly understood; the countryside is certainly difficult
to get and one cannot manage it at the first go and in such haste" (20
March 1889; L. 922). The tersely rhymed phrase "mal pris, mal choisi" is
repeated from a letter of eleven days earlier like some cherished motto of
self-abuse, and we also find Monet remarking that he will be able to do
better at nearby Crozant. Like the unvisited Breton coast of the Belle-Ile
campaign and the once-glimpsed but never painted Agay of the Antibes
trip, Crozant will remain an elusive dream during Monet's stay in the
Creuse.

We first read of the Creuse River itself in the next letter to Mme
Hoschedé: "Alas, alas, the weather is worse and worse, a tempest of rain
and wind. I return home soaked, drenched, not having been able to hold
on; I am consternated, for it has now been three days like this, and today
it is two weeks since I arrived here. With the two days spent in Paris
[where he had gone to discuss his exhibition with Rodin and Petit], I have
only been able to work ten days; this is necessarily going to slow me
down and this damn rain will make everything green. And you have good
weather; it is astonishing. The Creuse is swelling up once more and again
becoming yellow, in short all the calamities; with that nothing from Petit.
Here is a day very hard to endure that casts a real pall over me." Although
Monet portrays himself as the victim of the rising waters of the Creuse,
he insists that Mme Hoschedé not become its victim too: "You were quite
wrong to worry yourself, so stop having these anxieties." Here the waters
of the Creuse spill over into the worries of the verb *se creuser*. It seems
that Mme Hoschedé was jealous on account of Monet's installation at
Fresselines, where the actress Cécile Pouettre presided over Rollinat's
home. There Monet claims to be "each day more charmed by Rollinat,"
finding in him the very type of the artistic personality: "What a veritable
artist: he is at times certainly the most discouraging there is, full of bitter-
ness and sadness precisely because he is an artist and therefore never content
and always unhappy" (21 March 1889; L. 923). Rollinat is the perfect
masochistic double of Monet's perpetually anxious artistic self.

The *tristesse* of Rollinat's personality is mirrored in the trying weather
and the tortuous landscape: "Desolation, here it is snowing this morning
with wind and glacial cold, what bad luck. Yesterday evening I was a bit
more content with myself. I had managed to put two studies into shape
and this in spite of the rain or perhaps because of it, because the two
canvases were of a sinister aspect that I was not able to do as I liked."

What Monet craves is "a regular weather that will permit me to work more surely and more rapidly," yet he also recognizes that in view of a particular effect, bad weather may actually be more conducive than good. Snow is more than he bargains for and he takes its arrival as a personal affront: "There remains enough to bother me and not enough to tempt me to do it." Monet is prepared to turn disadvantage to his favor and so he concludes that "if [the snow] persists after lunch, I will attempt something." In spite of such desperation or because of it, "what a continual struggle" (22 March 1889; L. 924).

Monet calls his Creuse landscapes sinister, the introductory epithet in Rollinat's volume of poems, L'Abîme (1886). In the first poem Rollinat evokes a sinister landscape of the human face ("Le Facies humain"): "Our soul, this cloaca unknown by the sounding probe, / Suspiciously shows through in the human face; / —Like a sinister pond alongside an old road / Dissembles its mud in the mirror of its surface."[4] In Les Névroses (1883) the watery mirrors of rivers and ponds are held up by the poet the better to see his own anguish. In "Les Rocs," dedicated to Victor Hugo, the river's massive blocks of stone stand in for the poet-painter who bends above the rising waters: "The river that howls and froths at their base / Becomes for them a mirror torrential and mad, / And when the winter makes her overflow her banks, / She whips them with foam and slaps them with mud."[5] The sadomasochism of this drama casts the rocks as passive male figures whose bodies are dissolved in the caustic waters of the feminine river.

Elsewhere in Les Névroses the river is more calm if no less deadly. "La Rivière dormante" is dedicated to the landscape painter Cazin, a colleague of Monet at Georges Petit's: "Her moss, which resembles the great kelps of the seas / Tenderly sponges the tears of her willows, / And her tall hazel trees, supple as poles, / Bend over to see her with the bitter box trees."[6] In a later poem of the 1890s Rollinat will explicitly compare the tearful waterside willow to Narcissus, but for now the myth provides the self-reflective posture the artist adopts while bending over the mirrored surface of the river, the canvas, the page.

This introverted posture is the perspective from which the artist inspects his bodily image. In 1882 the critic Léon Bloy had pejoratively written that Rollinat "is of those who go off adrift from all the currents of life and who darken all its waters by letting their image fall upon them; tenebrous Narcissuses of hell, madly smitten with their own deformity."[7] In contrast to this sense of narcissism as autoerotic perversion, Geffroy will later situate the poet among those for whom "nature will always be the

mirror where this man will go to seek the vision of a rapid image, the source where he will go to beguile his thirst to know."[8]

The aspect of Narcissus under which Monet toils is the aspect of obsession, madness, death. "I worked like a madman," he writes; and yet the work is of little avail, "for up to the present I am only very slightly satisfied, I say in vain that it is always thus, that upon return home I will find it better; I would finally like to arrive at finding it so on the spot." The conditional tense is the sign of Monet's deferral of his desire to possess what he knows he can never have. He understands this all too well, for "it grows and it changes" (25 March 1889; L. 926). Even were nature to stay the same, Monet's desire would still change and grow.

When the weather is bad, Monet wants it to be good; when the weather is good, that too can be horrid: "I continue to work like a madman but with more and more trouble, and if the sun were to persist all my somber and sinister canvases would be done for" (28 March 1889; L. 930). Monet writes this record of mad persistence on a day when death is on his mind. Appealing to "the void" in his life left by the death of Camille, Monet sends condolences to Boudin, whose wife had just died and whose art and fellowship had long since been dead to Monet: "I have many reproaches to make of myself in your regard. I make them often. Do not maintain any rancor toward me, my dear friend. I am always in the fields, often on a trip and always in transit in Paris. But do not be on that account any less certain of the friendship I bear you, as of my gratitude for the first counsel that you gave me, counsel that made me what I am" (28 March 1889; L. 931).

In contrast to this acknowledgment of dependence, Monet usually represents himself as an artist quite alone. The weather is "ignoble, rain, wind, cold; it is really meager luck," yet Monet works on, "but with such trouble, I alone know." Monet's anxiety is reflected in Rollinat: "He is anxious to know what of his was published" (3 April 1889; L. 935). On the day that he writes this letter home to Giverny, Monet repeats to Rodin the familiar litany from the Creuse, but he adds the seductive promise of self-recognition to his self-lacerating lament: "I continue to work a lot in spite of the most appalling weather and begin to recognize myself a bit in what I do" (3 April 1889; L. 936). Monet's redemption turns out to be a matter of iconographical repetition, and the self that the painter claims again to recognize is portrayed in the nihilistic rhetoric of Belle-Ile:

Alas, the weather is becoming more and more terrible, and this morning there is so much rain and wind that it was not possible for me to hold

on. Moreover I am obliged to take certain precautions, since as a result of the dampness and my feet in the mud I caught a sore throat that bothers me, so I would be very glad for you to send me a remedy for it without delay. Do not think me sick; it is nothing and it does not prevent me from working. Thus with this damn weather too sinister moreover by a lot, one advances slowly and in looking at my canvases I am terrified to see them so somber; along with that, some of them are without any sky. It will be a lugubrious series. Of course I have a few in the sun, but it has been so long since they were begun that I am very afraid that the day when there will finally be some sun I will find my effects very transformed. From another side, this terrible rain at this moment will make the Creuse rise and considerably change her in color. In sum I live in a continual trance, and it will be necessary to consider me very happy if I can bring to a successful outcome a quarter of the canvases I have begun, since I have absolutely renounced Crozant in spite of all my regrets; it will be for another time. (4 April 1889; L. 937)

I cite this letter at length because its burden of ambivalence, obsession, elation, and despair is constantly reshouldered by Monet as he sits down to write his nightly missives to Mme Hoschedé. In their forms of address, their clipped or dragged-out syntax, their compulsive confessions, their obsessive repetitions, Monet's letters reweave that dense tissue of personal utterance that since Freud we have come to attend to with an allusive eye and ear. Physical martyrdom and hypochondria; imprecations at the sinister weather and invocations of its lugubrious beauty; the persistent pursuit of an ever-elusive goal; a desire for permanence and a fear of transformation; the accepted tortures of the present and the renounced joys of a beneficent future: all these dichotomies bear the conflictual traces of Monet's efforts to hold intact an ideal of the self that he can never more than fleetingly glimpse.

The narcissistic model of artistic personality is displayed for Monet in the melancholic introversion of Rollinat and in Albrecht Dürer's famous *Melencolia I* (1514), which the poet kept above his bed. Monet also refers to Rollinat's inspirational character. "What an extraordinary artist!" he writes to Mme Hoschedé (5 April 1889; L. 938)—and he requests photographs of Belle-Ile and of himself to present to Rollinat. As his identification with Rollinat mounts, so do the waters of the Creuse, and the level of Monet's self-confidence correspondingly drops: "I am desperate this morning; it is still raining in buckets; there is no will or courage that can

stand up to it. What to do? Everything is changing in front of my eyes; the waters rise. I am terribly afraid not to be able to pull myself out of this and am of such humor and quite ready to be altogether discouraged. Never have I had such a persistence of bad weather. Yesterday I was able to work a bit in spite of everything, but in the face of this driving rain I am in despair" (6 April 1889; L. 939).

Monet's image of himself is heroic when it is not despondent. As at Belle-Ile, Monet casts himself in the death-defying mold of the artist in the grip of the storm: "Still this horrible weather, but I am here and it is necessary for me to find a way out, so I work all the same between two downpours and even in the rain, and without boasting I have to have a fine courage. My hand is so chapped, so cracked by the rain and the cold that I have had to take steps to smear a glove with glycerine and I wear it day and night" (7 April 1889; L. 940).

Monet endures the travails of his art in the mode of the future conditional. "Would that it were different" is his constant refrain, a refrain whose cadences variously refer to the weather, his health, his love, and his art: "I would like somber weather, but not to this point; what bothers me a lot is that everything being wet becomes more somber still and I do not dare to transform all my canvases because, the rain finally coming to an end, I would have to put them back as they had been." Monet always claims that he would prefer not to distress Mme Hoschedé with the recitation of his woes, but under the painful conditions of this "useless trip" he finds that he has no choice but to unburden himself to her: "I have no one who can revive me in these moments; Rollinat never comes near me while I am painting and only wants to see my canvases when I will have finished; moreover I think that he is a bit closed to painting, in which he only sees and likes fantastic and strange things." Rollinat is not the perfect mirror for Monet after all, but the poet is a most certain Echo, "and both of us in chorus lament the difficulties of our art." In this connection Monet urges Mme Hoschedé to read *Les Névroses* (8 April 1889; L. 942).

Writing to Berthe Morisot, Monet waxes dramatic and despairing in his habitual way: "As you see, here I still am in a lost land and at grips with the difficulties of a new countryside. It is superb here, of a terrible savagery that reminds me of Belle-Ile. I came here on an excursion with friends and I was so amazed that here I am back again for the last month. I thought that I was going to do astounding things, but alas, the further I go, the more difficulty I have in rendering what I would like" (8 April 1889; L. 943). Back in 1864 Monet had written to Bazille of his ambitious

projects for "astounding things." What remains constant over these twenty-five years is the gesture of desire and deferral that characterizes Monet's search for the image of his dream.

A current diagnosis of Monet's oscillating moods might well be some form, relatively benign, of manic-depressive illness in which the narcissistic personality traits are especially pronounced.[9] Rather than attempt a dubious diagnostic assessment of Monet's character, I prefer to remain close to the surface of his discourse and merely to signal the possibility of a correlation between rhetorical trope and psychological style. Most important is the impact Monet's self-characterization might have upon our redescription of his art: "As for work, alas, one day I am full of hope and ardor, and the next I am completely flattened out, and it is that way today. . . . I am in an atrocious state of enervation and anxiety; it is already so difficult when one has the weather one wishes for." The weather Monet wishes for today never completely accords with the effect already embedded in the painting begun yesterday, and as the tomorrows roll by and with them the seasons, the ever-mobile effect proves to be irrecoverable. "Yesterday I thought that I was saved; it was beautifully sunny" (12 April 1889; L. 947): but the sun goes down, the rain returns, and Monet's quest for the salvation of good weather results only in the repetition of the language of loss.

Monet was aware of the desperate nature of his complaints. As he writes to Mme Hoschedé, "it is useless to be forever repeating the same lamentation" (13 April 1889; L. 950). Yet repeat it he does; and his mistress is likewise unrelenting in the repetition of her need for him to return: "I would like to be able to announce my return. I see that you are impatient but what do you want? I am giving myself trouble enough and I must not botch things through too much haste which precisely need all my care in order to be approximately well done and finished. . . . Imagine that upon these final days depends the fate of many canvases. I repeat this to you that you might be reasonable and patient. I too, I am longing to return" (16 April 1889; L. 953).

In spite of his longing for home he lingers for a further month of work, and Monet finds himself "in a complete state of discouragement ready to chuck [*foutre*] everything into the river; I did not want to write to you since I am so desolate; then I decided that you would buck me up and it is a consolation to speak one's pain." Monet's narcissistic suspension above the unpaintable waters of the Creuse constantly requires a shoring up on the part of his attendant nymph, whose role it is silently to endure his repeated laments: "In brief, very bad day yesterday, and this morning still worse; a canvas that could have been very good is completely lost and

I am very afraid for others. Moreover the weather is deadly, a terribly cold wind that I would scarcely care about if I had my effect at least, but it is clouds and sun without discontinuing, which for me is the worst of things, especially for finishing; but what distresses me even more is that, as a result of this dryness, the Creuse is dropping in front of my eyes, that in dropping she changes so much in color that she transforms everything around. In brief, in places where the water flowed in green torrents one sees the bottom all brown. I am desperate, I do not know what to do, because this dry weather is going to last. Not one canvas is possible in its current state. I was counting on these final days to save a good number of them; to abandon them is to lose all my efforts, and to fight on frightens me because I am all in and impatient to come back" (17 April 1889; L. 954).

A few days later Monet gives a definitive name to his enterprise: "I am attempting the impossible." The rhetoric here is both ridiculous and sublime, at once the bold trope of an epistemological project to know the instantaneous truth of a changing world and at the same time a tired conjugal excuse to stay away from home. Between the Creuse River and Mme Hoschedé it is nature who is the more exigent mistress: "What efforts I will have yet to do here, but how I long to come back and be near you. I do not want to jump ahead of myself and fix a date, because more than ever I am here, completely at the mercy of the weather and the success of my work" (21 April 1889; L. 959).

"Toujours des hauts and des bas": this is the laconic formula with which Monet characterizes his interaction with the paintable world (22 April 1889; L. 960). The inflation of his image as courageous battler against all odds is annulled in a hypochondriacal portrayal of himself as sick and old, "tired, dazed, still" (23 April 1889; L. 961). The oscillation of his affect finds its mirror in the changing effects of the landscape: "Everything having changed, it was necessary for me to make transformations, even these last days, because everything is growing terribly." Renunciation of his enterprise looms as a possible fate, and the "severity of the Creuse" comes to be opposed to the salvation envisioned in the "charm of Giverny." But Monet is not yet ready to write off the series: "May the heavens see that from now until then [his projected departure date one week hence] I am finally a little favored by the weather" (24 April 1889; L. 962).

On the day he writes this letter to Giverny he writes another to Geffroy. Monet's idealized twinning with Geffroy is rather different from his masochistic identification with the melancholic Rollinat or the long-suffering Alice, but the burden of his self-disclosure remains much the same: "Dear friend, I am heart-broken, almost discouraged and fatigued

to the point of being somewhat sick. I arrive at nothing good, and despite your confidence, I am very fearful that all these efforts will come to naught! Never have I had such bad luck with the weather! Never three favorable days in a row, such that I have been obliged to make continual transformations, because everything is growing and getting green. I who dreamed to paint the Creuse as we had seen her! In brief, by force of transformations I am following nature without being able to seize her; and then this river that falls, rises again, one day green, then yellow, now dry, and which tomorrow will be a torrent after the terrible rain that is falling at the moment! Finally, I am in a state of great anxiety. Write to me; I have great need of comforting and you understand that it is not Rollinat who will buck me up! When I tell him my anxieties, he can only go still higher, and then, if he knows the difficulties of his art, he does not realize the trouble I have to give myself in order to do what I do. In painting he only sees the strange side" (24 April 1889; L. 963). In letters such as this, psychosomatic illness, depression, and anxiety are the symptomatic markers of Monet's narcissistic wound. He laments that he cannot enjoy the world on his own terms, terms which he claims to share with his faithful companion and champion Geffroy.[10]

As the waters of the Creuse rise and fall, Monet's account shifts from eulogy to dirge. Caught up in the variously meteorological, pictorial, textual, and psychological rhythms of his "transformations," Monet begins to comprehend this unending drama of difference and deferral. A note of humor intermittently intervenes and Monet manages to glimpse the folly of his practice: "and then the Creuse has gotten so swollen and yellow, it is a happy thing that she pulls back and clears up as quickly as she rises." "You know how I am," Monet writes to Mme Hoschedé; and though here he refers to the tenacity of his will, we are entitled to see in this appeal to personality an acknowledgment, I think, of a fundamental instability in the processes of his art. Stability arrives from the outside by post, from Geffroy if not from Rollinat, from Mme Hoschedé on one day if not on another: "From all sides I receive letters; they tell me they are sure of the marvels that I will bring back." But support such as this is scarcely enough: "Alas, I hope it is not a deception" (26 April 1889; L. 964).

By this time in the campaign "two canvases are as though finished, but I am so anxious for the others" (27 April 1889; L. 965). Bad weather returns and with it his "rage," and this on the heels of the "joy" that a brief bout of sun had brought in its wake. But now the Creuse is "all yellow and muddy [*trouble*]," trouble being here a further marker, perhaps, of the convergence of mud and mood. Salvation is the prize and physical

suffering is the risk: "Two gray days and three or four of fine sun. I would be saved, what I would not do for that. . . . I would prefer to suffer more and have the weather I need." Beyond the pictorial pain of the weather and the physical pain in his kidneys Monet has to deal with Mme Hoschedé's pain of separation as well: "You always give me pain in doubting me and by asking if I am really yours. But yes and yet I may not ever be near a woman without you getting these ideas, you who will never know me. My only care, my life, is Art and you" (28 April 1889; L. 966). In the face of the unrelenting jealousy of Mme Hoschedé, Monet prefers the joys of his capitalized mistress Art. By a curious slip of the pen Monet defers the date of this letter from the current month of April into the future month of May.

Monet's lament continues even though he knows that this causes Mme Hoschedé pain and even though "this does not change the weather." Given the Creuse's unstable weather of cloudbursts and sunshine, Monet's "rages" smack of irrational obstinacy. Home intervenes not only in the wishful form of fine weather but also in the guilty form of familial obligations left undone: "I am in such a daze that I do not think of others and forgot Suzanne's birthday; let her pardon me." His mistress's daughter thus dealt with, the self-absorbed artist "replunge[s] into the examination of my canvases, that is to say, into the continuation of my tortures." Here Monet pauses to reflect: "Ah well! If Flaubert had been a painter, what would he have written, good God!" (30 April 1889; L. 968).

In the chapter on Belle-Ile we observed Flaubert precariously poised in the face of the annihilating indifference of the world. As a result of his effort to fashion an illusion of permanent presence out of the shifting strands of representational language, Flaubert wrote with painstaking care. Likewise Monet, who painted and repainted in identification with the writer and in despair for the possibility of representing in art that which seemed elusively present to him in the Creuse.

A fantasy of madness and death persists in Monet's letters from the Creuse. "It has been two months that I have been buried in this land," he writes to Durand-Ruel (1 May 1889; L. 969); and to Mme Hoschedé he whines (his word), "it is disgusting, heartbreaking, maddening." Salvation is impossible as long as the rain continues and Monet frets and blusters at "that devilish Creuse" in the knowledge that the weather is fine at Giverny: "It has not stopped to rain in buckets; it is appalling and I cannot believe that you have passable weather. It would console me to think that the weather is not miserable only for me." Monet's egocentric thinking does not remain oblivious to reality and in the end he acknowledges that "it is

madness to persist." He does persist, but "I only persist in order to have neither reproaches nor regrets" (1 May 1889; L. 970).

With the return of "superb weather" Monet seeks to take advantage of the "yellow Creuse." This coloration permits him to resume work upon several canvases, and he looks forward to the "green" river of the morrow in order to "catch up" with still other unfinished paintings. Even though the weather is once again fine the motif is no longer as it was: "What changes, and the sun reflecting itself in the water in sparkles of diamonds. I almost gave it up because it is blinding, but it was heartbreaking to abandon an entire series, and, my word!, I made myself up to it and if I have three or four days like this I will be saved." Salvation comes from the weather and also from the press; in translations of articles from London sent by Theo van Gogh, Monet learns that he is currently considered the *"true hero of art"* (his emphasis), and his perennial fear of not being appreciated is for the instant held in check (3 May 1889; L. 971).

But only for an instant: "It is written that all the efforts I make will be in vain. The weather has again become horrible: the storm lasted the entire night, torrential rain, and this morning everything, everything is green; the Creuse has run over and is like mud. I must resign myself to lose all this; do not think that once returned I will find my canvases good; that is not possible." The wintry trees are now green with leaves, his initial motifs are gone, so he settles for "a large sketch of my poor oak with the yellow Creuse; through it you will realize the rage and difficulties that I had" (6 May 1889; L. 974). Of the twenty-four catalogued paintings from the Creuse, four feature Monet's "poor oak" (W. 1229–32), a Narcissus-like tree standing alone at the water's edge and writhing its limbs in response to the "sparkles of diamonds" that cast back fragments of its water-borne image. Most of the paintings of the Creuse series are on no. 25 and 30 canvases (65 × 81, 65 × 92, 73 × 92 cm). Unique among them is Monet's "large sketch of my poor oak," painted on a no. 40 canvas, 81 × 100 cm (W. 1229; fig. 59). Once utilized for the reflective expanse of *The River* in 1868 (W. 110), and again for the paintings of Etretat's massive rocks in 1873 and 1883 (W. 258, 821), this enlarged format will return in the *Water Lilies* of 1899 and beyond (W. 1517, 1657).

The vicissitudes of narcissism are not done. "My old oak" gradually succumbs to life as the green of spring begins to transform its wintry skeleton into full foliate form. In order to preserve the image of the naked oak, Monet seeks to pay its owner to strip bare its leaves. Monet doubts the good will of this "little likable rich man," but "there alone lies salvation for these canvases" (8 May 1889; L. 975). In this anecdote we observe the

obsessive lengths to which the painter will go in pursuit of a once-glimpsed and now lost vision; and we see as well Monet's morbidly feared dependence upon the moneyed interests that both thwart and sustain him throughout his career.

It sometimes takes little to make Monet happy: "I am in a state of joy: the unhoped-for permission to remove the leaves of my handsome oak has been graciously granted! It was a big business to bring large enough ladders into the ravine. Finally it has been done; two men have been occupied with it since yesterday. Is it not the limit to finish a winter landscape at this season?" (9 May 1889; L. 976) By now it is time to go home, and so Monet recommences a number of unfinished paintings: "Yesterday I was able to work on eleven canvases, something which never happened to me. Arisen at four-thirty I came back at eight in the evening, but it was a rare day, alas, never followed by a second; bad luck pursues me up to the end. Never an apparently fine day without a storm; what tenacity I need to persist. When I think of Giverny where I would so much like to be, which must be so beautiful, I am afraid of what I have done, it seems terrible and frightful to me. In sum it is high time to see all this far from here" (12 May 1889; L. 977).

Monet's hopes for the reviewing of his canvases at Giverny are coupled with expressions of chagrin at Mme Hoschedé: "How can you be so demanding and spiteful, you who know in what a state I am, you who know how greatly I suffer in not being able to do what I want, suffering from the weather, fatigue, and anxiety, and especially to feel myself so distant at such a time; it is not nice, and on the eve of my return" (14 May 1889; L. 979). Monet disowns responsibility for the depression of his mistress, blaming the mail rather than himself for any delays in their correspondence. He insists that it is her obligation to censor her feelings during this uncertain period in his work: "You should have spared me this little quarrel [about money it seems], I am so irritable at this moment, you should have thought of it. . . . And do not blame me for my persistence in delaying this so greatly desired return, it will not be delayed without end" (15 May 1889; L. 980).

Soon after Monet's return Rollinat writes to the painter to thank him for a present of apples and to declare that his departure has left "a void in our solitude": "Do not seek to speak ill of yourself: at the same time that you represent the absolute type of the sincere artist, you are the best man that we have known, always endowed, even when you are at your saddest or most preoccupied, with an ultrasympathetic word, a good smile, and a good look." A gift of plums occasions a subsequent letter from

Rollinat in which the special character of Monet's "look" is again subject for comment: "I often evoke the memory of your homecoming in the evenings, when in front of the warm but smoky fireplace we fraternally exchanged more looks than words, numbed as we were by the melancholy of the temperature and the perforating obsession of the subject sketched out." It is this obsession that makes Rollinat see the teeming spring hillsides of the Creuse as "immense inclined cemetaries whose crosses would have been hidden by the profusion of everlasting flowers."[11] And it is this same association-laden landscape that predominates in the fourteen paintings from the Creuse which Monet included among the one hundred forty-five canvases that went on view in June at the galleries of Georges Petit.

The exhibition canvassed the twenty-five years of Monet's career with a degree of comprehensiveness that surpassed even the posthumous retrospectives of the works of Courbet and Manet in 1882 and 1884. Among the paintings included were five seascapes of the 1860s (W. 39, 72, 77, 92, 94); two views of the Seine at Bennecourt and Bougival painted in 1868 and 1869 (W. 110, 135); five water paintings from Trouville, London, and Zaandam from 1870 and 1871 (W. 154, 166, 172, 177); the infamous *Impression* and two other scenes of the port at Le Havre painted in 1873 and 1874 (W. 263, 296); and some eighteen pictures of the banks of the Seine at Argenteuil, Courbevoie, and Vétheuil from 1872 to 1881 (W. 200, 311, 336, 368 or 369, 373, 455, 518, 528, 559, 567, 568, 574, 576). Included here was the notorious *Vétheuil in the Fog,* as well as the major and minor versions of two compositions of ice floes and reflections that Monet had unsuccessfully prepared for the Salon of 1880. Representing an enduring aspect of Monet's enterprise, this selection of water paintings from the past announces the strategies and formats of the water series of the coming decades.

All Monet's maritime campaigns of the 1880s were well represented in 1889. The group of nine paintings from 1882 of the coast of Pourville-Varengeville (W. 727, 730, 732, 741, 751, 759, 768, 769, 797) recalls in its preoccupation with cliff-sea silhouettes and plunging angles of vision a precocious Sainte-Adresse canvas of 1867 (W. 94). This telescoped format persists in three pictures from 1884 of the towers of Bordighera set against the sea (W. 853, 864, 867). The arching rocks of Etretat were featured in six paintings from 1885 and 1886 (W. 1032, 1044), one of which was the rain scene commemorated by Maupassant and Le Roux. Belle-Ile's piercing rocks were represented upon twelve canvases from 1886 (W. 1084, 1089, 1091, 1093, 1096 or 1097, 1102, 1107, 1109, 1114, 1117); and the placid waters and lithe trees of Antibes and Juan-les-Pins painted in 1888 reap-

peared seventeen times in the exhibition of 1889 (W. 1164, 1167 or 1168 or 1169, 1170, 1172, 1173, 1174, 1176, 1177, 1179, 1181, 1186, 1187, 1190, 1191, 1192 or 1193).

According to a visitor to the exhibition, Monet's recent paintings from the Creuse were hung together as a separate group (W. 1219, 1220, 1221, 1222 or 1223, 1224, 1226, 1229, 1230, 1233, 1234, 1235, 1237 or 1238, 1239 or 1240). These canvases were more readily available to the artist and his dealer than paintings from earlier epochs, but it is nonetheless a striking fact that the Creuse grouping is already marked by the strategies of repetition that would be systematically exploited in the series exhibitions from 1891 to 1912. Paintings of reflections upon the waters of Giverny included a view of Vernon from 1883 (W. 837), an unidentified scene of the banks of the Epte from 1886, a further pair of views of the Epte from 1888 (W. 1210), and a painting about which I will have more to say in the next chapter, *In the Norwegian Canoe* from 1887 (W. 1151).

For the preface to the catalogue Mirbeau contributed an expanded version of his *Figaro* article of the preceding March. In it he refers to the new works from the Creuse as "tragic landscapes, veiled with a so poignant and almost biblical mystery," and also introduces a considerable amount of descriptive material not found in the earlier article. The first of these passages evokes the riverscapes of Argenteuil, where Monet's boats "glide softly upon the lapping and sparkling water that propels along, with the fragmented gold of the sun, the skipping and magic gaiety of the changing reflection that passes away." In Monet's early marines from the Normandy coast Mirbeau finds a "sea surprised in her most mysterious rhythms, fixed in her most distant atmosphere with her solitudes lulled by the eternal lamentation of the waves, with the teeming of her boats, her beaches of sand, her cliffs, her rocks; the sea, upon which he seems to have placed one of the great passions of his life and through which, as a magnificent poet, he physically translated the poignant sensation of the infinite." After the sea Mirbeau turns to the depiction of flowers and women, all three of them seen as screens for the projection of Monet's dream of "fairytale birds, gods, and metamorphoses."[12]

The artist's Ovidian dream, "with its hot breath of love and its spasms of joy," is understood by Mirbeau as "the rage of possession": "One feels rumbling in him the impatience of fecundity, moving in him the ferocious and masculine desire to embrace everything, to grasp everything, to submit everything to the domination of his genius." Mirbeau enumerates Monet's cultivated fields and flowering trees, his steaming engines and teeming streets, but he brackets all these terrestrial motifs between Monet's rivers

and seas. The effects of snow, frost, fog, mist, and ice upon the Seine are described as purplish chill, diamond iridescence, pallid decoloration, and tragic melancholy. Mirbeau's description of Monet's aquatic world ends with a reference to a project never carried out—"his seas, of which he will soon celebrate the grandiose epic with an eloquence never achieved, in any art, by any artist"—unless it be in the reprised series in 1896 and 1897 of the Pourville and Varengeville motifs of 1882.[13]

The greatest distortion in Mirbeau's account is the insistence on Monet's utter lack "of the contemporary malady so conducive to failing, so fatal to production: anxiety."[14] In his personal correspondence with the painter, Mirbeau often recounts the agonies of his own creative process and admonishes Monet not to be depressed and not to martyr himself "in wishing for the impossible."[15] All such traces of despair are expunged from the public text in the name of the self-assured hero. Monet's career is invoked as an exemplum of moral virtue as Mirbeau follows the artist "along the shaded banks of the Epte, upon the rocks at Etretat and the gray sea that bathes them, as upon the savage cliffs of Belle-Ile and the black water that howls at their feet." Whether it is the "calm green seas of Antibes" or the "gorges of Fresselines" it is always one thing alone that guides Monet's steps: "the *characterization* of a terrain, a corner of the sea, a rock, a tree, a flower, a figure in their special light, in their instantaneity, that is to say in the very instant when vision poses itself upon them and embraces them, harmoniously."[16] In the instant of the posing of the artist's vision the world is made one with his flesh through the hallucinatory power of the gaze.

Within a week of the opening, reviews began to appear in the daily press. Writing in *Le Siècle* Fernand Bourgeat deploys a string of corporeal metaphors to capture the allegedly unique personality of Monet's "material practice": "This rough flickering, these small colliding blows of the brush, this sort of brutal mosaic seems atrocious. . . . The more one looks, the more one becomes accustomed to this dizzying fashion of disseminating light."[17] The Dionysian energy of dissemination elsewhere tinges the discourse of 1889, whether in the "liquid waves" or "savage swells" of Charles Frémine or in the "exquisite and penetrating perfume of nature" of the anonymous critic of *Le Matin*.[18] In yet another article Mirbeau continues to exploit this idiom in his designation of the power of Monet's art over its beholders. The artistic genius of Monet (and Rodin) is said to project upon the public "something that subdues and violates its mental inertia and fills it with respect."[19]

Mirbeau's masculine bravado engenders aversion in many critics:

"Modernistic criticism has beneath its pen exaggerations of expression and admiration that it takes perhaps for independence; let us leave them aside here." The author of this remark, Auguste Dalligny, concedes the "friendly exaltation" of Mirbeau's critical writing but rejects the claims made on behalf of Monet's paintings: "Let no one ask me to proclaim them the only landscapes of our time, and especially let no one further seek to demolish my anterior admirations on their account." In spite of the disagreeable stimulus of the optic nerve which Dalligny claims to experience in front of the paintings, he offers a pertinent definition of the artist's recent enterprise in the Creuse: "He pursues at fixed times for months on end the impression that one day he glimpsed and that moved him once. . . . His manner of execution permits him to carry on ten to twelve canvases at a time by devoting to each one in turn only the time necessary to seize the fugitive impression."[20]

In an article entitled "L'Art contre nature," Alphonse de Calonne labels Monet's pictures deviant, savage, and infantile. Color blindness may have been a precipitating cause according to the critic, but now a "moral ill" is to be feared. Calonne rejects the notion that Monet's paintings correspond to verifiable states of nature, insisting instead that the paintings are "imaginary landscapes like the Ossianic or Scandinavian mind might give birth to, a nature out of Hindu visions or still more from the maladroit hands of the Red Indians." The arrogant ethnocentrism of this writer paradoxically permits him to confirm something of the mythic consciousness that other critics see as informing Monet's art: "After having confected an implausible nature, water and trees that never existed, it could happen that the painter would show us all things upside-down and that he would insist on thus showing them with an unalterable conscience. The fixed idea touches closely upon madness."[21] Pierre Janet's papers on the dynamic relationship of fixed ideas, subconscious impulses, and mental illness were beginning to be widely known in Paris around 1889, and though I have no wish to draw de Calonne's remarks on Monet's *ideé fixe* into the confines of contemporary psychiatric theory, I do want to stress the overlapping edges of the discourses on painting and personality.[22]

References to Monet's artistic personality are registered across the critical spectrum in 1889. "L'oeuvre si personnelle" is the anonymous formula for an art that in its novelty "disconcerts and alienates."[23] The symbolist writer Jules Antoine esteems Monet's "beautiful personal execution" as the appropriate rendering of "temperament," but his colleague Fénéon insists that Monet's "emancipated" personality of color and touch fails to discipline "the chemical conflict of pigments."[24] Against Fénéon's assertion of imper-

sonal laws in art Emile Cardon proclaims the rule of the individual: "Never will the juries of the annual Salons refuse a mediocrity; they come together only against the strong and the powerful; as there is no truth, in art, but individualism, they are pitiless against original personalities." Mirbeau's doctrine of autonomous individualism is paraphrased here, and Cardon portrays Monet as "someone, an individuality, who, smitten with nature and truth, seeks to render her as faithfully as possible, without copying anyone, who executes his work without recommencing that of his neighbor."[25]

For Cardon, Monet's individuality is the mirror of nature, but others such as J. Le Fustec disagree: "It is not a question here of the ocular impression, all on the surface. On this account M. Monet is far, very far from the truth. The aim he proposes is to express the aerial flash that envelops things. Hence this palette, these raw tones, these reds, these yellows, these greens that at first would seem to be used out of place but that in sum translate, one must confess, the thought of the artist." This thought transforms Antibes into an ardent "sunlit blaze" and imbues the landscapes of the Creuse with the blue tones of melancholy.[26] For Paul Foucher, Monet's "valleys of the Creuse, at different hours of the day, are of an incomparable majesty,"[27] and for Emile Verhaeren these are "tragic landscapes, narrow valleys full of shadow, ravines traversed by a torrent, blocks of rock of tormented form."[28]

Although Verhaeren is struck by the imagery of desolation of the Creuse, his attention is focused on the temporal sequence that is inscribed across the intervals of Monet's pictures. In this he follows Mirbeau, whom he quotes at length: "Everything becomes animated or stilled, noisy or silent, colored or uncolored, according to the hour that the painter expresses and according to the slow ascent or the slow decline of the bodies that distribute the light." Verhaeren goes on to measure Mirbeau's general account against the visual evidence of particular paintings: "It is so to such a point that one can quite exactly, in his series of landscapes that reproduce the same *motif,* seize the different hours at which he saw them; not only the contrasting effects of dawns and sunsets, but, even in the evening or in the morning, the successive aspects arrested in flight by an eye of an extraordinary acuity."[29] What Monet once saw, Verhaeren now sees; the flight of time thus is stopped; and the jubilance of *le temps retrouvé* becomes the rationale for serial display.

We must turn to Gustave Geffroy for the most allegorical interpretation of the Creuse series. In his monograph of 1922 Geffroy recalls the circumstances of thirty-three years before: "In 1889 I carried off Claude

Monet to the Creuse, to Maurice Rollinat's, where I knew he would paint admirable landscapes." Melancholia, solitude, and renunciation are the values which Geffroy assigns to Rollinat's absorption within these "stupefying and somber beauties." Smitten by this landscape, "Monet stopped for long whiles to contemplate the low and foaming waters which collided amongst the rocks, above a bed of stones." Geffroy recalls in particular Monet's anthropomorphic tree—"hoary, solitary, terrible"—that stretched its branches above the torrent whose waters rushed by "like the waves of the sea." As at Belle-Ile, here too the painter and writer are the beholders of an allegorical drama that is said to inhere in the natural world: "The rocky hills, covered with moss and briar, rose up on all sides and formed a somber arena for the combat of the waters. The spectacle was fierce, of an infinite sadness." "Buried in this decor of grandiose melancholy," Rollinat and Monet are at home.[30]

In Geffroy's reminiscence the Creuse is personified as growling, jumping, murmuring, howling; yet it is death that lives in this landscape of water and rocks, the death of "an eternal solitude, of a winter's sleep that was not to end." Hence the old tree, "forever ready for renewal," which had to be stripped of its verdant growth in order to remain before Monet's eyes as "the old skeleton" of the Creuse. Geffroy speculates that the perversity of this embrace of death may have been a factor in the fate of the works in 1889: "As almost always in front of strong manifestations of a personality, the French State abstained."[31] Americans soon became the purchasers of the majority of these works which, as a result, enjoyed little critical fortune in France.

In 1889 Geffroy published an article about the geography of the Creuse, and in 1922, in what he calls "an essay in transposition," Geffroy recycles this earlier text as a commentary on Monet's art. The paintings, "reflected upon in front of the Creuse," evoke "aspects of landscapes, phenomena of nature, which may inspire daydreams and emotion in all those whose souls hold on to things by means of the invisible links of sensation." Monet's paintings are thus said to manifest "the boldest synthesis of dream, and the newest mystery"; they provide the jumping-off point for Geffroy's own literary transformation of memory: "Toward Fresselines, there where Claude Monet installed himself this year, there are no sadder or more obsessive landscapes than certain turnings of the Creuse, during the months of rain, wind, and cold." These affect-laden landscapes are given a seasonal elaboration by Geffroy as well as an allegorical transposition into the forms of nature's feminized body. In spring, "then she seems to unwrinkle her anxious face, abandon her cracked and decrepit body beneath the brightness

of azure and fine light which comes to her from the soft sky and the rejuvenated sun. But she quickly again becomes ardently sinister or harshly shut in and indifferent." Summer is just such a time, when the solitary man who stumbles into the river's torrid ravine "is as though sucked up by this brazier's breath." Autumn proves to be more hospitable and more harmonious, for this is "the fine season of the river" when she seems most in tune with her environment: "The irresistible descent she endures, and which appears in its effect like the accelerated and angry will of an element, pulls and pushes her by a force of attraction toward a larger stream, toward the river, toward the sea that calls, so distant, with her tireless voice, all the rivers, all the streams, all the brooks, all the water lost by the seepage of the lakes and ponds, all the inhaled, sucked-up water that wanders the sky in courses of clouds, in masses of mists, in trails of vapors." Finally, in winter, the force of the river's flow is arrested in ice: "It is a mineral landscape, impenetrable and fantastic, a polar region illuminated by an ungrowing dawn, by a level dusk of gray ash, a fragment in high relief of the lunar map."[32]

In 1922 Geffroy appends a single paragraph of art criticism to the landscape description written in 1889. Here, in "the waters of lead and silver in which the blue and gray of the sky grow deeper," we find an intimation of the water paintings of the intervening years. Geffroy concludes his chapter by insisting on the parallelism between the seemingly naturalistic poems and paintings of his two friends: "The soul of Rollinat [who died in 1903] floats upon these waters, on these heaths, on these rocks, at the same time that the visionary spirit of Monet reigns thereon."[33] The common reservoir of image and affect from which these two artists jointly draw in 1889 yields up the allegorical reflections of Narcissus.

Mallarmé, Women, and
Water Lilies (1889–91)

AT THE END of the catalogue of the exhibition of 1889 Monet listed a group of four paintings entitled "essays in open-air figures." These works recall the ambitions of his youth when he had sought to rival Manet and win acceptance at the Salon as a large-scale figure painter of the out-of-doors. Monet's desire to be the painter of modern life may have been competitively reactivated after Manet's death by the monumental efforts of Seurat's *Grande Jatte* and Renoir's *Bathers* in 1886 and 1887, but it was only in 1889 at the exhibition he shared with the sculptor Rodin that Monet for the first time gathered together a group of figural works painted over the course of the previous several years. Mirbeau, who stresses the importance to Monet's career of the "greatly insulted" figure paintings of the 1860s, briefly refers to the "dazzling figures of Giverny" yet chooses not to reprint from the earlier version of his text the full passage on Monet's renewed enterprise: "Today, he has set himself back again at figures. And as he invented a new poetry for the life of things, he discovered, for the life of human beings, an art that had not yet been attempted until now."[1]

Monet's figural discoveries were not achieved without stress to the artist, his friends, or the works themselves. Intimates such as Mirbeau knew of the violence done to the figure paintings: "I saw Geffroy in Paris. And we spoke a lot about you. He told me that he was furious with you; because he saw your figures from this autumn and he found them superb. I certainly suspected as much, my dear friend. So can you not repair them? It is a real murder. Beware of the folly of the forever perfect."[2] Monet's perfectionism is a by-product of his narcissism, as he explains to Paul Helleu: "I have undertaken open-air figures that I would like to finish in my manner, as I finish landscape" (19 August 1887; L. 795). Formerly

filled with the presence of Camille, in the aftermath of her death the landscape itself now re-endows Monet's new figural subjects—the daughters of Mme Hoschedé—with the qualities the painter deems characteristic of his manner alone. The dreamlike quality of displacement that operates in Monet's work is made explicit in a letter to Duret in which the artist apologizes for yet again deferring a promised visit to the critic's country place in Cognac: "I am entangled in some large canvases that I have been working on for months and from which I cannot extricate myself, and, as I am tenacious and I want to extricate myself, I must renounce for a time all travel plans. . . . I am at work as ever, and on new initiatives, open-air figures as I understand them, done like landscapes. It is an old dream that still plagues me and that I would one day wish to achieve: but it is so difficult! In sum, I give myself plenty of trouble; it absorbs me to the point of almost becoming ill" (13 August 1887; L. 794). As he had written to Frédéric Bazille almost twenty years before: "I certainly have a dream, a picture, the baths of the Grenouillère, for which I have done some miserable sketches, but it is just a dream" (25 September 1869; L. 53). These narcissistically abused *pochades* (W. 134–36) turn out to be among Monet's most famous paintings today and are often hailed as originary moments of the impressionist style.

I do not know whether Monet's self-absorbed ailment was somatic as well as rhetorical, but family legend insists that Suzanne Hoschedé became nervously exhausted from the rigorous posing sessions that the artist demanded. Two paintings oriented to the right and to the left (W. 1076–77) represent an almost featureless Suzanne holding a parasol in a blazing field in a pose that uncannily repeats the posture of Camille Monet from a decade before (W. 381). Although dated 1886, the large-scale pair of works (131 × 88 cm) was exhibited for the first time only in 1891 alongside fifteen *Haystacks* and several other unfigured landscapes.

Apart from Mirbeau's general reference, a comic lampoon by Alphonse de Calonne (who likens them to *images d'Epinal*), and very brief commendations by several others, Monet's "essays in open-air figures" provoked little comment in the press in 1889.[3] This specially bracketed grouping of pictures features Suzanne Hoschedé posing alone with a parasol (W. 1133), as well as several other children of the Hoschedé-Monet household strolling in the fields of Giverny (W. 1135–36) or boating on the nearby river (W. 1151; fig. 60). *In the Norwegian Canoe* is the name given to this last painting, in which Germaine, Suzanne, and Blanche Hoschedé (ages fourteen, nineteen, and twenty-two) are seen fishing, floating, or gazing into the dark

green water's depths. Immobilely suspended above their inverted images, they are the artist's three female Narcissuses of Giverny.

The motif of the woman's introverted gaze is associated with the mood of melancholy from Dürer down to Constance Charpentier, Corot, and a host of academic painters (fig. 61).[4] The water-gazing fisherman is already featured in Monet's earliest painting to be preserved (W. 1), but the transgendered figure of the female Narcissus emerges in Monet's art in 1868 in the over-the-shoulder view of the twenty-one-year-old Camille Doncieux sitting on the riverbank and gazing past a slender canoe onto the brightly reflecting waters of the Seine (W. 110; fig. 62). Commonly known as *The River*, this is a crucial painting in the corpus of Monet's images such as I am reconstructing it here. Not only does the painting more or less openly advert to Monet's rivalries with Courbet and Manet in the foliate fringe and beached boat that frame Camille with key elements from the *Young Ladies on the Banks of the Seine in Summer* (1857) and *Luncheon on the Grass* (1863), but *The River* also anticipates the whole subsequent history of the water paintings in its concentration upon the screen of reflections as seen by a pair of unseen eyes.

The 1868 painting was exhibited for the first time in 1889. Entitled *At the Waterside, Bennecourt*, it is iconographically and formally echoed by *In the Norwegian Canoe*. Within the context of the exhibition these two large works (81 × 100 cm, 98 × 131 cm) call to one another across the two decades, the two families, and the several kilometers that span Monet's repetitive work at Bennecourt and Giverny. The identification of the painter's gaze with that of his water-gazing female subject recurs in 1876 in Monet's first painting of Alice Hoschedé, *The Pond at Montgeron* (W. 420; fig. 63). Intended for a permanent decorative installation, this large canvas (172 × 193 cm) represents Mme Hoschedé bent over the pond of her country estate, her paintbrushlike fishing rod in hand. This same waterside posture of the female angler is repeated in 1887 in a picture of the same 81 × 100 cm dimensions as in 1868, *Fisherwoman with a Line on the Banks of the Epte* (W. 1134; fig. 64). Rod at the ready, eyes fixed on the tautly stretched surface of water that is also that of the canvas, Suzanne is Alice is Camille is Monet, the self-absorbed Narcissus of the illusory realms of being and painting. Soon even Suzanne will disappear, and the same composition in a squared-off vertical format (81 × 81 cm) will reemerge as the definitive image of Monet's series of *Poplars* in 1891 (W. 1309).

I would now like to turn to two prose-poems by Mallarmé that present pictures that are similar to those of the painter. First published in periodi-

cals in 1885 and 1886 and in book form in 1887, Mallarmé's poems were intended to figure in the never-published illustrated volume *Le Tiroir de laque,* for which Monet had promised his collaboration just prior to his trip to the Creuse: "I will not forget your drawing, but I have not yet had time for it" (15 February 1889; L. 911). Monet never made good on his promise and a lone frontispiece by Renoir was all that Mallarmé could marshall from his friends for the volume that finally appeared in 1891 under the title *Pages.*

"Le Nénuphar blanc" was assigned for illustration to Berthe Morisot, and to Monet fell the task of contributing a drawing for "La Gloire": "I am truly ashamed of my conduct and I deserve all your reproaches. However there is no ill will on my part as you might think. The real truth is that I feel myself incapable of doing anything for you that is worthy: there is in it perhaps an excess of self-love, but truly, as soon as I want to do the least thing with pencil, it is absurd and of no interest, in consequence unworthy of accompanying your exquisite poems (*Glory* ravished me and I fear that I do not have the necessary talent to make something good for you" (12 October 1889; L. 1007). Mallarmé's response makes clear his disappointment in not receiving a drawing from Monet, in "yellow or red, or blue," but the poet takes the blame partially upon himself for not having sought to overcome the painter's anxiety: "If I had been able to go to Giverny, I would have forced you to find your efforts excellent, which they indeed must be; but I respect, from afar, your solitary timidity and all that emanates sincerely from you."[5]

In an unusual gesture perhaps motivated by his feelings of guilt, Monet sought to compensate Mallarmé for the promised illustration: "You know the sympathy and the admiration that I have for you; so then! permit me to prove it to you by offering you as a remembrance of friendship a little canvas (a sketch) that I will bring you when I come to Paris one of these days and which you will do me the pleasure of accepting quite simply as I offer it to you" (12 October 1889; L. 1007). Mallarmé, in reply, writes that he has not "the heart to hide my joy."[6]

Monet and Mallarmé had the opportunity to see one another at the house of Berthe Morisot when the poet delivered a memorial lecture on the recently deceased Villiers de l'Isle-Adam before a select audience of friends. The art and life of Villiers de l'Isle-Adam may stand at this time as an emblem for the narcissistic agonies of Monet's "self-love" and "solitary timidity," for as the mystical author had only recently written: "I do not get out of myself. That is the story of Narcissus."[7] In the summer of 1890 Monet finally wrote to Morisot in order to arrange for Mallarmé's

long-deferred visit: "We will all be very happy to have you with your husband and friend Mallarmé, and I hope that you will revive my morale a bit, for I am in a complete state of discouragement. This satanic painting tortures me and I can do nothing. I do nothing but scrape and slash canvases." The canvases to which Monet refers feature his "pretty models" who had been ill (11 July 1890; L. 1064), Suzanne and her sister Blanche canoeing on the Epte (W. 1249–50; fig. 65). It is this final pair of "essays in open-air figures" that have traditionally been thought to be designated by the most famous of all Monet's letters, only a fragment of which is preserved by Geffroy: "I have again taken up things impossible to do: water with grasses that undulate in the depths . . . it is admirable to see, but it is enough to drive one mad to wish to do it. In the end I always attack things like that" (22 June 1890; L. 1060).

At Giverny, Monet apparently invited Mallarmé to select as the promised gift a painting of the poet's own choice: "One does not disturb a man in the midst of a joy like that caused in me by the contemplation of your picture, dear Monet. I am drowning in this bedazzlement, and esteem my spiritual health in the fact that I see it more or less, according to my hours. I slept little the first night, looking at it; and, in the carriage, Mme Manet was mortified that I feared the prancing of the horse, amidst the noise of the fête, only from the point of view of my canvas."[8] According to Geffroy it was this canvas (W. 912; fig. 66), "a landscape as though glimpsed, and yet of a delicious precision, a meander of river, an arabesque of water across the countryside, that Mallarmé compared to the smile of the *Mona Lisa.*"[9]

Throughout this book I have insisted on the narcissistic quotient of Monet's aquatic landscapes; what may be more deeply submerged in these waters than the elusive smile of the painter's own dead mother's youth? There is also a more manifest connection between the autumnal setting of "La Gloire" and Monet's golden landscape of silent reverie broken only by the noise of a passing train. In Mallarmé's poem the narrator, much like the poet himself on his homeward journey to Valvins or on his voyage of friendship to Giverny, boards a smoke-belching train in order to flee "the omnipresent tourists," "the urban delegation," the "enormous monotony of capital." As a result the poet finds himself a lone escapee amid the landscape of Fontainebleau, where no one but he is able to recognize the day's "secret splendor, too inappreciable a trophy to appear."[10] As we will soon see in the Narcissus poems of Mallarmé's disciples Valéry, Gide, and Mauclair, the glimmering appearance of *paraître* is the goal of symbolist art.

Like "La Gloire," "Le Nénuphar blanc" is also an allegory of the

fluid indeterminacies of artistic vision. The poem opens in the mode of remembrance: "I had rowed a great deal, with a large clean drowsy motion, my eyes fixed within on the entire forgetfulness of movement, as the laughter of the hour flowed all around. So much immobility idled away that, brushed by an inert noise into which the yawl slid up to its middle, I did not verify the stop except by the steady sparkle of initials upon the bared oars, which recalled me to my worldly identity. What was happening, where was I?"[11]

Rowing pictures abound from the nineteenth century, with Thomas Eakins's paintings of American sportsmen of the 1870s finding their most notable French counterparts in the work of Monet's friend and fellow boatsman, Gustave Caillebotte. In a letter to Caillebotte, Monet seems to refer to his own female boaters of 1887, including the exhibited *In the Norwegian Canoe* and the two unexhibited versions of *Young Women in a Boat* (W. 1152–53; fig. 67): "I have scraped and split almost everything I had done and I am very disgusted with myself: a superb summer lost. Ah, painting, what torture!" (4 September 1887; L. 1424). Monet's monumental boating pictures stayed in his collection into the 1920s, and one can perhaps gauge their importance in a contemporary photograph which shows one of the largest of the compositions (145 × 132 cm) hanging by the side of the large fragment of Monet's ruined *Luncheon on the Grass* from 1865 (fig. 68).[12]

Monet depicts an oarswoman rather than an oarsman in his figural compositions of 1887–90, the period of his closest association with Mallarmé. The dialectic of gliding motion and sudden immobility is much the same in the cropped framing and clipped syntax of the poet and painter alike. Their affinity for the perceptual fragment is evident in the singularly unstable and unpeopled *The Boat* (W. 1154; fig. 69), another work that is visible on the wall of Monet's studio in the photograph of 1920.

As Monet might have done in the act of scouting locations for his paintings, Mallarmé's oarsman runs aground in an aquatic landscape thoroughly saturated with an elusive feminine presence. On the drowsy lookout for a flower or a female figure that might arrest his constant flight, the self-absorbed rower is shocked into the fixity of a focused gaze: "Without being retained by the ribbon of any plant in front of one landscape more than another chased away with its reflection in the water by the same impartial stroke of the oars, I had run aground in some tuft of reeds, the mysterious end of my course, in the middle of the river: where all at once broadened out into a fluvial grove, she displays a pond's negligence to flow, pleated with hesitations, such as has a spring."[13] For critic Barbara Johnson

it is this tuft of reeds and other related symbolic markers that "fleshed out on the figurative level" the poem's allegorical "strip-tease."[14]

On the literal level Mallarmé's text always remains naturalistically cogent: "Detailed inspection apprised me that this obstacle of pointed greenery in the current masked the sole arch of a bridge prolonged on land, on this side and that, by a hedge enclosing lawns. I came to a recognition. Simply the park of Madame . . . , the unknown woman I was to greet." Both Mallarmé and Monet accept the naturalistic responsibilities of their artistic generation. Born within fifteen months of each other, both men remain constrained by the Baudelairean program of the 1860s, yet both men increasingly struggle to forge a complex form of realism that does not do violence to the habit of allegorical association which they and others attributed to modern consciousness itself: "A pleasant neighborliness, during the season, the nature of a person who has chosen for herself a retreat so damply impenetrable not being other than in conformity with my taste. Surely, she had made of this crystal her interior mirror sheltered from the glaring indiscretion of the afternoon; she came here and the breath of silver glazing the willows was soon none other than the limpidity of her gaze grown accustomed to each leaf."[15] This is Mallarmé's unseen but vividly imagined lady of the spring, a sister of the nymphs of Giverny whose own bridge across the narrow neck of their stepfather's pond came to be constructed in 1893 (W. 1392, 1419–19 bis; fig. 70). Although the woman of Monet's desire is explicitly pictured in the key waterside portraits of Camille, Alice, and Suzanne in 1868, 1876, and 1887, it is as an invisible Mallarméan presence that she remains unpictured in the numerous pond-and-bridge pictures of Giverny.

A mythic consciousness of their respective ladies in the lake is maintained by both the poet and painter through acts of considerable physical effort. Fresh from the rigors of his efforts to capture the floating images of Suzanne and Blanche upon the Epte, Monet exclaims to Mallarmé, "the poor painter despairs" (21 July 1890; L. 1065). On the same day that he writes this letter he expounds on his predicament to Geffroy: "It decidedly is a continual torture! Do not expect to see anything new; the little that I was able to do is destroyed, scraped or split. You do not take into account the horrid weather that has not stopped for two months. It is enough to drive one furious mad, when one seeks to render the weather, the atmosphere, the ambiance. With this, all the bothers, here I am stupidly afflicted with rheumatism. I am paying for my sessions in the rain and the snow, and what desolates me is to think that I will have to renounce braving all sorts of weather and working out-of-doors, except in good weather. What

stupidity life is" (21 July 1890; L. 1066). Monet sustains his bent-over posture in front of the natural motif regardless of the risk to his health or to that of his female models. Mallarmé's oarsman also endures the masochistic posture of Narcissus at the pool: "Bent over in the sportive attitude in which my curiosity maintained me, as though beneath the spacious silence out of which the unknown woman was announcing herself, I smiled at the beginning of enslavement released by a feminine possibility: which was not badly signified by the straps attaching the rower's shoe to the wood of the boat, as one does not make but one with the instrument of one's enthrallment."[16] In this last sentence the play of phonic identity and graphic difference in *on/un* sets the words adrift upon a shifting sea of signifiers that embraces the Ovidian text itself, as in the famous "si se non noverit"—"if he ne'er knows himself."[17] As Roger Dragonetti has argued, Mallarmé's rower is that "strange hero of the mirror, this Narcissus who refuses to see himself in the features of his 'feminine possibility' and thus defers his own death!"; yet within the shackled terms of the poem's simile the rower acknowledges his own painful dependence upon the imaginary woman of his dreams.[18]

For the poet and painter in the position of Narcissus every woman is a cipher of desire, whether it is Camille, Alice, Suzanne, or the unknown Madame: "'As well as any woman . . .' I was about to conclude." This hesitant self-disclosure is broken off by the intervention of an unanticipated event: "When an imperceptible noise made me doubt whether the inhabit-ant of the bank haunted my leisure, or contrary to all hope, the pool. The steps ceased, why? Subtle secret of feet that go, come, lead the mind in the direction wished by the dear shadow hidden in the batiste and lace of a shift flowing upon the ground as though to circumvent from the heel to the toe, in a watery line, that initiative by which the gait opens out, all the way down and the folds thrown back in a train, a clearing for its knowing double arrow." Seen here close to, the alluringly mobile, arrowlike skirt of Mallarmé's lady is the very image of the all but invisible Suzanne Hoschedé with her umbrella from around 1886 (W. 1077; fig. 71); seen from afar, she is Suzanne standing upon the bank of the Epte in the following year (W. 1134). Under the title of *The Stroller* (W. 1133) Su-zanne's stilled gait is the subject of one of the "essays in open-air figures" of 1889: "Does she know a reason for her stopping, she the stroller: and is it not, I, to lift too high my head so as to rise above these rushes and all the mental somnolence in which my lucidity is veiled, to interrogate the mystery to that point."[19]

Mallarmé's question needs no conventional punctuation, for its query

is wholly self-reflexive. Rather than confront the lady, the poet stages an interior monologue. Much the same could be said of Monet's incorporation of his female models into his private system of perception and affect: " 'To whatever type your features are fitted, I sense their precision, Madame, interrupt something installed here by the rustling of an arrival, yes! this instinctual charm of an underneath not defended against the explorer by the most authentically knotted of belts with a buckle of diamonds. Such a vague concept suffices: and will not transgress the delight imprinted with generality which permits and ordains all faces to be excluded, to the point that the revelation of one (do not in the least bend it, avowedly, over the furtive threshold where I reign) would chase away my agitation, with which it has nothing to do.' "[20] Mallarmé's "aquatic marauder" will on no account chance a close encounter with the lady whose face he cares not to see. The watery mirror serves the double purpose of screening out the actual features of the woman's face—whether Camille in 1868 or Suzanne in 1887—while at the same time reflecting whatever features the poet-painter is privately moved to imagine in his mind's eye.

Monet adapted his practice of the rowing-painter not from Mallarmé but from Daubigny, whose *Banks of the Oise* the young painter had admired at the Salon of 1859 (fig. 72). A Narcissus-like representation of Monet's engrossed contemplation aboard his *bateau-atelier* figures in a little-known painting of 1876 (W. 390; also see 316, 323, 334–35, 391–93, 591), but a much more famous representation is Manet's portrayal in 1874 of *Monet Painting on His Studio-Boat* (figs. 73–74).[21] In this image Camille Monet is depicted in the interior of the craft looking at her husband at work out on the boat's deck. She is not the object of the gaze of the painter, who sits to her right in the bow of the boat and who focuses on a river scene on the easel at her left; filling up the surface of the canvas between the painter and his painting, she is the medium of contact between the artist and his art.

Monet's and Mallarmé's unseen woman permits both men to achieve their representations of landscape in which her literal absence yields an allegory of her essential presence. In Monet's oarswomen of 1887 the square-formatted and water-twinned image is the double sign of a reflexivity of vision and thought (W. 1152); in Mallarmé's oarsman of 1885–91 this reflexiveness is mapped in the imagery of watery reflection and echoed in the tropes of assonance, alliteration, and ambiguity: "Separated, one is together: I intermix myself with her indistinct intimacy, in this suspension upon the water where my thought makes the indecisive one tarry, better than a visit, followed by others, will authorize. How many idle speeches

in comparison to the one I made in order not to be heard would be necessary before recovering as intuitive an accord as now, my ears at the level of the mahogany straining toward the entire silent strand. The pause is measured by the time of my [in 1891: her] determination. Advise, o my dream, what to do?"[22] Mallarmé's shift between the *ma* and *sa* is a further index of the minute calibrations of a self-absorbed art made under the sign of Narcissus. Like the repetitions of Monet's paintings of the rivers and seas of France and the waters of Giverny, Mallarmé's adjustments of sound and sense are the symptoms of a yearning for a richness of personal meaning in a medium stripped by common usage to the positive bone. "Séparés, on est ensemble": separated we are together; separated, one is an ensemble. Rather than idly reenact division as merely an inconvenient social condition of the relation between the sexes, Mallarmé and Monet face up to the existential dilemma of self-division as both the abyssal groundlessness of being and the fecund ground of art.

Suspended over the waters of his dream, Mallarmé's oarsman dilates the moment of his looking into an indefinitely frozen future even as he risks his dilution in the fluid medium of his desire. So he stops and waits; and she waits too: "To sum up, in a look, the virgin absence scattered in this solitude and, as one picks, in memory of a site, one of those magic closed water lilies which all at once surge up, enveloping in their hollow whiteness a nothing, made of intact dreams, of the happiness which will not occur and with my breath held back in the fear of an appearance, to leave therewith: tacitly, by rowing away little by little without by a blow breaking the illusion and lest the lapping of the visible bubble of foam unfurled by my flight throw up at the feet of an arriving person the transparent resemblance of the rape of my ideal flower."[23] The water lily was perhaps the ideal flower to figure the oxymoron of Mallarmé's image. An emptiness of form that yet holds the fullness of dream; a blankness of color that yet conceals the darkness of lust: the water lily in the 1880s was just that sign for an ambivalence of meaning that was seen to inhere within the objects of the phenomenal world. As a contemporary horticulturalist wrote of the flower, "such is the configuration of the damp palace of the divinities of the pool, for in antiquity the Nymphaeaceae enjoyed this signal regard and the old Lotus can testify to it still."[24] Closer to Mallarmé and Monet, their friend Maupassant saw the water lily as the symbolic *axis mundi* around which everything of value in the world revolved: "All the color given to the world, charming, diverse, and intoxicating, seemed to us deliciously finished, admirably vivid, infinitely nuanced, around a water lily's leaf. All the reds, all the pinks, all the yellows, all the blues, all the

greens, all the purples are there in a bit of water that shows us all the sky, all of space, all the dream, and in which the flights of birds pass." This passage is from *Sur l'eau,* in which the author's meditation before a piece of water yields "the confused revelation of an unknowable mystery, the original breath of primitive life which was perhaps a bubble of gas risen out of the swamp at the fall of day."[25]

Monet's earliest close-up representations of *Water Lilies* date from around 1897 and might be seen as belated incarnations of the illustration that the painter had failed to deliver to Mallarmé some eight years before (W. 1501–8; fig. 75). The poet's description of the dream-enclosing void of these virginal blossoms is as apt as that which later heralded the paintings' existence to the Parisian press. In this article it is Mallarmé's name which presides over the description of Monet's personal environment by way of the poet's "lapidarily inscribed" address to the painter which the author observed at Giverny: "Monsieur Monet, that winter nor / Summer does his vision delude / Inhabits, while painting, Giverny / Situated near Vernon, in the Eure."[26]

In the final paragraph of Mallarmé's poem, the rower's simile of culling the woman's virginal absence as one plucks the closed blossoms of the water lily modulates into allegory: "If, attracted by a feeling for the strange, she appeared, the Meditative or the Haughty, the Fierce, the Gay Lady, so much the worse for that indescribable face of which I shall forever be ignorant! for I accomplished the maneuver according to the rules: disengaged myself, turned, and was already passing round an undulation of the stream, carrying off like a noble swan's egg, from which flight will never spring, my imaginary trophy, which will swell with nothing other than the exquisite emptiness of self which, in summer, every woman loves to pursue in the alleys of her park, stopping sometimes and for long whiles, as at the banks of a spring to cross or of some piece of water."[27] Through a transgendered identification with the woman, it is her self that is projected as swollen with the rower's own dilatory vacancy of self-absorption. The trophy "too inappreciable . . . to appear" in "La Gloire" reappears as the "imaginary trophy" here. I would stress the Lacanian construal of the latter adjective as pertaining to the experiential register of images, for it is there, in the imaginary posture of a desired yet feared fusion of male and female selves, that we situate the uncanny condensations of simile, metaphor, assonance, and allegory that mark and re-mark Mallarmé's texts. And so it is with Monet, whose water-doubled oarswomen and disquieting aquatic plants bear comparable traces of the signifying pressures to distort, disfigure, and displace.

In 1891 Mallarmé had his publisher reserve for Monet a copy of *Pages*, in which the prose-poems finally reappeared, though without the painter's promised illustration. In his note of thanks belated by more than a month Monet indicates that he has not yet taken an opportunity to pick up the book (which he eventually does do), and continues to express a residual guilt in Mallarmé's regard. A visit by the poet to Giverny is hoped for the fall, but in the meantime Monet begs off from his social responsibilities on account of the "quantities of new canvases" (presumably the *Poplars*) that he feels he must finish: "And then, I must confess, I have a great deal of difficulty in leaving Giverny, especially now that I am arranging the house and the garden to my taste" (28 July 1891; L. 1121). "In my manner," "to my taste": these are the markers of that process of transformation to which Monet submits his landscapes and figures. This allegorical metamorphosis is evoked in 1891 by Octave Mirbeau in a piece of writing that is almost a prose-poem in itself, and in which the names of Mallarmé and Monet are for the first time publicly linked.

Although Monet had been unable or unwilling to contribute an illustration to Mallarmé's *Pages,* he did eventually collaborate with Mirbeau by making three drawings after his own paintings for reproduction in Durand-Ruel's *L'Art dans les Deux Mondes.* Referring to the drawn work, Monet insists to his dealer that "it has the appearance of nothing at all, but it frightens me a lot, I am so awkward with black and white, and I am so absorbed by what I have underway that I can do nothing else" (21 December 1890; L. 1088). In the article Mirbeau presents an extended seasonal portrait of Monet's garden in which the painter, through "the splendid life of color," is said "to touch the intangible, express the inexpressible," at the very instant "when the dream becomes the reality."[28] This presentation of Monet's enterprise is wholly in keeping with Mallarmé's celebrated programmatic statement which appeared within a week of the article on Monet: "*To name* an object is to suppress three-quarters of the pleasure of the poem that is made to be guessed at bit by bit; *to suggest* it, there is the dream. This is the perfect utilization of that mystery which the symbol constitutes: to evoke an object little by little in order to show a state of mind, or, inversely, to choose an object and disengage a state of mind from it, by a series of decipherments."[29]

In addition to their agreement on the dreamlike interpretability of the work of art, Mirbeau and Mallarmé were also in accord in their view of the contemporary task of the artist in society. As his frequent letters to Mirbeau attest, Mallarmé was an appreciative reader of his friend's novels and essays and echoed Mirbeau's anarchistic politics of withdrawal from

the commodified intercourse of the bourgeoisie: "For me, the case of the poet, in this society which does not permit him to live, is the case of a man who isolates himself in order to sculpture his own tomb. . . . For I, at bottom, I am a solitary man. . . . The attitude of the poet in an epoch such as this, when he is on strike against society, is to put aside all the vitiated means which might be offered to him. Everything that one might propose to him is inferior to his conception and to his secret work."[30]

Once again the anarchic figure of the solitary Narcissus is suggested but not named, for Mallarmé opposes the literal naming of the idea-laden figure as in the work of the Parnassian poets who "take the thing entirely and show it." The key here is a sort of democratic notion of the artistic institution in which the directives of explicit allegory are rejected in favor of an interactive process that unites artists and audiences in "that delicious joy of believing they create."[31]

In 1891 Mirbeau and Mallarmé were in particularly close touch, with numerous exchanges of letters, books, favors, and visits. In one letter Mallarmé affected to see himself as reflected in Mirbeau's admiring eyes: "It is good to mirror oneself in a friendship, in order to become such a one."[32] For his part, at the moment of drafting his "urgent article" on Monet, Mirbeau sought as a respite from his journalistic efforts "to rejoice in" a piece of writing that Mallarmé had recently sent as a gift.[33] Even in front of Monet's paintings Mirbeau still has Mallarmé in mind: "And I think that, in front of such works which suggest to the mind, solely through the pleasure of the eyes, the most noble, the most high, the most distant ideas, the critic must renounce his petty, dry, and sterile analyses, and that the poet, alone, has the right to speak and to sing, for Claude Monet who, in his compositions, does not bring in directly literary preoccupations, is of all painters, with Puvis de Chavannes perhaps, the one who addresses himself, the most directly, the most eloquently, to poets."[34]

Mirbeau insists that Monet is a realist who "does not limit himself to translating nature." Passion, mystery, and dream are the Mallarméan passwords of Mirbeau's text, which gives rise to an allegory of "the Hours," a mysterious memento of "the states of unconsciousness of the planet, and the suprasensible forms of our thoughts."[35] In this last phrase we are in the philosophical world of Schopenhauer as much as in the poetic realm of Mallarmé.

Mirbeau is most like Mallarmé in his description of *Canoeing on the Epte* (W. 1250): "In a yawl, at rest upon the almost black water, upon the deep water of a shaded river, of which one does not see the bank that the frame cuts, two young ladies in bright dresses, charming in their grace

and supple abandon, are seated. The current is rapid; it causes the trembling, amid the sparkles of sun and the moving greens of the reflected leaves, of the mauve and rose reflections of the dresses. But the drama is not there. In the foreground of the painting which is altogether water, a brilliant, sparkling, flowing surface, the eye bit by bit penetrates this watery coolness and discovers by way of the fluid transparencies, right down to the bed of golden sand, an entire lacustrine floral life of extraordinary submerged vegetation, of long wild, greenish, purplish filamentary algae which, beneath the thrust of the current, become agitated, twisted, disheveled, dispersed, reassembled, soft and bizarre heads of hair; and then undulate, wind, coil, lengthen, like strange fishes, fantastic tentacles of marine monsters." Like Mallarmé's mysterious tuft of reeds but eerily more Medusan in the horror of this jellyfish-like head of underwater grass, Mirbeau's monstrous *chevelure* threatens the manifest charm of the virginal scene set atop these black depths. Monet's two bright oarswomen are relegated to the framing fringe of the painting, and the viscous water becomes the medium of a self-annihilating drama whose narcissistic implications are perhaps made clearer in the original French: "s'agitent, se tordent, s'échevèlent, se dispersent, se rassemblent, . . . et puis ondulent, serpentent, se replient, s'allongent."[36] These verbs mime the self-splitting moves of sexuality and consciousness alike.

In his article Mirbeau elaborates upon two other paintings of Suzanne Hoschedé, the soon-to-be exhibited *Essay in Open-Air Figures (To the Left)* (W. 1077) and the all but unknown *Portrait of Suzanne with Sunflowers* (W. 1261; fig. 76). Seated in the position of Dürer's *Melencolia I*, this morbid female avatar of the artist makes Mirbeau think of Poe's sad Ligeia, "ghostly and real, or rather one of those figures of women, spectral souls such as some of the poems of Stéphane Mallarmé evoke." Mirbeau does not offer to unravel the private mystery of the sitter's Echo-like introversion, but with him we do well to ask not only of Suzanne but also of her mother's lover, "what is the secret of [his/her] soul?"[37]

11

Allegories of Narcissus: Valéry, Gide, Mauclair (1891–95)

ONE WEEK AFTER the appearance of Mirbeau's article, the young Paul Valéry published "Narcisse parle," a fragmentary poem that initiates a career-long preoccupation with the mythological figure. Although the day before the poem appeared in print Mallarmé had explicitly chastized the Parnassian practice of directly naming the ancient figures of allegory, he admitted to being "charmed" by this Narcissus.[1]

Before the two poets had met, Valéry already associated Mallarmé with the idea of Narcissus. Drawing upon the image of the reflecting glass from Mallarmé's "Hérodiade," Valéry sought the master poet's advice concerning their common craft: "I am bold to importune you in this way, but your Soul fascinates me like this mirror: 'I appeared to myself in you like a distant shadow' ["Hérodiade," ii, 49], and it would be cruel of You to refuse me a good Word and this Grain which, I feel, *must* germinate in my heart." Valéry sent Mallarmé a somewhat less exalted version of this letter, and the poet's response was that "only solitude gives" counsel.[2]

At the time of writing "Narcisse parle," Valéry had not yet met either Mallarmé or Monet, but as an intimate of the Mallarmé-Morisot circle (he married Berthe Morisot's niece in 1900) Valéry came to know Monet and his art quite well. At Mallarmé's apartment in Paris, Valéry would have seen Monet's painting of the Seine at Jeufosse, and as a visitor to Giverny in later years Valéry personally inscribed a volume of his poems for the painter and also recorded in his notebooks his admiration for the *Water Lilies*.[3] The poetic or allegorical dimension of Monet's work was a matter of open discussion from the 1890s on, and it is my argument here that the allusive naturalism of Valéry's poem corresponds to evocations of Monet's paintings that might have been heard from Mallarmé or read in writers

such as Mirbeau. There may appear to be a more evident connection between Valéry's antique scene and the neoclassical idiom of a painter such as Jules-Cyrille Cavé, an award-winning pupil of William Bouguereau, who exhibited a *Narcissus* at the Salon of 1890 (fig. 77), but for me it is Monet's art that offers the suggestive decor within which Valéry's figure appears: "How I deplore your fatal and pure glitter, / Deadly source predestined for my tears, / Where in a deathly azure my eyes drew in / My image crowned with wet flowers." Over the course of the next five decades Valéry elaborates his "metaphysic of this myth" in numerous letters, journal entries, and a late public lecture in which he acknowledges that the Narcissus poems comprise "a sort of poetic autobiography."[4]

For Valéry, Narcissus figures the cleavage between subject and object, possibility and contingency, the universal and the particular. In his daily *cahiers* he notes the implications of the myth:

> *Narcissus*—The confrontation of the self and the Person. The conflict of the memory, of the *name,* of the habits, of the penchants, of the reflected form, of the distinct, fixed, inscribed creature—of the history, of the *particular* with—the—universal center, the capacity for change, the eternal youthfulness of *forgetting,* the Proteus, the creature who cannot be enchained, the turning movement, the renascent function, the self that may be entirely new and even multiple—with several existences—with several dimensions—with several histories—(cf. pathology). (1907–8)

> Narcissus. The response of the mirror to whom is reflected there, to the unknown who sees himself there—is a Man. The response of the mirror to the Whole is an element / a part / of the Whole. Its response to the universal is the particular. Its response to the possible is the fact, the object. Its response to the substance is the accident. (1926)

> Narcissus. I seek you and you seek me, and sometimes you find me, often lose me. (1945)[5]

For Valéry the legend of Narcissus entails the self-discrepancy of our enfleshed being. As Valéry writes in 1907 concerning the attempt to stave off the particularity of one's death through the plunge into the virtual worlds of art, "and there is Narcissus: reflection of the cold truth in a magnificent mirror—and the inverse—reflection of my idea in my nothingness, but let us go on looking, always looking. And let us love one another!"[6] A later prose reflection entitled "Avec Soi Seul" makes the stakes clear: "NARCISSUS. Is it not at all to think of death to regard oneself in the mirror? Does one not see there one's perishable part? The immortal sees there the

mortal. A mirror takes us out of our skin, of our face. Nothing resists one's double."[7]

Valéry finds Narcissus in every face; he also projects Narcissus onto nature at large. It is here, in the realm of this "generalized Narcissus," that I wish to situate the arts of Monet and Valéry side by side.[8] In a late text entitled "Louanges de l'eau" which Valéry wrote on behalf of Source Perrier, the cosmic dimension of Narcissus is splayed out across the landscape: "Divine lucidity, transparent Rock, marvelous Agent of life, universal WATER, I would gladly offer you the homage of endless litanies. I will speak of tranquil WATER, supreme luxury of sites where she spreads sheets of absolute calm, upon the pure plane of which all reflected things appear more perfect than themselves. There, all of nature makes Narcissus of herself, and loves herself."[9] Although Valéry's metaphor of the world's self-reflection dates from 1935, the allegory of the mirrored landscape as Narcissus already appears in the 1890s in poetic and critical discourse.

Prior to the publication of "Narcisse parle" Valéry confided his thoughts on the subject to his friend André Gide, yet another young disciple of Mallarmé: "There is a mad fusion of me in him."[10] Valéry describes to Gide the "anguish" of writing, much as in other contexts Monet laments the psychic pain of his own work: "For the long-dreamed *Narcissus* ought not be done but minutely, in brief moments! And I suffer to feel him growing almost *easily,* and I am very upset for I see the Work detaching itself ungratefully from me and luring away my dream of the solitary ephebe."[11] In response Gide urges his friend to redo the work: "The piece is worth the trouble and I know you enough to hope for an exquisite poem: you will do it in long hours, haunted and solitary in the enchantment of your single dream: that would be needed for the reflective unity of Narcissus in his watery dream."[12]

Gide also turned to poetry in a never-published "Narcisse secret," a fragment of which he sent to Valéry: "The mystery / Of the grotto which opens in the flank of the sonorous rock / Hairy with wild golden herbs, where the negligence / Of the nymph allowed to flow toward the water it tints / The warm blood of her ripe vulva."[13] Here the narcissus is the residual flower that grows alongside the rocky clefts which Gide likens to the genitalia of the spurned nymphs. In view of the bodily discretion of Valéry's imagery it is not surprising that in later years he rejects the charge of autoeroticism that comes to be laid against both his works and Gide's: "What irritates me is this *waterproof* of narcissism which sticks to my shoulders. . . . Have I moreover ever so greatly regarded my navel? Have I ever spoken of the cultivation of the Self?"[14] Later still Valéry explicitly

contrasts his Narcissus with that of his friend: "I only give a local impor-
tance, conceded with regrets, endured and not necessary, to that which
G[ide] finds on the contrary essential. And reciprocally. Questions of sex,
conventions, etc., always appear to me of limited importance. . . . What
truly interests me in myself, and in the world, has no sex—nor resem-
blance—nor history. . . . My Narcissus is not his. Mine is contrast, the
marvel that the reflection of a Pure Self is a Mister—an age, a sex, a past,
probabilities and certitudes."[15]

Gide cites Valéry, Kant, and Schopenhauer as the principal sources of
his own prose version of the myth, *Le Traité du Narcisse (Théorie du Sym-
bole)*, published in 1892: "At least the effort in writing it will not have
been lost; it clarified for me my entire aesthetic, my morals, and my philoso-
phy."[16] I want now to turn to Gide's text, but only to take from it those
motifs that it shares with the critical reception of Monet's art. Furthermore,
I infer Gide's interest in Monet at this time on the basis of a letter to Valéry
in which Gide calls attention to the "exquisite" physical characteristics of
a mutual friend, whose hair has "the air of being made by Monet."[17]

Gide's treatise opens with the claim that several myths alone have
sufficed to constitute the core of Western culture: "The people were aston-
ished by the appearance of fables and without understanding they adored;
the attentive priests, bent over the depths of the images, slowly penetrated
the intimate meaning of the hieroglyphic. . . . Thus the myth of Narcis-
sus."[18] Bent over the surface of the water, the picture, or the page, these
penchant hierophants and their modernist avatars reproduce the physical
posture of the myth.

Gide concedes that everything has already been said, "but since no one
listens, it is always necessary to recommence." Starting over is the gesture
of Monet's art in its physical facture, serial format, and aquatic iconography,
and repetition is similarly at the center of Gide's account: "Narcissus was
perfectly beautiful,—and that is why he was chaste, he disdained the
Nymphs—because he was in love with himself. No breath troubled the
spring, where, tranquil and bent, all the day he contemplated his image."[19]

"You know the story," Gide writes, but he has new intentions for it:
"No more metamorphosis and no more reflected flower; —only the lone
Narcissus then, only a Narcissus dreamy and isolated in grisaille." The
graphic transformation could scarcely be more complete: "I fuse into this
landscape without lines, which does not contrast its planes." Unable to see
himself against this undifferentiated backdrop, Narcissus goes off in search
of his reflection: "From afar, Narcissus took the river for a road, and as
he was bored, all alone in all this gray, he approached in order to see

things pass by. His hands on the frame, now, he bends over, in the traditional posture. And now, as he looks, a thin apparition suddenly mottles the water. —Flowers of the banks, trunks of trees, fragments of reflected blue sky, an entire flight of rapid images that were only waiting for him in order to come into being, and which beneath his gaze take on color. Then the hills open up and the forests stretch out along the slopes of the valleys,—a vision which undulates with the water's course, and which the flow diversifies. Narcissus looks on amazed; —but does not fully understand, for one and the other sways, whether his soul guides the flow, or whether it is the flow that guides it."[20]

Gide's description of the river might almost be an evocation of Monet's *Poplars,* to which we will soon turn. The works of Monet and Gide are contemporaneous but independent, yet it is their common share in a symbolist discourse of reflections and self-reflection that I will seek to stress. Gide approaches the domain of the painter in his descriptions of a trip to Brittany which had even taken him to Belle-Ile: "I thought especially about the translation of thoughts, about expression. I would have wanted to be able to paint, for myself alone; almost no drawing, some tints, and above all those fugitive appearances that never, hardly ever, have I seen reproduced, perhaps because they cannot be restated; sparkles of water in which are indistinctly confounded the reflected banks and the algae of the depths; transparencies of mist, mysteries of shade; some of those tints that, related to one another, become revelations." Monet looks into the oceans and rivers of France and what he sees there is always the same fact of his own looking. Gide similarly constitutes the self-reflecting point of view: "It seemed to me that the landscape was no longer but a projected emanation of myself. . . ; it was sleeping before my arrival, inert and virtual, and I created it bit by bit by perceiving its harmonies; I was its very consciousness. And I advanced amazed into this garden of my dream."[21]

In his treatise Gide removes Narcissus from the springs of Greece to the garden of Eden: "Paradise was not large; because they were perfect, the forms flowered there only once, and a garden contained them all. . . . Everything there crystallized into a necessary form, and everything was perfectly as everything needed to be. —Everything remained immobile, for nothing needed to be better. Only the calm gravitation made the whole slowly turn." Amidst this immobility Gide finds the tree named Ygdrasil, a "logarithmic tree" that expresses its meaning in its appearance: "Chaste Eden! Garden! garden of Ideas. Where the forms, rhythmic and sure, effortlessly revealed their number; where each thing was what it appeared; for proving it was unnecessary." In this garden "a harmony emanated from

the relations of lines; upon the garden there hovered a uniform sym-
phony."[22] Here we are back in Baudelaire's "forest of symbols" where
"perfumes, colors, and sounds correspond," but also in the realm of Monet's
"trees of allegorical profile."[23]

The tree of knowledge provides the shade in which Adam sits: "Immo-
bile and in the center of this entire enchantment, he looks at it unroll."
Enchantment or *féerie* is a word often encountered in the critical response
to Monet's art, and the fairyland which Adam observes evokes the installa-
tion of Monet's waterscapes in which the spectator takes in the sequence
of scenes from a point at the center of the room: "But, ever-obligated
spectator of a spectacle in which he has no role except always to look, he
grows tired. . . . Ah! to seize! to seize a branch of Ygdrasil between his
infatuated fingers, and let him break it."[24] *Saisir* is another recurring motif
in Monet's pursuit of the impression; his repetitive flailing of the brush is
the mark of that existential risk that Adam insists on taking in spite of
the Edenic panorama of which his gaze is the apparent source.

Adam's defiance splits open the symmetry of Eden and ushers in the
differential dimensions of space and time. The result is catastrophic, for
across these twin dimensions leaps the spark of desire. Gide repeats Plato's
myth of sexual engenderment here, just as Freud and Lacan will later have
recourse to the ancient text for their allegories of human subjectivity: "And
the horrified Man, androgyne who becomes doubled, cried with anguish
and horror, feeling, with a new sex, stir in him the disquieting desire for
that almost identical half of himself, that woman all at once sprung up
there, whom he embraces and whom he would wish to take back."[25] At
this point Gide leaves Adam to his fate as the progenitor of prophets and
poets who will ever be on the alert for Paradise Lost.

Narcissus comes back in the second of the three movements of Gide's
treatise: "If Narcissus turned around, he would see, I think, some green
bank, a sky perhaps, the Tree, the Flower, something stable finally, and
that endures but whose reflection, falling upon the water, breaks and is
diversified by the mobility of the flow. When then will this water cease its
flight? and in repose finally, a stagnant mirror, will it tell, in the identical
purity of the image,—identical finally, to the point of being confounded
with them—the lines of these fatal forms,—to the point of becoming them,
finally." Turned as he is away from the forms and toward their broken
reflections, Narcissus remains unaware of the world. Yet Narcissus has
the knack for the "recrystallization" of the "divine and perennial forms":
"Everything strives toward its lost form; it appears, but soiled, warped,
and unsatisfied, since it always recommences; pressed, knocked by the

nearby forms which also strive each one to appear,—for, to be does not suffice: one must prove oneself,—and pride infatuates each one. The passing hour upsets all."[26] So Monet plucks the leaves from the Creuse's oak and at home along the Epte he stays the threatened axman's blows so that he can paint his poplars in peace; but he must always recommence his quest, since each succeeding moment alienates him from the finality which he seeks.

Gide's emblem of timeless repose is Christ on the cross. The problem is that "someone was not looking" and therefore the substitutive mass must be tirelessly repeated until everyone looks: "If we knew to be attentive and to look, what things we would see, perhaps."[27] At this point Gide alerts the reader to a note printed at the back of the text. In this *hors-texte* which threatens to explode "the narrow frame" of the fiction, Gide lays bare the aesthetic morality that will guide not only his own career but also the modernist interpretation of Monet's art which insists on the primacy of form.

Gide's note is crucial for understanding his distinction between the unworthy narcissism of self-adoration and the moral narcissism of self-reflection. In self-adoration one is lured by the merely accidental appearance of the world; in self-reflection, conversely, one glimpses the objectivity of one's enworlded being: "The Truths reside behind the Forms—symbols. Every phenomenon is the Symbol of a Truth. Its only duty is that it manifest it. Its only sin: that it prefer itself." Gide's narcissism is therefore far from the egoism of Barrès, even though it was the author of the *Culte du moi* who had introduced Gide to Mallarmé. Gide's narcissism turns out to be a form of redemptive Kantianism whereby the allure of the phenomena of appearance is annulled in the intuition of a numinous truth. The goal of life and art then—for Gide insists that "the rules of morality and aesthetics are the same"—is just to be as one is seen to be: "Every representative of the Idea tends to prefer itself to the Idea it manifests. To prefer oneself—there is the fault. The artist, the scholar, must not prefer himself to the Truth he wishes to tell. There is his whole morality; —not the word, nor the phrase, to the Idea he wishes to show. I would almost say, that there is the whole of aesthetics." Along with Schopenhauer and the Stoics Gide then declares that "the doctrines of renunciation do not preach anything else." Narcissus repudiates Echo not from the banal conceit of self-love but from a radical conception of self-regard. Narcissus repudiates Echo in the acknowledgment that anterior to his subjective acts of seeing, his own deepest truth in the world is that he is the objective occasion of sight: "The artist and the man truly a man, who lives for something—

must have made in advance the sacrifice of himself, his whole life is but a procession toward that." How are we to recognize the lifework or art-work of self-manifestation? "One learns that in silence."[28]

In the third and final movement of the treatise we are told that "the Poet is the one who looks": "For Paradise is everywhere; let us not believe appearances. Appearances are imperfect: they stammer the truths which they conceal; the Poet, with but half a word, must understand, then retell these truths. Does the Scholar do anything else? He too seeks the archetype of things and the laws of their succession; he finally recomposes a world, ideally simple, where everything is ordered normally."[29] Monet similarly valorizes his own activity in terms of "the comparison and succession of the entire series," but elsewhere he undermines in both gestures and words Gide's holistic intuition of the truth behind the forms.[30]

In Gide's description of the Poet's activity I see an analogy to Monet at work: "The pious Poet contemplates, he bends over the symbols, and silently descends deeply into the heart of things,—and when he has per-ceived in a vision the Idea, the intimate harmonious Number of its Being which subtends the imperfect form, he seizes it, then, unconcerned for that transitory form which clothed it in time, he knows how to regive it an eternal form, *its* veritable Form finally, and fatal,—paradisical and crystal-line." With identical words Narcissus had earlier noted that all things in the world "strive toward some thing, toward a primordial lost form,—paradisical and crystalline." It is this recovery that distinguishes the artist's intuitive grasp from the scholar's groping among empirical appearances: "For the work of art is a crystal—a partial Paradise in which the Idea reblossoms in its superior purity; in which, as in the vanished Eden, the normal and necessary order has disposed all the forms in a reciprocal and symmetrical dependence, in which the pride of the word does not supplant Thought,—in which the rhythmical and sure phrases, symbols still but pure symbols, in which the utterances become transparent and revealing."[31]

Gide now asks, "Has one understood that I call symbol: *everything that appears.*" This is Gide at his most Platonic, fully committed to the primor-dial myth of Western philosophy that material things matter little in the face of the immaterial truths which they reveal. Works of art transform matter into meaning, but "such works only crystallize in silence." Like Mirbeau, who celebrates Monet's repudiation of the worldly cliques of Paris and his heroic withdrawal into the isolation of Giverny, Gide has a similar vision of solitary creation: "There are silences sometimes in the midst of the crowd, where the refugee-artist like Moses on Sinai isolates

himself, escapes from things, from time, envelops himself in an atmosphere of light over and above the busy multitude."[32] Gide's conflation of Adam-Moses-Christ-Narcissus-Scholar-Poet in a single allegorical figure construes the manifold of past and present as a series of interlocking myths of paradise lost and refound.

Unlike the agony of Adam in the garden, Moses on the mountain, or Christ on the cross, the anguished isolation of Narcissus transpires not in some unique historical location but along the banks of an ordinary river: "Narcissus meanwhile contemplates from the bank this vision that a loving desire transfigures; he dreams. Solitary and youthful, Narcissus falls in love with the fragile image; he bends over the river with the need for a caress, in order to quench his thirst for love. He bends over and suddenly this phantasmagoria disappears; upon the river he no longer sees but two lips before his own that stretch themselves out,—two eyes, his own, that look at him. He understands that it is he,—that he is alone—and that he is in love with his face. All around, an empty azure which his pale arms pierce, stretched out by desire through the broken appearance, and which plunge themselves into an element unknown." It is at this point in the narrative that Valéry consigns Narcissus to a watery death, but Gide transforms the familiar plot: "Then he lifts himself up, a bit; —the face draws away. The surface of the water mottles as before and the vision reappears. But Narcissus tells himself that the kiss is impossible,—one must not desire an image; a gesture to possess it tears it. He is alone. —What to do? —Contemplate. Grave and religious again he takes up his calm attitude; he remains—a symbol that grows,—and, bent over the appearance of the World, vaguely feels absorbed in himself the human generations that pass."[33]

Gide immobilizes Narcissus in the traditional bent-over posture and in his later writing Narcissus often reappears as a figure of the divided self. In *Si le grain ne meurt* of 1926 Gide remembers the lost years of youth when, "like Narcissus, I used to bend over my image; all the phrases that I was writing then remain on that account somewhat bent." Nineteen twenty-six was the year of the incompletion of the *Water Lilies* at the time of Monet's death, and in a passage describing the flower known as *narcissus poeticus* Gide demonstrates a Monet-like sympathy for an extension of the allegory to the rivers and fields: "In these ever solitary meadows, there was an extraordinary profusion of them; they embalmed the air to a far distance all around; certain ones bent their faces over the water, as in the fable that one had taught me, and I did not want to pick them; others half disappeared in the thick grass; but most often, standing high on its stalk in the midst of the dark grass, each one shone like a star."[34]

Through his friendship with painter and critic Jacques-Emile Blanche, Gide stayed abreast of developments in painting. In 1907, for example, Blanche was opposed to the antiillusionistic strategies of Matisse and Cézanne, "the master of a generation of crazed mannerists, of pupils of Gustave Moreau, already rotted through contact with the over-ripe fruits of this maniacal old man." In Blanche's view these men were no longer entitled to the designation of painter if by painter one meant Claude Monet, who sought "to render an object, to copy nature, to draw near to it (via diverse paths)."[35] Moreau and Monet are here deployed antithetically, but at the time of the treatise they were viewed within the circle of Gide and Valéry as a complementary pair.

Valéry's interest in Moreau and Monet is recorded in notes of 1889 for an unpublished volume that was to have been entitled "L'Art inductif." In his notes Valéry joins the name of Rembrandt to those of Moreau and Monet, the former standing among the moderns for the art of "today" and the latter for the art of "tomorrow." In slightly later notes for a project of "fire/water" that was to renovate painting, Valéry places Leonardo da Vinci in the company of Monet as well as the "unseen" Renoir and Pierre Puvis de Chavannes. What characterizes Monet's art at this time is its "materialism" and "complete sensualism," qualities which Valéry returns to in later notes of 1925 on Monet's "extreme poetry of vision" whereby "form and color are exchanged in perception."[36] Elsewhere Valéry allegorizes this perfect reciprocity of the eye and its objects in the split person of the artist-Narcissus. Referring to the artist's almost corporeal oneness with the very medium of his art, Valéry writes: "He is a Narcissus."[37]

If Monet may be said to offer in the surfaces of his art the materialization of Narcissus's gaze, Moreau depicts and describes the statuesque figure himself (fig. 78): "Already the ardent foliage, already the enlacing flower, already the avid vegetation take hold of the adored body of this lover forgetting himself in himself in the ideal contemplation of being. And at night, the beautiful body and this mysterious nature will fuse together in a supreme and ineffable embrace."[38] In the imagery of Moreau and Monet we find the attempted fusion of the embodied self and the cosmos at large. Here again we trace the lines of a cultural archaeology from Kant to Lacan whereby the individual overcomes in fantasy the primordial split caused by bodily insufficiency and the uncontrollable stimuli of the surrounding world.

The personas of Moreau and Monet are curiously linked in the pseudonym of Gide's friend Pierre Louÿs, who signs himself "Claude Moreau" in *Art et Critique*.[39] Monet and Moreau are also linked in the writing of

Camille Mauclair, to which I now turn. Mauclair is yet another young disciple of Mallarmé who worked through his relationship with the master with the aid of the myth of Narcissus: "I am afraid that my ideas may not at all be my own, that impregnated with your works and your theories I may have taken for an interior light their lucid reflection."[40] In the month in which he sent this letter and first met Mallarmé, Mauclair also wrote a review of Monet's *Haystacks* and open-air figure studies for *La Revue Indépendante*. Invoking recent texts by Mirbeau and Geffroy, Mauclair grants Monet the Mallarméan title of "pure artist," "the jewel-setter of smaragdine seas within strands of gold." Monet is placed alongside Gustave Moreau and Puvis de Chavannes within a redemptive "trinity" that promises consolation to those who abominate the "patented and academicized pseudo-talents" of official art.[41]

While Mauclair was reviewing the *Haystacks,* Monet was embarked on the first major water series of Giverny, his twenty-odd paintings of poplars along the banks of the river Epte. To Mallarmé, Monet writes of the "quantities of new canvases" he has under way (28 July 1891; L. 1121), paintings which he describes to Caillebotte as "compromised" despite the fine weather, and regarding the completion of which Monet asks his fellow painter and boatsman for the loan of a craft larger than his Norwegian canoe (24 August, 14 September 1891; L. 1431–32). Not only is the weather variable, but Monet is preoccupied with the purchase of his house, for which he requests an advance of 20,000 francs from Durand-Ruel: "If I can, I will come myself to get [the money] this week, but I can never make anything definite on account of the weather, for since your last visit I have had nothing but disappointments and difficulties with my poor trees, with which I am not satisfied at all" (19 October 1891; L. 1122). In the end Monet prefers to send his son to collect the money rather than make the trip to Paris himself, for "in spite of this nasty weather which makes me despair for my trees, I do not dare leave Giverny and I am taking advantage of it to retouch some canvases" (20 October 1891; L. 1123).

In a letter to an unidentified painter who had apparently asked for his advice, Monet acknowledges his "illness of always hoping to do better, as though one could do what one wished." He then describes the vicissitudes of the *Poplars,* whose essential form still eludes his grasp: "In sum I have yet again struggled for better or for worse with the admirable landscape motif that I had to do in all weathers in order to make only one which would not be of any weather, of any season [W. 1309; fig. 79], and this is reduced to a certain number of good intentions. The moral, one must do what one can while absolutely fucking [*se foutant*] the rest" (November

1891; L. 1124). Perhaps nowhere in his writing does Monet more closely approach the metaphysical narcissism of Mallarmé, Gide, or Valéry, but at the same time the artist's unsublimated idiom remains distinctly his own. In spite of evident differences in literary style, Valéry similarly indulges in a painful meditation on the theme of waterside trees: "Narcissus—Final— Sketch. . . . The night disperses the Narcissus—He no longer sees his hands or his image. He is no more than his strength and his thought. It is not at all death, but the symmetry of death,—*his reflection*—for the soul is *present,* the body *absent.* Then, he is the subject and the prey of a desperate love—Theme of grand trees—in their darkness."[42]

Fifteen or so of Monet's trees were exhibited at Durand-Ruel's in March 1892 (W. 1291–1313; figs. 80–81). By that time Monet was engaged on his paintings of Rouen Cathedral, but he broke off work and traveled to Paris at the end of February in order to hang the *Poplars* and attend the opening of the show. In a letter to Mallarmé, Monet makes a special point of inviting the poet to be present when he does "the honors of my little exhibition" (28 February 1892; L. 1136 bis), and we learn of Mallarmé's response in a letter to Mirbeau: "I, in the matter of exhibitions, I end up no longer looking at anything other than the Monet situated there on my wall; it delights and suffices me. How beautiful it was, the poplars; and now there he is in front of a cathedral; that one is a certain genius."[43] Mirbeau is more expansive on the exhibition in his own letter to Monet: "It is an absolutely admirable work, this series, one work, in which you again renew yourself by way of craft and sensation and in which you attain the absolute beauty of grand decoration. I experienced there complete joys, an emotion that I cannot render, and so profound that I would have wanted to kiss you. The beauty of these lines, the novelty of these lines and their grandeur and the immensity of the sky and the shiver of all of this . . . you understand, my dear Monet, never, never has any artist rendered such things and it is again a revelation of a new Monet."[44]

Mirbeau contrasts Monet's *Poplars* with those of Rollinat, whose poetry Mirbeau considers "an explosion of masturbatory joy." Whereas Monet is described as resonating at the same erotic frequency as nature, Rollinat is said to have no true empathy: "He lends things and creatures functions, meanings that are not theirs." Referring to Rollinat's poem "Les Peupliers," Mirbeau writes: "One expects a quivering, svelte, light music in order to express that spring, that grace, that delicious aerial sonority that is the poplar. Ah well! my dear Monet, the verses make a terrifying and absurd din."[45]

Whereas Mirbeau emphasizes the underlying naturalism of Monet's

and Mallarmé's aesthetic, Valéry, Gide, and Mauclair all emphasize its idealism. There is no evidence that Mauclair discussed Monet's paintings with either Mallarmé or Mirbeau, but as a regular *mardiste* the young writer was in an excellent position to overhear the latest debates at Mallarmé's famous Tuesday gatherings. There the vogue for the artistic analysis of the self had inaugurated "a new state of mind: that of those who examine themselves with frankness."[46]

"Fifteen studies of a single place at various times, the same disposition as for the celebrated *Haystacks,* such is this exhibition. M. Claude Monet appears to have achieved in it the impossible." With that unknowing echo of Monet's own discourse of the impossible, Mauclair commences his account of the artist's work: "His impetuous, extraordinary painting, overflowing with enormous life—whether he sang the sunlit sea, whether he erected silhouettes in the enflamed air and beneath the implacable azure, whether he nuanced snowy and desolate fields, saddened by all the crepuscular or sickly roseate melancholy of a hibernal sun—his painting had for a long time given us the measure of his infinite comprehension of the life of aspects, of his knowledge of lines, colors, and ornamental harmonies, a spectacle of the full possession of an unheard-of genius." Mauclair deemphasizes the transcriptive dimension of Monet's paintings and insists instead on their transcendental significance: "Here M. Monet has arrived at a pictorial ideal in which the triturated matter is no longer of account, in which the pictures are truly made of a dream and a magical breath, in which the process of the color-patch is manipulated so impeccably that it disappears, leaving for the eyes only an insane enchantment that gives a paroxysm to vision, reveals an unsuspected nature, lifts it up unto the symbol by way of this irreal and vertiginous execution."[47]

For Mauclair, Monet's art is an amalgam of reality and dream: "This magician has arrived, by force of knowledge, to give us in the contemplation of his canvases, seen up close, the illusion of a colored rain and a chaos of multicolored spatterings in which no design is disclosed, in which delirium seems to triumph by far; the assertion of a disconcerting sureness of vision, of such an exactitude, of such a faithful rendering of realities that these very realities find themselves suddenly transfigured into the ideal, lose their value as real sensorial notions in order suddenly to double themselves, by way of the phantasmagorical vision of the master, with a mysterious *meaning* which causes them suddenly to participate in the symbolic universe dreamt of by the poets."[48] Recalling Gide's treatise in which the perceived reflection perfectly signifies the imperceptible realm of forms, Mauclair situates Monet's paintings within an idealist tradition that traces

its lineage through Mallarmé and Schopenhauer back to Ovid and Plato. For the critic, Narcissus will turn out to be the embodiment of this improbable contact between the phenomenal and noumenal worlds.

Monet's reflected trees are seen to condense the registers of matter and idea into a double-sided sign: "The trunks of trees, the marvelous shafts of poplars, the grasses, the shivering waters, the rows of slender shrubs berosed by the setting sun are observed by an eye from which nothing real escapes; and up close, their appearance is no longer other than an ocean of pluricolored patches in which one discovers relations of everything and values so unexpected that from the very truth of the vision of the painter surges up this consoling certitude that *the world is as we create it*."[49] This is Mauclair's rendition of Schopenhauer's maxim that the world is our representation. First, from a distance, there are some trees that appear impeccably real to the eye; next, from up close, there are colored patches of paint that equally appeal to the eye; then, suddenly and all at once, both surface and scene disappear and instead of the eye it is now the mind that brings forth a new world.

In keeping with the erotic idiom of contemporary criticism Mauclair initially describes Monet as an artist-lover: "Thereby, in his honest and tireless labor as lover of nature, M. Claude Monet has touched the sublime, the consciousness of a signification, of a reason in things; he has skimmed the philosophy of appearances, he has become conscious of eternal nature in her passing aspects." Love's physical embodiment here gives way to a neo-Platonic fusion of mind and its objects of contemplation: "This for me is the infallible mark of the purest genius: and this is the reason for a respect that pushes me to say that M. Claude Monet is the greatest of landscapists for having known how, while remaining within the strict limits of his art, infinitely to surpass it by way of the mind, to lift the process up unto the sublime, and thus to restore to us an immortal nature which will subsist for a long time in our memories as an apotheosis of light."[50]

Although copies of *La Revue Indépendante* exist in Monet's library at Giverny, there is no evidence that he read Mauclair's article in 1892. Thirty years later Mauclair insisted that "the impressionists did not read us, did not understand us,"[51] yet from Rouen, Monet anxiously writes to Durand-Ruel for information on "the effect produced by my *Poplars*" (9 March 1892; L. 1138). In a letter to Mme Hoschedé, Monet indirectly approaches the concerns of Mauclair: "I have enormous luck with this weather, but I have now taken up such a singular method of working that I work in vain; it does not move visibly forward inasmuch as each day I discover

things not seen the day before: I add and I lose certain things. In sum, I am seeking the impossible" (9 April 1892; L. 1151). Without benefit of symbolist theory Monet invokes the impossible less in the sublime register of Mauclair's text than in the language of melancholic despair; the occasion is yet another instance of Monet's deferral of his promised return. It is perhaps a point of irony that in order to facilitate one such recent visit home the self-absorbed artist requests Mme Hoschedé to send to meet him "le beau Narcisse" (26 March 1892; L. 1142).

I do not know who this handsome Narcissus was nor do I mean to suggest that the myth of Narcissus was in any way present in Monet's mind at this or any other time. Nevertheless I wonder whether Monet, as a sometime reader of *La Revue Blanche,* would have noted with any interest the publication of Mauclair's poem "Narcisse" only several months after the critic's adulatory article on the *Poplars.* At about this time Monet was once again in regular correspondence with Mauclair's mentor Mallarmé, who had managed to interest the director of Fine Arts in a visit to Giverny with the aim of purchasing a painting for the Luxembourg Museum (11 May 1892; L. 1156 bis). Though mentioned in the press by Mauclair and others, the proposed acquisition never took place.

Mauclair's poem is dedicated to André Gide, yet the changing illumination of the scene equally recalls the sunset, dusk, and evening effects of the *Poplars* series: "A golden sickly sky cries, empurples and burns / In the fragile water of a spring at dusk. / It is the hour when starred with luminous eyes, the azure / Is astounded, in its exquisite candor, by the future / Exile of the foliage with which the water is strewn / And which, beneath the indecisive and swooning light / Sweet death rocks itself in distant murmuring, / Dedicating a sorrowful silence to the vain reflection / Of a young man swooned upon his smile."[52] In an earlier review Mauclair had described the *Haystacks* as "saddened by all the crepuscular or sickly roseate melancholy of a hibernal sun,"[53] and here it is the waterside decor of Narcissus that takes on this sorrowful color and mood. Geffroy, whose writing Mauclair had expressly claimed to admire, employs comparable phrases in his description of the *Poplars:* "The pure matutinal light ignites, burns, dissolves the tender treetops in pink ash. Noon resounds visibly in luminous notes above the blossoming landscape in the heat. The night comes, plunges the space into mourning, changes the masses of foliage into curtains of lace, pacifies the reflections upon the water, neutralizes the colors."[54]

In the waters at his feet Narcissus sees his own universality reflected: "And it is you yourself, / O you my mouth unslaked and without hope /

Of breaking this implacable crystal, and of having / Beneath your burning a burning of petals!"[55] The darkness of evening is the natural backdrop for the recognition that the desired other is but a fading reflection of oneself. Monet's critics also insist on the melancholy that accompanies the failing of the light, "when the poplars plunge, tragically, into the moist sadness of the night."[56]

Night blinds Narcissus and obliterates the reflected image: "O reflection! Illusory silk where I lie down / And from which, fluid, this crystal banishes my flesh / In the divine and mournful fall of the bright night, / Radiate an exile of myself toward the shadow / Yes, there I want to recover the vast or somber secret!" The transient image of Narcissus disappears "in the shiverings of the dismal water."[57] The familiar word *frisson* is repeatedly used to characterize Monet's poplars, which shiver "in the coolness of the dawn"; in these paintings it is the "grand design of things" that Monet traces "by way of the slight shiver of the leaves, and which he repeats and renders symmetrical by way of the reflection in the trembling water of this crown suspended in the fluid air."[58]

In this inverted crown of shivering foliage Monet's critics come as near to naming Narcissus as they will do. Here Geffroy draws from the same literary reservoir as does Mauclair, their most notable antecedent perhaps being the letter of Cyrano de Bergerac appropriated twenty years before by Verlaine: "My chest lain down upon the turf of a river, and my back stretched out beneath the branches of a willow that mirrors itself there, I see renewed in the trees the story of Narcissus; one hundred poplars thrust one hundred other poplars into the water, and the aquatic ones were so terrified by their fall that they still tremble every day from the wind that touches them not."[59]

In Cyrano's meditation upon "this fluid mirror," "this little inverted world," the reflected trees are former nymphs who like Daphne have resisted the blandishments of Apollo and have in consequence thrust themselves into the river or been thrust there by the god.[60] For Mauclair the gods still harbor such primal powers, but they are also incarnate in the self: "O powerful gods! I love myself, I love myself! / . . . Everything is born in me, everything dies there!"[61] As Geffroy writes of Monet, "never yet had the pantheistic poem been written in so strong and moving a manner."[62]

In 1892 Narcissus is an emblem of "eternal love," of the eternal moment of mind face to face with its own mortality. This entails both celebration and lament: "But alas, amidst the end of day, / A too jealous crystal refuses you to my mouth, / Flower of my lips! reflection where my hand

touches / Only a puerile troubling of the juvenile water. And alone / I hear sobbing in his chaste shroud / Where formerly throbbed the hope of a sweeter dream / That being on whose account I die from adoring the lie. / Flowers rise up, come toward me, encircle my forehead, / Lily-like beneath the impalpable shade, and the depth / Of my poor soul in which silence is inflected / Is filled with a somnolent and sorrowful dusk."[63] In his flower-wreathed portrait of a dying Narcissus, Mauclair rejoins the traditional iconography of the youth whose demise is marked by the bending blossoms that bear his name. This figural tradition is carried on into the 1890s by Gustave Moreau and by his pupils, such as George Desvallières (fig. 82), but in the transient play of light and shade Mauclair also shares in the imagery of the *Poplars* as described by the critic Clément Janin: "This master of the impression, who notes with a so troubling precision the unseizable slipping of the Hours, who plays with the impalpable, measures himself with respect to the dream, in spite of all these elements—translators of a particularly mobile state of matter and mind—suggests to us the idea of Indestructibility by way of what one divines beneath the essentially fleeting form of things, the presence of the primary cause, of the ever subsisting, ever ready force that will remake tomorrow, at an undetermined but certain minute, what it has done today. M. Monet does not translate Nature; he uses Nature to translate Eternity."[64] In this passage echoes of the philosophy of force of Spencer and Schopenhauer resonate alongside the symbolist imagery of Valéry, Gide, and Mauclair.

Janin's description of "what one calls the series of poplars" parallels the writing of Mauclair in many particulars: "Three or four poplars along the edge of a marsh. Their tops reflect themselves in the water; the hair of their heads shiver against the sky; other poplars, farther away, flee into the distance of a road, this repeated fifteen times, at all the hours of the day, with all the varieties of aspect which the modifications of the ambient atmosphere and light bring to things; here, the clear and soft song of a summer day's end, before the falling of the night but when the firmament already is mottled and a disquiet of light amethyst or turquoise troubles the cerulean serenity of the horizon; there, in the ferocious depths of infinity, dark lapis masses up through which the rays of the sun concentrate and burn; elsewhere, resembling pink ships upon Oriental seas, pink upon a sky of forget-me-nots, frail clouds sail by pushed by the evening breeze; and, everywhere, the poplars sleep, breathe, and rustle, shooting up their supple trunks, melding the living efflorescence of their own life with that great collective life of nature." In Janin's anthropomorphic images of shivering heads reflected in the water and supple limbs reaching out to embrace

the world we find the landscape equivalent of the self-conscious Narcissus. In order to read such an allegory in Monet's reflected trees "one less needs eyes than a poet's and psychologist's brain."[65]

Janin understands Monet's art as the repudiation of empirical analysis in favor of repetition and synthesis: "To give the idea of this whole that is a stack of straw or a tree, a single reproduction was not enough; it was necessary to make the rounds of this idea-tree, of this idea-stack, to show its persisting life through the multiple influences of the day and the seasons." Through his "elimination, in art, of all that is particular or accidental, so as to allow to subsist only that which is characteristic of the species, diversified by the indications of time and place," Monet's trees are at once real and ideal. The duality of Janin's account closely parallels Gide's and Mauclair's: "His atmospheres, his terrains, his vegetations are true with a typical truth, and diversify themselves, according to the hour or the season, by way of the richest, as the most exact, sheathing of exquisite and marvelous colors. The division of color furnishes him the means of realizing his dream, but the process is of no account if the brain does not receive the intense sensation that the hand must translate." Monet's "decorator's talent" becomes the vehicle for symbolic meaning as the visible surface of the real is made to manifest an imaginary truth.[66]

One of the chief advocates of the decorative mode is Georges Lecomte, who insists that the "concern for decorative beauty" is the "distinctive mark" of the greatest art of both the past and the present: "Finally, the vigorous talent of M. Claude Monet, who . . . limited himself—but with what power of evocation!—to rendering rapid natural effects in their fugacious intensity, seems more and more to abstract from complex appearances the durable character of things, to accentuate through a more synthetic and reflective rendering their meaning and their decorative beauty."[67] Lecomte offers an account of Monet's *Poplars* in which figures of allegory and myth are veiled beneath an imagery that still cleaves to the visible surfaces of water and trees: "Their tall nude trunks rise up along the banks of a river which slowly snakes amongst the fields. They reflect their haughty slenderness in its limpidity. The balls of foliage which crown their tops are, in the sky, like a mobile and rebellious head of hair, like a soft plume of glory. . . . At their feet, wild vegetations become entangled, attempt escalades, then fall back, mixed up, bushy, toward the calm water that reflects them. . . . And, within the melodious liveliness of its banks the tranquil mirror of the river, which repeats all this joy in attenuated form, seems not to flow away!" Lecomte also emphasizes the austerity of Monet's representation: "The stiff majesty of the poplar that carries high

its short bouquet of leaves, its nervous silhouette like zigzags of lightning, and its yellow-greenish tones possess a moving grandeur." The scenario of the naked swaying trunk and the stilled watery mirror might seem to clear a way for Narcissus to appear, but his figure is displaced from the plane of the depicted body to that of the artist's depictive gesture: "Seventeen times, M. Claude Monet repeats the same motif; but he interprets it in diverse atmospheres and lights and never does the motif retain the same meaning. The artist perceives and expresses all the metamorphoses by which nature, always the same nonetheless, renews its decor."[68]

As in Ovid, Lecomte's metamorphoses are performed in nature across the axis of time:

> Now the poplars vividly detach their intense greenery from a gray or light lilac sky; now dried and yellowed, their leaves that scatter to the wind shiver with reflections of gold, in still sunny atmospheres of autumn. Or else, it is spring and the fresh tones of the young growths, the joyous burst of buds that sing in the pink morning, the luxuriance of summer foliage that opens its splendor in the glory of radiant sunshine. Finally, the gleams of dawn, the oranges of the setting sun, the purples of dusk, and the subtle mystery of shadowy envelopments by turns modify the physiognomy of the trees. And the limpid water of the little river that seems not to flow reflects the melancholic gray skies, the golden shiverings of the autumn, the dewy freshness of the spring, the illumination of summer, its pinks, its oranges, and its purples. Finally, when the mystery of the night spreads over it, it still remains transparent and luminous even though there is no more light in the sky![69]

"Now . . . , now . . . Or else, . . . Finally, . . . And . . . Finally . . . !": in their syncopated repetition these temporal indicators end up by transposing the physical extension of Monet's series into a realm of perpetual time.

Lecomte sums up his meditation on Monet in the formula "nature and dream all at once."[70] The reciprocity of empirical observation and self-reflexive imagination is the theme of much of the art and science of the 1890s. "Nature and dream all at once" might have been both Mallarmé's and Freud's motto during these years, and for poets, painters, and philosophers Narcissus incarnates the torn dialectic of embodied thought.

G.-Albert Aurier is the critic who perhaps comes closest to a frank application of allegory to the paintings of Monet. In an article on Monet published in the *Mercure de France* in April 1892 Aurier appropriates the mythology not of Greece but of the Near East: "In the beginning, alleges an old tradition of the Chaldees, Baal created the heaven and the earth

and the gods. Then, he ordered one of them to cut off his head, to throw it into space, and to spread upon the world the blood that would flow from his neck. . . . And, since that ineffable hour, the blinding head of Baal rolls, majestic and without cease, in infinity, inundating with light, life, joy, and beauty his daughter, his lover, the earth." This originary event engendered an ancient corps of priests, and in Aurier's view Claude Monet is their modern descendant, "one of those unconscious depositaries of the ancient truths, on behalf of which, in spite of themselves and no matter what they do, souls and hands eternally appear to officiate, according to new and unforeseen rites, at the glorious mass of lights in a modern temple of the sun." This recalls Gide's imagery of priests bent over the hieroglyphic truths written in nature's book, and in Aurier's subsequent image of the temple of the sun we come closer still to the crystalline metaphor of Gide's text: "A fantastic temple, dazzling and joyous, whose walls and ceilings would be of pure crystal carved in prismatic bevels. . . . A temple of transparent crystal erected upon a high hill in such a way as to be inflamed, from all the points of the horizon as well as of the zenith, by the gleamings of the star. . . . A temple where the light, the good, gay, holy light of the sky unceasingly floods down, metamorphosed into a dazzling deluge of gems by the translucent prisms and rhomboids of the walls and roofs."[71]

It is in this solar temple that Aurier situates Monet, "a somewhat schismatic priest of the religion of Baal, infinitely more benevolent and good-natured than his Mesopotamian ancestors, a pious and gay priest, very inexpert to be sure in theogonic myths but adoring with fervor, but truly loving his god with love, his benevolent, smiling, not at all sanguinary Baal, his Sun, his divine Sun, sower of all the splendors and all the joys, and addressing to him, kneeling down in the midst of blinding rays, effervescent and joyous, infinitely jaculatory prayers though perhaps somewhat too, if I dare say it this way, telegraphic." Aurier's reservations concerning what he calls Monet's telegraphy parallels the allegations of many earlier critics concerning the artist's sketchlike haste in execution. What makes Aurier's utilization of the critical commonplace interesting is his assimilation of the painter's rapid brush technique to the ejaculatory urgency of both religion and sexuality: "Such are, I believe, and in spite of the insanity of such an allegory, the work and destiny of Claude Monet, an exclusive and passionate adorer of the omnipotence of the sun in the dark molehill of our age."[72]

Aurier's disclaimer concerning the unlikeliness of his allegory in no way annuls the metaphorical productivity of his text. After repeating his

reservations concerning "the rudimentariness of these instantaneous sketches," Aurier admits that he cannot withhold his admiration for "the magician who has known how to steal, for us, the fabulous gems scattered in the gleaming hair of the wandering head of Baal."[73]

The allegory of Monet's "heliotheism" stands in contrast to Aurier's insistence on the artist's unscholarly habits of mind: "He does not wish to argue at all, he does not wish to explain a thing, he is satisfied to love, to fuse himself with the burning effluvium of the glorious globe, to adore and to be amazed, and his adoration and his amazement and his loving felicity are all he esteems worthy of being expressed." Aurier concedes that it is "not without some unavowed coquetry" that Monet chooses "insignificant pretexts, banal subjects, in order to metamorphose these nothings into enchantments, into radiant poems: a haystack on a plain, a ravine of the Creuse, a few waves of the Mediterranean, a few poplars on the banks of the Epte; it suffices for him to bathe all this in the divine bedazzlement with which his eyes and his fingers are full in order that this contemptible reality be transmuted into a delicious paradise flowering with gems and with smiles."[74] Aurier's idealized scenario of metamorphosis evokes the decor of the Narcissus legends of Valéry, Gide, and Mauclair.

Among Monet's critics it is Mauclair who enunciates the most extreme version of idealism. In "Notes sur l'idée pure," published in September 1892 in the *Mercure de France,* Mauclair brings Narcissus together with the figure of the artist, and Mallarmé provides the epigraph for the article: "What good is the miracle of transposing a fact of nature into its almost vibratory disappearance according to the play of the word, however, if it is not so that from it may emanate, without the constraint of a near or concrete reminder, the pure notion?" In the opening sentence Mauclair tersely restates his master's doctrine: "Every object is reabsorbed in its pure idea."[75]

As an example of objective idealism Mauclair cites the flower: "Its notion endures from the lilies that have not faded to the lotus of the Orient. And this rose at my fingers manifests this notion in diverse modalities or substantive aggregates which are revealed to my senses in the form of perfumes, nuances, lines, etc. But this evidently only serves to make me remember, through a passing intervention that a moment may pluck or burn, the idea that is immanent in the object." According to Mauclair "the idealist thus conceives by way of the plastic mediator or symbol constituted by the object." In a typical metaphor of the period Mauclair presents his theory of symbolism as an analogue of electrical dynamics. Just as a battery stores or "condenses" electrical energy in the form of chemical substance,

so too "the symbol, for the idealist, is nought but the means to the idea." Pursuing his analogy into yet another realm, Mauclair defines "the intimate axiom of painting: the motif mattering only by reason of its revelation of the light."[76]

Light, then, is the "pure idea" of painting. A task such as Monet's is worthwhile for Mauclair only when the perceptual field is displayed not for itself but for what it reveals: "Naturalism, for example, could only, can only be the vain study of symbols: and, as the attentive examination of a battery in no way reveals the electrical influence, or the examination of a cadaver the life, but only the means of perceiving the electricity or the life, so the sole study of the object is imprinted with an inevitable vanity since it trusts and results in contingencies." With admirable concision Mauclair insists, "there is always something behind some thing."[77]

If painting were a matter of contingent appearance alone it would be "a vain thing indeed." Appearance is the mere stuff of the world, and its utility is that it may be converted through thought into "the momentary fixation of the abstract": "It results that the meditator, by becoming conscious of incarnate ideas, tends to lift himself up to the comprehension of general laws and their associations, and consequently cannot neglect metaphysics."[78] Six months earlier Mauclair had written much the same thing in his article on Monet, who lifts up nature "unto the symbol by way of this irreal and vertiginous execution."[79]

Many words and phrases from the Monet text of March reappear in the metaphysical text of September. In the earlier review it is the spectator who endures a paroxysm of vision in the face of Monet's unsuspected revelation; in the later speculation it is the artist who is constituted as a subject of consciousness in the instant of this paroxysm. Perception at its paroxysmic extreme may endanger the physical organism of the artist, but such conditions endow the otherwise "puerile" object with a "symbolic potency" whose erotic idiom is surely not haphazard in Mauclair's account: "The more it manifests itself, the more it reveals: the idealist cherishes revelation." Mauclair insists that the plenitude of life is only the means of an "unveiling": "It may be formulated that objects are hieroglyphic characters in which the pure idea is complexly inscribed, and that in this assemblage of forms, as in any geometry, the profound knowledge and the careful formulation of the script or the figures aid in comprehension and endow the reading with greater clarity."[80]

In his vocabulary of *écriture, lecture,* and *signification* Mauclair manifests the metaphysical desire for a total comprehension of the world's signs: "The mind tends toward the complete understanding of this script."

Mauclair acknowledges the utility of classifying the forms of the world's self-inscriptions, its "colors, sounds, linealities," but for this idealist the tabular mentality of empiricism entails a fatal flaw: "The error came fatally from this fact that: the work, coming into being only within a single consciousness at one time, only admits the validity of these notions after they have been recreated by the individual for himself, whence the recommencement and differentiation of ideas."[81] This footnoted acknowledgment of repetition as difference imperils the intersubjective modality of Mauclair's objective idealism, but from its relegated position at the bottom of the page Mauclair's note scarcely diverts the main movement of the text.

For Mauclair the metaphysical reading of nature yields "a meaning, which is the notion of pure ideas or the revelation of the inalterable within the modified, of the type within the descendants, of the primordial within the evolution." Pictorial matter is the symbol of an immaterial light; similarly, "the artist is the symbol of his work." Striving "against any diminution and any deformation of the harmony," the artist seeks to forestall the anarchy of appearance and to evoke the single "cause within the multiple rite of objects." Aesthetic harmony thus becomes synonymous with virtue, and the desire for form comes to comprise the ethic of self-constitution: "Finally the being who lifts himself up from real knowledge to ideal knowledge is a synthesizer of art, a recreator reflecting his consciousness in his acts—the work is the act of art—and reflecting as well his acts in his consciousness, like Narcissus. This parallelism constitutes the rhythm or personality of the aesthetician. Hence, moral state indivisible from artistic state."[82] Monet's art is thus Monet's most moral act and the watery reflections of Giverny become the looking glasses of his soul.

Mauclair affirms that his philosophy is the "undeniable preoccupation of the new intellectuals!" His pet term for this trend is "ideorealism," which he defines as "occupying itself with the realization of ideas in a plastic medium (Goethe, Poe, Mallarmé), Idealism considering Ideas in themselves (Plato, Hegel), the one completes, explicates, justifies the other." For Mauclair "ideorealism" is both an aesthetic and an ethic, "a mode of consciousness and an individual asceticism." Entailed here is the notion of the artist's solitude, his repudiation of the lures of society which Mauclair further valorizes by way of reference to Thomas Carlyle's doctrine of the artist as hero: "The poet who manifests himself to the crowd does nought but manifest to it a type of superior man." Nietzsche's *Ubermensch* and Barrès's *Culte du moi* are implicated here as well, but Narcissus is the mythological avatar of this ethical posture. The manifestation of the self is seen as a potentially radical social act, for in the person of the autonomous

artist the members of society "all contemplate what they could be and take consciousness of themselves."[83]

Narcissus is the apotheosis of the artist and his pool is the mirror of the work in which "the pure crystal of the visible Idea is unpolluted." Through an implicitly political strategy of allegory Mauclair reaffirms "the flourishing and honored legend of ancient hermeticisms, the reforged and reknotted symbolic chain over and above the crumblings of time."[84] In the early 1890s it was not yet apparent that the antique revival of which Mauclair is an important part would ultimately bear the marks of fascism, but in the light of subsequent events in his own life during the Vichy regime it is hard to resist seeing in Mauclair's political narcissism the anticipation of an ultraconservative ideology.[85]

Mauclair published his most comprehensive treatise on aesthetic and ethical narcissism in 1894 in the form of a book entitled *Eleusis: Causeries sur la cité intérieure*. Although Monet is not compared to Narcissus, he is mentioned as a paradigmatic modern artist, and indeed Mauclair's *Eleusis* is the only text where I can actually point to the names of Narcissus and Monet within the confines of a single work. Mauclair cites Monet's *Haystacks* and "resplendent" *Poplars* as prime instances of what he calls illusion: "Study them, these soft, powdery, greenish skies, snows, suns, leafy opulences of the autumn, always the delicate sensation of a mirage is reborn, and the slight fear of seeing these decors of nature vanish in a breath mixes in a sharp and special taste." The importance of these paintings by Monet (and Mauclair also cites the less well known landscapes of Degas) lies in the "absolute dissimilarity between what is on the canvas and what is represented thereon." This is Mauclair's axiom for art and it is the foundation of his ethical imperative of self-manifestation as well: "For drawing is not the graphic notation of the differentiations in colored planes, but the means of thereby imposing the illusion: and the more the drawing frees itself from the graphic, an optical error, the more it becomes the fictive work of the illusionist, the more its worth." Monet's tangible artifice is exemplary here: "The interpretations of poplars by Claude Monet, so assured of a truth and yet so little conformable to it, are so subtle as to be inconceivable in this sense. The interest of the site does not lie in its contour but in its plastic material, and what pictorially counts is this plasma." This is a near paraphrase of Mauclair's review of the *Poplars*, as is his concluding sentence on the affective solicitations of Monet's art: "Admirable art, such that the man who is destined for it thinks in violet, becomes sad in aquamarine, rejoices in purple, or, what do I know!, a morality supplemented by nuances, according to a marvel of nature."[86]

A long chapter on Narcissus opens Mauclair's informal book of modern mysteries patterned after the Eleusinian cults of ancient Greece. Dedicated to the seasonally reenacted abduction of Persephone and her return from Hades, the Eleusinian mysteries ritually encode the cycle of the earth's vegetation. According to a well-known tradition, Persephone was lured into Hades' clutch by the sight of narcissi in the field and was moreover rendered insensible by their narcotic appeal.[87] The waterside narcosis of Narcissus partakes of this ancient cult of death and renewal, and Mauclair accordingly places the self-mirroring man rather than the ravaged maid at the center of his modern mystery.

Mauclair's book "of idealist faith is respectfully and filially dedicated" to Mallarmé, and Narcissus is the icon of the cult: "We stand before life as before a glass, and we contemplate ourselves in it." Mauclair's self-contemplation derives from Kant: "The laws of the mind proclaiming that sensation exists in this alone, that it is perceived, and perception being a purely intellectual property, man, in thinking of phenomena, cannot but take consciousness of his own intellect." Mauclair's epistemology is joined to Mallarmé's poetics in the image that Richard Rorty has shown to subtend virtually the whole of Western metaphysics: "It is said of every human being examining a notion that he reflects: the same term expresses the property of the mirror."[88] By way of the metonymy of the mirror Narcissus becomes the allegorical figure of thought.

Here in telescoped form is a series of vignettes of Narcissus:

> Strange and naive child, in love with his image contemplated in a lucid water, dying of languor on the bank, bent over toward the illusory rose of his lips seen and desired by his real lips, bit by bit expiring and fading in his flesh in order to blossom into white petals around a heart of gold, eternal and sterile child, Narcissus, whose history and fatality and all his vital emotions are contained in: to find himself beautiful, to die and to flower again. . . .

> Bent over the river, he distracts himself with the glaucous flight of the water upon the reeds. . . . His image, seen in the fugitive mirror, is nought but the allegory in which, suddenly, he takes consciousness of that love of himself that he contained without knowing it. . . . Narcissus loves himself. The first age of thought has been accomplished. . . .

> Loving everything in himself, Narcissus is Love. Beyond his Ego [Moi], he begins to conceive of his Self [Soi], which his body represents and which is his veritable end. . . .

His story, begun in coquetry, developed in sensuality, completes itself in thought. . . . It is no longer in the river that he contemplates himself and loves himself, it is in the whole of Life. . . .

A sign of his adventure—a flower with a heart of gold blossoms, an efflorescence of matter. It perpetuates the symbolic name of Narcissus.[89]

In narrating this account Mauclair draws on the literary resources of Ovid, Valéry, and Gide as well as on the iconographical tradition of Poussin and Moreau. Nonetheless Monet's "symbolic universe dreamed of by the poets" remains an implicit backdrop to the action.[90]

Like Gide, Mauclair appends several explanatory notes to his allegorical text. In the "metaphysical note" Mauclair acclaims the Narcissus myth the "most sublime" allegory of human thought, "for here is the union of the knowing and the known, of the perception and the perceived." Long before Valéry notes down his metaphysic of the myth, Mauclair fuses bits and pieces of German philosophical idealism and French political anarchism into an epistemological theory and ethical praxis of his own: "Narcissus, loving himself in himself, body, soul, intellect, loving everything in himself, desired to exit from his Ego by way of love of the Self. I understand by Self the ideal end of the comparison between phenomena and the mind— by Ego, the contingent figuration of the Self, the human form which manifests it, or: its symbol." The reflected body of Narcissus is the symbol of his self just as the surfaces of Monet's art comprise the symbols of an immaterial realm of ideas: "Thus Narcissus has reascended from his symbol, from his material incarnation, to himself." Here Mauclair acknowledges his allegiance to the anti-Cartesian tradition of psychological displacement which runs prominently in French literature from Arthur Rimbaud to Jacques Lacan via the following quotation from Barrès: "I am not that frail man that you see: but I only live there."[91]

It is a paradox of Mauclair's theory that the I that resides in the body accedes to its intuition of ideality only in consequence of the fullest activation of its sensory apparatus. As an example of the self-reflective implications of sensuous experience Mauclair alludes to Le Traité du Narcisse: "Narcissus picked the forbidden fruit of the tree Ygdrasil: he surpassed . . . the right to remain a man. . . . For no man surpasses his ego except ideally: he tends in that direction only: it is what one calls the dream."[92] In the generation prior to The Interpretation of Dreams (1900) and the elaboration of the ego-ideal in the essay "On Narcissism: An Introduction" (1914), Freud's forerunners were precisely the poets and critics who insisted on the self-regulatory mechanism of narcissistic introspection. Like Narcissus,

Monet also achieves the ideality of dream only by means of an obsessive fixation upon the real, and in the last sentence in the article on the *Poplars* Mauclair neatly anticipates the corresponding phrases in his later "metaphysical note." In 1894 it is Narcissus who surpasses the realm of the senses; in 1892 it is the painter who is applauded "for having known how, while remaining within the strict limits of his art, infinitely to surpass it by way of the mind."[93] To surpass the limit of the real is at once an act of transgression and transcendence; for if Monet-Narcissus proves incapable of finally tasting the forbidden fruit because of the body's embeddedness within the physical world, the painter and the boy nonetheless are seen to pass beyond the perceptual limit of sense impressions into the register of ideas: "He is dead; the substance of the symbol that was his body, no longer signifying his mind but rather constraining it, has been abolished. Narcissus, liberated, has become immaterial, truly a pure idea."[94]

In his second note Mauclair passes from metaphysics to theology and again repeats the terms of Gide's treatise in claiming Narcissus as the "pagan Jesus." Narcissus and Christ are seen by Mauclair as "masters of the mirages of the Incarnation," and their interchangeability is confirmed in virtue of their transformation into signs: "of the one the blood of the Grail, of the other the flower with the heart of gold, witness of their momentary incarnation." In Mauclair's third and final aesthetic note, the symbolic network of the flower and the blood is extended to include the poet whose posture above the page comes to stand as his own allegorical sign: "Then, ingenuous, he bends over the river of tumultuous appearances which fleetingly enlace, sparkle, sing; and he contemplates in this running pool his immobile image."[95]

The poet's bent-over posture gives rise to an intuition: "The poet, having conceived the truths that reside behind the forms, knots in a gesture of grace and of rhythm the innumerable relativities of forms."[96] In a partial anticipation of the psychoanalytic tradition, Mauclair imagines the introspective solitude of aesthetic idealism to be capable of yielding "the triumph of the Conscious over the Unconscious."[97] What makes Mauclair the near forerunner of psychoanalytic thought is his acknowledgment of dreams and works of art as knotted configurations of sensory impressions and otherwise inaccessible states of mind. Racine and Mallarmé provide examples of such a practice of the poet who takes up the multithreaded skein of appearance: "He knots them into a single tress, hairdo of Bérénice, ideal headdress of a glacial Hérodiade."[98] The inverted and shivering *chevelure* of Monet's *Poplars* might be added here as well.

The narcissistic artist sees in the world his own reflected image, but

this image has value only as a reflex of the ethical act of self-manifestation: "To manifest oneself, it is to be like the light that exists only insofar as it creates the shade: for if the shade were to conceive of the light, it would itself be the light. But it knows nothing." The painting or the poem is not an illumination of the world but merely its symbol or shadow; or, as Mauclair puts it within the context of the self, "the ego tends to represent God, not to be [God]."[99]

As Mauclair looks about him in 1894 he sees many artists who willfully embrace the pain of Narcissus: "The present moment shows me spiritual brothers smitten with this abstract intoxication, this holy sadism. Yes, Narcissuses they are, and I too. . . . All of them confine themselves to themselves, and all of them are Narcissuses, from taste, from need, and from a horror of anything other than their own image."[100] Whatever may have been the sociological facts of the matter—and indeed Balzac had long since written that all poets are "more or less Narcissuses"—Mauclair's observation is not restricted to artistic behavior but aims at a universal psychological condition.[101] As Narcissus is the sign of the artist, the artist is the sign of us all, "for we all are Narcissuses, depositories of the world, and you attest for us, o flower of our instinct, refuge of ourselves, omnipotent witness, heart of gold."[102]

One result of Mauclair's self-absorption is to invert the traditional motto of the avant-garde. The famous romantic-realist battle cry of Daumier and Thoré—"il faut être de son temps"—is now reformulated by Mauclair as "one must be liberated from one's time."[103] Mauclair's strategy of isolation and withdrawal ostensibly mimes the radical anarchist attitudes of Mirbeau and Mallarmé, but the ambiguity of its political implications leaves many activist writers unmoved in 1895. In opposition to Mauclair, Edmond Pilon insists that "whatever may be the intensity of life manifested by a few very rare individuals, most of them were solitary and haughty Narcissuses."[104] This is the vain Narcissus of traditional emblematics and of Baudelaire's romantic disdain rather than the renovated Narcissus of modernist self-consciousness; in spite of this symbolist transvaluation, the perversion of self-love remained the standard interpretation of the myth during the course of the 1890s and hence the basis for Havelock Ellis's and later Freud's descriptions of a rare form of autoerotic pathology.[105] Another anti-idealist version of Narcissus is that of the naturist poet Saint-Georges de Bouhélier, who implicitly castigates Valéry, Gide, and Mauclair for their solipsistic reading of the myth. Wishing to stress the human need for social solidarity and collective action, Saint-Georges de Bouhélier writes, "it would suffice to look. —But Narcissus, in love, bends over." For this

author of the *Discours sur la mort de Narcisse, ou l'impérieuse métamorphose: Théorie de l'amour,* to forsake the upright posture and straight-ahead vision of communal life is foolish: "Narcissus was pure, candid, and charming, like a seraph. —The flora loved him no less than the nymphs of the forests. —One day, having bent over the surface of a river, his shadow in the water appeared. The lovable pride of its attitude surprises him. He finds himself so exquisite that he thinks it impossible that any person be more beautiful. He ceases to seek some nymph whose splendor surpasses his grace. —That is why ever since he has been the Indifferent One." The salvation of Narcissus would have been to embrace the social world as represented by Echo (fig. 83); his death thus bears the trace of the vengeance of Venus, and its sign is the flower that in warning perpetuates his name: "Opaque, the water cracks, heavy, numbly. From the green and thick fissure springs up the miraculous flower."[106] Is it the repudiated face of the feminine other that Monet paints in the landscape; or is it his masculine self alone that he loves as reflected on her face?

Allegories of Narcissus:
Régnier, Gasquet,
Rollinat (1895–99)

THE BENT-OVER POSTURE of the symbolist artist is embodied at the Salon of 1895 in the figure of Echo, vainly bending over the upturned corpse of Narcissus, who would not reciprocate her love. As depicted by Léon Oble, an obscure pupil of Luc-Olivier Merson and Jean-Léon Gérôme, the gap between desire and possession reverberates with the sobs of Echo, who laments the antisocial consequences of self-reflection (fig. 84). In 1895 Monet exhibited a series of river reflections, but if for him there subsists any vividness at all in the Narcissus myth, it is displaced onto a "curtain of poplars along the banks of a river, whose tragic forms rise up, with admirable clarity, against an azure sky punctuated with pink by way of an entire flotilla of clouds" (W. 1292, 1302, 1309); onto "the combined effects of the light and the frost, the ice and the wintry sun, upon the waters" (W. 1333, 1336, 1344); and onto "his dear little town of Vernon [which] has always had the love of the artist: in all weathers, gray or foggy, sad or sunny, he loves to see her bathing in the river, doubling herself, dissolving herself therein" (W. 1386–91).[1] A repetition of motifs of the prior decade, these water paintings lend Monet's career a retrospective dimension of self-absorption even as they touch on the contemporary discourse of self-reflection.

Reflections are repeated in a number of individual paintings, pairings, and groupings that Monet displayed alongside his major showing of twenty paintings of Rouen Cathedral in 1895. Along with the *Cathedrals* Monet exhibited some seventeen riverside subjects from Vétheuil in 1878, Holland in 1886, the Creuse in 1889, Giverny in 1891, Bennecourt in 1893, Port-Villez and Vernon in 1894, Norway in 1895. Six Hokusai-like paintings of snowclad Mount Kolsaas in Norway formed a waterless group apart.

As he writes to Geffroy, "I have not been able to see a bit of sea or any water at all; everything is frozen and covered with snow" (26 February 1895; L. 1274).

In 1895 and to this day the predominance of critical response has focused on Monet's massive display of *Cathedrals,* but here I will discuss the general commentary only as related to the various water paintings that formed subordinate aspects of the show. Published to coincide with the exhibition's opening, Geffroy's review probably reflects some degree of prior consultation with the artist. In the face of the retrospective continuity of the works on display the critic stresses the anxious pursuit over the course of thirty years of Monet's singular vision: "It is his dream of light which he causes to rise up before him in the stones of Rouen. . . . It is this dream which he deciphers along the banks of the Seine amongst these phantom houses, trees, upon the surface of this deep water."[2]

What is the nature of Monet's dream and how does it relate to what another writer of 1895 calls "our most hidden dreams"?[3] Geffroy points to an intuitive fusion of realms: "The real is present, and it is transfigured. . . . It is everywhere a reality at once immutable and changing. Matter is present, submitted to a luminous phantasmagoria. What Monet paints is the space that exists between himself and things." Like Narcissus bending over the source in the attempt to annul the gap between his body and its unseizable image, Monet is seen to overcome the facts of material discrepancy in a fantasy of consubstantiality. As Geffroy later augments his account at the time of the reexhibition of seven *Cathedrals* in 1898, "from now on, whatever the hour represented on the canvas, a supreme accord will be wrought amongst all the parts of the subject: the water, the sky, the clouds, the foliage, reunified by the atmosphere, will form a whole of an irreproachable homogeneity, a grandiose and charming image of natural harmony."[4]

This notion of interdependence is emphasized in Georges Clemenceau's account of Monet's exhibition. Republished in 1896 in his book *Le Grand Pan,* Clemenceau's article transposes his friend Geffroy's still empirical discourse into an allegorical register of mythology and psychology: "While the unfortunate constricts himself, shrivels his faculty of seeing and feeling, paralyzes, petrifies his powers of emotion, I go around the world, I interrogate things, I strive to seize their fleeting aspects, to put myself in unison with their harmony, to penetrate their inexpressible mystery, to take pleasure in these changing spectacles in an acuity of joy which I leave to the mobile world to care to renew without cease." The twenty paintings of Rouen Cathedral are Clemenceau's principal proof of the

phenomenological unity of subject and object in Monet's work: "Into its depths, its projections, its powerful recesses or its vivid edges, the flow of the immense solar tide rushes from infinite space, breaks in luminous waves which beat the stone with all the fires of the prism, or abate in obscurities of light." Similar too is the riverside motif of the church at Vernon, "exploding with light or dissolved in the mist."[5]

The genealogy of the architectural and aquatic motifs of 1895 stems from before 1872 when Monet painted his first view of the cathedral of Rouen reflected in the waters of the Seine (W. 217; fig. 36). Continuously reused in its architectural and arboreal symmetries as the paradigm for paintings of the waterside church towns of London, Zaandam, Argenteuil, Vétheuil, Dieppe, Vernon, Jeufosse, Giverny, Antibes, and Venice, the reflections of Rouen Cathedral also find counterparts in the quasi-architectural configurations of riverside trees. For the ice floe paintings exhibited in 1895 the lineage can be traced to a pair of paintings of the Seine at Bougival from the winter of 1867 (W. 105–6), but the motif is first elaborated most insistently and systematically during the frigid season following Camille Monet's death twelve years later. At that time Monet painted some two dozen pictures of snowy stands of trees and their reflections in the ice-choked waters of the Seine. In 1895 these earlier renditions of ice floes may have been still keen with memories of loss not only by way of their linkage to the death of Camille but also to the rejection of the largest picture in the group by the Salon jury in 1880 (W. 568, 97 × 150 cm; fig. 85). In that year Monet was able to take a vengeance of sorts by selling the picture for 1,500 francs to Mme Georges Charpentier and by exhibiting it at her husband's editorial offices of *La Vie Moderne*. Monet subsequently borrowed the painting for exhibition in 1882 and 1889, whereafter it passed out of France and on to America. In 1895, as though in its place, Monet exhibited two paintings from his six-part series of ice floes executed in the cold days of 1893 at Bennecourt in which the centrally placed grove of trees seems slowly to writhe above its uncertain reflection in the icy pool (W. 1333, 1336). Painted on oblong marine formats of 60 × 100 and 65 × 100 cm, these frozen waterscapes instantiate a monumentality of scale and a morbidity of mood which Monet increasingly exploits during the coming decade.

After the exhibition of 1895 Monet was unwilling to part with a painting of the breakup of the ice, which he was moreover unprepared to "redo." He writes to Durand-Ruel that he has "set it aside for myself having already refused it to several individuals," but concedes that he would give it up "only if one offered me a good price" (23 November

1886; L. 1354). In a subsequent letter Monet invokes the embarrassment of having promised the work to someone else (in fact, the rival dealer Montaignac), insists that he ought never to sell the painting at all, yet concludes by setting a tentative price for Durand-Ruel at the very high figure of 12,000 francs (30 December 1896; L. 1355). In spite of pleas from his principal dealer that the painter conclude the affair prior to an upcoming sale at auction of a very similar work, Monet persisted in stalling. Montaignac turned out to be the high bidder at 12,600 francs for the *Ice Floes,* and within the year Durand-Ruel may have become a partner in its ownership as well (W. 1335; fig. 86).

The sale in which Monet's painting figured in 1897 was given advance notice in the *Gazette des Beaux-Arts.* Accompanied by an article on Raphael by Bernhard Berenson as well as others on Byzantine mosaics, Oriental vases, and Goya, the anonymously initialed article on Henri Vever's collection of modern paintings presented the sale as a signal event in the formation of public taste. Corot and Monet are seen as the poles of the collection in which the "free, eloquent and harmonious landscape" takes center stage. Riverscapes by the two artists from Ville d'Avray and Argenteuil (1874; W. 312) illustrate the article along with a Norman seascape by Cazin, a military maneuver by Meissonier, an antique idyll by Puvis de Chavannes, and an interleaved etching and aquatint after Théodore Rousseau which is said to call up the "troubled waters of the Styx." Also of interest here is the description of Daubigny's *Banks of the Oise* from the Salon of 1859 "in which the skies and the waters marry and love one another" (fig. 72). This metaphorical language of love in the landscape is further consolidated in an interpretation of Renoir's *Bathers,* a painting which Monet admired (see letter to Durand-Ruel, 13 May 1887; L. 788). Renoir's women are seen as possessing "the ingenuousness of a wholly virginal and timid dream" and are evoked as "nacred with pleasure and impregnated with a rosy milk of dawn, unconscious Galateas of a childlike and naive cosmogony."[6]

If Renoir's *Bathers* can recall the sea nymph Galatea, then Monet's riverscapes might also elicit memories of Narcissus. That does not happen here, but the author of the article does have recourse to the analogy of Diogenes in order to account for the artist's relentless shedding of convention in his pursuit of "an inexpressible absolute." Monet's strategy of renunciation is figured most insistently in the *Ice Floes:* "Such an effect of snow, such a vaporous islet, light like a dream, which seems to float between a river encumbered with ice and a sky of nacred cold, are forceful and suave samples, eloquent stenographic notes, radiant winks of the eye from which

the light emanates in scarcely nuanced vibrations, in gentle effluvia, in caressing palpitations."[7]

For the writer of this article the art of Corot (fig. 87) offers the eye of the beholder its most refined and subtle pleasures, whereas that of Monet tempts it into a sort of irresistible "perversion." In spite of the anxiety provoked by Monet's "abridgments of nature" and by those of his impressionist colleagues, the critic does not rush to judgment. Like Rousseau, Daubigny, Millet, and Corot before them, the younger artists are said to possess a disciplined vision which is encapsulated in the intergenerational motif of "the same bouquets of trees reflecting themselves in the water of a well-known river or pond."[8]

Monet exhibited a closely related version of his icy reflections at the Galerie Georges Petit in 1899, the venue of the Vever auction of two years before (W. 1333). One critic simply describes the painting at this time as "blue, pale pink and green, with a slightly oranged sky,"[9] but another writer converts the materiality of this account into an uncanny interiority of mind. Corot, it seems, had seen such a painting in a dream and "this landscape has just been painted by M. Claude Monet": "What the one dreams, the other paints." As a result of this "mysterious, but certain, meeting of Corot and Monet in a single impression," the painting takes on an "ideal and double" quality.[10]

At the exhibition of 1895 the static symmetries of the *Ice Floes* were also evident in a second pair of pictures from a six-part riverside series, this time painted in the spring of 1894 at Port-Villez (W. 1370–75; fig. 88). Here Monet repeats in barest outline another prominent mirror motif of the prior decade; the repetition is sufficiently close to have yielded the subsequent misdating on Monet's part of one of the later serial works to 1885 (W. 1373; cf. W. 834–36, 1003–5). This suggestion of a potentially conflictual motive in the reworking of his past may find corroboration in the seven-part series of the church at Vernon from 1894 (W. 1386–91 bis; fig. 89). This series repeats the format of an 1883 painting of the church which had been widely noted at the centennial exhibition of French art back in 1889 (W. 843). Unlike that sunlit view of Monet's neighboring Gothic church, the paintings of 1894 veil the ecclesiastical architecture of Vernon in muted skeins of gray mist. The uniformity of color so confounds the orders of objects and reflections that for once the Narcissus-like nave of the church makes a single vessel with the inverted (and as though drowned) image of itself (W. 1387–88, 1391–1391 bis).

Geffroy and Clemenceau stress the unity of Monet's paintings in their

symmetrical imagery and uniform fabrics of paint, but other critics express some skepticism regarding the viability of the work. After praising Monet's "epic" interpretation of "the mobile caprice of the waters," the critic of the daily *Le Temps,* François Thiébault-Sisson, confesses not to be able to follow the painter in his extreme attenuation of contrast: "But we confess with regret to understand nothing of two views of Vernon in the fog, where the artist, it seems, has lost the exact notion of the effects that art is permitted to translate and of those that painting may not render."[11] Thadée Natanson of *La Revue Blanche* also notes the "very knowing and so sure series of [Vernon] which, one by one, disengage themselves from the morning mists and the fog in order to shine forth in the sun," and similarly complains that Monet deviates from "the proper object of painting": "Is it not to be feared that in pursuing the formula of unseizable moments one lose sight of the concern to complete an object which takes its value only from its own qualities and which remains independent?"[12]

Monet's narcissistic annulment of what commonly passes for objective reality is ambivalently remarked in much of the criticism in 1895. Like *Vétheuil in the Fog* in 1889, *Vernon in the Fog* comes to stand in its state of near nondifferentiation as a further instance of Monet's repudiation of the canons of pictorial sense. Evoking the transgressive "white spot" of Manet's *Olympia* of thirty years before in which the axiom of chiaroscuro was similarly put at risk, Adolphe Brisson dramatizes the offense of Monet's painting: "You will see in a frame a whitish spot, with vague silhouettes in profile against the background, and you will see inscribed in the catalogue this mention: Vernon in the fog. And you will say perhaps that it was useless to give oneself so much trouble in order to brush in a picture in which there is nothing; and perhaps you will smilingly evoke the memory of the famous Impressionist picture representing The Combat of Negroes at Night." The nothing here that so gives offense, the blankness that elicits the memory of blacks, the whiteness that is both a spot and stain—all these strands weave a web of violence and death, an unspeakable image affectually akin to that of the dying Narcissus or the grieving Echo. Such an image could be placed on view in the safely illustrative fashion of Ernest Bisson or Isaac-Edmond Boisson at the Salon of 1896 (figs. 90–91), but many of Monet's critics will continue to be unsettled by his less literal mirror of myth with its unreflective tain. Unheeding of such views, the artist is said to show both a combative "stubbornness" and "hermitlike" humility in repeatedly putting this image on display.[13]

Monet's repetitions take on a systematic orientation on the occasion of his return to Pourville and Varengeville, the sites of extended marine

campaigns in 1882. Enervated by the exhibition of 1895, Monet finds a respite in his return to the sustaining sea of his past: "I needed to resee the sea and am enchanted to resee so many things that I made fifteen years ago. And so I have set to work with ardor" (to J. Durand-Ruel, 25 February 1896; L. 1324). Twenty years later the need will still be the same: "Here I am returned, ravished by my little trip where I resaw and relived so many memories, so much labor: Honfleur, Le Havre, Etretat, Yport, Pourville, and Dieppe; it did me good and I will set myself back to work with greater ardor" (to J. Durand-Ruel, 29 October 1917; L. 2247).

Utilizing the oblong formats of the Bennecourt, Port-Villez, and Vernon series of 1893–94, in 1896–97 Monet recapitulates the smaller, more anecdotal views of the beaches and cliffs of 1882 in larger, almost wholly depopulated frames (W. 739, 1451; figs. 92–93). In spite of this increase in scale and decrease in internal differentiation of tone, the similarities between the two series were sufficient once again to occasion a subsequent misdating on Monet's part (W. 1429, 65 × 92 cm; cf. the corresponding views of 1882, W. 742–43, which measure 60 × 73 and 60 × 81 cm). Monet seems to have worked more or less simultaneously on six separate motifs; forty-eight paintings have been preserved in all, and of these some twenty-five were eventually exhibited in 1898.

Work at the site proceeded with the same rhythm of aspiration and frustration that we have come to expect from his letters to Alice Monet, the painter's wife since their marriage in 1892: "Be content, I worked all day long despite a bit of rain from time to time. I have four canvases underway, three different motifs. I will not tell you that I am delighted with these beginnings, for I am proceeding timidly and am stammering a bit, but finally I have confidence and do not wish to be too demanding the first day. A single thing terrifies me: it is the fear of bad weather which I feel certainly coming and which worries me a lot. Finally, I am full of courage" (20 February 1896; L. 1323). It soon proves foolhardy to have hazarded in the dead of winter a northern coastal campaign.

For a while Monet's confidence holds: "This morning, rain and hail, and always this same wind. I could only get to work after lunch, not satisfied, very slow. Moreover I do no more than begin and often begin again, but something will come of it, it is so beautiful" (28 February 1896; L. 1326). On the day he writes this to his wife he confides to Geffroy, "I am rather somewhat timid and tentative, but finally I feel myself in my element and I hope to be able to work a bit" (28 February 1896; L. 1327).

In its changeability the watery element is Monet's perpetual undoing: "I am working, but very very slowly and painfully; I do not yet have the

courage to do five and six canvases a day. I am working on two or three, and always with hesitation, not happy with the framing, with the choice of site, which leads me to make changes. Finally I am not into it yet and, accordingly, am extremely indecisive, timid. But not discouraged. I want to do something and I will manage it. In any case it will not be for lack of courage, for the weather is consistently very harsh and the wind very troublesome, and worst of all is the continuous change in the weather" (29 February 1896; L. 1328). The result of this meteorological mutability is a bout of self-diagnosed melancholia; and always in the background "the sea makes a terrible racket" (6 March 1896; L. 1329): "Je suis désespéré" (7 March 1896; L. 1330).

Monet's engagement with the weather is no mere masochistic self-affection; it is also the occasion for a resilient adaptation to circumstance. The system of the series is in part a defense against what Monet perceives as nature's aggressive transformations: "I must resolve myself to place canvases underway in all weathers, all winds: to do little and remain with arms crossed when the effect is not there is impossible for me" (8 March 1896; L. 1331). No matter how quickly he proceeds, however, "I am no longer what I was" (11 March 1896; L. 1332). The facility of 1882 is gone, but "I want to struggle still" (12 March 1896; L. 1333).

Rain, wind, and cold beset Monet, who turns for consolation to dreams of his garden at Giverny. With a bit of fair weather his courage returns, and Monet races up and down the beach "in order to be at each motif for at least a moment!" (19 March 1896; L. 1338). This good fortune scarcely lasts and within days the season's relentless advance makes "all my motifs . . . unrecognizable": "Everything has turned green and those beautiful dry grasses which made me happy have been invaded by the new green growth, and this rain that is falling will make it grow still more. It is really a shame, because it was beginning to go better and, now, I fear that I will be obliged to leave without being able to finish a thing. . . . In sum, it is a queer job to be a landscapist" (25 March 1896; L. 1340). Nevertheless, "the sea is admirable" (26 March 1896; L. 1341).

A brief visit from Mme Monet seems to have lifted the painter's spirits, "but once alone I felt all discouraged and sad." Forced to acknowledge that his temporizing would prove to be of no avail, he promises to return: "Finally this at least will have given me back the taste for work and the desire to come back here next winter, when, with more time ahead of me, I would be able to make and carry through the beautiful things that I have in my head" (31 March 1896; L. 1342). For more than thirty years Monet had been both enamored and frightened of what he saw in his head (see

letter to Bazille, 15 July 1864; L. 8), but this fantasy of interior vision was always more comforting than the acknowledgment of his deep dependence upon what an indifferent nature might or might not display.

Monet's self-inflation is soon exploded by nature's intervention: "Yesterday I thought I would become mad: the wind carried off my canvases, I put down my palette to pick them up, and it goes off in turn. I was furious and almost threw it all away." But he did not, "and if I had some time in front of me, what things I could do" (1 April 1896; L. 1343).

Time is just what Monet lacks. "Driven from Pourville by an impossible weather, but very pleased to have gone there and with the intention to return there to pass the next winter," he writes to Durand-Ruel from Giverny of the "different things" he now has in view (12 April 1896; L. 1345). This may refer to the first stages of the *Mornings on the Seine,* four of which are classed in 1896, with twenty-five additional pictures catalogued in the following year (W. 1435–37, 1472–94, 1499–1500).

The river and shore series of Pourville and Giverny were intertwined in their production over the course of 1896 and 1897 and in their eventual exhibition at George Petit's in 1898. Work at home in 1896 proceeded to the same inconclusive end as had the earlier work away, and once again Monet deferred the completion of his project: "I have not come to Paris for many months nor have I budged from Giverny where I have worked, but not according to my liking, on account of the dreadful weather that we have not stopped having for an infinite time, and everything that I have undertaken, or nearly, will be to complete next year. So I propose to go soon to the sea to complete an entire series of canvases begun last year which interest me a lot and with which I am fairly happy." Against the vexed background of the worsening chronic illness of Suzanne Hoschedé-Butler, which "quite saddens our life" (17 November 1896, L. 1353), it is perhaps no wonder that Monet soon writes to Geffroy, "it is a joy for me to resee the movement of the sea" (14 January 1897; L. 1356).

Pourville proves to be a deception with its "lugubrious weather, somber mist, glacial wind" (20 January 1897; L. 1360), yet "the furious sea is admirable" (22 January 1897; L. 1364). At home briefly, Monet discovers Mallarmé's new prose anthology *Divagations,* which the painter proposes to take back to Pourville "in order to read it in the evenings, the day's work complete, with all the care and meditation it deserves" (27 January 1897; L. 1364 bis). Monet might have felt that his own divagations along the banks of the Seine and by the shores of the sea shared with the prose wanderings of the poet that same singularity of "a unique subject of thought" which Mallarmé notes in the preface to his collection.[14] In this

book Monet would have had the chance to reread Mallarmé's prose portraits of their friends Whistler, Manet, and the recently deceased Morisot, upon whose commemorative exhibition at Durand-Ruel's Monet and Mallarmé had collaborated at the time of the previous year's campaign at Pourville. Whistler's wife had even more recently died (see Monet's letter of condolence, 18 May 1896; L. 1349), and a pall of self-reflective morbidity might well have lain heavy upon the aging artist as he sat alone by the wintry sea.

Alone by the sea Monet might have read Mallarmé's remarks on solitude, or perhaps the poet's aquatic adventure of self-abnegation in "Le Nénuphar blanc." In an essay on *Hamlet* also included in the collection Mallarmé refers to the water-lily pool as part of the Shakespearean apparatus of death whereby objects and settings take on the dynamic force of myth. In his 1880 translation of Cox's *Ancient Gods* Mallarmé had described the sun plunging into the sea as the natural equivalent of the myth of Narcissus, and in *Divagations* this image reappears in the opening of the book, where "the sun . . . , beneath the water, plunges in with the desperation of a cry."[15]

Back at work Monet finds that if it is not the inclement weather it is a group of real-estate developers which puts him at risk by transforming his pictorial motifs into recreational sites. Even when good weather supervenes, Monet's anxiety fails to abate: "I am so long [on the job] that I despair. . . . With the hours of the tides I often have the weather I need, but the sea is low when I need her full" (ca. 20 February 1897; L. 1372). With all his canniness for the merchandizing of his art Monet still remains incapable of freeing his mode of production from an agonizing dependence upon nature: "I feel nature transforming herself in plain sight, finally I fight back, I grind away and am looking well." In a postscript Monet notes, "here are the narcissi already beginning to bloom" (21 February 1897; L. 1373).

The narcissi herald the coming of the spring when Monet's wintry motifs must inevitably quicken from their frozen forms: "I am altogether steady, but good God, how beautiful but difficult it is, how difficult it is to do what I want!" (22 February 1897; L. 1374); "I have no time to waste, everything changes so quickly" (10 March 1897; L. 1379); "I want finally to look at my canvases. I will reflect a bit in front of them and organize myself for tomorrow morning if the fine [weather] persists" (23 March 1897; L. 1382); "What a damn job I am doing here; it is in vain that I see beautiful things. It is really too difficult by a lot" (25 March 1897; L. 1384);

"The best thing would be not to touch certain canvases any more and if the weather became fine, to start them over, what I ought to have done already instead of transforming them and arriving only at making bastard and imprecise things. . . . What I must confess as well is a terrible impotence" (29 March 1897; L. 1386). And so Monet flees the narcissi of Pourville and heads back to the consolation of the reflections of Giverny.

In the summer of 1897 Monet was visited by an interviewer from the *Revue Illustrée,* Maurice Guillemot, whose article provides the fullest account of the *Mornings on the Seine* prior to their exhibition in 1898. The text is accompanied by Theodore Robinson's drawing (after his own photograph) of Monet in sabots and tweed, leaning on a walking stick in a field at Giverny. This self-possessed image of Monet is amplified in a myth-making description of the painter setting off to work at 3:30 A.M.: "His torso muffled in a sweater of white wool, his feet shod in heavy hunting boots with strong soles impenetrable to the dew, his head covered with a picturesquely indented maroon felt hat with a flattened brim to protect himself from the sun, a cigarette in his mouth—a point of brilliant fire in the depths of his great beard—he pushes the door of the stoop, goes down the steps, follows the median path of his garden where the flowers are stretching themselves and waking up in the dawn, crosses the road deserted at this hour, passes between the palings on the track of the little railway from Gisors, skirts the pool of water mottled with water lilies, steps over the stream that splashes between the willows, enters the meadows all misted with fog, arrives at the river." With the help of the assistant gardener Monet rows off in his boat: "There are fourteen pictures begun at the same time, almost a gamut of studies translating a same and single motif of which the hour, the sun, the clouds modify the effect." Monet has arrived in all but name at the pool of Narcissus: "It is at the spot where the Epte throws herself into the Seine, among the little islands shaded by tall trees, the arms of the river as it were forming beneath the foliage solitary and peaceful lakes, the watery mirrors reflecting the verdure, it is here that since last summer Claude Monet has worked—his winters occupied with another series, the cliffs at Pourville, near Dieppe."[16]

At this point in his narrative Guillemot lends Monet a voice: "Formerly, the artist told me, we all made sketches. . . . The landscape is only an impression, and instantaneous. . . . I would like to paint as the bird sings. . . . I would like to prevent one from seeing how it is done." In the studio-completed works of Jongkind and Corot the beholder had been able to detect the traces of studies made on the spot, but Monet claims to elide

this gap by repeatedly returning to the same canvas in front of the motif. Hence "the length and patience of the labor, the anxiety of the result, the conscientious search, the feverish haunting of this work of two years."[17]

To Guillemot, Monet's residence at Giverny recalls the retreat of Jean-Jacques Rousseau at Ermenonville, famous for its reflecting pools. Monet's *Poplars* are said to manifest the Hugolian form of "boredom," his portraits "the Whistlerian penumbra of an interior," and his pond an image of stillness and death: "Upon the immobile mirror water lilies float, aquatic plants of singular species, with large spread-out leaves, with disquieting flowers, of a strange exoticism, and, with sluices at each end to permit the renewal of the water each day, the local people set themselves up in opposition at the start, suspicious of this flora which they did not know, saying that the artist was poisoning the countryside, that their cows could no longer drink."[18] The suspicion of the peasants was reciprocated in the mind of the painter, who felt that he was being persecuted as a Parisian outsider out of a "pure spirit of wicked tormenting" (to the Prefect of the Eure, 17 July 1893; L. 1219).

The lily-strewn water of Monet's pond may or may not have seemed fit to drink, but it was fit to paint (W. 1419): "The oasis is charming on account of all these models which he had wanted: for they are models for a decoration for which he has already begun the studies, large panels which he subsequently showed me in his studio. Let one imagine a round room whose walls, beneath the supporting plinth, would be entirely occupied by a horizon of water spotted with these plants, walls of a transparency by turns green and mauve, the calm and the silence of dead waters reflecting the spread-out blooms; the tones are imprecise, deliciously nuanced, of the delicacy of dreams."[19] On the basis of Guillemot's description, Wildenstein has assigned to this period the close-up series of *Water Lilies* that I earlier discussed in relation to Mallarmé (W. 1501–8; fig. 75). Painted on a graduated series of rectangular formats, including a metrical square (65 × 100, 73 × 100, 81 × 100, 89 × 130, 100 × 100, 130 × 152 cm), these pictures never exhibited in Monet's lifetime exceed the scale of his contemporary landscape paintings and anticipate the decorative works of 1900 and beyond.

In its meter and a half of breadth the largest of these *Water Lilies* recaptures the dimension of Monet's Salon paintings of the sea and the Seine of 1865 and 1880 (see W. 51–52, 568, 576, 578); in its proportions it repeats the format of *Canoeing on the Epte* of 1890 (W. 1250, 133 × 145 cm; fig. 65), in which the monumental figural ambition of the 1860s is reconciled with the open-air program of the intervening years. In addition

to this recapitulation of scale, the largest of the *Water Lilies* represents a reduction of scope wherein less and less watery expanse comes to fill more and more of the frame. This presages Monet's close-up focus upon the surface of his pond in a number of paintings of 1914–26 (see W. 1783, 1786, 1797, 1808, 1839, 1864, 1870; figs. 94–95). Taken all together, these paintings of more than sixty years effectuate an exchange between the feminine element of the river and the sea, the flowerlike female forms of the canoers, and the figurelike female forms of the water lilies. In bending over the source of his dream Monet stills the flow of life in the mirror of *eau morte*. A comparably posed sculpture of the water-gazing bent-over Narcissus was exhibited at the Sociéte Nationale des Beaux-Arts in 1897 by Alexandre Charpentier (fig. 96).

"Bent over the source where Narcissus was seen by himself, so much so that there remains no more than an azure soul in the sky inverted in the water": with these words Francis Jammes describes his existential predicament to André Gide in 1898.[20] During these last years of the decade and on into the first years of the new century a diverse company of writers continue to allude to the myth in relation to the individual's split sense of being both subject and object of psychological reflection and physical desire.

As a sometime reader of *La Revue Blanche* Monet might have chanced to come across Robert Scheffer's "Le Prince Narcisse" in 1896. In the love of others Narcissus only seeks himself—"in the eyes that looked at him he sought less the expression of a thought than the reflection of his own image"—but soon only the look of his own eyes can suffice: "He was before the mirror; with a sob he made the simulacrum of those who kiss. His frail ephebe's body would vainly press against the cold crystal, and the ardent application of his lips thereupon would tarnish it with a mist in which his image disappeared." This mirror-gazing Narcissus is a modern Rumanian prince who, "loving no one, had, so as the better to love himself, the need that he be loved." Had he read the story, Monet might or might not have seen his own personality reflected in the behavior of Narcissus, but my concern here remains iconological. Like Monet bent over the waters of Giverny, Scheffer's Narcissus sees the natural sign of self-reflection in the vivid waterscape before his eyes, in this case Venice, to which the artist will travel in 1908 (W. 1736–72): "Bent over her lagoons as over some propitious mirror, she took pleasure no less than he in her own contempla-tion. . . . 'She wished to flourish in a tranquil basin, nearby but sheltered from the indiscrete crowd of waves, in order there to endure and there to admire herself. Thus myself, born mobile, I limit and immobilize in the factitious water of mirrors my vision of humanity and satisfy myself with

my own appearance.'" Here psychology and iconography are fused as the individual projects his feelings upon the reflections in the water, and there "he experienced with certitude that the soul of the city and his own were intermingled."[21]

In "Narcisse" of 1897 by the Belgian poet Iwan Gilkin the autoerotic scenario places the poem at a still further distance from Monet's landscapes, yet verses and paintings nonetheless straddle the equation whereby a mirror is likened to "a limpid basin which no wave ripples / But is mottled by a play of reflections of green and pink." "Like a lily intoxicated with its divine flesh," this youthful Narcissus gives way to the desperate embrace of himself.[22] Like Monet's art, subject to its own obsessive touch, the bodily self-absorption of Narcissus is both the symptom of a sexual dread and the symbol of a spiritual hope.

In "Narcissus" of 1897 by Jean Lorrain perhaps we come somewhat closer to Monet's world, where "down into the black lilies I pose my brow."[23] This Narcissus is the disillusioned figure of flesh who now longs for the purity of disembodied thought. A critic as well as a poet, Lorrain seems to have sensed an affinity with Monet's paintings of water lilies when he encountered them in 1900: "Painted fantasies. . . . Blue luminosities, moist transparencies, the fantasy of light and shadow of ten studies entitled: The Water-lily Pool, a landscape of fairy-nature. . . . Faithful to his manner of proceeding, visionary painter of this decor elected by himself, Monet has painted ten times this Pool of water lilies, at all the hours of the day and in the enchantment of their diverse lights: it is the timetable of reality and dream."[24]

"L'Allusion à Narcisse" of 1897 by Henri de Régnier is closer still to Monet by way of a shared commitment to the aesthetics of Mallarmé. Yet another of the younger *mardistes* along with Valéry, Gide, and Mauclair, Régnier supplements the suggestiveness of Mallarmé's naturalism with the neoclassical allegories of his Parnassian father-in-law, José Maria de Hérédia. As I am arguing relative to Monet's water paintings, Narcissus appears in Régnier's landscape only as a conjured-up image: "And in the bright source where I had wished to drink, / I caught sight of myself as someone who appears. / Was it that at that hour, in you yourself, / For having wanted to place his lips upon his own / The beloved adolescent of the mirrors died, O Fountain?"[25] Walking in the landscape and encountering his reflection in the water, the poet finds himself absorbed in the scenario of the myth. Culturally latent in the phenomena of the world, such mythic patterns offer occasions of self-constitution for an observer such as Monet: "When you had painted a thousand canvases, a trophy / Brilliant and

serene which no gall can spoil, / You went to sit down by the banks of the Nymphaeum / Where the flowered water slept in the face of the sky."[26] In this poem of 1919 Régnier's access to the language of allegory is facilitated by the etymology of water lilies, or *nymphéas,* which so readily calls up the watery dwelling of the nymphs.

Of all the writers on Narcissus around 1897 Joachim Gasquet is the one most familiar to historians of art. He sent Monet a dedicated copy of his poems *Les Chants séculaires* (1903), and in his monograph of 1921 on Cézanne he makes approving mention of Monet. Gasquet was an avid reader of Geffroy's *La Vie artistique* during the 1890s and thus thoroughly familiar with the critical discourse on Monet.

"Le monde est un immense Narcisse en train de se penser": it was around the citation of these words of Gasquet in Gaston Bachelard's *L'Eau et les rêves* that my first thoughts on Monet's reflections began to crystallize. "The world is an immense Narcissus in the process of thinking itself"; and, as Bachelard continues, "where better would it think itself than in its images?": "In the crystal of the fountain a gesture agitates the images, repose restores them. Superb creation that demands only inaction, that demands only a dreamy attitude, in which one will see the world depict itself all the better the longer one will motionlessly dream! A *cosmic narcissism* . . . thus quite naturally prolongs the narcissism of the ego."[27] As Gasquet writes elsewhere of Narcissus, "the world is made in your image."[28]

I am quoting here from Gasquet's *Narcisse,* published in a revised edition in 1931 ten years after the author's death. Initially written between 1892 and 1896, the text was entitled "La Mort du grave et du voluptueux Narcisse" at the time of its fragmentary publication in 1892, 1897, and 1899 in *La Syrinx* (Aix-en-Provence), *Revue Naturiste* (Paris), and *L'Effort* (Toulouse). Monet's name is not mentioned anywhere in these texts, although in the posthumous publication a prominent place is given to the waterscapes of Cézanne: "It is in this corner of the river, beneath these trees, in this floating watercolor of Cézanne, by the banks of this meadow, that he would come to find me, my pagan companion, the grave, the voluptuous, the happy Narcissus who disdained the nymph Echo. In order to be able to continue my story in its order and reality it is necessary that you receive this avowal. I am Narcissus, and I am not mad. I wanted to tell you that. It is the essential thing, the very essence of the world. The world is an immense Narcissus in the process of thinking itself, a thought that does not know itself suspended above a thought in the process of knowing itself. Do not take me for a fool. I am the world." Here, in the

characteristic mix of the 1890s, we find the peculiar blend of psychology and metaphysics which binds together what Gasquet calls "my sources, my pools," namely Goethe, Plato, Virgil, da Vinci, Schopenhauer, and Ribot. Gasquet cites psychiatrist Pierre Janet on the recovery of repressed memories in the form of "certain sensuous images which language brings us," and thus brings us to the threshold of the psychoanalysis of Freud.[29]

For Gasquet, Narcissus is both myth and mind: "And Narcissus found himself, shivering, bent over the lake of his soul, for it is necessary for me to avow it in the end, Narcissus, this Narcissus, it is I." Revised sometime after his demobilization from the 1914–18 war, this sentence already had its variant in the earlier version of 1892: "And Narcissus found himself, shivering, bent over the lake of his soul where, beneath the fine water strewn with flowers, something vague was trembling, going away."[30] What would Gasquet have thought of Monet's paintings of that date, "water with grasses which undulate in the depths" (to Geffroy, 22 June 1890; L. 1060)?

"The whole world sends back to me my image."[31] Gasquet inserts this idealist maxim in the "Narcisse" fragment of 1897, and he repeats its gist more than twenty years later in some remarks of Cézanne: "The landscape reflects itself, humanizes itself, thinks itself in me. I objectify it, project it, fix it upon my canvas. . . . The other day, you were talking to me about Kant. I am going to talk nonsense, perhaps, but it seems to me that I would be the subjective consciousness of this landscape, as my canvas would be its objective consciousness."[32] Regardless of the dubious attribution to Cézanne, we find in this passage the same strategy of self-reflective interpretation that I am identifying in this book with both Narcissus and Monet.

When Gasquet's narrator retreats from the city to seek the river's tranquillity he might almost be Monet in search of his motif: "It is in this corner of the river that I evoke my pagan patron, the grave, the voluptuous, the happy Narcissus who disdained the nymph Echo. . . . I meld myself into the soft fogs, above the meadows where they linger, I float in the evening and, lost, I dream. . . . A murmur envelops me, the fields speak to me, I hear the very voice of the sea. The shadow intoxicates me." And Narcissus? "He bends over, spreading the reeds, and smiles at the source. . . . Narcissus gets up, he carries armfuls of lilies to the sphinxes of the crossroads. . . . Rarely does he gain the forests, he prefers the slender rivers and the poplars." If Monet is Narcissus in his enthrallment with the waterscapes of Giverny, it is because the mythic gaze is already constitutive of his own: "And I, as I think of it, I, how I am similar to Narcissus!"[33] Here the text of 1897 ends.

Two years later Gasquet published a third and final fragment of his text: "The world is made in your image. What a mirror, say, Narcissus! You represent the world. . . . It is in front of the mirror of your senses that the old mother combs her forest-hair and smiles with all the flashing teeth of her rocks. You represent the world. Living mirror! . . . Indifferent to doubting creatures, indifferent to fugitive things, it is yourself that you must vanquish and, amidst the appearances, in the bosom of the reflections, you will be free. That is why I am Narcissus."[34] Here the world-representing subjectivity of Gasquet's beholder animates a maternal allegory of nature, but what may suffice as allusion in poetry may not succeed when visualized in painting: "Make a tour of the Salons. A fellow does not know how to render the reflections of water beneath the leaves, he sticks in a naiad. The *Source* by Ingres! What does that have to do with water."[35] Gasquet has Cézanne speak these words, but this is not to say that myth can no longer continue to function. It is precisely *in absentia* that the mythical body of Narcissus is to be represented: "Life departed the panting flanks of a cadaver and in the last breath of the man-god matter expired, matter spoke, the Verb was born, the Verb, Narcissus, the Verb was born!"[36] Narcissus is Christ's surrogate here, the very principal of metamorphosis, of semiosis, of the endless circulation of signs.

In June 1898 Monet exhibited sixty-one recent paintings at the Galerie Georges Petit. On view were seven *Cathedrals;* eight Norwegian paintings, consisting of three different views of mountain, fjord, and town; twenty-four *Cliffs,* divided into six different six-, four-, three-, and two-part subsets painted over a two-year period near Dieppe, Pourville, and Varengeville (W. 1421–34, 1440–71); four decorative panels of *Chrysanthemums,* on varied formats of 81 × 100, 79 × 119, and 130 × 89 cm (W. 1495–98); and eighteen *Mornings on the Seine.* This last series was the largest and least differentiated of the show, comprising only two motifs, of which one, *The Nettle Island,* was represented in only three versions (W. 1489–94), with the remaining fifteen pictures reproducing a single composition of trees and their reflections upon the Seine. Of this group, one, dating 1896, measures 73 × 92 cm (W. 1435; fig. 97); the rest, all from 1897, vary in size from 65 × 92 to 73 × 92 to 81 × 92 to 89 × 92 cm, the first two rectangular formats being standard no. 30 landscape and figure canvases, whereas the two increasingly square formats are irregularly stretched variants of no. 40 and 50 canvases (W. 1474–86; fig. 98). One precisely square canvas also exists (W. 2037–1436 bis; 92 × 92 cm), as does a final pair of paintings measuring 72 × 89.5 and 75 × 92.5 cm in which the mirrored surface of the water is ruffled by the movement of the wind (W. 1487–88).

The majority of canvases in the series are painted on nearly identical squarish formats, but substantial differences of light and color diversify the unchanging composition of the site.

In *Le Figaro* Arsène Alexandre suggests that "it is air that circulates in his canvases, true, soft, delicate air that bathes these bouquets of trees, plays in the anfractuosities of the cliffs, caresses the transparent waters of the Seine at Giverny." If the air's caress of the water recalls the cultural master-trope of Narcissus, so does the image of the "meanders of the Seine imprisoned by trees like a pond."[37] Like the youth of myth Monet looks at a water-borne image and, according to a pseudonymous critic in *Le Journal,* sees not a mere simulacrum but the fullness of sensuous life: "The seventeen studies of Giverny, so monotonic and so varied in tone according to the light of the hour, enchant like a succession of dreams, of calm, and of light; impossible to push any further the poetry of the mist and the water. . . . What shall I say of the bouquet of willows of his island and of the savory terrains of his cliffs?"[38]

For Gustave Geffroy, also in *Le Journal,* Monet's paintings exemplify "the law of unity that regulates the manifestations of life." Geffroy finds this axiom everywhere evident in 1898, whether in the re-exhibited *Cathedrals* and paintings of Norway or in the newly displayed paintings of Giverny: "Returned home, in his peaceful village, in his flowered house, amongst the familiar fields, by the banks of the stream and the river, Monet wanders amongst the meadows, beneath the soft shade of the poplars; he goes up and down the current in his boat, skirts the islands, seeks with a deliberation and infinite care an aspect of nature propitious by its arrangement, its form, its horizon, by the play of light, its shadows, its colorations." What Geffroy calls propitiousness is the criterion according to which perceptual data are interpreted in conformity to a preexistent ideal. Monet may appear to be copying nature directly, but to Geffroy the painter depicts the world only as a reflection of mind: "For it is one of the numerous fantasies born of the chance label of 'impressionism' to believe in the nonchoice of subjects by these reflective and willful artists. Choice was on the contrary always their vivid and important preoccupation. But legends are thus made: one has become accustomed to represent these painters like cameras indifferently leveled at any spectacle, and the error goes on being repeated, even by those who are capable of self-examination."[39]

The traditional commitment to the selective transformation of nature had been cited against Monet ever since the rejection of his submissions to the Salon of 1867. In 1897 the same confrontation reappeared in the Acad-

emy's protest against state acceptance of paintings by Monet and his col-
leagues from the bequest of Gustave Caillebotte. The irony in the historical
situation is that just when a nonempirical understanding of Monet's art
could have been achieved through symbolist theory, Monet is still perceived
as unselective: "He does not dispute with nature, he abandons himself to
her; she reflects herself in him rather more than he reflects her." What is
missing for the author of these remarks, the philosopher Gabriel Séailles,
is the reflective transformation that makes of art "a mental thing," in the
words of Leonardo which he commends.[40] Geffroy criticizes Séailles insofar
as Monet's paintings of reflections seem to him to epitomize the idealist
attitude the philosopher seeks.

Geffroy's article was reprinted in an exhibition supplement published
by *Le Gaulois* along with a photograph of the artist, three reproductions
of recent works (W. 1421, 1457, 1487), and excerpts from writings by
Alexandre, Thiébault-Sisson, Roger Marx, Georges Lecomte, and Roger-
Milès. Geffroy's insistence on the deliberation of Monet's choice focuses on
the *Mornings on the Seine*: "How could one believe, for example, that Monet
had not expressly chosen the admirable decor of greenery which shades
the *Arm of the Seine near Giverny,* this double ornamental cutout of branches
profiled against the sky and reflected by the water, this alley of foliage
where the delicious phantasmagoria of the sky and the clouds glide by?"
Geffroy does not explain what "distant phantoms," what "mysterious evo-
cations," are reflected in "these limpid mirrors," but the Narcissus-like
imagery extends into his interpretation of the *Cliffs,* in which "great skies
rise up from the waters, breathe in the oceanic mass: it is an exchange and
confusion which leads to an admirable unity." The phenomenological unity
of nature and artist is symbolized in these doublings and meldings of
Monet's "painting of air": "By the side of these fluid harmonies, all land-
scapes run the risk of appearing fragmented and opaque."[41]

Like his friends Mirbeau and Clemenceau, Geffroy proposes a trium-
phant fiction of Monet's quest for possession of world and self. In the
light of Monet's written discourse of disavowal and deferral—"I have
undertaken not a few new things that I could not do, especially on account
of the impossible weather" (to Helleu, 21 May 1898; L. 1407 bis)—I advo-
cate an interpretation of the paintings that destabilizes the harmonious
unity which Geffroy insists they achieve. Even Geffroy acknowledges the
impossibility of Monet's project in his concluding emphasis on the artist's
solitude. "From the Norman sea to the Norwegian fjord, from the Gothic
monument to the humble customs house, isolated upon the cliff, behind

its hedge, in the face of the immensity,"[42] Monet's voyage repeatedly renews the sublime posture of an embodied being that feels itself both witness and victim of space and time.

In the *Journal des Artistes* François de Plancoët presents Monet as a contemplative painter in language that seems derived from the articles by Alexandre and Geffroy: "It is air that circulates in the arms of the Seine at Giverny, in the coves of the cliffs of Dieppe, Pourville, Varengeville, amidst the sod and the branches of trees, and he knows how to interpret the morning fog just as well as the melancholic decolorations of dusk." Plancoët emphasizes Monet's "qualities of finesse, distinction, and fluidity whereby a mysterious and vaporous flux exerts upon delicate spectators a sensation of charm, pleasure, and astonishment."[43] The marvel of Monet's art is still situated in its "instantaneous" reproduction of the color-states of the world, but Plancoët's attention to the beholder's emotional response shifts the locus of criticism from world to self.

The exterior world is emphasized at the expense of the interior in Charles Frémine's account in *Le XIXe Siècle*. Previously Monet had painted the *Poplars* and *Cathedrals* in a multiplicity of weathers and lights; now he restricts himself to the effects of a summer's morning: "And it is a new enchantment for the eyes this series of pictures, this matutinal hymn cele- brating strophe by strophe the same corner of nature, this limpid and deep river open to the dawn, flowing with full banks between its double border of willows and great immobile trees, this fluvial landscape repeated fifteen times, always from the same point and owing its variety of aspect to the changes of the atmosphere and sky alone. . . . And moreover what grace in this bouquet of willows of the Island of Nettles, all pale and all shivering between the double transparency, between the double fluidity of the air and the river."[44] As in Geffroy's "double ornamental cutout," the specter of Narcissus lingers in Frémine's doubling of reflecting fluids within which a body is glimpsed.

Repetition and doubling are also emphasized in a brief review in *La Chronique des Arts*. "Seven *Cathedrals* are here in order to remind us of the exhibition of 1895," and indeed this unsigned article of 1898 reuses many of the phrases of Ary Renan's piece in the same journal from three years before. At that time Monet was said to remain "faithful to his practice of almost identical repetition of a single motif"; three years later "Monet has remained faithful to his practice of synthetic repetitions." These repetitions take on a differential significance vis-à-vis the work of the past: "It is always the same harmonies familiar to the painter of the open air, the same variations of arbitrarily chosen themes, the same glory of atmosphere

decomposed into its elementary vibrations. Only the vibrations seem to have muted themselves; the prism has grown pale; to the grand contrasts a milky and caressing coloration succeeds." In 1895 it is the water town of Vernon that is seen "bathing in the river, doubling herself, dissolving herself therein"; in 1898 it is "along the banks of the Seine or the Epte where the bouquets of trees bathe, double themselves and dissolve themselves beneath the mantle of the hours."[45]

The written and painted repetitions of 1898 are enacted within particular historical circumstances. Deadlines must be met and an unsigned article might conveniently repeat what had been written before. Monet's commercial motivations might similarly induce a repetition of the salable commodities of previous years. Repetition breeds a certain loyalty among consumers but it risks the alienation of the market as well, and it is to this phenomenon that the anonymous critic points in 1898: "The art of M. Monet already leaves behind the preoccupations of our school and—let us speak plainly—will have no morrow. His personal excesses lose their imitators. Is it the consequence of the spiritualist movement that stirs the present generation? The fact is that the master of true impressionism has for himself some collectors of high taste and no longer conquers the youth with his parabolic aesthetic." The geometry of the parabola traces the self-reflexive embrace of Narcissus bending over the stream; the parable of the artist-as-Narcissus reconfigures this symmetrical shape as the symbol of pictorial representation. What is at stake for me in this image of the *parabole* is the bimodal task of allegory. Renan had sounded a note of caution already in 1895: "A facture synthetic to excess, brutal and yet caressing, a summary coloration and yet rich like the rainbow serve as plastic support to his hyperacute visions; let no one imitate them if, unlike Monet, he does not possess the secret of transposing real spectacles into artistic *paraboles*!" Monet, of course, persists in imitating himself, a narcissistic trait assigned by the critic in 1898 to the painter's "artistic faith" and "inflexible obstination."[46] The pull of obsession registers its mark in Monet's work, but this regressive fact of repetition also yields the force to elaborate minutely differentiated series of works.

In the account of *La Chronique des Arts* the repetitions of Monet's art are interpreted as the signs of obstinacy, excess, brutality, domination, and a personal faith increasingly out of accord with contemporary spiritual concerns. For Georges Lecomte, however, Monet "does not repeat himself."[47] Already in 1892 Lecomte had insisted on the changing meaning of Monet's fixed motifs: "The artist perceives and expresses all the metamorphoses by which nature, always the same nonetheless, renews its decor."[48]

Any implicit Ovidianism in this passage is matched in 1898 by an explicitly Wagnerian evocation of Monet as Wotan, the Germanic god of poetry and war. For Lecomte myth remains an apt vehicle for the interpretation of the art of Monet.

The souvenir publication that accompanied the exhibition in 1898 reprints a passage on Monet's seascapes from Lecomte's book, *L'Art impressionniste:* "The Enormity of things seizes him."[49] In the review of the exhibition Lecomte's oceanic allegory is transposed to the towers of Rouen, which "make one think of the giant incising that the rushing of the waves makes in the rocks." The focus in 1898 is not on the sea but on the "progress" evident in the *Mornings on the Seine*: "Once again the great painter demonstrates, to those who accuse him of painting at random, with what taste he chooses his motifs, with what concern for the decor he interprets them. The twenty pictures of this series are admirably composed. The branches of the trees associate with one another and with their reflections in the water in harmonious curves of a great ornamental beauty; and, in this surround of foliage that the light caresses, the surface of the water softly lights up with silvery gleams."[50] The insistence on compositional choice may derive from Geffroy, but the stress on ornament is characteristic of Lecomte. In an earlier essay the critic finds the essence of ornament in the art of Claude Lorrain, Delacroix, Corot, Cézanne, Pissarro, Renoir, Monet, and Seurat, but insists against certain symbolists and "idealists" that their "very high concern for synthesis and decoration" must not be allowed "to annul, in order to attain it, the reality of appearances and of character."[51]

For Lecomte the formal beauty of decoration is the reflex of a moral way of life. Mirbeau had similarly stressed the ethical implications of Monet's work a decade before, but by 1898 the Dreyfus affair had urgently raised the issue of political engagement for members of Monet's circle. Monet commended Zola's "heroic conduct" in the matter of the famous article "J'accuse" (see Monet's letters to Zola and Geffroy, 3 December 1897 and 25 February 1898; L. 1397, 1403), but he also excluded himself from an explicitly political role in a letter to an anonymous correspondent—"as to taking part in any sort of committee, that is not at all my affair" (3 March 1898; L. 1404). Lecomte places the political burden elsewhere: "Attentive to all the flourishing of modern thought, to the so passionate efforts of our epoch for a better future, to the muffled travail of a society that wants to be more just and more free, does he not give us the reassuring example of his simple and straightforward life, all work and

reflection, full of tender respect for the at once so noble and so precarious human plant."[52]

In July 1898 the *Mercure de France* published a lengthy article on Monet written by the poet, critic, and art historian André Fontainas. In other writings Fontainas acknowledges his indebtedness to the critical writings of Mirbeau and Geffroy, but he chiefly proclaims himself the disciple of Mallarmé. This position does not keep Fontainas from appreciating the allegorical force of Mauclair's portrayal of Narcissus: "Art is a mysterious form of writing whereby sounds, colors, and lines awaken in us the memory of certain complex and unforgettable relations of which the notion may be fixed in no other way. The artist is the 'intermediary between humanity and the individual'; he provides the individual with the consciousness of what he is and what he aspires to be, and establishes the universal correlation whose sign he encloses within images."[53] In 1898 Fontainas treats Monet's art as an instance of just such a sign.

In front of Monet's paintings Fontainas discerns both repetition and difference: "Here is the river, in the morning, dozing beneath the fog, stretching herself, with the foliage that caresses her, toward a still timid smile of the sun. The cutout of the leaves, their reflections, and the watery creek have not varied; the poem that rises in the mind of the spectator is, on each occasion, of a different mode. The same for the fugacious and gracious *Nettle Island,* pearl gray of an evanescent green, and for the entire incredible series of these unforgettable cliffs." If formal repetition yields a differential bonus for the beholder it is only because Monet has already been diversely affected by "the stable motif, the immobile pretext of the picture": "It is not that he does not choose, with care, the site, not according to supposedly *picturesque* concerns but on account of an emotion that he felt there." The result is a "series of impressions" which correspond to the artist's ongoing experience of the world.[54]

To preside over a selection of his poetry Fontainas invokes an ancient figure of myth in order to symbolize the synthesis of mind and world which he also seems to see in Monet's art: "Man is the unique creator of the splendid universe. The fire of enthusiasm, flaming in him since the abduction of Prometheus, ignites all the appearances of things, whether we name them imaginary or real. Nothing exists of which we have not projected the objective vision from out of ourselves."[55] Solitary figures of self-sacrifice, Prometheus and Narcissus are alternate names for that habit of projection by way of which art places our various worlds on view.

By 1899 Maurice Rollinat had shared in Monet's imagery of reflections

for more than a decade: "Yes, for my eye smitten with shadow and with glow, / They have so much suppleness and so much nonchalance, / In their mysterious and gliding to-and-fro, / . . . They impregnate my art with their mysticity / And filter like a dream into my haunted soul." Both men elicit the anthropomorphism of poplars by the river: "Against sulfurous grounds tinted with verdigris / The poplars would trace horrible arabesques; / Lightning accompanied their gigantic laments, / And the north wind emitted dreadful cries." Each depicts the dread allure of dormant water: "The soul of the landscape at all hours flutters / Above this lake benumbed by a fatal sleep, / Paved with flat stones and of which the fine crystal / Has the sparkles of dream and of vertigo."[56] And in the work of each, "One sees between the water lilies / Half ruddy, half pale, / The soul of the river afloat." For Rollinat, as for Monet perhaps, "the changing state of the atmosphere / Is reflected in our own,"[57] and the vast expanse of the world is embraceable in a single inverted gaze: "The sky having set its great pink clouds, / Emerald, lilac, coppery, and violet, / The bright pond, sparkling in the softness of things, / Sends back their image with all its reflections. / . . . Such was the power of this most beautiful mirage / That I was admiring the sky without lifting up my eyes, / Taking the water for the azure with all its clouds."[58] Rollinat does not name Narcissus here, but in the next poem I will consider, he does.

In 1898 Monet turned away from the mirror imagery of the *Mornings on the Seine,* and in one solitary painting he reorients his view downward upon the trembling water at his feet, cropping the resulting composition with a pendulous fringe of foliage at the top (W. 1500). Entitled *Willows,* it is reminiscent of a unique painting of 1876 (W. 396) as well as anticipatory of the willow's featured role in the watergarden paintings from 1903 to 1922 (W. 1657–58, 1848–53, 1857–62, 1866–77, 1941–43, 1971, 1980; figs. 99–101). Perhaps Monet's *Willows* weep for Suzanne Hoschedé, who died in 1899 after a long, debilitating illness. As a mournful sign it is the twin of Rollinat's contemporaneous sonnet "Le Saule":

> Just now, beneath the flashes
> And the blasts of the storm,
> The willow was brandishing its head,
> And the pond was pounding its flat banks.
> With mortal alarm,
> In this wind, these clamors, these fires,
> The tree was twisting its long hair
> Upon the water, sweeping away its tears.

> Calm now, the pond glistens,
> The sky illuminates the night,
> And, without a breeze to graze it,
> The Narcissus of the vegetable realm
> Still admires in the water
> Its green face that weeps.[59]

In seeing in the posture of the willow the weeping body of Narcissus does Rollinat join with Monet in a naturalistic practice of allegory? *Ut pictura poesis,* perhaps; but among his own iconographic precursors, such as melancholy nature poet André Chénier, there is ample precedent for Rollinat's metamorphosis. For Chénier it is not the tree but the flower that reverberates with the history of the youth: "Leaving his form, alas! but not his primordial soul / The handsome Narcissus in flower, by the banks of the streams, / Loves still to see himself in the crystal of the waters."[60]

Like the narcotizing narcissus, the weeping willow had long been associated in Western culture with women, melancholy, mourning, and death, as we have seen in Constance Charpentier's *Melancholy* of 1801 (fig. 61). In the intertwining of past and present tenses in Rollinat's poem the self-reflection of the waterside tree is conflated with both the anxiety and allure of the figure of myth. In a similar fashion Geffroy later evokes "that stirring pallor, that slender grace of the willow which can best incite, in the vague hours of the evening, the poetry of the mythologies of the river for troubled and charmed eyes."[61] Though not mentioned here by name, perhaps the troubled and charmed eyes in question are those bedimmed by age of Monet himself. In the aftermath of the world war, at a time of public and private mourning which occupied the remaining years of his life, Monet incorporated three monumental panels into a decoration to be donated to the state in which the anthropomorphic willow comes to stand, perhaps, as allegory of the mortal struggle to seize the impossible image of his dream (W. 4: 332–33; 2 × 12.75, 2 × 17, 2 × 12.75 m; fig. 102). In the encircling embrace of Monet's death-deferring murals in the Orangerie, *Morning with Willows, The Two Willows,* and *Clear Morning with Willows* may finally bring a kind of closure to the artist's career and life. There we come face to face with the writhing body of the aged artist. Bending over the scumbled surface of his art, we watch as he entrusts his inevitably vain efforts at self-possession to the allegories of Narcissus, or at least to their real counterparts in the weeping willows and passing reflections of a pond.

Giverny and Paradise
(1899–1909)

In 1898 Arsène Alexandre applauded Monet's self-imposed restriction to "four or five motifs" because, "upon these general themes, M. Claude Monet has noted the most subtle effects." Monet invited Alexandre to visit him while he was at work on the first *Water Lilies* series (31 August 1899; L. 1472), but the critic's eventual review of the paintings in 1900 offers an ambivalent evaluation. Unlike the Japanese whose prints the painter's arched wooden bridge recalls, Monet "has not sufficiently diversified his effects, and the series does not proceed without certain similitudes." Moreover, "for pictures of this dimension [i.e., 81 × 100, 89 × 92 (four times), 89 × 93 (twice), 89 × 100, 90 × 90, 90 × 100, 93 × 74, and 93 × 90 cm] the motif is perhaps a bit simple and of rather a secondary interest" (W. 1509–20, 1628–33; figs. 103–4). For Alexandre the *Water Lilies* provoke a crisis regarding the adequacy of such nearly identical pictures, yet "often, however, M. Monet has dissimulated this insufficiency beneath the splendor of his symphony."[1]

Alexandre's doubts stand in contrast to Julien Leclercq's opinion in *La Chronique des Arts:* "Some severe individuals, who tell themselves that in order to have a more penetrating air than formerly it is time to criticize a bit after having for a long time admired, reproach Monet for not having taken a turn around his bridge, for not having varied the angle of his observation. They cite the Japanese." Unlike Alexandre, Leclercq does not draw the analogy with Japan to Monet's disadvantage: "It is the light, always the light, whose play he pursues; and, so that we may have no doubt of it, he does not wish to distract us through variations in composition. My yes! it is ten times the same bridge; but what does it matter if the water is different ten times, if the shadows between the trees are softer or more

accentuated, if the water lilies sing ten melodies that the greenery accompanies in ten ways!"[2] In Leclercq's view Monet's art captures a differentiation in time within an invariant armature of place.

In much of the criticism of 1900 the focus is on Monet's serial practice. An anonymous reviewer in *La Justice* insists that "through the comparison of these canvases of the same type one seizes the entire effort which the artist had to conquer in order to give us not *impressions* but *sensations* and illusions." This development of the signifying differential of the series is related to the cultivation of the garden as a subject to paint: "In his garden of Giverny which he flooded he had planted irises and water lilies that live on the water's surface beneath a luxuriant vegetation which hides the sky. . . . Everything is hidden from us of external life; we find ourselves in a wooded spot where the light arrives by diffusion and not by rays and in spite of it all we become perfectly aware that such and such a canvas represents nature around eight o'clock in the morning in clear weather; no breeze blows, the tranquil water of the pool holds up in a bent-over bearing the tufts of water lilies which float; in the purity of her transparency she lets us see the green and lustrous tufts and the roots of an earthen red."[3] The hermeticism of this place of limit and light, of bending flowers and aquatic roots, evokes the seclusion of Narcissus's pool.

In 1900 Monet's works provide a ready pretext for such allusive descriptions. In his review in *Le Journal* Geffroy lingers over "this minuscule pool where some mysterious corollas bloom," "a calm pool, immobile, rigid, and deep like a mirror, upon which white water lilies blossom forth, a pool surrounded by soft and hanging greenery which reflects itself in it."[4] An article in the *Journal des Artistes* elaborates a similar imagery: "Delicious jumble—in its coloration, in its lighting, in its arrangement,—a jumble of dazzling greenery enclosing, as in a narrow clearing, the sleeping water of the 'Pool,' a profound harmony participated in by the thick foliage of the surrounding thicket and the lightweight boughs of the disheveled willows and the capricious undulations of the tall grasses that cover the ground, making the extent and form of the pool disappear, hiding the water itself, so as to permit to appear, in a thousand exploding spots, only the short flowers, in exquisite colors, the ravishment of this retreat,—not so much however that the water is no longer seen, absorbing the vague reflections of the grove and giving it its very distinct savor,—in sum, one of these enchanting corners where everything is riant as well, illuminated by an invisible sky." The author of this long serial sentence, A. E. Guyon-Vérax, finds Monet's "variants" or "transpositions" to be appropriately "diversi-

fied," but he also concedes that the individual paintings "provoke in the public quite opposed preferences."[5]

Jean Lorrain demystifies the paintings by observing that Monet's garden is an "Eden" which costs the artist 40,000 francs per year.[6] For Charles Saunier, however, the artist's garden evokes anxious thoughts of paradise: "The motif: a pool peopled with water lilies crossed by a footbridge. And Claude Monet relates to us the splendor of paradisical corollas grouped upon the transparent water, as of flowering rafts for fairy tales. The vapor distilled by the crushing heat permits strange irisations and makes this corner of nature pass from pink to mauve and from these hues to other hues." Like Baudelaire in 1859, who laments the unpopulated expanse of Boudin's marine studies, Saunier decries what he sees as the inhuman quality of Monet's motif: "The place is deserted: not a soul. The *Haystacks,* the *Cathedrals* told us of the labor of man, his collaboration in the work of nature. Here he is too absent; the interest of the decor consequently suffers and one has in front of these canvases the afterthought of a cinematographic film which would note not movement, but color. —Color, I say, but not the nuance."[7]

Saunier acknowledges that his judgment is an "entirely personal feeling," and accordingly prefers a re-exhibited trio of *Mornings on the Seine* (W. 1474, 1476, 1485): "The site is here so beautiful, nature appears so grandiose with her grand masses of trees which overhang the river that one is recaptured, in front of these splendid evocations, by that religious sentiment which is at the basis of the human sensibility." This religious sentiment is yet another instance of the tendency to impute allegorical self-reflection to the naturalistic work of art: "Man is no more visible here, one will say. Certainly, but the personality of the painter, it is."[8]

Monet's artistic personality is celebrated in 1901 by Emile Verhaeren, who had first written about the painter's work in 1885. In a series of poems written between 1896 and 1916 Verhaeren reiterates a restricted range of watergarden motifs not unlike Monet's. The poet lingers over his garden pond without naming Narcissus yet all the while deploying the myth's familiar tropes: "The beautiful garden flowering with flames / That seemed to us the double or the mirror / Of the bright garden we were carrying in our soul / Crystallizes in gel and gold, this night."[9] In Verhaeren's description of Monet, the artist is similarly seen as the Narcissus-like mirror of nature: "Whether he admits it or not, the term of great poet may be applied to him, if one means thereby an intelligent and particularly sensitive force in sympathy with the beauty of the world. For a poet may not, unless

he negate himself, become a virtuoso; he is condemned to remain grave, sincere, and anguished in front of nature. Little by little he lives from her and she lives in her turn in the parts of his brain which look at her, study her, admire her, and reproduce her. In the hours of fruitful labor, the union is complete. The individual's life and the life of the whole fuse. The poet becomes the universe he translates. It is only through this communion that great works are elaborated. In them cosmic force becomes conscious and, by grace of this consciousness, adorns itself with beauty. Claude Monet is the sole contemporary painter who sometimes achieves such a miracle."[10]

The flowering decor of Monet's pond captures Verhaeren's attention: "Oh! the beautiful vegetal violence, the mad abundance, the tightly woven enlacement of colors and lights! One would say a congestion of flowers, of grasses, of shoots, and of branches." In front of these paintings Verhaeren finds himself disagreeing with a commonly held view: "The *Water Lilies* have permitted certain visitors to affirm that finally Monet had succeeded in treating the motif. The motif? Oh! a piteous term for such an art! The motif? That cutout, that piece of reality arbitrarily isolated from the ensemble of things. There are painters who, out of impotence, are condemned to it. But, in good grace, let one not ask the strong to go down to them." For Verhaeren, Monet's art goes beyond the isolated artifice of the motif to a hallucinated experience of the entire world: "In the *Water Lilies,* some of which however are displeasing whether because of certain heavy tones marking the shadows or whether because of certain cold and hard aspects, beauty is precisely attained because the totality of nature is evoked. One divines the entire garden in these simple displays of water and plants. One senses the subterranean life in the depth of the ponds; the tufted growth of roots, the intermeshing of shoots whose clumps massed upon the surface are no more than their blossoming forth. Monet will never succeed in limiting himself to the motif, because his force will always push him beyond."[11]

Turning away from the arbitrary limits of the *découpure,* Verhaeren shares the fate of Narcissus in annulling the difference between the world and its reflected signs: "One forgets in front of [the canvases] the moldings that delimit them and the walls that support them and the people who look at them."[12] As Verhaeren's colleague at the *Mercure de France,* Rémy de Gourmont, writes about the same exhibition of works, "one feels oneself in front of a painting that differs very little from nature herself. There is the miracle."[13]

The metaphor of the miracle subtends the texts of Verhaeren and Gourmont. The unnamed Narcissus is the avatar of the artist who seeks

to animate a flat image with life: "When one has looked attentively at a series of paintings by Claude Monet one experiences as though a fright; it seems that one finds oneself in the presence of the creations of a god, and it is true." Gourmont refers to the "almost patiently transplanted" *Water Lilies*, where the creativity of the godlike painter is horticulturally brought down to earth.[14]

In 1900 Rémy de Gourmont was one of the most influential critics in France. A founding editor of the *Mercure de France* in 1890 and its frequent contributor until his death in 1915, Gourmont articulated the philosophical basis of symbolism in numerous essays, many of which were translated into English, German, Italian, Spanish, and Japanese. His work was explicated in dozens of articles by Bouhélier, Ghéon, Gide, Louÿs, Mauclair, Mirbeau, and Régnier, to name only writers who have been treated here. Gourmont was one of the first theorists of his generation to use the term "narcissism" and one of the first writers in France to undergo the impact of Freud. In "La Création subconsciente" (1900) Gourmont shows his familiarity with the writing of Schopenhauer and Eduard von Hartmann on the "unconscious" as well as with the psychiatric literature of Ribot, Janet, and Paul Chabaneix on the "subconscious" determinants of artistic creativity. Gourmont's aquatic metaphors are of particular pertinence to my discussion of Monet: "Memory is the secret pool into which, without our knowledge, the subconscious casts its net; . . . consciousness is less adept at provisioning itself from it, even though it has at its service several useful methods, such as the logical association of ideas or the localization of images."[15]

In an essay written in 1894 Gourmont seeks to negotiate a middle way between objectivity and subjectivity that will do justice to the claims of each. Rejecting the "pathological" social outcomes of the idealist philosophy of the period, Gourmont decries the condition he dubs "mental Neroism, more clearly called narcissism": "Narcissus, 'quid videat nescit, sed quod videt, uritur illo' ['What he sees he knows not; but that which he sees he burns for'], and knowing only himself, he is ignorant of himself: Ovid, without knowing it, has put plenty of philosophy in the fifteen syllables of his elegant verse."[16]

Writing at a time when it was "the fashion to go drink at the fountain of Narcissus," Gourmont acknowledges the heuristic utility of the favorite symbol of Valéry, Gide, and Mauclair even as he worries about its potential abuse. He accepts the Schopenhauerian maxim that "the world is for me only a mental representation," but then refuses to dismiss the significance of the thought of others: "I know myself and I affirm myself; I am, for I

think myself, and the exterior world where I encounter this brother is nothing other, I know it well, than my thought even hypothetically exteriorized. But if this brother gravitates around my lover, particle of my desire, I too, particle of *his* desire, I gravitate around *his* lover; the world of which he is a part exists only in me; but the world of which I am a part exists only in him,—and, relative to his thought, I depend upon his thought: he creates me and he annihilates me, he conceives me and he negates me, he writes me and effaces me, he illuminates me and he casts me in shadow." The *he* of Gourmont's proto-Sartrean scenario is given the name of Homunculus-Hypothesis, but the scenario's constructive and deconstructive rhythms (what Gourmont calls "the dissociation of ideas") is quite similar to the reflexive to-and-fro of the symbolist Narcissus.[17]

Unlike those colleagues who exalt the transfiguration of the self, Gourmont—stricken since 1891 with a severely disfiguring form of lupus—constantly stresses the limits of idealism and the dependence of the self's illusory autonomy upon the social and physical world. Salvation will lie in a "life of relation" in which subject and object coexist. The reflection of Narcissus offers Gourmont an image of the externality of self-constitution: "The thought of others is the very mirror of Narcissus, and without which he would have ignored himself eternally. He loves himself, because he has seen himself; one sees oneself in a mirror, in the eyes, in the lake of external thought. Such an intellectual Narcissus, content with an audience comprised by a woman who claims to listen to him, would develop less if he had for confidants only the trees of the forest, or Mnemosyne [Memory], an indulgent plaster all the same. But, in default of the object-thought, Narcissus still amuses himself by interpellating the mute patience of the rocks and the rustling sympathy of the trees; he listens, he has created Echo. Echo is the thought in which he might live: he denies her and he dies."[18]

The self-absorption of Narcissus is an error in social relations that must be overcome. Fellowship is the key even in a solipsistic world, and here Gourmont demonstrates his erudition in an excursus on the late Greek author Athenaeus, whose metaphysical symposiasts garland themselves with the plucked narcissi of Narcissus's death. Had he been "reasonable and logical," Narcissus "would not even trouble himself about the reflections that sleep in the pools." This is not the Narcissus of most of his symbolist colleagues, but it is not unlike the portrait he later paints of Monet: "Apart from everything, in a rigorous and ferocious solitude, he would tend, jealous and silent, the precious flower of his garden, too pre-

cious for another's eye. Like perhaps the hermits of old? No, for they cultivated their selves only to rip it out, waiting until the plant had become sturdy enough to give a grip to the hands of renunciation. Illogical, he invites others to visit his borders and his greenhouses, for as a horticulturalist of fashion and no longer the poor gardener, he exhibits alluring collections of azaleas and phenomenal orchids, images brought forth from his pride. He alone is the great horticulturalist, but his own affirmation fails if others do not confirm it."[19]

The *hortus conclusus* of Monet's art, of Gourmont's invalidism, is narcissistic not in the splendor or misery of its isolation but only in the paintings and writings that find their confirmation in other minds. This is true even of the prototypical narcissist Friedrich Nietzsche, whose posture of ironic self-display Gourmont claims as an exemplary embodiment of modern consciousness along with the kindred spirits of Verlaine, Rodin, Mallarmé, and Monet.[20]

Garden metaphors abound in Gourmont's work, and in his poem "Hiéroglyphes" of 1894 he morbidly evokes Monet's favored flower: "Ah! I die, I sink away, I pour out my blood in your arms / Like a living source full of water lilies."[21] In "L'Abandonnée" of 1899 Rollinat also situates the flower in a decor of death: "She sobs / By the banks of the pool that shivers / Beneath the trembling poplars, / While her gaze floats / And loses itself beneath the white water lilies. / Then, pale and haggard, / She bends over, she looks / At the blackest water's deep / That will be her tomb."[22] The iconography of flowers was a familiar language in Monet's circle— Mirbeau, an avid gardener, writes in 1900 that "narcissi with very long stems were dying, like souls"—and through a series of witness accounts the allegorical horticulture of Giverny became a familiar topic in the press.[23]

For Alexandre in *Le Figaro* in 1901 Monet's garden is "the materialized reflection of his tastes, his desires, his faults, or his culture." Driving to Giverny via Vétheuil, Alexandre describes the village which Monet was then painting again after a twenty-year lapse as "that lovable Vétheuil whose capricious and delicate silhouette he painted more than once, laid out upon the hillside and reflecting herself in the mirror of the Seine like a coquettish woman" (W. 1635–49). Arriving at Giverny, Alexandre invokes Germanic myth: "You may raise your imagination and figure for a moment that you are some Parsifal subjected to all the intoxicating provocations of the Flower-Maidens, or still yet, when you are among the gladioli darting their flames, that you are a sort of Siegfried who has just discovered the Valkyrie asleep among these flamboyant expanses." A more mundane real-

ity intrudes to nudge such fantasy aside, and Alexandre concludes that "you are in the domain of a market-gardener of genius."[24]

In Monet's paintings of the watergarden Alexandre finds an intrinsic impossibility in the effort to depict the "reflections that interplay, unseizable, upon this marquetry of large blooming flowers and of molten metals." Alexandre's description of the water-lily pond supplements Guillemot's earlier account with information about Monet's technique of out-of-door painting under some sort of observatory-tent: "Damascened with large round leaves of water lilies, incrusted with the precious stones that are their flowers, this water seems, when the sun plays upon its surface, the masterpiece of a goldsmith who has combined the alloys of the most magical metals." In the end Alexandre insists that Monet's withdrawal from the collective life of Paris is in the name of a "supreme refinement" of self: "Thus I was telling you that the garden is the man."[25]

An important article on Monet's garden appeared in *Le Temps* in 1904. Traveling to Giverny to interview the artist, Maurice Kahn finds Monet "beneath his large parasol, by the banks of the pool, bent over toward his dear water lilies, he exerts himself to seize the sparkling of the water, the reflection of the large leaves, the capricious play of the sun."[26] By this time the painter had exhibited his thirty-seven views of the Thames at London (W. 1521–1614) and there was public anticipation of an extensive series of *Water Lilies*.

Water lilies are the "strange flowers of death and of silence" which Persephone picked upon Hades' shore in a poem of 1903 by Renée Vivien.[27] The queen of the underworld is similarly invoked in a poem by Gérard d'Houville, the wife of Henri de Régnier, who notes that the narcissus is her "future scepter."[28] In 1904 Marie Dauguet approaches the "burbling fountain / Where Narcissus admired his body of pure marble / Amidst the azure reeds / To sit and listen to your unceasing pain."[29] The familiar "you" of the feminine fountain is the poet's interlocutor, and throughout the Narcissus poems written during this late phase of symbolism the cerebral self-scrutiny of the Ovidian Narcissus of Valéry, Gide, and Mauclair is supplemented by the alternate version of the myth deriving from Pausanias in which what Narcissus sees under his own traits in the pool is the likeness of his deceased twin sister. The tragic inaccessibility of the feminine is the theme in 1907 of Jean Royère's series of strophes dedicated to the "Soeur de Narcisse nue" in which their pool becomes "a mortuary hymen": "But I, had I, on the threshold of this face tomb, / Smilingly to evoke, while I was blowing / Bubbles in the sun, bluish reflections / And in parallel to gradate the nuances / Of so many skies in bloom and of so

many silences?"[30] Royère's funereal image of inverted skies in bloom will match the commentary on the *Water Lilies* in 1909.

In Jean-Marc Bernard's eclogue of 1905, "La Mort de Narcisse," Echo implores Narcissus to acknowledge her love: "You will have only to bend over your face upon the waters / To see there in your eyes all my love enclosed." Narcissus does not heed her cry, but neither does he give in to the allure of his own bodily beauty: "In this fluid mirror in which my gaze travels / Perhaps I have sought the deceptive mirage / Of surprising my soul in the reflection of my eyes. . . . / I know every secret of my offended flesh; / But my soul, like a stranger, has passed, / For on the blue mirror where I bent myself over, / I saw only the Form and not at all the Thought." In an epilogue Narcissus speaks of his immortality from beyond his watery grave: "I no longer wish to see myself but in the accomplished work / That through my gesture is stretched toward a new desire: / I do not wish to be—I—but a reflection of the life / Which one day will bear forth my arm and my brain!"[31] As death crowds about Monet in these later years of his life, the *Water Lilies* will comprise both the tomb of his personal failures and a posthumous memorial to his work. This seems especially true as he envisions the mausoleumlike installation of the final *Water Lilies* during the death-filled war years after 1914, but already at the time of the *Water Lilies* series of 1903–8 the mortal shadow of Narcissus falls upon the pond at his feet, as captured in an uncanny photograph taken by Monet himself (fig. 105).[32]

Like Narcissus bent over the watery plane of his obsession, Monet "replunged" again and again into his watergarden works (to the photographer Paul Nadar, 5 May 1900; L. 1556). An early trace of the artist's project had come in a letter to Geffroy in which Monet writes of his need "to take up work again" (10 May 1899; L. 1465). This was soon followed by the characteristic disclaimer that he "was only making trash," but also by the assertion of his will to succeed: "In sum, I am not letting go and am beginning a bit to refind myself in [the works]" (5 July 1899; L. 1468). The *re-* prefix is ubiquitous in the letters of this period, in which retaking, refinding, reiterating, reworking, resetting, rethinking, replunging, remounting, reseizing, recapturing, reseeking, redoing, retouching, rebecoming, reattempting, refeeling, recommencing . . . are so many indices of a repeated movement of return that is also one of renunciation.[33] *Remettre,* for instance, is sometimes used in the sense of hopefully setting to work again and sometimes in the sense of indefinitely putting off the completion of the work. The major thematic operators of this rhythm of repetition and deferral are *travail* and *temps,* time and travail, work and weather;

and in this dual obsession with the world's passing and the work's becoming, Monet enacts an ever-repeated scenario of joy and pain. Until, of course, he dies.

"When I work I forget all the rest," he writes to Dr. Georges Viau (26 July 1899; L. 1470), and Monet cultivates the oblivion of his garden as assiduously as any ornamental plant. He repeatedly writes to excuse himself from various social responsibilities, such as attending, in the summer of 1900, the double marriage of Berthe Morisot's daughter and niece, Julie Manet and Jeannie Gobillard, to Ernest Rouart and Paul Valéry. The premier poet of Narcissus will later come to visit Monet's watergarden, but for the moment this crossing of paths is an opportunity missed. In apologizing for failing in the "duty" and "joy" of seeing his dead friend's daughter married, Monet insists that he is "at grips with nature; canvases that I cannot get myself out of and that I have only two or three days to save" (29 May 1900; L. 1560). A decade later it is the flooded garden itself that Monet is seeking to save and, "as a perfect egoist," he excuses himself for not having responded earlier to a charitable request Julie Manet-Rouart had made (6 February 1910; L. 1912).

The obsession of work also "deprives" Monet of the "joy" of attending the opening of a major exhibition of sculpture by Rodin for which he had provided a brief written testimonial: "Alas, I am retained here by work that I cannot quit for some days on pain of losing all that I have done" (31 May 1900, L. 1561). In spite of these dismissals of social relations beyond his garden walls, Monet's self-absorption is by no means solitary, for he delights in showing the garden to intimates such as Geffroy: "If you delay, the garden will be deflowered and I would so much like [you] to see it as it is. Come quickly; I am writing to Clemenceau for him to reach an understanding with you" (29 May 1900; L. 1559).

Monet repeatedly writes to Durand-Ruel of his dissatisfaction with the series of paintings that eventually would be exhibited at the end of the year: "I am in a phase of great discouragement. Thus it is not the moment to come, even though I have not ceased to work since my return from London, but without arriving at being able to finish anything to my taste. I have nothing interesting to show, and even still less to sell, having resolved from now on only to sell what I will find to be more or less good. And I am afraid that that will be rare" (27 June 1900; L. 1562). Two months later a dramatic turn of events leaves the message much the same: "Excuse me for having left you so long without news and for not having invited you to come as I had promised, but the summer has not been very good for me in spite of the good weather. Nevertheless I have worked a great

deal, but, as I am becoming slower and more difficult, I have not been able to do what I wanted, having in addition had an accident in which I nearly lost an eye and which for the last month has prevented me from seeing, which in consequence has obliged me to stop all work. You can imagine whether I was afraid and I have been quite anxious for a while but it is over now and I hope soon to be able to work again and to recapture the lost time" (21 August 1900; L. 1564). *A la recherche du temps perdu* is as fitting a maxim for Monet's enterprise as it is for Marcel Proust's; in the criticism as well as the fiction of the writer, Monet's watergarden figures as the emblem of a scarcely attainable ideal.

For Proust, Monet had placed an indelible mark on Giverny, "along the banks of the Seine, on this bend of the river which he lets us barely distinguish through the morning's fog." Giverny will henceforth carry "like an unseizable reflection the impression" which it had given the artist, and nature will have been made over in Monet's image.[34] Proust will later point to the "forty water lilies" of 1909 as corroboration of the serial form of his own work,[35] but only after he had already imagined for himself the sort of "dematerialized" images that Monet's famous but unseen garden might yield: "Flowers of the earth, and also flowers of the water, those tender water lilies which the master has depicted in sublime canvases of which the garden (true transposition of art rather more than a model for pictures, a picture already executed within nature itself which becomes illuminated from beneath by the gaze of a great painter) is like a first and vivid sketch, at the very least the palette already set out and delicious in which the harmonious colors are prepared."[36] The familiar metaphors of Narcissus are present in the blurring of boundaries between art and life: "We are there, bent over the magic mirror, distancing ourselves, trying to chase away any other thought, striving to comprehend the sense of each color, each one calling up in our memory past impressions that are associated one with the other in as airy and multicolored an architecture as the colors upon the canvas and build up a landscape in our imagination." Monet's paintings make Proust love the landscape which has inspired them, teaching him to see that "its soil is full of gods." In ancient religion the pool of Narcissus was a sacred place, and so is Giverny for pilgrims such as Proust: "And so we depart for these blessed sites. And [Monet's pictures] also show us the celestial nourishment that our imagination may find in less determinate things, rivers strewn with islands in the inert hours of the afternoon when the river is white and blue from the clouds and the sky, and green from the trees and the lawns, and pink from the already setting rays upon the trunks of the trees, and in the bright red shade of the garden

copse in which the great dahlias grow. . . . It is of the ideal that we are smitten."[37] In contrast to Baudelaire's worries about Boudin fifty years before, it is precisely the depopulated aspect of Monet's water paintings that evokes for Proust the divinity of the place.

Proust is an acute observer of the late work of Monet, which he places above the work of Manet, yet Proust is also aware of the gulf that separates Monet's admirers from the advocates of the most recent forms of modernism.[38] During these years Monet continued to labor in his open-air manner seemingly unaffected by the new anti-impressionist styles, constantly oscillating between "a fine fever of work" and the "bile from doing nothing" (to Geffroy, 23 August 1900; L. 1565). To Durand-Ruel he writes of monitoring the season in view of returning to an unfinished canvas of his pond, "but it is not yet the moment to be able to work on it in front of nature" (15 April 1901; L. 1631). Monet remains "on the watch, altogether ready to set myself to the task" (10 May 1901; L. 1635), but two months later he reports that on account of the weather it has been "a lost year" (19 July 1901; L. 1639). By the time of the next letter Monet has seen the end of the rain and the cold: "I have quite set myself back to work for the last month, but without great success" (13 August 1901; L. 1640).

Little concerning the *Water Lilies* can be gleaned from the correspondence of 1902, for at this time Monet was absorbed in the studio with dozens of unfinished canvases from his campaigns along the Thames. At the end of the year he acknowledges his depression to Geffroy: "I have such a need to have the feeling of friendship, if you were to know how sad I am in my depths, but I do not want to dwell upon this subject; come see me soon, won't you" (26 December 1902; L. 1679). Monet had always depended upon his friends for reassurance, and in the spring of 1903 Mirbeau, who himself had suffered from recurrent depression for much of the previous decade, played out his allotted role in the required way: "You are at the moment when *you must not* remain alone face-to-face with yourself, hypnotizing yourself with fantasies which you perpetually entertain and developing a neurasthenia which it would take nothing to dispel. . . . Come to Paris, often, despite your distaste for coming here. . . . You believe that it is still at Giverny that you are best off. That is an error."[39] The error of Narcissus, perhaps; yet still Monet refuses to turn away from the mirror of his work.

With the summer's return the enterprise of the watergarden picks up and Monet writes to Geffroy that he is "fully at work, at grips with the weather . . . fully struggling and altogether in what I am doing" (3 August

1903; L. 1696). The redundancy in Monet's image of fullness scarcely conceals an anxiety of unfulfillment which repeatedly mounts to the surface of his discourse. In the following year he writes to Durand-Ruel that he is "desolated by the weather which prevents me from setting myself back to work" (1 June 1904; L. 1731), but within days, to Geffroy, he commends the garden "so beautiful at this moment" (4 June 1904; L. 1732). The perception of beauty, however, remains subject to the eye of the beholder: "It is true that since the change in weather, I no longer see things as being beautiful. I was excited and full of ardor, an arrest of several days and here I am disgusted, malcontent" (to Durand-Ruel, 28 July 1904; L. 1738).

A year later Monet is still at work, still "furious and desolated with this frightful weather" (8 May 1905; L. 1805). Even with more clement weather the impediment to progress fails to disappear: "I am working but with quite a lot of difficulty in spite of the fine weather, but more and more I have difficulty in satisfying myself and this grieves me at moments" (13 June 1906; L. 1805). By this time Monet's preparations for a new exhibition of *Water Lilies* had been noted in the press, as in an illustrated interview with Louis Vauxcelles, who describes the sequential effects of the series "at all the hours of the day, in the liliaceous early morning, in the bronzed dustiness of noon, in the violet shadows of dusk." These "dazzling *Water Lilies*" Monet "repaints numbers of times," but with "never the least trace of fatigue": "There are certain canvases that one would swear were painted with verve in an afternoon upon which the illustrious master has worked for several years."[40]

At the end of 1906 we find the first indication of Monet's willingness to bring his work to a close in a letter to Durand-Ruel (28 December 1906; L. 1818), but within a few months he withdrew his commitment to an exhibition that year: "You will not be happy with me and I beg you to excuse me for breaking my word, but I prefer to put off my exhibition until next year; it will only be the better for it, at any rate so I want to hope. The few canvases that could be finished between now and the end of the month would be insufficient to make an exhibition of them, and the rest need to be taken up again in front of nature" (8 April 1907; L. 1831). At the end of the month his lament is the same: "Like you I am desolated not to be able to exhibit this year the series of *Water Lilies* and, if I have taken this position, it is because it was not possible. I am very difficult with myself, that is perhaps true, but that is better than showing things that are mediocre. And it is not because I want to exhibit a large number that I am delaying this exhibition, certainly not, but I truly have

too few satisfactory ones to bother the public with. It is at the most if I have five or six possible canvases and moreover I have just destroyed at least thirty, and to my great satisfaction" (27 April 1907; L. 1832).

Monet eventually acknowledges some progress to Durand-Ruel: "It is still a matter of groping and searching, but I believe there are some better ones" (20 September 1907; L. 1837). Unfortunately for the painter, Durand-Ruel initially seems to have found the *Water Lilies* beyond his grasp and hesitated to pay the high prices Monet was demanding: "I did not want to write to you the day after your visit which has not stopped troubling me. I have reflected on it with mature consideration since then and I must confess to you that I greatly hesitate to do the projected exhibition. From the moment that my new canvases do not have your complete approbation, it seems to me difficult for you to mount their exhibition" (20 March 1908; L. 1844). Monet threatens to "renounce the exhibition" and "take back [his] liberty" rather than submit unsold works to an unpredictable public (30 March 1908; L. 1846). "Overflowing and absorbed" (23 April 1908; L. 1849), Monet's affect is like his pond: "It costs me a great deal but I am obliged to renounce once and for all the continuing plans of the projected exhibition. . . . I am all upset by what I am writing to you, but tomorrow I will be calm, I will go rest, and if the weather is good, it is in front of nature that I will console myself" (29 April 1908; L. 1850).

Two days later Monet repeats to his dealer his need for rest: "Yes, I have a great need of rest. To be no longer obsessed with the thought of this exhibition, to think of something else will do me a deal of good and perhaps afterward I will see things with a better eye" (1 May 1908; L. 1851). Obsession in a nonclinical sense is certainly an appropriate word for Monet's repeated bouts of self-absorption by the banks of his pond, but a morbid obsessiveness may be at issue as well. In a letter available only in Geffroy's published transcription the artist's relentless focus is given concise verbal form: "Know that I am absorbed by work. These landscapes of water and reflections have become an obsession. It is beyond my powers as an old man, and yet I want to arrive at rendering what I feel. I have destroyed some. . . . Some I recommence . . . and I hope that after so many efforts, something will come out" (11 August 1908; L. 1854).

The account of Monet's destruction of his canvases circulated widely in the press. Press clippings in the archives of Durand-Ruel document the story as far away as Montreal, Boston, New York, Philadelphia, Washington, D.C., Syracuse, Columbus, Cincinnati, and Duluth. An initial rendition has Monet destroying all the *Water Lilies;* a later version in the *Standard* in London is less extreme: "Partly because of overstrain, partly because of

dissatisfaction, M. Monet became extremely irritable and morose, and at last actually cut a few of his canvases to shreds. The majority remain, however. Persuaded by his friends, M. Monet has decided to turn them to the wall. . . . Possibly the remaining pictures will be exhibited next year."[41]

Alice Monet's letters have not been published in full, but available excerpts show her to have been preoccupied with her husband's moods. Here is a condensed digest for 1908:

> Monet is still in low spirits because of his exhibition and the demands of Durand; he is complaining of giddiness and blurred sight. (30 March 1908)

> Today Monet is so very frustrating; he has just told me that he would definitely refuse to have the exhibition. He punctures canvases every day, it is truly distressing. One day, things are not too bad; the next day all is lost. (12 April 1908)

> He keeps putting the blame on himself, on old age and his own inability, as he says, and the way he treats the result of eight years' work is most unfair! (16 April 1908)

> He refused to have lunch and stayed in his room all day long in spite of our entreaties. . . . It is so sad when one is healthy and happy to make a hell of one's life. (4 May 1908)

> He no longer enters the Water-lilies studio, he stays right here without reading and as soon as I leave the room, he falls asleep. (7 May 1908)

> Monet has received a long letter from Mirbeau, who compliments him unsparingly and tries to perk up his spirits. Fortunately he has Monet's ear and is more successful than we are. Monet keeps reading his letter with pleasure and seems to be less pessimistic. (21 May 1908)[42]

Like Narcissus of myth, it seems that Monet too cannot accept what his female Echo has to offer. Instead he turns to the male mirror of Mirbeau, one of those idealized twins in whose eyes he had become accustomed to gaze upon his own admired reflection.

As in earlier letters Mirbeau's ploy is to praise and cajole, to flatter his friend and yet rebuke his narcissistic paralysis: "And you, dear Monet? Here you are demoralized again! A man like you! It is insane and sad! Why did you let yourself go and not do your exhibition? That, you know, is sheer folly. When one is what you are one does not have the right to think only of oneself. One must think of others, of those who love you,

who admire you and for whom a manifestation of your genius is more than a joy, an entire education. You do not know to what point all this gives me chagrin." Mirbeau records his chagrin against the backdrop of an exhibition of Monet's landscapes at Durand-Ruel's: "It is just simply vertiginously beautiful, it made everyone utter cries of admiration."[43] Coming from Durand-Ruel's stock, the forty-two paintings stretched in date from a view of the Seine at Argenteuil of 1872 (W. 198) to one of the river at Vétheuil of 1901 (W. 1645). No paintings of *Water Lilies* were included, but sufficient waterscapes were there to remind the public of the series that it would not be permitted to see that year.

Mirbeau counted some ten of these landscapes as already having "the eternity of the masterpiece." Praise such as this seems precisely to be what Monet wanted to be told, but he seems equally to have required the scoldings of his friend: "And there you are demoralized, like a child! You who ought to have full consciousness of yourself and to tell yourself, quite tranquilly, without an artist's vanity, that you have done all that a man can do that is grand. Look, Monet, put yourself in face of reality, for once and for all. Impose a human discipline upon your reason. Tell yourself that there are dreams that a strong soul ought not to attempt, because they are unrealizable. One cannot go further than the sensible world and, hang it all, what you feel, what you see is a vast enough domain, infinite enough for you!"[44] The cajolery of Mirbeau and the patience of Mme Monet were eventually answered in the painter's renewed commitment to his series. By mid-June his wife records him "ready to set to work,"[45] but the "accursed" weather hampers his efforts throughout the summer (to Geffroy, 3 September 1908; L. 1856). In spite of these difficulties Monet continued to receive visitors and permitted himself to be photographed in full manorial possession of his home and gardens for the illustrated magazine *Fermes et Châteaux*.

The author of the accompanying article was J. C. N. Forestier, an officer in the Legion of Honor, an inspector of Waters and Forests, and the landscape architect of the recently installed rose garden at the Bagatelle and the plantings on the Champ de Mars. Forestier was principally interested in Monet's horticultural achievement, but a tinge of allegory may be detected even here. Once again Monet's garden is an Eden, a "Paradou,"[46] where an Adam-like Monet takes pleasure in assigning "their little names to these beautiful faithful friends, familiar and compliant." Forestier also takes time to observe the serial works to which the changing forms of Monet's garden had given rise: "And this canvas which he visited this morning at dawn is no longer that in front of which we find him attached

this afternoon. Returned to the attraction of the water and its mobile reflections, of the shivering and somber water beneath the large drowsy leaves of the water lilies, he will follow in the morning the opening of the flowers which, by the middle of the day, begin to close."[47]

Monet apparently came to feel that a change of venue would do him good, and so in the last days of September he and his wife embarked on a ten-week visit to Venice. Ravishment and enchantment, *souvenir* and *revenir,* comprise the familiar refrain of the dozen letters that are preserved from the trip, and after this restorative visit Monet finally agreed to exhibit his paintings: "In response to the request of your son, I come to tell you that, this time, you may announce without fear that the exhibition, so frequently deferred, will take place this year, in May. But only on the 5th if it is all right with you, a day that will be more convenient for me than the 3rd. In any case you may absolutely count on me; I will be ready, for my trip to Venice has had the advantage of making me see my canvases with a better eye. I have put aside all those which do not merit to be exhibited, and the rest will make, I believe, a hardly banal exhibition. I was going to forget, do not announce this series under the name of 'The Reflections,' but like this: 'The Water Lilies, series of water landscapes'" (28 January 1909, L. 1875). Within five weeks thirty paintings had been completed and signed (3 March 1909; L. 1880); no individual titles proved "possible" to provide (22 April 1909; L. 1885); and on the eve of the exhibition (29 April 1909; L. 1887) Monet enumerated the dates of a total of forty-eight paintings begun in 1903 (one), 1904 (four), 1905 (eight), 1906 (five), 1907 (twenty-one), and 1908 (nine). In the next chapter we will consider the critical reception of these works.

14

Bending over the Source (1909)

THE EXHIBITION OF *Water Lilies* in 1909 was a commercial and critical success (W. 1656–91, 1694–1735; figs. 106–7). All the major newspapers of Paris covered the show and most assigned their most prominent critics. The upper-bourgeois readers of *Le Gaulois* were granted a special preview in an interview with Jean Morgan published the day before the exhibition was opened to the public. Morgan's visit to Giverny had been set up more than six weeks earlier in spite of some grumbling to Durand-Ruel on Monet's part: "I do not like this very much, and as I am still very much occupied with my *Water Lilies,* I have asked him to please delay his visit" (15 March 1909; L. 1881). Monet was involved at this time with the director of *Le Gaulois* in a commission to provide two tiny paintings on vellum for a luxury edition of Zola's *La Terre* (W. 1773–74), and nonaesthetic factors such as this surely played a role in shaping the attitudes of many of the critics.

Morgan's article rehearses most of the themes of Monet's modernist myth. Originality, struggle, glory, freedom, ardor, perseverance: these are the familiar constituents of the drama wherein Monet emerges triumphant "despite the obstacles of a tradition resolved to avoid a truth too damaging to it."[1] The irony is that by 1909 this tradition had become incarnated in the readership of *Le Gaulois* and in the very art which once had been said to transgress what it now could be said to affirm.

Morgan is dazzled by the sight of Monet's canvases: "We go from one to the other, we endure their varied despotism with the fear of not being able to seize it all. On easels, other superposed, piled-up canvases represent the effort of these last years, what only a few privileged already know. For we touch upon an instant in the solitary life of M. Claude Monet; he is,

in effect, going to deliver to the public, after a long hesitation, anxiety, and modesty which true artists will understand, if not a new manner of his generous talent at least an unforeseen application of his qualities, something that is the result of a slow gestation, a severe control of his impression, the present point of his evolution in which we unravel the successive acquisitions made at each stop on the road."[2]

After a lengthy itinerary, from the "rejected" fragment of the *Luncheon on the Grass* of 1865 (W. 63b; fig. 10) to the discontinued figures of the *Young Women in a Boat* of 1887 (W. 1152–53; fig. 67), Morgan turns with "enchantment" to the most recent works: "For several years he has reduced the landscape to the pool in his garden and to the reflections of the immediate environment. This new series which he himself names water landscapes comprises yet a further progression in his vision which increasingly is simplifying itself, limiting itself to the minimum of tangible realities in order to amplify, to magnify, in a sense, the impression of the imponderable."[3]

The limit of Monet's consciousness is emblematized in the reflexive verbs which throughout the criticism of 1909 play such a prominent role. As though of its own accord it is Monet's vision that *se simplifie, se limite.* This reflexivity is mirrored in the watery reflections: "At first there are smooth waters, cold in places, penetrated elsewhere by light, surrounded at ground level by grasses, reeds, some shrubs. But soon this vivid belt diminishes in importance, the water invades the entire canvas, becomes the fluid field upon which the mysterious blossoms of the water lilies open out, floating leaves, pink white flowers that double themselves in pallid images. And these forms translated by spots of yellow, green, blue increasingly envelop themselves, dissolve themselves through the course of this pursuit, in the measure that the painter becomes master of his impression; the air and the water intermingle in a single light mist that partakes of each element and in which the invisible sun incorporates its impalpable golden dust."[4] In the reflexivity of language—*s'épanouir, se dédoubler, s'envelopper, se fondre, se confondre, s'approfondir, s'élever, s'avancer*—Monet's quest for mastery doubles back upon itself as a natural force.

Born in 1875, Jean Morgan was among the younger writers who produced articles on Monet in 1909. On the older side was Arsène Alexandre, born in 1859, who in 1901 had been one of the first to provide a witness account of Monet's garden. By 1909 he was a *chevalier* in the Legion of Honor, curator of the Palace of Compiègne, art editor at *Le Figaro* as well as *Comoedia,* and author of numerous novels and books on art. For Alexandre, Monet has painted "the surface of the pond upon which, in a Japanese

garden, the water lilies bloom; but he has painted only that surface, seen in perspective, and no horizon is given to these pictures which have no other beginning and no other end than the limits of the frame; but which the imagination easily prolongs as far as it likes." The result is forty different paintings, but the effects "do not repeat themselves a single time": "Now there are mauve mornings, soft and silky; now ardent and profound harmonies of bronze waters and green leaves heightened with all the jewelry of the flowers; now one distinguishes, upside down, the clearing of an alley of trees that forms, in reflecting itself, something like the image of a luminous cascade incorporating itself into the aquatic bed. Sometimes there are sunsets that reproduce themselves inversely in the water, and then the cascade is of fire and molten metal."[5] Here the verbs *s'incorporer* and *se reproduire* evoke Narcissus as do the words *renversé* and *inversement*. In the context of symbolist theory the passion of the bent-over youth can be seen to quench itself in the image of the setting sun plunging into the waters of the pool.

On the day following his article in *Le Figaro* Alexandre augmented his account of the paintings in *Comoedia*. Invoking literary authorities from Montesquieu to Catulle Mendès, Alexandre asserts the axiom that "water, in a word, is a great inspireress of art."[6] Today's English does not properly permit this genderized attribution of water; given, however, that in the nineteenth century the presumptively male artist's relationship to nature was fundamentally seen as an allegory of the male-female sexual relationship, it is not surprising that Alexandre and so many of his colleagues should exploit the grammatical categories of language for the prime fantasies of their society.

Alexandre offers an insider's account of Monet's prolonged withholding of the new series from the public. "Fatigue" and "neurasthenia" are cited as Monet's malady, and there is a sense that the writer himself is one of those who had doubted the painter's ability to complete works which he had been destroying and repainting for some six years. Unlike the *tantôt ... tantôt* temporalizing of the paintings in the *Figaro* article, here Alexandre reiterates a series of sentences beginning with the partitive phrase "il en est": "There are some suave and vaporous ones, formed from all the mauves and all the pale greens of spring mornings. There are some powerful ones, strongly colored, in which the steel of the pond enriches itself with bronzed tones. There are finally some in which the large opening of an alley of trees, reflecting itself upside down among the water lilies, seems in its design, which becomes increasingly amplified, like a kind of cataract of light precipitating itself amidst the flowers and superposing itself upon

them. There are some upright ones which evoke the idea of cathedrals; other lengthwise ones are like meadows of dreams."[7]

The repeated use of "il en est" introduces a note of heterogeneity which negates the sequential trope of the *Figaro* piece. Alexandre understands that the *Water Lilies* will not readily be limited to a single interpretation: "Strange thing, these water landscapes, all representing a plane surface seen in perspective but without horizon, give birth to the idea of all the other dimensions, of all atmospheres, of all vicinities." In the age of Henri Bergson, Pablo Picasso, and Marcel Duchamp it may be still too soon, here, to speak of an interest in the relativity of the fourth dimension, and Alexandre's indeterminacy of *voisinage* more likely evokes a Mallarméan suggestiveness of place such as we encountered in "Le Nénuphar blanc." There the feminine emanation of place remains elusive for the aquatic voyeur who chooses not to cast up his gaze. By a similar refusal to look beyond the bounds of the frame Monet also gives rise to the paradox of a constricted view and an infinite vision: "I have just said to you that one may see waterfalls of light, mysterious palaces. You will see many more things still according to the will of your imagination and your senses." In this solicitation of the beholder's projective activity Alexandre sees proof that "we were not barbarians after all."[8]

Monet's allusive art may be proof against the barbarism of the empirical view of the world, but if so it is only because Monet is "superbly isolated, a man apart, an exceptional nature."[9] Stendhalian election, Baudelairean dandyism, Barrèsian egoism, Mirbeauesque anarchism, Gidean narcissism are all subsumed in Alexandre's myth of the artistic isolate. This is the modernist myth of the self-sufficient artist.[10] Alexandre also portrays the bourgeois corollary of the myth in the figure of the collector who partakes of the artist's gift through acquisition: "Will the millionaire who is needed read these lines? The painter would have wished to have a circular room to decorate, of modest, carefully calculated dimensions. All around, up to the middle of a person's stature, there would have reigned, passing through all possible modulations, a painting of water and flowers like the radiant series we see at Durand-Ruel's. Nothing else. No furniture. Nothing but the central table of this room, which would be a dining room surrounded by all that mysterious seduction of reflections of which we have vainly tried to give you an idea by way of words." Alexandre singles out four paintings in round frames (W. 1701–2, 1724, 1729) as "a uniquely enviable decoration";[11] its acquisition would presumably not require the full re-sources of the elusive millionaire whom Monet's friends in the press had been conjuring since Clemenceau's article on the *Cathedrals* in 1895.

One of the most influential daily papers in Paris was *Le Temps* and its art critic, François Thiébault-Sisson, a *chevalier* in the Legion of Honor, held membership on a series of state committees, including those of the Gobelins tapestry manufacture and the provincial museums of France. Like Alexandre, Thiébault-Sisson repeats the saga of Monet's "cloistered" seclusion at Giverny. The critic encloses the diversity of the paintings within a sequential unity of prose; a unity of pose as well, for Thiébault-Sisson pictures a Narcissus-like Monet on the banks of the watergarden: "During the season of the water lilies, at the moment when their large lenticular leaves of light green sport their summer adornment and garnish themselves with an admirable variegation, a button of gold and citron, white and rose, or vivid red, the artist, at all hours of the day, has bent over the flowering surface of his pond." *Se pencher* is the reflexive sign of Monet's self-conscious scrutiny of his own gaze: "He has seen the sky reflect itself, in the morning beneath a tenuous veil of vapor, in saffron notes, in shimmering iridescence in which azure and mauve alternate with lilac, soft pink, and pearly gray. Later, in the hours of heat, deep blues have replaced soft blues and have formed with a darkened green full and sonorous harmonies of leaves. Later still, the sky has turned to storm and the clouds that float in the blue have reflected upon the mottled water of the pond their rounded tufts of muted, slightly rosy gray. Then the sun slowly dips down. Between the slender poplars whose inordinately lengthened image projects itself in blackish silhouette upon the still glistening watery sheet the copper notes of the setting sun light up with dancing gleams of fire until the hour when the floating garden plunges itself back into the dusk in the mystery and in the transparent shadows of bright summer nights."[12]

An "infinite variety of effects" is the theme of Thiébault-Sisson as well as Louis Vauxcelles, art critic of *Gil Blas, chevalier* in the Legion of Honor, member of the committee of the Salon d'Automne, and a visitor to Giverny back in 1905. Alongside the memorable coinage of the terms "cubist" and "fauve" Vauxcelles also proposed the term *givernisme* for Monet's imitators, many of them American, who thronged the official salons from the 1890s on. Far from being a pictorial imitator, Monet himself is said to be like Beethoven in the diversification of a simple motif: "a corner of a river upon which float softly placed corollas of pink, blue, green, mauve, delicious aquatic flowers, the reflection of the sky in the water, and that is all." Theme-and-variation is Vauxcelles's device for organizing the disparate paintings into a musiclike suite that also partakes of the familiar daily rhythm: "at all hours of the day, under every effect, vaporous mist of

purplish gauze, tender blue, more vivacious indigo, pale mornings, glaring noons, flaming sunsets like fireworks." All of this in order to have "penetrated the secrets of the most unseizable matter."[13]

There may be a latent sexual allusion in this penetration of a feminized "Nature," but for Jules Renard, yet another *chevalier* in the Legion of Honor and noted author of *Histoires naturelles* (1896), Monet's art is itself too feminine. As Renard confides to his journal after a visit to the gallery, it is "painting for women." The *joli* of Monet's art strikes Renard as unnatural, like women's own self-enhanced beauty perhaps. In this respect Renard's judgment effects a reversal of Baudelaire's celebrated encomium to cosmetics in "Le Peintre de la vie moderne" and is generally consistent with the turn-of-the-century disparagement of women. It is Monet's seemingly feminine artifice, his unmanly narcissism, that seems to threaten Renard here; yet he remarks of a young man's fixed contemplation of the *Water Lilies,* "I would much like to see what he sees."[14]

Renard's rejection of Monet is not widely shared among the critics in 1909. Henry Eon had reviewed Monet's *Cathedrals* for the little magazine *La Plume* in 1895; by 1909 he held the art column at the daily newspaper *Le Siècle.* Eon's symbolist culture is perhaps still evident in the talismanic word *frisson:* "In the placidity of the flowering lake, upon the dormant water which squalls scarcely skim, the shivers of all this exterior life rouse themselves: shivers of the morning, very pale, nimbed with lilac, rose, and gray; shivers of limpid afternoons when the breeze stirs the trees' heads of hair in the azure and indigo; gleams of the night which bring forth a spurting in the water, in sinuous undulations, of cascades of emerald and gold." Contrasting with this evocation of nature's body is Eon's citation from Théodore Duret, who had published a major book on impressionism just three years before. Realist and symbolist idioms converge in the subjectivity of Monet's scrutiny of his motifs: "Painting arrived at this degree of fluidity in some sense joins up with music and executes variations on a colored theme analogous to music's own. Monet has reached the final degree of abstraction and imagination allied to the real which his art of the landscapist allows."[15]

The idealist interpretation of Monet is evident in an article by F. Robert-Kemp for Clemenceau's newspaper *L'Aurore.* Perhaps Clemenceau acted as a conduit of discussions which he and Monet had on the subject of the "clear and sensitive mirror [upon which] the sky reflects itself . . . and the leaves admire themselves": "It is as in the Platonic myth of the Cave. We do not see the real world; but we seize its appearances. All the nuances of the hour find themselves here: these tints of opal, it is an

autumn sky that illuminates itself with them; these orange and violet tones come from the setting sun; this shimmering water, into which the powerful images of the green trees plunge, upside down, offers itself to the flashing gaze of the midday."[16] Here only the ancient allegory of reflection is explicitly named by Robert-Kemp, but the critic's aquatic imagery and eroticized metaphors also leave behind a sense that Narcissus, the nymphs, and the full pantheon of the gods may still be invisibly present in a naturalistic art such as Monet's in 1909. In 1906 Antonin Mercier had exhibited at the Salon a painting of *Echo Lamenting Narcissus*, and the youth and the nymph reappeared in separate paintings by Henri Guinier and Yves-Edgard Muller in 1908. The hybrid interpretation of Monet's *Water Lilies* as both ancient and modern, allegorical and real, fits thoroughly within the exhibition history of these years.[17]

The allusive discourse of the period is again apparent in an article for the *Journal des Débats* by Edouard Sarradin, a member of the committee of the Salon d'Automne and later an officer in the Legion of Honor and curator at Compiègne. Sarradin emphasizes the paradox of Monet's "sonnet"-like juxtaposition of "infinity with the real": "The *Water Lilies* are quite exactly, just as he indicates, landscapes of water; but that water contains the sky." Sarradin validates Monet's achievement by invoking the deceased authority of Manet, who had reputedly called Monet "the Raphael of water," and he situates Monet's strategy within the realist orbit of Courbet, for whom a sea painting was allegedly "not a study but an hour." The fluidity of time is seen to be encapsulated in Monet's "hours of a sheet of water," but spatial extension is subsumed as well, since Monet's paintings are "bounded liquid mirrors" of the entire universe: "This mirror contains the sky, the clouds, the trees, all the verdure and the quivering of the leaves. Everything reflects itself in it, resumes itself in it, dissolves itself in it, confounds itself in it." Sarradin's rhythmically doubled and redoubled text is worth printing in French for it offers a condensed formula of cosmic narcissism: "Tout s'y reflète, s'y résume, s'y fond, s'y confond." In spite of this apparent unity Sarradin discerns beneath the harmonious surface a history "of struggles, of doubts, of recommencements."[18]

For Pascal Forthuny in *Le Matin* the labor which Sarradin detects is scarcely of any consequence: "One morning Claude Monet was passing by. He saw [the water lilies] amidst the reflections of the verdant woods, agape upon their rafts of round leaves. He went off and soon returned at every moment of the day. Their beauty changed according to the inclination of the sun. At times they were swimming in liquid gold; at other times in that profound and unsoundable blue which makes the sky a peaceful ocean,

the marsh an immobile and cold slab of azurite. The prism of the hours played upon this sleeping mirror. All the modulations of light succeeded themselves upon the palette of the pond. Tirelessly, infinitely renewed, nature improvised variations. And Monet made fifty pictures."[19] Here nature's perpetual process of differentiation is an automatic mirror in which the painter finds pictures ready-made.

An exemplary psychological interpretation of the *Water Lilies* is presented in 1909 by Pierre Mille, a doctor in diplomatic law, *chevalier* in the Legion of Honor, war correspondent from the Congo, and future front-line journalist of World War I. The organizing conceit of Mille's article, "Ecrits sur l'eau," is to appear not to be writing about paintings at all. This ploy permits Mille to develop an allegory of water that leaves in suspense the iconography of Monet's paintings. Mille's aquatic reverie recalls the criticism of Diderot, Baudelaire, and Thoré as well as the writings of Flaubert, Mallarmé, Maupassant, or Valéry, but the journalist's psychological stress represents an accent of his own. He begins fully immersed in his subject by way of an opening ellipsis: " . . . The water is at once very pure and very dormant; somewhere there is a source which comes from the bottom: it is she who before spilling herself forth into a stream that one does not see opens herself out in the fashion of basins and pools, beneath the sky, in the midst of grasses and reeds, in the shade of great trees. I am sure of it, and yet I know it very nearly only through feeling: neither this sky, nor this sun whose course I follow from hour to hour, nor even these storms whose blasts and showers I know, I see none of them directly. I see only the water, because her alone I love, only she amuses me, only she lives. I only see what I am looking at. I am thus rejuvenated, what joy! for it is thus that I felt when I was a child."[20] From Baudelaire in 1863 to Freud in 1908 it was a common theme of European literature to link the imaginative capacities of certain artists to the child's nostalgically posited freshness of vision.[21] Conversely, Monet also absorbed much critical abuse on account of his so-called *enfantillages*.

The child, of course, is the prime narcissist, whom Freud in 1914 calls "His Majesty the Baby."[22] Already in 1910 in his essay on Leonardo, Freud links the autoaffection of Narcissus and children with the self-absorption of the artist, a linkage which will later become enshrined in the psychoanalytic dictum of regression in the service of the ego. Along with the linkage of artist and child Mille also shares with contemporary psychoanalysis the metaphoric recourse to mythology and allegory: "This water is light, clear, translucent; she is the atmosphere of the world she creates, and like the very air she is without color. There is no color but on the bottom upon

which she sleeps and from which she departs, a bottom suddenly opaque on which things come to reflect themselves. But all these things are vague and irreal upon this wicked and delicious, quivering and miraculous mirror, all these things are trembling, hesitant, somewhat doubtful—except the sky. The sky continues to exist. He is the eternal and changing truth of this strange and magnificent world."[23]

Mille imagines an allegory of psychophysical interaction embodied in the gendered give-and-take of the water and the sky. In this relationship the masculine sky does the giving and the feminine water the taking. Only the feminine body is directly observable; but upon this matrix the masculine mind is inferred by means of signs: "If the sky is blue, the water is blue; if he darkens himself, as in the burning and savage hours of arduous summers, she is almost violet; if he animates himself with clouds that run about or heap themselves up, she becomes like those piles of living pearls seen beneath a glass." The feminine reflexivity of water partakes of a certain secondariness, "being already a work of art: for she shows what is only by way of signs, with abridgments, foreshortenings, flashes more forceful than the truth, and more often still with genial dissimulations, salutary oblivion."[24] Conceived under the sign of water's reflection, artistic representation is a secondary revision of the world, a salutary lie.

Mille acknowledges the metaphysical nature of his philosophy: "This multiple life of reflections is in the depths. It exists, since one sees it; it is without proof, since it is unseizable; it is as though the emotional, mystical, religious side of this liquid universe upon which I restrict my gaze. . . . By way of seeing only this water one has come to believe that this water is the sky, and these banks of water lilies troops of clouds soaring in the imponderable air."[25] Water's artlike reflections mime for Mille the movement within philosophy from an empiricist conviction in the perceptible world to an epistemological skepticism buttressed only by faith.

After three long paragraphs Mille begins to describe the formal and affectual *differentia* of the water lilies that teem at the water's edge. The feminine designation *elles* is repeated five times: "They are red, they are pink, they are mauve, white, violet, or yellow; they have their manners, their passions, their sympathies, their physiognomies; they attack one another, intermingle with one another, enlace themselves with one another, distance themselves from one another; no one is just like another: some starry and huge, others quite small, quite frail, quite round. There are some timid ones who live only in groups; others of a violent red, or pale rose, or yellow who go off all alone, or perhaps by threes and fours, toward gay and loving spaces upon surfaces of blue and gold; others who scarcely

show themselves at all, lost among the flat and leafy isles."[26] Mille's voyeuristic observation of the nymphs glimpsed amid the array of water lilies is akin to the water writing of Valéry or Proust. Whether Monet's paintings are more than suggestive opportunities for the critic and are also intentionally allegorical of course remains moot.

Mille's discourse continues to appeal to the literary tradition before finally acknowledging Monet's paintings: "Thus the water lilies live and metamorphose themselves, while remaining themselves, upon the magic water, the water which illuminates them, carries them, transforms them, makes them pale or violently shaken. I still have not told you where I have seen them, where I have lived with them, where I have again found that marvelous and delicate impression, which one experiences only when one is an infant—unless one has genius. . . . They are forty-eight pictures where the painter Claude Monet has painted the same water lilies, growing and flourishing upon the same pond at different hours of the day throughout six long years, a work of enthusiasm and love and also of that adroit and certain patience without which there is perhaps no true perfection."[27]

Mille invites his readers to share his childlike vision: "We have all seen, at the ingenuous epoch of our existence—it only lasts a few days for the immense majority of humans, things as they are in themselves. Later we will no longer distinguish them except in relation to what surrounds them. Besides this is an indispensable education, even though rather melancholy, and which almost all of us must undertake if we do not wish, alas!, to drown in the pools of the lotus and the water lilies."[28] Narcissus drowned in the pool of illusion rather than forsake an ideal image. Mille's regret for the innocence of primordial vision is similar in tone to the somewhat later ruminations of psychoanalysts such as Freud and Lacan on the loss of an infant's imaginary onnipotence in the face of its unavoidable entry into the symbolic order of proper names and proper relations. As in psychoanalytic theory Mille makes a partial exception to this seemingly inevitable process on behalf of the artist; for in the perpetual restaging, as in the *Water Lilies,* of the refusal to distinguish between a body and its images, something of the preverbal state of visual grace is recovered even as its loss is grieved.[29]

In an article by René-Marc Ferry in the "absolutely independent" *L'Eclair* the bipolar split of body and reflection is found in Monet's juxtaposition "of a double element and a double perspective." The ideal fusion of image and object in Monet's paintings is unsettled in reference to the body's habitual orientation: "One sees in the water only the trees of the banks, and it is upside down in the water, beneath this cool mirror sensitive to

the most delicate nuances of the day and the light, embroidered with the leaves and flowers of water lilies of all colors, that they dispose the masses of their airy heads of hair and open up bright avenues between themselves. . . . In justice, [the painting] is a piece of water; the sky, the light, the trees are in the water, upside down, filtered and transposed by it." *Renversé, à l'envers, transposé;* Monet's inverted views suggest a basic problem for art criticism which Ferry acknowledges: "One feels all the difficulty of giving in words some idea, an even distant impression, of these singular works in which the art of the painter, in what is at once most delicate and most material, has renewed the same feat of prowess fifty times, each time different." Difference here may imply no more than a standard sort of difference-between, as between temporalized pictorial instants and spatialized "decorations" or "tapestries," in Ferry's words. But difference may also connote a difference-within, a split in the painting between the obdurate materialities of objects and pigments and the "delicate" immaterialities of images and allusions.[30] Such a difference may be seen as an index of the metamorphosis of Narcissus, the being that is simultaneously body and sign.

Many critics perceive the mood of Monet's metamorphoses as melancholy. In *La Chronique des Arts et de la Curiosité,* Jean-Louis Vaudoyer, a young friend of Proust who later went on to become curator of the Museé des Arts Décoratifs and member of the Académie Française, cites some lines from the *Fleurs du mal*: "Many a flower pours out with regret / Its sweet perfume like a secret / In profound solitude." Vaudoyer invokes the flow of music in connection with Monet's serial work, but the example of poetry predominates in the critical discourse if only because so many critics, like Vaudoyer himself, were also poets: "Upon the pale blue or deep blue water, upon the water of fluid gold, upon the perfidious green water, the reflections delineate the sky and the banks, and, among these reflections, the livid or bursting water lilies open themselves and bloom." Here Vaudoyer's image recalls a verse from Verlaine's "Paysages tristes" in the *Poèmes saturniens*: "The sunset darted its supreme rays / And the wind rocked the pale water lilies; / The great water lilies, among the reeds, / Sadly glistened upon the calm waters."[31]

Vaudoyer's notice was the first to appear in a weekly review, but even though the exhibition was then well into its second week, articles continued to be printed in the dailies. For *La Dépêche* (Toulouse) Gustave Geffroy reiterated his longstanding complaint against the Parisian press. Geffroy was a distinguished writer in 1909 with numerous volumes of prose, fiction, political biography, and art criticism; he was also an officer in the Legion

of Honor, the vice president (and later president) of the Académie Gon-court, and the chief administrator of the Gobelins tapestry manufacture. In this latter capacity Geffroy was able to procure a tapestry commission for Monet based on three of the paintings exhibited in 1909 (W. 5:179), but the critic was not able to prevent what he took to be the revolutionary individualism of Monet's art from being contested not only by reactionary elements but also by younger writers as well.

Much of the evidence for Geffroy's indictment of the press was provided by Monet himself and later served as documentary basis for the 1922 biography of the artist: "Claude Monet is one of the men who has excited artistic polemic to furor and stupidity. He has at his home, at Giverny, in his charming and simple country house, a really extraordinary collection. It is of critical articles, chronicles, news items, rumors, witticisms, etc., which were inspired in the press by his art. . . . It is quite simply indescrib-able in its shortness of view, ignorance, indifference. . . . One might also think that these persons, so prompt to render their verdicts, had never looked at a landscape at any hour, in any season, to be to this degree insensitive to the grandiose and subtle poetry which these luminous can-vases revealed, fresh like the mornings, rich and mysterious like the eve-nings."[32] People who disagree with Geffroy are viewed as insensitive or vindictive; and in spite of the decline in the clamor since 1889 as he himself concedes, Geffroy goes out of his way to reopen old wounds in 1909.

Geffroy must do this in order to sustain the key modernist myth of Monet as the solitary battler against the established orders of the bourgeoi-sie. Perhaps Geffroy felt that the distant Toulouse readership required a historical account of Monet's career as prelude to an engagement with the *Water Lilies*. In the three rooms of paintings at Durand-Ruel's, Geffroy sees not only the true record of the landscape at Giverny but also "an admirable decorative ensemble; one dreams of retaining it thus, upon wall panels, in peaceful rooms where strollers would come to seek distraction from social life, appeasement from fatigue, love of eternal nature."[33] The similarity of these remarks to those of Alexandre and Guillemot suggests Monet's own complicity in this account, the terms of which are echoed by Henri Matisse in his 1908 "Notes d'un peintre."[34] Matisse, who later visited Monet at Giverny, chose to be his own spokesman, but as Monet writes to Geffroy, "it is always you who says best what there is to say and it is always a pleasure for me to be praised by you" (1 June 1909; L. 1892).

For Geffroy, Monet's pond is a microcosm that registers "all the air that plays through the trees, all the movements of the wind, all the nuances of the hours, the whole pacified image of surrounding nature." Monet's

painting is thus "a world, one of those resumes of an instant in which the impressionism of Claude Monet has known how to evoke the universality of things." For Geffroy, Monet's knowledge of universality comes about principally through empirical observation, but a symbolist allusiveness is also entailed in this "magic mirror in which we had not yet looked."[35]

Georges Meusnier, the editor of the *Journal des Arts,* also evokes the magical metamorphosis of Monet's art: "Imagine that on a slightly inclined plane you had placed, above a calm stream, a gilt frame of approximately one meter square [see W. 1730, 100 × 100 cm], and that with a slow and reflective movement you were passing this frame above the surface of water on which a collection of various water lilies lies resplendent from dawn to sunset, from spring to the beginning of autumn, but especially during the period of bloom: you will clearly have the impression that the forty-eight new works of Claude Monet leave in the mind, so much does it seem that Nature, at the call of the painter, has come in person to place herself on the canvas." Meusnier's hallucination of nature's feminine manifestation is tempered by an acknowledgment of the painter's technique, yet in the only picture in the show to portray the entire decor of the pond, the water lilies, the weeping willows, and the Japanese bridge (W. 1668; fig. 108), Meusnier sees a lapse in the effort of the artist to prevent our "recognition" of his execution: "Yes, nevertheless: in no. 7, in the fall of leaves bent over the flowers and the water, he made his potent virtuosity play with an impress that surpasses anything the mind may conceive, even and including the great Turner."[36] *Puissance, empreinte,* and *penché* together evoke the doomed masculinist scenario wherein Narcissus seeks to possess the re-flected impression of what would soon be a corpse.

We have already seen that for the poet Gérard d'Houville the narcissus is indelibly marked by the narcosis of death. A rather different imagery characterizes the passage she devoted to the *Water Lilies* in her regular column of feminine cultural instruction, "Lettres à Emilie," in *Le Temps.* Many of the key words of her male colleagues are to be found here, but she also imagines among the water lilies a female presence that is not the familiar object of masculine scrutiny but rather the agent of her own pleasure: "Imagine for yourself several rooms where such luminous, such limpid, such transparent pictures are hung that after a quarter of an hour one has the sensation of being in the water, of being an inhabitant of the ponds, the lakes, and pools, of being a nixie with glaucous hair, a naiad with fluid arms, a nymph with fresh legs, or a green frog singing at night with a crystalline yet rather raucous voice, a little frog setting its little jade-colored bottom upon the large leaves of these water lilies."[37] Unlike

the melancholy Narcissus who forgoes the voice of Echo in favor of an ideal image of himself, Gérard d'Houville frolics noisily in the water and transforms the prince into a frog. Perhaps this frog prince awaits the kiss of a Germanic water sprite or an aquatic Greek demigod, but whatever the frog's gender or origin the affect is not one of melancholy but of joy.

Monet's paintings activate a time and space of fantasy which Gérard d'Houville seeks to share with her young reader: "The impression felt is almost inexpressible; there is in these waters the inverted reflection of trees one does not see; and then one's head in the end starts to turn a bit: one is astonished not to be walking on the ceiling and to see upside down the people who have come to admire with us these rather magic portraits of fragile flowers, perfidious waters, changing reflections, rapid hours, fugitive instants. There are water lilies largely opened like beautiful round cups on green plates laid out for a fairy meal upon a wet cloth; there are some that are in bud, like the eggs from which will hatch perhaps pink or white aquatic birds." Just as the critic becomes a nymph in the midst of Monet's watery world he is her lustral conjuror: "It is the painting of an elf or imp, of an inhabitant of the woods and the springs." The emphasis of the article is not on the fate of Narcissus, who turns into his own prey by the pool, yet "the colors which comprise these pictures seem to have been ravished from nature and not mixed by a human hand."[38] The sadomasochism of Monet's project is perhaps only glimpsed here, but elsewhere d'Houville writes of her own childhood, "I bent my face over the Styx without fear." In another poem it is a second female self whom the poet sees: "The black reflection of the sky redoubles your torment / When you bend toward the water your dolorous head / And you see, obstinately fixed to your own, / The eyes, the sad eyes of your tenebrous Sister."[39]

For Edmond Sée, doctor of law, later *chevalier* in the Legion of Honor, and a popular playwright of manners born in the same year as Gérard d'Houville (1875), the exhibition of *Water Lilies* is the occasion for an ironic article on the Monetmania of *le tout-Paris*. Everyone is there, at Durand-Ruel's, strutting, parading, and dreaming, everyone, that is, in "the Letters, the Arts, Society, Ignorance, High Commerce, Low Industry, Theft, or Prostitution!"[40] Back in 1889 Frantz Jourdain had similarly ridiculed the fashionable audience, but he had exonerated Monet from the charge of catering to this dubious clientele. Now Monet is its darling; but via the pretext of private allegory Sée still finds a way to redeem the pictures from the mercenary clutches of the crowd.

Sée's literary conceit is an hourly journal of the crowd between 4:00 and 7:30 P.M. on Wednesday, 19 May. Private carriages and automobiles

are standing outside the door of the gallery as he makes his way inside the "sanctuary," down a long corridor hung with sketches, and finally into "Their" presence, paintings "of water, of miraculously nuanced waters, of bits of pond upon which all the lights of the day successively play themselves, . . . of water; and of water lilies on their rafts of round leaves."[41] The job is to admire, but of course the crowd gets in the way.

At 4:20 Sée's attention is caught by two women of "heartrending" distinction who rapidly go from painting to painting in an anxious quest for meaning. Sée indicates that these women (and their parenthetical male companion) are habitués of all the "Grand Manifestations" in the arts who now find themselves at a loss: "What to say? What to say to oneself? What to say to *him,* to this companion who perhaps did not want to come and whom one has dragged here by making him shamed of his ignorance!" His discomfiture gives them the excuse to leave, and at 4:50 Sée's attention turns to "the most vigorous dramatic author of the year" and "the great writer" who have just come in. Like the women of fashion, they too seem to be searching for "a great definitive word" and Sée offers the writer one of his own: "Have a look here. . . . It is beautiful, is it not?. . . . And this water that appears fervent." The writer's ferocious response is that "all this is not worth a beautiful verse!"[42]

Sée interprets the writer's cry as a lament for the lack of that "Literature" by way of which "our sensibility translates itself to us." Sée and his colleagues are in the business of supplementing painting with just this literary quality, but at 5:40 Sée turns to a professional painter for art's intrinsic standard of value. Unfortunately from this painter's perspective Monet's pictures are not paintings at all: "Ah! Then what is it?"; "I do not know . . . Music . . . Poetry!"[43]

At 6:00 Sée sits down to make sense of the paradox that for the poet Monet's pictures are just paintings whereas for the painter they are mere poems. Sée sets aside this interpretative dispute upon the appearance of the rich collector, the living proof of art's value in the marketplace. This collector seems to be the very one foreseen in Clemenceau's plea for the wholesale acquisition of the *Cathedrals,* for he positions himself in the center of the gallery in order "to embrace the whole in a single glance." A chase then begins and the quarry is soon in sight: "He has stopped himself in front of a canvas; he no longer moves. Why this one? A mystery. However it may be, it is finished. He has made his choice. He looks only at this canvas harshly, hard, with all his force. It is the one he wants and will have. Why? Why? Does he himself know?" No, he does not, Sée implies, but others now do, and the admiration of the noncollectors in the

room now begins to validate itself in reference to the pictorial commodity's newly assigned worth. In spite of his critique of this merchandising of art, Sée acknowledges its sublimating function for the rich man with Baudelairean irony: "A moment of adorable reverie has just been acquired, seized, carried off by a man who has never had much time to dream!"[44]

Finally, at 7:00, Sée is alone and his solitary meditation begins: "And I am alone! . . . Finally! I remain. . . . And now little by little it seems to me that in this solitude, beneath this declining light of the day, these canvases around me only begin to reveal themselves, to live, to palpitate with a new life, quivering, eloquent, as though *delivered*!" In spite of his sense of the self-interested engagement of the spectators he has observed, Sée entertains the fundamentally narcissistic fantasy of criticism; he alone sees the paintings in their proper light: "Yes, I understand now, it seems to me that I am going to comprehend and experience the prodigious effort of this Man, of this great man; what he required of ferociouslike patience, extraordinary will, serene courage to seize, to fix *uniquely this,* this fluidity: the Water!!" As one will perhaps have expected, the superhero's object of fixation is nothing other than the eternal female: "The stagnant, dormant Water; everything she reflects that is complexly luminous, glaucously melancholic; these dismal gleams, these fulgurant opacities. And all that lives in Her, through Her: these water lilies, bedded flowers that slackly enlace themselves, embrace themselves with nonchalance; or then take themselves off, take themselves off to float adrift in a glaring solitude; some so frail, the others so vast. . . . Some feverishly coiled up upon themselves, the others stretched out with pride."[45] In this hothouse vision of Monet's flowers it is hard to suppress the allusive tug of something like Ingres's *Turkish Bath.* Monet is Man and his Water is Woman; or women rather, nymphs at least, for every budding lily evokes for Sée the voluptuous movements of bodies in his humid dream.

Sée's narcissism matches Monet's, for according to the critic his solitary joy is simply the reflection of the artist's lone pleasure: "Yes, the Man who knew, who was able to isolate himself for long hours in the frenetic contemplation of this element, the Water, to which one submits but which one *cannot* fix for long without an oppressive ennui, a dolorous unease; without an ardent need to deliver oneself, to throw one's eyes elsewhere, above . . . toward the clear sky; or to the right, to the left, toward the reassuring banks. . . . The Man who did this, he offers perhaps the most troubling example of a human will placed in the service of an art which has no more to learn of itself!"[46] For Sée, Monet's pictorial self-discipline

effectively annihilates the world's troublesome feminine allure and erects an autonomous masculine ideal in its place.

It is 7:30 P.M. The light has passed and Sée's emotion dies. Sée's pleasure is bracketed by a sociological description of the pleasures of others, but his own escapes the burden of self-analysis.

Sée's article was the second published on the show in *Gil Blas* (Vauxcelles had reviewed it twelve days before). *Le Gaulois* also published a lengthy account of the exhibition by its art critic Louis de Fourcaud seventeen days after Morgan's preview. At age fifty-eight Fourcaud was one of the oldest reviewers of the *Water Lilies* and had been writing favorably on Monet for more than twenty years. He was a *chevalier* in the Legion of Honor, professor at the Ecole des Beaux-Arts, and author of recent volumes on Jean-Baptiste-Siméon Chardin and François Rude. His front-page article in the largest circulating morning paper in Paris was well positioned to ratify the emerging consensus which his title suggests, "Claude Monet et le lac du Jardin des Fées."

In Monet's *Water Lilies* the theme is no more than "a plastic center called upon to transfigure itself." Fourcaud's preferred form of artistic practice is "a mitigated idealism," "a tempered realism," as he had written in 1886; twenty-three years later he still insists on the hybrid nature of Monet's paintings: "The art of an ingenious gardener has prepared the site and has as though seeded the waters. What has one done otherwise at the start than to put the forces of nature in position to manifest themselves with a special sumptuousness within a frame that has been delicately arranged for them?"[47] An echo of Gidean self-manifestation is perhaps evident in this idealized staging of nature's visible form.

Fourcaud plays out the well-worn dialectic of existence and appearance in his description of the paintings: "The motif defines itself by way of two devices. On one side, the sheet of water, all decked out with floating bouquets, covers the canvas and overflows; on the other, a curtain of foliage is cut into at the rear, and, through this indentation, a cascade of foamy light seems to precipitate itself into the limpid basin. Of the two parts, the ground and the trees reflect themselves in the clear crystal where, in addition, the clouds and the sky gaze upon themselves. One has, as a result, the sensation of having the landscape at one's feet, with the pure irradiation of the zenith above one's head." Sky and earth unite themselves "in this divinely enchanted, sleeping glass," not unlike Thoré's earlier account of the cosmic marriage of sky and sea. Fourcaud makes no explicit mythological mention, but the language of allusion is nonetheless present: "[The

sky], by turns, makes the water blue or green, rosy, orange, golden, mauve, purple. Here the depth sapphirizes itself and becomes iridescent in the sun; there, it takes on in the shade the cold tones of emerald; elsewhere, it is entirely floral; or else, in the fires of the sunset, it has the air of harboring the image of some incinerated Babel. The flowers are red, pink, yellow, white. In the distance, sometimes the greenery is blued. This little pool, diapered with corollas, has a broader horizon than the legendary Sargasso Sea and more mirages than words would know how to evoke."[48] In his neologisms and reflexivity Fourcaud elaborates just the sort of evocative interpretation that he claims is beyond the power of words.

Like Narcissus before the pool, Fourcaud cannot tear himself away from the contemplation of Monet's "radiant ensemble." He is struck by the decorative unity of the paintings and laments "the impending dispersal of these ravishing works, which only make up one single work": "Never again, no where else, will one see them grouped as we see them. They will be at the four corners of the world, exquisite, but each one yielding only a part of the secret of them all, *Disjecta membra.*"[49] Like Pentheus and Orpheus torn apart by the maenads for having questioned the divinity of Dionysus, like Actaeon torn apart by his dogs for having glimpsed the nakedness of Diana, like Narcissus as well, metamorphosed into stands of fragile flowers for having desired the integral possession of his fractured reflection, Monet's series will meet a similar fate of self-dispersion in the sell-off of its interdependent parts.[50] Up to the end of Ovid's narration Narcissus holds together the fragmented forms of his self-representation; Monet exercises a comparable effort of will during the exhibition's brief run, but his unified body of work must inevitably fall to pieces in view of the marketplace's call for its commercial dissemination. It will only be in the posthumous murals of *Water Lilies* that Monet will seek to deny the law of automutilation wherein his series paintings had repeatedly given up their uniform virtuality as idea for the disparate particularity of things.

In an anonymous article in *Le Cri de Paris* the author claims to prefer the earlier paintings in the series from 1904 and 1905: "There are two ponds where the green water sleeps beneath the willows which let their hair down upon it. Nothing more powerful than this vividness which is like a gushing forth of life from out of the fecundatory moistness. On the contrary in the more recent works color and force disappear: alone the nuance reigns." A quotation from Verlaine is used to point out the oversubtlety of an art in which "the nacreous dawn miraculously reflects itself in the calm pool where the flowers open." The anthropomorphism of this floral opening—"just like the lids of eyes"—fails to inspire conviction:

"Without a doubt the magician painter has evoked on his canvases the most fluid transparencies of the air and the water. . . . But what will remain, in only ten years, of all this incredible finesse!" Like Narcissus punished for his repudiation of love in favor of the egoistic pursuit of an ideal, Monet will be punished by the force of time: "The painter will have worked; the light, jealous of the brush that wished to rival her, will have annihilated these impalpable dreams." In the meantime the newspaper's anonymous emissary of Nemesis concedes that Monet's dreams have a prestigious following: "Clemenceau came to see the water lilies of Claude Monet: —There is in these flowers, he said, a symbolism which ought to please a minister. . . . They float above the waves."[51] Like Clemenceau's political career Monet's paintings survive, *surnagent;* in the end it will be Clemenceau's effort that will enable the unitary symbolism of the paintings to endure in their permanent installation at the Orangerie.

Clemenceau's visit to the exhibition was remarked in *Le Figaro, Le Gaulois, Le Temps,* and *L'Aurore.* Another notable visitor to the exhibition was Lucien Descaves, secretary of the Académie Goncourt and as such a frequent dinner companion of Geffroy, Mirbeau, Monet, and Clemenceau: "I leave your exhibition dazzled, amazed! Thus I can say that I have seen in painting living water, mobile like the face of a happy young woman, water whose mysteries are revealed to me, water which the shadow clothes and the sun undresses, water upon which all the hours of the day inscribe themselves like age upon a human face."[52] The face that Descaves sees in Monet's waters is that of a happy young woman, just as twenty years earlier Mallarmé had seen the smile of the *Mona Lisa* in Monet's mirrored riverscape of the Seine. The face that Descaves sees in Monet's waters is also the human face in its most generic form, Narcissus's face, a face undergoing in the vicissitudes of the series the ineluctable impress of time.

Descaves may bear witness to Monet's own remarks in an article of 1920 based on a recent visit to Giverny. Descaves writes of Monet's love for his "ideal mistress: the Light"; of the haunted concern to find her again "tomorrow where I left her, and as beautiful"; of the *Genesis*-like fecundation of the painter's garden—" 'let the water blossom!' "; and of Monet's protest against the mournful associations of the weeping willows he planted along the banks of the pond: "The willows of Giverny, when I saw them again the other day, in the sun, bent over the mirror of water a riant image."[53] Narcissus does not usually laugh, but Monet's denial of mourning in the aftermath of the war and the deaths of his son and wife may represent a manic warding off of depression.

The war figures in Descaves's account in the person of Clemenceau,

who made a recuperative visit to Giverny after his loss in the elections of 1920, and in the general invocation of French *victoire* which the final *Water Lilies* panels, then under way, are said to represent. A similar portentousness already resonates in the 1909 assessment of Romain Rolland, professor of history of art at the Sorbonne, Nobel Prize winner for literature in 1916, and later a correspondent of Freud. In a letter of thanks to Monet on behalf of a young musician-friend whom the artist had materially assisted, Rolland writes of his admiration: "An art such as yours is the glory of a nation and a time. When I am a bit disgusted by the mediocrity of contemporary literature and music I have only to turn my eyes to painting, where works such as your *Water Lilies* bloom, in order to reconcile myself to our artistic epoch and to feel that it is worthy of the greatest that ever were."[54]

Monet's canonization in 1909 is prominently registered in a long article published in the *Gazette des Beaux-Arts* by its editor-in-chief, Roger Marx, *commandeur* in the Legion of Honor and inspector-general of Fine Arts. He and Monet had already collaborated in 1900 on the occasion of the Centennial Exposition. Having too long "lived outside all officialdom," Monet initially refused to participate in that exhibition (9 January 1900, L. 1491), but in the end the painter was represented by fourteen paintings, with two Riviera seascapes illustrated in the catalogue (W. 1168, 1191). In preparation for his article in 1909 Marx sent Monet a questionnaire on his watergarden: "Yes it is a piece of water created by me fifteen years ago, the aforementioned piece of water of approximately 200 meters around being fed by an arm of the Epte River; it is bordered by irises and diverse aquatic plants in a framework of various trees, but within which the poplars and willows dominate, among them several weeping willows. It is in this same place that I previously painted the *Water Lilies* with a Japanese-style bridge. I formerly dreamed also of making a decoration with these same *Water Lilies* as theme, a project which I will realize one day" (1 June 1909; L. 1893).

The credentials of Roger Marx were of the highest prestige, and the pages of his journal further consecrated Monet's paintings by way of juxtaposition with illustrated articles on El Greco, eighteenth-century French and British portraits of women, and the contemporary artist and member of the Institute, Pascal Dagnan-Bouveret (1852–1929). In the *Gazette*'s review of the Salons of the year, Pierre Goujon takes up the theme of national glory and emphasizes the tradition of landscape painting: "In the great French lineage which Poussin initiates, to which a Monet attests, across two centuries, that the genre is still intact, there is nought but to celebrate those who were able to aerate an instant of its life, to enlarge or change

the frame of its activity, to add to its chances for action." In its dual modes of luminosity and plasticity landscape is seen as preeminently French, since, from Poussin to Monet, "the light and the air of France have mysterious qualities that can be felt only by souls habituated to the level and temperature by long hereditary use." In a subsequent essay on sculpture at the Salons of 1909, in which Goujon admires among others a bust of Monet by Paul Paulin, the critic again insists on the importance of the renovation of tradition in a marble statue of Narcissus by H. L. Greber (fig. 109): "His fountain is a charming masterpiece, for which I wish the harmonious frame of a deep silent park. There the marble is enveloped with love, served with devotion, softened even so far as to translate the fragility of flowers, the inutility of these thin gestures. The leg which twists and effaces itself in order to permit the body to bend over the mirror of the water, the applied arms, which crown with a bit of fever all this lassitude, this loving embrace of the head, ravish in their originality."[55] This bending body above the mirrored water might have been Monet at Giverny or his spectators at the exhibition in Paris.

Marx's article on the *Water Lilies* is illustrated with one of the issue's five bound-in reproductions, a heliotype of a painting of 1904 (W. 1666); the other *hors-texte* images reproduce four female portraits by Hans Memling, Jean-Baptiste Perronneau, François Guiguet, and Ernest Laurent. The *Water Lilies* are allotted three further photographic reproductions, including one from the earlier series of 1899 (W. 1512) as well as two paintings from 1905 and 1906 (W. 1668, 1684).

Marx's opening gambit is to recount his disorientation in the face of the forty-eight works on display. What troubles Marx is the repetition of an identical subject and its fragmentary aspect. Marx considers these traits "alien to painting," and he uses the contemporary language of the alienist in diagnosing the artist's disease: "There is here an affirmation of authority and independence, a supremacy of the I, which offends our vanity and humiliates our pride. M. Claude Monet has cared only to satisfy himself; he expends his pains and finds his pleasure in differentiating the joys experienced, throughout the day, in looking at a single site; such are the ends, egoistic in appearance, of his art, and it is suitable that everything subordinates itself to them: a theme is of value in the measure that it enriches vision with more abundant and more precious sensations." Monet's Narcissus-like self-absorption had never before been so blatant nor had the spectator's Echo-like exclusion been so profound. In Monet's previous series, including the *Mornings* in which "the Seine enlaces with her arms the wooded isle," each individual painting formed "a whole complete in itself."

In 1909 there is a rupture with this axiom of easel painting and now it is only "his optic and his own means" that are at stake.[56]

Marx notes an affinity between Monet and the glass artist Emile Gallé and the dramatist Maurice Maeterlinck, with whom Monet shared Art Nouveau's predilection for eroticized floral motifs: "For a long time the paradox of aquatic flora intrigued and seduced him; he promised himself to provoke it and rejoice in it." The water-lily pond becomes under Monet's horticultural gaze a spectacle contrived to gratify the artist's voyeurism: "Henceforward periodic fêtes will institute themselves in honor of the painter, beneath his eyes, at the reach of his daily gesture, and each return of the beautiful season will see M. Claude Monet equally jealous to disrobe the ephemeral vision, to immortalize the flowering plane of water and her enchantments."[57]

Marx finds a link between the *Water Lilies* of 1909 and those of 1900 in the only painting in the exhibition where the formerly ubiquitous Japanese bridge is depicted (W. 1668). The bridge and its attendant weeping willows reassure Marx by way of their affirmation of terra firma, but he concludes that this is "an exceptional recollection, fortuitous perhaps." In the remaining forty-seven paintings "a new will indicates itself": "Here the painter has deliberately withdrawn himself from the tutelage of the Western tradition; he does not look for lines that pyramid or that center the gaze upon a single point; the character of that which is fixed, immutable, seems to him contradictory to the very principle of fluidity; he wants the attention diffused and distributed everywhere; he judges himself free to cause to move, according to his point of view, the little gardens of his archipelago, to locate them at the right, at the left, at the top, or at the bottom of the canvas; in this regard, in the obligatory setting of their frames, the 'excentric' representations make one think of some bright *fukusa* capriciously beclouded with bouquets which the hem suddenly interrupts and cuts across their midst."[58] Monet's displacement of the Western spectator from the centered and upright position is redeemed for Marx by way of the alternative tradition of oriental art, but the willfulness of Monet's gesture retains a residue of aggression at the viewer's expense.

In spite of his orientalism Monet is still regarded as steeped in a reality familiar to the Western eye, but "to the evidence of reality will supplement the evocative magic of the reflection." In Marx's text the masculine reflection seems personified: "It is he who recalls the vanished banks; here again, inverted and trembling, are the poplars, the great willows with weeping branches, and here, between the trees, the clearing, the alley of light in which the sky tinted with gold and purple shines; the fires of the dawn

and the dusk ignite the transparent glass, and such is the brilliance of these glimmers of apotheosis that their reverberation makes it difficult at first to distinguish the humble plants lost in the shadow which lengthens upon the mirror of the waters."[59]

Marx writes of the *Water Lilies* that "in them the soul refreshes itself through the benefit of dreams." What Monet dreamed in his watergarden remains unavailable to us; what Monet dreams in his paintings, however, is variously available in the interpretations of critics such as Marx who call upon shared cultural themes even as they intrude independent associations of their own. In the *Water Lilies* "the elements penetrate one another and confound with one another,"[60] and an allegorical imagery of cosmic and sexual fusion becomes the sign of an individual's doubled and split experience as both body and idea.

Marx enlists nature in the pursuit of his own hermeneutic ends: "At the height of the heat, in the environs of a pond, nature seems to float in the moist air, to vanish, and to second the play of imaginary interpretations." "Imaginary" acknowledges the projective aspect of criticism, whether Marx's or my own; but in the French tradition of which Marx's symbolism and Lacan's psychoanalysis form a close chronological series, *imaginaire* also refers to the realm of images.[61] In Lacan's allegory of the mirror-stage the orthopedically unstable infant, much like the perceptually disoriented spectator in Marx, sees her or his reflection in the mirror, and in that shimmering image grasps an ideal totality of self that does not then, and indeed never does, find a perfect match in the bodily imperfection of our real condition: "It is these mirages, transposed in the minor mode of bluish and ashen colorations, that the water-lily pool reflects; now it is like a sheet of soft azure; spots of pale green foam mottle it, here and there spangled by the flash of a topaze, a ruby, a sapphire, or the nacre of a pearl. Beneath the light veil of a silvery mist, through the incense of soft haze, '. . . the indistinct joins itself to the precise,' certitude becomes conjecture, and the enigma of the mystery opens to the mind the world of illusion and the infinity of dreams."[62] Marx is almost an exact contemporary of Freud (born in 1859 rather than 1856), but he need not have read the psychoanalyst in order to be enmeshed in a shared generational discourse of that intermediate cultural zone where we imagine ourselves joined to the world via the wish-fulfilling media of poetry, painting, and dreams.

At this moment in his speculation Marx permits the persona of the artist to intervene. Marx gives this putative Monet a contrarian voice, a voice which may or may not echo a personal experience of the painter's conversation: "What demon of the ideal torments you, protests the artist,

and what good is it to tax me as a visionary? Is it thus to fantasies of beyond that will have led this exaltation and this ecstasy of the senses through which my devotion to nature translates itself, satisfies itself, appeases itself? At any rate do not attribute to me the detours of chimerical designs. The truth is more simple; my only virtue resides in my submission to instinct; it is from having recovered and allowed to predominate the intuitive and secret forces that I was able to identify myself with creation and absorb myself in her."[63] What these instinctual forces are, Marx's Monet does not say, but we may situate them on the historical borderlines between Schopenhauer's metaphysical will and the unconscious drives of Freud.

The modernist myth that is articulated here is that through the mysterious force of artistic creativity the male artist becomes identified with female creation. Like Narcissus seeing in his own reflection the beloved traits of his dead twin sister or his water-nymph mother, Marx's Monet sees in the feminized face of nature his own ideal image. In 1910 Freud first proposed the scenario of artistic narcissism as a transgendered identification with the mother: according to Freud, Leonardo came to see the world's manifold beauties as a reflex of his earliest internalization of how his mother regarded him. Freud uses this identificatory mechanism in order to explain what he takes to be Leonardo's homosexuality, but I make no biographical claim regarding Monet here. Rather I would stress that Monet's identification with Mother Nature is in Marx as much a socially transmitted myth of the modernist artist as it may have been a private psychological fantasy.

Monet insists that his painting is "an outburst of faith, an act of love and humility." In contrast, Théodore Duret is cited without attribution to the effect that the artist had "arrived at the last degree of abstraction and imagination allied to the real."[64] Without rejecting this characterization of his enterprise Marx's Monet shifts the argument to psychological terms which recall Gasquet's version of the fusion of Narcissus with the environing world. Regarding scholars who write dissertations on his art the painter offers the following caveat: "It would please me more were they willing to recognize the gift, the integral abandonment of myself. These canvases, I have brushed them as the monks of former times illuminated their missals; they owe nothing but to the collaboration of solitude and silence, nothing but to a fervent exclusive attention which touches on hypnosis." The allusion to the religious art of the Middle Ages points to the redemptive potential of self-reflection and also explains the resistance to this project in a positivist age: "One refuses me the liberty to adopt a single motif and

to pursue its representation beneath all incidents, at every hour, in the diversity of its successive charms: but to protect the faculties from the effort of accommodation that a new theme at first demands, is that not to avoid their diminution and to concentrate them in order the better to surprise in its fugitive and changing play the life of the atmosphere and the light, which is the very life of painting? Then, of what importance is the subject! An instant, an aspect of nature, contains her altogether."[65] This is the epistemological justification for Monet's world-constricting narcissism, for his obsessive reelaboration of a narrowly delimited but deeply plumbed theme.

Monet positions himself in the posture of the self-absorbed artist bending over the banks of his pond: "I set up my canvas in front of this bit of water that embellishes my garden with freshness; it is not two hundred meters around yet its image awakens in you the idea of infinity; you discover there, as in a microcosm, the existence of the elements and the instability of the universe that transforms itself, at each moment, beneath our gaze." The painter's voice insists upon the reality of the scene, rejecting the "fatal comparison" with Joseph Turner and Claude Lorrain even though he recognizes the critic's need for "the support of the parallel." Monet differentiates his strategy from these pictorial forebears and from writers of fantasy as well: "I have not built by the shores of distant seas implausible palaces whose terraces rise and stack themselves against an Oriental sky; my landscapes would fail at enframing the tragic gesture of Salammbô or Akëdyséril." The references are to the sanguinary heroines of Flaubert's tale of Carthaginian decline (1862) and Villiers de l'Isle-Adam's fable of ancient Indian life (1885); in both of these texts the mythological threshold that separates the human and the divine is legible as an allusion to political and personal divisions in contemporary French society. Marx's Monet would reject any allegorical scenario, including that of Narcissus no doubt, and locates his particular gift in perceptual psychology: "Perhaps originality reduces itself, in me, to the receptivity of a supersensible organism and to the suitability of a stenography that projects upon the canvas, as upon a screen, the impression gathered upon the retina."[66]

This retinal channel between the painter's eye and the world's body by-passes the antinaturalistic pathways of Claude, Turner, Flaubert, and Villiers. On the other hand, Marx's Monet does acknowledge the claim upon his art of the Japanese—"who evoke the presence by the shadow, the whole by the fragment"—and of certain unnamed masters of eighteenth-century France.[67] He also declares an alliance with Claude Debussy and Mallarmé, but the latter would hardly have disdained the fantastic

atmosphere either of *Salammbô,* so close to his own "Hérodiade," or of "Akëdyséril," of which he wrote to a friend that he knew "of nothing so fine."[68]

Although Marx invokes the Baudelairean doctrine of correspondences, he rejects the notion of "a precise and clearly enunciated mother-idea." The mother is the most widely implied transcendental idea in the French poetry and painting I have been tracing, and her lost and desired matrix may once again be seen in the allegedly nonallegorical description which Marx's Monet gives of his art: "Indeterminacy and vagueness are means of expression that have their own raison d'être and their own properties; through them sensation prolongs itself; they form the symbol of continuity." The maternal holding environment embodies the fantasy of Narcissus to step outside of time to fix temporality as a continuous present. This is also the painter's project: "One moment the temptation came to me to employ this theme of water lilies in the decoration of a salon: transported along the walls, enveloping all the panels with its unity, it would have procured the illusion of a whole without end, of a wave without horizon and without shore; nerves overcome by work would have unwound themselves there, according to the restful example of these stagnant waters, and, to whomever would have lived there, this room would have offered the asylum of a peaceful meditation in the center of a flowering aquarium."[69] The image of the flowering aquarium is one of the period's chief metaphors for the introspective life of the mind. The Belgian poet Georges Rodenbach—who in 1899 had written of Monet's "marvelous water landscapes, with all the cosmetics, the feverish tatooing of reflections"—explored this aqueous epistemology in his "Aquarium mental" of 1896, where water's variable conditions are seen as "mental canvases" of the soul.[70] The mental aquarium is the retreat of Narcissus in the cerebral unity of its enclosed state.

Something of the morbidity of the aquarium seems to unsettle Marx, for at this point he interjects a disclosure of neurotic illness. Neurasthenia had often been cited in the press as a reason for Monet's repeated deferral of his exhibition, but now the painter strikes back against this charge: "You smile, the name of des Esseintes wanders upon your lip. Is it not a shame, really, to deny to strength the right to express that which is delicate and so willingly to declare the refinements of research to be incompatible with flourishing health? No, des Esseintes is not my prototype." The artist's rejection of the effeminate self-cultivation of Huysmans's narcissist in *A Rebours* gives rise to the masculinist self-assertion of the hero of Barrès's *Le Culte du moi,* "who cultivates with method spontaneous emotions."[71]

Age is said to hold no fear for Monet as long as the world continues to arouse his "ardor of curiosity" and as long as his "hand will remain the prompt and faithful interpreter of my perception."[72] The perceptualist axiom that Norman Bryson has traced from Pliny and Vasari to modernism is seen here in one of its prime moments of constitution. What is missing is the psychosocial dimensions of Narcissus's fate: Narcissus's eye sees, Narcissus desires, Narcissus's hand seeks to grasp the image but cannot, Narcissus recognizes the impossibility of his own desire, Narcissus dies.

Salvation comes from the body of nature: "I form no other wish but to mingle myself more intimately with nature and I covet no other destiny than to have worked and lived, according to the precept of Goethe, in harmony with her laws. She is the grandeur, the power, and the immortality beside which the human creature seems no more than a miserable atom."[73] The subordinated coupling of the miserable male artist and the grandiose female landscape occasions a fetishistic venting of self-belittlement which both inverts the gendered hierarchy of society and displaces the artist's dependence upon its impersonal market force.

At this point in the painter's monologue the critic reasserts narrative control. "So be it," he says; but the painter's account will not be permitted to comprise the entire story: "It nonetheless remains that nature could not afford to banish man; her beauty, altogether subjective, would not appear without the thought that defines her, without the poetry that chants her, without the art that reveals her." Monet's world is uniquely his, not objectively present, and his vision is distinguishable from all others who had come before: "He differs from them by hyperesthesia, and also by the oppositions that unify his temperament; passionately cold, he oversees his impulses and masters them with reason; he is obstinate and lyrical, brutal and subtle; his art palpitates with all the fever of enthusiasm, and yet serenity emanates therefrom; the transport of technique does not impede the search for graduated and muted nuances; in such work the material, lovingly wrought, gives to the surface of the canvas the porousness of an unpolished pottery that the hand would love to caress. For all these years that there have been men, and who paint, no one has ever painted better, nor of this sort."[74] Baudelaire's rationalized passion; Gasquet's disciplined eye; Valéry's self-abnegating Narcissus; Freud's id-mastering ego: all of these scenarios portray the transcendence of the sensuous body in the ideal reembodiments of art. What Marx's modernist scenario principally lacks is an acknowledgment of the inevitable failure of this project fully to encompass the ideal.

Rather than affiliate his account with the failure of Narcissus as I have

done, Marx associates Monet with the optimism of modern science. Unlike the painters of earlier generations who "gave themselves the task to isolate the eternal from the transitory" (these are Baudelaire's terms), Monet is "smitten with the vertigo of speed, wherein the creator wishes to take, by way of brief and violent impressions, a rapid cognizance of the universe and of himself." Monet is both the physicist of the world's enveloping "diaphanous network" and the phenomenologist of his own states of response: "He is the painter of the aerial wave and of the luminous vibration, the painter of affinities and reflexive actions, the painter of the fleeing cloud, the dissipating haze, the ray which the earth displaces in its revolution." Monet is all that is scientifically modern, but this is not all Monet is for Marx: "He is moreover the painter of ambiences and harmonies, less the grave harmonies dear to Lamartine than the 'loving and light' harmonies celebrated by the saint of Assisi in the *Canticle of the Creatures.*"[75] We find ourselves at once enfolded in the mystical embrace of medieval Christianity and swept up by the *élan vital* that transforms Bergsonian science into a philosophical ethic.

Monet is "an adept of pure sensation" and "a dispenser of emotion." His art evokes the calibrations of "the lens and the compass" and a "clairvoyance" of vision that transcends the protocols of scientific experimentation. This dual practice of measurement and mysticism may appear somewhat bizarre within the English-language history of impressionism, where several generations of scholars have come to regard Monet's art as an optical matter of the eye somehow disengaged from the desiring body and the imagining mind. The French tradition, however, appropriates British empiricism in tandem with German idealism. Marx cites Goethe's pantheism as a prototype for Monet, but it is Goethe's younger contemporary Novalis who is given the last word regarding Monet's transcendental semiology of the natural world: "'A long and indefatigable commerce; a free contemplation; an attention directed toward the least signs and the least indices; the inner life of a poet; experienced senses, a simple soul.'"[76]

Marx's attribution to Monet of a Goethe-like pantheism is echoed by Francis de Miomandre, whose 1908 novel about the unconsummated loves of a self-absorbed young idealist entitled *Ecrit sur de l'eau* had earlier provided Pierre Mille with the title of that critic's review of Monet's paintings. Miomandre reviews Monet's exhibition in *L'Art et les Artistes* against the backdrop of the 1857 paintings on view at the Salon des Artistes Français. Such exhibitions are "big international bazaars where each manufacturer sends, exhibits the products of his brand, and in such a manner as to be recognizable right away"; each commercialized artist gives up the

"personal character" of the work and does nothing but "recopy himself, without referring himself any longer to nature." The self-reflexive verbs indicate a sterile mode of capitalist repetition opposed to the impress of the "personal" which Monet's paintings are said to display. The vast majority of Salon paintings in 1909 are little more than "sentimental anecdotes" and "photographs in color" from which are lacking sincerity, vividness, and truth.[77]

The commodified self-repetition which Miomandre reproaches is not apparent in the *Water Lilies*: "Forty-eight times this motif solicits the brush of the greatest painter we possess today. And forty-eight times he resolves the problem with passionate virtuosity." Passion is the key to Monet's project: "The pantheistic bard of Nature completes the tumultuous ode he has been celebrating for fifty years in these appeased accords of muffled richness, of veiled brilliance, magnificent and full of reverie." Monet's paintings are poems or musical pieces which repeat the rhythms of the natural world: "It is a marvel. The poem of all the hours of the day in all the seasons of the year suavely chants upon the listening, immobile water from the pale and blue preludes of the dawn to the splendid purple finales of the dusk." The occasion of this artistic performance is both a banal bit of landscape and an elegant form of artifice: "Corners of a pond having no other banks than the gold of the frame. Water; upon this water water lilies and at times the reflections of the sky. That is all."[78]

In contrast to Miomandre, Charles Morice, a friend and partisan of Gauguin, takes Monet to task in the *Mercure de France* for having outlived his allotted art-historical role. The critic's appraisal of Monet had been on record since 1904, when he had seen in the paintings of London a "perfect art—of which it is impossible not to sense the limits."[79] In his own analysis of these paintings Mirbeau ridiculed the symbolist writer's desire to see an impressionist painter concern himself with "great social, moral, interna- tional, political, philosophical, psychological, psychiatric, scientific, esoteric, and teratological problems."[80] Since it is largely the project of this book to make just such monstrous claims about Monet, I am sympathetic to Mo- rice's desire though not to his judgment, for he concludes that Monet's art "does not take sight upon our mind, it stops at our eyes." Morice does not doubt the truth of the artist's vision, "such as one thinks to see it," but he rejects what he takes to be the narrow empiricism of the enterprise: "This art, splendidly and exclusively physical, falls back amidst the elements of matter."[81]

Not all symbolist writers share Morice's view. Henri Ghéon visited Monet's exhibition in the company of André Gide, and like his friend's

Narcissus of 1892 Ghéon portrays the painter in the posture of the mythic youth: "It is no old man but the exalted painter who, five years running, every day and yesterday still, bent himself over the flowering pond of water lilies that is the theme of his recent works in order to celebrate with a tireless passion the reflection of the trees and the sky in the water." The medium of Monet's passion is the physical matter of his art: "And by turns the matter of these stupifying pieces will show itself to us all smooth of glaze, all granulose and porous, all hatched with impasto, and the indication of a flower upon the water will be born from a willful and heavy touch, from a subtle scumble, from a fortuitous blot, or from a curiously expressive nervous flourish." What Ghéon describes is the calculated elaboration of a repertory of strokes whose purpose is not mere virtuosity but emotional self-expression in "its absolute and definitive form." "As though spontaneously": this is the burden of the dandyism of Baudelaire or the narcissism of Gide, to show oneself in the physicality of one's being and thereby— "miraculously," Ghéon says—to be transfigured into the idea for which the body stands. Material signifiers recede and ineffable signifieds surge forward, or as Ghéon writes, "there is no more painting here: water itself, that which reflects itself there, and an emotion in front of the water."[82]

The transformation of matter into mind distinguishes Monet from the painter's closest counterparts, such as Corot, Degas, Cézanne: "They paint in space, he—if I dare say—in time."[83] There may be some sense of Bergsonian or Einsteinian space-time here, but what is clear is that Ghéon imagines himself to be making a radical statement. Matter in Monet's art is thus elided twice, for not only does paint yield to world but the world's plasticity also yields to the becoming of time.

Even as Monet projects into time's fourth dimension the three dimensions of traditional plastic art, he also constrains the scope of his scrutiny: "Remark how over the course of five years of studies by the shore of the same flowering pond, Claude Monet restricts the field of his vision in a progressive fashion. First he paints the pond ringed in by banks, then the banks give way, leaving their reflection; the next year, no more than the reflection of the trees, then nothing but the sky in the water. And thus, from the flower bed of water lilies scarcely a single flower remains at the end. —In the same way, it is the solidity of the landscape that at first he evokes in a limpid and glassy weather, then its conflagration, then its slackness and subtlety; thus up until its evanescence. . . ." The final ellipse is Ghéon's own, a sign perhaps of the indeterminacy he glimpses in the fragmentary framings and temporal gaps of the forty-eight-part series. The disconcerting result of Monet's endeavor is that it has nothing of substance

to teach, only the example of an artist who pursues "his deepest impulses" to the end: "Having achieved consciousness of his 'lyrical' value, Claude Monet will have cultivated it exclusively, to the disdain of traditions and formulas. Painting or not: it is beautiful." If this is not painting perhaps it is ethical narcissism: "Isolated affirmation, strong-headed, formidable, and inimitable, without past and without tomorrow, of a power that one names 'genius,' a force of instinct, a force of will."[84] And to give historical context to Monet's acts of self-reproduction Ghéon adduces the late works of Michelangelo and Beethoven.

Ghéon warns painters not to take the idiosyncratic art of Monet as model. A similar concern is expressed in the magazine *La Flamme* by Louis Godefroy: "The quasi-mysterious isolation in which he has been working since his genius, finally recognized, gave him that quietude dear to Horace and which is much more than a simple *aurea mediocritas* [golden mean] has caused marvelous legends to germinate which for some have carried him into that ideal sphere where the demigods reign, when they did not merely inspire in others a lowly jealousy, an anxiety that did not wish to betray itself, a sarcasm that dared not formulate itself before 'having seen.'" Godefroy calls the conflicting predispositions in Monet's audience *prévention,* and the literal English equivalent suggests that such attitudes are as much modes of preventing meaning as of enabling it. The semantic saturation of Monet's art prevents the public from attributing fresh meanings to the *Water Lilies;* worse yet, the unavailability of alternative critical vocabularies encourages the disavowal of what Godefroy takes to be a simple fact about the works: "But I especially believe that the same surprise disoriented the ones and the others, and that even his most fervent admirers experienced a deception which they forced themselves to dissipate or which many did not perhaps acknowledge to themselves."[85] Godefroy's keen sense of the dynamics of critical reception does not justify his own effort to evade the determinations of discourse through a purportedly direct appeal to the paintings.

Godefroy relates the history of the *Water Lilies* of 1909 by recalling the earlier series in which "a small Japanese bridge spanned a narrow stream that reflected, among the marvelous aquatic vegetation, the disheveled foliage of weeping willows, at times in the dazzle of the June sun, at times in the gleaming brilliance of a September eve." These paintings seemed "a mad wager, an unheard of antithesis at a time when each artist had his genre, and a defiance flung at the public which loves to recognize its familiar masters from afar." Having thus prepared the public nine years previously, Monet could now afford to count on the marketability of his

works: "The water of a pool is a strange mirror in which everything that reflects itself there transforms itself and veils itself. The Chinese poets chanted the reflection of the May Moon between the wisteria, the Japanese made basins of bronze in the image of a tiny pond so as to be able to extend upon the limpid water where a single rose petal floats the landscape painted upon a favorite Kakemono, and all of us have stopped ourselves by the shores of lakes and pools in order to discover the mysterious landscapes enframed within their banks. Claude Monet has done the same; he has sat himself down in front of his pool filled with water lilies, he has remained there for hours and hours, from the vapors of the dawn to the fanfares of dusk, and he has chanted his joy in the nuance upon the organ of his palette." The painter's orientalism is joined to Verlaine's doctrine of the nuance in order to explain how each of the *Water Lilies* is "Neither altogether the same. / Nor altogether another."[86]

Godefroy's recitation follows a familiar pattern: "There were pink water lilies in the bright tenuity of a gray afternoon and others illuminated by the last gleams of a setting sun; several scattered their scarcely opened flowers upon the green reflections of a morning in spring or upon the crepuscular pallor of a cloudless sky; others cut through the leafy and upright masses with their long parallel streaks, like a gothic vault of an alley ignited by the sun in its decline, others more pale, then others still more pale, more gray, more indistinct, as far as those which almost confounded themselves with the sky, up until the night." Godefroy claims to have experienced the "marvelous enchantment" of this day in the country until the moment when he became aware of "the frame and the gray cloth of the hangings which arrested the charm, which destroyed the illusion." This recognition at once puts an end to Godefroy's dream: "One could not forget the gilded moldings which surrounded these impastos of multiple reflections; there were even some round ones like medallions in which one thought to glimpse the effaced pastel of a bewigged marquise."[87] Just at this time an exhibition of portraits of eighteenth-century women was on view in the Tuileries at the Jeu de Paume, and I imagine that the aristocratic association may not have been uncongenial to many of Monet's antinaturalistic advocates. For Godefroy, however, the gilt materiality of the frame ruptures the illusion, which thus proves to be fugitive and insubstantial.

Godefroy writes as though he has only reluctantly come to this appraisal. The *Water Lilies* constitute "the apogee of a magnificant career," but a career that now seems to have endured too long: "Like a fine wine that divests itself in aging and loses some of its aroma, the will no longer

to represent real objects but only their attenuated reflections in the mirror of a lake, the folly of the nuance brought to its paroxysm, had impoverished his art." Seventeen years earlier the perceived paroxysm of Monet's art had propelled the painter's practice into the symbolist orbit of Camille Mauclair; for Godefroy, all that is accomplished is the collapse of Monet's worldly illusion into a mere debris of canvas and paint. No symbolic program redeems Monet's signs from their descent into asemantic materiality: "Each one of his canvases was still a note of delicious harmony, but it takes more than a few harmonious phrases to make a symphony."[88]

Godefroy sees Monet's error as a symptom of the times when "there always is something lacking," yet Monet's lack is the product of an excess of self-love: "Far from being to impotence, it is to his ever renewed force that one must attribute [the error] that carried away Claude Monet, for far from having remained on the nether side of the Beauty he had attained, it is on the far side that he has fallen from having wanted to go too far." Like Narcissus athwart the meniscus of the pool, Monet's art is imperiled by its encroachment upon an axiomatic threshold of painting: "One sees what has become of the art of Claude Monet when he removes from it its most beautiful reasons for being, when he reduces it to painting the reflection of a cloud upon the water of a pond." Others are advised not to follow Monet's example, yet Godefroy acknowledges the irony of this sixty-nine-year-old artist surpassing himself at an age when "so many younger artists had long since *arranged* themselves and, with the serenity of the large-scale merchant who has placed upon his sign 'reliable firm,' manufacture merchandise that is always the same and also of mediocre quality." In spite of Monet's refusal of his own commodification other artists must now aspire "toward a new ideal."[89]

There is one final response to the *Water Lilies* which I wish to consider, that of art historian Louis Gillet, eventually a distinguished member of the French Academy. In 1909 Gillet was already the author of monographs on the French primitives and on Raphael; later he became curator of the Musée Jacquemart-André at Chaalis, a property famous for its eighteenth-century park and ponds and indeed one of the prototypes of Monet's watergarden at Giverny. Today Gillet is best known for his books on Poussin, Jean-Antoine Watteau, Jacques-Louis David, and Monet, on whom he published a trio of essays in 1927. These "three variations" consist of articles on the *Water Lilies* first published in 1909 and 1924 as well as a further set of remarks written after Monet's death in 1926 and upon the installation of the artist's decorations in 1927. Gillet visited Monet at Giverny as early as 1907, but he seems to have become an especially welcome

visitor around 1924 when Monet wrote to thank him for the "joy" he anticipated from two of Gillet's recent books, a monograph on Watteau and the 600-page *Histoire des arts* (20 June 1924; L. 2568). In this compendium the *Water Lilies* are described as works "in which nature is no more than a pretext, in which the subject disappears and vanishes in the light, in which the entire universe is no more than a vibration, a luminous quivering, a blazing, blurred mirage, a brilliant enchantment, something unknowably uncertain and suspect like a phantasmagoria, a diaphanous and multicolored world of appearances." Monet's "subjectivism," his "negation of all reality," is the constant theme of Gillet's writings on the artist.[90]

Gillet first published his eighteen-page "Epilogue de l'impressionnisme" in the *Revue Hebdomadaire*. He cites Vernet and Corot as precursors in a tradition wherein the formulaic *clair-obscur* of landscape painting ultimately came to be replaced by the touches of pure color of Monet: "By force of reducing, of decomposing everything, the light and the tone, of resolving the shadow itself into colored reflections, by force of regarding all things as though bathed, as though swimming in an aerial fluid; by force of seeing them modified, altered by all the influences of the milieu into which they plunge: by force of unstitching, unraveling this envelope and infinitely applying his method of division, the artist arrived at envisioning the spectacle of the universe as a marvelous drama or a fairy tale of the atmosphere. The contours are volatilized, the margins set themselves to undulating in a halo of pale gleams. Everything metamorphoses itself in a dazzle." Gillet insists that Monet's "incandescence" is aesthetically on a par with the former convention of light-and-dark, but he worries somewhat about the epistemological implications of Monet's practice: "Never has a painter more resolutely denied matter. Never, in the face of the evidence of things and of form, has one more boldly substituted the law of an imagination intoxicated with colors, with poetry, and with beauty."[91]

Like Roger Marx, Gillet imagines Monet as claiming for himself an immediacy of sensation: "To reproduce instantly upon the canvas the picture of his emotions, to project as though on a screen the interior spectacle, the collection of nervous shocks of which the visual image is composed, here is his entire objective." For Gillet this process of vision is not simply a mechanical reflex but rather an emotional interpretation yielding "brilliant synonyms and simulacra of the real": "The touch imitates nothing, it evokes. It is abrupt, pulverized, hatched, scratched, slashed, turning, now thick, now thin, never slick, never treated as an 'end': it is the reverse of

a tapestry whose obverse has just painted itself in the consciousness of the spectator."[92]

Gillet recognizes that not all spectators are prepared to form an image of reality on the basis of the tapestrylike strands of Monet's brushwork, and he insists that Monet ought to have clarified his enterprise: "You demand from my painting the information of an engineer: you have come to the wrong address. If you are curious for this knowledge, the photographer is there to respond to such needs. . . . Praised be the daguerreotype, for it delivers us from idle questions; by its grace art is absolved from the role of the document. . . . Henceforward what is the import of what you call my subjects? Of what import is the label that I place on my pictures? This [Saint-Lazare] Station that makes you indignant because it is not in the canons of the Greeks, it is only a title, the name that I lend to a state of my sensibility; it no more conforms to the visible station than does the horse of Phidias to a cabby's nag." Gillet goes on to have Monet contrast the illusionistic expectations of European spectators with those in Japan, where prints are made "that have the air of coats of arms."[93] Gillet's Monet augments this reference to the emblematic aspect of Japanese prints with a complementary emphasis upon the stained glass of the Middle Ages.

Had the artist spoken in this way during the 1870s much misunderstanding would have been avoided, but Gillet acknowledges that it would not have been possible for Monet to do so given the painter's own commitment to the naturalistic tradition within whose norms his work was being judged: "By way of the intrepidness of his 'subjectivism,' the luxuriousness of his vocabulary and of his metaphors, the dazzling transformation that he makes things undergo, this painter—as realist as one believed him and as he believed himself to be—in reality is a lyric and even one of the greatest lyrics in painting."[94]

The iconology of Narcissus resonates in Gillet's references to Monet's "mirages which have no existence but in himself," to the painter's "fine indifference to what is the occasion or the pretext of his works." A sense of the artist's defensiveness and aggression also emerges here, prompting the question as to whether "this great landscapist truly loves nature." This thought seems to trouble Gillet and he declares that in Monet's art "one does not sufficiently sense the life of the model"; Monet "lacks sympathy"; "I would not affirm that he is truly convinced that nature exists." Here we come quite close to Freud's contemporaneous sense of narcissism as a melancholy void that is mirrored over with highly idealized images of others and of one's self: "This is the portion of 'mystery' that hides itself in this dazzling art." Gillet backs away from any neat characterological

assessment and compares Monet with "that other Norman Flaubert who intones against 'the brutes who believe in the reality of things.'" Gillet trembles for the lost intersubjective reality, "but perhaps it suffices, for an artist, to believe powerfully in his art": "What does it matter in what sense M. Monet has resolved the enigma of this world if his hymn is one of the most beautiful that the universal nothingness has ever inspired?"[95]

If Gillet's skepticism finds support in Flaubert, his transcendentalism is rooted in Baudelaire, whose famous doctrine of correspondences of perfumes, colors, and sounds he subtly misquotes: "Forms, colors, and sounds to one another respond." These interartistic affiliations are taken as further evidence of Monet's negation of matter: "Indifference to the material or moral content; incuriosity, apathy with regard to reality; pronounced taste for the combination of colors; faculty of dissociating them in order to associate them with others, to extract from them harmonies and accords; ceaselessly renascent enthusiasm for this genre of emotions, indefinite capacity to conceive them afresh, to analyze them, to multiply them by subdivision into different images, to fecundate a theme and deploy it in exhaustible variations: one sees by what stages M. Claude Monet was called upon to give in the form of the 'series,' with a minimum of real landscape, the most astounding sonatas of modern painting."[96]

Transfixed by what fairy tales call the "color of time," Monet affirms "the miracle of appearances": "A tree is no more than a blur, a light breath scarcely less incorporeal than its image on the surface of the river where it admires itself. . . . Nothing more inconsistent and more fugitive, nothing more audacious and more intoxicating than this absolute nihilism that takes refuge in pure art and creates for itself in the imaginary a realm of fantasy where, like the nuances in the neck of a dove, the jewel-box of dreams of the *Thousand and One Days* passes by."[97] The author of *The Thousand and One Nights* offers the stories as a prelude to the dreams of sleep; in Gillet's transposition the artist's paintings facilitate a form of shared dreaming by day.

"For a long time water attracted him." With this simple formula Gillet finally arrives at the *Water Lilies* after thirteen pages of preparation: "A painting without borders, a liquid sheet, a mirror without a frame. . . . Without the two or three groups of aquatic leaves strewn upon this mirror, nothing would indicate with which fragment of infinite extension one may be dealing: no other mark with which to determine the point of view and the angle of the perspective. In order to animate this neutral space, the artist strictly limits himself to reflections: with this consequence that one

has an upside-down picture. The (invisible) trees announce themselves only through their images. The sky—ingenious surprise—instead of forming a cupola touches the lower border of the frame, and the brightest note, ordinarily the highest, is here at the base."[98] The perspective basis of Western illusionism is thus inverted, yet for Leon Battista Alberti, writing at the beginning of the Renaissance tradition which Gillet claims Monet liquidates, it is precisely in the reflection of the body of Narcissus that the art of painting is said to have its birth: "Consequently I used to tell my friends that the inventor of painting, according to the poets, was Narcissus, who was turned into a flower; for, as painting is the flower of all the arts, so the tale of Narcissus fits our purpose perfectly. What is painting but the act of embracing by means of art the surface of the pool?"[99]

For Gillet "the pure abstraction of art can go no further." According to the critic, the *Water Lilies* possess "the charming idealism" of music, arithmetic, and geometry, "the most conventional and most purified things, those in which subsists the least carnal and perishable character." In Monet's "spiritualization" of the landscape Gillet sees a fundamental challenge to the positivism of the West: "One smiles, in front of these motifs of a limitless fantasy, of the good-heartedness of the naive Aryan always persuaded that man is the center of things. What lack of discretion, of true education! How much better company are Oriental effacement, impersonality! Water and reflections, an exchange of imponderables across fluids, the play of the ether and the wave glimpsed one through the other, a tangling up of slight errors, shadows playing on a mirror, what spectacle more worthy of the mortals that we are."[100] In the 1927 re-edition of this essay the orientalizing force of Gillet's critique is substantially attenuated. Instead of his prewar chiding of Western anthropocentrism Gillet later seeks a redemptive consolation in Christianity. In the text printed after Monet's death the *Water Lilies* are apostrophized as "lustral bath, baptism which washes us!"[101]

Despite the Orient's eventual erasure, Gillet's skepticism always persists: "Never have philosophical doubt, the fear of every affirmation (apart from that of art), gone further. And yet with what poetry has not the master known to clothe his *Allzumenschliches*!"[102] *Human, All-Too-Human* is the title of the aphoristic work for "free spirits" in which Nietzsche insists on the historical relativism of all claims to truth.[103] Monet's doubt is thus set alongside Nietzsche's radical attack on empiricist epistemology, and it is this unbridgeable gap between concepts and things that I have repeatedly sought to allegorize by way of the reflections of Narcissus.

The myths and legends of all nations converge upon the surface of Monet's pond: "There are the grottoes of Fingal, the arches of coral such as Sinbad the Sailor saw, the forests of madrepores like those of which Gustave Moreau dreamed as a retreat for his Galateas." Gillet feigns to hear upon Monet's sunset waters "the solemnity of the fanfare of a dying horn in the depths of the woods," but it is a morning effect which yields the greatest allusive crop: "A sort of blue gulf, a river of sapphire then seems to draw itself between the double top of the inverted trees: one would say the marine map of an ocean with no name, according to the naive perspective of the ancient pilots' charts, a sea veined with an azure road, a bluish *gulf-stream* of dreams. Upon this sea the large lotuses of sacred flowers, the blue lotus of the Nile, the yellow lotus of the Ganges, space out their light squadron. Like those isles of legend which announce themselves from afar and seem to come to the navigator's fore by way of their perfume, each flower, according to its nuance, tints an entire picture: its note spreads itself throughout the entire range. Who would not wish to hear this voyage's call, to depart on these floral skiffs for a virginal Delos or a tender Polynesia? Here painting is no more than an essence, a sigh. What more nobly delicate fete than this scene without personages, this lake where one may put under sail the charming swarm of dreams and where the divine galley of the *Embarkation for Cythera* might glide by?"[104] Monet's painting is the decor in which Gillet dreams of Venus's Cythera, Diana's Delos, Galatea's Sicily, perhaps Kali's Ganges, and Isis's Nile. In front of the *Water Lilies* Gillet dreams of Paul Gauguin's voyage to Tahiti, of the invitations to voyage issued by Baudelaire, Mallarmé, and Rimbaud, of the adventures of New World explorers and Old World heroes and heroines of epic and myth. The erotic melancholy of Watteau presides over the text, just as it will later figure in Gillet's personal inscription of his book to Monet "in memory of a divine day, and of all the joys that he has given me, and because of his great love for *The Embarkation to Cythera.*"[105]

Gillet puts great stress on Monet's eighteenth-century sensibility. The four round *Water Lilies* in the exhibition (W. 1701–2, 1724, 1729; fig. 110) point to boudoir decorations by Jean-Honoré Fragonard as well as to the contemporary appreciation of this "long French tradition" by a collector on the model of Huysmans's des Esseintes. On the eve of renewed political conflict with Germany and at a moment of vigorous avant-garde assault upon the traditions of French art, Monet, for Gillet, is France; hence the importance of securing a pedigree for Monet not only in the arts of the

Orient and the Middle Ages but above all in an indigenous aspect of French art. In order to sustain the interpretation of Monet's work as authentic French decoration, Gillet must overcome the actual fate of dispersal that by August of 1909 had overtaken the ensemble of *Water Lilies.* "For one hundred thousand francs the round boudoir set might have been preserved intact," Gillet suggests, for "who will know in a few years, when the works of the artist will find themselves scattered in all the museums of the two worlds, that their most precious part will have evaporated and that one will have uselessly allowed the effort of an artist's life to be lost, the most powerful effort ever attempted to give to the intimate landscape, to the interior picture, a decorative value and to insert into painting the sense of *continuity?*"[106] Marx had already affirmed that Monet's art comprised "the symbol of continuity,"[107] but the nostalgic tone of Gillet's text suggests a still more intense narcissistic desire to recompose a harmonious unity that was once possessed and subsequently lost. At stake in the *Water Lilies*' narrative continuity of instants, decorative continuity of colors, and iconographical continuity of reflections is nothing less than the ideological continuity of France.

In the final paragraphs of Gillet's essay the philosophical stakes of Monet's art are also enunciated. Monet's "analysis of sensations, his divisionism" is identified with the Kantian "analysis of consciousness in the neocritical school," a school that can now be said to be properly French in the "phenomenalism" of Charles Renouvier (1815–1903): "One must admit that rarely has a philosophical doctrine found in the plastic arts a more seductive expression."[108] Renouvier embraces the poetic narratives of world mythology in order to repudiate the post-Kantian lament for the unavailability of numinous knowledge. Things *are* just that which they are when known, and the thing-in-itself can only be *said* to lie beyond. Knowledge of one's self-reflective abyss need not conduce to a drowned despair but may instead be accepted with artlike grace.

Like Renouvier's neocriticism, which attempts to bridge the gulf between an idealist affirmation of human imagination and an empiricist disavowal of transcendental realms, Gillet's criticism positions contemporary French painting on the cusp between Monet's naturalistically enrooted *Water Lilies* and more frankly non-naturalistic work, such as the murals destined for the Faculty of Law by René Ménard, *The Golden Age, Antique Dream,* and *Pastoral Life* (or, in the revised text of 1927, the eleven-part *History of Psyche* cycle by Maurice Denis): "Painters have not renounced mythology; they still draw forth from antique sources. One has not expelled

from the palette shadows and blacks (nor do the delights of feeling make us forget the muses of intelligence)." Painters have not "said adieu to the nymphs and the dryads," Gillet writes in 1927, and indeed these companions of Narcissus proliferate not only in Salon paintings by forgotten Academic artists but also in contemporary works by painters such as Picasso and Matisse.[109]

15

War, Water Lilies, *and Death (1909–26)*

IN 1909 MONET's exhibition was impressionism's "epilogue"; in 1924 a further exhibition of paintings will be its "testament." In the fifteen years between these two essays by Louis Gillet, Monet endured the deaths of his wife Alice (1911) and his son Jean (1914); the deprivations of World War I; the debility of his cataract-affected vision; and the old cycle of elation and despair attendant upon his resolve to carry through the decorative project which was unveiled only in the year after his death. During the dozen or so years before his death in 1926 Monet sustained an involvement in the commercial market for his work; with biographers and journalists he entertained a more or less reluctant collaboration; with delegates of the French state he undertook a grueling negotiation regarding the disposition of the *Water Lilies;* and with his closest advisers he sought to insure the best medical treatment for his eyes.

"I am annihilated," he writes three times to Geffroy of the loss of his wife (7 and 29 May, 7 September 1911; L. 1962, 1968, 1977). To her daughter Blanche he writes that his "poor painting" had become a "horrible joke" and laments having spoiled some canvases of Venice which he ought to have preserved "in memory of the so happy days spent [there] with my dear Alice" (4 December 1911; L. 1989). To Blanche he threatens to give up painting altogether, but in a letter written on the same day to her friend Julie Manet-Rouart we read the familiar disclaimer, "but it is not going the way I would wish" (4 December 1911; L. 1990). Twenty-nine of the Venice paintings of 1908 were exhibited at Bernheim's in May 1912, but in a letter of thanks to Paul Signac, Monet repudiates the praise lavished on these works by "the imbeciles, snobs, and traffickers" (5 June 1912; L. 2014). To Geffroy, who had published two laudatory articles, Monet refuses

the epithet "great poet": "I only know that I do what I can to render what I experience in front of nature" (7 June 1912; L. 2015), this in spite of the fact that the Venice paintings were finished at Giverny.

At Giverny nature proves to be as refractory as ever: "Nature is not at our orders and does not wait. One must seize her and seize her well" (1 July 1912; L. 2018). This seizing is made more uncertain by the "torment" inspired by the cataracts that were eventually operated upon only ten years later (26 July 1912; L. 2023). For a time Monet's vision improves and a handful of paintings from 1912–13 projects an image of the house and gardens he had for so many years shared with the deceased Alice. In three paintings of the *Flowering Arches* it is as though we see a human figure or face floating in a nimbus of reflections and roses (W. 1779–81; fig. 111). Monet had memorialized the death of Camille with a watery portrait in 1879 (W. 543; fig. 26); perhaps now Alice finds a watery grave as well, if not as Echo then perhaps as another doomed heroine, whom Georges Grappe had seen "floating, like Ophelia, on the sheet of water at Giverny."[1] Upon receipt of Grappe's monograph, the first on the painter, Monet thanked the writer for having "completely understood" (6 March 1912; L. 2001).

Ophelia or not—and perhaps it is rather a self-portrait as Narcissus that I see here—the series of *Flowering Arches* signals the return of the aquatic preoccupation which will attain a new level of obsession in 1914: "[I] am obsessed by the desire to paint. . . . I even plan to undertake large things, of which you will see the old attempts which I found again in a basement. Clemenceau saw them and is amazed" (to Geffroy, 30 April 1914, L. 2116). Clemenceau subsequently recalled that upon seeing these discarded studies he said, " 'Monet, you ought to hunt out a very rich Jew who would order your water-lilies as a decoration for his dining room.' "[2] This casual stereotyping of Jewish wealth may refer to the painter's dealings with the Bernheims, but the ultimate patron turned out to be no collector or dealer but rather the French state itself.

The preliminary studies in view of the "large things" which the *Water Lilies* would become are the paintings of 1897–98 first recorded by Guillemot, and from 1914 on the monumental decoration was continuously on Monet's mind:

I have undertaken a great work that impassions me. (To Félix Fénéon, ca. 1 June 1914; L. 2119)

It is a very big thing that I have undertaken, especially at my age, but I do not despair in achieving it if I conserve my health. As you have

guessed, it is indeed the project that I had had already a long time ago: water, water lilies, plants, but on a very large surface. (To Raymond Koechlin, 15 January 1915; L. 2142)

I continue to work on these famous *Decorations* that impassion me. They are far from being finished, but they have the merit of occupying my mind, which is a great deal at the present hour. (To Koechlin, 1 May 1916; L. 2180)

In spite of all the anguish and anxiety of this war, I have so set myself to work (a very large *Decoration*) that I am literally haunted by what I have undertaken. (To P. Desachy, 26 August 1916; L. 2191)

Clemenceau has just come; he left enthusiastic for what I am doing. I told him how much I would be happy to have your opinion of this formidable work which is truly madness. (To Geffroy, 13 November 1916; L. 2200)

Naturally I continue to work hard, which is not to say that I am satisfied. Alas, no! and I think that I will die without having been able to make something to my liking. I am always seeking to do better . . . but without great result, for I am seeking the impossible. (To Geffroy, 10 September 1918; L. 2281)

I am on the eve of finishing two decorative panels, which I want to sign on the day of Victory, and am come to ask you to offer them to the State through your intermediacy. It is a little thing, but it is the only way that I have of taking part in the victory. (To Clemenceau, 12 November 1918; L. 2287)

The end of the war sees the return of Monet's ophthalmological symptoms and an attendant depression that is occasionally alleviated through the repeated cajoling of his family and friends.

Soon after the war, rumors of Monet's gift began to be published. Starting in 1919 a few of the larger easel paintings of weeping willows and smaller decorative panels of the pond's surface showed up in galleries in Paris and New York but to virtually no critical comment. The four-part watergarden series of 1917–19, one of which Monet donated to the museum in Grenoble in 1923, perhaps comes closest to presenting a decor in which Narcissus might appear (W. 1878–81; fig. 112), but a complex of Narcissus remains nonetheless inferable in the artist's rhetoric: "Once again my sight is altered and I will have to renounce painting, and have to leave in midstream so many works underway and which I will not be able to bring

to completion. What a sad end for me, and yet, all this summer, I have worked with a fine ardor, but it is necessary to confess that that ardor concealed an impotence" (to Geffroy, 19 November 1919; L. 2326); "My sight declines each day and I sense very well that it is all over for the hope that I have always had to arrive at doing better" (to Geffroy, 20 January 1920; L. 2332). The context here is Geffroy's request for answers to a questionnaire for the biography he was compiling. Monet eventually cooperated with Geffroy but for the moment he refuses, insisting moreover that his "works belong to the public, and one may say of them what one likes."

Monet offered his confidence to other journalists in 1920, among them Thiébault-Sisson of *Le Temps,* who describes Monet's landscapes as the means by which the painter achieves "consciousness of himself." In the sea-sky oppositions of the *Belle-Ile* paintings Thiébault-Sisson sees an analogue of the Zoroastrian belief that the good of Ormuzd is set against the evil of Ahriman. The critic claims no metaphysical intention on Monet's part, but he contends that "for us the philosophical interpretation mingles itself inevitably with the artistic sensation": "Without thinking about it, the artist nonetheless, at every instant, suggests to us rapprochements of this kind."[3] This is just what Thoré had written seventy-five years before.

Regardless of what Monet might have thought of Thiébault-Sisson's allegorical interpretation, he soon became agitated over the writer's unauthorized revelation of Clemenceau's role in the *Water Lilies* project. Thiébault-Sisson advocates the installation of the *Water Lilies* as a matter of postwar prestige for France and quotes the recently retired premier as prodding Monet not to procrastinate any further in their completion. Alongside this account Thiébault-Sisson juxtaposes an anecdote about Courbet's role in the incompletion of the *Luncheon on the Grass* of 1865–66. Courbet allegedly advised Monet to set the painting aside, "and that, he said with a smile, is how I ruined my career."[4] Monet's overt humor may conceal an enduring experience of anger, and the perseverations of the *Water Lilies* might accordingly be seen to comprise an ambivalent form of reverence and revenge relative to the fatherlike mentor and failed monumental ambitions of Monet's youth.

No note of thanks to Thiébault-Sisson survives, but we do have a letter of appreciation for the "very beautiful article" which the young writer Marc Elder published in the newspaper *Excelsior* on the same day as his senior colleague's article in *Le Temps* (10 April 1920; L. 2343). Elder also insists upon the monumentality of Monet's enterprise and particularly upon an affinity with the decorative cycles of Venice, reminiscences of which

Elder later included in his 1924 book of the painter's conversations. Speaking of the old masters, Monet makes an observation that is pertinent to the modernist problematic of the self with which this book has been centrally concerned: "They considered themselves to be like artisans, good workers always in school. One had not yet invented the mission of art, the sacerdotalism of genius, an omniscient individualism and other nonsense. It was a question of knowing one's trade and practicing it honestly."[5] It is ironic that Monet voices this opinion in spite of the fact that it was precisely his painting that had come to be seen as a prime index of the self-expressive myth of the modern artist.

"For many moons Monet has been dreaming of a vast decoration which would be around the spectator like a lake with its reflections, the multicolored blossoming of the water lilies and the drooping down . . . of the willows."[6] To judge from his letters the painter's dream sometimes took on the quality of a nightmare, and journalistic demands upon his time were often rebuffed. To Geffroy, Monet insists that he was conserving his strength "in order to work on my *Decorations* whenever the heat in my studio is not too strong" (11 June 1920; L. 2355). To Thiébault-Sisson he protests "that all these disturbances . . . compromise my work and that I have no time to lose at present" (8 July 1920; L. 2359). To Alexandre he postpones a scheduled interview since he was "at grips with nature and the weather and would like to come to the end of some canvases that I have undertaken" (10 September 1920; L. 2366). Ultimately Alexandre received Monet's collaboration for his book of 1921, as did Geffroy for his book of 1922, but Thiébault-Sisson's book never materialized. In a letter to Alexandre, Monet criticizes the unnamed Thiébault-Sisson: "Your article is very beautiful and I beg you to believe in my sincere thanks, but you put my modesty to a very cruel test. I was so deceived these past days by certain shocking articles in their useless and out-of-place tale-bearing that yours, coming after, shows that for you the question of art takes precedence over all and for that I am grateful to you" (22 October 1920; L. 2378).

Quite apart from Monet's unhappiness, Thiébault-Sisson's article offers an important first-hand account of the painter's decoration: "Installed at the center of the room, the visitor will have the illusion of finding himself, at the hour of noon, in the summer's sun, upon the islet populated with quivering bamboo which, at the property of the artist at Giverny, occupies the center of the water-lily pond. . . . Upon the banks, weeping willows will from place to place raise up their solid and rugged trunks and will bend over their heads of hair in long weeping threads."[7] This double narcissism of the bending tree and of the solitary viewer recurs in

Alexandre's article in *Le Figaro* one week later: "These decorations, placed very low, will seem to surge up from the ground, and the spectator will be, so to say, not only placed in the middle of the water-lily pool, . . . but plunged in full into the passion of color and the centupled dream of the great artist." Here the self-extinction of Narcissus is that of the spectator compelled to plunge into the aqueous illusion: "The spectator, finding himself as though in the very middle of the water-lily pond even though at some distance from it thanks to the bold artifice, the singular yet veridical convention of the relief and the suppression of the horizon, believes that he feels the reflected sky above his head and the watery mirror all incrusted with thick-leaved plants, a support for plants in full bloom, fleeing before him even though he is only in front of vertical surfaces which develop themselves in a circular fashion."[8]

Alexandre sets Monet's achievement on a continuum with ancient and modern mythopoetic beliefs: "These sorts of communication with the immense and fecund unconscious simultaneously explain the prodigies of antique life, which are by no means fables, and the inspiration with which it is still prepared to sustain the modern artist who has the happiness, the wisdom, or the energy to guard himself against the artificial." In this fusion of the life-forces of the individual and of the world Alexandre claims to discover an axiom of culture: "Thus is effected the great illusion of life and of art which, in order fully to exist, must mingle the fictive and the tangible, . . . reciprocally engender the real and the imaginary." For Alexandre, Monet's war memorial will be like a temple to this union of the physical and the psychic, where "the dialogue of the sky and the water" will be architecturally punctuated by the trunks of willows as though they were "somber votive columns beyond which the mirage extends."[9]

Like Alexandre, Geffroy makes no mention of Clemenceau in remarks on the *Water Lilies* which preface a long retrospective article in *L'Art et les Artistes*. Monet writes that he is profoundly touched by Geffroy's praises and at the same time proposes to correct several "small errors" of historical fact (4 December 1920; L. 2390). In the article Geffroy describes the governmental initiative to house the *Water Lilies* in a setting that would reproduce the dimensions of the garden at Giverny: "The whole [decoration] represents the circuit of the pond and must be placed at the base of the walls of the exhibition room in order to be seen from above by the spectator, exactly as are seen, in reality, the surface of the water and the enframement of the bank. The placement and this arrangement . . . is the sole condition of the gift, ceaselessly augmented, of Monet to the State." This installation would also reproduce the conditions of Monet's studio, "where there is

simply the length and breadth necessary to dispose, at a sufficient distance, the sixteen panels of the water landscape of the *Water Lilies*."[10]

Geffroy seems to get the details more or less right, but his interests had always been more interpretative than expository. For him the decoration constitutes Monet's "dream" of posthumous transcendence: "It appeared disastrous and impossible that this poem would be fragmented, that these canvases forming a single composition of which the spectator will be the center would go out into the world in pieces, each one of which would say no more than the dismemberment of a masterpiece." Geffroy's work-in-pieces recalls Fourcaud's *disjecta membra* of 1909, but his meditation on bodily mutilation takes a further step. Bending over the surface of the pond and acknowledging the potential for the self-dispersion of all things, "future man will come like us to dream of the poetry of the world and to scrutinize the fathomlessness of the void."[11] Lacan will similarly imagine the nihilistic fantasy of the body-in-pieces as lurking beneath the illusory configuration of the self.[12]

The void is centrally at issue in an article by Georges Grappe where Shakespeare is adduced. Grappe had previously been drawn to consider the fate of Ophelia in the face of Monet's works, but here Monet is Duke Prospero of *The Tempest*, both in his wizardlike appearance and "by way of the enchantment he creates, by way of the sublime conjurations he achieves."[13] Monet warmly thanked Grappe for his essay (24 October 1920; L. 2380), the terms of which reappear in the final paragraphs of Geffroy's book: "Shakespearean poetry abruptly takes possession of this domain where Monet becomes the Prospero of a decor with invisible beings. The nacreous and blond skin of Titania gleams through the branches, Ariel dances the will-o'-the-wisp upon the stems of the flowers, Caliban is locked up with his growls beneath the rugged bark of the old willow. And then all this phantasmagoria gives way to another. The pale figure of Ophelia goes gliding upon the water, the flowers she has picked go drifting off, periwinkle and buttercup, iris and rosemary. The branch of the willow where she goes to hang herself already bends beneath the wind."[14] Here the decor of Ophelia merges with that of Narcissus, for indeed the two of them had met in Gasquet's book: "She plunged herself into the river. As the stars were extinguishing themselves, she went off with the current. I was crying and holding out to her my arms. She lifted herself up a bit, her head gaunt, thrown back, for her sad hairs were streaming, and with a voice that still makes me ill, she breathed to me: 'You know who I am. I am your reason, your reason, you know, and I am going away, I am going away. . . .' "[15]

Grappe insists that "at all times [Monet] had experienced the aesthetic vertigo of the water": "The sea, the rivers, the canals, the ponds had fascinated his gaze. Bent over the tumultuous wave, the stream of regular and slow course, the sleeping surface of the pool, he had suffered the charm, the lure of the undine who scintillates in the light and seems to bend her body to all the tremblings of its rays. But, in painting the furious wave, the nonchalant billow, the slyly peaceable piece of water, it was above all the light which he pursued in the wake of the naiad, that mysterious and unseizable specter who brushes things with her ocellated train, coloring them, animating them, then vanishing."[16] For Lacan the ocellated or eyelike spots with which animals face the world's gaze mark "the pre-existence to the seen of a given-to-be-seen." Lacan distinguishes this self-decentering lesson from the self-consciousness of Valéry, in whose Narcissus-derived iconography of "seeing oneself seeing oneself" Lacan finds "an avoidance of the function of the gaze."[17] In pursuing the light that looks at him does Monet similarly acknowledge the limits of the humanist psychology of the self?

Unlike the psychoanalyst, Grappe does not openly insist on the self-alienation that may follow from contemplating "the whole universe" in a water-lily pool. Like Michelangelo at the Sistine Chapel (an analogy later repeated by the surrealist André Masson), Monet is said to transform a biblical "chaos" of matter into a sacramentally "sublime vintage." In spite of this eucharistic transubstantiation of matter, there nonetheless lingers for Grappe something "disquieting such as the marine depths appear to the swimmer who dives";[18] or who dies, like Ophelia and Narcissus perhaps.

The narcissistic allure of a watery death is present in the anecdote which Geffroy tells of Monet's wish to be interred in the sea in front of which he had grown up: "'I would like,' he used to say to me, 'to always be before it or upon it, and when I die to be buried in a buoy.'" Geffroy indicates that Monet "used to laugh in his beard at the thought of being shut up forever in this sort of invulnerable cork dancing among the waves, braving the tempests, resting softly in the harmonious movements of calm weather, beneath the light of the sun."[19] The immuration of the *Water Lilies* as the painter's aqueous mausoleum—simultaneously a womb and a tomb—is consistent with Monet's refusal to part with the panels prior to his death. As he writes to Alexandre, "it will be the gallery of the Orangerie [and not the previously proposed Hôtel Biron] which will shelter, forever, my decorative essays" (13 November 1921; L. 2464). The word *essais* recalls the decorative figure paintings exhibited under that title back

in 1889, and suggests to me that in this watery tomb are interred not only Narcissus but all Monet's Echos and Ophelias as well.

Throughout these months of waiting for death Monet endured difficulties in vision as well as contractual difficulties with the Ministry of Fine Arts:

> Painting disgusts me; I mean my own, since I have hardly been able to do any on account of my sight which declines from day to day. I am seeking to bring to completion these *Decorations,* but without managing to do it. I have given them to the State but that is going to cause me more worries than it is worth. At last, it is the decline. I have had enough. (To Lucien Pissarro, 17 January 1921; L. 2398)

> In spite of everything I persist in working hard, but sometimes with bursts of excitement which rejuvenate me but which are followed by cruel fits of discouragement. (To Senator Etienne Clémentel, 21 August 1921; L. 2446a)

> I no longer know myself what to think of this work. The essential is that it should be well presented and I think that after mature reflection I believe that I have arrived at a good result. (To Clemenceau, 31 October 1921; L. 2458)

> I am old and have not an instant to lose, and then the least disturbance at present derails me altogether in my work, derails me completely. (To Geffroy, 12 January 1922; L. 2480)

> Finally it was very necessary to acknowledge that I was ruining [the *Decorations*], that I was no longer capable of making anything beautiful. And I have destroyed several of my panels. Today I am almost blind and must give up any work. (To Elder, 8 May 1922; L. 2494)

> I have undertaken a pile of things that are giving me a lot of trouble . . . especially on account of my powerlessness to do what I want. (To Albert André, 21 June 1922, L. 2499)

> It remains for me to beg you to arrange as quickly as possible the work at the Orangerie, if you wish for me to be able to direct in person the placement of my *Decorations,* this because I feel my sight giving way each day and because it will be painful for me no longer to see well enough. (To Paul Léon, 27 June 1922; L. 2501)

I am working by force and would like to paint it all before seeing nothing at all. (To Joseph Durand-Ruel, 7 July 1922, L. 2503)

In the very different ocular circumstances of his first painting campaign fifty-eight years earlier, Monet's desires are stated in much the same terms: "It is enough to become mad; so much do I have the desire to do it all, my head is cracking" (to Bazille, 26 August 1864; L. 9).

Monet acknowledged Geffroy's monograph in the near-blind summer of 1922: "I have no need to tell you how touched I am, all modesty apart, by the good you say concerning my works and myself, but I remain profoundly touched" (25 June 1922; L. 2500). The final chapter's "last reverie before the watergarden" encapsulates the twinning of these two men, each engaged in the dreamlike evocation of the water-lily pond: "It is the supreme signification of the art of Monet, of his adoration of the universe ending in a pantheistic and Buddhist contemplation. . . . One of his dearest friends [almost surely Clemenceau] almost became irritated to see him obstinate himself, hypnotize himself before this water hole when so many other spectacles might have solicited him. It is that Monet knew what signification might come from this endless standing before this repeated fragment of space." Geffroy's prose takes on the rhythm of a funeral eulogy: "This man who one quickly judged by the word Impression and the title Impressionist—which will become terms of glory, for in the future they will take on their true signification of spontaneous emotion in front of nature and of a more and more knowing reflection in front of the mysterious and admirable phenomena of life—this man with a technique judged rapid because he ended up in effects of mathematical appearance and in a simplified and grandiose truth always adequate to the subject, this man was in reality, I believe to have proved by way of the preceding recitation, a perpetually anxious person, a daily tormented person, at the same time a solitary person with an idée fixe, racking his brains into exhaustion, forcing his will to the fixed and desired task, pursuing his dream of form and color almost unto the annihilation of his individuality in the eternal nirvana of things at once changing and immutable." In a single sentence Geffroy touches on the key themes of this book: "This endless measure of his dream and of the dream of life he formulated, reprised, and formulated anew and without end in the mad dream of his art before the luminous abyss of the *Water Lilies* pool."[20] The epistemological void of Giverny makes way for an ethic of contemplation at the Orangerie, still unfilled when Geffroy wrote his words and which he was never to see prior to his death in April 1926. Inasmuch as Geffroy draws

on many of the same sources in German idealism and oriental thought as does Freud, the critic's words of nirvana and nothingness may be read in conjunction with the drive toward the dissolution of the self—which is the aim of the self—which in 1920 the psychoanalyst places in a still controversial realm "beyond the pleasure principle."[21]

Like Narcissus, Monet lays down his arms by the banks of a reflecting pool: "He has discovered and demonstrated that *everything* is *everywhere,* and after having run about the world adoring the light that illuminates it, he knew that this light came to reflect itself with all its splendors and mysteries in the magic hollow surrounded by the foliage of willows and bamboo, by the flowers of iris and rosebushes, across the mirror of water from which springs those strange flowers which seem more silent and more hermetic still than all other flowers." Geffroy's description of Monet's lily pond shuttles back and forth across the gap between nature and art: "Within this frame, in the depths of the flowering mirror, the splendid fairy tale of the air plays itself out, having become the incomparable fairy tale of the water. . . . One needs the power of nature, these rugged tree trunks sprung up from the soil, these plants issuing from the banks, these tresses of hair which hang from the branches of the willows and which graze the quivering water, in order to bring the mind back toward other images of a closer reality." The Shakespearean drama of Prospero and Ophelia is introduced here, but in the end these invisible figures of Giverny yield before a formless iconology of death: "Then, everything returns to nothing, images and thoughts. There is nought before us but the immobile and mute water, the flowers that open and reclose, the light that quivers, the cloud that passes,—nature and its mystery, a man who thinks, a great artist who expresses the dream of infinity."[22] And here Geffroy writes "END."

Less than a year from the date of the first of three operations on his right eye Monet began to report substantial improvement, "having completely resumed work and having to make up for so much lost time" (to J. Durand-Ruel, 20 November 1923; L. 2543). Soon afterward a retrospective exhibition was held at the Galerie Georges Petit, with Geffroy recounting Monet's recent triumph over "a crisis of darkness" in the short preface to the show's catalogue.[23] Gillet published an article on the exhibition entitled "Le Testament de l'impressionnisme" which Clemenceau described to the artist as "the best anyone has done on you";[24] Monet himself thanked the critic, "I am very sensitive to your judgment!" (5 February 1924; L. 2548).

The proceeds from the exhibition were designated for the victims of a recent earthquake in Japan, an appropriate enough destination given both

Monet's *japonisme* and the funereal pall that hung over the show. "One had been too hasty to bury Impressionism," Gillet insists, and the unveiling of Monet's "secret" project of the previous eight years turns out to be a kind of exhumation of the artist's corpus of work. A list of the dead precedes the account of Monet's survival. He was twenty-three when Eugène Delacroix died in 1863; he was the contemporary of Jean-Auguste-Dominique Ingres (d. 1867) and Camille Corot (d. 1875), the friend of Gustave Courbet (d. 1877) and Edouard Manet (d. 1883). His colleagues Edgar Degas and Pierre-Auguste Renoir had died in 1917 and 1919, and now he alone, like Vasari's venerable Titian, was left: "For those who have had the good fortune to see the latest works by M. Claude Monet, it is clear that Impressionism is every morning killed in vain by an ungrateful youth: the dead that these gentlemen kill are carrying themselves rather well."[25]

As a sign of Monet's age Gillet notes the presence in the exhibition of a large *Willow* of 1919 (W. 1876; 100 × 120 cm; fig. 113), "a bit disheveled, ruddy, flamboyant." Gillet stresses Monet's anxiety, "the harshness of a search which condemned [him] to an increasingly solitary life, his canvases cruelly scraped, recommenced, that arid torment of art which dragged him in all weathers in front of the motif, going, in order not to lose an hour, as far as having his hair cut in place, without leaving his work, by the barber of the village." The "imperturbable work" of the recent past had been conceived "in spite of the years, the griefs, and the trials": "The artist, in the evening of his life, was finishing up as a lyric and, following the counsel of the sage, was employing his final hours in making music."[26]

These "chords, . . . preludes, . . . sonatas" are the *Water Lilies*: "M. Claude Monet has been all his life a sort of genie of the waters. From his childhood spent at Le Havre, and from his first master Eugène Boudin, he retains the nostalgia of the sea, the love of the liquid, multiple, and feminine element, of that which glides, undulates, reflects, sparkles, ruffles and enrages itself; river or ocean, always he loved the nymph or the siren. It is that for an eye like his there is no subject more impassioning than that of this fluid in perpetual metamorphosis."[27] Here traditional Ovidian culture intersects with something akin to contemporary psychoanalysis, and Monet emerges as a man-child still fixated on the amniotic sea of his birth but productively displacing that cathexis along the wave of association that runs from the figurative iconography of the siren and the nymph to the allegorical iconology of rivers and seas. Another of Monet's younger admirers in 1924, Marc Elder, similarly writes that "the inspiration born of the waters bewitches him as the naiad the ancient poet." It is accordingly the

painter's aim to transcribe "the symphony in which the eternally youthful laughter of old Pan bursts forth."[28] This woodland god had been the lover of Echo before Narcissus encountered the nymph.

The sirens and nymphs hold a place in Monet's work alongside the tritons and atlantes of Etretat and Belle-Ile, but the denizens upon whom Gillet especially dwells inhabit the realm of Flora: "All the kindly tribe of the waters, the willow, the rush, the bamboo, and those floating plants which carry upon their oily palettes the pensive watcher of the water lilies." Here the mien of the flower mimes the painter's attentive posture, and Gillet recalls Monet's preoccupation with these aquatic plants. "'I have taken up again things impossible to do,'" Gillet writes following Geffroy's citation of this letter (22 June 1890; L. 1060), "'water with grasses that undulate in the depths. It is admirable to see, but it is enough to drive one mad.'" In 1899 Monet's initial depictions of his water-lily pond had taken the form of an empirical "portrait of the place" according to Gillet, but a decade later almost nothing remained "but the liquid surface, nothing but that which swims, floats, glistens, quivers; mirrors of dreams, fragments of extraterrestrial nature, where nothing more subsists of the banks, the limits, where the sky and the clouds appear upside down, where the universe reduces itself to what is most subtle, to the marriage of two fluids and two depths, where this immaterial space, formed by the intersection of two ideal planes, received and reverberated all the nuances of the light, and where—the only solid thing in this world of pure vision,—flowers were born like dreams."[29] In a later essay on the *Water Lilies,* Gaston Bachelard asks whether the aquatic flower had not been "in the mythological life that precedes the life of every thing, Heraclion, that powerful Nymph dead of jealousy for having too greatly loved Heracles?"[30] Closer to home than this reference to Pliny's *Natural History* is Thoré's image of a marriage of elements which we encountered near the beginning of this book.

The marriage of elements of the *Water Lilies* of 1909 did not survive the postexhibition reality of separation: "There remained . . . the regret that this miraculous ensemble would have been dispersed, that the poem would have disappeared, lacerated into shreds." In the midst of the war Monet resolved to resuture these disparate pieces into an organic whole in a process which Gillet views as a triumph over the forces of disunity: "One of these studies, of incredible fire, appeared at the Exhibition carrying the date of the year of Verdun: 1916."[31] This is the large square panel now in Tokyo (W. 1800; 200 × 200 cm; fig. 114) which appeared at Petit's in 1924 in spite of Monet's angry insistence to the show's curator Léonce

Bénédite that this and a second painting from Baron Matsukata's private collection be withdrawn. In his letter of thanks to Geffroy for the critic's contribution to the catalogue Monet expresses his rage: "Imagine that this Bénédite said nothing to me about this exhibition, that he did it without even consulting me, as though I no longer existed. He is a skunk" (6 March 1924; L. 2554). Monet eventually succeeded in obstructing the exhibition of the second decorative panel with the aid of Clemenceau.

Gillet stresses the political circumstances in which the decoration took shape: "Finally, on the day of the armistice, the grandiose work sketched out in all its parts, the artist, happy to do something for France, decided to offer it to the country: and on the 18th of November, as our troops were entering Strasbourg, M. Georges Clemenceau went to Giverny to receive the royal gift from his friend."[32] The fate of the gift turned out to be a great deal more vexed, Monet's original intention having been simply to donate a decorative panel of *Water Lilies* and an easel painting of *Weeping Willows,* as his letters to Clemenceau and Bernheim-Jeune attest (12 and 24 November 1918; L. 2287, 2290).

In a lengthy, drawn-out sentence Gillet describes the decorative panels he has seen at Giverny: "In the confusion of my memory, I distinguish only a few strophes of the poem: I see an expanse of pale azure and silver, a matutinal limpidity, the coolness of a liquid surface losenged with pure patterns of watered silk, a youthful stream glimpsed between the trunks of the paternal willows which form a kind of portico for these suave waves, while the fringe of their foliage shades with delicate lashes the upper margin of the picture; elsewhere I see pink and slightly acidic harmonies, a serried fleet of water lilies, a dazzling flowering of corollas of coral similar to the multitude of dreams, to the happy abundance of the springtime of adolescence; further away, more troubled waters where stormy skies languish, where clouds with flanks of ocher rotate their large wheels; here, a somber retreat, a glaucous and secret grotto, the bend of a mysterious Cocytus where two twisted willows appear upside down, as though one were approaching some strange shore where the things of this life no longer exist but in the state of images, of memories, upon an irreal plane in funereal shadows; there, a water of violet and iris, as though veiled by a crape, a sort of seraphic limb where some Amor from beyond the earth ought to appear; finally, sunsets of flame, of purple, and of gold, a vision of apotheosis."[33] Gillet's allusions to Amor and Cocytus are of particular interest here. One of the five rivers surrounding Hades, Cocytus is the Wailing River of dead souls. The four other rivers are the woeful Acheron, the forgetful Lethe, the fiery Pyriphlegethon, and the hateful Styx, into

whose waters Narcissus continued to gaze after his death. Gillet may have had no thought of Narcissus in the grips of his interpretation of Monet's panel, but the myth seems especially applicable to the paintings of the willow's reflection which the critic describes. The largest of these is the Matsukata panel withdrawn from the exhibition at Monet's insistence (W. 1971), an index perhaps of the autobiographical resonance of this tree's drowning trunk. Two preparatory drawings are related to this panel of 2 × 4.25 m as well as to a further series of inverted willows which range in dimension from 1 × 2 m, to 1.3 × 2 m, to a human-scaled panel of two meters square (W. 1857–62; fig. 115). The Orangerie diptych known as *Reflections of Trees* (2 × 8.5 m) preserves the submerged motif of the willow in attenuated form, but it is in the painting withdrawn from Petit's in 1924 that a ritual reenactment of Narcissus's death is perhaps most keenly to be felt.

I have said that Gillet need have been no Ovidian for the ghost of Narcissus to lurk in his text. No more need he have been Freudian, but his juxtaposition of Eros and Thanatos bears a resemblance to the dual-drive theory formulated by the psychoanalyst in the 1920s. Like Freud's own myth of the self torn between erotic conjugation and narcissistic equilibrium, Gillet also depicts a split in Monet's persona as seen in the *Water Lilies*: "It is, as one sees, the river of existence, all the dreams of childhood, of youth—of love, of death, the whole history of a soul, the most insatiable for rays of light, the most smitten with beauty, the most sensitive to phenomena, to the drama and the joy of appearances: all this history reflected in a drop of water, in the contemplation of a pool of some few feet,—enough to reflect the sky and the universe,—and where the flowers, more adorable for being ephemeral, ignite themselves like the gleams of stars."[34]

Gillet compares the scope of Monet's water cycle to the decorative programs of Renaissance mythology: "What the great Venetians demanded of Olympus, from their ceiling creations, from their populace of neuter and indeterminate divinities seated on clouds on the cornices of the palace of the Doges,—that complete representation of experience, that profound humanization of nature, landscape here obtains for the first time." Gillet also invokes the influence of the Orient, for "here naturalism attains the Tao upon the leaf of the lotus, the vision of the profound rhythms and supreme laws of nature." For the Chinese the Tao, or path of the universe, is characterized by the effortlessness of water's flow even when met by the most adamant resistance. Meditation on the Tao is held to yield a selfless state of fusion with the universe, much as in the will-subduing philosophy

of Schopenhauer or in the Nirvana principle of Geffroy and Freud. Via the Tao of the *Water Lilies* Gillet also returns us to the postillusory moment of Narcissus's drama when the strivings of desire give way to the acceptance of contemplation. In the *Water Lilies* Gillet sees Monet's "new manner of identifying himself with the elements of the universe."[35]

Having announced in his article the imminent installation of the *Water Lilies,* Gillet was soon contradicted by Monet himself: "I can give you no details on the subject of the opening of the Musée de l'Orangerie of which I have no news, for which, moreover, I do not complain, not being absolutely ready myself" (24 May 1924; L. 2561). This letter was written to invite Gillet to Giverny before the end of the brief season of spring blooms; at this time Monet was still at work on the decorations, "reserving for the moment my poor eyes for the work of the painter, which I must bring to completion during brief intervals" (20 June 1924; L. 2568). An early fall visit of Gillet and his daughters "will find a very discouraged man," Monet later writes, "for with this so miserable weather, I have not been able to arrive at anything good in spite of a good start and the joy of again seeing a bit better." In a mood such as this, nature is the artist's mirror of body and mind: "You will find a garden in the decline of its flower. It was marvelous this summer, but alas! everything passes" (13 September 1924; L. 2575).

Far from being put off by Monet's self-denigration, Gillet finds his own anxiety reflected there: "Shall I tell you? How your worries give me pleasure! I say to myself: 'What! Him too. . . . Then it must be alright.' What an honor to think that one is worthy to pass through the same anxieties . . . and to undergo the same doubts and the same trials." Gillet and Monet appear to relish the mutual propping of their creative pain, yet the critic cautions the painter against damaging the *Water Lilies* through further worried revisions: "I think it imprudent to return, with this vigorous manner, to canvases already executed in another system. . . . I am greatly frightened lest you burn those beautiful, grandiose, mysterious, and savage things that you showed me."[36]

Gillet's New Year's wishes to the artist elicited a further declaration of deferral: "Crisis of profound discouragement which made me so sad that I have failed in all my duties. The crisis is attenuating itself without great confidence however, and I have great remorse to have given to the State these poor *Decorations* undertaken with passion but certainly beyond my powers. Do not say anything about it. I am still struggling to bring them to completion, but without too much hope" (18 January 1925; L. 2589). A letter to Pierre Bonnard written the next day links Monet's state

of discouragement to the delivery of his panels to the authorities: "This obsesses me, and I curse the idea that I had to give them to the State" (19 January 1925; L. 2590).

In spite of dismal vision and deepening depression Monet continued to receive visitors at Giverny. Among them were the painter Maurice de Vlaminck and his friend Florent Fels, who, in his description of the visit, imagines the aged artist as "the god of [the Seine's] banks and of her light, with the allegorical face of an antique river, a freshwater Neptune, patriarch of painting."[37] To many younger contemporaries Monet had become an anachronism, but belying this premise is Fels's inclusion of Monet at the head of a collection of interviews with painters such as Marc Chagall, Fernand Léger, Matisse, and Picasso. Monet's stature among younger poets was still very high at this time, with Gaston Berardi's prize-winning "Nymphéas, A Claude Monet" proposing a Mallarméan interpretation of the painter's serial works:

> When the air becomes more tender and a more
> silvery sky
> Descends into the depths of the waters which its
> springtime lights up,
> The noble water lilies of the century-old pond
> Languishly leave their wintry sleep;
> Like the hearts of lovers carried off by their dream,
> They rise, quivering to offer, as they awake,
> Their ivoried flesh to the kisses of the sun
> With which their ephemeral candor one morning
> becomes drunk
> But, at the first adieu of the summer that fleets away,
> They close their calyx, carrying off into the night
> The inviolate pride of their splendor intact.
> Happy is thus to be able, vanishing phantom,
> To flower and disappear amidst a dazzling dream,
> For having one single day contemplated the light![38]

In the summer of 1925 Monet's vision suddenly improved and he returned to work not only upon his *Water Lilies* but also on an outdoor series of his house and garden (W. 1953–62; fig. 116) in a squarish, frontal format whose origin dates to a painting of 1900 (W. 1627). Gillet had equated the sculptural features of Monet's Rouen Cathedral facades to "a great face full of a divine daydream on the nature of things,"[39] and it is in a similar spirit that I see in the dim window apertures and obscure

floral dishevelment of the facades of 1925 a last self-image of the dying painter. Paul Valéry saw these new works when he visited Giverny: "Strange tufts of roses seized beneath a blue sky. A somber house. . . . We go to the studio of the nenuphars upon the water. Vast pure poetry." Valéry considered the *Water Lilies* "really marvelous marvels," and I wonder whether he gave them any further thought as he saw his revised Narcissus poems through the press for the *Charmes* edition of 1926. It may not be coincidental that in Valéry's illustrations for *La Cantate du Narcisse* of 1939–41 the myth is evoked less by the figure of the youth than by the weeping willows, water lilies, and reflections of a Monet-like pond (fig. 117).[40]

In the weeks following Valéry's visit Monet repeatedly referred to his resolution to complete the long-deferred project. *Me remettre, reprendre,* and *retrouver* are the reflexive signs of this task. To Geffroy he insists "I am going to set myself back at my *Decoration* so as finally to deliver it" (11 September 1925; L. 2611). To his dealer Bernheim he excuses himself for not previously acknowledging the gift of a book, "but, taken up by work, I forget everything, so happy am I to have finally recovered my color-vision. It is a true resurrection" (6 October 1925; L. 2612). To the author of the book, Marc Elder, he confesses "that finally I have recovered my true sight, that for me this is like a second youth, that as a result I have set myself back to work outdoors with an unparalleled joy, and that finally I am giving the last touch to my *Decorations*" (16 October 1925; L. 2683). And to his old friend Helleu he maintains, "I am well, although very old and I have finally recovered my sight with such joy" (29 October 1925; L. 2613). The intention to deliver the panels in the spring was ultimately adjourned yet again, and the familiar litany is re-echoed one last time in the final fall of Monet's life. To Clemenceau, Monet declares his intention "to prepare palette and brushes in order to take up work again, but relapses and reprises of pain have prevented me." In spite of the pain, or because of it, Monet continues to identify himself with nature's eternal return: "I do not lose courage . . . and occupy myself with great changes in my studios and with projects for the perfection of the garden" (18 September 1926; L. 2685). Soon after he drafted this last surviving letter to Clemenceau, Monet wrote the final letter that we have from his hand: "I have taken up courage again and in spite of my weakness I have set myself back at work, though in small doses" (to P. Léon, 4 October 1926; L. 2630). On the fifth of December he was dead.

Wildenstein has catalogued more than seventy obituary notices and necrological articles in the regional, national, and international press. The

dailies, weeklies, and monthlies all noted Monet's passing, but I will discuss only the article by Gillet, in order to illustrate the legend of Monet at the time of his death. For Gillet, Monet was "the god of the landscape" in the valley of the Seine, the river whose waters Monet made his own in "a mirror of black bronze reflecting the sky, the garden of water, the pond of the water lilies." In antiquity *nymphaia* was a bridal epithet of Aphrodite and perhaps some trace of this meaning impels Gillet to say that the watergarden was "the nymph with whom [Monet] was in love."[41]

Many of Monet's interpreters have feigned to see the nymph in the *nymphéas*. But if the nymph is the denizen of the pool, who is Monet in the moment of bending over the source in search of that watery face? And whose face does he finally see? "Every day, the master went down [to the pond] and absorbed himself for some hours in a mute contemplation: liquid, immobile face, where skies in reverse, the reflections of clouds, of dawns, and of dusks were afloat, mirror of phenomena, image of the uncertain abyss of life upon whose surface blossomed the flower of thought, the divine dream of the lotus."[42]

Anxiety, trembling, and despair characterize Monet's suspension above the impossible knowledge of the sky on the deceptive surface of his pond: "It seemed to him that beauty is worth the pain that one suffers for it and that there is its dignity." Beauty was Monet's own declared aim and it was what many of his critics thought they saw in his works: "By the banks of the pond full of dreams, his melancholy reverie will stroll alone. Weep, o water lilies! The master is no more who came to spy out upon your corollas, amidst the reflections of the sky and the waters, the face of the eternal dream of life."[43] This face of love and death is Narcissus's as well; as Ovid concludes, "his naiad sisters / Mourned him, and dryads wept for him, and Echo / Mourned as they did, and wept with them, preparing / The funeral pile, the bier, the brandished torches, / But when they sought his body, they found nothing, / Only a flower with a yellow center / Surrounded with white petals."[44] On the day of Monet's funeral Clemenceau replaced the black drape on the coffin with a printed fabric of flowers.[45]

The Orangerie opened to the public in May 1927 and once again among the crowd of reporters Gillet was there. Situated along the banks of the Seine the oval rooms of the Orangerie are seen as "deux lacs," two lakes or love knots encompassing the "floating reveries" of the dead painter: "One has two neighboring flows, two rivers, two mirrors of life."[46]

Gillet insists on the reflexive unity of the work and the worker who fashioned it: "Here . . . are paintings of which none could have been executed from nature, an ensemble whose parts dispose themselves and

respond to one another and which he had to carry altogether in his head."[47] Here Gillet seems to paraphrase a sentence attributed to Monet which had headlined an interview of 1921: " 'One is not an artist,' he says, 'if one does not carry a picture in one's head before executing it.' "[48] According to Gillet the picture in Monet's head never varies: "It is always the same fairy, the same fleeing undine whom he attempts to seize from Water Lilies to Water Lilies." Monet's ideal is the feminine being of myth we have encountered before, the unseizable object of the pictorial quest whose face and figure elude him in the reflections of his pool: "The organ was only a ruin, sensation existed no more, the painter without sight and plunged into the night no longer had the means to control his expression, and yet the great visionary conserved his vision intact and the supernatural power of projecting it externally through an operation independent of the senses and as though through the pure working of the Holy Spirit. Thus Beethoven, without hearing them, gave birth, his ears sealed, to his final quartets."[49]

Gillet deprecates his ability to fill the void of the *Water Lilies* with words: "Am I going to try to describe it, this unnarratable work, this uncertain river in which the hours bathe, this ring, this round of invisible Nymphs, this magical wave in which the sky looks at itself, in which the clouds trail by, in which the adolescent azure of the mornings arises beneath the transparent veil of virginal mists, in which happiness appears all blue between the porticos of willows whose leaves fringe the painting with a drapery of lashes, in which the weight of noon sets rolling the chariot of storms, in which the evening, amidst fanfares of purple, excavates ports, gulfs of apotheosis, while the musing squadron, the fleet of water lilies gets under way upon this divine mirror and there brings into bloom turn by turn the dreams of life?"[50] Gillet's question mark suggests that his prose is not the transparent description of a painting but rather its poetic transposition. He associates the impossibility of description with an allusiveness peculiar to Monet's work, but I would argue that Gillet's allegorical animation of the *Water Lilies* is precisely what any verbal account of a visual object cannot help but do.

Gillet assists his readers by historicizing his own discourse. His interpretation of Monet depends upon a set of assumptions according to which it makes sense to speak of "pure painting" and "pure poetry." According to this modernist program Gillet concludes that "since the time one has been tormenting oneself to invent an art which no longer imitates anything but contents itself to evoke, if only by allusion, suggestion, symbol, I do not believe that one has found a superior formulation to that of the *Water*

Lilies of Claude Monet."[51] Gillet may have a polemical intention here, for by 1927 many of the newer schools of painting had come to dispute the value of Monet's work.[52]

A dispute of still longer standing involved the figureless iconography of the *Water Lilies*. Raphael, Rembrandt, and Goya had each created their own "world"; without benefit of the human figure can Monet have done so as well? "But why can a garden, the marvelous border in which he enclosed himself at the age of forty hardly to leave it thereafter, why can this vegetal empire, this realm of flora, not be a world as charming as another?" Baudelaire had worried about this same issue in front of Boudin's marine studies back in 1859, but Gillet's response is much more affirmative: "For me, I have always admired the prodigious dreamer and lover of the waters who has drawn an immense work from a pool of a few feet square and has derived from such little space the nutriment of his dreams. By force of returning there, by force of meditation, by force of seeing in turn the dawns and the evenings regard themselves in this source, the strange contemplator invents this domain of the impalpable and the imaginary, this singular theater of water, this world of pure extension, of atmosphere, and tonality, this half-aquatic, half-aerial universe that is of none other but he and in which the spectacle of the universe reflects itself."[53] This last leap from self to cosmos is the familiar one of the symbolist and psychoanalytic Narcissus. Monet's contemplation in the pool is the reflex of his personal imagination but it is also an index of that order of images in which we all dwell.

As Monet repeats himself, as I repeat myself, Gillet also repeats himself in his third variation on the *Water Lilies*. The phrases of 1909 and 1924 return in many of the old combinations in this final text and we come repeatedly face-to-face with the modernist ideology of the self-reflective artist: "Astonishing painting without design and without borders, canticle without words, pictures in which the painter has no other subject but himself; in which art, without the aid of forms, without vignettes, without anecdotes, without fables, without allegories, without bodies, and without faces, through the sole virtue of tones is no longer anything but effusion, lyricism, in which the heart tells its story, unburdens itself, sings of its emotions." From an unnarratable visual work we arrive at a blank book whose invisible personifications are named "Youth, Love, Regrets, Melancholia." These Mallarméan embodiments inhabit the waters of Monet's decoration; in them "the soul flows up to the brim."[54]

Gillet worries that the *Water Lilies* will not be understood. Cubist painter André Lhote contrasts Monet unfavorably with Picasso and insists

that in the Orangerie Monet has committed "plastic suicide": "Ophelia of painting, his soul languishes without glory in the shroud of the water lilies,"[55] but for Gillet the *Water Lilies* decoration takes its place in "the sky of ideas" alongside Renaissance programs of Olympus and Parnassus and more recent religious murals by Delacroix and Puvis de Chavannes. In spite of the Gallic classicism which Gillet vaunts in Monet, the classical-Christian consortium of culture is not the most distinctive context for the painter's work· "It is perhaps necessary to see in it the sole European work which is truly related to Chinese thought, to the vague hymns of the Far East on the waters and the mists and the passing of things, on detachment, on nirvana, on the religion of the Lotus."[56]

The sanctity of the lotus leads Gillet back to the contemplation of love and death. He recalls John Keats's epitaph in the English cemetery in Rome "writ in water," and in Renoir's art he celebrates the goddess Venus risen from the waves. Unlike these other representatives of European tradition, Monet is seen to have remained faithful to the cults of the West even while aspiring to the wisdom of the East. Western religion and mythology will continue to retain their purchase over our imaginations, Gillet implies, but "let us not lament that one of our own, in a drop of water, beneath the sky of the Vexin, where the breezes and clouds from the Ocean come by, should have rediscovered the great ecstasy of the other side of the world, this secret of oblivion in which our meager individualities lose themselves and which is nonetheless one of the forms of adoration."[57]

Gillet transposes the erotic adoration of Venus into religious worship, a move that is explicit in the response to the *Water Lilies* of Gillet's friend Paul Claudel, an international diplomat and perhaps the principal French writer of Christian conviction at this time. Visiting the Orangerie shortly after its opening, Claudel sees in Monet's "passion for color" the aura of medieval stained glass: "By grace of the water [Monet] made himself the indirect painter of what one does not see. He addresses himself to this almost invisible and spiritual surface that separates light from its reflection. The aerial azure captive of the liquid azure."[58] In Claudel's symbolist-tinged Christianity the water-mediated relation of a celestial entity and its embodied reflection is analogous to the specular doctrine of the incarnation of Christ.

Claudel's metaphysical response to the *Water Lilies* is absorbed into a series of philosophical and religious "conversations." Like the realm of appearances whose empirical limits are pierced only in the instant of the believer's death, Monet's room of paintings is a fissureless world, "a conjuration of colors around me which enveloped me and from which there

was no other issue than in closing my eyes." The phenomenology of the *Water Lilies* is continuous with perceptual experience, but its iconology is extramundane: "The subject was that imponderable and as though spiritual surface where the ray encounters the mirror, that liquid cut between two worlds. The refracted gaze interrogates the depths which respond by way of those slow water lilies, marvels of the mud."[59] As Claudel later writes in *Un Poète regarde la croix*, "the lily and especially the aquatic lily, which one also calls lotus or nenuphar, has always held a large place in the symbolic imagery of all religions." For Claudel the flower's calyx is the prototype of the chalice of the mass. In its floating rootedness the water lily is thus a natural avatar of the body-embedded soul: "It takes its origin in substantial and profound regions separated from our gaze by those fluid, contemplative, sparkling levels which are the domain of the contingent, of the provisional, of illusion, and of 'time,' of that reflection which responds to circumstance."[60] Or as he writes elsewhere, "everything that the heart desires may always be reduced to the form of water."[61]

Self-Portrait of the Artist
as an Old Man

WE HAVE TRAVELED in this book from the *fleurs du mal* of 1857 to the *merveilles de la boue* of seventy years later. From Baudelaire to Claudel water has solicited a series of Platonist, orientalist, and Christian reveries of shifting ideological proportions. In 1927 Claudel embodies the Christian pole of this allegorical tradition while Clemenceau, the anticlerical author of *Le Grand Pan,* personifies the pagan pole in the interpretation of Monet's art. Gillet was personally closer to Claudel than to Clemenceau, but in my view the critic's variations on Monet mediate the chronic split in French political and cultural discourses that is represented by the pantheistic premier and the religious ambassador. In 1924 Clemenceau had warmly commended Gillet's writing, but within several years Clemenceau devoted a chapter of his own book on Monet to a critique of the "unrelenting" metaphysics of Gillet, "who claims that the painter of the *Water Lilies* leads us, along floral paths, to the bottomless abyss of Nothingness." In spite of this criticism Clemenceau himself elsewhere evokes the painter's "enchanting flowers of the spring readying themselves in the unsoundable abyss of eternal renewal."[1]

What seems to rankle Clemenceau is that Gillet's nothingness is not simply the scientifically explorable physical void to which he himself points (e.g., Brownian motion) and which he sees Monet as filling up with a pictorial materialization of light. Gillet's nothingness is different, a noumenal realm which Clemenceau claims that neither he nor Monet can see: "No possible reconciliation between this metaphysics of the unknown and the spontaneous impulse of Monet, which is not to maintain a thesis, against which the man and his brush would have rebelled, but to sacrifice everything to the expression *of what there is,* in the measure that he might accede

to it." This has precisely been the debate of this book: just who is to say *what there is,* either in the world or in the work, other than those who actively do so in their variously contradictory ways? Even Clemenceau acknowledges the "divergent opinions which are the fact of humanity."[2] And of the history of art.

I would like to think that Monet voiced some skepticism regarding the empiricist faith of his friend, but of course I do not know: " 'While you philosophically seek the world in itself,' he would say with a wide smile, 'I simply exercise my efforts upon a maximum of appearances, in strict correlation with unknown realities. When one is on the plane of concordant appearances, one cannot be very far from reality, or at least from what we can know of it. I have done nothing but look at what the universe has shown me, so as to bear witness with my brush. Is this then nothing? Your fault is to want to reduce the world to your measure whereas, increasing your knowledge of things, your knowledge of yourself will find itself enhanced.' "[3] The question remains as to what the context of this knowledge of self will be. Will it be Clemenceau's pride of scientific certainty or Gillet's oblivion of self-knowledge?

Clemenceau imagines that he has a final trump to play in his effort to turn back Gillet's interpretative gambit. Gillet had noted a lack of "life" in Monet's art, and so Clemenceau brings out as counterproof a supposedly vivid self-portrait of the artist from 1917 (W. 1843; fig. 118). In this shifting game of projection and counterprojection both Gillet and Clemenceau invest much of themselves in their portrayals of the artist. For Gillet, Monet's painting is like faith, and therefore the redemptive annulment of life is paramount; for Clemenceau the "unbeliever," Monet's painting is like politics, and all that matters is staying in office, in thereby forestalling death.[4] Clemenceau sees Monet as his alter ego, as the embodiment of the Third Republic's ideology of individualism heroically personified by Clemenceau himself, twice premier (1906–9, 1917–20) and "Father Victory" of the first world war.

The intricately documented account in Wildenstein reveals the integral role of Clemenceau in the *Water Lilies* project from 1914 on. The form of the eventual installation may owe something to Clemenceau's 1895 notion of a "large circular glance" that might encompass an arrangement of Monet's pictures in a graduated series of time and weather effects.[5] During the war years Clemenceau and his minister of commerce, Etienne Clémentel, assisted in the procurement of scarce materials and services that were required in the execution of the *Water Lilies,* and it was to Clemenceau that Monet made the offer of his decorative panels at the time of the

armistice (12 November 1918; L. 2287). In 1920 Clemenceau was defeated for the presidency as a result of public dissatisfaction with the Treaty of Versailles which he had negotiated, but after his retirement from active political life he continued to intervene with the administration on Monet's behalf; and with Monet on the state's behalf whenever the painter threatened to renege on his commitments. Clemenceau's function as *entrepreneur* of the decoration appears to have been important to both of the parties, but his most intimate role was in advising Monet over the care of the painter's eyes, a role for which Clemenceau was qualified as a trained physician and as Monet's oldest friend (the two men were born within a year of one another and had known each other since the 1860s). After Monet's death Clemenceau took it in hand to insure not only that the commitments to the *Water Lilies* would be honored but also that Monet's self-portrait would enter the collections of the Louvre without the normally prescribed ten-year delay.

Back in the 1880s Monet had painted a self-portrait (W. 1078; fig. 119) in conjunction with his series of paintings of women silhouetted against the sky or against the cloud-filled waters of Giverny (W. 1075–77, 1150–53; figs. 67, 71). Airy and watery blues predominate in the self-portrait of 1886, with the aquatic and aerial dissolution of the female figures matched by the permeability of the painter's bust across its broadly brushed upper contour and especially by the bleeding of its brushwork into the unpainted corners of the lower margin. These techniques of unfinish reappear in extreme form in the self-portrait of 1917.

By 1917 Monet had not painted the human figure for almost thirty years, since the period when the Hoschedé daughters had posed for him with parasols and boats. One last figural reminiscence of their silhouettes and reflections is registered in an abortive watergarden series of 1903, of which only one painting seems to have escaped destruction (W. 1654), perhaps on account of the minuscule presence of two strollers who are glimpsed on the far bank. Figures recur in only the most cursory notation in some of the Venice paintings of 1908–12, where they are merely ghostly presences who operate the gondolas of a waterlogged world.

The reasons for Monet's return to self-portraiture remain obscure, but two events of 1911–12 may have some bearing. Not long after the death of his wife left Monet "annihilated" (to Geffroy, 29 May 1911; L. 1968), Clemenceau visited Monet at Giverny and reportedly exercised a "calming" influence upon his friend (to Geffroy, 11 July 1911; L. 1971). The day after Monet wrote this letter and complained of the return of his "terrible solitude," Clemenceau wrote to him as follows: "You know what I wish for

you from the depths of my heart. Do you remember the old Rembrandt in the Louvre, furrowed, ravaged beneath the cloth that hides his denuded head. He clasps himself to his palette, resolved to stand firm up to the last through terrible trials. There is the example" (fig. 120).[6]

At the end of 1912 the self-portrait of yet another old master turns up in Monet's thoughts and actions. This is the self-portrait by Delacroix from the Rouart collection which Durand-Ruel failed to buy on Monet's behalf (8 December 1912; L. 2040): "I am altogether desolated that you did not think it necessary to buy the portrait of Delacroix as I had begged you. This is a real disappointment for me" (11 December 1912; L. 2041). Delacroix's *Journal* was reportedly Monet's favorite book, and if on this occasion he lost the opportunity to possess Delacroix's effigy, Clemenceau later saw to it that Monet and his hero would be reunited in the Louvre.

Clemenceau first refers to Monet's accession to the Louvre after his own fall from power and at a rare moment of cordial entente with the government concerning the painter's gift: "I have opened the negotiations to place your portrait in the Louvre and Paul Léon will do his best for it. I showed it to him in full light; he was enthusiastic."[7] Monet had given Clemenceau the painting several years earlier, and it was at the former premier's home that the picture was photographed for the cover illustration of Geffroy's book in 1922. In an ambivalent note of thanks Monet concedes that "I smiled in effect in front of my portrait," but he berates Geffroy for the quality of the color plates in general (25 June 1922; L. 2500), this in spite of Geffroy's own assurance to Clemenceau that "the portrait that you possess has *come out* admirably."[8] A year later, when Monet had finally returned to work after the three operations on his eye, Clemenceau writes once again of his machinations: "I will not hide from you that I said to Paul Léon that after the inauguration of the panels the hour would have come for your portrait to take the path to the Louvre. 'You will only have to speak,' he answered me. 'I will come myself to take it from your house.' As to the place, I will ask you your opinion."[9]

Within a week of Monet's death Clemenceau refers to the self-portrait in a letter to Blanche Hoschedé-Monet: "I cannot however delay any longer in telling you that I have given the Louvre the incomparable masterpiece of the portrait of Claude Monet by himself. I have placed as sole condition that it be hung in the great room where the *Burial at Ornans* is and in the place that I will choose."[10] In a dialogue in his book Clemenceau reveals that Courbet's painting was his favorite in the Louvre, whereas Monet's was Watteau's *Embarkation for Cythera* (figs. 121–22).[11] Love and death

recur as the bedrock of life in this art-historical coupling; furthermore both paintings were widely seen as representative not only of their painters' personalities but also of their respective epochs. Thus for Clemenceau, Monet's self-portrait would be to the aging Third Republic (1871–1940) what Courbet's *Burial* and Watteau's *Cythera* were to the short-lived libertarian experiments of the Regency (1715–23) and the Second Republic (1848–52).

Clemenceau's appropriation of Monet's self-portrait is meant to embody more than the program of a single party: "I have chosen the emplacement of the picture, it is the best in the Museum. The great Salle des Etats where *Olympia* and the *Burial at Ornans* are. The portrait of Monet by himself having as pendant the portrait of Delacroix by himself" (fig. 123).[12] The symbolism here is at once personal and political: in 1890 Monet had led the campaign to acquire Manet's *Olympia* for the state's Luxembourg Museum, but it was only after Clemenceau rose to the premiership for the first time that the painting was transferred to the Louvre. Monet thanked Clemenceau for his intervention (8 February 1907; L. 1823), and fairly bragged to Julie Manet-Rouart of his own role in the affair: "I had the idea to go find Clemenceau with whom I am connected. I spoke to him as was necessary, so well that two days later the painting was transported to the Louvre. You may imagine whether I am congratulating myself on my idea, for otherwise it would doubtless have been very long" (20 February 1907; L. 1825).

In contrast to the importance of Manet and Courbet as ego-ideals for Monet and Clemenceau, it is the self-portrait by Delacroix that ostensibly secures Monet's identity as a painter beyond partisan politics. Monet's first letters from Paris to Boudin express the impact of Delacroix's "verve" and an impression of one of the painter's most "splendid" water-subjects (3 June 1859 and 20 February 1860; L. 2–3). This is the *Shipwreck of Don Juan* of 1840, a painting whose marine imagery of death may find a distant echo in the funereal *Water Lilies* of the 1920s. As a celebrated seventy-year-old artist Monet sought to acquire a rather minor self-portrait from Delacroix's youth; still later Monet reputedly made the claim that in his own youth he had observed Delacroix painting in the studio prior to his death in 1863.[13] It is perhaps with a fitting sense of narrative closure that in the year after Monet's death his late self-portrait should find its way into the Louvre to hang across from the well-known self-portrait of Delacroix's maturity. Monet's painting of 1917 is chronologically posterior to Delacroix's of around 1837, but in the identification with his predecessor the

seventy-seven-year-old Monet turns out to be older than the forty-year-old Delacroix; the son thus becomes the elder and the father the cadet, and the self-made hero of the bourgeois republic surpasses the Baudelairean dandy of the last decades of the monarchy in France.

News of the arrival of Monet's self-portrait at the Louvre was published in *Beaux-Arts* in January 1927. In spite of its status as "testament" it is doubtful that without Clemenceau's influence the self-portrait would have been allowed to enter the Louvre "without further waiting."[14] The self-portrait was still news in March when Raymond Régamey specified the significance of its entry to the Louvre: "The former President of the Council divested himself of the portrait of his friend for the profit of the public. He himself carried it to the museum and, with that decisiveness that formerly served the glory of Manet, when he transferred the *Olympia* from the Luxembourg to the Louvre, he forthwith had the effigy of Monet hung in the Salle des Etats, in the place which the *Portrait of a Young Lady* by Hippolyte Flandrin was occupying. The gesture may have a symbolic value. The impressionist expels the classicist. Henceforth the door of the great room of French painting in the 19th century is as though guarded by Delacroix and Monet. A cycle of pictorial history, opened by the author of *Dante and Virgil,* is closed by the author of the *Water Lilies.*"[15] The credit for acclaiming Delacroix's painting in 1822 generally goes to Adolphe Thiers, then a journalist, later an Orleanist premier, and finally first president of the Third Republic. It was Thiers who from the loser's position negotiated the Peace of Versailles with Germany in 1871, and it was Clemenceau who took France's revenge with the Treaty of Versailles in 1919. Clemenceau never became president, but he empowered Monet's entry into the Louvre.

Not for long however: "Paul Léon, whom I have seen, suddenly appears engaged in a troublesome enterprise. Revenge of the painting of the administration. Forward Bouguereau and Co., Olympia flees before the apotheosis of Homer, and the *Portrait of Monet* has disappeared. For the *Water Lilies* one has been content to bring obscurity. On my last visit, the passers-by were demanding candles. When I complained I only obtained a pale smile from Paul Léon."[16] As late as the early 1970s when I first saw it, Monet's self-portrait was in the reserves of the Jeu de Paume; in view of the recent reorganization of the nineteenth-century collections of the Louvre in the Musée d'Orsay, it behooves us to reconstruct insofar as we can the vicissitudes in the canon of modern French art. For Clemenceau, Monet's self-portrait was the political and metaphysical portrait of France: the nation as the Great Pan, the relentless life-force; the nation as the

wave-subduing Demosthenes, the orator who had borne with constant dignity both the praises and invectives of the Athenian citizenry.[17]

In his book Clemenceau recalls that Monet would speak of his self-portrait "only with hesitation," and speculates that this may have been due to the painter's sense of the work as "the highest trait of his final vision," unsurpassable in the time that remained to him to live.[18] Clemenceau reads in the self-portrait the signs of triumph and despair; as he recounts to an associate who disapproved of this "trivial" book, "what I want to tell is the story of [Monet's] conflict—a conflict which ended both in victory and defeat, a victory because he left behind a vast body of work, including many splendid things, a defeat because in that domain there is no such thing as success."[19]

According to Clemenceau, Monet painted three self-portaits in 1917, two of them showing "the face in full light, emerging from beneath a large straw hat," the sort of working hat we see in various photographs of the period. No trace survives of these paintings in the manner of Vincent van Gogh or Paul Cézanne (or indeed in the hatted manner of the Rembrandt in the Louvre to which Clemenceau had earlier referred), and Clemenceau recounts that the two self-portraits "perished on an unhappy day" at the hands of the artist: "Chance allowed that the one in the Louvre was saved. One day when some bad words had been spoken by him against that incomparable work, he went off to find the canvas at the moment of my departure, and throwing it into my car: 'Take it away,' he said in a surly tone, 'and let no one speak to me of it again.' One would have said that he was trying to arm himself in advance against the madness of a new summary execution. And as I was announcing to him that on the day of the inauguration of the panels we would go, arm in arm, to see this canvas at the Louvre: 'If it is necessary to wait until then,' he retorted, 'I will say good-bye to it for ever.'" In this passage Clemenceau stipulates the folly of Monet's destructive gesture. He describes the painter's "redoubtable habit of lacerating with blows of a scraper, ripping with kicks of the feet, the pieces which did not give him satisfaction," but he is clearly not sympathetic to Monet's tendency of "always finding some way of cursing his pretended insufficiencies": "For, to violently blow off steam he never denied himself, at all times swearing that his life was a failure and there only remained for him to destroy all his canvases before disappearing. Studies of the first order thus foundered in these accesses of furor." Rather than interrogate the significance of Monet's aggression toward his own self-representations, Clemenceau commends himself for knowing better than the artist and thereby saving for posterity not only the self-portrait

but the decorative panels as well. By his own gesture of "permitting" Clemenceau to take the self-portrait away, Monet also colludes in his friend's action.[20]

This is how Clemenceau describes Monet's picture: "The last portrait (the one in the Louvre), I cannot speak of it with composure, so does it render the blossomed state of soul of Monet in view of the foreseen triumph, before the frightful menace of blindness tragically crashed itself down upon him. . . . It is the interior consecration of the leap of art which will complete itself in the flight of the *Water Lilies.* The two destroyed portraits must count above all as very urgent preparations for the triumphal piece. Here, victory assures itself even before the battle. Fanfare of anticipation of the soldier who is master of the day."[21] The thick flurry of military metaphors overwhelms Clemenceau's acknowledgment of the infirmities of the body which threaten the soldierly triumph he holds so dear. Under the guise of his friend's traits Clemenceau offers a portrait of himself as his nation's military savior, a portrait that can only marginally accommodate the veils of melancholy that Clemenceau prefers not to see in Monet's face.

Clemenceau's self-projection into Monet's self-portrait points up the transferential aspects of all historical and biographical writing. Like Freud's highly personal interpretation of Michelangelo's *Moses,* wrathful in the face of his followers' apostasy around the golden calf, Clemenceau's portrait of Monet provides a similar occasion for the unconscious venting of fantasies of aggression and mastery at a time when the author is preoccupied with writing the history of his own vexed leadership, *Grandeurs et misères d'une victoire* (1928).[22] Monet is a self-object for Clemenceau as Clemenceau is for Monet—as Monet is for me and you who read this book.

In Clemenceau's account Monet's blindness is that of Samson, the biblical hero: "The solid construction of this brow that the catapults of the 'Philistines' could not penetrate tells all the tragedy of that glorious life. Between two large, highly framed temples, his cranial energies have fixed the imprint of great struggles for the ideal. It is the chair of command, the imperious seat of the idea, of authority. . . . The trembling nostrils, the throat convulsed in an irrepressible explosion, the master-worker has just come to discover deep within himself the clear consciousness of an ultimate achievement annunciated even in the nimbus of springtime reflections in the 'flowering beard,' *labarum* of Charlemagne, emperor of a new world." From Samson, to Charlemagne, to Clemenceau's own military surrogate, General Foch, this is Monet of the *labarum,* the military standard held aloft by the armies of the Roman and Holy Roman imperium. But

for all the imagery of power and authority, there is also a counterimage of foredoomed struggle. For in the brain-born idea and the head-engarlanded nimbus we are back in the symbolist realm of Narcissus, the floral Christ of agonized self-knowledge, "the eyes half-closed the better to savor the interior dream."[23]

Unlike Narcissus, Monet laughs, yet elsewhere Clemenceau is quoted that the artist "only knew joy in suffering."[24] The *Water Lilies* and the self-portrait together portray figure and ground of the myth, but Clemenceau imagines that somehow the portrait escapes from the tortuous mediations of the panels: "Without the trap of reflections, the portrait in the Louvre, in my opinion, should be taken for the last word of Monet. A flash of triumphant joy passed over him when his supreme essays showed that being able to conceive at the height of himself, he would be in a state to execute. It is this flash of superhuman ambition that the admirable portrait of the final hour has fixed."[25]

Raymond Régamey also heard the painter's laugh, but in him it had a different echo: "In the middle of a canvas left white for the most part, Claude Monet has represented himself, in a moment of joyous humor and with a generous brush, the flesh violet, the hair and the beard green, two slits of shadow in the guise of eyes. The work dates, it seems, from the war years. It is one of the rather numerous portraits which Monet would have executed of himself. He lacerated, threw out, or burned the others, with the energy of destruction which in him accompanied so naturally the drunkenness of creation." Unlike Clemenceau, who sees Monet's destructiveness as the by-product of an unworthy trait of self-denigration, Régamey associates the artist's gesture with a drive of aggression that corresponds to an equally potent creative drive: "This rapid painting, this portrait without gaze, is significant as the logical issue—parallel to the final *Water Lilies*—of the art of Monet, which is instinctive as to means and, as to aim, indifferent to all spirituality, even in a face."[26] Here Narcissus recognizes that the self is nothing but an image, its humanistic depth an illusory fiction to be torn to bits.

In 1929 Marthe de Fels published the first book on Monet written by a woman. Her narrative is perhaps unreliable if treated as documentation, but her sense of particular paintings such as the self-portrait comes close to the notion with which I want to conclude: "The portrait of Monet painted by himself, now at the Louvre, is very significant. This is a Monet,—man of nature,—who rejuvenates himself in the contact with the freshness of the leaves. He is melded with the decor, melded with the flowers, melded with the movement of all things, and this fusion with

the sensible world is a poem in itself, more expressive than a true portrait which would render with less rigor the spiritual atmosphere of the painter."[27] The modernist myth of Narcissus is present both in the masculine fantasy of youthful beauty and in the movement of excess whereby the bodily self is dissolved within the feminine embrace of nature. This allegorical process is related to the oceanic feeling discussed by Romain Rolland and Freud, and even more to the cosmic narcissism of Bachelard's reverie on the waters of Monet: "When one sympathizes with the spectacles of water, one is always ready to take pleasure in its narcissistic function."[28]

A photograph survives that lets me imagine something of Monet's stance before the dual mirror of his self-portraiture and his decorations (fig. 124).[29] This photograph shows Monet in his studio with two of his dead wife's daughters, Germaine and Blanche, subordinate Echos both. Monet stands in the middle distance, his eyes to the front, his right hand on the top of a bench at his side, his left hand tucked into the jacket pocket of his tweeds; he has a handkerchief at his breast and holds a cigarette in his lips. Behind him is a life-size mirror, not precisely the swiveling sort known as a *psyche* but nonetheless the glass in which he chose to consider the image of his body—and perhaps its specular relationship to what he might have called his soul. Behind Monet to his right are smallish panels of *Water Lilies;* one of them is turned to the front and what I suppose to be others are turned to the wall. Behind Monet and his stepdaughters to their left is one of the two-meter panels of the sort that eventually made up the painter's completed decoration. The indistinct quality of the photograph makes a firm identification of this painting dubious, but the pattern of flowers and strokes conforms to the panels known as *Reflections of Trees* (W. 1971 and panel 1a in the second room of the Orangerie; fig. 125). The inverted, twisted willow is invisible if indeed it was ever present, and moreover its place is effaced by a fourth of Monet's self-portraits of 1917, known only from this photograph and presumed destroyed (W. 1844). More frontal perhaps than the self-portrait in the Louvre, the blurred image seems almost to bleed as the aerial nimbus and earthen bust which frame the bearded head merge with the surrounding canvas in oily smears. Propped against the vertical wall of water as though expressly to be photographed, the painter's self-portrait seems to float face-up on the surface of the pond. Ophelia or Narcissus: for this is less a submerged body than a body's impalpable image, a painted mirror-reflection already alienated from its physical incarnation by the liquid metal of the glass.

Narcissistic self-alienation is embodied in a painting of around 1918 in which a bending youth turns toward the reflective surface of an iris-

bordered pool. Known as *The Innocent* (fig. 126), the painting was made by a young Dutchman named Philippe Smit (1886–1948) who was inspired by the poetry of Maurice Rollinat and who reputedly struck up a friendship and correspondence with Monet around 1911, although no letters between them are now known.[30] Had Monet been of the generation, temperament, and cultural background of Smit he might have painted the figure of an ancient or modern Narcissus by the banks of his lily pond; instead he painted a series of aqueous self-portraits amidst his studio clutter of water lilies, daylilies, agapanthus, and iris writhing and bending along the banks of his pond (W. 1818–42; fig. 127). Unlike Smit, Monet was not of the iconographical disposition to depict the dilemma of Narcissus, but the image of his bending body and the reflection of his brooding gaze preoccupied him all the same. In the mutilated and surviving self-portraits, we possess his image as an embodied absence; and in the obsessively reiterated water paintings both intact and destroyed we reanimate the absence of that body by way of the enduring presence of a gaze.[31]

> Surrounded by his arm like a shell,
> she hears his murmuring being,
> while he supports the outrage
> of his image that is forever too pure . . .
>
> Pensively in following their example,
> nature withdraws into herself:
> the flower that contemplates itself in its sap
> grows too tender, and the rock endures . . .
>
> It is the return of every desire that withdraws
> toward the life that enlaces itself from afar . . .
> Where does he fall? Does he wish, beneath the surface
> that disappears, to renew a center?[32]

Notes

PREFACE

1. Monet and Narcissus are brought tantalizingly close together in Gaston Bachelard, *L'Eau et les rêves: Essai sur l'imagination de la matière* (Paris, 1978), where a brief evocation of the late *Water Lilies* is framed by "remarks on the relations between egoistical narcissism and cosmic narcissism" (p. 40). Bachelard's idiosyncratic blend of phenomenology, iconography, and psychoanalysis made a strong impression on me when I first read it in the late 1970s, and my account here found much of its initial stimulus in his work. Narcissus also figures in the literature on Monet in Hanspeter Zürcher, *Stilles Wasser: Narziss und Ophelia in der Dichtung und Malerei um 1900* (Bonn, 1975); Christopher Yetton, "The Pool of Narcissus," *Royal Academy Magazine* (1990), in *The Impressionists: A Retrospective,* ed. Martha Kapos (New York, 1991), pp. 372–74; and Virginia Spate, *Claude Monet: Life and Work* (New York, 1992), pp. 310–12.

2. For a sense of "reading" as I wish to practice it here with regard to paintings as well as texts, see Michael Payne, *Reading Theory: An Introduction to Lacan, Derrida, and Kristeva* (Oxford, 1993): "For Lacan, Derrida, and Kristeva, writing and reading are activities of immense importance, since they are means of representing the unconscious, of challenging and reassessing the history of thought, and of understanding the signifying processes of the human subject" (p. ix).

3. On biography, social history, iconography, and formal analysis as rhetorical strategies of art-historical narration, see Mark Roskill, *The Interpretation of Pictures* (Amherst, Mass., 1989); David Carrier, *Artwriting* (Amherst, Mass., 1987); and idem, *Principles of Art History Writing* (University Park, Pa., 1991).

4. That the self is not a source but rather a reflex of a repressed inscription is a premise of deconstruction. See Jacques Derrida, *Of Grammatology,* trans. Gayatri Chakravorty Spivak (Baltimore, 1976), p. 36; the passage quoted refers to Rousseau: "Representation mingles with what it represents, to the point where one speaks as one writes, one thinks as if the represented were nothing more than the shadow or reflection of the representer. A dangerous promiscuity and a nefarious complicity between the reflection and the reflected which lets itself be seduced narcissistically. In this play of representation, the point of origin becomes ungraspable. There are things like reflecting pools, and images, an infinite reference from one to the other, but no longer a source, a spring. There is no longer a simple origin. For what is reflected is split *in itself* and not only as an addition to itself of its image. The reflection, the image, the double splits

287

what it doubles. The origin of the speculation becomes a difference. What can look at itself is not one."

5. See Christopher Lasch, *The Culture of Narcissism: American Life in an Age of Diminishing Expectations* (New York, 1979).

6. See Jürgen Habermas, "Modernity versus Postmodernity" (1981), in *Postmodern Perspectives: Issues in Contemporary Art*, ed. Howard Risatti (Englewood Cliffs, N.J., 1990); Charles Taylor, *Sources of the Self: The Making of the Modern Identity* (Cambridge, Mass., 1989); Anthony J. Cascardi, *The Subject of Modernity* (Cambridge, 1992); and *Who Comes After the Subject?*, ed. Eduardo Cadova, Peter Connor, and Jean-Luc Nancy (New York, 1991).

7. See Michel Foucault, *The History of Sexuality*, 3 vols. (*An Introduction, The Use of Pleasure, The Care of the Self*), trans. Robert Hurley (New York, 1978–86).

8. See William Ray, *Story and History: Narrative Authority and Social Identity in the Eighteenth-Century French and English Novel* (Cambridge, Mass., 1990); and Robert C. Solomon, *Continental Philosophy since 1750: The Rise and Fall of the Self* (Oxford, 1988).

9. See Carolyn J. Dean, *The Self and Its Pleasures: Bataille, Lacan, and the History of the Decentered Subject* (Ithaca, 1992).

10. See *Freud's "On Narcissism: An Introduction,"* ed. Joseph Sandler, Ethel Spector Person, and Peter Fonagy (New Haven, 1991); and C. Fred Alford, *Narcissism: Socrates, the Frankfurt School, and Psychoanalytic Theory* (New Haven, 1988).

11. The fundamental study is Louise Vinge, *The Narcissus Theme in Western European Literature up to the Early Nineteenth Century* (Lund, 1967). On Ovid, see John Brenkman, "Narcissus in the Text," *Georgia Review* 30 (Summer 1976): 293–327; on the medieval tradition, see Kenneth J. Knoespel, *Narcissus and the Invention of Personal History* (New York, 1985); on Renaissance poetry, see Ullrich Langer, "Ronsard's 'La Mort de Narcisse': Imitation and the Melancholy Subject," *French Forum* 9 (January 1984): 5–18; on Baroque poetry, see Gérard Genette, "Complexe de Narcisse," in *Figures* (Paris, 1966), pp. 21–28; on the eighteenth century, see Jean Starobinski, "Jean-Jacques Rousseau: Reflet, réflexion, projection," *Cahiers de l'Association Internationale des Etudes Françaises*, no. 11 (May 1959): 217–30; on the nineteenth century, see Helga Esselborn Krumbiegel, "Das Narziss-Thema in der symbolistischen Lyrik," *Arcadia: Zeitschrift für vergleichende Literaturwissenschaft* 5 (1980): 278–94. Also see Jacques Lacan, "On Narcissism" and "The Two Narcissisms," in *The Seminar of Jacques Lacan: Book I, Freud's Papers on Technique 1953–1954*, trans. John Forrester and ed. Jacques-Alain Miller (New York, 1991), pp. 107–28; Julia Kristeva, "Narcissus: The New Insanity" and "Our Faith: The Seeming," in *Tales of Love*, trans. Leon S. Roudiez (New York, 1987), pp. 103–36; Cyraina E. Johnson, "The Echo of Narcissus: Anxiety, Language, and Reflexivity in 'Envois,' "

International Studies in Philosophy 22 (1990): 37–50 (on Derrida); and Claire Nouvet, "An Impossible Response: The Disaster of Narcissus," *Yale French Studies,* no. 79 (1991): 103–34 (on Blanchot).

12. See Cesare Ripa, "Amour de soy-mesme," in *Iconologie,* trans. Jean Baudouin, 2 vols. in 1 (Paris, 1644; rpt. New York, 1976), 2: 103. The theme of female narcissism that we will encounter in the nineteenth century is already introduced here. Also see *Emblemata: Handbuch zur Sinnbildkunst des XVI. und XVII. Jahrhunderts,* ed. Arthur Henkel and Albrecht Schöne (Stuttgart, 1967), pp. 1627–28.

13. "Narcissus, too taken with your own beauty, / You have been turned into a flower without sensitivity. / Thinking of oneself is and has been the ruin / Of many learned men who, casting off the doctrine / Of the ancients, have chosen another way, / Teaching nothing but their fantasies"; from Andrea Alciati, *Emblèmes* (Paris, 1561), in *Andreas Alciatus,* ed. Peter M. Daly, Virginia W. Callahan, and Simon Cuttler, 2 vols. (Toronto, 1985), 2: no. 69. "The Beautiful Narcissus" represented in Daumier's *Histoire ancienne,* no. 23, published in *Le Charivari,* 11 September 1842, was the Count Narcisse de Salvandy, academician and former minister of public information, who, like the figure of myth, was enamored of contemplating "his own traits."

14. See T. J. Clark, "Clement Greenberg's Theory of Art"; Michael Fried, "How Modernism Works: A Response to T. J. Clark"; and T. J. Clark, "Arguments about Modernism: A Reply to Michael Fried"; in *The Politics of Interpretation,* ed. W. J. T. Mitchell (Chicago, 1983), pp. 203–48.

15. Also see Steven Z. Levine, "Manet's Man Meets the Gleam of Her Gaze: A Psychoanalytic Novel," in *Current Methodologies: Twelve Approaches to Manet's "Bar at the Folies-Bergère,"* ed. Bradford R. Collins (Princeton, forthcoming).

16. Solomon, *Continental Philosophy,* p. 7.

17. On the inevitably vexed necessity of holding conflicting, hence ambivalent, views on the sociolinguistic constitution of the individual (artist/critic) in society and on the individual's (artist's/critic's) capacity to transcend that determination, see Taylor, *Sources of the Self,* pp. 105–7.

18. See Steven Z. Levine, "Monet's *Cabane du Douanier,*" *Fogg Art Museum Annual Report 1971–72* (Cambridge, Mass., 1975), pp. 32–44; and idem, *Monet and His Critics* (New York, 1976).

19. See E. Régis and A. Hesnard, *La Psychoanalyse des névroses et des psychoses: Ses Applications médicales et extra-médicales* (Paris, 1914).

20. See Naomi Segal, *Narcissus and Echo: Women in the French "Récit"* (Manchester, U.K., 1988).

21. See *Difference in Translation,* ed. Joseph F. Graham (Ithaca, 1985).

22. For a reading of the female gendering of the landscape in the critical response to the work of Monet and his colleagues, see Norma Broude, *Impression-*

ism: A Feminist Reading (New York, 1991). Also see Griselda Pollock, *Vision and Difference: Femininity, Feminism, and Histories of Art* (London, 1986).

23. For color plates as well as a brief presentation of my argument concerning Monet and Narcissus, see Steven Z. Levine, *Claude Monet* (New York, 1994). In the following text I refer to Monet's paintings (W. plus number) and letters (L. plus number and date) according to their enumeration in the indispensable volumes published by Daniel Wildenstein, *Claude Monet: Biographie et catalogue raisonné,* 5 vols. (Paris, 1975–91).

CHAPTER ONE

1. Charles Baudelaire, "Salon de 1859," in *Oeuvres complètes,* ed. Claude Pichois, 2 vols. (Paris, 1975–76), 2: 617.

2. See Eugene Holland, "On Narcissism from Baudelaire to Sartre: Ego-Psychology and Literary History," in *Narcissism and the Text: Studies in Literature and the Psychology of Self,* ed. Lynne Layton and Barbara Ann Schapiro (New York, 1986), pp. 149–69.

3. Baudelaire, "Le Salon caricatural de 1846," and "Le Peintre de la vie moderne" (1863), in *Oeuvres,* 2: 510, 719.

4. Ibid., "Salon de 1859," p. 660.

5. Ibid., p. 665.

6. Ibid., pp. 665–66.

7. Ibid., "Le Poème du haschisch" (1860), 1: 440.

8. Ibid., p. 431.

9. Diary entry of 3 December 1856, in Georges Jean-Aubry, *Eugène Boudin: La Vie et l'oeuvre d'après les lettres et les documents inédits* (Paris, 1968), p. 22.

10. Baudelaire, "Salon de 1859," in *Oeuvres,* 2: 660, 666.

11. Ibid., p. 666.

12. Ibid., "L'Homme et la mer" (1852), 1: 19.

13. Leo Bersani, *Baudelaire and Freud* (Berkeley, 1977), p. 43.

14. Baudelaire, "Mon Coeur mis à nu" (1863), in *Oeuvres,* 1: 696.

15. Anon., "L'Exposition du Havre" (1858), in Gilbert de Knyff, *Eugène Boudin raconté par lui-même: Sa Vie, son atelier, son oeuvre* (Paris, 1976), p. 51.

16. Charles Blanc, "Grammaire des arts du dessin . . . ," *Gazette des Beaux-Arts,* 1st ser. 19 (July 1865): 66–67; Léon Lagrange, "Bulletin mensuel," ibid., p. 104; Philippe Burty, "La Gravure, la lithographie et la photographie au Salon de 1865," ibid., p. 92.

17. Paul Mantz, "Salon de 1865," ibid., p. 16.

18. Ibid., p. 18.

19. Ibid., p. 26.

20. Théophile Thoré [Willem Bürger], "Salon de 1866," in *Salons (1861 à 1868),* 2 vols. (Paris, 1870), 1: 285–86.

21. Théophile Thoré, "Salon de 1845," in *Salons de T. Thoré 1844, 1845, 1846, 1847, 1848* (Paris, 1868), p. 105.

22. Thoré, "Salon de 1861," in *Salons 1861–68,* 1: 144.

23. Ibid., "Salons de 1863," 1: 401–2, 404.

24. Thoré, "Salon de 1844," in *Salons 1844–48,* pp. 6, 78; and idem, "Salon de 1864," in *Salons 1861–68,* 2: 25–26.

25. Thoré, "Salon de 1864," in *Salons 1861–68,* 2: 133.

26. Ibid., "Salon de 1865," 2: 223–24.

27. Théophile Silvestre, "Courbet d'après nature" (1856), in *Courbet raconté par lui-même et par ses amis,* ed. Pierre Courthion, 2 vols. (Geneva, 1948–50), 1: 27. Also see Michael Fried, *Courbet's Realism* (Chicago, 1990), pp. 274–78.

28. Thoré, "Salon de 1866," in *Salons 1861–68,* 2: 281–82.

29. Courbet entitles the painting "le podoscaf ou l'amphitrite moderne," in a letter to Urbain Cuénot, 16 September 1865, in *Gustave Courbet (1819–77)* (Paris, 1977–78), p. 41.

30. Thoré, "Exposition universelle de 1867," in *Salons 1861–68,* 2: 382–83.

31. Ibid., p. 383.

32. Elisée Reclus, "L'Océan: Etude de physique maritime," *Revue des Deux Mondes,* 2d ser. 70 (15 August 1867): 963–64.

33. Thoré, "Salon de 1868," in *Salons 1861–68,* 2: 508–9.

34. Jules Michelet, *La Mer* (Paris, 1861), p. 110.

35. Théophile Gautier, "Salon," *Le Moniteur Universel,* 11 May 1868.

36. Ibid.

37. Théophile Gautier, *L'Art moderne* (Paris, 1856), p. 152.

38. Théophile Gautier, *Mademoiselle de Maupin* (Paris, 1836), in M. C. Schapira, *Le Regard de Narcisse: Romans et nouvelles de Théophile Gautier* (Lyons, 1984), p. 9.

39. Emile Zola, "Mon Salon: Les Actualistes" (1868), in *Le Bon Combat: De Courbet aux impressionnistes,* ed. Jean-Paul Bouillon (Paris, 1974), pp. 111–12.

40. Ibid., p. 112.

41. Ibid., pp. 113–14.

42. Emile Zola, *La Curée* (1871), in *Les Rougon-Macquart,* ed. Henri Mitterand, 5 vols. (Paris, 1960–67), 1: 552–53. Also see John C. Allan, "Narcissism and the Double in *La Curée,*" *Stanford French Review* 5 (Winter 1981): 295–312.

43. Zacharie Astruc, "Salon de 1868 aux Champs-Elysées: Paysages— Marines," *L'Etendard,* 5 August 1868.

44. Zacharie Astruc, "Le Salon: Première Journée," *L'Echo des Beaux-Arts*, 8 May 1870.

45. Philippe Burty, "Le Salon," *Le Rappel*, 2 May 1870.

Chapter Two

1. Armand Silvestre, *Galerie Durand-Ruel: Recueil d'estampes gravées à l'eau forte* (Paris, 1873), p. 22.

2. Louis Leroy, "L'Exposition des impressionnistes," *Le Charivari*, 25 April 1874.

3. Marie-Amélie Chartroule [Marc de Montifaud], "Salon de 1877," *L'Artiste*, 1 May 1877, p. 337.

4. Paul Mantz, "L'Exposition des peintres impressionnistes," *Le Temps*, 22 April 1877.

5. Paul Mantz, "Salon de 1872," *Gazette des Beaux-Arts*, 2d ser. 5 (June 1872): 454.

6. Paul Verlaine, "Ariettes oubliées IX" (1872), in *Oeuvres poétiques complètes*, ed. Y. G. Le Dantec and Jacques Borel (Paris, 1962), p. 196. The epigraph is taken from Cyrano de Bergerac's letter, "Sur l'ombre que faisoient des arbres dans l'eau" (1654), in *Oeuvres complètes*, ed. Jacques Prévot (Paris, 1977), pp. 45–46.

7. Pierre Larousse, *Grand Dictionnaire universel du XIXe siècle*, 15 vols. (Paris, 1866–76), 11: 837–38.

8. Ibid., 11: 838.

9. Jacques-Charles-Louis Malfilâtre, *Poésies*, ed. L. Derome (Paris, 1884), p. 102.

10. Larousse, *Dictionnaire*, 11: 838. The quotation from Alfred de Musset is from "Namouna: Conte oriental," in *Oeuvres complètes*, ed. Philippe van Tiegham (Paris, 1963), p. 134.

11. Larousse, *Dictionnaire*, 11: 838.

12. Paul Mantz, "Le Salon de 1863," *Gazette des Beaux-Arts*, 1st ser. 15 (July 1863): 51–52.

13. Anatole de Montaiglon, "La Sculpture à l'exposition universelle," *Gazette des Beaux-Arts*, 2d ser. 18 (September 1878): 343.

14. Paul Collin and Jules Massenet, *Narcisse: Idylle antique pour solo et choeur* (Paris, n.d. [1878]), pp. 46–48.

15. *Explication des ouvrages de peinture, sculpture, architecture, gravure et lithographie, des artistes vivants, exposés au palais des Champs-Elysées le 1er mai 1877* (Paris, 1877), p. 73. Also see the poet's further reference to the myth in a poem illustrating a military painting by Albert Aublet; see Charles Grandmougin, "Le Lavabo des réservistes," in *Nouvelles Poésies* (Paris, 1881), pp. 77–78: "It's all

done, tooth powder, / Tooth brush! Little scissors! / Just like divine Narcissus / One has only the water for a mirror!"

16. Charles Tardieu, "Le Salon de Paris 1877: Les Récompenses," *L'Art* 9, no. 2 (1877): 275–76.

17. Henry Houssaye, "Le Salon de 1877: La Grande Peinture," *Revue des Deux Mondes,* 3rd ser. 21 (1 May 1877): 596.

18. Arsène Houssaye, "Les Artistes contemporains: Souvenirs du Salon de 1877," *L'Artiste,* 1 September 1877, p. 170.

19. Edmond Duranty, "Réflexions d'un bourgeois sur le Salon de peinture," *Gazette des Beaux-Arts,* 2nd ser. 16 (July 1877): 78.

20. Théodore Duret, "Arthur Schopenhauer" (1878), in *Critique d'avant-garde* (Paris, 1885), pp. 306–7.

21. Ibid., pp. 308–9, 312.

22. Ibid., p. 313.

23. Ibid., "Les Peintres impressionnistes" (1878), pp. 64–65, 70.

24. Ibid., p. 72.

25. Louis Leroy, "Beaux-Arts," *Le Charivari,* 17 April 1879.

26. Edmond Renoir, "Les Impressionnistes," *La Presse,* 11 April 1879.

27. Armand Silvestre, "Le Monde des Arts: Les Indépendants," *La Vie Moderne,* 24 April 1879, p. 38.

28. Jules Poignard [Montjoyeux], "Chroniques parisiennes: Les Indépendants," *Le Gaulois,* 18 April 1879.

29. E. Bouchut, *De l'Etat aigu et chronique du névrosisme . . .* (1860), in Theodore Zeldin, *France 1848–1945,* 2 vols. (Oxford, 1974–77), 2: 833.

30. Montjoyeux, "Chroniques parisiennes."

31. Emile Taboureux, "Claude Monet," *La Vie Moderne,* 12 June 1880, p. 380.

32. Ibid., pp. 380–82.

33. Anon., "Notre Exposition: Claude Monet," *La Vie Moderne,* 19 June 1880, p. 400.

34. Duret, "Claude Monet" (1880), in *Critique,* pp. 103–4.

35. Paul Decharme, *Mythologie de la Grèce antique* (Paris, 1879), p. 335.

CHAPTER THREE

1. Ernest Chesneau, "Groupes sympathiques: Les Peintres impressionistes," *Paris-Journal,* 7 March 1882, in *Annuaire illustré des beaux-arts et catalogue illustré de l'Exposition Nationale,* ed. F. G. Dumas (Paris, 1883), p. 261.

2. Ernest Chesneau, *La Chimère* (Paris, 1879), in Lionello Venturi, *Les Archives de l'impressionnisme,* 2 vols. (Paris, 1939), 2: 333.

3. Joris-Karl Huysmans, "Appendice" (1882), in *L'Art Moderne* (Paris, 1929), pp. 292–93.

4. Charles Flor, "Deux Expositions," *Le National*, 3 March 1882.

5. J. P., "Beaux-Arts: L'Exposition des artistes indépendants," *Le Petit Parisien*, 4 March 1882.

6. See Harold Bloom, *The Anxiety of Influence: A Theory of Poetry* (New York, 1973); and Norman Bryson, *Tradition and Desire: From David to Delacroix* (Cambridge, 1984).

7. Louis de Fourcaud, "Beaux-Arts: Exposition d'oeuvres de M. Claude Monet, 9, boulevard de la Madeleine," *Le Gaulois*, 12 March 1883.

8. Arthur d'Echerac [C. Dargenty], "Exposition des oeuvres de M. Monet," *Courrier de l'Art*, 15 March 1883, pp. 126–27.

9. Paul Labarrière, "Exposition de Claude Monet," *Journal des Artistes*, 16 March 1883.

10. Armand Silvestre, "Exposition de M. Claude Monet," *La Vie Moderne*, 17 March 1883, pp. 177–78.

11. Stéphane Mallarmé, *Les Dieux antiques* (1880), in *Oeuvres complètes*, ed. Henri Mondor and G. Jean-Aubry (Paris, 1945), p. 1248.

12. Alfred de Lostalot, "Exposition des oeuvres de M. Claude Monet," *Gazette des Beaux-Arts*, 2d ser. 27 (April 1883): 346.

13. Philippe Burty, "Les Paysages de M. Claude Monet," *La République Française*, 27 March 1883.

14. Adolphe Monet to Frédéric Bazille, 11 April 1867, in Gaston Poulain, *Bazille et ses amis* (Paris, 1932), pp. 74–77.

15. Burty, "Paysages."

16. Ibid.

17. Philippe Burty, "Exposition de la Société anonyme des artistes," *La République Française*, 25 April 1874.

18. Ibid.

19. Burty, "Paysages."

20. Ibid.

CHAPTER FOUR

1. See Oscar Reutersvärd, "The 'Violettomania' of the Impressionists," *Journal of Aesthetics and Art Criticism* 9 (December 1950): 106–10.

2. Judith Gautier, "Exposition internationale de peinture," *Le Rappel*, 21 May 1885.

3. Albert Wolff, "L'Exposition internationale," *Le Figaro*, 15 May 1885.

4. Paul Gilbert, "Exposition internationale," *Journal des Artistes*, 13 June 1885.

5. Paul Guigou, "L'Art en 1885: Exposition internationale—Le Salon—Les Indépendants," *La Revue Moderniste* 5 (June 1885): 6–7.

6. Baudelaire's metaphorical "correspondence" between Delacroix's color and Weber's music makes up a quatrain of "Les Phares" in "Exposition universelle—1885—Beaux-Arts," in *Oeuvres*, 2: 595.

7. Guigou, "L'Art en 1885," pp. 7–8.

8. Emile Verhaeren, "L'Impressionnisme" (1885), in *Sensations* (Paris, 1927), p. 178.

CHAPTER FIVE

1. Octave Mirbeau, "Notes sur l'art: Claude Monet," *La France*, 21 November 1884, in *Correspondance avec Claude Monet*, ed. Pierre Michel and Jean-François Nivet (Tusson, 1990), p. 233. In return for Mirbeau's article, Monet presented the writer with a painting of the Pourville cabin (W. 739), yet another avatar of the artist's Narcissus-like gaze.

2. [François] Thiébault-Sisson, "Autour de Claude Monet: Anecdotes et souvenirs—II," *Le Temps*, 8 January 1927.

3. Zacharie Astruc, *Les 14 Stations du Salon, suivies d'un récit douleureux* (Paris, 1859), p. 400.

4. Jean Richepin, "La Gloire de l'eau," in *La Mer* (Paris, 1886), p. 319. Elsewhere in the volume the poet insists that "An obscure instinct pushes us / Never to forget / That before seeing the light / We had our first water / For familiar element" (p. 345). Monet owned this edition and knew the poet quite well (see Monet's letter to Auguste Rodin, 12 June 1887; L. 792).

5. Albert Wolff, "Exposition internationale," *Le Figaro*, 19 June 1886.

6. For Moréas's poem "Monet (Claude)" (1886), see Robert A. Jouanny, *Jean Moréas: Ecrivain français* (Paris, 1969), p. 812.

7. Paul Gilbert, "Exposition internationale," *Journal des Artistes*, 27 June 1886, p. 213.

8. Marcel Fouquier, "L'Exposition internationale de peinture et de sculpture," *Le XIXe Siècle*, 17 June 1886.

9. Félix Fénéon, "Ve Exposition internationale de peinture et de sculpture," *La Vogue* 1 (28 June 1886): 341–46; revised in *Les Impressionnistes en 1886* (Paris, October 1886), in *Oeuvres plus que complètes*, ed. Joan U. Halperin, 2 vols. (Geneva, 1970), 1: 41, 51n.

10. Ibid., 1: 41.

11. Helen Cecelia De Silver Abbot Michael [Celen Sabbrin], *Science and Philosophy in Art* (New York, 1886), pp. 3–4, 7, 11, 14–15, 18.

12. Fénéon, "Dix Marines d'Antibes de M. Claude Monet," *La Revue Indépendante de Littérature et de l'Art*, n.s. 8 (July 1888): 154, in *Oeuvres*, 1: 113.

13. Guy de Maupassant, "La Vie d'un paysagiste," *Gil Blas,* 28 September 1886, in *Etudes, chroniques et correspondance,* ed. René Dumesnil (Paris, 1938), pp. 167–68.

14. Ibid., pp. 168–69.

15. Hugues Le Roux, "Silhouettes parisiens: L'Exposition de Claude Monet," *Gil Blas,* 3 March 1889, pp. 1–2.

CHAPTER SIX

1. Marc-Antoine de Saint-Amant, "La Solitude," in *Anthologie de la poésie baroque française,* 2 vols., ed. Jean Rousset (Paris, 1961), 1: 239. An earlier version of this chapter was published as "Seascapes of the Sublime: Vernet, Monet, and the Oceanic Feeling," *New Literary History* 16 (Winter 1985): 377–400.

2. Gustave Flaubert, *Par les champs et par les grèves* (Paris, 1910), pp. 130–31.

3. Maxime Du Camp, *Le Salon de 1859* (Paris, 1859), pp. 75–76. In "Monet et Belle-Ile en 1886," *Bulletin des Amis du Musée de Rennes,* no. 4 (1980): 27–55, Denise Delouche illustrates the painting by Penguilly-l'Haridon as well as Théodore Gudin's *Tempest on the Coast of Belle-Ile* (1851; Musée des Beaux-Arts, Quimper).

4. Baudelaire, "Salon de 1859," in *Oeuvres,* 2: 653.

5. Gustave Geffroy, *Pays d'ouest* (Paris, 1897), p. 261, in *Claude Monet: Sa Vie, son oeuvre* (Paris, 1922), p. 185.

6. Anon., "Chronique régionale: Morbihan," *Phare de la Loire,* 6 November 1886.

7. *Explication des ouvrages de peinture, sculpture, architecture et gravure, des artistes vivants, exposés au Musée royal des arts* (Paris, 1822), p. 185.

8. Longinus, *On the Sublime,* trans. W. R. Roberts, in *Critical Theory since Plato,* ed. Hazard Adams (New York, 1981), p. 97. Also see Neil Hertz, "A Reading of Longinus," *Critical Inquiry* 9 (March 1983): 579–96.

9. Immanuel Kant, *Critique of Judgment,* trans. J. H. Bernard, in Adams, *Critical Theory,* p. 396.

10. Arthur Schopenhauer, *The World as Will and Idea* (1819; rev. ed. 1844), trans. R. B. Haldane and John Kemp, in *Philosophies of Art and Beauty: Selected Readings in Aesthetics from Plato to Heidegger,* ed. Albert Hofstadter and Richard Kuhns (Chicago, 1964), pp. 464–65.

11. Sigmund Freud, *Beyond the Pleasure Principle* (1920), in *Standard Edition of the Complete Psychological Works of Sigmund Freud,* ed. and trans. James Strachey and Anna Freud, with Alix Strachey and Alan Tyson, 24 vols. (London, 1953–75) (hereafter *S.E.*), 18: 50.

12. Pierre-Henri [de] Valenciennes, *Elémens de perspective pratique, à l'usage des artistes, suivis de réflexions et conseils à un éleve sur la peinture et particulièrement sur le genre du paysage* (Paris, 1800), p. 495.

13. Anne-Louis Girodet-Trioson, *Oeuvres posthumes,* ed. P. A. Coupin, 2 vols. (Paris, 1829), 1: 105, in George Levitine, "Vernet Tied to a Mast in a Storm: The Evolution of an Episode of Art Historical Romantic Folklore," *Art Bulletin* 49 (1967): 95.

14. Henri Beyle [Stendhal], *Oeuvres intimes* (Paris, 1961), p. 1368, in Levitine, "Vernet Tied to a Mast," p. 98. Monet wrote to his friend Bazille of an apparent suicide attempt by drowning (29 June 1868; L. 40).

15. Arsène Houssaye, *Histoire de l'art français* (Paris, 1860), p. 284, in Levitine, "Vernet Tied to a Mast," p. 96; and Victor Hugo to E. Deschanel (1854), in Jay K. Ditchy, *La Mer dans l'oeuvre littéraire de Victor Hugo* (Paris, 1925), p. 45.

16. Julien Viaud [Pierre Loti], *Pêcheur d'Islande* (Paris, 1924; orig. ed., 1886), pp. 343–44.

17. Joris-Karl Huysmans, "L'Exposition internationale de la rue de Sèze," *La Revue Indépendante de Littérature et d'Art,* n.s. 3 (June 1887): 352.

18. Jules Desclozeaux, "L'Exposition internationale de peinture," *L'Estafette,* 15 May 1887; and Alfred de Lostalot, "Exposition internationale de peinture et de sculpture," *Gazette des Beaux-Arts,* 2nd ser. 35 (June 1887): 524.

19. Gustave Kahn, "La Vie artistique," *La Vie Moderne* 9 (21 May 1887): 328.

20. Arthur d'Echerac [G. Dargenty], "Exposition internationale de peinture et de sculpture: Galerie Georges Petit," *Courrier de l'Art* 7 (27 May 1887): 163.

21. P[ierre] H[éela], "L'Exposition internationale de la rue de Sèze," *Le Journal des Arts,* 7 June 1887.

22. Octave Mirbeau, "Chronique parisienne: Kervilahouen," *La Revue Indépendante de Littérature et d'Art,* n.s. 2 (January 1887): 25–26.

23. Mirbeau, "L'Exposition internationale de la rue de Sèze," *Gil Blas,* 13 May 1887, in *Correspondance,* p. 239.

24. Gustave Geffroy, "Salon de 1887. VI. Hors du Salon: Claude Monet," *La Justice,* 2 June 1887, in *La Vie artistique,* 8 vols. (Paris, 1892–1903), 3: 71–72.

25. Ibid., p. 72.

26. Ibid., p. 73.

27. Ibid., p. 74.

28. Freud, *Beyond the Pleasure Principle, S.E.,* 18: 42. For Freud's first references to art and sublimation, see *Three Essays on the Theory of Sexuality* (1905), *S.E.,* 7: 156–57, 178–79, 238–39; and *Leonardo da Vinci and a Memory of His Childhood* (1910), *S.E.,* 11: 78, 80–81, 97, 122–23, 132–36. I discuss Freud's theory of art in relation to the language of Monet's critics in "Monet, Fantasy, and Freud," in *Psychoanalytic Perspectives on Art,* ed. Mary Mathews Gedo, 3 vols. (Hillsdale, N.J., 1985–88), 1: 29–55.

29. Le Roux, "Silhouettes parisiennes," p. 1.

30. Monet's remark is quoted in Geffroy, *Claude Monet,* p. 8.

Chapter 7

1. Pol Neveux, "Guy de Maupassant: Etude" (1907), in Guy de Maupassant, *Boule de suif* (Paris, 1926), p. lxxxv.

2. Guy de Maupassant, *Sur l'eau* (Paris, 1888), p. 8.

3. Ibid., p. 10.

4. Ibid., pp. 10–11.

5. Ibid., p. 11.

6. Vincent van Gogh to John Russell, June-July 1888, in *Verzamelde Brieven van Vincent van Gogh,* ed. J. van Gogh-Bonger, 4 vols. in 2 (Amsterdam, 1955), 3: 241.

7. Maupassant, *Sur l'eau,* p. 15.

8. Ibid., pp. 43–45.

9. Ibid., pp. 79–80.

10. Ibid., p. 78.

11. Ibid., p. 82.

12. Ibid., pp. 163, 165.

13. Geffroy, "Chronique: Dix Tableaux de Claude Monet," *La Justice,* 17 June 1888, in *La Vie artistique,* 3: 78–79.

14. Maupassant, *Sur l'eau,* pp. 75–76. In *Les Dieux antiques* Mallarmé relates the love of Echo for the solar Narcissus to that of the lunar goddess Selene for the sleeping Endymion, in *Oeuvres,* p. 1248.

15. Geffroy, "Dix Tableaux," in *La Vie artistique,* 3: 79–80.

16. Ibid., p. 81.

17. Gustave Geffroy, *Images du jour et de la nuit* (Paris, 1924), pp. 156–57.

18. Morisot to Monet, June 1888, in *Correspondance de Berthe Morisot avec sa famille et ses amis Manet, Puvis de Chavannes, Degas, Monet, Renoir et Mallarmé,* ed. Denis Rouart (Paris, 1950), pp. 135–36; and Mallarmé to Monet, 11 June 1888, in *Correspondance,* ed. Henri Mondor and Lloyd J. Austin, 11 vols. (Paris, 1959–84), 3: 212. Also see André Fontainas, "Rêverie à propos de Stéphane Mallarmé: L'Oeuvre et l'homme," *Mercure de France,* n.s. 304 (September 1948): 61: "I had gone up to Mallarmé, happy . . . to tell him that . . . I had noticed a dazzling tree exhibited in the window by Claude Monet. Yes, Mallarmé said ecstatically, that superb Monet, a peacock burning up the landscape with his spread-out tail."

19. Mallarmé, "Brise Marine" (1866), in *Oeuvres,* p. 38.

20. Baudelaire, "Parfum exotique" (1857), in *Oeuvres,* 1: 25–26.

21. Geffroy, "Dix Tableaux," in *La Vie artistique,* 3: 81.

22. Maurice Bouchor, *Les Symboles* (Paris, 1888), p. 129.

23. Bouchor to Monet, July 1888, in Wildenstein, *Monet,* 3: 299, no. 116.

24. G[eorges] J[eanniot], "Notes sur l'art: Claude Monet," *La Cravache Parisienne,* 23 June 1888, p. 1.

25. Ibid.

26. Ibid.

27. Ibid.

28. Ibid., pp. 1–2.

29. Raoul dos Santos, "Exposition Claude Monet," *Journal des Artistes,* 8 July 1888, p. 223.

30. Paul Robert [Eaque], "Claude Monet," *Le Journal des Arts,* 6 July 1888.

31. Fénéon, "Dix Marines d'Antibes," in *Oeuvres,* 1: 113.

32. Camille Pissarro to Lucien Pissarro, 8 July 1888, in *Lettres à son fils Lucien,* ed. John Rewald (Paris, 1950), p. 171.

CHAPTER EIGHT

1. Le Roux, "Silhouettes parisiens," p. 1.

2. Ibid., p. 2.

3. Ibid.

4. Ibid.

5. Ibid.

6. Loti, *Pêcheur d'Islande,* pp. 204, 334.

7. Le Roux, "Silhouettes parisiens," p. 2.

8. Ibid.

9. Paul Mantz, "Salon de 1863," pp. 60–61.

10. See André Arnyvelde, "Chez le peintre de la lumière," *Je Sais Tout* 10 (15 January 1914): 29–38. For a press report on the action for libel, see *The Daily News* (London), 26 November 1878, in *From the Classicists to the Impressionists: A Documentary History of Art and Architecture in the Nineteenth Century,* ed. Elizabeth Gilmore Holt (Garden City, N.Y., 1966), p. 391.

11. James McNeill Whistler, "Mr. Whistler's 'Ten O'Clock,'" in *The Gentle Art of Making Enemies* (New York, 1890), p. 144. Also see "Le 'Ten O'Clock' de M. Whistler," in Mallarmé, *Oeuvres,* p. 574.

12. Whistler, "Ten O'Clock," pp. 143–45.

13. See Whistler's undated letter in which the resemblance to Poe is mentioned, in Mallarmé, *Oeuvres,* p. 1606; and Edgar Allan Poe, *Complete Poems,* ed. Louis Untermeyer (New York, 1943), p. 185.

14. Poe, *Poems,* pp. 67, 135–36; and "Les Poëmes d'Edgar Poe," in Mallarmé, *Oeuvres,* pp. 195, 206, 212.

15. Marcel Fouquier, "Petites exposition: L'Exposition Claude Monet," *Le XIXe Siècle,* 6 June 1889.

16. Charles Frémine, "Claude Monet et Auguste Rodin," *Le Rappel,* 23 June 1889.

17. Joseph Gayda, "L'Exposition de la rue de Sèze: Monet et Rodin," *La Presse,* 25 June 1889.

18. See Reg Carr, *Anarchism in France: The Case of Octave Mirbeau* (Montreal, 1977), pp. 25–29.

19. Octave Mirbeau, "Le Chemin de la Croix," *Le Figaro,* 16 January 1888, in *Des artistes,* 2 vols. (Paris, 1922), 1: 65–66.

20. Ibid., pp. 67–68.

21. Mirbeau, "Claude Monet," *Le Figaro,* 10 March 1889, in *Correspondance,* p. 241.

22. Ibid.

23. Ibid., p. 242.

24. Ibid.

25. Ibid.

26. Ibid., p. 243.

27. On the cult of the self, see Daniel Moutote, *Egotisme français moderne: Stendhal, Barrès, Valéry, Gide* (Paris, 1980).

28. Mirbeau, "Claude Monet," in *Correspondance,* p. 243.

29. Ibid., pp. 243–44. Mirbeau's undated letter on p. 61 appears to have been written to Monet at Antibes in March 1888.

30. Ibid., p. 244. The letter from late February 1889 is on p. 75.

31. Ibid., p. 244.

32. See Jacques Lacan, "What Is a Picture?" (1964), in *The Four Fundamental Concepts of Psycho-Analysis,* trans. Alan Sheridan (New York, 1978), pp. 105–19.

33. Mirbeau, "Claude Monet," in *Correspondance,* pp. 244–45.

34. Ibid., p. 244.

35. Ibid., p. 245.

36. Léon Roger-Milès, "Beaux-Arts: Claude Monet," *L'Evénement,* 15 March 1889.

37. Frantz Jourdain, "Claude Monet: Exposition du boulevard Montmartre," *La Revue Indépendante de Littérature et d'Art,* n.s. 10 (March 1889): 513.

38. Ibid., pp. 514–15.

39. Ibid., p. 515.

40. Ibid., pp. 515–16.

CHAPTER NINE

1. Gustave Geffroy, "Maurice Rollinat: *Les Nevroses*" and "*Dans les brandes,*" *La Justice,* 1 March and 25 August 1883, in *Notes d'un journaliste: Vie, littérature, théâtre* (Paris, 1887), pp. 283, 288.

2. Ibid., pp. 286–87, 280, 289, 281.

3. Rollinat to Geffroy, 16 June 1888 and January 1889, in *Fin d'oeuvre* (Paris, 1919), pp. 272, 274–75.

4. Maurice Rollinat, *L'Abîme* (Paris, 1886), p. 1. Monet owned dedicated copies of this and other volumes of Rollinat's verse.

5. Maurice Rollinat, *Les Névroses* (Paris, 1883), p. 204.

6. Ibid., pp. 137–38.

7. Léon Bloy, "Les Artistes mystérieux: Maurice Rollinat," *Le Foyer Illustré,* 17 and 24 September, 10 October 1882, in Maurice Rollinat, *Oeuvres,* ed. Régis Miannay, 2 vols. (Paris, 1971–72), 2: 402–3.

8. Gustave Geffroy, "Maurice Rollinat," in Rollinat, *Fin d'oeuvre,* p. 25.

9. See Salman Akhtar, "Narcissistic Personality Disorder: Descriptive Features and Differential Diagnosis," *Psychiatric Clinics of North America* 12 (September 1989): 505–28.

10. On the "secret sharing" or narcissistic partnerships of creative artists, see John E. Gedo, *Portraits of the Artist: Psychoanalysis of Creativity and Its Vicissitudes* (New York, 1983).

11. Rollinat to Monet, 25 May and 11 August 1889, in Geffroy, *Claude Monet,* pp. 207–9.

12. Octave Mirbeau, "Claude Monet," in *Exposition Claude Monet–Auguste Rodin: Galerie Georges Petit* (Paris, 1889), pp. 23, 10–11. A facsimile of the catalogue is included along with selected reviews of the exhibition in *Claude Monet–Auguste Rodin: Centenaire de l'exposition de 1889* (Paris, 1989–90).

13. Mirbeau, *Exposition Claude Monet,* pp. 18–20.

14. Ibid., p. 23.

15. See Mirbeau to Monet, 7 July 1889, late December 1889, 25 July 1890, in *Correspondance,* pp. 82–83, 90–91, 101–3.

16. Mirbeau, *Exposition Claude Monet,* pp. 23–24.

17. Fernand Bourgeat, "Paris vivant: A la galerie Georges Petit," *Le Siècle,* 22 June 1889.

18. Frémine, "Claude Monet et Auguste Rodin"; and Anon., "L'Exposition Monet–Rodin," *Le Matin,* 23 June 1889.

19. Octave Mirbeau, "Auguste Rodin," *L'Echo de Paris,* 25 June 1889. Rodin's sculptures, many of them depicting mythological subjects, could be said to animate with their violent and erotic presence the imaginary world projected upon the walls of the gallery by Monet's landscapes.

20. Auguste Dalligny, "Auguste Rodin et Claude Monet à la rue de Sèze," *Le Journal des Arts,* 5 July 1889.

21. Alphonse de Calonne, "L'Art contre nature," *Le Soleil,* 23 June 1889.

22. See Pierre Janet, *L'Automatisme psychologique* (Paris, 1889). Janet utilized

the term "subconscious" in order to distinguish his psychodynamic approach from the "unconscious" of Schopenhauerian metaphysics (to which, in the end, Freud's "unconscious" is perhaps more closely akin); see Henri F. Ellenberger, *The Discovery of the Unconscious: The History and Evolution of Dynamic Psychiatry* (New York, 1970), p. 413.

23. Anon., "Concours et expositions," *La Chronique des Arts,* 6 July 1889. Also see Alfred Ernst, "Claude Monet et Rodin," *La Paix,* 3 July 1889: "This painter is one of the most personal of the present time."

24. Jules Antoine, "Beaux-arts: Exposition de la galerie Georges Petit," *Art et Critique* 1 (29 June 1889): 75–76; and Fénéon, "Exposition de M. Claude Monet," *La Vogue,* September 1889, in *Oeuvres,* p. 162.

25. Emile Cardon, "Exposition des oeuvres de Rodin et Claude Monet," *Moniteur des Arts* 31 (28 June 1889): 237–38.

26. J. Le Fustec, "L'Exposition Monet–Rodin," *La République Française,* 28 June 1889.

27. Paul Foucher, "Libres chroniques," *Gil Blas,* 28 June 1889.

28. Verhaeren, "Claude Monet–Auguste Rodin," *L'Art Moderne,* 7 July 1889, p. 210 (unsigned), in *Sensations,* p. 184.

29. Ibid., pp. 210–11.

30. Geffroy, *Claude Monet,* pp. 199–200.

31. Ibid., pp. 200, 203.

32. Geffroy, "Chronique: La Creuse," *La Justice,* 2 and 4 August 1889, in *Claude Monet,* pp. 203–6.

33. Ibid., p. 206.

CHAPTER TEN

1. Mirbeau, *Exposition Claude Monet,* pp. 9, 23; and idem, "Claude Monet," in *Correspondance,* p. 245.

2. Mirbeau to Monet, ca. March 1888, in *Correspondance,* p. 61.

3. See the reviews by Calonne, Cardon, Antoine, and Verhaeren cited in the previous chapter.

4. See Steven Z. Levine, "Monet, Madness, and Melancholy," in *Psychoanalytic Perspectives on Art,* 2: 111–32.

5. Mallarmé to Monet, 18 October 1889, in *Correspondance,* 3: 363–64.

6. Ibid., p. 364.

7. Villiers de l'Isle-Adam, *Tribulat Bonhomet,* ed. P. G. Castex and J. M. Bellefond (Paris, 1967), p. 132. In the text God is described as a narcissistic projection, and the ideas of Kant and Schopenhauer are invoked.

8. Mallarmé to Monet, 21 July 1890, in *Correspondance,* 4: 123–24.

9. Geffroy, *Claude Monet,* p. 323.

10. Mallarmé, "La Gloire" (1886), in *Oeuvres,* pp. 288–89. The translations from Mallarmé are my own, but I have been assisted here and elsewhere by the prose renditions of Anthony Hartley in *Mallarmé* (Harmondsworth, 1965).

11. Mallarmé, "Le Nénuphar blanc" (1985), in *Oeuvres,* pp 283–84.

12. The photograph taken by Cl. Choumoff in 1920 is reproduced in Duc de Trevise, "Le Pèlerinage de Giverny," *La Revue de l'Art Ancien et Moderne* 51 (January-May 1927): 45.

13. Mallarmé, "Le Nénuphar blanc," in *Oeuvres,* p. 284.

14. Barbara Johnson, "Allegory's Trip-Tease: *The White Waterlily,*" in *The Critical Difference: Essays in the Contemporary Rhetoric of Reading* (Baltimore, 1980), p. 16.

15. Mallarmé, "Le Nénuphar blanc," in *Oeuvres,* p. 284.

16. Ibid.

17. Ovid, *Metamorphoses,* trans. Frank Justus Miller, 2 vols. (London, 1925), 1: 148–49.

18. Roger Dragonetti, " 'Le Nénuphar blanc': A Poetic Dream with Two Unknowns," *Yale French Studies,* no. 54 (1977): 133. Also see Lucienne Frappier-Mazur, "Narcisse Travesti: Poétique et idéologie dans *La Dernière Mode* de Mallarmé," *French Forum* 11 (January 1986): 41–57.

19. Mallarmé, "Le Nénuphar blanc," in *Oeuvres,* p. 285.

20. Ibid.

21. On Monet's depiction of his studio-boat as a self-portrait, see Paul Tucker, *Monet at Argenteuil* (New Haven, 1982), pp. 112–13; and Charles S. Moffett, "The Boat Studio," in Richard J. Wattenmaker et al., *Great French Paintings from the Barnes Foundation* (New York, 1993), pp. 98–101. For an unfinished version of Manet's painting from Monet's collection, now in the Staatsgalerie, Stuttgart, see Wildenstein, *Monet,* 5: 291. Also see Monet's drawing of the scene as viewed from within the studio-boat (W. D148).

22. Mallarmé, "Le Nénuphar blanc," in *Oeuvres,* pp. 285–86.

23. Ibid., p. 286.

24. Bory Latour-Marliac, *Notice sur les nymphaea et nelumbium rustiques: Leur culture et celle d'autres plantes aquatiques* (Temple-sur-Lot, 1888), p. 8.

25. Maupassant, *Sur l'eau,* pp. 114–15.

26. Maurice Guillemot, "Claude Monet," *Revue Illustrée* 13 (15 March 1898): n. pag.

27. Mallarmé, "Le Nénuphar blanc," in *Oeuvres,* p. 286.

28. Mirbeau, "Claude Monet," *L'Art dans les Deux Mondes,* 7 March 1891, pp. 183–84, in *Correspondance,* pp. 252–53.

29. Mallarmé, "Sur l'évolution littéraire," *L'Echo de Paris,* 14 March 1891, in *Oeuvres,* p. 869.

30. Ibid., pp. 869–70.

31. Ibid., p. 869.

32. Mallarmé to Mirbeau, 1 October 1890, in *Correspondance,* 4: 135.

33. Mirbeau to Mallarmé, 2 March 1891, ibid., 4: 201.

34. Mirbeau, *L'Art dans les Deux Mondes,* p. 184, in *Correspondance,* p. 254.

35. Mirbeau, *L'Art dans les Deux Mondes,* p. 184, in *Correspondance,* pp. 254–55.

36. Mirbeau, *L'Art dans les Deux Mondes,* pp. 184–85, in *Correspondance,* p. 255.

37. Mirbeau, *L'Art dans les Deux Mondes,* p. 185, in *Correspondance,* p. 256.

CHAPTER ELEVEN

1. Mallarmé to Valéry, 5 May 1891, in *Correspondance,* 4: 233. Also see Walter A. Strauss, "Speculations on Narcissus in Paris," *The Comparatist* 10 (May 1986): 13–29.

2. Valéry to Mallarmé, unsent letter of October 1890, in *Correspondance,* 4: 152–54.

3. For the reference to Monet's *The Train at Jeufosse* (1884; W. 912), see the biographical sketch by the poet's daughter, Agathe Rouart-Valéry, in Paul Valéry, *Oeuvres,* ed. Jean Hytier, 2 vols. (Paris, 1957–60), 1: 21–22. Valéry gave Monet a dedicated copy of *La Jeune Parque* (1917): "A M. Claude Monet, hommage de mon admiration toujours plus grande et d'un affectueux respect"; and later recorded his visit to the aged artist on 7 October 1925, in *Cahiers,* ed. Judith Robinson, 2 vols. (Paris, 1973–74), 2: 948–49.

4. Paul Valéry, "Narcisse parle," *La Conque* 1 (15 March 1891): 4, in *Oeuvres,* 1: 1551. Also see idem, "Note sur 'Narcisse' à Monsieur Julien P. Monod" (17 May 1926), in *Etudes pour Narcisse* (Paris, 1927), n. pag.; and idem, "Sur les 'Narcisse'" (19 September 1941), in *Cahiers du Sud,* special number *Paul Valéry vivant,* 1946, pp. 283–87, partially cited in *Oeuvres,* 1: 1556–59, 1662. From among the many essays on the topic see Carolyn Josenhans Simmons, "An Echo in the Text: The Narcissus Poems of Paul Valéry," *French Literature Series* 18 (1991): 77–86.

5. Valéry, *Cahiers,* 2: 284–85, 307, 1665. The *cahiers* contain numerous notes on Narcissus dating from 1905 to 1945.

6. Valéry to André Lebey, undated [1907], in Paul Valéry, *Lettres à quelques uns* (Paris, 1952), pp. 80–81.

7. Valéry, "Avec soi seul" (1939), in *Oeuvres,* 1: 332.

8. See Jeannine Jallat, *Introduction aux figures valéryennes (imaginaire et théorie)* (Pisa, 1982), p. 153.

9. Valéry, "Louanges de l'eau" (1935), in *Oeuvres,* 1: 202.

10. Gide to Valéry, 26 January 1891, in André Gide and Paul Valéry, *Correspondance 1890–1942,* ed. Robert Mallet (Paris, 1955), p. 46.

11. Valéry to Gide, 1 February 1891, ibid., pp. 48–49.

12. Gide to Valéry, 1 March 1891, ibid., pp. 56–57.

13. Gide to Valéry, 21 March 1892, ibid., p. 154.

14. Valéry to Gide, late June 1917, ibid., p. 451.

15. Valéry's remark is from a notebook of 1931, in *Cahiers,* 1: 128.

16. Gide to Valéry, 23 June and 3 November 1891, in *Correspondance,* pp. 99–100, 134.

17. Gide to Valéry, 27 November 1893, ibid., p. 192.

18. For an annotated edition of the work that includes an excellent introduction, see Réjean Robidoux, *Le Traité du Narcisse (Théorie du Symbole) d'André Gide* (Ottawa, 1978), p. 103.

19. Ibid., pp. 103–4.

20. Ibid., pp. 105–7.

21. André Gide [André Walter], "Notes d'un voyage en Bretagne" (1891), in *Oeuvres complètes,* ed. L. Martin-Chauffier, 15 vols. (Paris, n.d. [1932]), 1: 7–8. Also see Jean Rousset, *L'Intérieur et l'extérieur: Essais sur la poésie et sur le théâtre au XVIIe siècle* (Paris, 1968), p. 227.

22. Robidoux, *Traité,* pp. 108–9. Ygdrasil, most likely familiar to Gide from Wagnerian opera, is an evergreen tree in Scandinavian mythology that binds together the abodes of the gods, the living, and the dead.

23. Louis Désiré, "Claude Monet," *L'Evénement,* 19 May 1891.

24. Robidoux, *Traité,* pp. 110–11.

25. Ibid., p. 112. On Plato's myth of the cloven sexual dyad as treated by Freud and Lacan, see Samuel Weber, *The Legend of Freud* (Minneapolis, 1982), pp. 148–64.

26. Robidoux, *Traité,* pp. 114–15.

27. Ibid., p. 116. For a pictorial exchange between the images of the dying Narcissus and the dead Christ, see Erwin Panofsky, "Imago Pietatis: Ein Beitrag zur Typengeschichte des 'Schmerzensmanns' und der 'Maria Mediatrix,' " in *Festschrift für Max J. Friedländer zum 60. Geburtstage* (Leipzig, 1927), p. 296, n. 5, where he notes the formal similarity between the *Dead Christ* by Paris Bordone in the Palazzo Ducale, Venice, and Poussin's *Echo and Narcissus* in the Musée du Louvre, Paris. Not noted by Panofsky is the neo-Platonic tradition in which Narcissus and his reflection are seen as an allegory of God's reflection as Christ in the pure well of the Virgin's womb. See Pierre de Marbeuf, "Le Tableau de Narcisse" (1620): "The Virgin is a fountain / . . . In this crystal you see yourself, / Great God perfect Narcissus. / And you yourself admire yourself in yourself, / In love with your object," in Vinge, *Narcissus,* p. 227. Also see

Hubert Damisch, "D'un Narcisse l'autre," in the special number *Narcisses, Nouvelle Revue de Psychanalyse*, no. 13 (Spring 1976): 109–46.

28. Robidoux, *Traité*, pp. 123–24.

29. Ibid., p. 117.

30. See Willem G. C. Byvanck, *Un Hollandais à Paris en 1891: Sensations de littérature et d'art* (Paris, 1892), p. 177.

31. Robidoux, *Traité*, pp. 117–19. Also see Emily S. Apter, "Gide's *Traité du Narcisse*: A Theory of the Post-Symbolist Sign," *Stanford French Review* 9 (Summer 1985): 189–99.

32. Robidoux, *Traité*, p. 119.

33. Ibid., pp. 120–21.

34. Ibid., pp. 19–20.

35. Blanche to Gide, 27 October 1907, in André Gide and Jacques-Emile Blanche, *Correspondance André Gide Jacques-Emile Blanche 1892–1939*, ed. Georges-Paul Collet (Paris, 1979), p. 156.

36. See Jallat, *Figures valéryennes*, pp. 251–52; and Valéry, *Cahiers*, 2: 948.

37. Valéry, *Cahiers*, 2: 1008 (ca. 1920–21).

38. *Musée Gustave Moreau: Catalogue des peintures, dessins, cartons, aquarelles* (Paris, 1974), p. 62. Ten representations of Narcissus are listed in the catalogue. Also see André Guyaux, "Narcisse au crépuscule," in *Fins de Siècle: Terme—Evolution—Révolution?*, ed. Gwenhaël Ponnau (Toulouse, 1989), pp. 345–54.

39. Jallat, *Figures valéryennes*, p. 252. The original title page of Gide's treatise displays beneath the hand-lettered words *TRAITÉ DU* a drawing by Pierre Louÿs of a bent-over narcissus and its fragmentary reflection in the water; the name of Narcissus does not appear (for an illustration, see Robidoux, *Traité*, p. 102).

40. Mauclair to Mallarmé, 2 May 1891, in Mallarmé, *Correspondance*, 4: 232.

41. Séverin Faust [Camille Mauclair], "L'Exposition Claude Monet: Durand-Ruel," *La Revue Indépendante de Littérature et d'Art*, n.s. 19 (May 1891): 267–69.

42. Valéry, *Cahiers*, 2: 1327 (1927).

43. Mallarmé to Mirbeau, 5 April 1892, in *Correspondance*, 5: 65.

44. Mirbeau to Monet, 17 February 1892, in *Correspondance*, p. 134.

45. Ibid., p. 133.

46. Séverin Faust [Camille Mauclair], "Notes éparses sur le Barrésisme," *La Revue Indépendante de Littérature et d'Art*, n.s. 22 (January 1892): 159.

47. Séverin Faust [Camille Mauclair], "Exposition Claude Monet: Durand-Ruel," *La Revue Indépendante de Littérature et d'Art*, n.s. 22 (March 1892): 417–18.

48. Ibid., p. 418.

49. Ibid.

50. Ibid.

51. Séverin Faust [Camille Mauclair], *Servitude et grandeur littéraires: Souvenirs d'arts et de lettres de 1890 à 1900* (Paris, 1922), p. 195.

52. Séverin Faust [Camille Mauclair], "Narcisse," *La Revue Blanche* 3 (July 1892): 43.

53. Faust [Mauclair], "Exposition Claude Monet" (1892), p. 417.

54. Gustave Geffroy, "Chronique artistique: Les Peupliers," *La Justice,* 2 March 1892, in *La Vie artistique,* 3: 91, and in *Claude Monet,* p. 298. Elsewhere in the text of *Claude Monet* (1922) Geffroy refers to Monet's "funereal poplars" (p. 266).

55. Faust [Mauclair], "Narcisse," p. 44.

56. Anon., "Chez les peintres: Claude Monet–Albert Besnard," *Le Temps,* 1 March 1892.

57. Faust [Mauclair], "Narcisse," pp. 44–45.

58. Firmin Javel, "Claude Monet," *Gil Blas,* 2 March 1892; and Geffroy, "Les Peupliers," in *La Vie artistique,* 3: 93–94.

59. Cyrano de Bergerac, *Oeuvres,* p. 45.

60. Ibid. The erotic-aquatic myths of Apollo and Daphne and Narcissus and Echo are also juxtaposed in Nicolas Poussin's near-contemporary painting of 1665 in the Musée du Louvre, Paris.

61. Faust [Mauclair], "Narcisse," p. 45.

62. Geffroy, "Les Peupliers," in *La Vie artistique,* 3: 95.

63. Faust [Mauclair], "Narcisse," pp. 45–46.

64. Clément Janin, "Claude Monet," *L'Estafette,* 10 March 1892.

65. Ibid.

66. Ibid.

67. Georges Lecomte, "Des tendances de la peinture moderne," *L'Art Moderne,* 14 February 1892, p. 50; and idem, "Des tendances de la peinture moderne (suite)," ibid., 21 February 1892, p. 58. Also see Richard Shiff, *Cézanne and the End of Impressionism: A Study of the Theory, Technique, and Critical Evaluation of Modern Art* (Chicago, 1984).

68. Georges Lecomte, "Peupliers de M. Claude Monet," *Art et Critique* 4 (5 March 1892): 124–25.

69. Ibid., p. 124.

70. Ibid., p. 125.

71. G.-Albert Aurier, "Claude Monet," *Mercure de France,* n.s. 4 (April 1892): 302–3. Also see Patricia Townley Mathews, *Aurier's Symbolist Art Criticism and Theory* (Ann Arbor, 1986).

72. Aurier, "Claude Monet," p. 303.

73. Ibid., p. 305.

74. Ibid., p. 304.

75. Séverin Faust [Camille Mauclair], "Notes sur l'idée pure," *Mercure de France,* n.s. 6 (September 1892): 42. Also see Pierre Hadot, "Le mythe de Narcisse et son interprétation par Plotin," in *Narcisses,* pp. 81–108.

76. Faust [Mauclair], "Notes," p. 42.

77. Ibid., pp. 42–43.

78. Ibid., p. 43.

79. Faust [Mauclair], "Exposition Claude Monet" (1892), p. 418.

80. Faust [Mauclair], "Notes," p. 43.

81. Ibid., p. 44.

82. Ibid.

83. Ibid., p. 45.

84. Ibid., p. 46.

85. See Michael Marlais, *Conservative Echoes in "Fin-de-siècle" Parisian Art Criticism* (University Park, Pa., 1992), pp. 151–53.

86. Séverin Faust [Camille Mauclair], *Eleusis: Causeries sur la cité intérieure* (Paris, 1894), pp. 164–65.

87. See Larousse, *Dictionnaire,* 11: 838.

88. Faust [Mauclair], *Eleusis,* pp. 8–9. Also see Richard Rorty, *Philosophy and the Mirror of Nature* (Princeton, 1979).

89. Faust [Mauclair], *Eleusis,* pp. 11, 13–21.

90. Faust [Mauclair], "Exposition Claude Monet" (1892), p. 418.

91. Ibid., p. 22. For a rather skeptical account of Mauclair's eclectic appropriation of Barrès, Mallarmé, and Plato, see Lucien Muhlfeld, "Chronique de la littérature: Eleusis," *La Revue Blanche* 6 (March 1894): 260–63.

92. Faust [Mauclair], *Eleusis,* p. 22.

93. Faust [Mauclair], "Exposition Claude Monet" (1892), p. 418.

94. Faust [Mauclair], *Eleusis,* p. 23.

95. Ibid., pp. 23–25.

96. Ibid., p. 24.

97. Faust [Mauclair], "Notes," p. 45.

98. Faust [Mauclair], *Eleusis,* p. 24. For the ambivalent charge of female narcissism in the late nineteenth century, see Armand Silvestre, *Le Nu au Salon des Champs Elyseés* (Paris, 1891): "The immortal fable of Narcissus has been brought to life again in this graceful painting [by Fichel, of a woman kissing her own mirror reflection]. But how much more excusable is this woman than the melancholic hero of the fable, this woman who is shown to us here so madly in love

with her own image! Man certainly has better things to do than to contemplate himself in the reflection of his doubtful beauty"; in Bram Dijkstra, *Idols of Perversity: Fantasies of Feminine Evil in Fin-de-Siècle Culture* (New York, 1986), pp. 143–44. Silvestre was an early enthusiast for Monet's river scenes, and it may be appropriate to speculate that the middle-class prejudice against the cultivation of a masculine image of beauty played a role in Monet's displacement of self-reflection onto the body of a feminized nature with which he might covertly identify.

99. Faust [Mauclair], *Eleusis*, pp. 25, 28.

100. Ibid., p. 30.

101. Honoré de Balzac, *Modeste Mignon* (1844), in *La Comédie Humaine*, ed. Marcel Bouteron, 11 vols. (Paris, 1935), 1: 467.

102. Faust [Mauclair], *Eleusis*, pp. 35–36.

103. Ibid., p. 30. Also see George Boas, " 'Il faut être de son temps,' " *Journal of Aesthetics and Art Criticism* 1 (1941): 52–65.

104. Edmond Pilon, "L'Année poétique," *L'Ermitage*, December 1895, in Michel Décaudin, *La Crise des valeurs symbolistes: Vingt Ans de poésie française 1895–1914* (Toulouse, 1960), p. 56.

105. For his retrospective account of the clinical origin of the term around 1898, see Havelock Ellis, *Studies in the Psychology of Sex*, 2 vols. (New York, 1936), 2: 355–57. Freud corroborates Ellis's terminological priority in "On Narcissism: An Introduction" (1914), *S.E.*, 14: 73.

106. Saint-Georges de Bouhélier, *Discours sur la Mort de Narcisse, ou l'impérieuse métamorphose: Théorie de l'amour* (Paris, 1895), pp. 29, 47, 66.

CHAPTER TWELVE

1. [François] Thiébault-Sisson, "L'Exposition Claude Monet," *Le Temps*, 12 May 1895; and A[ry] R[enan], "Cinquante Tableaux de M. Claude Monet," *La Chronique des Arts et de la Curiosité*, 18 May 1895, p. 186.

2. Gustave Geffroy, "Claude Monet," *Le Journal*, 10 May 1895, in *La Vie artistique*, 6: 167, but omitted from *Claude Monet*, p. 303.

3. Hippolyte Fiérens-Gevaert, "Chronique artistique de Paris: Exposition des oeuvres de Corot et de Claude Monet," *L'Indépendance Belge*, 20 June 1895.

4. Geffroy, "Claude Monet" (1895), in *La Vie artistique*, 6: 167; and idem, "Claude Monet," *Le Journal*, 7 June 1898, in "Claude Monet," *Le Gaulois*, 16 June 1898 (supplement), p. 1, and in *Claude Monet*, p. 303.

5. Georges Clemenceau, "Révolution des cathédrales," *La Justice*, 20 May 1895, in *Le Grand Pan* (Paris, 1896), and in *Claude Monet: Les Nymphéas* (Paris, 1928), pp. 82, 85, 87–88.

6. A[ry] R[enan], "Une collection de tableaux modernes," *Gazette des Beaux-Arts*, 3rd ser. 17 (January 1897): 73–76.

7. Ibid., p. 78.

8. Ibid., pp. 78–80.

9. Julien Leclercq, "Galerie Georges Petit," *La Chronique des Arts et de la Curiosité,* 25 February 1899, p. 70.

10. J. Buisson, "Un Claude Monet de l'exposition Petit," ibid., pp. 70–71.

11. Thiébault-Sisson, "L'Exposition Claude Monet."

12. Thadée Natanson, "Expositions: I. M. Claude Monet . . . ," *La Revue Blanche* 8 (1 June 1895): 521, 523.

13. Adolphe Brisson, "Claude Monet," *La République Française,* 28 May 1895; and anon., "Les Hommes du jour: M. Claude Monet, peintre français," *L'Eclair,* 26 May 1895.

14. Stéphane Mallarmé, *Divagations* (Paris, 1897), p. 1.

15. Ibid., pp. 5, 371–72. Also see the later image by a younger poet-acquaintance of Monet of "the sun who, in the water, makes his little Narcissus"; see Jacques Darnetal, "Entr' acte," in *Désordres: Poèmes* (Paris, 1926), p. 26.

16. Guillemot, "Claude Monet."

17. Ibid.

18. Ibid.

19. Ibid. Also see Steven Z. Levine, "Décor/Decorative/Decoration," *Arts Magazine* 51 (February 1977): 136–39.

20. Jammes to Gide, December 1898, in André Gide and Francis Jammes, *Correspondance 1893–1938 Francis Jammes et André Gide,* ed. Robert Mallet (Paris, 1948), p. 150.

21. Robert Scheffer, "Le Prince Narcisse: Monographie passionnelle," *La Revue Blanche* 11 (15 September 1896): 244, 248–52.

22. Iwan Gilkin, "Narcisse," in *La Nuit* (Brussels, 1897), in *La Poésie symboliste* (Paris, 1971), ed. Bernard Delvaille, pp. 167–68.

23. Jean Lorrain, "Narcissus," in *L'Ombre ardente* (Paris, 1897), in Delvaille, *La Poésie symboliste,* pp. 160–61.

24. Jean Lorrain, 10 December 1900; unidentified newspaper article in Philippe Jullian, *Jean Lorrain ou le satiricon 1900* (Paris, 1974), pp. 244–45.

25. Henri de Régnier, "L'Allusion à Narcisse," in *Les Jeux rustiques et divins* (Paris, 1897), p. 16.

26. Henri de Régnier, "Claude Monet" (1919), in *Vestigia Flammae: Poèmes* (Paris, 1921), pp. 239–40.

27. Bachelard, *L'Eau et les rêves,* pp. 36–37.

28. Joachim Gasquet, *Narcisse* (Paris, 1931), pp. 45, 89.

29. Ibid., pp. 42, 45, 59.

30. Ibid., pp. 96, 299.

31. Ibid., p. 262.

32. Joachim Gasquet, *Cézanne* (Paris, 1921), in *Conversations avec Cézanne*, ed. P. M. Doran (Paris, 1978), p. 110. Also see *Joachim Gasquet's Cézanne: A Memoir with Conversations*, trans. Christopher Pemberton and ed. Richard Shiff (New York, 1991).

33. Gasquet, *Narcisse*, pp. 267–68.

34. Ibid., p. 273.

35. Gasquet, *Cézanne*, in *Conversations*, p. 114.

36. Gasquet, *Narcisse*, p. 282.

37. Arsène Alexandre, "La Vie artistique: I. Paysages de M. Claude Monet," *Le Figaro*, 3 June 1898, in "Paysages de M. Claude Monet," *Le Gaulois*, 16 June 1898 (supplement), p. 2.

38. Raitif de la Bretonne, "Pall-Mall semaine," *Le Journal*, 7 June 1898.

39. Geffroy, "Claude Monet" (1898), pp. 1–2, in *La Vie artistique*, 6: 170–71, and in *Claude Monet*, pp. 303–5.

40. Gabriel Séailles, "L'Impressionnisme," in *L'Almanach du Bibliophile pour l'année 1898* (Paris, 1898), pp. 47, 51.

41. Geffroy, *La Vie artistique*, 6: 171–73.

42. Ibid., p. 174.

43. François-H. [de] Plancoët, "Silhouette artistique: Claude Monet," *Journal des Artistes*, 12 June 1898, p. 2314.

44. Charles Frémine, "Notes d'Art: Claude Monet," *Le XIXe Siècle*, 12 June 1898.

45. Anon., "Exposition d'oeuvres de M. Claude Monet," *La Chronique des Arts et de la Curiosité*, 25 June 1898, p. 212; and A[ry] R[enan], "Cinquante Tableaux," p. 186.

46. Anon., "Exposition d'oeuvres de M. Claude Monet," p. 212; and A[ry] R[enan], "Cinquante Tableaux," p. 186.

47. Georges Lecomte, "Exposition Claude Monet," *Revue Populaire des Beaux-Arts* 2 (25 June 1898): 58.

48. Lecomte, "Peupliers de M. Claude Monet," p. 124.

49. Georges Lecomte, *L'Art impressionniste d'après la collection privée de M. Durand-Ruel* (Paris, 1892), in "M. Claude Monet," *Le Gaulois*, 16 June 1898 (supplement), p. 4.

50. Lecomte, "Exposition Claude Monet," p. 58.

51. Georges Lecomte, "Des tendances de la peinture moderne (suite et fin)," *L'Art Moderne*, 28 February 1892, p. 66.

52. Lecomte, "Exposition Claude Monet," pp. 58–59.

53. André Fontainas, "Camille Mauclair," *Mercure de France*, n.s. 10 (April 1894): 340.

54. André Fontainas, "Claude Monet," *Mercure de France,* n.s. 27 (July 1898): 165–66; and idem, "Art Moderne: Galerie G. Petit; Exposition Claude Monet . . . ," ibid., pp. 278–79.

55. See *Anthologie des poètes français contemporains: Le Parnasse et les écoles postérieures au Parnasse (1866–1906),* ed. G. Walch, 3 vols. (Paris, n.d. [1906–7]), 2: 521.

56. Rollinat, "Les Reflets," "L'Allée de peupliers," "La Rivière dormante," in *Les Névroses,* pp. 11, 131, 139.

57. Maurice Rollinat, "Au crépuscule," "La Couleur du temps," in *La Nature: Poésie* (Paris, 1892), pp. 168, 176.

58. Maurice Rollinat, "Le Mirage," in *Paysages et paysans: Poésies* (Paris, 1899), p. 21.

59. "Le Saule," ibid., p. 37.

60. André Chénier, undated fragment (ca. 1790), in *Oeuvres complètes,* ed. Gérard Walter (Paris, 1940), p. 563.

61. Gustave Geffroy, "La Rivière," in *Images du jour et de la nuit,* p. 166. Rather than Narcissus per se Geffroy more generally evokes "the surging forth and warm undulation of the naiad, playful and wandering along the river's banks, of the gracious and nocturnal divinity of the streams and fountains" (p. 167).

CHAPTER THIRTEEN

1. Alexandre, "Paysages de M. Claude Monet," p. 2; and idem, "La Vie artistique: Exposition Claude Monet," *Le Figaro,* 23 November 1900.

2. Julien Leclercq, " 'Le Bassin aux Nymphéas' de Claude Monet," *La Chronique des Arts et de la Curiosité,* 1 December 1900, p. 363. Also see Geneviève Aitken and Marianne Delafond, *La Collection d'estampes japonaises de Claude Monet* (Paris, 1983).

3. Anon., "L'Impressionnisme: Exposition d'oeuvres nouvelles de Claude Monet," *La Justice,* 5 December 1900.

4. Gustave Geffroy, "Claude Monet," *Le Journal,* 26 November 1900.

5. A. E. Guyon-Vérax, "Exposition Claude Monet, galeries Durand-Ruel," *Journal des Artistes,* 9 December 1900, p. 3314.

6. See Jullian, *Jean Lorrain,* p. 244.

7. Charles Saunier, "Claude Monet," *La Revue Blanche* 23 (15 December 1900): 624. Also see Steven Z. Levine, "Monet, Lumière, and Cinematic Time," *Journal of Aesthetics and Art Criticism* 36 (Summer 1978): 441–47.

8. Saunier, "Claude Monet," p. 624.

9. Emile Verhaeren, *Les Heures du soir, précédés de Les Heures claires, Les Heures d'après-midi* (Paris, 1929), p. 65.

10. Emile Verhaeren, "Art moderne," *Mercure de France,* n.s. 37 (February 1901): 544–45.

11. Ibid., p. 545.

12. Ibid.

13. Rémy de Gourmont, "Note sur Claude Monet," *La Vogue,* 15 January 1901, in "Note sur Claude Monet," *L'Art Moderne,* 28 July 1901, p. 255, and in "L'Oeil de Claude Monet" (1900), *Promenades philosophiques* (Paris, 1905), p. 224.

14. Gourmont, "L'Oeil de Claude Monet," in *Promenades,* p. 224.

15. Rémy de Gourmont, "La Création subconsciente" (1900), in *La Culture des idées* (Paris, 1916), pp. 47–48.

16. Gourmont, "Dernière Conséquence de l'idéalisme" (1894), ibid., pp. 260–61.

17. Ibid., p. 262. (Also see idem, "La Dissociation des idées" [1899], in ibid., pp. 69–106.)

18. Ibid., pp. 264–68.

19. Ibid., pp. 268–69.

20. See Rémy de Gourmont, "Le Succès et l'idée de beauté," in *Le Chemin de velours: Nouvelles dissociations d'idées* (Paris, 1911), p. 156.

21. Rémy de Gourmont, "Hiéroglyphes," in *Divertissements: Poèmes en vers* (Paris, 1919), p. 29.

22. Rollinat, "L'Abandonée," in *Paysages et paysans,* pp. 69–70.

23. Octave Mirbeau, *Le Journal d'une femme de chambre* (Paris, 1900), p. 204. See Emily Apter, "Hysterical Vision: The Scopophilic Garden from Monet to Mirbeau," in *Feminizing the Fetish: Psychoanalysis and Narrative Obsession in Turn-of-the-Century France* (Ithaca, 1991), pp. 147–75.

24. Arsène Alexandre, "Le Jardin de Monet," *Le Figaro,* 9 August 1901.

25. Ibid.

26. Maurice Kahn, "Le Jardin de Claude Monet," *Le Temps,* 7 June 1904.

27. Pauline M. Tarn [Renée Vivien], "Water Lilies" (1903), in *Poésies complètes,* ed. Jean-Paul Goujon (Paris, 1986), p. 103, where the flowers are associated with Ophelia as well as Persephone. Charles Maurras pejoratively refers to Renée Vivien as a "Narcissus in mob-cap," in "Le Romantisme féminin" (1903), in *L'Avenir de l'intelligence* (Paris, 1905), p. 158.

28. Marie-Louise-Antoinette de Régnier [Gérard d'Houville], "Invocation," in *Les Poésies* (Paris, 1931), p. 73.

29. Marie Dauguet, "Romance," in *Par l'amour* (Paris, 1904), in Julien Eymard, *Ophélie ou le narcissisme au féminin: Etude sur le thème du miroir dans la poésie féminine* (Paris, 1977), pp. 173–74.

30. Jean Royère, "Soeur de Narcisse nue" (1907), in *Poésies* (Amiens, 1924), p. 87.

31. Jean-Marc Bernard, "La Mort de Narcisse: Eglogue" (1905), in *Oeuvres de Jean-Marc Bernard*, 2 vols. (Paris, 1923), 1: 87–88, 99.

32. See Claire Joyes, *Claude Monet: Life at Giverny* (New York, 1985), p. 123.

33. See Steven Z. Levine, "Monet's Series: Repetition, Obsession," *October*, no. 37 (Summer 1986): 65–75.

34. Marcel Proust, "Journées de lecture" (1905), in *Contre Sainte-Beuve, précédé de Pastiches et mélanges et suivi de Essais et articles*, ed. Pierre Clarac and Yves Sandre (Paris, 1971). Proust also suggests that work such as Monet's may play a spiritually curative role "analogous to that of psychotherapists with certain neurasthenics" (p. 178).

35. Ibid., "Sainte-Beuve et Balzac" (1906), p. 276.

36. Marcel Proust, " 'Les Eblouissements' par la comtesse de Noailles," *Le Figaro*, 15 June 1907 (literary supplement), in *Contre Sainte-Beuve*, pp. 539–40.

37. From an undated note by Marcel Proust, "Le Peintre—Ombres—Monet," in *Contre Sainte-Beuve*, pp. 675–76.

38. See Proust's preface to Jacques-Emile Blanche, *Propos de peintre: De David à Degas* (Paris, 1919), in *Contre Sainte-Beuve*, p. 584. Also see idem, *La Prisonnière* (1922), in *A la recherche du temps perdu*, ed. Jean-Yves Tadié, 4 vols. (Paris, 1987–89), 3: 811, for the opposition between Monet and the cubists.

39. Mirbeau to Monet, June 1903, in *Correspondance*, p. 210.

40. Louis Meyer [Louis Vauxcelles], "Chez les peintres: Un Après-midi chez Claude Monet," *L'Art et les Artistes*, December 1905, pp. 85–90, in "Claude Monet," *L'Art Moderne*, 28 October and 4 November 1906, pp. 340, 348.

41. "The Conscientious Artist," *The Standard* (London), 20 May 1908, in *Monet: A Retrospective*, ed. Charles F. Stuckey (New York, 1985), p. 251.

42. Alice Monet to her daughter Germaine Salerou, excerpted by Philippe Piguet in *Claude Monet au temps de Giverny* (Paris, 1983), pp. 270–72.

43. Mirbeau to Monet, 19 May 1908, in *Correspondance*, p. 215.

44. Ibid., pp. 215–16.

45. Alice Monet to Germaine Salerou, 18 June 1908, in *Monet au temps de Giverny*, p. 272.

46. "Paradou" is the Provençal-sounding name of the paradisical garden of seduction featured in Zola's novel *La Faute de l'abbé Mouret* (1875); see *Les Rougon-Macquart*, 1: 1248, 1690.

47. J. C. N. Forestier, "Le Jardin de M. Claude Monet," *Fermes et Châteaux*, no. 39 (1 September 1908): 13, 16.

CHAPTER FOURTEEN

1. Jean Morgan, "Causeries chez quelques maîtres: M. Claude Monet," *Le Gaulois*, 5 May 1909.

2. Ibid.

3. Ibid.

4. Ibid.

5. Arsène Alexandre, "Les Nymphéas de Claude Monet," *Le Figaro,* 7 May 1909.

6. Arsène Alexandre, "Un Paysagiste d'aujourd'hui et un portraitiste de jadis," *Comoedia,* 8 May 1909.

7. Alexandre, "Paysagiste."

8. Ibid.

9. Ibid.

10. Rosalind Krauss characterizes the alleged self-sufficiency of the modernist artist as rooted in "the rapt, self-admiring gesture of Narcissus," in "Antivision," *October,* no. 36 (Spring 1986): 149.

11. Alexandre, "Paysagiste."

12. [François] Thiébault-Sisson, "Choses d'art: Les Derniers Travaux de Claude Monet," *Le Temps,* 8 May 1909.

13. Louis Meyer [Louis Vauxcelles], "Les 'Nymphéas' de Claude Monet, *Gil Blas,* 8 May 1909. Also see idem, "Le Salon d'Automne," *Gil Blas,* 17 October 1905.

14. Diary entry of 11 May 1909, in Jules Renard, *Journal 1887–1910,* ed. Léon Guichard and Gilbert Sigaux (Paris, 1965), p. 1241.

15. Henry Eon, "Notes d'art: Claude Monet," *Le Siècle,* 11 May 1909. Also see Théodore Duret, *Histoire des peintres impressionnistes* (Paris, 1906), translated as *Manet and the French Impressionists* (Philadelphia, 1910), p. 146.

16. F. Robert-Kemp, "Un Peu d'Art," *L'Aurore,* 11 May 1909.

17. See Spate, *Claude Monet,* p. 237.

18. Edouard Sarradin, "Les 'Nymphéas' de Claude Monet," *Journal des Débats,* 12 May 1909.

19. Pascal Forthuny, "Les Petits Salons: Paysages d'eau de Claude Monet," *Le Matin,* 13 May 1909.

20. Pierre Mille, "Ecrits sur l'eau," *Le Temps,* 13 May 1909.

21. See Baudelaire, "Le Peintre de la vie moderne" (1863), in *Oeuvres,* 2: 687–94; and Freud, "Creative Writers and Day-Dreaming" (1908), *S.E.,* 9: 143–53. Also see Natasha Staller, "Early Picasso and the Origins of Cubism," *Arts Magazine* 61 (September 1986): 80–91, on the turn-of-the-century literature on childhood and art.

22. Freud, "On Narcissism," *S.E.,* 14: 91; in the phrase "His Majesty the Baby" the masculine pronoun is not incidental, and indeed my entire effort in this book is meant to interrogate the still presiding paradigm of the masculine, self-sufficient, creative artist. My aim is not primarily to point to this as a psy-

chosocial structure that is oppressive to women, which it undoubtedly is, but by way of the tribulations of Monet and Narcissus to point to the ways in which this configuration is also an anxious burden upon men.

23. Mille, "Ecrits."

24. Ibid.

25. Ibid.

26. Ibid.

27. Ibid. Mille's coy disclosure that he is writing of art and not of nature is akin to Diderot's rhetorical ploy in the face of Vernet's seascapes; see Michael Fried, *Absorption and Theatricality: Painting and Beholder in the Age of Diderot* (Berkeley, 1980), pp. 122–27.

28. Mille, "Ecrits."

29. For Melanie Klein, writing in the 1920s, the "paranoid-schizoid" self-scattering that is attendant upon the traumatic loss of one's internalized images must be followed in the maturational process by the "depressive" acknowledgment that in spite of this loss the self and its external doubles retain the capacity to endure; one grieves for the loss even while accepting imperfection and ambivalence. See Adrian Stokes, "Form in Art," in *New Directions in Psycho-Analysis,* ed. Melanie Klein, Paula Heimann, and R. E. Money-Kyrle (London, 1955), pp. 406–20, and in "Form in Art: A Psychoanalytic Interpretation," *Journal of Aesthetics and Art Criticism* 18 (1959–60): 193–203.

30. René-Marc Ferry, "Notes d'art: Les Paysages d'eau de M. Claude Monet," *L'Eclair,* 14 May 1909.

31. Jean-Louis Vaudoyer, "Petites expositions: Claude Monet (Galerie Durand-Ruel)," *La Chronique des Arts et de la Curiosité,* 15 May 1909, p. 159. Also see Baudelaire, "Le Guignon" (1852), in *Oeuvres,* 1: 17.

32. Gustave Geffroy, "Les Paysages d'eau de Claude Monet," *La Dépêche* (Toulouse), 15 May 1909.

33. Ibid.

34. Henri Matisse, "Notes d'un peintre," *La Grande Revue* 52 (25 December 1908): 741–42: "What I dream of is an art of equilibrium, of purity, of tranquillity, without disquieting or preoccupying subject, which would be, for every cerebral worker, for the man of business as much as for the man of letters, for example, an assuagement, a cerebral calmant, something analogous to a good armchair that relaxes him from his physical fatigue." Also see Roger Benjamin, *Matisse's "Notes of a Painter": Criticism, Theory, and Context, 1891–1908* (Ann Arbor, 1987).

35. Geffroy, "Les Paysages d'eau."

36. Georges Meusnier, "Notule: Aux Galeries Durand-Ruel: Notre 'Claude': 'Les Nymphéas,' paysages d'eau," *Journal des Arts,* 16 May 1909, p. 6085.

37. Marie-Louise-Antoinette de Régnier [Gérard d'Houville], "Lettres à Emilie," *Le Temps,* 18 May 1909. The implicit female presence in Monet's lily pond has been recently visualized by Sally Swain in *Great Housewives of Art* (Harmondsworth, 1988), n. pag., where "Mrs. Monet cleans the pool." Also see the naked female depictions in Richard George's *Monet's Garden* series of paintings of 1981, and Nikki Pahl's photomontage "Monet and Me" (1978), where the photographer interpolates her rather Echo-like image into a photograph of a Narcissus-like Monet on the bridge of Giverny in 1925 (Wildenstein, *Monet,* 4: 141). I owe the latter reference to Robert Bambic; see Denis Roche, *Autoportraits photographiques 1898–1981: Brève rencontre (l'autoportrait en photographie)* (Paris, 1981).

38. Régnier [Houville], "Lettres."

39. Marie-Louise-Antoinette de Régnier [Gérard d'Houville], "Jeux d'enfants" and "Sur le fleuve," in *Poésies,* pp. 55, 71.

40. Edmond Sée, "Devant les paysages d'eau," *Gil Blas,* 20 May 1909.

41. Ibid.

42. Ibid.

43. Ibid.

44. Ibid.

45. Ibid.

46. Ibid.

47. Louis de Fourcaud, "Claude Monet et le lac du Jardin des Fées," *Le Gaulois,* 22 May 1909. Also see idem, "Exposition internationale, à la Galerie Georges Petit," *Le Gaulois,* 19 June 1886.

48. Fourcaud, "Claude Monet."

49. Ibid.

50. The fates of Narcissus and Actaeon are compared in Leonard Barkan, *The Gods Made Flesh: Metamorphosis and the Pursuit of Paganism* (New Haven, 1986). Also see Steven Z. Levine, "To See or Not to See: The Myth of Diana and Actaeon in the Eighteenth Century," in *The Loves of the Gods: Mythological Painting from Watteau to David,* ed. Colin Bailey (Fort Worth, 1992).

51. Anon., "Les Nymphéas de Monet," *Le Cri de Paris,* 23 May 1909.

52. Lucien Descaves to Monet, 30 May 1909, in Geffroy, *Claude Monet,* p. 244.

53. Lucien Descaves, "Ceux dont on parlera longtemps: Chez Claude Monet," *Paris-Magazine,* 25 August 1920, p. 344. Also see idem, *Souvenirs d'un ours* (Paris, 1946), pp. 246–48.

54. Romain Rolland to Monet, 14 June 1909, in Geffroy, *Claude Monet,* p. 245.

55. Pierre Goujon, "Les Salons de 1909," *Gazette des Beaux-Arts,* 4th ser. 1 (June 1909): 497; and 2 (September 1909): 243.

56. Roger Marx, "Les 'Nymphéas' de M. Claude Monet," *Gazette des Beaux-Arts,* 4th ser. 1 (June 1909): 523–24, in *Maîtres d'hier et d'aujourd'hui* (Paris, 1914), p. 285.

57. Marx, "Les 'Nymphéas,' " p. 524.

58. Ibid., pp. 524–26. A *fukusa* is a printed fabric gift-cover.

59. Ibid., p. 526.

60. Ibid.

61. See Jacques Lacan, "The Mirror Stage as Formative of the Function of the I" (1949), in *Ecrits: A Selection,* trans. Alan Sheridan (New York, 1977), pp. 1–7. The original version of this text dates to 1936, a scant ten years after the unveiling of Monet's posthumous mirrorings at the Orangerie.

62. Marx, "Les 'Nymphéas,' " p. 526. The quotation is from Paul Verlaine's "Art poétique" (1874), in *Oeuvres,* p. 326.

63. Marx, "Les 'Nymphéas,' " p. 527.

64. Ibid., p. 527. Henry Eon had earlier borrowed the identical phrase from Duret, whom he properly cites (see n. 15).

65. Ibid., pp. 526–28.

66. Ibid., p. 528.

67. Ibid.

68. Mallarmé to Edouard Dujardin, 1 August 1885, in *Correspondance,* 2: 293.

69. Marx, "Les 'Nymphéas,' " pp. 528–29.

70. Georges Rodenbach, "M. Claude Monet," in *L'Elite: Ecrivains, orateurs sacrés, peintres, sculpteurs* (Paris, 1899), p. 256; and idem, "Aquarium mental," in *Les Vies encloses: Poème* (Paris, 1896), p. 4.

71. Marx, "Les 'Nymphéas,' " p. 529.

72. Ibid. Also see Norman Bryson, *Vision and Painting: The Logic of the Gaze* (New Haven, 1983).

73. Marx, "Les 'Nymphéas,' " p. 529.

74. Ibid., pp. 529–30.

75. Ibid., pp. 530–31. Against Marx's sense of the incompatibility of Monet and Lamartine I would consider the poet's rewriting of the Narcissus legend in *La Chute d'un ange* (1838): "Bending toward himself and wishing to seize himself; / Then seeing that his hands which troubled the limpid water / Were embracing only the wave which the ripple obscured / He wept for this image; and the better to see it again / He let the mirror for a moment flatten itself out"; in Alphonse de Lamartine, *Oeuvres poétiques,* ed. Marius-François Guyard (Paris, 1963), pp. 862–63.

76. Marx, "Les 'Nymphéas,' " p. 531.

77. F[rancis de] M[iomandre], "Le Salon des Artistes Français," *L'Art et les Artistes,* July 1909, p. 187.

78. F[rancis de] M[iomandre], "Les Nymphéas, série de paysages d'eau, par Claude Monet," ibid., p. 191.

79. Charles Morice, "Vues de la Tamise à Londres, par Claude Monet," *Mercure de France,* n.s. 50 (June 1904): 796.

80. Mirbeau, *Claude Monet: Vues de la Tamise à Londres* (Paris, 1904), p. 2, in *L'Humanité,* 8 May 1904, and in *Correspondance,* p. 258.

81. Charles Morice, "Art Moderne: Claude Monet," *Mercure de France,* n.s. 80 (16 July 1909): 347.

82. Henri Ghéon, "Les 'Paysages d'eau' de Claude Monet," *Nouvelle Revue Française* 1 (1 July 1909): 533. See Gide's letter to Ghéon, May 1909, "Try to come for the Monets," in André Gide and Henri Ghéon, *Correspondance 1897–1944,* ed. Anne-Marie Moulènes and Jean Tipy, 2 vols. (Paris, 1976), 2: 722.

83. Ghéon, "Les 'Paysages d'eau,' " p. 534.

84. Ibid., pp. 534–35.

85. Louis de Godefroy, "Claude Monet, peintre de nymphéas," *La Flamme,* 20 September 1909, p. 468.

86. Ibid., pp. 469–70. The citation is from Verlaine's "Mon rêve familier" (1866), in *Oeuvres,* p. 63, where the integer of difference registered by Godefroy in the *Water Lilies* is projected upon the loving face of the unknown woman of the poet's dream.

87. Godefroy, "Claude Monet," pp. 470–71. On the disruptive heterogeneity of the frame, see Jacques Derrida, *The Truth in Painting,* trans. Geoff Bennington and Ian McLeod (Chicago, 1987).

88. Ibid., p. 471.

89. Ibid., pp. 471–72.

90. Louis Gillet, *Histoire des arts,* Histoire de la nation française, ed. Gabriel Hanotaux, vol. 11 (Paris, 1927), p. 511.

91. Louis Gillet, "L'Epilogue de l'impressionnisme: Les 'Nymphéas' de M. Claude Monet," *Revue Hebdomadaire* 8 (21 August 1909): 401–2, in *Trois Variations sur Claude Monet* (Paris, 1927).

92. Gillet, "L'Epilogue," p. 403.

93. Ibid., pp. 403–4.

94. Ibid., p. 404.

95. Ibid., pp. 405–6.

96. Ibid., pp. 407–8.

97. Ibid., pp. 408–9.

98. Ibid., pp. 410-11.

99. Leon Battista Alberti, *On Painting and On Sculpture*, trans. Cecil Grayson (London, 1972), pp. 61–63.

100. Gillet, "L'Epilogue," pp. 411–12.

101. Gillet, *Variations*, p. 35.

102. Gillet, "L'Epilogue," p. 412.

103. "Lack of historical sense is the hereditary defect of all philosophers. . . . Many of them take man automatically as he has most recently been shaped by the impression of a particular religion or even of particular political events. . . . But everything [that is] has become [what it is]; there are neither eternal facts nor indeed eternal verities. Therefore what is needed from now on is historical philosophizing, and with it the virtue of modesty"; from *Human, All-too-Human* (1878), in J. P. Stern, *Friedrich Nietzsche* (Harmondsworth, 1979), pp. 55–56.

104. Gillet, "L'Epilogue," pp. 412–13.

105. Louis Gillet, *Un Grand Maître du 18e siècle: Watteau* (Paris, 1921). The dedicated copy is in the Musée Claude Monet, Giverny.

106. Gillet, "L'Epilogue," p. 414.

107. Marx, "Les 'Nymphéas,' " p. 529.

108. Gillet, "L'Epilogue," p. 415. Also see Charles Renouvier, *Histoire et solution des problèmes métaphysiques* 3 (Paris, 1901).

109. Gillet, "L'Epilogue," p. 415; and idem, *Variations*, p. 40. René Ménard's large Ingresque diptych, *Pastoral Life*, is given a two-page spread in Société Nationale des Beaux-Arts, *Catalogue illustré du Salon de 1909* (Paris, 1909), pp. 152–53. These neoclassical panels were widely noted in the press in 1909, but by 1927 Gillet apparently had come to regard as even more characteristic of the period's neomythological impulse the decorations painted for Morosov in Moscow by Maurice Denis in 1908–9 (now in the Hermitage Museum, St. Petersburg). Also in the Hermitage are Matisse's *Nymph and Satyr*, painted for Shchukin in Moscow in 1909, as well as Picasso's huge *Dryad* of 1908. Brancusi executed a marble as well as a plaster fountain of Narcissus in 1910–13 (Musée National d'Art Moderne, Paris), and Dali's well-known *Metamorphosis of Narcissus* (Tate Gallery, London) dates to 1937.

CHAPTER FIFTEEN

1. Georges Grappe, *Claude Monet* (Paris, n.d. [1912]), pp. 72–75.

2. Jean Martet, *Clemenceau peint par lui-même* (Paris, 1929), p. 81.

3. [François] Thiébault-Sisson, "Claude Monet," *Le Temps*, 6 April 1920.

4. Ibid.

5. Marc Elder, *A Giverny, chez Claude Monet* (Paris, 1924), pp. 53–54.

6. Marc Elder, "Le Peintre à la campagne: Une Visite à Giverny chez M. Claude Monet," *Excelsior*, 6 April 1920.

7. [François] Thiébault-Sisson, "Un Don de M. Claude Monet à l'état," *Le Temps,* 14 October 1920.

8. Arsène Alexandre, "L'Epopée des Nymphéas," *Le Figaro,* 21 October 1920.

9. Alexandre, "L'Epopée."

10. Gustave Geffroy, "Claude Monet," *L'Art et les Artistes,* n.s. no. 11 (November 1920): 51; and idem, *Claude Monet,* p. 333.

11. Geffroy, *Claude Monet,* p. 334.

12. On the Lacanian fantasy of the *corps morcelé,* see Richard Boothby, *Death and Desire: Psychoanalytic Theory in Lacan's Return to Freud* (New York, 1991).

13. Georges Grappe, "Chez Claude Monet," *L'Opinion,* 16 October 1920, p. 443.

14. Geffroy, *Claude Monet,* p. 336.

15. Gasquet, *Narcisse,* p. 102.

16. Grappe, "Chez Claude Monet," p. 443.

17. Lacan, "The Split between the Eye and the Gaze" (1964), in *Four Fundamental Concepts,* pp. 73–74.

18. Grappe, "Chez Claude Monet," p. 443. Also see André Masson, "Monet le fondateur," *Verve* 7, nos. 27–28 (December 1952): 68.

19. Geffroy, *Claude Monet,* pp. 5–6.

20. Ibid., p. 335.

21. On the so-called Nirvana principle in Freud, see J. Laplanche and J. B. Pontalis, *The Language of Psycho-Analysis* (1967), trans. Donald Nicholson-Smith (New York, 1973), pp. 272–73, where the stress is upon the "profound link between pleasure and annihilation," a masochistic theme I have tried to trace in the various versions of the myth of Narcissus.

22. Geffroy, *Claude Monet,* pp. 335–36.

23. Gustave Geffroy, *Exposition Claude Monet organisé au bénéfice des victimes de la catastrophe du Japon* (Paris, 1924).

24. Clemenceau to Monet, 1 March 1924, in Georges Suarez, *Soixante Années d'histoire française: Clemenceau dans l'action,* 2 vols. (Paris, 1932), 2: 326.

25. Louis Gillet, "Après l'exposition Claude Monet: Le Testament de l'impressionnisme," *Revue des Deux Mondes,* 7th ser. 19 (1 February 1924): 661–62.

26. Ibid., pp. 662, 666, 669.

27. Ibid., pp. 669–70. For an intrauterine etiology of narcissism, see Béla Grünberger, *Narcissism: Psychoanalytic Essays,* trans. Joyce S. Diamanti (New York, 1979).

28. Elder, *A Giverny,* pp. 78–79.

29. Gillet, "Le Testament," pp. 670–71.

30. Gaston Bachelard, "Les Nymphéas ou les surprises d'une aube d'été," *Verve* 7, nos. 27–28 (December 1952): 59–64, in *Le Droit de rêver* (Paris, 1970), pp. 10–11. Bachelard notes the classical interpretation of the flower as "clavus Veneris," the distaff of Venus, an insignia of the domestic conjugality of the goddess and a euphemism for the female genitalia.

31. Gillet, "Le Testament," p. 671.

32. Ibid., pp. 671–72.

33. Ibid., p. 672.

34. Ibid., pp. 672–73.

35. Ibid., p. 673.

36. Gillet to Monet, 14 September and 2 October 1924, in Wildenstein, *Monet,* 4: 123.

37. Florent Fels, *Propos d'artistes* (Paris, 1925), p. 12.

38. Gaston Berardi, "Nymphéas, A Claude Monet" (1920), in *Sonnets de guerre et d'après-guerre* (Paris, 1924). A dedicated copy is at Giverny.

39. Gillet, "Le Testament," p. 668.

40. Valéry, *Cahiers,* 2: 948–49. Also see idem, *Mélange de prose et de poësie: Album plus ou moins illustré d'images sur cuivre de l'auteur* (Paris, 1939), for an etching which eerily recalls Monet's low-angle painting of willows bending over the Seine (W. 1500); and idem, *La Cantate du Narcisse* (Paris, 1941), in which photographs by Laure Albin-Guillot closely resemble well-known painted and photographic images of the watergarden at Giverny.

41. Louis Gillet, "Claude Monet," *Le Gaulois,* 8 December 1926, in *Variations,* pp. 90, 92.

42. Ibid., pp. 92–93.

43. Ibid., pp. 97–98.

44. Ovid, *Metamorphoses,* trans. Rolfe Humphries (Bloomington, 1955), p. 73.

45. See Henry Vidal, "L'Enterrement d'un peintre," *Le Figaro,* 9 December 1926.

46. Louis Gillet, "Sur la terrasse au bord de l'eau" (27 May 1927), in *Variations,* pp. 100–101.

47. Ibid., p. 102.

48. Marcel Pays, "Un Grand Maître de l'impressionnisme: Une Visite à M. Claude Monet dans son ermitage de Giverny," *Excelsior,* 26 January 1921.

49. Gillet, *Variations,* pp. 102–3, 105.

50. Ibid., pp. 106–7.

51. Ibid., pp. 107–8.

52. Monet is unfavorably compared to Picasso in Jacques-Emile Blanche, "En me promenant aux Tuileries: Les 'Nymphéas' de Claude Monet," *L'Art Vivant* 3 (September 1927): 695–96, in *Propos,* p. 54.

53. Gillet, *Variations,* pp. 108–10.

54. Ibid., pp. 110–11.

55. André Lhote, "Manet et Picasso," *Nouvelle Revue Française* 39 (July-December 1932): 290, in *Les Invariants plastiques* (Paris, 1967), pp. 82–83.

56. Gillet, *Variations,* pp. 112–13.

57. Ibid., pp. 113–14. Also see Norman Bryson, "The Gaze in the Expanded Field," in *Vision and Visuality,* ed. Hal Foster (Seattle, 1988), pp. 86–113.

58. Diary entry of 8 July 1927, in Paul Claudel, *Journal,* ed. François Varillon and Jacques Petit, 2 vols. (Paris, 1968), 1: 778.

59. Paul Claudel, "Conversations dans le Loir-et-Cher, Dimanche, 31 July 1927," in *Oeuvres en prose,* ed. Jacques Petit and Charles Galpérine (Paris, 1965), pp. 716–17.

60. Paul Claudel, *Un Poète regarde la Croix* (Paris, 1935), p. 11.

61. Paul Claudel, *Positions et propositions,* 2 vols. (Paris, 1927–34), 2: 235.

CHAPTER SIXTEEN

1. Clemenceau, *Claude Monet,* pp. 103, 54.

2. Ibid., pp. 109–10.

3. Ibid., pp. 101–2.

4. Ibid., p. 104.

5. Clemenceau to Monet, 21 May 1895, in André Wormser, "Claude Monet et Georges Clemenceau: Une Singulière Amitié," in *Aspects of Monet: A Symposium on the Artist's Life and Times,* ed. John Rewald and Frances Weitzenhoffer (New York, 1984), p. 199; and Monet to Geffroy, 24 May 1895 (W. 2938–1300b): "We will see to making the arrangement dreamed by Clemenceau."

6. Clemenceau to Monet, 12 July 1911, ibid., pp. 204–5.

7. Clemenceau to Monet, 2 November 1921, in Wildenstein, *Monet,* 4: 432, no. 304.

8. Geffroy to Clemenceau, 2 April 1922, ibid., no. 308.

9. Clemenceau to Monet, 11 November 1923, ibid., no. 315.

10. Clemenceau to Blanche Hoschedé-Monet, 12 December 1926, ibid., p. 433, no. 328.

11. Clemenceau, *Claude Monet,* p. 68.

12. Clemenceau to Blanche Hoschedé-Monet, 15 December 1926, in Wildenstein, *Monet,* 4: 433, no. 329.

13. See Poulain, *Bazille et ses amis,* pp. 47–48; and Wildenstein, *Monet,* 1: 28, n. 176. Delacroix's painting is in the Emil Bührle Foundation, Zurich. On "the productive narcissism of genius" in Delacroix, see Jack J. Spector, "Delacroix: A Study of the Artist's Personality and Its Relation to His Art," in *Psychoanalytic Perspectives on Art,* 2: 48.

14. Anon., "Musée du Louvre: Peintures et dessins: Oeuvres de Claude Monet," *Beaux-Arts* 5 (1 January 1927): 5.

15. Raymond Régamey, "Oeuvres de Claude Monet," *Beaux-Arts* 5 (15 March 1927): 89.

16. Clemenceau to Blanche Hoschedé-Monet, 2 April 1929, in Jean-Pierre Hoschedé, *Claude Monet, ce mal connu: Intimité familiale d'un demi-siècle à Giverny de 1883 à 1926*, 2 vols. (Geneva, 1960), 1: 97.

17. Clemenceau hoped that his biography of Demosthenes would not make Monet "yawn too much," 8 February 1926, in Wormser, "Monet et Clemenceau," p. 215.

18. Clemenceau, *Claude Monet*, p. 25.

19. Martet, *Clemenceau*, pp. 203, 206.

20. Clemenceau, *Claude Monet*, pp. 25, 30–31.

21. Ibid., p. 26.

22. Freud comments on the transferential nature of historical and biographical writing in *Leonardo, S.E.*, 11: 134: "If in making these statements I have merely written a psychoanalytic novel, I shall reply that I am far from overestimating the certainty of these results. Like others I have succumbed to the attraction of this great and mysterious man."

23. Clemenceau, *Claude Monet*, p. 26.

24. Martet, *Clemenceau*, p. 237.

25. Clemenceau, *Claude Monet*, p. 28.

26. Régamey, "Oeuvres de Claude Monet," p. 89.

27. Marthe de Fels, *La Vie de Claude Monet* (Paris, 1929), p. 196.

28. Bachelard, *L'Eau et les rêves*, p. 40. Also see Freud, *Civilization and Its Discontents* (1930), *S.E.*, 21: 65, where the psychoanalyst defensively queries the view of Monet's correspondent Romain Rolland as to the "feeling of an indissoluble bond, of being one with the external world as a whole." For a study of pre-oedipal, or narcissistic, object-relations in contemporary psychoanalysis, see Victoria Hamilton, *Narcissus and Oedipus: The Children of Psychoanalysis* (London, 1982).

29. See Wildenstein, *Monet*, 4: 87.

30. See the catalogue *Philippe Smit* (Springfield, Mass., 1957); and the typescript in the museum's files by Kasper Neuhaus, "Philippe Smit: Unknown Genius" (1955).

31. For the lingering of the gaze of Narcissus in contemporary art, see Giorgio di Genova, *Narcissus* (Rome, 1982); and Barbara Bloom, *The Reign of Narcissism* (London, 1990). Also see Stephen Bann, *The True Vine: On Visual Representation and the Western Tradition* (Cambridge, 1989).

32. Rainer Maria Rilke, "Narcisse" (1925), in *Sämtliche Werke,* 5 vols. (Wiesbaden, 1955–57), 2: 669–70. Written in French perhaps as a tribute to Valéry, Rilke's poem casts masculine consciousness face-to-face and mouth-to-ear with the feminine source of its self-affirming and self-annihilating enterprise of self-reflection. As Rodin's friend and secretary Rilke was fully familiar with Monet's work.

Adams, Hazard, ed., *Critical Theory since Plato* (New York, 1981).

Aitken, Geneviève, and Marianne Delafond, *La Collection d'estampes japonaises de Claude Monet* (Paris, 1983).

Akhtar, Salman, "Narcissistic Personality Disorder: Descriptive Features and Differential Diagnosis," *Psychiatric Clinics of North America* 12 (September 1989): 505–28.

Alberti, Leon Battista, *On Painting and On Sculpture,* trans. Cecil Grayson (London, 1972).

Alexandre, Arsène, "La Vie artistique: I. Paysages de M. Claude Monet," *Le Figaro,* 3 June 1898.

————, "Paysages de M. Claude Monet," *Le Gaulois,* 16 June 1898 (supplement).

————, "La Vie artistique: Exposition Claude Monet," *Le Figaro,* 23 November 1900.

————, "Le Jardin de Monet," *Le Figaro,* 9 August 1901.

————, "Les Nymphéas de Claude Monet," *Le Figaro,* 7 May 1909.

————, "Un Paysagiste d'aujourd'hui et un portraitiste de jadis," *Comoedia,* 8 May 1909.

————, "L'Epopée des Nymphéas," *Le Figaro,* 21 October 1920.

Alford, C. Fred, *Narcissism: Socrates, the Frankfurt School, and Psychoanalytic Theory* (New Haven, 1988).

Allan, John C., "Narcissism and the Double in *La Curée,*" *Stanford French Review* 5 (Winter 1981): 295–312.

Anon., "L'Exposition du Havre" (1858), in Gilbert de Knyff, *Eugène Boudin raconté par lui-même: Sa Vie, son atelier, son oeuvre* (Paris, 1976), p. 51.

————, *The Daily News* (London), 26 November 1878, in *From the Classicists to the Impressionists: A Documentary History of Art and Architecture in the Nineteenth Century,* ed. Elizabeth Gilmore Holt (Garden City, N.Y., 1966), p. 391.

————, "Notre Exposition: Claude Monet," *La Vie Moderne,* 19 June 1880, p. 400.

————, "Chronique régionale: Morbihan," *Phare de la Loire,* 6 November 1886.

————, "L'Exposition Monet–Rodin," *Le Matin,* 23 June 1889.

————, "Concours et expositions," *La Chronique des Arts,* 6 July 1889.

———, "Chez les peintres: Claude Monet–Albert Besnard," *Le Temps*, 1 March 1892.

———, "Les Hommes du jour: M. Claude Monet, peintre français," *L'Eclair*, 26 May 1895.

———, "Exposition d'oeuvres de M. Claude Monet," *La Chronique des Arts et de la Curiosité*, 25 June 1898, p. 212.

———, "L'Impressionnisme: Exposition d'oeuvres nouvelles de Claude Monet," *La Justice*, 5 December 1900.

———, "The Conscientious Artist," *The Standard* (London), 20 May 1908, in *Monet: A Retrospective*, ed. Charles F. Stuckey (New York, 1985), p. 251.

———, "Les Nymphéas de Monet," *Le Cri de Paris*, 23 May 1909.

———, "Musée du Louvre: Peintures et dessins: Oeuvres de Claude Monet," *Beaux-Arts* 5 (1 January 1927): 5.

Antoine, Jules, "Beaux-arts: Exposition de la galerie Georges Petit," *Art et Critique* 1 (29 June 1889): 75–77.

Apter, Emily S.,"Gide's *Traité du Narcisse*: A Theory of the Post-Symbolist Sign," *Stanford French Review* 9 (Summer 1985): 189–99.

———, *Feminizing the Fetish: Psychoanalysis and Narrative Obsession in Turn-of-the-Century France* (Ithaca, 1991).

Arnyvelde, André, "Chez le peintre de la lumière," *Je Sais Tout* 10 (15 January 1914): 29–38.

Astruc, Zacharie, *Les 14 Stations du Salon, suivies d'un récit douleureux* (Paris, 1859).

———, "Salon de 1868 aux Champs-Elysées: Paysages—Marines," *L'Etendard*, 5 August 1868.

———, "Le Salon: Première Journée," *L'Echo des Beaux-Arts*, 8 May 1870.

Aurier, G.-Albert, "Claude Monet," *Mercure de France*, n.s. 4 (April 1892): 302–5.

Bachelard, Gaston, "Les Nymphéas ou les surprises d'une aube d'été," *Verve* 7, nos. 27–28 (December 1952): 59–64.

———, *Le Droit de rêver* (Paris, 1970).

———, *L'Eau et les rêves: Essai sur l'imagination de la matière* (Paris, 1978; orig. ed. 1941).

Balzac, Honoré de, *Modeste Mignon* (1844), in *La Comédie Humaine*, ed. Marcel Bouteron, 11 vols. (Paris, 1935).

Bann, Stephen, *The True Vine: On Visual Representation and the Western Tradition* (Cambridge, 1989).

Barkan, Leonard, *The Gods Made Flesh: Metamorphosis and the Pursuit of Paganism* (New Haven, 1986).

Baudelaire, Charles, *Oeuvres complètes,* ed. Claude Pichois, 2 vols. (Paris, 1975–76).

Benjamin, Roger, *Matisse's "Notes of a Painter": Criticism, Theory, and Context, 1891–1908* (Ann Arbor, 1987).

Berardi, Gaston, *Sonnets de guerre et d'après-guerre* (Paris, 1924).

Bernard, Jean-Marc, *Oeuvres de Jean-Marc Bernard,* 2 vols. (Paris, 1923).

Bersani, Leo, *Baudelaire and Freud* (Berkeley, 1977).

Beyle, Henri [Stendhal], *Oeuvres intimes* (Paris, 1961).

Blanc, Charles, "Grammaire des arts du dessin . . . ," *Gazette des Beaux-Arts,* 1st ser. 19 (July 1865): 64–79.

Blanche, Jacques-Emile, *Propos de peintre: De David à Degas* (Paris, 1919).

———, "En me promenant aux Tuileries: Les 'Nymphéas' de Claude Monet," *L'Art Vivant* 3 (September 1927): 695–96.

Bloom, Barbara, *The Reign of Narcissism* (London, 1990).

Bloom, Harold, *The Anxiety of Influence: A Theory of Poetry* (New York, 1973).

Bloy, Léon, "Les Artistes mystérieux: Maurice Rollinat," *Le Foyer Illustré,* 17 and 24 September, 10 October 1882.

Boas, George, " 'Il faut être de son temps,' " *Journal of Aesthetics and Art Criticism* 1 (1941): 52–65.

Boothby, Richard, *Death and Desire: Psychoanalytic Theory in Lacan's Return to Freud* (New York, 1991).

Bouchor, Maurice, *Les Symboles* (Paris, 1888).

Bouchut, E., *De l'Etat aigu et chronique du névrosisme . . .* (1860), in Theodore Zeldin, *France 1848–1945,* 2 vols. (Oxford, 1974–77).

Bouhélier, Saint-Georges de, *Discours sur la Mort de Narcisse ou l'impérieuse métamorphose: Théorie de l'amour* (Paris, 1895).

Bourgeat, Fernand, "Paris vivant: A la galerie Georges Petit," *Le Siècle,* 22 June 1889.

Brenkman, John, "Narcissus in the Text," *Georgia Review* 30 (Summer 1976): 293–327.

Brisson, Adolphe, "Claude Monet," *La République Française,* 28 May 1895.

Broude, Norma, *Impressionism: A Feminist Reading* (New York, 1991).

Bryson, Norman, *Vision and Painting: The Logic of the Gaze* (New Haven, 1983).

———, *Tradition and Desire: From David to Delacroix* (Cambridge, 1984).

———, "The Gaze in the Expanded Field," in *Vision and Visuality,* ed. Hal Foster (Seattle, 1988), pp. 86–113.

Buisson, J., "Un Claude Monet de l'exposition Petit," *La Chronique des Arts et de la Curiosité,* 25 February 1899, pp. 70–71.

Burty, Philippe, "La Gravure, la lithographie et la photographie au Salon de 1865," *Gazette des Beaux-Arts,* 1st ser. 19 (July 1865): 80–95.

———, "Le Salon," *Le Rappel,* 2 May 1870.

———, "Exposition de la Société anonyme des artistes," *La République Française,* 25 April 1874.

———, "Les Paysages de M. Claude Monet," *La République Française,* 27 March 1883.

Byvanck, Willem G. C., *Un Hollandais à Paris en 1891: Sensations de littérature et d'art* (Paris, 1892).

Cadova, Eduardo, Peter Connor, and Jean-Luc Nancy, eds., *Who Comes After the Subject?* (New York, 1991).

Calonne, Alphonse de, "L'Art contre nature," *Le Soleil,* 23 June 1889.

Cardon, Emile, "Exposition des oeuvres de Rodin et Claude Monet," *Moniteur des Arts* 31 (28 June 1889): 237–39.

Carr, Reg, *Anarchism in France: The Case of Octave Mirbeau* (Montreal, 1977).

Carrier, David, *Artwriting* (Amherst, Mass., 1987).

———, *Principles of Art History Writing* (University Park, Pa., 1991).

Cascardi, Anthony J., *The Subject of Modernity* (Cambridge, 1992).

Chartroule, Marie-Amélie [Marc de Montifaud], "Salon de 1877," *L'Artiste,* 1 May 1877, pp. 334–43.

Chénier, André, *Oeuvres complètes,* ed. Gérard Walter (Paris, 1940).

Chesneau, Ernest, *La Chimère* (Paris, 1879), in Lionello Venturi, *Les Archives de l'impressionnisme,* 2 vols. (Paris, 1939), 2: 333–34.

———, "Groupes sympathiques: Les Peintres impressionistes," *Paris-Journal,* 7 March 1882, in *Annuaire illustré des beaux-arts et catalogue illustré de l'Exposition Nationale,* ed. F. G. Dumas (Paris, 1883), pp. 259–62.

Clark, T. J., "Clement Greenberg's Theory of Art" and "Arguments about Modernism: A Reply to Michael Fried," in *The Politics of Interpretation,* ed. W. J. T. Mitchell (Chicago, 1983), pp. 203–20, 239–48.

Claude Monet au temps de Giverny (Paris, 1983).

Claude Monet–Auguste Rodin: Centenaire de l'exposition de 1889 (Paris, 1989–90).

Claudel, Paul, *Positions et propositions,* 2 vols. (Paris, 1927–34).

———, *Un Poète regarde la Croix* (Paris, 1935).

———, *Oeuvres en prose,* ed. Jacques Petit and Charles Galpérine (Paris, 1965).

———, *Journal,* ed. François Varillon and Jacques Petit, 2 vols. (Paris, 1968).

Clemenceau, Georges, "Révolution des cathédrales," *La Justice,* 20 May 1895.

———, *Le Grand Pan* (Paris, 1896).

———, *Claude Monet: Les Nymphéas* (Paris, 1928).

Collin, Paul, and Jules Massenet, *Narcisse: Idylle antique pour solo et choeur* (Paris, n.d. [1878]).

Cyrano de Bergerac, Savinien, *Oeuvres complètes,* ed. Jacques Prévot (Paris, 1977).

Dalligny, Auguste, "Auguste Rodin et Claude Monet à la rue de Sèze," *Le Journal des Arts,* 5 July 1889.

Daly, Peter M., Virginia W. Callahan, and Simon Cuttler, eds., *Andreas Alciatus,* 2 vols. (Toronto, 1985).

Damisch, Hubert, "D'Un Narcisse l'autre," *Nouvelle Revue de Psychanalyse,* special number *Narcisses,* no. 13 (Spring 1976): 109–46.

Darnetal, Jacques, *Désordres: Poèmes* (Paris, 1926).

Dauguet, Marie, *Par l'amour* (Paris, 1904).

Dean, Carolyn J., *The Self and Its Pleasures: Bataille, Lacan, and the History of the Decentered Subject* (Ithaca, 1992).

Décaudin, Michel, *La Crise des valeurs symbolistes: Vingt Ans de poésie française 1895–1914* (Toulouse, 1960).

Decharme, Paul, *Mythologie de la Grèce antique* (Paris, 1879).

Delouche, Denise, "Monet et Belle-Ile en 1886," *Bulletin des Amis du Musée de Rennes,* no. 4 (1980): 27–55.

Delvaille, Bernard, ed. *La Poésie symboliste* (Paris, 1971).

Derrida, Jacques, *Of Grammatology,* trans. Gayatri Chakravorty Spivak (Baltimore, 1976).

———, *The Truth in Painting,* trans. Geoff Bennington and Ian McLeod (Chicago, 1987).

Descaves, Lucien, "Ceux dont on parlera longtemps: Chez Claude Monet," *Paris-Magazine,* 25 August 1920, p. 344.

———, *Souvenirs d'un ours* (Paris, 1946).

Desclozeaux, Jules, "L'Exposition internationale de peinture," *L'Estafette,* 15 May 1887.

Désiré, Louis, "Claude Monet," *L'Evénement,* 19 May 1891.

Dijkstra, Bram, *Idols of Perversity: Fantasies of Feminine Evil in Fin-de-Siècle Culture* (New York, 1986).

Ditchy, Jay K., *La Mer dans l'oeuvre littéraire de Victor Hugo* (Paris, 1925).

Doran, P. M., ed., *Conversations avec Cézanne* (Paris, 1978).

Dragonetti, Roger, " 'Le Nénuphar blanc': A Poetic Dream with Two Unknowns," *Yale French Studies,* no. 54 (1977): 118–39.

Du Camp, Maxime, *Le Salon de 1859* (Paris, 1859).

Duranty, Edmond, "Réflexions d'un bourgeois sur le Salon de peinture," *Gazette des Beaux-Arts,* 2nd ser. 16 (July 1877): 48–82.

Duret, Théodore, *Critique d'avant-garde* (Paris, 1885).

———, *Histoire des peintres impressionnistes* (Paris, 1906).

———, *Manet and the French Impressionists* (Philadelphia, 1910).

Echerac, Arthur d' [C. Dargenty], "Exposition des oeuvres de M. Monet," *Courrier de l'Art,* 15 March 1883, pp. 126–27.

———, "Exposition internationale de peinture et de sculpture: Galerie Georges Petit," *Courrier de l'Art* 7 (27 May 1887): 163–64.

Elder, Marc, "Le Peintre à la campagne: Une Visite à Giverny chez M. Claude Monet," *Excelsior,* 6 April 1920.

———, *A Giverny, chez Claude Monet* (Paris, 1924).

Ellenberger, Henri F., *The Discovery of the Unconscious: The History and Evolution of Dynamic Psychiatry* (New York, 1970).

Ellis, Havelock, *Studies in the Psychology of Sex,* 2 vols. (New York, 1936).

Eon, Henry, "Notes d'art: Claude Monet," *Le Siècle,* 11 May 1909.

Ernst, Alfred, "Claude Monet et Rodin," *La Paix,* 3 July 1889.

Explication des ouvrages de peinture, sculpture, architecture et gravure, des artistes vivants, exposés au Musée royal des arts (Paris, 1822).

Explication des ouvrages de peinture, sculpture, architecture, gravure et lithographie, des artistes vivants, exposés au palais des Champs-Elysées le 1er mai 1877 (Paris, 1877).

Eymard, Julien, *Ophélie ou le narcissisme au féminin: Etude sur le thème du miroir dans la poésie féminine* (Paris, 1977).

Faust, Séverin [Camille Mauclair], "L'Exposition Claude Monet: Durand-Ruel," *La Revue Indépendante de Littérature et d'Art,* n.s. 19 (May 1891): 267–69.

———, "Notes éparses sur le Barrésisme," *La Revue Indépendante de Littérature et d'Art,* n.s. 22 (January 1892): 150–65.

———, "Exposition Claude Monet: Durand-Ruel," *La Revue Indépendante de Littérature et d'Art,* n.s. 22 (March 1892): 417–18.

———, "Narcisse," *La Revue Blanche* 3 (July 1892): 43–46.

———, "Notes sur l'idée pure," *Mercure de France,* n.s. 6 (September 1892): 42–46.

———, *Eleusis: Causeries sur la cité intérieure* (Paris, 1894).

———, *Servitude et grandeur littéraires: Souvenirs d'arts et de lettres de 1890 à 1900* (Paris, 1922).

Fels, Florent, *Propos d'artistes* (Paris, 1925).

Fels, Marthe de, *La Vie de Claude Monet* (Paris, 1929).

Fénéon, Félix, *Les Impressionnistes en 1886* (Paris, 1886).

———, "Ve Exposition internationale de peinture et de sculpture," *La Vogue* 1 (28 June 1886): 341–46.

————, "Dix Marines d'Antibes de M. Claude Monet," *La Revue Indépendante de Littérature et de l'Art,* n.s. 8 (July 1888): 154.

————, "Exposition de M. Claude Monet," *La Vogue,* September 1889.

————, *Oeuvres plus que complètes,* ed. Joan U. Halperin, 2 vols. (Geneva, 1970).

Ferry, René-Marc, "Notes d'art: Les Paysages d'eau de M. Claude Monet," *L'Eclair,* 14 May 1909.

Fiérens-Gevaert, Hippolyte, "Chronique artistique de Paris: Exposition des oeuvres de Corot et de Claude Monet," *L'Indépendance Belge,* 20 June 1895.

Flaubert, Gustave, *Par les champs et par les grèves* (Paris, 1910; orig. ed. 1886).

Flor, Charles, "Deux Expositions," *Le National,* 3 March 1882.

Fontainas, André, "Camille Mauclair," *Mercure de France,* n.s. 10 (April 1894): 338–41.

————, "Claude Monet" and "Art Moderne: Galerie G. Petit; Exposition Claude Monet . . . ," *Mercure de France,* n.s. 27 (July 1898): 159–66, 278–82.

————, "Rêverie à propos de Stéphane Mallarmé: L'Oeuvre et l'homme," *Mercure de France,* n.s. 304 (September 1948): 52–61.

Forestier, J. C. N., "Le Jardin de M. Claude Monet," *Fermes et Châteaux,* no. 39 (1 September 1908): 13–16.

Forthuny, Pascal, "Les Petits Salons: Paysages d'eau de Claude Monet," *Le Matin,* 13 May 1909.

Foucault, Michel, *The History of Sexuality,* 3 vols. (*An Introduction, The Use of Pleasure, The Care of the Self*), trans. Robert Hurley (New York, 1978–86).

Foucher, Paul, "Libres chroniques," *Gil Blas,* 28 June 1889.

Fouquier, Marcel, "L'Exposition internationale de peinture et de sculpture," *Le XIXe Siècle,* 17 June 1886.

————, "Petites expositions: L'Exposition Claude Monet," *Le XIXe Siècle,* 6 March 1889.

Fourcaud, Louis de, "Beaux-Arts: Exposition d'oeuvres de M. Claude Monet, 9, boulevard de la Madeleine," *Le Gaulois,* 12 March 1883.

————, "Exposition internationale, à la Galerie Georges Petit," *Le Gaulois,* 19 June 1886.

————, "Claude Monet et le lac du Jardin des Fées," *Le Gaulois,* 22 May 1909.

Frappier-Mazur, Lucienne, "Narcisse Travesti: Poétique et idéologie dans *La Dernière Mode* de Mallarmé," *French Forum* 11 (January 1986): 41–57.

Frémine, Charles, "Claude Monet et Auguste Rodin," *Le Rappel,* 23 June 1889.

————, "Notes d'Art: Claude Monet," *Le XIXe Siècle,* 12 June 1898.

Freud, Sigmund, *Three Essays on the Theory of Sexuality* (1905), in *Standard Edition of the Complete Psychological Works of Sigmund Freud,* trans. and ed. James Strachey and Anna Freud, with Alix Strachey and Alan Tyson, 24 vols. (London, 1953–75) [hereafter, *S.E.*], 7: 130–243.

———, "Creative Writers and Day-Dreaming" (1908), *S.E.,* 9: 143–53.

———, *Leonardo da Vinci and a Memory of His Childhood* (1910), *S.E.,* 11: 63–137.

———, "On Narcissism: An Introduction" (1914), *S.E.,* 14: 73–102.

———, *Beyond the Pleasure Principle* (1920), *S.E.,* 18: 7–64.

———, *Civilization and Its Discontents* (1930), *S.E.,* 21: 65–145.

Fried, Michael, *Absorption and Theatricality: Painting and Beholder in the Age of Diderot* (Berkeley, 1980).

———, "How Modernism Works: A Response to T. J. Clark," in *The Politics of Interpretation,* ed. W. J. T. Mitchell (Chicago, 1983), pp. 221–38.

———, *Courbet's Realism* (Chicago, 1990).

Gasquet, Joachim, *Cézanne* (Paris, 1921).

———, *Joachim Gasquet's Cézanne: A Memoir with Conversations,* trans. Christopher Pemberton and ed. Richard Shiff (New York, 1991).

———, *Narcisse* (Paris, 1931).

Gautier, Judith, "Exposition internationale de peinture," *Le Rappel,* 21 May 1885.

Gautier, Théophile, *Mademoiselle de Maupin* (Paris, 1836).

———, *L'Art moderne* (Paris, 1856).

———, "Salon," *Le Moniteur Universelle,* 11 May 1868.

Gayda, Joseph, "L'Exposition de la rue de Sèze: Monet et Rodin," *La Presse,* 25 June 1889.

Gedo, John E., *Portraits of the Artist: Psychoanalysis of Creativity and Its Vicissitudes* (New York, 1983).

Geffroy, Gustave, "Maurice Rollinat: *Les Nevroses*" and "*Dans les brandes,*" *La Justice,* 1 March and 25 August 1883.

———, *Notes d'un journaliste: Vie, littérature, théâtre* (Paris, 1887).

———, "Salon de 1887. VI. Hors du Salon: Claude Monet," *La Justice,* 2 June 1887.

———, "Chronique: Dix Tableaux de Claude Monet," *La Justice,* 17 June 1888.

———, "Chronique: La Creuse," *La Justice,* 2 and 4 August 1889.

———, *La Vie artistique,* 8 vols. (Paris, 1892–1903).

———, "Chronique artistique: Les Peupliers," *La Justice,* 2 March 1892.

———, "Claude Monet," *Le Journal,* 10 May 1895.

———, *Pays d'ouest* (Paris, 1897).

———, "Claude Monet," *Le Journal,* 7 June 1898.

———, "Claude Monet," *Le Gaulois,* 16 June 1898 (supplement).

———, "Claude Monet," *Le Journal,* 26 November 1900.

————, "Les Paysages d'eau de Claude Monet," *La Dépêche* (Toulouse), 15 May 1909.

————, "Claude Monet," *L'Art et les Artistes,* n.s. no. 11 (November 1920), pp. 51–81.

————, *Claude Monet: Sa Vie, son oeuvre* (Paris, 1922).

————, *Exposition Claude Monet organisé au bénéfice des victimes de la catastrophe du Japon* (Paris, 1924).

————, *Images du jour et de la nuit* (Paris, 1924).

Genette, Gérard, *Figures* (Paris, 1966).

Genova, Giorgio di, *Narcissus* (Rome, 1982).

Ghéon, Henri, "Les 'Paysages d'eau' de Claude Monet," *Nouvelle Revue Française* 1 (1 July 1909): 533–35.

Gide, André, *Oeuvres complètes,* ed. L. Martin-Chauffier, 15 vols. (Paris, n.d. [1932]).

Gide, André, and Jacques-Emile Blanche, *Correspondance André Gide Jacques-Emile Blanche 1892–1939,* ed. Georges-Paul Collet (Paris, 1979).

Gide, André, and Henri Ghéon, *Correspondance 1897–1944,* ed. Anne-Marie Moulènes and Jean Tipy, 2 vols. (Paris, 1976).

Gide, André, and Francis Jammes, *Correspondance 1893–1938 Francis Jammes et André Gide,* ed. Robert Mallet (Paris, 1948).

Gide, André, and Paul Valéry, *Correspondance 1890–1942,* ed. Robert Mallet (Paris, 1955).

Gilbert, Paul, "Exposition internationale," *Journal des Artistes,* 13 June 1885.

————, "Exposition internationale," *Journal des Artistes,* 27 June 1886, pp. 213–14.

Gilkin, Iwan, *La Nuit* (Brussels, 1897).

Gillet, Louis, "L'Epilogue de l'impressionnisme: Les 'Nymphéas' de M. Claude Monet," *Revue Hebdomadaire* 8 (21 August 1909): 397–415.

————, *Un Grand Maître du 18e siècle: Watteau* (Paris, 1921).

————, "Après l'exposition Claude Monet: Le Testament de l'impressionnisme," *Revue des Deux Mondes,* 7th ser. 19 (1 February 1924): 661–73.

————, "Claude Monet," *Le Gaulois,* 8 December 1926.

————, *Histoire des arts,* Histoire de la nation française, ed. Gabriel Hanotaux, vol. 11 (Paris, 1927).

————, *Trois Variations sur Claude Monet* (Paris, 1927).

Girodet-Trioson, Anne-Louis, *Oeuvres posthumes,* ed. P. A. Coupin, 2 vols. (Paris, 1829).

Godefroy, Louis de, "Claude Monet, peintre de nymphéas," *La Flamme,* 20 September 1909, pp. 468–72.

Gogh-Bonger, J. van, ed., *Verzamelde Brieven van Vincent van Gogh*, 4 vols. in 2 (Amsterdam, 1955).

Goujon, Pierre, "Les Salons de 1909," *Gazette des Beaux-Arts*, 4th ser. 1 (June 1909): 496–522; and 2 (September 1909): 236–61.

Gourmont, Rémy de, "Note sur Claude Monet," *La Vogue*, 15 January 1901.

———, "Note sur Claude Monet," *L'Art Moderne*, 28 July 1901, pp. 254–55.

———, *Promenades philosophiques* (Paris, 1905).

———, *Le Chemin de velours: Nouvelles dissociations d'idées* (Paris, 1911).

———, *La Culture des idées* (Paris, 1916).

———, *Divertissements: Poèmes en vers* (Paris, 1919).

Graham, Joseph F., ed., *Difference in Translation* (Ithaca, 1985).

Grandmougin, Charles, *Nouvelles Poésies* (Paris, 1881).

Grappe, Georges, *Claude Monet* (Paris, n.d. [1912]).

———, "Chez Claude Monet," *L'Opinion*, 16 October 1920, pp. 442–43.

Grünberger, Béla, *Narcissism: Psychoanalytic Essays*, trans. Joyce S. Diamanti (New York, 1979).

Guigou, Paul, "L'Art en 1885: Exposition internationale—Le Salon—Les Indépendants," *La Revue Moderniste* 5 (June 1885): 6–9.

Guillemot, Maurice, "Claude Monet," *Revue Illustrée* 13 (15 March 1898): n. pag.

Gustave Courbet (1819–77) (Paris, 1977–78).

Guyaux, André, "Narcisse au crépuscule," in *Fins de Siècle: Terme— Evolution—Révolution?*, ed. Gwenhaël Ponnau (Toulouse, 1989).

Guyon-Vérax, A. E., "Exposition Claude Monet, galeries Durand-Ruel," *Journal des Artistes*, 9 December 1900, p. 3314.

Habermas, Jürgen, "Modernity versus Postmodernity" (1981), in *Postmodern Perspectives: Issues in Contemporary Art*, ed. Howard Risatti (Englewood Cliffs, N.J., 1990), pp. 54–66.

Hadot, Pierre, "Le mythe de Narcisse et son interprétation par Plotin," *Nouvelle Revue de Psychanalyse*, special number *Narcisses*, no. 13 (Spring 1976): 81–108.

Hamilton, Victoria, *Narcissus and Oedipus: The Children of Psychoanalysis* (London, 1982).

Hartley, Anthony, trans. and ed., *Mallarmé* (Harmondsworth, 1965).

H[éela], P[ierre], "L'Exposition internationale de la rue de Sèze," *Le Journal des Arts*, 7 June 1887.

Henkel, Arthur, and Albrecht Schöne, eds., *Emblemata: Handbuch zur Sinnbildkunst des XVI. und XVII. Jahrhunderts* (Stuttgart, 1967).

Hertz, Neil, "A Reading of Longinus," *Critical Inquiry* 9 (March 1983): 579–96.

Holland, Eugene, "On Narcissism from Baudelaire to Sartre: Ego-Psychology

and Literary History," in *Narcissism and the Text: Studies in Literature and the Psychology of Self,* ed. Lynne Layton and Barbara Ann Schapiro (New York, 1986), pp. 149–69.

Hoschedé, Jean-Pierre, *Claude Monet, ce mal connu: Intimité familiale d'un demi-siècle à Giverny de 1883 à 1926,* 2 vols. (Geneva, 1960).

Houssaye, Arsène, *Histoire de l'art français* (Paris, 1860).

——, "Les Artistes contemporains: Souvenirs du Salon de 1877," *L'Artiste,* 1 September 1877, p. 170.

Houssaye, Henry, "Le Salon de 1877: La Grande Peinture," *Revue des Deux Mondes,* 3rd ser. 21 (1 May 1877): 581–613.

Huysmans, Joris-Karl, "L'Exposition internationale de la rue de Sèze," *La Revue Indépendante de Littérature et d'Art,* n.s. 3 (June 1887): 352–53.

——, *L'Art Moderne* (Paris, 1929).

Jallat, Jeannine, *Introduction aux figures valéryennes (imaginaire et théorie)* (Pisa, 1982).

Janet, Pierre, *L'Automatisme psychologique* (Paris, 1889).

Janin, Clément, "Claude Monet," *L'Estafette,* 10 March 1892.

Javel, Firmin, "Claude Monet," *Gil Blas,* 2 March 1892.

Jean-Aubry, Georges, *Eugène Boudin: La Vie et l'oeuvre d'après les lettres et les documents inédits* (Paris, 1968).

J[eanniot], G[eorges], "Notes sur l'art: Claude Monet," *La Cravache Parisienne,* 23 June 1888.

Johnson, Barbara, *The Critical Difference: Essays in the Contemporary Rhetoric of Reading* (Baltimore, 1980).

Johnson, Cyraina E., "The Echo of Narcissus: Anxiety, Language, and Reflexivity in 'Envois,'" *International Studies in Philosophy* 22 (1990): 37–50.

Jouanny, Robert A., *Jean Moréas: Ecrivain français* (Paris, 1969).

Jourdain, Frantz, "Claude Monet: Exposition du boulevard Montmartre," *La Revue Indépendante de Littérature et d'Art,* n.s. 10 (March 1889): 513–18.

Joyes, Claire, *Claude Monet: Life at Giverny* (New York, 1985).

Jullian, Philippe, *Jean Lorrain ou le satiricon 1900* (Paris, 1974).

Kahn, Gustave, "La Vie artistique," *La Vie Moderne* 9 (21 May 1887): 328–29.

Kahn, Maurice, "Le Jardin de Claude Monet," *Le Temps,* 7 June 1904.

Kant, Immanuel, *Critique of Judgment,* trans. J. H. Bernard, in *Critical Theory since Plato,* ed. Hazard Adams (New York, 1981).

Klein, Melanie, Paula Heimann, and R. E. Money-Kyrle, eds., *New Directions in Psycho-Analysis* (London, 1955).

Knoespel, Kenneth J., *Narcissus and the Invention of Personal History* (New York, 1985).

Krauss, Rosalind, "Antivision," *October,* no. 36 (Spring 1986): 147–54.

Kristeva, Julia, *Tales of Love,* trans. Leon S. Roudiez (New York, 1987).

Krumbiegel, Helga Esselborn, "Das Narziss-Thema in der symbolistischen Lyrik," *Arcadia: Zeitschrift für vergleichende Literaturwissenschaft* 5 (1980): 278–94.

Labarrière, Paul, "Exposition de Claude Monet," *Journal des Artistes,* 16 March 1883.

Lacan, Jacques, *Ecrits: A Selection,* trans. Alan Sheridan (New York, 1977).

————, *The Four Fundamental Concepts of Psycho-Analysis,* trans. Alan Sheridan (New York, 1978).

————, *The Seminar of Jacques Lacan: Book I, Freud's Papers on Technique 1953–1954,* trans. John Forrester and ed. Jacques-Alain Miller (New York, 1991).

Lagrange, Léon, "Bulletin mensuel," *Gazette des Beaux-Arts,* 1st ser. 19 (July 1865): 99–104.

Lamartine, Alphonse de, *Oeuvres poétiques,* ed. Marius-François Guyard (Paris, 1963).

Langer, Ullrich, "Ronsard's 'La Mort de Narcisse': Imitation and the Melancholy Subject," *French Forum* 9 (January 1984): 5–18.

Laplanche, J., and J. B. Pontalis, *The Language of Psycho-Analysis* (1967), trans. Donald Nicholson-Smith (New York, 1973).

Larousse, Pierre, *Grand Dictionnaire universel du XIXe siècle,* 15 vols. (Paris, 1866–76).

Lasch, Christopher, *The Culture of Narcissism: American Life in an Age of Diminishing Expectations* (New York, 1979).

Latour-Marliac, Bory, *Notice sur les nymphaea et nelumbium rustiques: Leur culture et celle d'autres plantes aquatiques* (Temple-sur-Lot, 1888).

Le Fustec, J., "L'Exposition Monet–Rodin," *La République Française,* 28 June 1889.

Le Roux, Hugues, "Silhouettes parisiens: L'Exposition de Claude Monet," *Gil Blas,* 3 March 1889.

Leclercq, Julien, "Galerie Georges Petit," *La Chronique des Arts et de la Curiosité,* 25 February 1899, p. 70.

————, " 'Le Bassin aux Nymphéas' de Claude Monet," *La Chronique des Arts et de la Curiosité,* 1 December 1900, pp. 363–64.

Lecomte, Georges, *L'Art impressionniste d'après la collection privée de M. Durand-Ruel* (Paris, 1892).

————, "Des tendances de la peinture moderne," *L'Art Moderne,* 14 February 1892, pp. 49–51; 21 February 1892, pp. 57–58; and 28 February 1892, pp. 65–68.

————, "Peupliers de M. Claude Monet," *Art et Critique* 4 (5 March 1892): 124–25.

————, "M. Claude Monet," *Le Gaulois,* 16 June 1898 (supplement).

————, "Exposition Claude Monet," *Revue Populaire des Beaux-Arts* 2 (25 June 1898): 58.

Leroy, Louis, "L'Exposition des impressionnistes," *Le Charivari,* 25 April 1874.

————, "Beaux-Arts," *Le Charivari,* 17 April 1879.

Levine, Steven Z., "Monet's *Cabane du Douanier,*" *Fogg Art Museum Annual Report 1971–72* (Cambridge, Mass., 1975), pp. 32–44.

————, "Monet's Pairs," *Arts Magazine* 49 (June 1975): 72–75.

————, *Monet and His Critics* (New York, 1976).

————, "Décor/Decorative/Decoration," *Arts Magazine* 51 (February 1977): 136–39.

————, "Monet, Lumière, and Cinematic Time," *Journal of Aesthetics and Art Criticism* 36 (Summer 1978): 441–47.

————, "The Window Metaphor and Monet's Windows," *Arts Magazine* 54 (November 1979): 98–104.

————, "The 'Instant' of Criticism and Monet's Critical Instant," *Arts Magazine* 55 (March 1981): 114–21.

————, "Monet, Fantasy, and Freud" and "Monet, Madness, and Melancholy," in *Psychoanalytic Perspectives on Art,* ed. Mary Mathews Gedo, 3 vols. (Hillsdale, N.J., 1985–88), 1: 29–55; 2: 111–32.

————, "Seascapes of the Sublime: Vernet, Monet, and the Oceanic Feeling," *New Literary History* 16 (Winter 1985): 377–400.

————, "Monet's Series: Repetition, Obsession," *October,* no. 37 (Summer 1986): 65–75.

————, "To See or Not to See: The Myth of Diana and Actaeon in the Eighteenth Century," in *The Loves of the Gods: Mythological Painting from Watteau to David,* ed. Colin Bailey (Fort Worth, 1992), pp. 73–95.

————, *Claude Monet* (New York, 1994).

————, "Manet's Man Meets the Gleam of Her Gaze: A Psychoanalytic Novel," in *Current Methodologies: Twelve Approaches to Manet's "Bar at the Folies-Bergère,"* ed. Bradford R. Collins (Princeton, forthcoming).

Levitine, George, "Vernet Tied to a Mast in a Storm: The Evolution of an Episode of Art Historical Romantic Folklore," *Art Bulletin* 49 (1967): 93–100.

Lhote, André, "Manet et Picasso," *Nouvelle Revue Française* 39 (July-December 1932): 285–92.

————, *Les Invariants plastiques* (Paris, 1967).

Longinus, *On the Sublime,* trans. W. R. Roberts, in *Critical Theory since Plato,* ed. Hazard Adams (New York, 1981).

Lorrain, Jean, *L'Ombre ardente* (Paris, 1897).

Lostalot, Alfred de, "Exposition des oeuvres de M. Claude Monet," *Gazette des Beaux-Arts,* 2nd ser. 27 (April 1883): 342–48.

———, "Exposition internationale de peinture et de sculpture," *Gazette des Beaux-Arts,* 2nd ser. 35 (June 1887): 522–27.

Malfilâtre, Jacques-Charles-Louis, *Poésies,* ed. L. Derome (Paris, 1884).

Mallarmé, Stéphane, *Divagations* (Paris, 1897).

———, *Oeuvres complètes,* ed. Henri Mondor and G. Jean-Aubry (Paris, 1945).

———, *Correspondance,* ed. Henri Mondor and Lloyd J. Austin, 11 vols. (Paris, 1959–84).

Mantz, Paul, "Le Salon de 1863," *Gazette des Beaux-Arts,* 1st ser. 15 (July 1863): 32–64.

———, "Salon de 1865," *Gazette des Beaux-Arts,* 1st ser. 19 (July 1865): 5–42.

———, "Salon de 1872," *Gazette des Beaux-Arts,* 2nd ser. 5 (June 1872): 449–78.

———, "L'Exposition des peintres impressionnistes," *Le Temps,* 22 April 1877.

Marlais, Michael, *Conservative Echoes in "Fin-de-siècle" Parisian Art Criticism* (University Park, Pa., 1992).

Martet, Jean, *Clemenceau peint par lui-même* (Paris, 1929).

Marx, Roger, "Les 'Nymphéas' de M. Claude Monet," *Gazette des Beaux-Arts,* 4th ser. 1 (June 1909): 523–31.

———, *Maîtres d'hier et d'aujourd'hui* (Paris, 1914).

Masson, André, "Monet le fondateur," *Verve* 7, nos. 27–28 (December 1952): 68.

Mathews, Patricia Townley, *Aurier's Symbolist Art Criticism and Theory* (Ann Arbor, 1986).

Matisse, Henri, "Notes d'un peintre," *La Grande Revue* 52 (25 December 1908): 731–45.

Mauclair, Camille. *See* Faust, Séverin.

Maupassant, Guy de, "La Vie d'un paysagiste," *Gil Blas,* 28 September 1886.

———, *Sur l'eau* (Paris, 1888).

———, *Etudes, chroniques et correspondance,* ed. René Dumesnil (Paris, 1938).

Maurras, Charles, *L'Avenir de l'intelligence* (Paris, 1905).

Meusnier, Georges, "Notule: Aux Galeries Durand-Ruel: Notre 'Claude': 'Les Nymphéas,' paysages d'eau," *Journal des Arts,* 16 May 1909, p. 6085.

Meyer, Louis [Louis Vauxcelles], "Le Salon d'Automne," *Gil Blas,* 17 October 1905.

———, "Chez les peintres: Un Après-midi chez Claude Monet," *L'Art et les Artistes,* December 1905, pp. 85–90.

———, "Claude Monet," *L'Art Moderne,* 28 October 1906, pp. 339–40; and 4 November 1906, pp. 347–48.

————, "Les 'Nymphéas' de Claude Monet, *Gil Blas*, 8 May 1909.

Michael, Helen Cecelia De Silver Abbot [Celen Sabbrin], *Science and Philosophy in Art* (New York, 1886).

Michelet, Jules, *La Mer* (Paris, 1861).

Mille, Pierre, "Ecrits sur l'eau," *Le Temps*, 13 May 1909.

M[iomandre], F[rancis de], "Le Salon des Artistes Français" and "Les Nymphéas, série de paysages d'eau, par Claude Monet," *L'Art et les Artistes*, July 1909, pp. 187–92.

Mirbeau, Octave, "Notes sur l'art: Claude Monet," *La France*, 21 November 1884.

————, "Chronique parisienne: Kervilahouen," *La Revue Indépendante de Littérature et d'Art*, n.s. 2 (January 1887): 25–26.

————, "L'Exposition internationale de la rue de Sèze," *Gil Blas*, 13 May 1887.

————, "Le Chemin de la Croix," *Le Figaro*, 16 January 1888.

————, "Claude Monet," in *Exposition Claude Monet–Auguste Rodin: Galerie Georges Petit* (Paris, 1889).

————, "Claude Monet," *Le Figaro*, 10 March 1889.

————, "Auguste Rodin," *L'Echo de Paris*, 25 June 1889.

————, "Claude Monet," *L'Art dans les Deux Mondes*, 7 March 1891, pp. 183–85.

————, *Le Journal d'une femme de chambre* (Paris, 1900).

————, *Claude Monet: Vues de la Tamise à Londres* (Paris, 1904).

————, *Des artistes*, 2 vols. (Paris, 1922).

————, *Correspondance avec Claude Monet*, ed. Pierre Michel and Jean-François Nivet (Tusson, 1990).

Montaiglon, Anatole de, "La Sculpture à l'exposition universelle," *Gazette des Beaux-Arts*, 2nd ser. 18 (September 1878): 327–46.

Morgan, Jean, "Causeries chez quelques maîtres: M. Claude Monet," *Le Gaulois*, 5 May 1909.

Morice, Charles, "Vues de la Tamise à Londres, par Claude Monet," *Mercure de France*, n.s. 50 (June 1904): 795–97.

————, "Art Moderne: Claude Monet," *Mercure de France*, n.s. 80 (16 July 1909): 347.

Moutote, Daniel, *Egotisme français moderne: Stendhal, Barrès, Valéry, Gide* (Paris, 1980).

Muhlfeld, Lucien, "Chronique de la littérature: Eleusis," *La Revue Blanche* 6 (March 1894): 260–63.

Musée Gustave Moreau: Catalogue des peintures, dessins, cartons, aquarelles (Paris, 1974).

Musset, Alfred de, *Oeuvres complètes*, ed. Philippe van Tiegham (Paris, 1963).

Natanson, Thadée, "Expositions: I. M. Claude Monet . . . ," *La Revue Blanche* 8 (1 June 1895): 521–23.

Neuhaus, Kasper, "Philippe Smit: Unknown Genius" (1955), typescript, Museum of Fine Arts, Springfield, Mass.

Neveux, Pol, "Guy de Maupassant: Etude" (1907), in Guy de Maupassant, *Boule de suif* (Paris, 1926), pp. xv–xc.

Nouvet, Claire, "An Impossible Response: The Disaster of Narcissus," *Yale French Studies*, no. 79 (1991): 103–34.

Ovid, *Metamorphoses,* trans. Frank Justus Miller, 2 vols. (London, 1925).

———, *Metamorphoses,* trans. Rolfe Humphries (Bloomington, 1955).

P., J., "Beaux-Arts: L'Exposition des artistes indépendants," *Le Petit Parisien,* 4 March 1882.

Panofsky, Erwin, "Imago Pietatis: Ein Beitrag zur Typengeschichte des 'Schmerzensmanns' und der 'Maria Mediatrix,' " in *Festschrift für Max J. Friedländer zum 60. Geburtstage* (Leipzig, 1927), pp. 261–308.

Payne, Michael, *Reading Theory: An Introduction to Lacan, Derrida, and Kristeva* (Oxford, 1993).

Pays, Marcel, "Un Grand Maître de l'impressionnisme: Une Visite à M. Claude Monet dans son ermitage de Giverny," *Excelsior,* 26 January 1921.

Philippe Smit (Springfield, Mass., 1957).

Pilon, Edmond, "L'Année poétique," *L'Ermitage,* December 1895.

Pissarro, Camille, *Lettres à son fils Lucien,* ed. John Rewald (Paris, 1950).

Plancoët, François-H. [de], "Silhouette artistique: Claude Monet," *Journal des Artistes,* 12 June 1898, p. 2314.

Poe, Edgar Allan, *Complete Poems,* ed. Louis Untermeyer (New York, 1943).

Poignard, Jules [Montjoyeux], "Chroniques parisiennes: Les Indépendants," *Le Gaulois,* 18 April 1879.

Pollock, Griselda, *Vision and Difference: Femininity, Feminism, and Histories of Art* (London, 1986).

Poulain, Gaston, *Bazille et ses amis* (Paris, 1932).

Proust, Marcel, *Contre Sainte-Beuve, précédé de Pastiches et mélanges et suivi de Essais et articles,* ed. Pierre Clarac and Yves Sandre (Paris, 1971).

———, *La Prisonnière* (1922), in *A la recherche du temps perdu,* ed. Jean-Yves Tadié, 4 vols. (Paris, 1987–89).

Raitif de la Bretonne [pseud.], "Pall-Mall semaine," *Le Journal,* 7 June 1898.

Ray, William, *Story and History: Narrative Authority and Social Identity in the Eighteenth-Century French and English Novel* (Cambridge, Mass., 1990).

Reclus, Elisée, "L'Océan: Etude de physique maritime," *Revue des Deux Mondes,* 2nd ser. 70 (15 August 1867): 963–93.

Régamey, Raymond, "Oeuvres de Claude Monet," *Beaux-Arts* 5 (15 March 1927): 88–90.

Régis, E., and A. Hesnard, *La Psychoanalyse des névroses et des psychoses: Ses Applications médicales et extra-médicales* (Paris, 1914).

Régnier, Henri de, *Les Jeux rustiques et divins* (Paris, 1897).

———, *Vestigia Flammae: Poèmes* (Paris, 1921).

Régnier, Marie-Louise-Antoinette de [Gérard d'Houville], "Lettres à Emilie," *Le Temps*, 18 May 1909.

———, *Les Poésies* (Paris, 1931).

R[enan], A[ry], "Cinquante Tableaux de M. Claude Monet," *La Chronique des Arts et de la Curiosité*, 18 May 1895, p. 186.

———, "Une collection de tableaux modernes," *Gazette des Beaux-Arts*, 3rd ser. 17 (January 1897): 73–80.

Renard, Jules, *Journal 1887–1910*, ed. Léon Guichard and Gilbert Sigaux (Paris, 1965).

Renoir, Edmond, "Les Impressionnistes," *La Presse*, 11 April 1879.

Renouvier, Charles, *Histoire et solution des problèmes métaphysiques* (Paris, 1901).

Reutersvärd, Oscar, "The 'Violettomania' of the Impressionists," *Journal of Aesthetics and Art Criticism* 9 (December 1950): 106–10.

Richepin, Jean, *La Mer* (Paris, 1886).

Rilke, Rainer Maria, *Sämtliche Werke*, 5 vols. (Wiesbaden, 1955–57).

Ripa, Cesare, *Iconologie*, trans. Jean Baudouin, 2 vols. in 1 (Paris, 1644; rpt. New York, 1976).

Robert, Paul [Eaque], "Claude Monet," *Le Journal des Arts*, 6 July 1888.

Robert-Kemp, F., "Un Peu d'Art," *L'Aurore*, 11 May 1909.

Robidoux, Réjean, *Le Traité du Narcisse (Théorie du Symbole) d'André Gide* (Ottawa, 1978).

Roche, Denis, *Autoportraits photographiques 1898–1981: Brève rencontre (l'autoportrait en photographie)* (Paris, 1981).

Rodenbach, Georges, *Les Vies encloses: Poème* (Paris, 1896).

———, *L'Elite: Ecrivains, orateurs sacrés, peintres, sculpteurs* (Paris, 1899).

Roger-Milès, Léon, "Beaux-Arts: Claude Monet," *L'Evénement*, 15 March 1889.

Rollinat, Maurice, *Les Névroses* (Paris, 1883).

———, *L'Abîme* (Paris, 1886).

———, *La Nature: Poésie* (Paris, 1892).

———, *Paysages et paysans: Poésies* (Paris, 1899).

———, *Fin d'oeuvre* (Paris, 1919).

———, *Oeuvres*, ed. Régis Miannay, 2 vols. (Paris, 1971–72).

Rorty, Richard, *Philosophy and the Mirror of Nature* (Princeton, 1979).

Roskill, Mark, *The Interpretation of Pictures* (Amherst, Mass., 1989).

Rouart, Denis, ed., *Correspondance de Berthe Morisot avec sa famille et ses amis Manet, Puvis de Chavannes, Degas, Monet, Renoir et Mallarmé* (Paris, 1950).

Rousset, Jean, *L'Intérieur et l'extérieur: Essais sur la poésie et sur le théâtre au XVIIe siècle* (Paris, 1968).

———, ed., *Anthologie de la poésie baroque française,* 2 vols. (Paris, 1961).

Royère, Jean, *Poésies* (Amiens, 1924).

Sandler, Joseph, Ethel Spector Person, and Peter Fonagy, eds., *Freud's "On Narcissism: An Introduction"* (New Haven, 1991).

Santos, Raoul dos, "Exposition Claude Monet," *Journal des Artistes,* 8 July 1888, p. 223.

Sarradin, Edouard, "Les 'Nymphéas' de Claude Monet," *Journal des Débats,* 12 May 1909.

Saunier, Charles, "Claude Monet," *La Revue Blanche* 23 (15 December 1900): 624.

Schapira, M. C., *Le Regard de Narcisse: Romans et nouvelles de Théophile Gautier* (Lyons, 1984).

Scheffer, Robert, "Le Prince Narcisse: Monographie passionnelle," *La Revue Blanche* 11 (15 September 1896): 244–54.

Schopenhauer, Arthur, *The World as Will and Idea* (1819; rev. ed. 1844), trans. R. B. Haldane and John Kemp, in *Philosophies of Art and Beauty: Selected Readings in Aesthetics from Plato to Heidegger,* ed. Albert Hofstadter and Richard Kuhns (Chicago, 1964).

Séailles, Gabriel, "L'Impressionnisme," in *L'Almanach du Bibliophile pour l'année 1898* (Paris, 1898), pp. 47–51.

Sée, Edmond, "Devant les paysages d'eau," *Gil Blas,* 20 May 1909.

Segal, Naomi, *Narcissus and Echo: Women in the French "Récit"* (Manchester, U.K., 1988).

Shiff, Richard, *Cézanne and the End of Impressionism: A Study of the Theory, Technique, and Critical Evaluation of Modern Art* (Chicago, 1984).

Silvestre, Armand, *Galerie Durand-Ruel: Recueil d'estampes gravées à l'eau forte* (Paris, 1873).

———, "Le Monde des Arts: Les Indépendants," *La Vie Moderne,* 24 April 1879, p. 38.

———, "Exposition de M. Claude Monet," *La Vie Moderne,* 17 March 1883, pp. 177–78.

———, *Le Nu au Salon des Champs Elyseés* (Paris, 1891).

Silvestre, Théophile, "Courbet d'après nature" (1856), in *Courbet raconté par lui-*

même et par ses amis, ed. Pierre Courthion, 2 vols. (Geneva, 1948–50), 1: 25–62.

Simmons, Carolyn Josenhans, "An Echo in the Text: The Narcissus Poems of Paul Valéry," *French Literature Series* 18 (1991): 77–86.

Société Nationale des Beaux-Arts, *Catalogue illustré du Salon de 1909* (Paris, 1909).

Solomon, Robert C., *Continental Philosophy since 1750: The Rise and Fall of the Self* (Oxford, 1988).

Spate, Virginia, *Claude Monet: Life and Work* (New York, 1992).

Spector, Jack J., "Delacroix: A Study of the Artist's Personality and Its Relation to His Art," in *Psychoanalytic Perspectives on Art,* ed. Mary Mathews Gedo, 3 vols. (Hillsdale, N.J., 1985–88), 2: 3–68.

Staller, Natasha, "Early Picasso and the Origins of Cubism," *Arts Magazine* 61 (September 1986): 80–91.

Starobinski, Jean, "Jean-Jacques Rousseau: Reflet, réflexion, projection," *Cahiers de l'Association Internationale des Etudes Françaises,* no. 11 (May 1959): 217–30.

Stern, J. P., *Friedrich Nietzsche* (Harmondsworth, 1979).

Stokes, Adrian, "Form in Art: A Psychoanalytic Interpretation," *Journal of Aesthetics and Art Criticism* 18 (1959–60): 193–203.

Strauss, Walter A., "Speculations on Narcissus in Paris," *The Comparatist* 10 (May 1986): 13–29.

Suarez, Georges, *Soixante Années d'histoire française: Clemenceau dans l'action,* 2 vols. (Paris, 1932).

Swain, Sally, *Great Housewives of Art* (Harmondsworth, 1988).

Taboureux, Emile, "Claude Monet," *La Vie Moderne,* 12 June 1880, pp. 380–82.

Tardieu, Charles, "Le Salon de Paris 1877: Les Récompenses," *L'Art* 9, no. 2 (1877): 274–78.

Tarn, Pauline M. [Renée Vivien], *Poésies complètes,* ed. Jean-Paul Goujon (Paris, 1986).

Taylor, Charles, *Sources of the Self: The Making of the Modern Identity* (Cambridge, Mass., 1989).

Thiébault-Sisson, [François], "L'Exposition Claude Monet," *Le Temps,* 12 May 1895.

———, "Choses d'art: Les Derniers Travaux de Claude Monet," *Le Temps,* 8 May 1909.

———, "Claude Monet," *Le Temps,* 6 April 1920.

———, "Un Don de M. Claude Monet à l'état," *Le Temps,* 14 October 1920.

———, "Autour de Claude Monet: Anecdotes et souvenirs—II," *Le Temps,* 8 January 1927.

Thoré, Théophile, *Salons de T. Thoré 1844, 1845, 1846, 1847, 1848* (Paris, 1868).

———— [Willem Bürger], *Salons (1861 à 1868),* 2 vols. (Paris, 1870).

Trevise, Duc de, "Le Pèlerinage de Giverny," *La Revue de l'Art Ancien et Moderne* 51 (January-May 1927): 42–50, 121–34.

Tucker, Paul, *Monet at Argenteuil* (New Haven, 1982).

Valenciennes, Pierre-Henri [de], *Elémens de perspective pratique, à l'usage des artistes, suivis de réflexions et conseils à un éleve sur la peinture et particulièrement sur le genre du paysage* (Paris, 1800).

Valéry, Paul, "Narcisse parle," *La Conque* 1 (15 March 1891): 4–5.

————, *Etudes pour Narcisse* (Paris, 1927).

————, *Mélange de prose et de poësie: Album plus ou moins illustré d'images sur cuivre de l'auteur* (Paris, 1939).

————, *La Cantate du Narcisse* (Paris, 1941).

————, "Sur les 'Narcisse'" (19 September 1941), *Cahiers du Sud,* special number *Paul Valéry vivant,* 1946, pp. 283–87.

————, *Lettres à quelques uns* (Paris, 1952).

————, *Oeuvres,* ed. Jean Hytier, 2 vols. (Paris, 1957–60).

————, *Cahiers,* ed. Judith Robinson, 2 vols. (Paris, 1973–74).

Vaudoyer, Jean-Louis, "Petites expositions: Claude Monet (Galerie Durand-Ruel)," *La Chronique des Arts et de la Curiosité,* 15 May 1909, p. 159.

Verhaeren, Emile, "Claude Monet–Auguste Rodin," *L'Art Moderne,* 7 July 1889, pp. 209–11 (unsigned).

————, "Art moderne," *Mercure de France,* n.s. 37 (February 1901): 544–46.

————, *Sensations* (Paris, 1927).

————, *Les Heures du soir, précédés de Les Heures claires, Les Heures d'après-midi* (Paris, 1929).

Verlaine, Paul, *Oeuvres poétiques complètes,* ed. Y. G. Le Dantec and Jacques Borel (Paris, 1962).

Viaud, Julien [Pierre Loti], *Pêcheur d'Islande* (Paris, 1924).

Vidal, Henry, "L'Enterrement d'un peintre," *Le Figaro,* 9 December 1926.

Villiers de l'Isle-Adam, Jean-Marie-Mathias-Philippe-Auguste, *Tribulat Bonhomet,* ed. P. G. Castex and J. M. Bellefond (Paris, 1967; orig. ed. 1887).

Vinge, Louise, *The Narcissus Theme in Western European Literature up to the Early Nineteenth Century* (Lund, 1967).

Walch, G., ed., *Anthologie des poètes français contemporains: Le Parnasse et les écoles postérieures au Parnasse (1866–1906),* 3 vols. (Paris, n.d. [1906–7]).

Wattenmaker, Richard J., et al., *Great French Paintings from the Barnes Foundation* (New York, 1993).

Weber, Samuel, *The Legend of Freud* (Minneapolis, 1982).

Whistler, James McNeill, *The Gentle Art of Making Enemies* (New York, 1890).

Wildenstein, Daniel, *Claude Monet: Biographie et catalogue raisonné,* 5 vols. (Paris, 1975–91).

Wolff, Albert, "L'Exposition internationale," *Le Figaro,* 15 May 1885.

————, "Exposition internationale," *Le Figaro,* 19 June 1886.

Wormser, André, "Claude Monet et Georges Clemenceau: Une Singulière Amitié," in *Aspects of Monet: A Symposium on the Artist's Life and Times,* ed. John Rewald and Frances Weitzenhoffer (New York, 1984), pp. 188–217.

Yetton, Christopher, "The Pool of Narcissus," *Royal Academy Magazine* (1990), in *The Impressionists: A Retrospective,* ed. Martha Kapos (New York, 1991), pp. 372–74.

Zola, Emile, *La Curée* (1871) and *La Faute de l'abbé Mouret* (1875), in *Les Rougon-Macquart,* ed. Henri Mitterand, 5 vols. (Paris, 1960–67).

————, *Le Bon Combat: De Courbet aux impressionnistes,* ed. Jean-Paul Bouillon (Paris, 1974).

Zürcher, Hanspeter, *Stilles Wasser: Narziss und Ophelia in der Dichtung und Malerei um 1900* (Bonn, 1975).

1. From the library of Conway Zirkle. 2. Courtesy of the Museum of Fine Arts, Boston, Babcock Bequest. 4. Courtesy of Noortman (London) Ltd. 5. Norton Simon Foundation, Pasadena. 6. ©1970 Inventaire Général— SPADEM. 8. ©Cliché du M.B.A. de Bordeaux. 11. Norton Simon Foundation, Pasadena. 12. ©Ole Woldbye. 17. Courtesy of the Trustees, The National Gallery, London. 20. Photo: Schweizerisches Institüt für Kunstwissenschaft, Zurich. 23. Munger Fund. 25. Courtesy of Boston Athenaeum. 27. Collection Rudolf Staechelin, Basel. 28. Mr. and Mrs. Lewis Larned Coburn Memorial Collection 1933.439, photograph ©1993, The Art Institute of Chicago, all rights reserved. 31. Courtesy of the Fogg Art Museum, Harvard University Art Museums, Cambridge, Mass., Bequest of Meta and Paul J. Sachs. 35. Courtesy of the Felton Bequest 1913, National Gallery of Victoria, Melbourne. 38. Chester Dale Collection, ©1993, National Gallery of Art, Washington. 39. Mr. and Mrs. Potter Palmer Collection, 1922.426, photograph ©1993, The Art Institute of Chicago, all rights reserved. 41. Courtesy of the Museum of Fine Arts, Boston, Juliana Cheney Edwards Collection. 42. Purchased with funds from the State of North Carolina. 43. The Metropolitan Museum of Art, New York, all rights reserved. 51. Oeffentliche Kunstsammlung Basel, Kunstmuseum, Dr. h.c. Emile Dreyfus Foundation. Photo by Martin Bühler. 52. Courtesy of the Museum of Fine Arts, Boston, Gift of Samuel Dacre Bush. 53. Bequest of Charlotte Dorrance Wright. 56. William L. Elkins Collection. 57. Courtesy of the Museum of Fine Arts, Boston, Juliana Cheney Edwards Collection. 58. Courtesy of the Museum of Fine Arts, Boston, Denman Waldo Ross Collection. 62. Mr. and Mrs. Potter Palmer Collection, 1922.427, photograph ©1993, The Art Institute of Chicago, all rights reserved. 63. Courtesy Scala/Art Resource, New York. 65. Assis Chateaubriand, São Paulo, photograph by Luiz Hossaka. 73. ©1995 by The Barnes Foundation, Merion, Pa. 75. Bequest of Mrs. Fred Hathaway Bixby. 76. Courtesy of Christie's Images, London. 79. The Metropolitan Museum of Art, New York, all rights reserved. 80. Given by Chester Dale. 81. Bequest of Anne Thomson as a memorial to her father and mother. 85. Photograph by Ken Burris. 86. The Metropolitan Museum of Art, New York, all rights reserved. 89. Photograph by Ken Burris. 92. Courtesy of the Fogg Art Mu-

seum, Harvard University Art Museums, Cambridge, Mass., Bequest of Annie Swan Coburn. 93. Courtesy of the Fogg Art Museum, Harvard University Art Museums, Cambridge, Mass., Gift of Ella Milbank Foshay. 94. ©1983 Sotheby's Inc. 97. Courtesy of the Museum of Fine Arts, Boston, Juliana Cheney Edwards Collection. 98. Courtesy of the Museum of Fine Arts, Boston, Gift of Mrs. W. Scott Fitz. 103. From the collection of William Church Osborn, Class of 1883, Trustee of Princeton University (1914–51), President of The Metropolitan Museum of Art (1941–47); gift of his family. 104. Mr. and Mrs. Carroll S. Tyson Collection. 106. Gift of Mr. Joseph Rubin. 107. John A. and Audrey Jones Beck Collection. 110. Gift of the Meadows Foundation, Inc. 126. Gift of the Reverend and Mrs. Theodore Pitcairn.